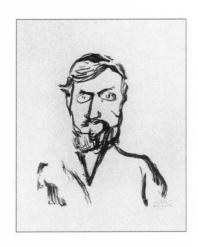

Matisse, My Portrait, 1900

ALSO BY HILARY SPURLING

~

Ivy: The Life of Ivy Compton-Burnett

Invitation to the Dance: A Guide to Anthony Powell's Dance to the Music of Time

Elinor Fettiplace's Receipt Book

Paul Scott: A Life

Paper Spirits: Collage Portraits by Vladimir Sulyagin

La Grande Thérèse: The Scandal of the Century

The Girl from the Fiction Department: A Portrait of Sonia Orwell

Matisse the Master: A Life of Henri Matisse: The Conquest of Colour, 1909–1954

THE UNKNOWN MATISSE

THE UNKNOWN MATISSE

A LIFE OF HENRI MATISSE: THE EARLY YEARS, 1869-1908

Hilary Spurling

THIS IS A BORZOI BOOK PUBLISHED BY ALFRED A. KNOPF

Copyright © 1998 by Hilary Spurling

Copyright © Succession H. Matisse/DACS London 1998 for all works by Henri Matisse
Copyright © Succession Picasso/DACS London 1998 for all works by Pablo Picasso
Copyright © ADAGP, Paris, and DACS London 1998 for all works by Antoine Bourdelle, Charles Camoin,
André Derain, Jules Flandrin, Maximilien Luce, Aristide Maillol, Henri Manguin,
Albert Marquet, Jean Puy, Paul Signac

Copyright © Les Héritiers Matisse, 1998, for all photographs from Archives Matisse, Paris
All rights reserved. Published in the United States by Alfred A. Knopf,
a division of Random House Inc., New York. Distributed by Random House, Inc., New York.

www.aaknopf.com

Knopf, Borzoi Books, and the colophon are registered trademarks of Random House, Inc.
Published in Great Britain by Hamish Hamilton, Ltd., London.

Library of Congress Cataloging-in-Publication Data Spurling, Hilary.

The unknown Matisse: a life of Henri Matisse: the early years, 1869–1908 / Hilary Spurling. —

1st ed.

р. *с*т.

Includes bibliographical references and index.

Contents: v. 1. 1869-1908.

ISBN 0-679-43428-3 (hardcover)

ISBN 0-375-71133-3 (paperback)

1. Matisse, Henri, 1869–1954. 2. Artists—France—Biography.

I. Title.

N6853.M33S68 1998

709'.2—dc21

[B] 97-46816 CIP

Manufactured in the United States of America

Published November 5, 1998

First Knopf Paperback Edition, November 2005

CONTENTS

Illustrations ix
Family Tree xvi
Preface xix

CHAPTER ONE · 1869—1881: Bohain-en-Vermandois 3

CHAPTER TWO · 1882—1891: Bohain and St-Quentin 33

CHAPTER THREE · 1891—1895: Paris 62

CHAPTER FOUR · 1895—1896: Belle-Ile-en-Mer 99

CHAPTER FIVE · 1897—1898: Paris, Belle-Ile and London 130

CHAPTER SIX · 1898—1899: Ajaccio and Toulouse 158

CHAPTER SEVEN · 1900—1902: Paris 191

CHAPTER EIGHT · 1902—1903: Paris and Bohain 236

CHAPTER NINE · 1904: St-Tropez 271

CHAPTER TEN · 1905: Collioure 298

CHAPTER ELEVEN · 1906—1907: Paris, Algeria and Collioure 339

Key to Notes 425 Notes 429

Index 465

CHAPTER TWELVE · 1907–1908: Paris, Collioure, Italy and Germany 377

~

AMP: Archives Matisse, Paris

Frontispiece: Matisse, My Portrait, ink on paper, 1900 (Private collection)

Title page: Figured silk gauze, woven in Bohain, late nineteenth century (Musée des Arts Décoratifs, Paris)

CHAPTER ONE

page 3 Anna and Hippolyte Henri Matisse (Courtesy AMP)

- 4 Matisse's birthplace in Le Cateau (Musée de l'Hospice Comtesse, Lille)
- 7 The seed-store in Bohain, where Matisse grew up (Coll. Georges Bourgeois)
- 9 German troops drawn up on the square in St-Quentin after the final French defeat in 1871 (Archives de la Ville de St-Quentin)
- Drill session for the boys of Bohain (Coll. Georges Bourgeois)
- 16 Matisse, Still Life with Earthenware Pot, oil on canvas, 1892 (Photo: courtesy AMP)
- Matisse, The Skein-winder from Picardy (La Dévideuse picarde), oil on canvas, 1903 (Courtesy AMP)
- 23 The Matisse family (with a young friend or cousin) outside the side entrance of the seed-store on the rue Peu d'Aise (All rights reserved)
- Emile Flamant, 1925: detail of a fresco in Bohain town hall (Photo: Coll. Mme Suzanne Manesse-Nambruide, Bohain; all rights reserved)
- 30 Street scene in Bohain (Coll. Georges Bourgeois)
- Donato the Hypnotist and Man-Tamer (photograph from *Le Fascination magnétique* by Edouard Cavailhon, Paris, 1882)

CHAPTER TWO

- Matisse and his mother, photographed by his uncle Henri Gérard at Ypres, 1887 (Courtesy AMP; all rights reserved)
- 35 Lycée Henri Martin in St-Quentin, engraved by Emile Ancelet (Archives de la Ville de St-Quentin; all rights reserved)
- Léon Bouvier, Swiss Chalet with Pine Trees, oil on canvas, 1890 (Coll. P. Bouvier)
- Matisse, Still Life with Books (My First Painting), oil on canvas, 1890 (Musée Matisse, Nice; photo courtesy AMP)
- 48 Maurice Quentin de La Tour, Self-portrait in Pastel, c. 1742 (Musée Antoine Lécuyer, St-Quentin, Aisne, France; photo: Bulloz, Paris)
- Matisse, sketch of the half-open door of Maître Derieux's office in St-Quentin (Private collection)
- Maurice Quentin Point, Portrait of Jules Degrave, lithograph, 1929 (Musée Antoine Lécuyer, St-Quentin, Aisne, France; all rights reserved)
- 52 Matisse, Iris, crayon, ink, and watercolour on paper, c. 1890 (Musée Matisse, Nice; photo: Ville de Nice, Service Photographique)

52 Israël Tavernier, Iris, 1890s: professional designer's motif for weaving, Bohain (Bibliothèque de la Ville de St-Quentin, Fonds Delplace)

Philibert Léon Couturier, Rooster and Hens on the Steps, oil on wood, n.d. (Musée Antoine

Lécuyer, St-Quentin, Aisne, France; photo: J. and S. Legrain)

57 Emmanuel Croizé, Spartan Girls Wrestling, oil on canvas, 1903 (whereabouts unknown; photo: © ND/Roger-Viollet, Paris)

CHAPTER THREE

- 62 Matisse at the Académie Julian with Emile Jean and Jules Petit, c. 1892 (Courtesy AMP)
- 64 William Bouguereau, Self-portrait, oil on canvas, 1895 (Koninklijk Museum voor Schone Kunsten, Antwerpen; photo: © A.C.L.–Bruxelles)
- 65 William Bouguereau, The Wasp's Nest (Le Guêpier), oil on canvas, 1892 (Private collection)
- Matisse, drawing of the death mask of Louis XV's gardener, 1891 (Musée Matisse, Le Cateau-Cambrésis; photo courtesy AMP)
- 70 Matisse, Standing Nude, pen and ink, 1892 (Musée Matisse, Le Cateau-Cambrésis; photo courtesy AMP)
- 71 Francisco de Goya y Lucientes, *Time*, or *The Old Women*, oil on canvas, c. 1808–12 (Musée des Beaux-Arts, Lille; photo: © RMN–P. Bernard)

78 Camille Joblaud (Courtesy AMP)

- 82 Gustave Moreau, Self-portrait, pen and ink, c. 1890s (Musée Gustave Moreau, Paris [Des. 12748]; photo: © RMN–R. G. Ojeda)
- 83 Gustave Moreau, *Hesiod and the Muse*, oil on canvas, 1891 (Musée d'Orsay, Paris; photo: © RMN–D. Arnaudet/G. Blot)

Moreau's students at the Ecole des Beaux-Arts, 1897 (Courtesy AMP)

- 91 Simon Bussy, Self-portrait, crayon on paper, c. 1895 (Private collection, all rights reserved; photo: © A. C. Cooper Ltd, London)
- 95 Henri Evenepoel, *La Petite Matisse*, oil on canvas, 1896 (Museum Dhondt-Dhaenens, Deurle, Belgium)
- 95 Matisse, Portrait Médallion 1, plaster cast of a bronze relief medallion, 1894 (Photo: Coll. M. Gueguen)

CHAPTER FOUR

- Matisse, photographed by Emile Wéry on Belle-Ile (All rights reserved; courtesy AMP)
- The port of Le Palais, on the wild coast of Belle-Ile (engraving from *Brittany and Its Byways*, Mrs. Bury Palliser, London, 1869)
- Emile Wéry, *Desperation*, engraving after a painting now lost, 1895 (whereabouts unknown, all rights reserved; photo: © Musée des Beaux-Arts de la Ville de Reims/Derleeschauwer)
- William Sylva: Mural depicting holiday painters outside the Hotel des Voyageurs at Pont-Croix in Brittany, 1897 (Photo: Coll. F. Decourchelles; all rights reserved)
- Henri Evenepoel, Self-portrait at the Easel, oil on canvas, 1895 (Musées Royaux des Beaux-Arts de Belgique, Brussels; photo: © A.C.L. Bruxelles)
- Henri Evenepoel, *The Cellar of the Soleil d'Or in the Latin Quarter*, oil on canvas, 1896 (Musées Royaux des Beaux-Arts de Belgique, Brussels; photo: © A.C.L. Bruxelles)

John Peter Russell's house on Belle-Ile (Coll. L. Garans)

124

John Peter Russell, 1888 (Courtesy Claude-Guy Onfray and John and Marianna Russell Association, 14 rue du Champ des vues, 22000 St-Brieuc, France)

Matisse, Breton Serving Girl (Clotilde), oil on canvas, 1896 (Private collection; photo courtesy AMP)

Matisse, The Open Door, Brittany, oil on canvas, 1896 (Private collection; photo courtesy AMP)

CHAPTER FIVE

- Henri Matisse at the time of his marriage, 1898 (Courtesy AMP)
- 130 Amélie Parayre at the time of her marriage, 1898 (Courtesy AMP)
- Matisse, Bussy Drawing in Matisse's Studio, oil on canvas, 1897 (Private collection; photo courtesy AMP)
- Camille Pissarro, Self-portrait, oil on canvas, 1903 (Tate Gallery, London)
- Vincent van Gogh, *Haystacks*, pen and ink on paper, 1888 (Photo: Marc Vaux, courtesy Pierre Matisse Foundation)
- The rocks near Goulphar painted by Monet, Russell and Matisse (Photo: Hilary Spurling)
- Matisse, Seascape, oil on canvas, 1897 (Photo courtesy AMP)
- John Peter Russell, *The Rocks at Belle-Ile*, oil on canvas, c. 1890 (Musée de Jacobins, Morlaix, all rights reserved; photo: Musée de Morlaix, G.P.O. Photographie)
- 142 Camille Joblaud (Courtesy AMP)
- Catherine Parayre (Courtesy AMP)
- 150 Amélie and Berthe Parayre (Courtesy AMP)
- 151 Armand Parayre (Coll. Gaetana Matisse)
- The Humbert family (Photo: © Jean-Loup Charmet, Paris)

CHAPTER SIX

- Gaston Vuillier, The Bay of Ajaccio, engraving, 1890 (from Les Iles Oubliées, Paris, 1890)
- The Villa de la Rocca and environs at the turn of the century (Coll. L. and J. Poncin)
- Matisse, Mme Matisse, pen, brush, and ink on paper, 1899 (Private collection; photo courtesy AMP)
- Vincent van Gogh, The Old Peasant, Patience Escalier, pen and ink on paper, 1888 (Photo: Marc Vaux, courtesy Pierre Matisse Foundation)
- Matisse, Toulouse, Pont des Demoiselles, pen and ink on paper, 1899 (Private collection; photo courtesy AMP)
- Paul Cézanne, *Three Bathers*, oil on canvas, c. 1879–82 (Ville de Paris, Musée du Petit Palais, Paris; photo: © Photothèque des Musées de la Ville de Paris/Pierrain)
- Frédéric Humbert in the studio run by Matisse's mother-in-law (Photo: © Jean-Loup Charmet, Paris)
- Matisse, Studio Interior, oil on canvas, c. 1899 (Coll. Musée Matisse, Le Cateau-Cambrésis)

CHAPTER SEVEN

- Matisse, Self-portrait, pen and ink on paper, c. 1900 (Private collection)
- Eugène Carrière and his family, photographed by Dornac, c. 1901 (All rights reserved; photo: © Archives Larousse/Giraudon, Paris)
- Matisse, Male Singer at the Café-Concert, pencil on paper, 1900 (Private collection; photo courtesy AMP)
- Matisse, Female Singer at the Café-Concert, pencil on paper, 1900 (Private collection; photo courtesy AMP)
- Matisse, *The Cab*, Chinese ink and brush on paper, 1900 (Musée Matisse, Le Cateau-Cambrésis; photo courtesy AMP)
- Albert Marquet, *The Handcart*, Chinese ink and brush on paper, 1900 (Musées des Beaux-Arts de Bordeaux; photo: © M.B.A. de Bordeaux/Lysiane Gauthier)
- Charles Camoin, Self-portrait, oil on canvas, 1901 (Musée Granet, Aix-en-Provence; photo: P. Lemare)
- Jeanne Thiéry and Auguste Matisse, with their mothers (Coll. L. Famechon)
- Dr. Léon Vassaux at the wheel of his de Dion Bouton (Coll. P. Bouvier)
- Matisse, Mme Matisse and Jean, pen and ink, 1901 (Private collection; photo courtesy AMP)

- Maximilien Luce, Self-portrait, oil on canvas, c. 1910 (Photo: © Musée Départemental Maurice Denis "Le Prieuré")
- Matisse, Jaguar Devouring a Hare (after Antoine Louis Barye), bronze, 1899–1901 (Photo Adam Rzepka, courtesy AMP; © ADAGP, Paris, and DACS, London, 1998)
- Matisse, Male Model (Bevilacqua), oil on canvas, 1901 (Private collection; photo courtesy AMP)
- Matisse, *The Serf*, bronze, 1900–c. 1906 (Photo Adam Rzepka, courtesy AMP; © ADAGP, Paris, and DACS, London, 1998)
- Antoine Bourdelle, Self-portrait in His Studio, oil on canvas, n.d. (Musée Bourdelle, Paris; photo: © Photothèque des Musées de la Ville de Paris/Joffre)
- Matisse in Bourdelle's studio, c. 1898–99, working on the plaster model of the Montauban War Memorial (Musée Bourdelle, Paris; photo: © Musée Bourdelle)
- 220 Antoine Bourdelle, *Mécislas Golberg*, bronze, 1900 (Musée Bourdelle, Paris; photo: Florin Dragu)
- Jules Flandrin, My Portrait, oil on cardboard, c. 1897 (Private collection)
- Jules Flandrin, Marval Reading, wash of Chinese ink and pen on paper, c. 1895 (Private collection)
- Matisse's mother taking a mud bath at St-Amand-les-Eaux, photographed by Louis Guillaume, 1901 (Coll. Claude Duthuit)
- The opening of the Humberts' safe on 9 May 1902 (© Hulton-Getty)

CHAPTER EIGHT

- 236 Matisse, Henri Matisse Etching, drypoint, printed in black, composition: 51/16 x 71/18" (15.1 x 20.1 cm), 1900–1903 (The Museum of Modern Art, New York. Gift of Mrs. Bertram Smith; photo: © 1998 The Museum of Modern Art, New York)
- 243 Matisse, Lucien Guitry (as Cyrano), oil on canvas, 1903 (The Museum of Modern Art, New York. The William S. Paley Collection; photo: © 1988 The Museum of Modern Art, New York)
- Jean Puy, Self-portrait, oil on canvas, c. 1908 (Musée des Beaux-Arts. J. Déchelette, Roanne)
- 245 Maurice Boudot-Lamotte, Self-portrait, oil on cardboard, c. 1903 (Private collection; all rights reserved)
- Mme Taquet in the doorway of the grocery shop in Bohain (Coll. Georges Bourgeois)
- Matisse, Little Massé, 1902 (Photo courtesy AMP)
- Matisse, Charles Guérin (?), Auguste Bréal and unknown, photographed at Emma Guieysse's house at Saint-Prix (Coll. K. and M. Brunt)
- Matisse, Still Life with Red Checked Tablecloth, oil on canvas, 1903 (Photo courtesy AMP)
- 263 Matisse, Path Beside the Stream, oil on canvas, 1902–3 (Private collection; photo courtesy AMP)
- 264 Thérèse and Frédéric Humbert and Emile Daurignac in court (Photo: © Jean-Loup Charmet, Paris)
- "Ah, poor Thérèse! You've gobbled up 100 millions. Now you'll have to live by gobbling beans." (Private collection, all rights reserved; photo: © MT/Giraudon, Paris)
- Matisse, Profile of a Child (Marguerite), bronze, 1903 (Photo Adam Rzepka, courtesy AMP;
 © ADAGP, Paris, and DACS, London, 1908)
- 267 Pippa Strachey, Hermann Dick (?), Pernel Strachey, Hermine Bréal, Emma Guieysse (seated), Michel Bréal, Dorothy Strachey and Simon Bussy; at Saint-Prix, 1899 (Coll. K. and M. Brunt)

CHAPTER NINE

- Letter from Matisse to Manguin, September 1904 (Archives Jean-Pierre Manguin)
- Paul Cézanne, Portrait of Ambroise Vollard, oil on canvas, 1899 (Ville de Paris, Musée du Petit Palais, Paris; photo: © Photothèque des Musées de la Ville de Paris/Pierrain)

IF MATISSE has so far eluded any serious attempt to write his life, he has not escaped the attentions of mythmakers who have invented for him an image that too often reflects the narrowness and banality of the minds from which it came. My aim has been to revise the myth by starting from what actually happened. Like all Matisse students, I owe a heavy debt to three monumental works of scholarship. First, and after nearly half a century still by no means superceded, Alfred Barr's Matisse: His Art and His Public (1951) laid down basic guidelines for all explorers in this field. Barr has been majestically supplemented in France by Pierre Schneider's Matisse (1984), and in America by Jack D. Flam's Matisse: The Man and His Art, 1869-1918 (1986). Both are indispensable. But, being essentially arthistorical in scope and origin, neither was written for the general reader, who has had to fall back on a number of simplified versions fairly described, in the words of the museum director Raymond Escholier (who wrote one of them), as memorials piously erected to the greater glory of the painter's memory. By far the best source for anyone wanting to know more about Matisse has always been his own words, collected in two invaluable editions: Henri Matisse: Ecrits et propos sur l'art by Dominique Fourcade (1972), and Flam's Matisse on Art (1973; revised in 1995). Without these crucial pathfinders, my attempt to map the still largely unexplored territory of Matisse's life would have been infinitely harder.

This effort should perhaps have been unnecessary, at any rate in theory. Judged by a strictly intellectual scale of ideal values, the artist's life matters little by comparison with the work, which needs no gloss beyond its creator's comments. But this theory has not worked for Matisse in practice. For one thing, his words nearly always reach us through interviews with other people, not all of them reliable witnesses, a few positively hostile, some—especially in the early years—with little or no understanding of what he was talking about. For another, Matisse's memory was excellent on nearly everything but dates. Subsequent commentators have based their accounts with little or no checking on the more or less casual recollections that surfaced at the end of the painter's life, when for the first time he lifted his eyes from his work to look back in retrospect over his long career. Much that has been treated as hard fact turns out to be nothing of the sort. The blank page that was to have been consecrated by posterity to the painter's life has steadily filled up with misunderstandings, inaccuracies and downright inventions.

Failing any rigorous or sustained biographical scrutiny, people have felt free, as Jack Flam pointed out in the introduction to his pioneering Matisse: The Man and His Art, to garble and rejig incidents from Matisse's life at will. This tendency has been if anything exacerbated by the invincible discretion of the painter himself, his family and friends. The reasons for their policy of discretion will become apparent in the course of this book. Initially adopted as an emergency precaution, its effect in the long run has insidiously damaged the painter's reputation. Work has been wrongly dated, crucial connections have been missed, whole sequences of Matisse's artistic development left out of account. Individuals who played key roles in his life and work have been downgraded, or passed over altogether. Matisse's motives have been misinterpreted, and his sayings misappropriated to be "used like Scripture," in Flam's expressive phrase, "which can be quoted to suit nearly any purpose."

A first biography can do no more than draw up a plan, as accurate as possible, of known and unknown territory, pointing out gaps and opening up fresh ground. I have tried to redress the balance between Matisse's life and work, to show how neglect or ignorance of the one has fed into and distorted understanding of the other. In this I have had unfailing support from Matisse's descendants, in particular from Claude Duthuit, without whom this book could not have been written. I have relied on his acute and lucid grasp of family identity, on his firsthand memories of both Henri and Amélie Matisse, and on his endorsement of my attempt to make their voices heard throughout by quoting directly from published, unpublished and oral sources. I owe more than I can say to both Claude and Barbara Duthuit. My next great debts are to Jacqueline Matisse Monnier for her unfailing patience, kindness and ingenuity in furthering my researches; and to Paul Matisse, whose moral backing proved as dependable as his practical reinforcement. I am grateful to Gérard Matisse, Georges Matisse, Marie Matisse and the late Alexina (Teeny) Duchamp for their encouragement, and to Gaetana Matisse, Jacqueline, Paul and Peter-Noël Matisse for so generously allowing me access to the Pierre Matisse Gallery Archives.

I should like most particularly to thank Wanda de Guébriant for placing her unrivalled knowledge of the Matisse archive at my disposal; and the late Lydia Delectorskaya for allowing me to draw over several years on the rich resources of her well-stocked and formidably accurate memory.

My next debt is to the Matisse scholars whose initial encouragement gave me confidence to embark on this biography, and whose advice has kept me going ever since: the late Sir Lawrence Gowing, Albert

Kostenevich at the Hermitage in St. Petersburg, Jack Flam, and above all Dominique Fourcade, whose firm belief that it could and should be done countered my doubts from first to last. I am grateful to David Sylvester for starting me off; to John Golding and Michael Holroyd for reading my manuscript; and to Richard Cohen, whose idea it was in the first place.

My special thanks for research assistance go to Marie-José Gransard, whose resourcefulness never failed, and whose insight illuminated much that might otherwise have remained dark; and to Georges Bourgeois of Bohain-en-Vermandois, whose expertise on Matisse's native region proved inexhaustible, and whose archives have been a priceless asset. In Bohain, Le Cateau-Cambrésis and their environs, I am grateful to all those whose private research, family papers or personal testimony helped to make the past come alive: André Alcabour, M. Blondeel, Fernande Blondiaux, Emile Bourdeville, M. Cazé, Mme M. Richard-Cousteix, Lucien Durin, Yves Flamant and M. le Maire de Fresnoy-le-Grand, Jean Gérard, Mme Greuze, Mme Jacqueline Joncourt, Mme Suzanne Manesse-Nambruide, M. and Mme Mercier, Colonel Claude Moreau, Mme Pigeon, Mme Pointier-Flamant and M. Pierre Pothron; and in St-Quentin to M. and Mme André Flayelle de Xandrin, Viviane Gransard, the late Dr R. Haye and Monique Séverin.

I should like to thank Annie Maillard, Mme Thierry, Mme Guillerme and Nicole Garans on Belle-Ile, together with the president of the island's Société Historique, Louis Garans; Françoise Decourchelles and M. and Mme Pierre-François Gloaguen in Pont-Croix; Marie-Louise Couppa, Jeanne Donnerd, Michelle Hélilan, Louis Yvon'nou, and most especially Soeur Jeanne Bohan and Michel Gueguen in Concarneau; Dorothy Carrington, Jacques and Lucette Poncin, M. Petrocchi and Rosine Gaudiani in Ajaccio; the former mayor M. Lafarge and Mme Andrée Montagnac in Beauzelle. In Collioure, my warmest gratitude goes to François and Lucile Bernardi for investigative, deductive and incomparably knowledgeable aid; also to Mme Germaine Nadal-Py, Mme Figuères, Mme Boisselet, M. and Mme Jean Pascot and M. Joseph Pous.

I have enjoyed unstinting support from the families of painters and others among Matisse's friends, in particular from Pierre Bouvier; Katharine and Martin Brunt; Françoise Cachin; Dr. and Mme Georges Flandrin; Claudine Grammont; the late Marie-Thérèse Laurenge; Jean-Pierre Manguin; Claude-Guy Onfray and the late J. A. S. Russell. Natasha Semyonova and Beverley W. Kean taught me much about Sergei Shchukin at a time when his name was still barely known in Russia. My thanks for help and information go also to Isabelle Alonso, Rosaline

Bacou, Eve Baume, Roger Benjamin, J. D. Bergasse, Rosamond Bernier, Catherine Bock-Weiss, Nicole Bonnetain, Ashley Brown, Rupert Burgess, Paule Caen, Eric de Chassey, Judith Cousins, Caroline Elam, Lucien Famechon, Hanne Finsen, Catherine Germond, Thomas Gibson, Catherine Giraudon, Billy Klüver, Peter Kropmanns, Rémi Labrusse, Clorinthe Landard, Julie Martin, Marilyn McCully, Daniel Morane, Marie Nielsen, Meg Perlman, Michael Raeburn, Magalie Redon, John Richardson, Bryan Robertson, John Russell, Serge Saulnier, Pierre Schneider, Richard Shone, Marina Warner and Nicholas Watkins.

I am grateful to the many museum curators, librarians and archivists who helped me, often far beyond the line of duty: D. Barrère, Archives Municipales, St-Quentin; Olive Bragazzi of the Pierre Matisse Foundation, together with Lily Farkas, Sandra Carnielli, Andrea Farrington and Margaret Loudon; François Calame, Direction Régionale des Affaires Culturelles de Picardie; Magda Carranza, Centro Cultural, Arte Contemporaneo, Mexico City; Denise Delouche, Université de Rennes 2; Danielle Derey-Capon, Centre Internationale Pour l'Etude du XIXe Siècle, Brussels; John Elderfield of the Museum of Modern Art; Ann Galbally, Department of Fine Arts, University of Melbourne; Geneviève Lacambre, conservateur, Musée Gustave Moreau, Paris; Isabelle Monod-Fontaine, conservateur-en-chef, and Claude Laugier, conservateur, Centre Georges Pompidou, Paris; Betty Mons and Véronique Gautherin, Musée Bourdelle, Paris; Mary Morganti, Bancroft Library, University of California, Berkeley; Alain Pecquet, Bibliothèque Municipale, St-Quentin; Ruth Rasael, Judah L. Magnus Museum, Berkeley, California; Marcia Reed, curator of Special Collections, Getty Center, Santa Monica, California; Marie-Dominique Roche, curator, Musée Fesch, Ajaccio; Kerry Sullivan, State Library of New South Wales, Australia; Dominique Szymusiak, conservateur, Musée Matisse, Le Cateau-Cambrésis; and Nancy Tyner, Getty Center, Santa Monica.

My heartfelt thanks to all those whose hospitality lightened my labours, especially to that good friend of biographers in general and this one in particular, Ellen Wagner; to Marjorie F. Iseman, Elaine Maltsin, Nerissa Moray, Jeanne C. Thayer and Arthur Wagner in New York; to Claudine and Phillippe Biérer, Sarah and Robert Mackenzie in Paris; to Josiane and Georges Bourgeois in Bohain; to Robert and Annick Dufour in St-Quentin; to Vera Nanivska in Moscow; to Paule Laudon in Paris and Tahiti; to Ann and Anthony Thwaite and Ian and Lydia Wright in Islington; and to William Whitney in San Francisco. I am grateful for a travel grant to the Getty Center for the History of Art in Santa Monica, and for

a writer's fellowship at Hawthornden Castle in Scotland, where I wrote my first two chapters.

I owe a great deal to the understanding, enthusiasm and meticulous attention to detail of my editor, Susan Ralston, her assistant, Rebecca Katz, and my copy editors, Amy Robbins and Kevin Bourke, at Knopf; to my editors at Penguin, Andrew Franklin, Peter Carson and Simon Prosser; and to the indefatigable Gráinne Kelly, whose determination in face of heroic odds made the illustrations possible.

Lastly, my best thanks go to my agent, Bruce Hunter, who guided me up the rock faces, through the tight spots and over the crevasses of the contemporary book world; and to my husband, John Spurling, who makes rough places smooth.

Hilary Spurling Holloway, London December 1997

THE UNKNOWN MATISSE

CHAPTER ONE

1869–1881: Bohain-en-Vermandois

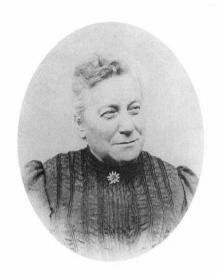

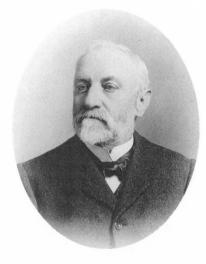

Anna and Hippolyte Henri Matisse, the painter's parents, photographed around the time he left home

fenri Matisse often compared his development as a painter to the growth of a seed. "It's like a plant that takes off once it is firmly rooted," he said, looking back at the end of his life: "the root presupposes everything else." He himself was rooted in northeastern France, on the edge of the great Flanders plain where his ancestors had lived for centuries before the convulsive social and industrial upheavals of the nineteenth century slowly prised them loose. His father's family were weavers. Henri Emile Benoît Matisse was born in a tiny, tumbledown weaver's cottage on the rue du Chêne Arnaud in the textile town of Le

THE UNKNOWN MATISSE

Matisse's birthplace on the left, place du Rejet, Le Cateau

Cateau-Cambrésis at eight o'clock in the evening on the last night of the year, 31 December 1869. The house had two rooms, a beaten earth floor and a leaky roof. Matisse said long afterwards that rain fell through a hole above the bed in which he was born.²

His parents, who worked in Paris, were paying a New Year visit to their hometown. They called their first child Henri after his father, following a family tradition that went back four generations. The first Henri Matisse had been a linen-weaver in the nearby village of Montay in 1789, when the French Revolution abruptly halved demand from the court for the fine linens of Cambrésis.3 This ancestor, Henri Joseph Matisse, married a tanner's daughter from Le Cateau and moved with his loom to the tanners' quarter outside the mediaeval town walls, settling round about 1800 on the place du Rejet at the top of the rue du Chêne Arnaud: a patch of low-lying wasteland heavily flooded each year when the winter rains washed liquid mud down from the high ground on one side to meet water rising up through the tanneries lining the banks of the river Selle on the other. Hardship and adversity bred strong wills and stubborn resistance in the Matisse family. Henri Joseph's son, Jean Baptiste Henri, abandoned the humble weaver's trade to become a factory foreman in one of the mechanised woollen mills beginning to spring up in the town in the 1850s. His son in turn would leave home and abandon textiles altogether.

This was Emile Hippolyte Henri Matisse, the painter's father, who found work in his twenties as a shop-boy in Paris. By January 1869, when he married Anna Héloïse Gérard, the daughter of another Cateau tanner,

1869-1881: BOHAIN-EN-VERMANDOIS

The seed-store (on the right, with a woman at the window) in Bohain, where Matisse grew up

The two brothers-in-law belonged to a breed of dynamic young businessmen who were turning away from the rural past all over France to build a brave new urban world. But the changes they dreamed of with such prodigious confidence were literally devastating. Henri Matisse was born just as the accelerating juggernaut of industrialisation and deforestation reached top speed in his native region. When his family settled on the rue du Château, Bohain was already halfway through its transformation from a sleepy weavers' village deep in the ancient forest of the Arrouaise to a modern manufacturing centre with ten thousand clanking looms installed in the town itself and the villages round about. The population, which had taken forty years to grow from two to four thousand before the large-scale installation of steam machinery in the 1860s, would very nearly double again in the twenty years before Matisse finally left home for Paris. 9

The town's principal product was textiles but sugar-beet output also doubled in the first ten years of his life. Energetic clearance meant that the last pockets of surrounding woodland were cut down to make way for beet plants in 1869, the year of Matisse's birth. The windmills and belfries that traditionally dotted the rolling flatlands of the Vermandois were far outnumbered in his childhood by the smoking chimneys of sugar refineries and textile mills. The streams on these chalky downs—Bohain stood high in the centre of a triangle marking the sources of the Somme, the Selle and the Escaut—ran with dye and chemical refuse on leaving the towns. The streets of Bohain were slippery with beet pulp in autumn, and the air was rank all winter with the stench of rotting and fermenting beets.

Visitors from the outside world in the 1870s and 1880s were shocked by the drabness of the town itself, and by the stark, treeless outlines of the newly denuded land round about. "Where I come from, if there is a tree in the way, they root it out because it puts four beets in the shade," Matisse said sombrely.¹¹

The memories he recalled with pleasure from his boyhood in Bohain were mostly of the countryside. He remembered parting the long grass in spring to find the first violets, and listening to the morning lark above the beet fields in summer. ¹² In later life he never lost his feeling for the soil, for seeds and growing things. The fancy pigeons he kept in Nice more than half a century after he left home recalled the weavers' pigeon-lofts tucked away behind even the humblest house in Bohain. Matisse said that for all the exotic specimens in the palatial aviary specially constructed for him in the 1930s, the best songbirds were still the robin and the nightingale, which could not survive captivity. ¹³ They sang freely in the copses and thickets round Bohain, and in the ruins of the mediaeval castle where he played as a boy within a stone's throw of his father's shop at 26 rue du Château.

Boys from the streets round the castle banded together to form a gang with headquarters in the crumbling keep from which underground passages, built for communication and supplies in mediaeval sieges, still ran out beyond the town walls. Each year the Château boys, armed with homemade shields and swords, challenged their contemporaries from other parts of town in a stylised form of gang warfare that dated back to the Middle Ages, when Bohain had been a fortified frontier town on the edge of the fertile European flatlands fought over successively for centuries by the armies of France, England, Austria and Spain. The local children were familiar from infancy with the folklore of battle and bloodshed attached to every stick, stone, ditch and hummock. They played at knights on horseback as their fathers had done before them, but the earliest invaders in these parts were Roman battalions marching against the Gauls (who included the tribe of Vermandii, or Vermandois) in 57 B.C. ¹⁴ Caesar's Gallic Wars, which would be one of young Henri's set books at school, took place partly in and around his hometown.

One of the castle's three subterranean passages led to the Chêne Brulé, or Blasted Oak, a vast, spreading ancient tree which bore the scars left by marauding Spanish soldiers who had attempted to destroy it in the seventeenth century. Henri Matisse climbed it as a child, painted it as a young man, and recalled it with affection to the end of his life. It was the town's only landmark (at least until the construction of a monumental town hall when he was fourteen), and it figured endlessly in fireside stories

1869-1881: BOHAIN-EN-VERMANDOIS

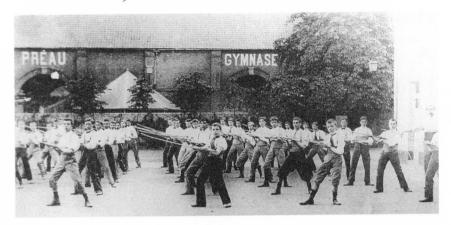

Drill session for the boys of Bohain

otic call to arms in 1897: "they know what we have suffered, and they have been brought up in the belief that they have a lofty duty to fulfil." It was drilled into Henri and his classmates at primary school in Bohain that it would be up to them to retrieve the lost honour of their country. They sang warlike songs ("Children of a frontier town, / Born to the smell of gunpowder...") and carved defiant messages ("Death to all Prussians!" and "Frenchmen never forget!") wherever they would catch the eye. They watched historic companies of archers, crossbowmen and cannoneers parading round the streets to military marches played by the town's uniformed brass band. They practised regularly in shooting booths at town and country fairs: Henri became a crack shot, and his cousin Edgard Mahieux won first prize in the town's grand shooting contest in 1887. 28

Matisse never talked afterwards about what it meant to have been born into this peculiarly intense phase of his native martial culture (save to say once, when he was under extreme pressure in his early sixties, that the only way he could forget his work for a few seconds was to level a gun at the target in his local shooting booth).²⁹ But he never entirely escaped the poisonous atmosphere of failure and humiliation in which he had grown up. "We were beaten, and we knew it," wrote one of his younger schoolfellows, describing the heavy weight of military and political disaster that pressed down on their childhood and youth.³⁰ Their mothers spring-cleaned the houses, but it took more than scrubbing to get rid of the sour smell of defeat. "He may not have understood it, but everyone around him recalled and retold the story; he saw through their memories what he had not seen at first hand," wrote the biographer of St-Quentin's most famous son, the historian Henri Martin, who was born just before the Russian occupation in 1815. "He knew the bitterness of it, he had

sensed the violence. Ten years—twenty years—later that humiliation could still make him flush and tremble. Memories like that do not fade."³¹ They profoundly affected Matisse's whole generation in France, especially those born on the front line, as he was. They would lead him to experiment in his twenties, like many of his contemporaries, with anarchism as an answer to the mistakes of the past. In the end it was Matisse who, of all his Bohain classmates, came closest to fulfilling the destiny drummed into them as children: that theirs was the generation born to bring fresh lustre to France's tarnished glory.

Not that there seems to have been anything out of the ordinary about Henri Matisse as a boy. The stringent demands of a new business meant that he was often sent to stay with his maternal grandmother in Le Cateau, where he said he was always happy.³² She shared her house, at any rate in the early years of her widowhood, with her son's family so she could look after both her grandsons, Henri Matisse and Emile Gérard, while their parents worked with the dogged perseverance of their northern race. In July 1872 the young Matisses had a second son, Emile Auguste, who died just before his second birthday, when Henri was four years old. His mother was already pregnant again, bearing her third and last child, Auguste Emile, two months later, on 19 July 1874.

The boys grew up in a world that was still detaching itself jerkily from a way of life in some ways unchanged since Roman times. The coming of the railway had put Bohain on the industrial map, but people still travelled everywhere on foot or horseback. They drew water from the town wells (one of the marks of belonging to the rising middle class was possession of a private well like the Matisses'), and lit lamps or went to bed at nightfall. Life was hard, monotonous and effortful even for the relatively affluent, and the young Matisses at this stage were far from well off. They lived in rented rooms behind the shop, and drove themselves regularly to the brink of exhaustion and beyond. Matisse remembered his father coming home from buying stock in Paris with his nerves so strung up that he would sleep for thirty-six hours at a stretch.³³ Hippolyte Henri said that a young man starting out had a choice between providing for his family and taking time off to rest ("Eat well or sleep well").34 His household rose before dawn, which meant 4 a.m. in summer, ready for the working day to start at five.³⁵ Even when there was no longer any need for him to do so, he drove a delivery cart himself, returning over the painfully slow, rutted country roads from outlying farms so dog-tired that his wife would meet him with a lantern at the stable door to unharness, feed and water the horses.³⁶

Matisse's memories of his childhood were of stern and single-minded

application. "Be quick!" "Look out!" "Run along!" "Get cracking!" were the refrains that rang in his ears as a boy. "He who does not honour the penny is not worth the dollar," Matisse's own son would repeat long afterwards on the streets of New York, echoing his Bohain grandfather's tart comment: "If you don't like the fruits, you're not fit to eat the jam." 37 Matisse's conversation to the end of his life was peppered with down-toearth sayings that looked back to a rural world where money was scarce, rations skimpy, work backbreaking and repetitive. Survival itself depended on habits of thrift, vigilance and self-denial. Matisse prided himself in later life on being a man of the North. Born in the Département du Nord, brought up just over the county border in the Département de l'Aisne, he could speak the raw, terse, expressive patois of Picardy like everyone else in Bohain ("Chacun s'n pen, chacun s'n erin," or "Chacun son pain, chacun son hareng," was his example of a typical local sentiment, roughly translated as "Everyone for himself.")38 His family name was often spelt in the Flemish style, "Mathis" or "Mathisse." 39 He came on both sides from Flemish stock with the touch of Spanish blood that accounts for the dark colouring, fine bones and fiery temperaments so common in the region. The painter's father bore a striking resemblance to the Holy Roman Emperor Charles V, who was also born and bred in Flanders.⁴⁰

The Matisses belonged on the border dividing the turbulent Picards from the relatively phlegmatic, law-abiding Flemings. So did the historian Gabriel Hanotaux, who grew up speaking the Picard dialect in Beaurevoir, five miles west of Bohain, a village where people on the outskirts were already Flemish-speakers:

Picardy or Flanders, the land is rude, rough...[and] scoured by winds from the north. I remember the great skies of my native country, crossed by lines of horizontal cloud stacked one above another over the flat plain, with long flights of crows strung out as in the naïve engravings of the Loensberg Almanac.... The Middle Ages lived on in our midst.⁴¹

Hanotaux put the harshness of his countrymen, their brute strength and fierce determination, down to the appalling climate, the vast horizons, the immense, daunting uniformity of the undulating downs and the soft, rainy, often glowering, sometimes radiant light.

If the sun brought a brief splendour even to the drab beet fields in summer, in winter the towns and villages turned in on themselves. Piled snow lined the streets of Bohain, ice covered the cobblestones two or three feet deep, water froze overnight indoors in jugs and basins. The roads were blocked for months at a time by snowstorms, blizzards, freezing fog and bitter winds raking the high plateau on which Bohain stood exposed, shorn of its protective forest, ringed by underground springs which welled up as soon as the ice thawed, flooding the unpaved streets in the poorer parts of town knee-deep in mud and slush. "I came into the world shivering with cold and, when I think of it now, it makes me shiver still...," wrote Hanotaux. "Our fathers knew how to endure, and we too had to grow accustomed to endurance."

Children who survived these ordeals (many did not) had to be tough, wary and defensive; and it was their fathers' job to make them so. In the traditional culture of the North, the father was masterful, demanding and often impossible to please, the mother indulgent and supportive. Henri's mother took his part all her life, while his father reined him in and spurred him on. When Matisse in turn had children of his own to bring up, he saw any lapse in discipline or open display of tenderness as weakness on his part. 43 This was especially true when it came to drawing and painting. Matisse felt it was his duty to his children to be their sternest critic, just as his father had always been to him. Any child who drew spontaneously as an instinctive form of free expression needed cracking down on: "When a father finds his kid scribbling on a bit of paper, he says: 'Come on now, throw that away and run along to your drawing lesson." "44 Drawing lessons in the 1870s and 1880s in Bohain and the vicinity meant strict mechanical copying of geometrical objects with penalties for straying even slightly from the approved method or attempting to use colour. For the young Henri they represented all that was dreariest and most stultifying about the adult world.

Providing unconditional encouragement was the mother's role, and Henri's played it with enthusiasm: "My mother loved everything I did." He was by his own account a dreamy child, docile and obedient but inattentive, frail and not outstandingly bright. His own delicate health, and the loss of his middle brother, made his mother specially attentive, and he in turn urged himself to special efforts for her sake. She was always the first person to whom he showed his early paintings, and on the rare occasions when she seemed less than satisfied, the effect on him was devastating. The ran the section of the shop that sold housepaints, making up the customers' orders and advising on colour schemes. The colours impressed Henri as a boy much as they did another future painter, Félix Valloton, whose parents also kept a provincial hardware store in the 1870s:

The second shopwindow was the best: twelve tubular glass bottles, drawn up in battle order on a stand and filled to the brim with colours whose very names made me feel proud. They were, in order, pale chrome yellow, dark chrome yellow, cadmium, cobalt blue, ultramarine, Prussian blue, milori green, English green, rose madder, Austrian vermilion, Turkey red and pure carmine.⁴⁸

Matisse said he got his colour sense from his mother, who was herself an accomplished painter on porcelain, a fashionable art form at the time, and almost the only one in which it was considered proper for a woman to indulge (twenty years later Marie Laurencin's mother would reluctantly permit her to train as a painter of china in the vain hope that she might retain at least some shreds of bourgeois respectability). Anna Matisse worked in gouache on breakable bowls and pots, which have long since disappeared except for a single plain white salad bowl, decorated with great charm and delicacy in a severely simple pattern of dark blue dots and lines. Descriptions of the salad bowl, decorated with great charm and delicacy in a severely simple pattern of dark blue dots and lines.

Her kitchen remained always a source of warmth and comfort. The life of the household revolved around the big stove, kept permanently alight with a pot of coffee on the hob, within easy reach of the shop on one side and the yard on the other, with its washhouse, well and herb-andvegetable plot. There was also a range of high brick outbuildings which included stabling for the horses, space for the wagons, and storage in the loft for kegs or crates of chemicals, sacks of seed, rice, grain and cattle cake. Anna Matisse had a tiny pair of brass scales with which she weighed out birdseed and fish food for the fancy cage-birds and ornamental goldfish that were traditionally part of a seed-merchant's stock-in-trade (both would reappear in Matisse's life and work).⁵¹ Sixty years afterwards in Nice, her son's thoughts reverted to the simple homely remedies and recipes passed down in the lost world of his childhood. He remembered the lime-blossom tea his mother took to calm her nerves and help her sleep, and he insisted that of all his own innumerable remedies for chronic insomnia, the best was beer and chips.⁵²

These were the basic staples of his native region, where meat was eaten sparingly (mostly hutch-rabbit, pigeon or pork in an area so famous for charcuterie—hams, patés, sausages, chitterlings and trotters—that the bells of St-Quentin were said to peal as a refrain, "Tripe and black pudding / Tripe and black pudding").⁵³ He wrote nostalgically of the pungent local cheese, le Maroilles, and he knew how to make three different

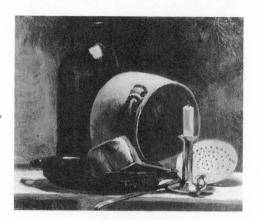

Matisse, Still Life with Earthenware Pot, 1892

sorts of onion soup, which was a speciality in Bohain.⁵⁴ Another was hot pickled herring served with stoved potatoes cooked in a flat covered clay pot. In his early twenties Henri painted one of these pots in his mother's kitchen along with the earthenware dishes and lidded pans, the apples, eggs and onions, the bottles, jugs and half-empty beer glasses that make up the traditional standbys of Flemish painting.⁵⁵

It was not only the paraphernalia of domestic life that remained unchanged. For a child growing up in Bohain in the last part of the nineteenth century (and well into the twentieth) contact with the outside world was still largely confined to itinerant traders, pedlars, tinkers and bands of exotic, dark-eyed Gypsies selling baskets, telling fortunes, sometimes even leading a chained dancing bear. They came in spring and summer, when the roads were passable, with the fairmen who set up their sideshows and booths on the town square, selling toys, gingerbread, striped humbugs and sticks of twisted barley sugar. The whole year was marked out by a seasonal round of markets, fairs and festivals (les fêtes de la Kermesse) which ranged from May Day and 14 July to a child's personal saint's day (Henri's was 15 July), or the celebrations for the different districts when the bigger boys disguised as knights staged their mock battles. The little ones rode on the merry-go-round—rogayo in the Bohain patois—with a donkey to turn the wheel that made the wooden horses go up and down on their painted poles. "How charming they were, how simple and sober, the dear old barrel organs that played for our rides on the rogayo," wrote Matisse's oldest friend, Léon Vassaux, reminding him of the fun they had together at the country fairs of their youth.⁵⁶

The grand annual fairs in the big towns were elaborate theatrical productions with clowns, tumblers and fast-talking salesmen who were also

seasoned Grand Guignol performers in shows as colourful as they were brutal and macabre. The painter Amédée Ozenfant, growing up in St-Quentin at the turn of the century, remembered the fairground rat-killer testing his poisons on the town's stray dogs before a circle of interested children hoisted on their parents' shoulders, and the tooth-puller in a gold-frogged silver uniform, with white and scarlet plumes tossing in his big black hat, who arrived in a carved and gilded carriage with a red-plush throne or scaffold on which public extractions were carried out to the sound of drumrolls.⁵⁷ Stunts like these—thrilling, grisly, richly freak-ish—answered people's need to blot out at regular intervals the dull, bleak grind of their daily lives. Although Bohain, like St-Quentin, officially belonged to Picardy, both were, as Ozenfant observed, "as Flemish as a Breughel painting."

IT WAS A SOCIETY that offered little imaginative outlet beyond its fairs, the occasional travelling circus and games of knights-on-horseback. Matisse said long afterwards that his twin ambitions as a child had been to be a clown or horseman (sometimes he varied the formula to acrobat or actor, on the one hand, and jockey on the other). He experienced early the overriding need to escape, to perform, to draw and hold an audience, and he described his need in terms of the travelling salesmen of his youth:

If there were no public, there would be no artists.... Painting is a way of communicating, a language. An artist is an exhibitionist. If you took away his audience, the exhibitionist would slink off too, with his hands in his pockets.... The artist is an actor: he's the little man with the wheedling voice who needs to tell stories. 60

In later years Matisse acquired a reputation for extreme seriousness which made him something of a butt behind his back to the younger Parisian artists who frequented the Cirque Medrano with Picasso. Matisse's single-mindedness worried them and made them nervous. By this time he had good reason for preferring the outside world to keep its distance, but his young detractors might have been surprised to know that when someone told him he was the spitting image of the Medrano's clown Rastelli, Matisse took it as a compliment.⁶¹

The young Henri was a champion mimic who could always reduce his friends to helpless laughter with his imitations of pompous or overbearing elders. As a student in Paris in the 1890s, he could sing or chant all the street cries and calls of the Latin Quarter, 62 a habit he picked up as a boy

on the streets of Bohain, which rang with the din of competing knife-grinders, salad-sellers, toffee-makers, men offering to mend broken umbrellas, glue cracked crockery, recane chair-seats or cobble shoes ("Each street vendor had his own song, cry, special call, whistle, bell, drum, clapper or rattle," wrote a contemporary from Bohain). Street life fascinated Henri as a child long before he started filling his student sketchbooks with Parisian street scenes—cabmen with their fares and horses, passersby, music-hall performers—drawn with an agile, observant line and a sardonic eye for detail.

On summer evenings the working people of Bohain would bring out their chairs and sit gossiping in front of their houses to the great delight of inquisitive small boys like Henri and his friend Léon, who lived next door to the Matisses. Even before they were out of short trousers, these two spent hours watching and listening to the neighbours on the rue Peu d'Aise: Cousin Becks with her Tartars and Kalmucks; the dressmaker, Old Mother Bifou, who upset Léon's mother by sending both boys home with fleas; and Mme Massé, who earned her living by winding wool and amused the boys by regularly adding a new baby to her tribe of handsome children.64 Henri would paint one of the Massé girls when he grew up, and he also painted Mother Massé herself, wearing the white cap of the region, seated at her spooling wheel in her comfortable, cluttered interior—the typical single work-cum-living room of Bohain's working class—with her woollen skeins laid out ready for the skein-winder on its wooden stool, and the coffeepot simmering beside her on the Flemish stove.65 Léon was a favourite with a melancholy spinster in a black lace bonnet called Clémence Lescot, who had a repertoire of songs dating back before the Revolution which she sang to the accompaniment of a guitar.66 Henri was fascinated by the three Mlles Merlot, hairdressers on the rue du Château, and the two Mlles Nobécourt, unmarried sisters one skinny, one plump and courted by a local farmer-who kept a hatshop a little further up the main street on the rue Fagard.⁶⁷ All his life he would take a fond and knowledgeable interest in anyone who made hats like his own mother, several of his aunts and both his grandmothers.

The two boys were inseparable. Léon was two years younger, the same age as Henri's brother who died, and perhaps in some sense he took his place. At all events, he would remain Henri's firm friend and follower—in time of crisis his most faithful supporter—for the rest of their lives. He was kind, clever and original in his own unobtrusive way, as independent and as much of a deadpan comedian as Henri himself. They roamed the countryside together in summer, and played in winter in the Matisses'

1869-1881: BOHAIN-EN-VERMANDOIS

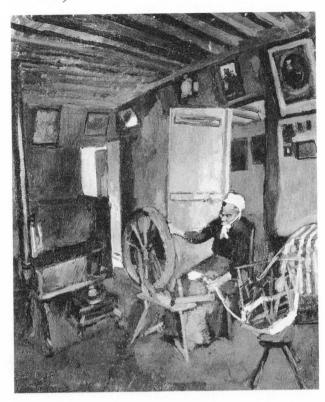

Matisse, The Skeinwinder from Picardy (La Dévideuse picarde), 1903: "Old Mother Massé" at her spooling wheel in her one-roomed weaver's cottage opposite the Matisse family's side door

loft or the Vassaux's kitchen. "I can see us still," Léon wrote, "seated at the kitchen table performing manoeuvres with a squad of lead soldiers—and our fright when we heard my mother ring the bell." Later they experimented with chemicals borrowed from Henri's father's storeroom (Valloton wrote an autobiographical novel in which one of the narrator's friends turned purple after falling into a vat of dye in the back room of the family hardware shop, and another died from tasting a mysterious green powder). Henri was about twelve years old and Léon ten when they helped themselves to materials for an experiment known as "the Philosopher's Lamp," which was supposed to produce hydrogen; when the lamp blew up in their faces, they were lucky to escape with nothing worse than holes burned in their clothes. "

Léon was also a loyal assistant a couple of years later in the great artistic enterprise of their childhood, which was Henri's toy theatre. It was made from a crate lined with coarse blue wrapping paper from the shop, and the parts were played by characters cut out from strip cartoons and glued onto strips of cardboard. Henri was director, stage manager, musician, scene designer and set painter. His greatest triumph was a piece that

ended with the sensational eruption of Vesuvius, for which his father provided sulphur and saltpetre. The volcano went up in puffs of smoke and flame against a background of blue-paper waves edged with painted foam to represent the Bay of Naples: "The décor was signed Matisse, and the musical effects were provided by your violin," Léon wrote in what remains the only extant account of this remarkable premiere. "The price of the seats was within everybody's reach: a trouser button, and I believe our parents ended up mystified by the increasing scarcity of that sartorial accessory." Vesuvius erupted in May 1885. The event was reported in provincial papers all over Europe and reproduced in far more spectacular theatrical productions, but perhaps none more interesting. Already, as a boy of fifteen who had never set foot outside his own small corner of northeastern France, Matisse's best efforts were inspired by the light of the Mediterranean.

The spectators who paid with trouser buttons presumably included Henri's eleven-year-old brother Auguste and Léon's twelve-year-old only sister Jeanne, perhaps the Matisses' cousin Edgard Mahieux from the hotel, possibly some of the director's school contemporaries. Henri's best friend at school was Gustave Taquet, a shrewd, expansive and entertaining grocer's son who looked forward (unlike his friend) to taking charge of his father's shop. The two would go on together to secondary school in St-Quentin, returning home in the holidays to share adolescent outings and escapades. Matisse's closest contacts as an adult in Bohain remained Gustave Taquet and a younger boy called Louis Joseph Guilliaume, a weaver's son who eventually opened the town's first photographic business next door to Henri's parents on the rue du Château. Taquet and Guilliaume slipped readily into the roles allotted to them, both achieving worldly success long before Henri did (or Léon, either, for that matter), and both living out their lives as pillars of the community in Bohain.

Henri and Léon both left for Paris as soon as they could, and before that each found different ways of pushing at the edges of the tight, narrow, restrictive world into which neither fitted comfortably. Léon was born into a banking family. The Banque Vassaux had been one of many small banks springing up to service the industrial expansion of the 1860s, and like countless others, it fell into difficulties. Héon's father and uncle resigned as directors when he was a baby, and he himself grew up old beyond his years with a precocious sense of responsibility, reinforced by his mother's death when he was twelve. An uncle who was a doctor offered an escape route which Léon took by studying hard, doing brilliantly in his

examinations, and enrolling at eighteen in the medical faculty of the Sorbonne.

Henri meanwhile dreamed and dawdled through his school career. Constant rote learning was the rule in the three local schools he attended under teachers who lashed out freely with the cane or ruler.⁷⁵ The daily routine consisted of tests, exercises, homework, and the punishments that followed automatically for faults or slips. Proud, stiff-necked and stubborn, none of the Matisses ever took kindly to this sort of treatment. Henri's father, Hippolyte Henri, had attended school in Le Cateau until the age of eighteen without apparently ever taking a public examination or achieving any mark in any subject except "poor" or "mediocre." A late developer who prospered only after he struck out on his own, he resolved to prevent his sons from repeating his own mistakes. Henri, no less resolute, responded with what had once been his father's strategy of passive resistance. The standoff between father and son, which eventually reached epic proportions, started with private music lessons, then as now thought to provide a flying start by parents anxious to reinforce their children's social credentials.

Henri and Léon, who was highly musical, shared the same violin teacher, whom they both detested. M. Pechy was leader of the town band, a formidable figure ranking second only to the superintendent of police as he marched at the head of his musicians with his black baton and goldbraided officer's cap. He beat his mutinous pupils with his violin bow, and they retaliated by playing truant. When Père Pechy knocked on the Matisses' door, Henri would climb over the Vassaux's party wall so that when his pupil failed to appear, Pechy went next door in search of Léon, who was also missing, both boys having by now prudently hopped back over the wall onto the Matisses' side. 77 Léon always insisted that Henri was the more gifted of the two, and that if it hadn't been for Père Pechy, he could have become a great virtuoso violinist. Certainly this episode rankled with Matisse, who tried long and hard in later life to make up for the practice he had missed in his youth. His violin always remained close to his heart. He obliged his own reluctant son to practise many hours daily, explaining that he himself bitterly regretted having opposed his father on this and other fronts.⁷⁸

As Matisse grew older, he came increasingly to understand and sympathise with a side of his father he had rebelled against with his whole being as a boy. In the last years of his life he looked with new eyes at his father's problems: the precariousness of his achievement, at any rate in the

early years; the anxiety and labour involved in setting up any kind of enterprise, the constant effort required to keep it going.⁷⁹ Hippolyte Henri, starting out with minimal capital and nothing like the Gérards' established family network to support him, had been confronted almost immediately by the catastrophic consequences of the German victory. The citizens of Bohain were obliged to pay over to the enemy almost 200,000 francs in reparations and requisitions,⁸⁰ a staggering sum for a town of just under seven thousand inhabitants mostly living on subsistence wages (less than a hundred francs a month for a skilled workman). The town's manufacturing base came within a hairsbreadth of being wiped out, recovering only through grinding collective retrenchment and reconstruction.

One of the regrets that nagged Matisse was that his father had never had the support he might have looked for from an eldest son. As a father in his turn, he understood only too well the nervous energy expended in efforts to correct and counteract anything that might leave a child exposed, vulnerable or unprepared for the harsh conditions of a future he would have to face alone. Already as a boy, he was riddled with conflicting impulses. He refused to please his father by taking violin lessons, but a few years later as a student, he couldn't be parted from his fiddle.81 He dreamed of being a jockey, although he did not know how to ride a horse. Matisse learned to ride only after his father's death, in spite—or perhaps because—of the fact that Hippolyte Henri had loved horses, ending up at the height of his success with at least ten in his stables: mighty, gleaming dray horses, harnessed five abreast, to draw the great wagons loaded with his stock all over the department. Hippolyte Henri also kept a light barouche with a fast, fine-paced mount for his personal use, one of the few luxuries he allowed himself in a life of disciplined and dedicated toil.82

His sons were brought up as good Republicans and Roman Catholics according to the custom of their class and time. Baptised at seven days old before he left Le Cateau, Henri was confirmed with all the other children of his age in 1881 in the church of St-Martin in Bohain. Seventy years later he said he still used the Hail Marys and Paternosters of his childhood to calm his nerves, 83 but for most of his life he looked back with distaste on his Catholic upbringing as part of the harsh authoritarian apparatus that had curbed and controlled his youth. He was sent as a small boy to the local primary school, transferring briefly when he was about ten years old to his father's old school, the College of Le Cateau. 84 Henri attended as a day boy, living with his grandmother Gérard in the rue du Chêne Arnaud, a

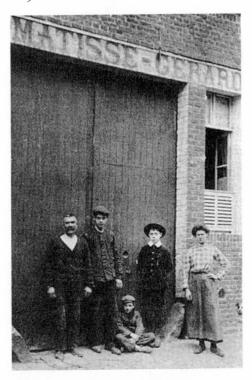

The Matisse family (with a young friend or cousin) outside the side entrance of the seed-store on the rue Peu d'Aise

stay chiefly memorable by his own account for an injury he got by slipping on the grease and mud outside her house (the Cateau tanneries not only produced a stench as powerful as the beet refineries of Bohain but impregnated the streets around them with slithery, slimy animal fat, or tallow).⁸⁵

Matisse said little of his schooling afterwards, save to mention his headmaster with a flash of unexpected warmth: "M. Francq, a grave but good man, with side whiskers." ⁸⁶ Joseph Francq had a good deal to be grave about in the early 1880s. Newly promoted to the post of head after twenty-six years in teaching, he was one of a staff of five (only one of whom had more than the most elementary qualifications) attempting to provide a classical education in a town which barely managed to produce even a single annual candidate capable of sitting the Baccalauréat examinations. His despairing predecessors forwarded regular complaints to the authorities about insufficient funding, dilapidated buildings, inadequate equipment and unsuitable or missing books. One of them, in charge when Hippolyte Henri was a pupil, blamed his staffing problems on the virtually universal drunkenness of the male population of Le Cateau. ⁸⁷

Drink was a greater scourge than the cholera epidemics that regularly swept densely packed industrial towns like Le Cateau before the installation of drainage and sanitation. Every street in every town and village in this part of Picardy or Flanders had at least one bar, often no more than a counter and a couple of barstools, run by a housewife trying to make ends meet. Hippolyte Henri's own parents had kept a bar on their retirement, and Anna's sister Sidonie ran another with her husband on the rue du Chêne Arnaud. The Matisses' employees at the Bohain seed-store started work at dawn with a nip of gin to help them face the day. Wives collected their husbands' pay packets at the end of the week, counting out just enough for the men to get blind drunk. Alcohol provided an essential truce for a people contending on a daily basis with overwork, sickness and malnutrition. Almost one fifth of the inhabitants of Bohain were epileptic by the 1890s, and 35 percent of possible army conscripts were turned down at twenty as alcoholics. 89

Men, women and children in the textile mills worked up to twelve hours a day with a single fifteen-minute break. Labourers, often migrants who came by train each summer from across the Belgian border, crouched in long lines bent double, nose to ground, all day to weed the beet fields. Resentment simmered and flared throughout the 1880s. Workers protesting against the lowering of their meagre wages staged a strike in Le Cateau in December 1883 which erupted into a riot on New Year's Day, the day after Henri's fourteenth birthday. Strikers stormed the woollen factory installed in the old archbishop's palace (now the Matisse Museum), smashing the doors down, breaking windows and threatening to kill the managing director. 90 Memories like these lay behind the images of physical violence that often startled Matisse's admirers later when he talked about his working methods. He once told the Hollywood film star Edward G. Robinson that the only thing that drove him to paint was the rising urge to strangle someone. "I've always worked like a drunken brute trying to kick the door down," he said, discussing plans for the chapel he designed at the end of his life in Vence on the Côte d'Azur.91

Matisse's brutal metaphors went back to the remorseless, mindnumbing, unending drudgery he had seen on all sides as a child. Weavers had feverish eyes, pale faces and gaunt, etiolated bodies from spending all the hours of daylight shut up in cramped and often humid spaces. Long after the neighbouring towns had switched to mechanisation, a high proportion of the men of Bohain kept their handlooms, working either at home or in back-street workshops crammed with anything from three or four to twenty times as many looms. There were half a dozen of these weavers' and embroiderers' workshops in and around the rue Peu d'Aise. "My cradle was rocked to the clicking rhythms of running shuttles....

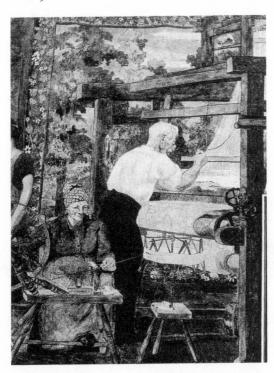

Emile Flamant, 1925: detail of a fresco in Bohain town hall showing textile workers and silk-weavers with the luxury fabrics they produced for the Paris fashion market. Matisse's contemporary Eugène Nambruide is at the loom.

Clickety-clack!... Clickety-clack!" wrote Emile Flamant, another painter born in Bohain in 1896. Matisse himself was just old enough to remember the vogue for Kashmir shawls which had brought Bohain its first taste of prosperity in the 1850s. "In the old days they used to make woven Indian shawls. It was a time when people still wore shawls on their backs, as in old Flemish paintings, decorated with palmettes and fringed edges," Matisse said, describing a simple weaver's dwelling like the one where he was born. "A peasant's house consisted of a single big room with a bed, a table in the middle and a loom in the corner, a Jacquard loom." "93

It was Parisian high fashion that lay behind Bohain's astonishing economic turnaround after the defeat of 1871. By the time Henri was ten, all but a handful of the town's forty-two textile workshops had switched to furnishing or dress materials, working directly for the big Paris fashion houses that supplied modern department stores like the Cour Batave. This was the basis of the town's booming economy during Henri's childhood and adolescence, when the luxury textile trade exploded "like fireworks" in an unprecedented display of creativity and invention. Throughout the time he lived there, the weavers of Bohain were famous for the richness of their colours, for their imaginative daring and willing-

ness to experiment. They worked to order for the top end of the market, supplying handwoven velvets, watered and figured silks, merinos, grenadines, featherlight cashmeres and fancy French tweeds (*cheviottes fantaisies*) for winter and, for summer, sheer silk gauzes, diaphanous tulles, voiles and foulades in a fantastic profusion of decorative patterns, weaves and finishes.

Bohain had long produced silk-weavers, aristocrats of the trade, in whom the tradition of skilled workmanship-inherited from linenweavers like Henri Matisse, the painter's great-grandfather-developed under pressure from new demand in the last quarter of the nineteenth century into a growing relish for change and innovation. The weaving of silk gauzes was an exacting discipline, "taught in Bohain much as they teach Latin and Greek elsewhere."96 Those who mastered it were highly sophisticated, resourceful and competitive, retaining an openness and flexibility unknown to machine operators turning out relatively coarse, massproduced textiles for a wider public. Bohain's preeminence was rapidly acknowledged. "Picardy, thanks to Bohain, leads the whole of France, and indeed the rest of the world, in the fashion field," wrote a government inspector in 1897. "Its pioneering claims are born out by the prodigal variety, the inexhaustible originality and constant innovation of its products.... This production—so energetic, so alive with new ideas, so bold in conception-meets with an executant of exceptional ability in the Picard weaver."97

Bohain's weavers drew dignity and pride from knowing they had few rivals and no superiors. Their traditional independence fed a radical subversive streak: the weavers of Bohain and its neighbouring village of Fresnoy-le-Grand were regarded with mistrust by the new property-owning middle class as potentially dangerous egalitarians, if not outright revolutionaries. Their craving for another world—an escape from the material hardship and confinement of their lives-found its only practical outlet in the fierce aesthetic satisfaction they got from their luxury fabrics, some so intricate that even the best workman could weave no more than one and a half centimetres a day (five to six was the usual rate of progress).98 They worked with threads as fine as hairs, wound on tiny bobbins in an array of miniature roving shuttles, each supplying a separate colour nuance. Weavers vied with one another to produce ever more ambitious, subtler and more opulent effects, ranging from sumptuous brocades, enriched with pearls or gold and silver thread, to filmy shot silks and gauzes which took on the tone and texture of a watercolour. "Each shuttle... performs the function of a paintbrush which the weaver guides at will and almost as

freely as the artist himself," wrote another contemporary, who was by no means the first to suggest that the ill-paid, illiterate peasant weavers of Picardy possessed an innate aesthetic sense of colour and design.⁹⁹

Descended from and surrounded by these weavers, Matisse grew up familiar from infancy with the sound of clacking shuttles and the sight of his neighbours loading and plying coloured bobbins, hunched over the loom like a painter at his easel day in, day out, from dawn to dusk. Textiles remained ever afterwards essential to him as an artist. He loved their physical presence, surrounding himself with scraps and snippets of the most beautiful stuffs he could afford from his days as a poor art student in Paris. He painted them all his life as wall hangings, on screens, in cushions, carpets, curtains and the covers of the divans on which he posed his models of the 1930s in their flimsy harem pants, their silk sashes and jackets, their ruffled or embroidered blouses, sometimes in *haute couture* dresses made by Parisian designers from the sort of luxury materials still produced in those days for Chanel in Bohain.

Throughout the single most critical phase of his career, in the decade before the First World War when he and others struggled to rescue painting from the dead hand of a debased classical tradition, textiles served him as a strategic ally. Flowered, spotted, striped or plain, billowing across the canvas or pinned flat to the picture plane, they became in Matisse's hands between 1905 and 1917 an increasingly disruptive force mobilised to subvert and destabilise the old oppressive laws of three-dimensional illusion. On a purely practical level, he resorted as a painter to old weavers' tricks like pinning a paper pattern to a half-finished canvas, or trying out a whole composition in different colourways. 100 He stoutly defended the decorative, non-naturalistic element in painting, and he made luxury—in the old democratic weavers' definition, "something more precious than wealth, within everybody's reach"—a key concept in his personal system of aesthetics. 101 In this, as in his unbudgeable determination, Matisse remained a true son of the weavers of Bohain, whose fabrics astonished contemporaries by their glowing colours, their sensuous refinement, their phenomenal lightness and lustre.

In the sternly utilitarian and materialist society in which he grew up, there was little other nourishment available for a nascent visual imagination. Bohain had no museum, no local big house or art gallery, no paintings to speak of in its town hall or church. Even a modest proposal to found a library met stiff opposition before the municipal reading room was finally opened in 1872. The town council had its hands full in the 1870s and 1880s with plans to pave the streets, put in gaslights, and

improve sanitation by filling in or covering over drains, stagnant ponds and open sewers. It was busy grappling with illiteracy (half the children of Bohain in 1868 could neither read nor write). It embodied its vision of the future in a gargantuan town hall, opened in 1884 with flags, bands, speeches and a five-course dinner¹⁰³ (in fact, Bohain had already reached its high-water mark by 1884: economic changes in the twentieth century compounded by two more German wars meant that its population subsequently declined, and its industry went into reverse).

The fine arts got their due in the shape of a small statue of the three Graces erected on the rue du Château. Bohain was run by a handful of bourgeois families, lawyers, tradesmen and small shopkeepers headed by the mayor and the Roman Catholic curé, who struggled to impose some sort of stability on an exploding population in what had been within living memory an inaccessible, in some ways still almost mediaeval country village. The ruling middle class may have been smug and ruthlessly conformist, but they were also confident, hopeful and pragmatic. For them the Third Republic, even more than the Second Empire before it, was an era of unparallelled expansion and achievement. They believed in Emile Zola's definition of progress: "going with the century, expressing the spirit of the century, which is a century of action and conquest, of effort in all directions."104 The bourgeois citizens of Bohain were themselves the small-town equivalent of the businessmen Zola portrayed in his "hymn to the modern age," Le Bonheur des dames, which celebrates the wholesale destruction and rebuilding of Paris under Baron Haussmann in the 1860s, symbolised by the launch of a great modern department store. The book's last chapter—in which the entire store is transformed by net curtains, drapery and streamers into a dazzling pristine white silk altarpiece for the grand White Sale—embodies everything for which the Cour Batave stood in the Matisse household during Henri's childhood.

Hippolyte Henri was born in the same year as Zola, and reached Paris as a young man at roughly the same age. Zola said that his novel was partly inspired by young shop assistants flooding in from rural France to Paris, where they hoped to rise up through the ranks from shop-boy to department head, fired by the "ambition to find broader horizons than anything their fathers knew." For Hippolyte Henri, the years he spent packing, unpacking, shelving and delivering white goods for a great Paris store became a lifelong yardstick. He came home with the British shopkeeper's proud motto—Nothing but the best—which stamped his own life and his son's. ¹⁰⁶ In Bohain's close and sometimes stifling microclimate, the

great adventure of his youth opened a window for the whole family on a

wider world of opportunity and aspiration.

Matisse said he had dreamed from his earliest years of the radiant light and colour he finally achieved in the stained-glass windows of the chapel at Vence in 1952. "It is the whole of me... everything that was best in me as a child." He told his grandson, who had been taken aback to find almost every conventional feature of a church interior missing from the chapel, that his whole life had been in some sense a flight. "I come from the North. You can't imagine how I hated those dark churches." One of the effects that pleased him most in the Vence chapel was a clear reflected blue of an intensity he said he had seen before only in the glint on a butterfly's wing, and in the pure blue flame of burning sulphur: ¹⁰⁹ the flames of the volcano that first erupted in a toy theatre in Bohain seventy years before. "Even if I could have done, when I was young, what I am doing now—and it is what I dreamed of then—I wouldn't have dared." ¹¹⁰

The young Henri was not by nature a rebellious child. He took all he could from his native region, which had its own peculiar poetry, harsh, dry and unromantic but full of energy and wit, a style encapsulated in the lullaby adopted as the national anthem of the North, "Petit Quinquin." Quinquin is a poor lace-maker's child who keeps his mother awake at night with his crying. After offering various unsuccessful bribes—a visit to the fair, a stick of barley sugar-she solves the problem in desperation by giving him a good thrashing. "A remedy for insomnia that strikes me as less than ideal, and I shouldn't care to prescribe it for you," Léon wrote genially to Henri in the 1950s. III But a slap was the traditional answer for most childish troubles in their youth. Matisse said later that a drawing should have the decisiveness of a good slap. Patois songs like "Quinquin" were hawked in song sheets at the factory gates, and sung on the streets and in the bars all over Bohain. They confronted head-on the actuality of impoverishment and want, covering everything from the latest gruesome crime or accident to cold, hunger, hangovers, marital troubles, unsatisfactory wives and unwanted children. "It's no good heading for the grave with your eyes shut," as Matisse was fond of saying. 112 He liked the blunt, selfmocking popular songs of his native region. Ironic, intensely realistic, flat in tone and richly detailed, a song equivalent to Flemish genre painting, they suited the matter-of-fact, caustic and irreverent side of his nature which he never lost.113

It served as undertow or counterweight to his rich dreams. Matisse's art, even at its purest and most transcendental, is firmly anchored in the

Street scene in Bohain: on the right, the Hôtel Lion d'Or, run by Matisse's Aunt Mahieux, where as a boy of fourteen he challenged and defeated the legendary hypnotist, Donato

essential bedrock of his being, which remained tough, durable, unyielding, wholly without sentimentality or self-pity. He summed up the two sides of his nature in a strange symbolic story which he told several times about his childhood. The episode took place in the summer of 1884, when Henri was fourteen and a half years old, in the Golden Lion Hotel kept by his mother's elder sister, his Aunt Joséphine, now the Widow Mahieux. Its central figure was a travelling Belgian showman called Donato, already a celebrity in the North, fresh from a successful tour of Brussels, Lille and Valenciennes. Billed for weeks beforehand as an indomitable man-tamer, Donato packed the circus in St-Quentin that July, easily eclipsing the London lion-tamer offered as a rival attraction by Wombwell's Great British Menagerie. I14

Donato was far from the usual ghoulish mountebank. Born Alfred Odonat, son of a teacher at the Royal Athenaeum in Liège, an ex-Polytechnic student himself, he had started out as a literary journalist before switching in a spirit of strictly scientific enquiry to a career in hypnotism. Hailed as Mesmer's true successor and Professor Charcot's rival, he made his name by a series of well-publicised encounters with eminent sceptics whose attempts to unmask him generally ended in triumph on his part and humiliation on theirs. He was short, dark and stocky, impeccably polite and gentle, the incarnation of mildness itself until confronted by a recalcitrant subject, when his eyes shot fire: "It was the petrifying glare of a tiger about to leap upon its prey," wrote a newspaper in Warsaw,

where a deputation from the medical faculty admitted defeat in 1881. ¹¹⁶ In Paris the same year, Donato caused a sensation at the Jockey Club. He regularly got the better of scientists, politicians, priests and medical men. What stupefied audiences, when he reached St-Quentin in 1884, was the contrast between his gentle voice, low stature, unassuming manner, in short his total lack of showmanship, and his apparent invincibility. "Donato comes close, darts the piercing rays emanating from his eyes deep into the eyes of one of his subjects, who, almost immediately, against his own will, rises to his feet, walks, and, oblivious of himself, carries out... any order he is given." ¹¹⁷

Power and submission were the point of Donato's act, and his speciality was adolescent boys. He liked nothing better than ten to twenty youths, the cockier and more arrogant the better, who would be first immobilised by the force of his hypnotic eyes, then stripped progressively of their senses—sight, sound, touch, taste—and made to perform shaming charades in public. In St-Quentin, he had them shaving one another with invisible razors, shamming dead, mending imaginary shoes and sitting cross-legged to sew imaginary patches on their trousers. One sixteen-year-old, roused from his trance halfway through eating a raw potato under the impression that it was a peach, left the ring literally spitting with disgust. Donato's audience, already laughing hard, became positively hysterical when he made the boys strip to their underpants and plunge into an imaginary stream.¹¹⁸

It was at this point that he came up against the young Henri Matisse. The water stunt was one of Donato's favourite standbys, easily staged without props on one-night gigs in provincial halls or hotels like the Golden Lion. It touched a nerve in these stern, buttoned-up, banked-down northern people, who responded to seeing the coercions of their everyday lives mocked and derided with wild, often frenzied laughter and applause. Donato's act in the North and the department of the Aisne had a grotesque, orgiastic edge—the kind of wildness people only otherwise permitted themselves in disguise at the Lenten carnival—which was not present, or not reported, in his more decorous performances in Paris and Warsaw. More than a century later, people in Bohain still dimly remember the visit of the foreign hypnotist who made fools of the town's great and good. One of them was made to urinate in public, another to ride on a broomstick through the streets to the railway station.

The third was Mme Mahieux herself, Henri's aunt and the hotel's proprietress, a highly respected matron in her late forties who had expressed doubts about Donato, and who found herself mesmerised into parading

down the stairs and through her own front hall carrying a brimming chamberpot in front of an incredulous, gawping crowd of fellow citizens. Her nephew and a group of his school contemporaries provided the climax to the night's revels. More than forty years later, Matisse himself described to an old friend what happened when the boys were "donatised" into believing that they stood in a flowery meadow beside a burbling stream: "They would stoop to pick the flowers, they would try to drink the water, so powerful was the hypnotic sugges-

tion. When it came to him, however, just as he was beginning to fall under the spell, something seemed to snap and through the grass and the stream he saw the carpet on the floor. 'No,' he cried, 'I can see the carpet.' "120"

The episode remained ever afterwards a yardstick for Matisse, who said that "however far fantasy might take him, he never lost sight of the carpet." Contemporaries regularly compared Donato at the height of his powers in the early 1880s to a tiger, lion or other unspecified wild beast, or fauve. In this still largely oral culture, his encounter with Mme Mahieux's young nephew took on an element of Flemish fairy tale: the brave local boy pitted against the potent spell of an enchanter. If Matisse used the story in later years to symbolise his firm grasp on reality, it also demonstrates something Donato himself was well aware of when, at the height of his Parisian triumph, he graciously acknowledged to the actor Jean Mounet-Sully of the Comédie-Française: "You, too, sir, are a hypnotist." Donato met his match that night at the Golden Lion in Bohain in a will more powerful than his own, and an imagination that would one day exert its spell on a scale even the boldest of those present could scarcely have envisaged.

CHAPTER TWO

1882–1891: Bohain and St-Quentin

Matisse and his mother, photographed by his uncle Henri Gérard at Ypres, 1887

The town of St-Quentin, with a population seven times as big as Bohain's, was the traditional meeting place between the flatlands of Flanders and the rest of France. It rose like an amphitheatre above the marshy valley of the Somme on a hilltop crowned by a graceful mediaeval collegiate church visible from the plain for miles around. To the

north of the church a sixteenth-century town hall, handsome in the sober Flemish style, opened onto a spacious square surrounded by bars, cafés, shops, offices and banks, and beyond them by tall old gabled town houses with pointed blue-slate roofs. By 1882, when Henri was sent to school there, the town had finally surrendered to an army even more invasive than the Germans. "The old St-Quentin bourgeoisie, besieged by the rising tide of commerce, had already been forced to take refuge on the acropolis of the upper town," wrote Gabriel Hanotaux, describing his own school days in the 1860s. "A belt of factories, with their seething population of workers, was surging up the flanks of the hill. The industrialists formed a new and distinct class, richer, more enterprising and far more forward-looking than the old bourgeois society." I

Their factories manufactured white goods, pioneering the latest techniques in machine-made muslins, nets and piqués, silk and cotton embroidery, guipure and lace. Business boomed in the 1880s. Lines of identical cheap brick workers' houses snaked out through the gates to wrap themselves round the mediaeval walls while factory chimneys infiltrated the town itself. Several can be seen belching smoke in the background of a classical engraving of the Lycée de St-Quentin, made by the head of the school art department a few years before Henri got there. The school (which changed its name in 1885 to Lycée Henri Martin after its most illustrious old boy) was where the victorious new class of mill-owners, managers and businessmen sent their sons to be moulded in their turn into a solidly dependable new bourgeoisie. Henri was twelve when he transferred there in 1882 from the College of Le Cateau.²

The school was a grim barracks built twenty-six years earlier, standing near the prison on the town's old parade ground: a sort of military monastery ruled by the drumbeat and the drill yard. Old pupils remembered ever afterwards the sound of the drum echoing lugubriously along the stone arcades of the high enclosed central courtyard where they took their exercise.³ There were 432 boys in kepis and dark, high-necked, brass-buttoned tunics, the usual soldierly uniform of the French state boarding school.⁴ Reading was censored, discipline austere and leisure strictly limited. Boarders were allowed out two Sundays a month (Henri visited a friend of his father's, Paul Flayelle, who kept a chemist's shop a few streets away on the rue St-Martin).

The boys slept in unheated dormitories in freezing temperatures of up to eleven degrees below zero in winter (fifty-five cases of boys gravely ill with chilblains were reported in Henri's last year).⁵ By day they worked in dark and dingy classrooms at a curriculum still firmly centred on Latin

1882-1891: BOHAIN AND ST-QUENTIN

Lycée Henri Martin in St-Quentin, engraved by Matisse's art master, Emile Ancelet, showing the ring of factory chimneys surrounding the old town

and Greek grammar. Even Hanotaux—a star pupil who took virtually every available prize, being beaten into second place in the 1870 departmental examinations only by the young Arthur Rimbaud—admitted that the education on offer was at best mediocre. After seven years of studying up to eleven hours a day, six days a week, he could read Virgil and Livy in the original and understood enough Greek to wish he knew it better. Otherwise he had a smattering of German, physics, chemistry, maths and music, had never played any form of sport, knew little history and nothing of any literature but Latin ("The immense intellectual world outside did not exist for us"). This was an education designed to promote solidarity, encourage bonding and reshape awkward customers into smooth, serious and reliable, rather than open or adventurous, minds.

Drawing was taught, like a classical dead language, as a series of prescribed routines based on plaster models of abridged or abbreviated Greek and Latin originals. All pupils started by studying the properties of straight lines and angles, moving on via steadily more complicated geometrical exercises, first to drawing solid objects in outline, then to shading them in with elaborate cross-hatching. Older boys progressed to copying stylised plaster foliage, scrollwork, fragments of statues, or the bases, shafts and capitals of columns. The senior art master, Emile Ancelet, was an unqualified sexagenarian who had been running the art room with min-

imal exertion for the previous twenty years: "an excellent engraver but a worse than useless drawing teacher," wrote a school inspector at the end of his inglorious career. Ancelet taught the senior forms, who were promoted to working on the human figure, generally in the shape of a bust, foot or limb from dismembered plaster statues. Favoured pupils were permitted to poke about in the attics of the nearby Palais de Fervaques, where they helped themselves to portraits for copying from among the eighteenth-century pastels of Maurice Quentin de La Tour, the only serious artist St-Quentin had yet produced. ¹⁰

The lower school was taught by Ancelet's newly appointed deputy, Xavier Anthéaume, a Parisian in his early forties struggling to survive in his first teaching job. He taught from diagrams on the blackboard and was completely unable to impose order on the huge, rackety classes, who regarded their afternoons in the art room, tucked away high up under the roof in a converted dormitory, as an invitation to let themselves go. Anthéaume's manner was dry, fussy and defensive. He was asthmatic, and his rambling instructions were frequently interrupted by a violent hacking cough. II Boys kept on a tight rein responded energetically to any slackening of discipline. Throughout Henri's school career, the juniors regularly danced in a derisive chanting ring round their form-master in the courtyard, while the seniors were reported for smuggling salted herrings into class, or keeping wine and knuckle-dusters in the dormitory. Anthéaume's art class became a weekly riot. 12 Once, in front of an assembled crowd of boys noisily waiting for the master to arrive and unlock the door, Henri leaned over the banister and spat on the top hat of Père Anthéaume as he puffed wheezing up the spiral stairs below. 13

It was a repeat of his earlier revolt against Père Pechy. Behind it lay a disillusionment still vivid more than half a century later when he told this story. Matisse said he had discovered by chance in the school art class an innate ability to draw, and his indignation with the mechanical exercises that blocked it off was correspondingly fierce. He remembered his teacher as a dusty greybeard (in fact, Anthéaume was forty-five in 1883, with a modest record of success behind him—including a bronze medal from the Royal Academy in London—as an enamellist and porcelain painter, like Henri's mother). Matisse never afterwards forgot his friend and rival Emile Jean, whose father was a primary-school teacher in St-Quentin:

We were the two who paid most attention, covering our sheets of drawing paper with versions of the model provided for us, a plaster fig leaf or a Roman bust: we took no notice of what was going on in the rest of the class, or what the various rioters got up to. ¹⁴

At the end of the year Matisse and Jean shared the drawing prizes. Matisse finally left school with no clear idea as to what he might do next ("I realised that I had a certain facility in drawing without having the least notion of going on with it"). Is Jean enrolled at the local art school, winning a silver medal and leaving St-Quentin for the Ecole des Beaux-Arts in Paris in 1890 with a municipal scholarship and his father's approval. Matisse, who got there three years later with neither, recalled with some bitterness in later life the contrast between his own inability to keep a footing on the academic ladder of promotion and his classmate's seemingly effortless upward progress. Pean for his part was no less despondent. In never really came up to scratch," he said at fifty, describing to Matisse's son how his ambition had unaccountably petered out on leaving school, at precisely the moment "when people expect that some purpose will be revealed to you so you can throw yourself into the struggle..."

Their initial timing was unlucky. Throughout their school careers, there were repeated calls for the curriculum to be updated, in particular for the expansion of modern-language teaching and a drastic overhaul of the art department. 19 In 1882 a damning report by the school's governing body (headed by the mayor of St-Quentin and the departmental subprefect) called for Ancelet's immediate retirement, together with Anthéaume's dismissal at the end of his second term, on the grounds that their oldfashioned teaching methods were hopelessly inadequate for a region whose industrial future depended on raising design standards. Rumbling dissatisfaction behind the scenes erupted in a brutal climax in Henri's last year. The headmaster's opinion of Ancelet had reached rock bottom ("He does what he can to fall in with the requirements of the programme but at his age he cannot catch up with a way of teaching that goes against all his habits").20 Anthéaume had struggled on under heavy and increasing pressure not only from the boys, the headmaster and the municipal authorities (who sacked him from his subsidiary post at the girls' school after a campaign of harassment) but also from the government inspector, whose harshest report was dated 18 May 1887.²¹ Two days later Anthéaume took to his bed with what proved to be his final asthma attack. His death six weeks later was reported without comment by the headmaster in a letter which proposed suppressing his post at a notable saving (Anthéaume's salary was 1,600 francs a year, not much more than a workman's wage), which might be put towards hiring a better-qualified, less out-of-touch

instructor to replace Ancelet (himself due to be forcibly retired just short of pensionable age the year after).²²

Twenty boys and masters followed Anthéaume's coffin to its grave on 16 July, by which time Henri had apparently left school for good. He had troubles of his own now that the time had come for him to take a more active part at home in the family business. "I was a child with my head in the clouds," he said, describing how his mother found him practising to be an acrobat, doing headstands among the seed sacks, when she came to fetch him for a serious discussion about his future with his father.²³ These conversations became increasingly frequent and gruelling. "I was very submissive. I would do whatever they wanted," Matisse insisted later.²⁴ His refusal or inability to comply took the form of regular bouts of illness when he had to be put to bed for up to eight weeks at a time—"the crises lasted a month, a month and a half, sometimes two months"—suffering from what he described later as a grumbling appendix, typhlitisparatyphlitis or colitis (which means a blockage or inflammation of the gut).25 The complaint was painful, inoperable, curable only by bed rest, probably spasmodic in origin (as many of Matisse's later health problems would be, according to his old friend Dr. Vassaux), caused by acute nervous tension and distress.26

Stomach cramps and colic were common enough among sensitive, intelligent, highly strung adolescent boys who baulked at the cramped horizons that had satisfied their fathers. Hanotaux and Ozenfant, attending the same school respectively fifteen years before and after Matisse, both suffered from a similar malaise—stomach pains, night fears, fainting fits, fever, nervous prostration—before finally escaping to a world of literature and the arts of which St-Quentin knew nothing. Lycée highfliers often took a perverse pride in emerging from the prolonged mental and physical ordeal of their education looking pale, gaunt, ascetic, wild-eyed and hollow-cheeked. Physical weediness was almost a badge of merit among French intellectuals of Matisse's generation. His friend the art critic Elie Faure left school with "an ingrained contempt for the body, sickly, devoured by anxiety, despising sport, despising health itself" (and was shocked to discover later that a painter as serious as André Derain could also box, smoke and drive a car).²⁷

But intellectual snobbery offered no consolation to those who got the worst of an examination system specifically programmed to fail half the candidates. Out of thirty-seven who sat the Baccalauréat from the Lycée Henri Martin in the year 1885–86, nineteen passed. Each year a handful of boys ducked their return to school after the Easter holidays to take exami-

nations in the summer term. In April 1885 Henri was one of them ("Matisse: being treated at home for an intestinal complaint," his teacher wrote in the school register). He was fifteen years old, due to sit the entrance exam for the upper school that term. Instead he stayed at home, planning the theatrical production based on the eruption of Vesuvius, to be staged with Léon (who returned home with a Greek prize at the end of his own first year as a boarder in St-Quentin at the Institut St-Jean). Perhaps this was when Henri thought seriously of becoming an actor, a universally despised profession that would have added an edge of public humiliation to his parents' already bitter disappointment. At all events, he said he would never have been a painter if he hadn't been unhappy: "You have to be sitting on a volcano."

Ill health had at least solved the problem of who was to succeed his father as seed-merchant. The family reluctantly accepted that Auguste would have to step into the shoes of an older brother whose intestinal troubles prevented his ever humping heavy sacks for delivery like their father.31 Hippolyte Henri's old friend Paul Flayelle, brother of one of his classmates at the College in Le Cateau, had an only son who would eventually inherit his chemist's shop in St-Quentin. Flayelle Jr., four months younger than Henri Matisse and also showing promise in the lycée's art class, was already working towards the necessary pharmaceutical qualifications.³² Hippolyte Henri decided that his own son should do the same on the advice of the family doctor in Bohain, who saw a chemist's shop, with an assistant to take over whenever the proprietor's health was playing up, as the perfect answer for a semi-invalid who would never be able to lead a normal life.³³ Henri returned obediently to school for two more years, but the plan had to be abandoned when it became clear that academic success would elude him as it had his father.

Whether he left before or was withdrawn partway through the summer examination term in 1887 is impossible to say. His memories of this period were patchy and confused. He recalled his parents' strain and worry, their exasperating indecision, and the periodic collapses that countermanded his own willingness to submit.³⁴ Halfway through the summer term they sent him to stay for a week with relations in Paris, perhaps to convalesce, perhaps to look round for some sort of training or job opening. He was certainly there, visiting the Opéra-Comique with his older cousin Hippolyte on 25 May 1887, the night the scenery caught fire as the curtain rose on the first act of *Mignon*.³⁵ Smoke engulfed the auditorium, the singers fled, the musicians leapt from the orchestra pit to escape with the audience through the stalls, the public in the upper tiers pressed out-

wards in a screaming, heaving mass to jump from balconies and windows. Henri and Hippolyte, trapped between the rising flames and the falling ceiling high up at the back, were separated in the stampede that blocked the stairways. Hippolyte, after searching for hours, gave his young cousin up for dead. Henri meanwhile fought his way down to the ground floor, where he found thirty bodies piled up against a glass-panelled door that opened inwards. When firemen finally smashed the door in, he clambered out onto the street and stood himself a brandy, keeping his head sufficiently to note that the price of fifty centimes was five or ten times as much as it would have cost in Bohain. He then made his way home alone to his cousin's family, who could see the blaze and reproached him for saving his own skin, until Hippolyte eventually turned up safe, too. 36

It was a close shave. More than four hundred people were burned, stifled or crushed to death that night. Solemn obsequies were held on 30 May in Notre-Dame. Henri suffered no physical damage beyond waking up with one deaf ear next morning, but this trip to Paris marked the end of his childhood hopes and daydreams. From now on there was no more talk of theatres or the circus. He remembered another crisis, followed by a walk in the beet fields round Bohain during his convalescence, when his father first suggested he might make himself useful by working as a lawyer's copying clerk. A place was found with the family lawyer, Maître Alfred Dezoteux, whose office was a little further up the rue du Château. "I went. I copied. I saw some extraordinary things, very colourful: the weird arrangements people make to safeguard their interests, the sort of thing you find in business, and inside families."37 The problem of Henri's future seemed to have been solved at last. He had his picture taken round about this time on a visit with his mother to Ypres in Belgium, where her younger brother Henri Gérard had set up as a photographer. Seated on a fake tree trunk before a painted backdrop, Henri Matisse holds a book, looking hopeful but a little blank beside his fond, beaming mother.³⁸

His father, nothing if not practical, was agreeably impressed when Henri himself proposed a year in Paris studying for the preliminary law examinations. The idea came from a visiting Parisian lawyer who had seen him copying documents in the office and insisted that a bright boy like him was bound to do well in the exam, which could even lead to running his own advocate's practice. This was a traditional compromise, acceptable to rebellious youth as well as to even the sternest and most puritanical northern father: Hanotaux and the great Henri Martin himself had both managed to get away to Paris under the pretext of taking the law matriculation course at the Sorbonne for which Henri enrolled in 1887. He was

seventeen years old, and by his own account this first year of liberty passed in a stupor. ⁴⁰ He had more than one set of relations to keep an eye on him in Paris. His mother's eldest sister, Victoire, had married a Parisian tailor, and another sister, Sidonie, had moved there with her husband, Jules Loncq (the former bartender on the rue du Chêne Arnaud), in the 1870s, when he too became a lawyer's clerk. Cousin Hippolyte, who sold artists' colours and canvases, ⁴¹ went out of his way to be kind to "the little cousin from St-Quentin," but Matisse said painting meant so little to him at this stage that in a whole year he didn't even step inside the Louvre. ⁴²

He drifted through his classes on the civil code, civil procedure and the criminal law, making up with assiduous attendance for the fact that the law meant nothing to him ("It was Hebrew to me").43 He matriculated in all four of the regulation courses in August 1888, explaining that all you had to do to satisfy the examiners was demonstrate that you had actually opened a lawbook and knew how to use the index. 44 Even that took its toll. Still not much older than a schoolboy, miserably bored and lonely, shut up alone with his revision on the sixth floor of a cheap hotel, Henri armed himself with a glass peashooter and ammunition made from balls of putty with which he took pot shots through the slats of his window blind at the top hats of passersby. Sometimes he knocked the newspapers out of their hands. Once he aimed at a dressmaker working on the ground floor of the house opposite, scoring a bull's-eye with his putty ball on her ample bosom: "My dressmaker jumped up and looked round to find where it had come from. She saw the tip of my peashooter poking through the blind and glinting in the sun. I was rumbled. There were complaints at the hotel. The proprietor came to tell me: 'You can't do that here.' "45

Henri returned from Paris as a newly qualified lawyer's clerk to work for Maître Théodore Duconseil, a cultivated and art-loving advocate with an office on the rue du Gouvernement in St-Quentin, which was the town's administrative and commercial centre. ⁴⁶ Henri's father had hopes of his ending up in some sort of ministerial office. ⁴⁷ Henri himself went back to the interminable lawyers' briefs that had to be copied out by hand, using steel-nibbed dip pens or goose-feather quills, and blotted with sand (the first primitive fountain pens went on sale at the lycée in St-Quentin round about 1900). ⁴⁸ When his sense of futility became too great to bear, he brought out his trusty peashooter, raking the passersby this time with paper pellets. ⁴⁹ He went home when he could, to see the family and go dancing with his friends, themselves also starting out as clerks and trainee shop assistants. Henri had something of a reputation as one of the boys in Bohain, a joker liable to go off the rails in the giddy nights of carnival,

a great one for balls and fêtes. Thérèse Moisselin, a niece of the Matisses' Cousin Lancelle, grew up on the rue Peu d'Aise hearing talk from her elder brothers of Henri dancing with the girls: stories of the wild oats they sowed together were spread by friends like Louis Guilliaume and Gustave Taquet. ⁵⁰

But beneath all his bravado, his determination to put on a brave front, his constant effort to conform, lay something close to desperation. Henri had grown a beard, like his father's, and acquired his own top hat, both essential props for the smart young city clerk. But unhappiness made him awkward and repellent. "Matisse at eighteen was far from good-looking," said Marie Clément, who danced with him when she too was eighteen at the annual ball in the town hall at Bohain: "Skinny and shy with a wispy beard ... he looked ugly as a nit, a real nit."51 Respectable young ladies like Mlle Clément (who would marry the director of a small textile factory and become the mother of another local painter, Emile Flamant) were permitted little or no contact with their male contemporaries apart from these town-hall hops. Strictly chaperoned, privately educated, often shut away in convent boarding schools, they were expected, at least in theory, to meet young men only after they were safely married. The boys, incarcerated in their lycées, were not much more experienced. From a practical point of view, sex for them meant married women, working girls or prostitutes, none of them a realistic proposition in a small town like Bohain where everybody knew everybody else and noticed instantly anything anyone got up to.

But in a rough, coarse, often brutal, intensely gender- and class-conscious age, women exerted a powerful imaginative pull. On the one hand, a French married woman was both sexually and economically far more liberated than her British counterpart: the law protected her right to control her own property, and, at any rate in Matisse's native region, her name was automatically joined with her husband's in what was regarded as a business partnership. On the other hand, for adolescent boys almost entirely cut off from the opposite sex, women represented a highly codified, generally Oriental ideal of glamour, strangeness and seduction. Sultanas, odalisques, veiled harem beauties, Algerian belly dancers, the flower-clad maidens of Tahiti and the voluptuous café singers of Tangiers all played their part in Bohain's popular culture. Young weavers drew them in their notebooks, conscripts pictured them in letters home, romantic ballads invoked them in yearning quatrains.⁵²

Local boys, accustomed to seeing their mothers and sisters encased in tightly boned and buttoned black, dreamed endlessly of something looser and more exotic. For the young Emile Flamant, it was the lascivious, darkskinned, fortune-telling Gypsies' wives "with their alluring and disturbing manner, their beautiful almond-shaped eyes, their bodies supple as a tigress in their full, swirling skirts...."53 For the novelist André Billy, it was a turbanned sultana seated on a divan waving an ostrich-feather fan whom he saw as a boy in 1890 or 1891 at a fairground sideshow in St-Quentin: "The sight of that sultana knocked me sideways. She invaded and rent my heart, not so much by her smile as by her gesture, the simple movement of her white hand which conveyed an indescribable longing. I should have liked to die for that woman, I should have liked to do I know not what, but above all I wanted never to be parted from her, to be able to contemplate her for all eternity."54 On one level, the odalisques Matisse painted in the 1920s and 1930s were a richer, subtler and infinitely more sophisticated version of the almost universal longings of his northern generation for a vision that would rise above the flat, drab, repressive reality of their daily lives.

Military service still represented for most Frenchmen the only glimpse they would ever get of the world beyond their own hometowns. In Bohain's military culture, the annual call-up ceremony in the town hall, with its attendant drama of selection and rejection, was a big day when the whole town turned out to watch the successful conscripts in redwhite-and-blue cockades parading through the streets behind the band. Henri was one of the rejects of his year in 1889. He had succumbed to the last and by far the most serious of his breakdowns, ending up in hospital with what he later called appendicitis, typhlitis or ulcerative colitis. In fact, it was a hernia, probably brought on by heaving sacks in his father's seedstore. 55 But Matisse talked afterwards almost as if the mysterious rupture or blockage in his gut were standing in for an obstruction that blocked and paralysed his will. Looking back later as a successful artist, he never underestimated the gravity of what he and his family both saw as a rejection of the world into which he was born. In that newly industrialised, barely urbanised society, order still seemed too precarious for breakdown or disruption to be readily tolerated ("The slightest opposition," wrote Gabriel Hanotaux, "... would be mistaken for anarchy and riot").56 Children trained to respond with instant obedience to their father's raised eyebrow or hand knew well enough that if they persisted in defiance, they would be bent or broken, more or less violently, for their own good.

But the other side of their dependence and submission was the heavy weight of responsibility that bore down on a loving father. "I know I am failing in my duty," Matisse wrote long afterwards, lamenting his own

leniency towards his children: "I ought to be firmer." The relationship between father and son was fraught for him with anxiety and foreboding, involving ceaseless effort on the father's part, little pleasure and no relaxation. In his gloomier moments he saw it as an unequal balance of thankless toil on one side, idleness and folly on the other. He looked back on the apathy and fecklessness of his younger self and hoped that his own sons would one day appreciate his attempts to train and guide them. "That is what happened to me personally with my father," he wrote sadly in his sixties: "I should have liked to tell him so, but it is too late." 18

At the time, his conflict with his father demanded all his strength, leaving him drained, listless and exhausted. Sometimes it seemed to him that he spent the better part of his twentieth year bedridden. At other times it seemed more like two months. There was admittedly an element of ritual in this clash of wills in which both sides were acting out their appointed roles in an accepted pattern. Lives of the great men of the region commonly start with a son whose refusal to conform (which generally meant training for the law) meets total incomprehension, followed by relentless opposition from his father. Quentin de La Tour himself was said to have run away to Paris to be a painter in the early eighteenth century, returning only long afterwards loaded with fortune, fame and honour. The writer Henri Martin did the same a hundred years later, leaving secretly without having the nerve to tell his father that he meant to be a poet. "He had a strong will but a timid heart," wrote his biographer approvingly, describing the predicament in which Matisse found himself.⁵⁹ Martin's disciple, Hanotaux, made himself ill with frustration at eighteen or nineteen like Matisse, and spent his convalescence reading Balzac:

What had I seen up till then? United families, obedient children, carefully regulated relationships, strict morals. The odd exceptional disturbance—signalled by pointing fingers, or by a smile for those who merely made themselves ridiculous—a commonplace and down-to-earth shrewdness which reckoned food and lodging the great business of existence; a tenacious concentration on savings by people who worried only about their limited future: that was all I was ever offered as a child. . . . And here, at a blow, was the revelation of life itself, of an ardent, ambitious, urgent life: a whole unknown world rose up and called me. 60

The story of the revelation that came no less dramatically to Matisse as he lay in hospital recovering from his final collapse became something

1882-1891: BOHAIN AND ST-QUENTIN

Léon Bouvier, Swiss Chalet with Pine Trees, 1890: the picture which turned Matisse into a painter

of a legend in his lifetime. It started with the man in the next bed whose hobby was copying Swiss landscapes in oils from coloured reproductions, or chromolithographs. "Seeing that I was becoming a burden to myself during my convalescence, my friend advised me to try the same distraction. The idea didn't please my father, but my mother took it upon herself to buy me a paint-box with two little chromos in the lid, one showing a water mill, the other the entrance to a hamlet."61 Matisse said his neighbour was copying a Swiss chalet with pine trees and a stream, the sort of chromo-simple, charming, sentimental-that was all the rage with the younger generation in Bohain at the time. The picture still survives in the family of this amateur painter, who might be said to have changed the face of twentieth-century art. He was Léon Bouvier, the twenty-six-year-old son of a local textile manufacturer and Léon Vassaux's future brother-inlaw, who was perhaps already courting Léon's sixteen-year-old sister Jeanne. Bouvier claimed there was no better form of relaxation after a hard day at the office than sitting down comfortably at home to paint a landscape (Matisse would define his own aim as a painter in strikingly similar terms in 1908). He clinched his advice to Matisse with the kind of wry, mocking aside that was the automatic response to any stepping out of line in their hometown: "And then, you see, you end up with something to hang on the wall."62 Gustave Taquet, remembering their dim view of Anthéaume and all his works at school, was astounded to find his friend

sitting up with a paintbrush in his hand and a canvas propped against his knees. Henri started with the water mill brought by his mother (Bouvier painted it as well), signing it with his name spelt backwards—Essitam—as if he saw himself reflected in a looking glass:

Before I had no interest in anything. I felt a great indifference to everything they tried to make me do. From the moment I held the box of colours in my hand, I knew this was my life. Like an animal that plunges headlong towards what it loves, I dived in, to the understandable despair of my father, who had made me study quite different subjects. It was a tremendous attraction, a sort of Paradise Found in which I was completely free, alone, at peace....⁶⁴

HE WAS TWENTY YEARS OLD. From now on he worried only about the time he had already wasted, and the need not to waste another minute. He bought a popular do-it-yourself handbook: Frédéric Goupil's General and Complete Manual of Painting in Oils, printed and sold by a local firm in St-Quentin, 65 which was aimed specifically at provincials who had never seen a real oil painting ("the countless mass of people outside the big cities who remain wholly deprived of contact with works of art... and either totally ignorant of their existence, or able to imagine the possibility only by listening to those who have seen them, and by reading about them in the newspapers"). 66 The manual was thorough, practical and above all up-to-date.

Goupil, an instructor at the Académie Julian in Paris, was a member of the family of art publishers and dealers who employed Vincent van Gogh's brother Théo. He still saw history painting as the highest rung on the artistic ladder, but he recommended starting at the bottom with subjects from contemporary life (and he even included a brief explanation of the principles of Divisionism, then the very latest thing in Paris, although it would be another ten years before Matisse finally gave it his attention). He included clear and copious advice on how to set up a studio, stretch and prepare a canvas, choose paints and hold a brush, together with a detailed discussion of the nature, properties and use of colours. He advised the beginner to copy engravings or other pictures before trying anything more ambitious, then to practise on modest still-life compositions ("everyday objects with dull surfaces, stoneware pots and wooden boxes; then . . . glazed pottery or porcelain with shiny surfaces; try to catch the

1882-1891: BOHAIN AND ST-QUENTIN

transparency of clear or coloured glass, to convey the shape of a bottle, a glass with wine in it, a silver tumbler to give the glint of metal"). 67

Goupil's recipe for success was observation, perseverance ("Success often means no more than great patience!") and concentration: "The education of the hand and eye will require your full attention."68 Over the next five years Matisse would carry out his programme to the letter. The canvas he ever afterwards called My First Painting was a test piece: a pile of scuffed leather-bound books arranged alongside a small opaque glass lampshade in a pottery saucer on a crisp sheet of newspaper with an artfully placed tear. He copied it from another chromo popular with his more advanced contemporaries in Bohain, signed it "Essitam" and dated it June 1890.⁶⁹ His second picture was an arrangement of the everyday objects most readily to hand for a lawyer's clerk: more books and a brass candlestick on a red woven table-cover. Digging this picture out of his father's attic ten years later, Matisse said it came so close to containing everything he had done since then that it hardly seemed worth having gone on painting.⁷⁰ Catching sight of it again, after another twenty years, he was even more dismayed ("It caused him the biggest discouragement he had ever felt: all that time of intense effort seemed to have brought no smallest bit of progress").71 The picture, which looks to the observer like a fairly standard Flemish still life, remained for Matisse a mirror that reflected the first passionate, almost animal uprush of feeling released by his mother's paint-box. "I realised, thinking about it, that what I recognised in it was my personality. But I also told myself that if I had only ever

Matisse, Still Life with Books (My First Painting), 1890

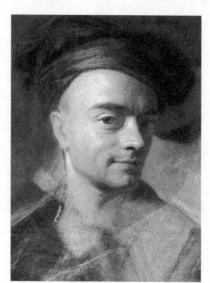

Maurice Quentin de La Tour, Self-portrait in Pastel, c. 1742

done that canvas, this personality would have remained unnoticed because it would never have developed."⁷²

Goupil's self-development programme began with the study of old masters. He recommended looking, and learning to retain what you looked at by taking notes. The only paintings accessible to a beginner in St-Quentin were the de La Tour pastel portraits so casually treated by generations of schoolboys from the lycée art class. "Since they were the first paintings I had ever seen, they seemed quite natural to me," wrote an older contemporary, Eugène Carrière, who got his first job at nineteen in St-Quentin working for the firm of engravers that printed Goupil's manual. "As I had no means of comparison, it seemed to me that they could not have been different."73 The portraits, presented by de La Tour himself to his native town, represented a cross section of characters in and around the court of Louis XV, all exuberantly alive, all smiling their different courtly smiles, all rendered with astonishing individuality within the same severely restricted range of colours, tones and poses. Matisse said he looked so closely at them that by the time he left the museum his jaws ached from the answering smile he had unconsciously kept clamped across his face for hours.⁷⁴ He ranked de La Tour with Rembrandt as the greatest of all portrait painters in point of psychological truth.⁷⁵

On his recovery, Matisse went to work for yet another lawyer, Maître Derieux, on the corner of the rue de l'Abbey-de-Pompière and the rue de la Nef d'Or, which opened onto the covered market behind the town hall in St-Quentin.⁷⁶ He treated the job as no more than a minor inconvenience, enrolling without his father's knowledge in classes at the free art school installed a two minutes' walk away in the attics of the ancient, crumbling Palais de Fervaques. Classes were held before and after work, from 6 to 8 in the morning and 7:30 to 10 at night.⁷⁷ Looking back more than half a century later, Matisse made a sketch of Maître Derieux's half-open office door, part revealing, part concealing an inner frosted-glass door with an engraved copper plate. It was the first in a long line of doors and windows that would open for him all his life, even if they had to be kicked in first. "This is what I find so particularly expressive," he said to a young cinéaste who wanted to make a film about his early life, "an open door like this, in all its mystery." ⁷⁸

Not that the Ecole Gratuite de Dessin Quentin de La Tour disclosed its mystery right away. Founded by the pastellist in 1782 for the training of poor weavers, it had become by the late nineteenth century a provincial outpost or feeder for the Ecole des Beaux-Arts in Paris. It saw itself as an entrenched bastion of the academic art establishment, engaged in a running battle to preserve the cultural inheritance, which had reached perfection during the Renaissance, from pollution by the native tradition of applied or decorative arts. Innovation, experiment, any sacrilegious tam-

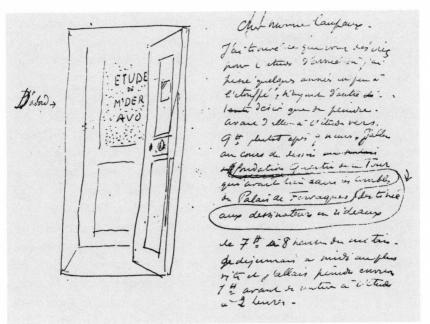

Matisse, sketch of the half-open door of Maître Derieux's office in St-Quentin, where the young Henri worked as a lawyer's clerk pering with received ideas or methods were adamantly opposed. In 1870 the young Carrière had left precipitately after a confrontation with the director, who had been scandalised by the audacity of his technique (Matisse, studying under Carrière briefly at the turn of the century, would be dismayed by its blandness). By 1890 the director was Jules Degrave, a local man trained at the Ecole des Beaux-Arts, who saw it as his mission to tend the sacred flame of classicism by playing down the importance the founder had attached to providing free teaching for poor textile workers.

In his five years as director, Degrave had reorganised the school, strengthened its academic bias and more than doubled the number of pupils, mostly middle-class amateurs—schoolboys, future shopkeepers and municipal employees, bank clerks and lawyers' clerks like Henri himself-who outnumbered by almost two to one the trainee designers sent along by local factories.80 The syllabus was strictly imitative. Clerks and boys from the lycée, who copied documents all day into ledgers or exercise books, spent their evenings copying printed sheets of engravings, then architectural bits and pieces, and finally classical statuary. The school's comprehensive repertoire of plaster casts—the sculptural equivalent of nineteenth-century sets of standard authors-ran from the Venus de Milo and the Victory of Samothrace to Donatello's John the Baptist and Michelangelo's Moses.81 Live human models were unknown. Drawing from nature was banned to all but exceptionally advanced students. Degrave taught that true colour was illusion, produced in the work of all the great colourists from de La Tour himself to Goya and Velázquez by the subtle juxtaposition of sober tones and tints. Even these were reserved for the top class, which copied the founder's pastels under the director in a spirit of quasireligious reverence.82

Austere, self-contained, by all accounts a man of iron, Degrave himself produced imitation de La Tours which were generally agreed to outstrip all the rest in the school's proud tradition of skilled copyists. He used eighteenth-century paper, manufacturing his own pastels according to the master's recipe. He seemed to his contemporaries to have taken the academic ideal of impersonation to a point where it verged uncannily on reincarnation. Amédée Ozenfant (who studied under Degrave a few years after Matisse) described him with considerable respect as a split personality, which was in itself a tribute to the way the Beaux-Arts system worked. The son of an innkeeper in St-Quentin called Patrouillard (Degrave would later change his name at the same time that he changed his nature), he had started out in the late 1860s as a brilliant and conspicuously bold student of the archconservative Jean Léon Gérôme. Under

Gérôme's tutelage, Degrave had succeeded, by the time Matisse and Ozenfant encountered him, in systematically eliminating the forceful brushstrokes and rich colouring of his youth to achieve an impeccable academicism licked clean-bien léché-of all character or individuality. This was the goal at which he aimed his students. His silver medallist in 1890 was a prodigious child called Arthur Midy, already at thirteen winning every prize St-Quentin had to offer (the mayor would be publicly congratulated on Midy's

scraped entry at twenty-five).85 Degrave's medallist from the year before was Matisse's friend Emile Jean, who marched with Midy at the head of the solemn annual procession of laureates parading through the town to

lay a wreath before the founder's bust.

Jules Degrave was a far more formidable proposition than Xavier Anthéaume. He gave no ground in repeated offensives mounted by the freebooting, forward-looking, endlessly experimental entrepreneurs of St-Quentin's textile trade. His lofty indifference to the needs of the town's design studios infuriated local businessmen, who vigorously criticised his aims, his attitude and his teaching programme. 86 St-Quentin was the high temple of the newly invented cult of the net curtain: fantastically intricate, miraculously fragile, cut out and embroidered in patterns of dazzling inventiveness, the flimsy, filmy curtains of St-Quentin took the whole of France by storm.⁸⁷ Crowds would collect in front of breathtaking displays of the town's latest lace curtains at the great Universal Exhibition in Paris in 1900.88 But Degrave remained unmoved by suggestions that the local lace-maker-"the creator of the marvels produced daily by the textile industry in silk, muslin, embroidery, guipure"-might be considered an artist in his own right.⁸⁹ The school's students continued to follow in the footsteps of their master along the narrow path that led in theory (though only twice in practice) to the Beaux-Arts' Prix de Rome. They petitioned in vain for twenty years for permission to work from a live model. As for Degrave's ban on colour, it remained in force until the Second World War.90

Maurice Quentin Point, Portrait of Jules Degrave, 1929, the head of the art school which expelled Matisse for painting in colour and out of doors

RIGHT: Matisse, Iris, C. 1890: doodle in the margin of one of the legal documents the painter was set to copy as a lawyer's clerk FAR RIGHT: Israël Tavernier, Iris, professional designer's motif for weaving, Bohain, 1890s

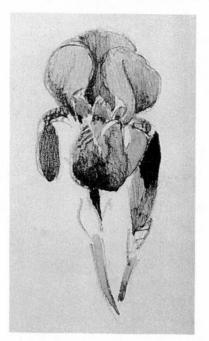

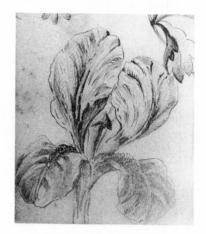

His authority rested in part on the speed and ruthlessness with which he crushed incipient revolt. Matisse's enrolment coincided with, and perhaps helped to precipitate, an early and potentially serious threat posed by a new assistant, Emmanuel Croizé, who was posted to the school on 6 October 1890. 91 Young, optimistic, energetic, an ambitious pupil of Léon Bonnat at the Ecole des Beaux-Arts, Croizé quickly gathered round him a band of Degrave's ablest and most adventurous pupils. He was exactly ten years older than Matisse, who became his chief supporter. Within two months of his arrival he had teamed up with the new deputy art master at the lycée, a twenty-one-year-old in his first job called Paul Marie. 92 Both were fresh from Paris, both determined to breathe new life into a stifling provincial backwater. Croizé's only previous post had been a temporary attachment to the academy of painting in Valenciennes, forty miles to the north, where he had worked on a set of large-scale decorative panels far too big for the new job's cramped quarters. Valenciennes, the ancient capital of French Hainaut, home of Watteau, Carpeaux and Carolus-Duran, styled itself "the Athens of the North,"93 a title viewed with no great enthusiasm by the people of St-Quentin (whose modern machine-made lace had long since seized the market from the handmade Valenciennes article). When Croizé and Marie cooked up a scheme to found a rival

academy of painting, they launched it with a shrewd appeal to civic pride, on the one hand, and cultural snobbery on the other: "the goal we have set ourselves is to fill a gap in educational provision which puts St-Quentin in a position of inferiority with respect to other less important towns, for instance Valenciennes. . . ."⁹⁴

Matisse was the star pupil of the new academy, which was in fact more of a painting class for fifteen or so boys. It was officially inaugurated on 1 December 1890 in a rented room in the Cité des Fossés, a working-class suburb built on marshy ground beside the Somme. The fees were a modest fifteen francs per month, and new premises were promised shortly in a specially converted studio on the rue Thiers. Hours were from 1 to 5 p.m. daily so as not to conflict with morning or evening sessions at the Ecole de La Tour. Thiers on the edge of town, a ten minutes' walk from Maître Derieux's office, where he was still supposedly working as a clerk.

Building plans for the academy seem to have amounted to no more than the removal of partitions and the insertion of a large north-facing skylight into the sloping roof of the attic above Croizé's modest lodgings at 11 rue Thiers (still the only house in the street with an attic skylight). 96 The studio, occupying the whole roof-space with dormer windows at front and back, would just about have held fifteen students crammed in with their stools and easels, two instructors, and the live model promised as a prime attraction. Pupils were to be prepared for direct entry to the Beaux-Arts (as old boys themselves, the two founders had enlisted their respective teachers—Bonnat, Hébert, Merson and Moillart—as a reassuringly conservative bunch of patrons). They offered practical instruction in still-life, flower and landscape painting as well as a life class, topped up by art history, perspective and anatomy lessons. "I remember classes on artistic anatomy in the attic of the rue Thiers," said one of the younger pupils, Gaston Lemire, "when Matisse, pretending to study the articulation of the shoulder blade and upper arm-bone, would let rip with hilarious silent clowning."97

Accounts of Matisse over the next few months suggest an exuberant energy in sharp contrast to the despairing lassitude of the previous year. Between painting sessions the whole class responded joyfully to his impersonations, or joined in the refrain of the latest patois pop song, which he sang to his own accompaniment. Matisse never turned up at the studio without his fiddle: "A cheerful joker, half-cracked, but an excellent fellow," said Lemire, who was still a pupil at the lycée, a conscientious and hardworking youth, four years younger than Matisse and clearly half

impressed, half shocked that anyone so gifted should have to be coaxed into taking the Beaux-Arts regulations seriously. Matisse had not got over the "horror of technique" so painfully drummed into him at school. Lemire remembered him working at still-life and religious subjects as well as studying the art of portraiture, equipped already with "a marked interpretative gift and a strong sense of colour." The younger boy seems to have played the same role of loyal and appreciative henchman as Léon Vassaux a few years earlier. After class Matisse and Lemire would go off together to paint sunsets.

Painting out of doors was another of Croizé's innovations. Intelligent, generous, perceptive, an idealist and an enthusiast, he had it in mind to do great things himself, and he sympathised with his pupils' similar aspirations. It was Croizé who first told Matisse that he could be a painter, advising him not to hesitate between art or music as a career, and to forget about the law. ¹⁰⁰ If the last was no longer a viable option by this time, the first two posed a genuine dilemma. Matisse, who prided himself on a natural bowing technique and an innate musical sense, retained always some faint remorse about the route he never took. A sense of waste, tinged also with regrets about his father, lay behind what remained ever afterwards his complicated feelings towards the violin. ¹⁰¹ But painting was already a consuming passion. Matisse was haunted by lost time. He rose before dawn in winter for drawing sessions at the art school, gave up his lunch hour for Croizé's painting class, and hurried home to his rented room in summer to slip in another few hours' painting before the light failed.

By his own account he ate only after dark, and sleepwalked through his time at the office, where he had by now been promoted to head clerk. 102 Sometimes he wrote out the fables of La Fontaine, or painted pictures in the margins of the special thick white paper on which he was supposed to copy out voluminous petitions and appeals (these were the dreaded requêtes grossoyées, divided into three parts—head, body and tail of which the court only ever required the first and last, summarising the case in question and the desired conclusion). Matisse remembered being paralysed by stage fright on his only court appearance, which proved a lamentable failure. "All I had to do was to pronounce one sentence: 'We ask that the case be postponed for a week.' And I could never manage to get it out."103 He said he was so bad at locating papers that his employer found it easier to fetch them himself, and eventually gave up even asking him for help. 104 Maître Derieux put up patiently with his head clerk's growing eccentricity, his absentmindedness if not his actual absence, and the shortcomings of his filing system, refusing to be manoeuvred into the

open confrontation Matisse was doing everything in his power to provoke. He also covered up for him with his father, now a highly successful and respected local seed-merchant (whose custom perhaps the lawyer valued). "When my father dropped in to see him, I hoped each time that he would say 'This isn't working,' and chuck me out. But I would hear him say: 'It's

going well, he'll make out fine.' "105

If Hippolyte Henri Matisse had his suspicions, he had as yet no hard evidence that his son was going off the rails again. Sometime that year, on the advice of someone in the lawyer's office, perhaps Maître Derieux himself, Matisse went to see the only living painter of any standing in St-Quentin, Philibert Léon Couturier. 106 Almost seventy years old, a Burgundian by birth, the friend in his youth of Millet and Corot, Couturier had studied at the Beaux-Arts in Paris with both Gustave Moreau and the far more fashionable William Bouguereau. He had moved to St-Quentin after the postwar economic boom, hoping for rich pickings as a portraitist among its newly affluent businessmen (practically every self-respecting local family ended up possessing at least one of his works), only to find to his chagrin that they preferred him to paint poultry. 107 He was renowned for barnyard scenes of unexpected elegance and vivacity ("brilliant, sparkling, shimmering canvases which show sharply defined ducks dabbling in blue duck ponds or shining dung heaps in a world that belongs neither to nature nor to fantasy . . . "). ¹⁰⁸ He was well liked in the town and had the makings of a reputation outside it, which boosted the morale of Croizé's painting class ("Each of them dreamed of one day achieving the same celebrity as Couturier"). 109

Couturier could be gentle and generous to hopeful young painters who presented themselves, with suitable modesty and the approval of their parents, at his studio on the quai Gayant above the Somme. Matisse found him pompous and unhelpful, recalling without amusement Couturier's habit of combing his patriarchal beard in public. It counted as a black mark later that, though the great man spoke readily enough of his links with Bouguereau, he barely so much as mentioned Moreau. Couturier was a famous raconteur with a strong line in anecdotes about the sufferings of poverty-stricken and persecuted youthful genius, but like many elder statesmen in the arts, he felt it his duty in practice to discourage aspirants without parental or professional backing. It was hardly surprising that Matisse, who had no reason to expect anything but further stiff opposition from his father, got on better with the more innocent and less experienced Croizé.

Croizé endorsed Matisse's belief in intensive study (he had himself

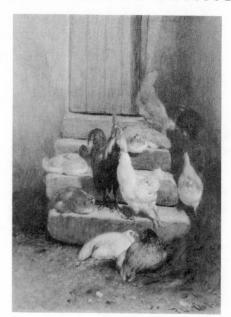

Philibert Léon Couturier, Rooster and Hens on the Steps, n. d.

left the Beaux-Arts only reluctantly on reaching the age limit of thirty in 1889), and the crucial importance of firsthand observation of nature. 113 This last, like much else in Croizé's programme, went against the deepest instincts of Degrave's generation without being intended as primarily, or even necessarily, subversive. Croizé's decorative panels have not survived, but his submissions from the mid-1890s onwards to the militantly reactionary Salon des Artistes Français were mostly history paintings, often featuring ample nudes with the cottage-loaf hairdos, nipped-in waists, cushiony buttocks and bosoms favoured by women's fashions of the period. 114 Nothing in his career, at the time or later, indicates the least desire to break with conventional Salon practice. But neither did Matisse show any sign at that stage, or for several years to come, of wanting to do anything except make up for lost time as fast as possible by acquiring a thorough grounding as a painter. So far as teaching went, Croizé could hardly have been more serious: "In spite of his free spirit, he was a born teacher, attentive, clear-sighted, impatient of slickness, ruthless when it came to facile solutions. For him, drawing was to art what syntax is to literature."115

Croizé encouraged his pupils to raise one another's stakes by impromptu competition, to gain confidence and fluency by making a habit of spontaneous sketching, to compare and criticise each other's output at the end of the day's work—all tips that would stand Matisse in good

1882-1891: BOHAIN AND ST-QUENTIN

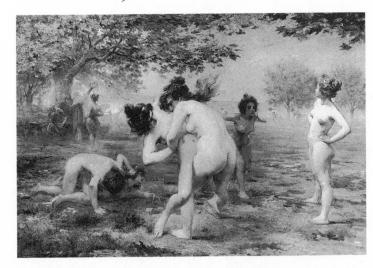

Emmanuel Croizé, Spartan Girls Wrestling, 1903

stead in the next few years. As soon as the weather permitted, the class set off with palettes, stools and easels for the fields and woods beyond the town. Croizé led expeditions down the hill from the rue Thiers and out along the tree-lined country road leading westwards to the village of Vermand. This was a favourite beauty spot for the townspeople who gathered on the weekend to walk in shady groves of oak, hornbeam and chestnut trees, or to dance and drink cider at the local inns. It Matisse and his friends met to drink and talk on summer evenings at a bar called the Bosquet des Roses, but they also brought their paintboxes to practise catching the fleeting effects of light and colour as Croizé had taught them: "In order to acquire the habit of working fast, he often asked them to catch impressions, colourful but fleeting, of the setting sun." It?

The spring of 1891 was late and bitterly cold in St-Quentin. Winter had brought the heaviest snowfall, the longest freeze and the worst February flooding anyone could remember. There can have been no question of painting sunsets in the polar temperatures that persisted well into the middle of April, nor of sitting out at night until late May or early June. It may have been weeks after that, perhaps months, before word of Croizé's alarmingly advanced teaching methods reached Degrave, who reacted much as his predecessor had done twenty years before to Carrière's audacities. Impressionism—even in the mild and dilute form represented by Croizé's sunsets—was still a dirty word to Degrave's old master Gérôme in Paris. To Gérôme's provincial pupil it smacked of anarchy and riot.

At some point that summer, Degrave called a sudden and violent halt. Croizé's dream of founding an academy was shattered. His students were packed off back to the drawing board with their palettes confiscated and colour once more out of reach. ¹²⁰ Croizé himself was publicly disgraced. Both he and Paul Marie promptly applied for posts elsewhere. ¹²¹ Croizé's request for a job at Cambrai was turned down, leaving him no alternative but to return to the art school, where he hung on for another twenty-three years as Degrave's assistant, teaching elementary drawing in the narrowest and most restricted terms (pupils were not allowed out of doors again to work from nature until 1907). ¹²² His sketching competitions became with time a hallowed school tradition, but he never fully recovered confidence or shook off the local legacy of hostility and contempt. When he eventually succeeded Degrave as director at the age of fifty-six, it was in 1914, the year the Germans once again occupied St-Quentin, commandeering the art school and looting or smashing its plaster casts. ¹²³

Pupils from the short-lived academy acted in accordance with the age-old unofficial motto of the region: Give in or get out. Of the younger boys who returned meekly to the art school, Gaston Lemire ended up a well-respected head of the lycée's art department, while several of the others—Fernand Frizon, Henri Caron, Paul Petit—became painters or designers in the town. ¹²⁴ Three of the older boys rose up against Degrave, rejecting his arbitrary decree and laying plans to escape rather than capitulate. The ringleader of this group—known locally as "the three renegades [les trois transfuges]"—was Henri Matisse. His companions were Louis van Cutsem, the twenty-year-old son of a Belgian gunsmith, and Jules Petit, who was eighteen and whose father kept a shop selling baskets and wickerwork on one of the town's main streets. ¹²⁵

Their scheme was to leave for Paris, where they meant to study for an art teaching diploma which would qualify them to work in state schools. All three knew well enough that their attempt to bypass the system in defiance of Degrave meant forfeiting any hope of public subsidy (local rumour claimed that Matisse was turned down when he applied for the same kind of municipal scholarship as his friend Emile Jean). Even with official sanction, their chances of survival in the professional art world would have been slim. The respective fates of Ancelet and Anthéaume had driven home the sacrificial lot of the school art teacher, struggling on little more than subsistence pay with no job security or provision for old age. The career of Croizé's partner Paul Marie (who was the same age as Matisse and had already gained his teaching diploma at twenty-one) supplied an even bleaker warning. Ineffectual and inexperienced, scarcely older than the boys he taught, he was transferred in the autumn of 1891 to a smaller and less prestigious school, where he collapsed in his second year

and, after clinging on through longer and longer sick leaves at half pay for another couple of years, was eventually dismissed.¹²⁶

None of this could do anything but confirm the worst forebodings of the three renegades' parents. "There were no painters in my family, there was no painter in my region," said Matisse. 127 He was the first and for a long time the only artist Bohain had produced, and his family was appalled. Without its backing, he would not get far as an unknown, unqualified, unsupported art student in Paris, and the full weight of family authority was now invoked against him. It would be hard to exaggerate the shock of Matisse's defection in a community which dismissed any form of art as an irrelevant, probably seditious and essentially contemptible occupation indulged in by layabouts, of whom the most successful might at best be regarded as a kind of clown. Henri was already well known in Bohain as an invalid, a failure who had proved unfit to take over his father's shop. Now he had failed as a lawyer, too, and was about to become a public laughingstock. "The announcement of his departure was a scandal for Matisse's parents," wrote a contemporary who grew up hearing the gossip in Bohain during the painter's youth: "They felt their son's folly to be a catastrophe that brought shame on the whole family." 128

Theirs was a culture based on well-understood concepts of self-respect, pride and achievement, regulated and reinforced by public and private humiliation. People who broke ranks were whipped back into line by ridicule and pointing fingers. The violent, bullying responses which were second nature to these northern people went with a corresponding readiness to take offence, to bear grudges, to relish long-rankling feuds ("Vengeance is a dish best eaten cold" was a saying all the Matisses could appreciate). Beneath their defensive pride and anger lay the tender, wincing sensibility which Matisse never lost, and which he said it was essential for an artist to preserve. He became painfully aware later that his decision to leave Bohain called his father's whole life in question. "My father had paid for my legal studies. When I said: 'I want to be a painter,' it was the equivalent of saying to the man: 'Everything you do is pointless and leads nowhere.' "129

Now that the conflict between father and son was at last out in the open, there were no holds barred. All accounts agree that it was a ferocious fight. Hippolyte Henri threatened to cut off his son's supplies and see him starve sooner than change his mind: "But it's a career for down-and-outs, d'you hear, you'll die of hunger." Henri himself described his resistance always with the same stonewalling phrase: "J'ai tenu bon [I held my ground]." In this final heroic struggle between father and son, Anna

Matisse played the traditional role described by Paul Cézanne, writing a decade later to a close friend of Matisse: "In time of sorrow and dejection, your mother will provide a safe support for you to lean on morally, and a deep well from which you can draw fresh courage to work at your art..." Henri's mother was a tireless mediator, arguing with her inflexible husband ("'Give him a year,' my mother said"), ¹³³ coaxing and cajoling her no less obdurate son. She even took the train to St-Quentin to beg their old friend Paul Flayelle to intercede: "Henri has to be persuaded not to go to Paris. He'll end up down-and-out." ¹³⁴

But nothing would change Henri's mind. Long afterwards he read Pearl Buck's *The Patriot* and recognised an allegory of his own experience ("It's about the love of one's country, not about an artist, but it comes to the same thing"). The novel tells the story of I-wan, the son of a banker in Shanghai who, having always loved, feared and obeyed his father, becomes a secret revolutionary at the age of twenty, vowing himself thereafter with stern and single-minded dedication to a glorious cause. "All that had seemed real in his life before now became of no importance. His family he scarcely thought about, knowing the day now inevitable when he must renounce them all.... For this was now a time when a deeper energy than blood united.... men were dividing themselves into these two parts between which there is no bridge, those who stay in the ways they know and those who must go on to other ways.... The old ways were gone. And from such meditation I-wan rose to every day like a sword drawn from its scabbard." ¹³⁶

By his own guarded statement more than thirty years later, it was Croizé who finally persuaded Matisse's father to allow his son to go to Paris: "I may tell you that it was with my collusion that he obtained leave from his parents to let him try for the Beaux-Arts." 137 Matisse himself said it was Couturier who touched his father's heart. 138 Both versions could easily be right. A direct plea from Croizé—a humble, impecunious and by now thoroughly discredited art teacher-would have carried little weight unless his collusion took the form of roping in Couturier, who could offer far more effective inducements. One was a letter of introduction to his old classmate William Bouguereau, by now among the wealthiest and most sought-after painters in France. 139 Another was a story Couturier had heard at first hand from Camille Corot, whose father—a shrewd, hardheaded tradesman like Hippolyte Henri Matisse—had fiercely opposed his own son's mad plan to be a painter. Nearly half a century later, Corot finally confounded his incredulous parent with his Légion d'Honneur. "All I can say is that I regret with all my heart, my

poor child, having tormented you, even with the best intentions, for so many years," said the repentant shopkeeper: "Yes, I recognise my wrongdoing, and sincerely confess it." ¹⁴⁰

Under steady pressure from his wife, Hippolyte Henri eventually relented sufficiently to make his son an allowance of one hundred francs (twenty dollars) a month for a single trial year in Paris. ¹⁴¹ Even in a direct assault on its deepest instincts to conserve, conform and stabilise, the family could not quite reject its boldest and most foolhardy child ("I hear the Bohain gossips repeating solemnly when it comes to family affairs: 'Blood is thicker than water,'" wrote Léon Vassaux). ¹⁴² Grief and bewilderment compounded the family's rage, bitterness and shame. Dramatic accounts of the affair circulated long afterwards in Bohain and beyond. One reported Matisse's father shaking his fist and shouting threats as the train pulled out of the station. ¹⁴³ Matisse himself said he slipped away without telling anyone of his departure. ¹⁴⁴ It would be a long time before he returned, longer still before he could admit that there was something to be said for his father's point of view. "He did right," Matisse declared cordially nearly half a century later: "he wanted to see if it would last." ¹⁴⁵

When people asked him afterwards about this rupture, and what lay behind it, the answer tended to be vague or metaphorical. "It was a seed," said Matisse, who was not for nothing a seed-merchant's son. "It had to grow, to put out a shoot. Before, nothing interested me. Afterwards, I had

nothing in my head but painting."146

CHAPTER THREE

1891–1895: Paris

Matisse at the Académie Julian flanked by Emile Jean and Jules Petit, c. 1892

The three renegades from St-Quentin reached Paris in October 1891, in time for the start of the autumn term at the Ecole des Beaux-Arts. The centralisation of the French state meant that the only route to a successful artistic career lay for all practical purposes through

the Beaux-Arts. By failing to secure the backing of their hometown, Matisse and his companions had already bungled the first qualifying round in an elaborate programme of tests, examinations, and competitions for medals and prizes culminating in the annual contest for the Prix de Rome which, as Matisse said bitterly, was the only outlet for those caught up in a bottleneck system expressly designed to eliminate most of the candidates. The school's painting professors routinely discouraged prospective pupils with tales of promising young artists who had dropped out or died under constant physical and mental pressure.

Over the next few years Matisse's two friends followed the rule. Louis van Cutsem abandoned painting altogether to train as an accountant, returning to St-Quentin to marry a brewer's daughter in 1899 and make a career as a sugar-broker.² Jules Petit stuck it out in Paris with Matisse (who admired him as a painter), sharing the same lodgings, working in the same studio, passing the Beaux-Arts examination in the same year, and going on to exhibit twice running at the official Salon. After eight years, disillusioned and worn down by the struggle to survive, he fell ill and went home to St-Quentin, where he died at the age of twenty-six in February 1899, two months before van Cutsem's wedding.³

Matisse himself said that in his early years in Paris he felt like someone stumbling about in a dark wood with no clear idea where he was heading. He began by presenting Couturier's letter of introduction to William Bouguereau, who received him in his custom-built studio near the Luxembourg Gardens on the rue Notre-Dame-des-Champs. At sixty-seven years old, Bouguereau occupied the top rung of the academic ladder on which his young visitor hoped for a first foothold. Bouguereau embodied the current classical ideal of an artist: the poet Théophile Gautier said that no one could be more modern or at the same time more Greek. Critics compared him to Raphael, or to a secular Fra Angelico because of the huge allegorical frescoes he painted in luxury hotels, municipal buildings, and the town houses of rich property-developers. His prices were astronomical. Rumour said that it cost him five francs by his own reckoning whenever he took time off to piss.

His lifelong goal as an artist had been to combine the flavours of Greece, Rome and the Italian Renaissance with the moral uplift of contemporary Christianity (asked to suggest a title for one of his noncommittal draped figures, he proposed Daphne, Venus, Mary Magdalene or the personification of Dreams, explaining they were all much the same to him). He spoke to an age with a vested interest in optimism: "William Bouguereau is not the painter for ugliness, grief or squalor; he is the

William Bouguereau, Self-portrait, 1895: the most fashionable painter in France, who told Matisse he would never learn to draw

Master of joy, grace and beauty."8 He had perfected a homogenised art of

"smiles and kisses"—small children, white doves and pink rose petals were his trademarks—that made him by the early 1890s an international household name. The public in Europe and America respected him both for his worldly success and for having achieved it through paintings of such unsullied purity, innocence and otherworldliness. His students underlined the point by attending one of the notoriously lewd and riotous Bals des Quat'z'Arts the freezing February of 1803 dressed

in the freezing February of 1893 dressed up as Greek shepherd lads clutching woolly

white lambs.9

Bouguereau was among the most powerful as well as one of the wealthiest painters in France. He had won the Prix de Rome at twenty-five and gone on to collect every honour the state could bestow, including a seat in the Institut de France, the academic governing body that ran the Ecole des Beaux-Arts. As president of the Société des Artistes Français, he controlled access to the official Salon (which blocked Paul Cézanne's annual applications for twenty years), and with it any serious hope of sales or public commissions. Being received by Bouguereau meant that the young postulant had been granted an audience with the pope of the French art world, whose word could make or break a career. Matisse found him ceremoniously preparing to start work on the copy of a copy of one of his own Salon paintings, attended by two sycophants, both successful artists in their own right, both marvelling aloud at the master's diligence and dedication. "Ah yes, I am a hard worker," said Bouguereau in the nasal whine Matisse reproduced with enthusiasm whenever he told this story later, "but art is difficult."10

It would become difficult for Bouguereau in more senses than one. For all its apparent impregnability, his position was already undermined. Disrespectful students mocked him behind his back. Degas and his friends, whose careers had been distorted by the academic stranglehold on power, privately described any canvas in danger of becoming fussy or slick as

William Bouguereau, The Wasp's Nest (Le Guêpier), 1892

"bouguereau'd [bouguereauté]." The president responded blandly by declaring that he could never see what the Impressionists saw (or pretended to see), and picking the academician Paul Baudry as, in his view, the only modern painter bound for immortality. The Wasp's Nest—the picture Matisse found him copying—shows a swarm of winged cupids chasing a half-naked woman with bows and arrows. Given Bouguereau's fondness for indiscriminate allegory, the shapely but vacuous central figure might easily be read as the official embodiment of contemporary art being jostled, pricked and shot at from behind and below by a younger generation of painters (the mob of reinforcement cupids arriving in the background already look more like men than boys).

Over the years Matisse's comic version of this encounter, with its surface pomposity tinged by underlying threat on both sides, developed into a star turn. But at the time, given Matisse's inadequate formal training and his burning desire to make up for it, Bouguereau's practical advice could hardly have been more helpful. He inspected the two St-Quentin still lifes produced by his visitor—"Aha, so we don't understand perspective! Never mind, you'll learn"—and suggested a stint in his class ("modelling in twenty lessons") at the Académie Julian. Matisse enrolled on 5 October, paying a whole year's fees in advance. The sum of 306 francs—

sixty-one dollars, or the equivalent to three months' allowance—must have been stumped up by his father on the understanding that Julian's academy was the recognised training ground for anyone seeking admission to the Beaux-Arts. It was the best-known of a number of unofficial private academies, run mostly by ex-models (like Rodolphe Julian himself) and offering no more than studio space with basic facilities: heating, live models, and visits once or twice a week from whatever teachers the proprietor could afford to hire. A shrewd, stocky dark-skinned southerner who had secured the services of more prestigious professors than anyone else, Julian moved his school shortly after Matisse's arrival down from the north of Paris to new premises at 31 rue du Dragon on the left bank of the Seine, near the Institute itself and handy for its academicians.¹⁶

Matisse's sponsor was a senior member of Bouguereau's class, his old friend and rival from St-Quentin, Emile Jean, who was the first person he and Petit called on in Paris. The master's approval of Jean ("a hardworking student with considerable natural gifts for whom I foresee a bright future") contrasted with his rough treatment of Matisse, who never forgot having been ticked off, as a new boy in his first drawing class, for rubbing out with his finger instead of using a clean rag, and for placing his drawing too high on the page.¹⁷ Bouguereau told him crossly that he couldn't draw and would never learn. The problem was that Matisse was unable or unwilling to follow Bouguereau's attempt to explain the academic principle of enhancement, which involved smoothing out any defects in the model, endowing the human figure with a classical authority or presence, picking out highlights and setting the whole off against a dark ground worked over with a fine badger brush. Success in the Beaux-Arts examinations (virtually guaranteed for any candidate backed by Bouguereau) depended on following these standard procedures.

Matisse was surprised to see his fellow students perfecting their life drawing by working not from the model but from studies by previously successful candidates stored in the Beaux-Arts library. ¹⁸ If he didn't pick up the same tricks and shortcuts himself, he said it was because they were beyond him: "What has been taken for boldness was no more than the fact that anything else proved too difficult. Freedom is really the impossibility of following the same road as everybody else: freedom means taking the path your talents make you take." ¹⁹ Matisse passed on to his own children a vivid sense of his desperation at Julian's, the hopelessness he felt at being left behind, his growing conviction that he could never compensate

for lack of early training no matter how hard he tried.²⁰

From now on he attached the same overriding importance to work as Bouguereau, who had himself been nicknamed Sisyphus as a student after the laborious Greek forever rolling his rock uphill. Bouguereau in his sixties and seventies still spent twelve hours a day in the studio, prey by his own account to nervous anxiety that could be appeased only by "prodigious, incessant and methodical work." He congratulated himself on a lifetime of sacrificial devotion to an art that had claimed him body and soul. He described with considerable pathos his own start as a young painter in Paris, wretchedly poor and unsure of himself, living on little more than bread and water, plagued by his father (a Bordeaux winemerchant invincibly opposed to his son's choice of career) and sustained only by his mother's faith in his vocation. ²³

If this view of himself as a hapless victim seems surprising in someone to whom success had come so swiftly and smoothly, odder still is the fact that Matisse in old age described his own career in strikingly similar terms. So did countless other painters, major and minor, fashionable or the reverse, accustomed by the Beaux-Arts system to a common framework of conformity and revolt, acceptance and rejection, liberation and despotism. One of the practical advantages of a rigid academic tyranny was that it fostered, in any individual strong enough to withstand it, a correspondingly powerful urge towards freedom and individuality. It also laid down ways of thinking and talking about their role shared by the entire spectrum of French artists in the nineteenth century, from the grand pontiff of the academic establishment to a long line of innovators who were initially reviled and eventually consecrated by the system, like Corot, Delacroix, Cézanne and Matisse himself.

However wide the gap in practice, Matisse later cordially endorsed many of Bouguereau's theories. "No amount of willpower, perseverance or doggedness in later years can ever make up for lack of technique," said Bouguereau. "Can there be a worse torment than that of the artist who knows that his own weak execution will prevent his ever realising his dreams?" He insisted that his job as a teacher was to give his students a solid enough grounding to enable each to develop his personal potential to the full. He recommended copying a plaster cast to Matisse (who would give identical advice to his students in the first class he taught in his own academy seventeen years later). He also told him to use the plumb line, a tip Matisse adopted with increasing enthusiasm over the next decade and more, to his friends' incredulous amusement. The plumb line imposed its own discipline on some of his boldest and most radical experiments (one of the running jokes of the Fauve summer of 1905, when

Matisse's painting exploded in colour in the light of the Mediterranean, was whether or not his plumb line would melt in the heat of the midday sun). ²⁵ "It took me several years to get the plumb line into my head, the sense of the vertical," he said more than half a century later. ²⁶ By this time Bouguereau's academic plumb line had become for Matisse a moral as much as a structural principle, symbolising clarity, rigour and firmness of purpose as opposed to the slackness and shapelessness of the Impressionists and their descendants.

But in the first weeks of his first term in 1891, Matisse was concerned with practice rather than principle. Baffled by Bouguereau's technical expertise and dismayed by his patronising manner, Matisse switched after only two correction classes to studying under Gabriel Ferrier, an excitable little man "with a nervous delivery, curled moustaches and kiss-curls." Ferrier took one look at the copy of a plaster cast undertaken on Bouguereau's instructions—the subject was a death mask of Louis XV's gardener, dated by Matisse 27 October 1891—and told him to stop wasting his time. The new pupil was held up to the whole class as a true artist who would outstrip all the rest once he started drawing from the live model. Matisse overcame his private doubts—"I daren't. I'm still a beginner"—only to be utterly demoralised when Ferrier damned his study of a nude the week after. "It's bad, so bad I hardly dare tell you how bad it is."

Overcome by emotion at his first sight of a naked girl, Matisse had started with the hands, rubbed out the head, and generally botched the standard procedure laid down in a sequence of separate manoeuvres to be carried out in an approved order at a specified rate of progress. Ferrier responded with the factitious rage of a sergeant major goading a clumsy recruit. "He seemed a crackpot to me," said Matisse, who skipped the correction classes from then on, struggling to cope on his own with a growing sense of inadequacy.²⁹ Conditions at Julian's were gruelling. Too many students crammed without supervision into airless, overheated studios produced an earsplitting din. They roared out the choruses of popular songs, flicked paper pellets, overturned one another's easels, lobbed missiles, and generally relieved their frustrations by horseplay and ragging, especially of newcomers.³⁰ Worse than anything else for Matisse was "the torment of not being able to paint like the others."31 Isolation made him retreat in on himself: "I was like someone who arrives in a country where they speak a different language. I couldn't melt into the crowd, I couldn't fall into step with the rest."32 If he felt mistrustful, he was also mistrusted. There was no one to control the rowdiness at Julian's except for one of the students who acted as massier, or studio head, organising the timetable, col-

Matisse, drawing of the death mask of Louis XV's gardener, 1891: Matisse's first and only success at the Académie Julian

lecting the fees and keeping the admissions register. Beside Matisse's name in Julian's register someone wrote the single word *sournois*, meaning sly, secretive or unforthcoming.³³

Driven by the need to catch up, and dread of what might happen when his father found out he had been right after all, Matisse pored over the highly finished, technically brilliant, emotionally void canvases hanging on Julian's walls: "I couldn't see any reason to paint that way. On top of which I hadn't the faintest notion how to set about doing it." ³⁴ In January he submitted a nude drawing, or académie, endorsed as a matter of form by Bouguereau and Ferrier, for the first round of the two-part Beaux-Arts entrance examination, which two thirds of the candidates failed, including Matisse ("It's a good drawing," he said, looking at his entry again sixty years later: "I don't draw any better now, I draw differently").35 Henri Evenepoel, who took the same exam a year later, blamed his own failure on the fact that his drawing was too detailed, not showy enough, above all too like the model, in contrast to the highly stylised drawing hanging next to it, "on a deep black ground (which didn't exist in nature) with extraordinary highlights (which weren't there either) by a pupil of Bouguereau... and Ferrier! It got one of the top marks!"36

Evenepoel, Flemish by birth and inclination like Matisse (who would become a close friend), fought a running battle from the start against the academic restrictions that forced him to substitute a bland, idealised perfection for the physical quirks and blemishes of the individual human fig-

Matisse, Standing Nude, 1892: the examination piece on the strength of which Matisse was turned down by the Ecole des Beaux-Arts

ure. But Evenepoel, whose talent had been recognised early in his hometown of Brussels, reached Paris at twenty already with considerable success behind him. Matisse had a history of repeated failure. At some point in the New Year, probably in February or March after the results were announced, he took the train to meet his father on neutral ground well away from Bohain at Lille.³⁷ The ancient capital of rural French Flanders had ballooned in the last quarter of the nineteenth century into a vast urban sprawl of factories and textile mills, but Lille still held its traditional seed-market on the central square of the old town on Wednesdays for farmers, suppliers, and seedsmen like Hippolyte Henri Matisse. The confrontation between father and son was bleak. Both were disappointed, one still as uncomprehending, the other as obstinate, as before. The possibility of cutting off Henri's allowance loomed over this encounter, as it would do for the next ten years whenever the two met for a serious talk about the future.

Matisse was fighting his own self-doubt as well as his father's lack of confidence: "I believed I would never be able to paint because I didn't paint like the others. Then I saw the Goyas at Lille. That was when I

understood that painting could be a language; I thought that I could become a painter."38 The pictures that spoke his language in the Galerie Véronèse on the ground floor of the cavernous, smoke-blackened Musée des Beaux-Arts at Lille were popularly known as Youth and Age. Matisse said Goya offered "the gift of life" (as opposed to the academic withdrawal of it). 39 He also said that Chardin had been as important to him as Goya at Lille, using the same metaphor for what happened to him there as for Croizé's art class in St-Quentin: "It was an open door. Back at Julian's was a closed door."40 Matisse's passionate response to Goya and Chardin marked the second of the critical turning points he picked out when he came to review his life in retrospect. Two other old boys from the same school, Gabriel Hanotaux and André Billy, described similar moments in front of works by Cuyp and Daumier respectively—when the bewildering variety and richness of the art of the past suddenly seemed to make sense. Matisse said it was as if everything had been back-to-front up till then. 41 "He was desperate," said his son Pierre. "He couldn't understand the academic method, a touch of grey, then a darker tone, all their tricks and dodges—and then there was Goya. He said: 'Ah, that I can do.' And his father went home without having understood anything."42

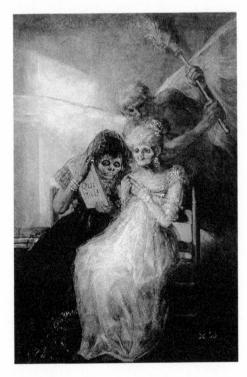

Francisco de Goya, *Time*, or *The Old Women*, c. 1808–12: the picture of old age that made
Matisse feel for the first time that he might become an artist

Hippolyte Henri returned to Bohain with a heavy heart, but his son travelled back with renewed resolution to Paris, where a friend advised him to bypass Bouguereau by trying a back way into the Beaux-Arts. The only one of the school's three painting studios likely to have vacant places was run by Gustave Moreau, a newcomer officially appointed on 1 January 1892, who was prepared to take on students regardless of their examination results. Matisse's friend (presumably Emile Jean, who switched his own allegiance from Bouguereau to Moreau at this point) correctly predicted that all he had to do was waylay the new professor at the afternoon drawing session held in the Cour Yvon, the great glassed-in hall which housed the school's collection of classical casts. Moreau accepted Matisse, initially perhaps because of his contacts ("ex-pupil of Bouguereau—H. B. Matisse of St-Quentin—knows Couturier" was the message scribbled on the card he gave Moreau). He But acceptance warmed over the next few years to approval, and even respect.

Over the same period Moreau's fellow academicians became increasingly suspicious of a colleague who struck them as altogether too permissive. By 1892, Gérôme and Léon Bonnat had been in charge of the Beaux-Arts' other two painting studios for twenty-seven and ten years respectively. Both ran highly efficient production lines turning out streamlined and standardised Prix de Rome candidates (Jules Degrave of the Ecole de La Tour had been a prize pupil of Gérôme, Emmanuel Croizé of Bonnat). Although almost the same age as Gérôme and considerably older than Bonnat, Moreau at sixty-six was fresh to the job, evidently stimulated by his young pupils, open-minded enough to admit at least the possibility of change, and still capable himself of genuine excitement about painting. For the first time since Matisse reached Paris, he felt solid ground under his feet from which he could at last begin to grope his way towards his own path as a painter.45 Fifty years later he drew Moreau as a stick figure with arms flung wide in welcome. Matisse's accounts of this period suggest mounting energy, confidence and an access of exuberant spirits in sharp contrast to the despondency of his time at Julian's.

Unable to count on his father's continuing support, he had decided from the start to make sure of a second year in Paris by halving his outgoings. His first five months in Paris were spent in a cheap hotel on the rue des Ecoles, just off the boulevard St-Michel, a few minutes' walk from the Seine and Jean's lodgings at 19 quai St-Michel (which would eventually become Matisse's own Parisian headquarters). The two ate together in the evenings at a restaurant on the faubourg St-Denis, near Julian's original academy, where the set meal cost 1.25 francs (or 25 sous). Evenepoel

described at the time the shock for a nicely brought-up middle-class boy of first encountering the stomach-churning smell, the grease and dirt, the sticky plates, stained tablecloths, and unswept floors littered with cutlet bones in the sort of place that served dinner for this price (watery soup, a tiny overcooked steak, dried-up cheese and squashy fruit washed down with flat beer or vinegary wine). As Matisse ordered half portions, and could still recite the bill fifty years later: "6 sous the half portion, 3 sous' worth of bread, 3 sous' worth of Brie, and a coffee at 2 sous, which comes to 13 sous in all." Economy on this scale made even Jean's meagre municipal stipend look princely. "Watching you drink water like that makes me sick," Jean said, reddening his friend's glass with wine from his own carafe: "You'll never stick it out."

After the trip to Lille, eating out, even at 13 sous, became too expensive. Matisse moved with Jules Petit to Montparnasse, then an outlying area of building sites and open fields with whole streets under construction round a monumental new station. They found two rooms next to the cemetery at 12 rue du Maine, where they did their own cleaning and cooking.50 Matisse's father supplied a sack of rice from the shop, and when money ran out at the end of the month, the pair kept open house for their friends, who dined off plain boiled rice, showing their appreciation by singing or bringing out their musical instruments while they waited for a second plateful.⁵¹ Once a batch of plump pigeons came up from Bohain: Léon Vassaux, already a second-year medical student, was asked to this feast, which he and Matisse marked by washing up solemnly in top hats afterwards.⁵² Another time it was a Bohain-brewed barrel of beer: the friends drank it down, then strained the dregs through a cloth and drank them off, too. 53 Matisse compared their rice diet at the end of the month to the can of olive oil which Paul Cézanne and Emile Zola brought back from their hometown of Aix-en-Provence to eat with bread when they too were starting out as poor young students in Paris.⁵⁴

The minimal subsistence budget Zola worked out for the twenty-two-year-old Cézanne in 1861 came to 125 francs per month, a quarter as much again as Matisse's allowance of 100 francs thirty years later (William Rothenstein, who enrolled at the Académie Julian the year before Matisse, found himself permanently in debt on 300 francs a month: Henri de Toulouse-Lautrec lived comfortably but far from extravagantly in Montmartre on a monthly 1,000 francs). Matisse was even worse off than the rest of his friends from home: Jean, Petit, Vassaux and a prodigiously gifted sixteen-year-old from St-Quentin, Alphonse Watbot, who arrived with the Ecole de La Tour's top prize to join Moreau's studio in 1892.

Watbot specialised in the scurrilous songs of their native region, which afterwards brought back more vividly than anything else the flavour of these years, when they made up with jokes, gags and send-ups for the lack of any more substantial nourishment.⁵⁶

Throughout his six years at Moreau's, Matisse belonged to a band of hardheaded, pipe-smoking, beer-drinking northerners who stood out for their toughness as much as for their sardonic humour, their strong musical sense and their flat way of speaking. Matisse kept his northern accent long after he began to look and behave like a sleek young doctor or businessman. "That impression vanished as soon as he opened his mouth," wrote another young painter from St-Quentin, Maurice Boudot-Lamotte: "Matisse was one of us. He was a joker who gave nothing away [C'est un pince-sans-rire]."57 When there was money to spare, they visited the local music hall, the Gaîté de Montparnasse, where a ticket cost ten sous. After one of their "rice galas," a dozen marauding friends once wrecked a performance at the Gaîté under the command of two ringleaders: Matisse himself and a ribald, half-famished engraver from the Dauphiné, both wearing white coats, both stationed high up in strategic positions at either side of the gallery with the rest of the band strung out between them, all calling out and capping the acts onstage. When they were eventually ejected, they continued their performance outside on the rue de Rennes, where Matisse collected a crowd of late-night loiterers by shamming dead drunk, in spite of having touched nothing but water all day.58

Montparnasse, Montmartre and the Latin Quarter were full of hardup, ill-housed, hungry, angry and dissatisfied students simmering on the verge of riot in the early 1890s. These were the years of assassinations and bomb explosions when the Parisian authorities felt seriously threatened by militant anarchism, a tendency to which every self-respecting student subscribed, including Matisse. 59 Moreau's pupils responded to their professor's relatively permissive approach by rampaging out of control at intervals. The studio became notorious for the ferocity with which new students were humiliated (their torments ranged from being made to sing rude songs and stand drinks for a jeering class to being forcibly stripped, held down and spat at). In December 1892 the studio had to be closed down briefly because of bad publicity after an especially vicious outbreak of bullying. Six months later the police intervened to control a Bal des Quat'z'Arts which had got out of hand at the Moulin-Rouge, perhaps the first and only one of these balls Matisse attended, disguised as an Arab in a bedsheet with a red headband and burnt-cork eye makeup (the fancydress Quat'z'Arts revellers were made up of male art students and their female models, who could expect to lose what little they wore in the first hour). On this occasion Moreau's students, armed with revolvers, joined in the street fighting that engulfed the Latin Quarter for three days of police baton charges against barricades built from ripped-up paving stones, producing many injuries and one death.

Eruptions like this were inevitable, given the pressures that built up when so many young men lived at close quarters on such competitive terms in conditions of constant hardship and want. The normal constraints and coercions of everyday life were temporarily in abeyance. For Matisse, living on half rations and determined to work twice as hard as anyone else, this was a time of wild and, by his own subsequent standards, uncharacteristic abandon. People who knew him later found it hard to credit that anyone so immaculately self-contained could ever have let himself go as he did in these years. He himself said that the iron discipline, neatness and punctuality of his later years were deliberately imposed to contain a nature of extreme and innate unruliness. He belonged after all to a race whose placid and industrious routines were regularly disrupted at home by outbursts of violent mayhem. "I... was born disorderly," Matisse wrote, looking back on his feckless youth, "never doing anything unless I really wanted to, dropping and breaking anything for which I had no further use, never making the bed except on the day when the sheets were changed, etc. etc."62

Matisse switched addresses five times in his first precarious hand-tomouth year in Paris, shuttling as he would do for the rest of his life between Montparnasse and the Left Bank. He moved out of the digs he shared with Petit into a windowless attic, little more than a cupboard lit by a skylight over the bed, on the sixth floor of Jean's lodgings at 19 quai St-Michel. It was here that he woke one night from a nightmare in which he was back in the lawyer's office at St-Quentin: "I said to myself: That's it, you've had it. I was in a cold sweat, I was terrified. Then my eyes opened. I saw the sky and the stars. I was saved."63 By the beginning of October he had moved south again in search of more space to a studio belonging to a sculptor at 350 rue St-Jacques. 64 A long, narrow thoroughfare running parallel to the boulevard St-Michel, the rue St-Jacques began grandly enough, passing between the Sorbonne and the Collège de France, but ended up at the far end, where Matisse lived, as a jumble of small shops, bars, cheap eating- and lodging-houses full of students, prostitutes and poor working people, unchanged in some ways since the time of the mediaeval poet François Villon.

In Matisse's day it was the regular beat of the poet Paul Verlaine, who supplied a conspicuously public reminder that even a celebrated artist could end up destitute. Verlaine had made a literary landmark out of the wineshop on the rue St-Jacques (absinthe at four sous the glass) where he drank, received homage and occasionally wrote (or dispatched requests for handouts to his faithful publisher, Léon Vannier, who kept a bookshop on the ground floor of 19 quai St-Michel). Pale, skull-like, emaciated, dressed in a battered hat and tramp's overcoat, Verlaine had become something of an intellectual tourist attraction by this time, but Matisse remembered him—and the women he lived with in various squalid rooms up and down the rue St-Jacques—as a grim embodiment of actual rather than romantic poverty. 66

Matisse's own humid room at no. 350 rue St-Jacques shared a wall with the icehouse of the butcher next door, which was no joke in the winter of 1892–93, when the Seine froze over and people died of cold on the streets of Paris. When his shoes began to grow mould, Matisse left—"so as not to die in that dump [pour ne pas crever dans ce local]"—to spend nights at a friend's place round the corner at 39 rue Claude Bernard. This was the hospital quarter, so the friend who took him in for the sake of his health was probably Vassaux, attached as an external student to the nearby Hôpital de la Pitié. The two often took the horse-drawn bus up to Montmartre from the place St-Jacques near Matisse's studio, sitting outside on top for three sous, and paying another ten sous for a cheap student ticket at the concert hall run by the Comte d'Harcourt on the rue Rochechouart.

The Concerts Harcourt, like the Concerts Colonne and Lamoureux, were private halls opened by enthusiasts in an age before broadcasting or recording to popularise classical music and build up an audience for modern composers like Wagner, Liszt, Berlioz and Saint-Saëns. Matisse attended all three halls as well as becoming a regular with Vassaux at the rebuilt Opéra-Comique, where they got free gallery seats as part of the claque hired to clap on first nights. Among the company's stars, their particular favourite was the statuesque Californian Sibyl Sanderson, whom they saw in the title role of Saint-Saëns's Phryné in May 1893 ("She died of syphilis later," Vassaux wrote sadly to Matisse. "She was too lovely, alas!").69 Together they discovered a musical world unknown to the brass bands of their youth ("Beethoven makes me ecstatic: Bach is great, Handel perhaps more human as a musician, Mozart is adorable, but Beethoven is Beethoven," wrote Vassaux, still swapping concert notes with Matisse when they were both in their eighties. "What lucky devils we are, you and me, to be so responsive to music"). 70 One of the main binding threads of

their friendship went back to the concerts they attended together in the 1890s, when Matisse slept at the rue Claude Bernard and worked in the cold, dank studio he had borrowed from a sculptor.

The only sculptor Matisse mentioned afterwards as a friend from these years was Georges Lorgeoux, who became a student of Moreau's in July 1892. It was Lorgeoux who first taught Matisse how to handle clay ("I can still see Lorgeoux kneading the clay for me"):71 his earliest surviving sculptures are a pair of terra-cotta medallions, bearing bas-relief portrait heads of a girl who posed for them both. Her name was Caroline Joblaud, but she was always known as Camille. 72 She was nineteen years old in 1892, a vivid, graceful, fine-boned creature with an appealing air of fragility and vulnerability. Matisse said she had shoulders as wide as the people in Egyptian frescoes, and she moved in such a way that, even in profile, she gave the impression of facing outwards.⁷³ She was pale and slender with long dark hair and large dark eyes ("the eyes of a true odalisque," said Matisse).74 In those days Camille was lighthearted and outgoing: "She loved life, and she made you want to live."75 She was musical, and so expressive some said she could have gone on the stage. She laughed at Matisse's clowning, and at the antics of Lorgeoux, who could be equally funny in person and on paper, producing a stream of lightning sketches, cartoons and caricatures. For a time the three went everywhere together, visiting the Colonne and Lamoureux concerts, sampling the pleasures of Paris on the boulevards and beside the Seine in summer.

Camille remembered constant outings, often attended by a troupe of friends. To the end of her life she told stories of her bohemian days on the Left Bank, the fun they had on trips and excursions, the excitement of being young and beautiful and admired by a band of penniless but promising artists. Matisse seldom spoke afterwards about these years, save to say that he hadn't needed imagination at twenty-five to know what it felt like to be in love. He also said at the end of his life that true love may sometimes find its own happiness in giving up its object to another. Léon Vassaux, who was also as a student in love with Camille, accepted her decision philosophically when she chose Matisse, transferring his allegiance to the young couple and remaining a bachelor for the rest of his life.

Like so many of the women in Matisse's life, Camille worked in a hatshop. 79 She belonged to a new breed of shopgirls: stylish, well-turned-out young Parisiennes who staffed the modern department stores that were rapidly evolving a new consumer culture and the lifestyle to go with it. Girls like Camille, with their tiny waists, their neat figures in svelte, tailored costumes, their turbans and parasols, exemplified the gaiety and self-

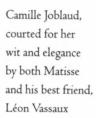

assurance of Paris in the last decade of the century. Many of them came originally from the country, like Camille, who was born on 23 April 1873, in the village of Le Veurdre in the Allier, halfway between Nevers and Moulins in the rich, sleepy cow pastures of central France. The child of a carpenter called Pierre Joblaud who died when she was seven, Camille was educated by nuns who taught her fine sewing, cultivated an innate refinement and provided a glimpse of horizons beyond the peasant life of the village. The was a natural recruit to the world of high fashion with its dazzling surface and sordid underside. Like Zola's heroine in *Le Bonheur des dames*, Camille was an orphan from the provinces who had never worn a silk frock or a pair of lady's slippers until she went to work as a shop assistant in Paris.

Camille had clever fingers and a feel for the fine luxury stuffs which even in those days Matisse could not do without. Surrounded by textiles at home, missing their physical presence in Paris, he began as a student a lifelong habit of collecting—"I started a little museum of samples"—with scraps and snippets of embroidery or tapestry-work picked up for a few sous from the secondhand stalls round Notre-Dame. Examille made her own clothes, and designed hats for herself and her friends. She embodied French chic and what another of Matisse's models called English panache, or the critical importance of style in face of atrocious

conditions.⁸³ Both formed part of the generous, libertarian and egalitarian concept Matisse had inherited from the weavers of Bohain of luxury itself as "something beyond price, available to all": a concept that would become in his hands an essentially spiritual defence against physical or moral squalor on all levels.⁸⁴ "The most mysterious thing about him," wrote Louis Aragon, contemplating the weight and power that can be felt but not seen behind Matisse's apparent facility as a draughtsman, "is, perhaps, that he understands better than anyone else the way fabric lies against flesh, and how the straps and ribbons cross and slip in a woman's garments, how they wind about her waist or close to her armpit or under the curve of her breast: so many secrets that are not to be found in any dictionary." ⁸⁵

MATISSE WORKED METHODICALLY in the early 1890s through the historical dictionary of Western art laid out in the Louvre ("I studied the old masters just as in literature you study different authors before deciding on one or another").86 He closed in on the goal he had set himself of being able to paint like the others with a determination that impressed everyone from Moreau downwards. It touched Matisse's cousin Hippolyte, the colour-merchant who was also a picture-dealer and who became at this point a useful ally, arranging introductions, supplying dealers' gossip and generally acting as guide to the contemporary art world. In the winter of 1892-93 Hippolyte took his young cousin to call on the proto-Impressionist painter Eugène Boudin, who was beginning for the first time at close on seventy years old to find a rising market for his work. What chiefly impressed Matisse was the disrespectful way the maid treated Boudin, who turned out to be a fretful little old man shuffling about in carpet slippers, dressed entirely in grey and only dimly visible in the shadows at the back of his studio. Boudin warned his young visitor to be careful what he copied in the Louvre, describing a recent visit on which he got so worked up over unnatural contrasts in the paintings of Jan van Goyen that he shouted out to the astonishment of the other gallery-goers: "What an old sham!"87

Egged on by Hippolyte, Boudin told stories of his beginnings as a colour-merchant himself in Le Havre, selling artists' materials to visiting painters including Jean-François Millet, to whom he confided his intention of giving up the shop to go to Paris to paint. "How can you talk like that?" asked Millet. "With a good job like you've got, you talk of going to become a painter in Paris!" Millet's incredulity would have made sense to Matisse's father. Hippolyte Henri's disquiet flared up and had to be

damped down again in 1893, ⁸⁸ when his son sat the Beaux-Arts examination for the second time with no more success than the first. "M. Matisse... is a very good student, a diligent worker, highly gifted and has made great progress in the last few months," wrote Moreau, who often had to send soothing letters like this one to anxious parents: "I am very pleased with him, and happy to testify to my satisfaction." Matisse himself provided practical reassurance by studying in the evenings for a teaching diploma at the Ecole des Arts Décoratifs, where he had enrolled in October 1892, when his time at Julian's ran out. ⁹⁰

Underequipped and overcrowded, the Ecole des Arts Décoratifs supplied free training on half the budget of the Beaux-Arts for local schoolleavers, mostly the sons of working people and small shopkeepers, aged between fourteen and twenty. Georges Rouault, who had gone there at fourteen, said the dark, drafty classrooms were infested with rats that stole the bread-balls meant for picking out highlights on the boys' charcoal drawings.91 Older and less prepared to be pushed around than the rest, Matisse made a stir in his first class by refusing to remove his hat for the master: "I'll take off my hat when there are no more drafts."92 He was promptly suspended for two weeks for insolence. The one lasting gain he brought away from the school was his alliance with two younger boys, Henri Manguin and Albert Marquet, who were the first close friends he made among painters outside his home circle. From now on the three worked side by side, swapping advice, criticising and comparing their respective canvases, urging each other on, indoors and out, in Paris and on the Mediterranean coast, throughout the struggles that convulsed the French art world, and painting itself, in the years leading up to and away from the Fauve summer of 1905. "The Marquet of my youth...was a fighter, reliable, rock-steady, a sure companion," said Matisse,93 who could have said the same of Manguin in the first decade of the century.

Manguin was eighteen in 1892, Marquet a year younger. Both still lived with their mothers, both had shown precocious artistic talent as schoolboys, both would soon join Matisse at Moreau's. Manguin, the handsome and headstrong only son of a widow, was eager, expansive, intrepid, a Parisian by birth and already something of a dandy. Marquet was shy, solitary, and small for his age with spectacles, a limp and a thick Bordeaux accent, all of which exposed him to merciless bullying. His mother, from whom he had inherited his sharp eye and sharper wit, kept a button-shop on the rue Monge. Manguin would shortly become independent, on the strength of a modest inheritance from his father. Marquet's mother had financed the move to Paris for the sake of her only child's vocation by sell-

ing the tiny parcel of land which was all she possessed, to the disgust of her husband, who had stayed behind working as a railwayman in Bordeaux.⁹⁴

On the face of it, Matisse's two allies had little in common except their determination to paint, and even here, each was the opposite of the other. Manguin was as direct as he was energetic: he applied himself with stamina and diligence; he whistled and sang at his easel, urging himself on at the top of his voice, bursting into snatches of Beethoven when things went well, seething and fuming if they didn't. Marquet's attack was darting, capricious and sidelong; he could not force himself, or be forced, to concentrate; even as a grown man, he worked as the whim took him, often spending whole days in bed, or dawdling and doodling, preferably on the edge of the sea or the Seine. It was typical of their respective approaches that whereas Manguin passed the Beaux-Arts exam straight off at twenty, Marquet had to take it nine times before he too scraped entry.

Marquet, whose childhood experience at school had given him a horror of authority, was as brilliant, as evasive and as hard to pin down as a blob of mercury. In Moreau's large class he took on the role of studio mascot or jester, called Quéquet, "a little limping gnome whose presence put everyone in high spirits." But Marquet had another side, the bitter, mocking spirit that had learned to forestall other people's jeers by making them burst out laughing first. A born dissident, he was captivated by the courage and confidence that made Matisse keep his hat on in class the first day they met. Marquet loved recklessness. He was always in favour of "indiscipline, fantasy and sarcasm," said the critic Georges Besson, who saw Matisse's relationship with Marquet as that of the sorcerer and his

apprentice.97

But Matisse, who knew what it was like to feel inadequate and rejected, recognised a stoicism and a shrinking sensitivity behind Marquet's deadpan façade that brought out the protective streak in his nature. "Do you realise how sensitive Marquet is?" he said privately to the woman who eventually married Marquet more than thirty years later: "do you see that he has suffered, and can you imagine how much? Have you noticed that he is easily bruised, and that you will have to guess at his bruises because he will never say a word?" Matisse understood Marquet's pride and reticence, his need to distance himself from other people, which they often mistook for coldness. Their unspoken compact had its roots in these years when Matisse, who was five years older, took practical charge of his timid and hopelessly impractical friend, protecting him against school bullies as he would later against unscrupulous collectors and

Gustave Moreau, Self-portrait, c. 1890s

greedy dealers: "He had no friends. He only really had me. I'd do what he wanted to do. We could live close together without having to talk."

If his friendship with Marquet at its deepest level was wordless, with Manguin he established a dialogue that lasted for two decades. They took long walks together round Paris and, when either was away, continued their conversations by letter, exchanging news, jokes, sketches, encouragement, commiseration and streams of bawdy postcards. For all his apparent boldness, Manguin could be painfully susceptible. "One was always aware that his nerves were close to the surface," wrote the musician Claude Terrasse. "He was either angry or laughing. It was all extremes with him.... Melancholy was no part of his makeup."100 The most impulsive of the three friends and the most open, Manguin was also the least prepared for assault from outside, which he survived, when it came, by drawing on reserves of stubborn endurance. Not a natural rebel, he was sensitive, generous and dependable. His marriage started early and lasted long. In time of personal disaster, Matisse turned for both practical and moral support to "indefatigable Manguin," who came to represent for him everything that was best and most durable in a solid, settled, defensive and protective domestic base. 101 Marquet by contrast remained a wanderer all his life: restless, rootless, provisional, reluctant to own possessions or property, always eager to abandon both in search of a fresh start. For Matisse, Marquet was the best possible travelling companion. He evoked a side of Matisse's nature unknown to Manguin: the fierce, implacable need to take off and cut loose, the periodic urge for risk and renewal in flight.

Even when they were students, it was Marquet who urged the others

to take to the streets with their sketchbooks, roaming around on the lookout for "anything that moves," drawing in doorways or along the quais in summer, taking refuge in winter in cheap cabarets and cafés. ¹⁰² Lightning sketches for training hand and eye were an approved part of the Beaux-Arts routine. Nothing in their early work suggests that any of the three were inclined at this point to make other than perfectly conventional artistic choices. ¹⁰³ Nor would they have been encouraged to do so by Gustave Moreau, whose reluctance to toe the establishment line himself had always taken the form of retreat rather than rebellion. The last six and a half years of his life, the period when he taught at the Beaux-Arts, saw an extraordinary opening out and unfolding in Moreau. He embarked with his pupils on a learning curve in these years during which he became acutely conscious of straddling the gap between the art of the past and the future.

For a decade and more before that, he had steadily cut himself off from the contemporary scene, declining to exhibit at the Salon, turning down public commissions, refusing either to let his work out of the house

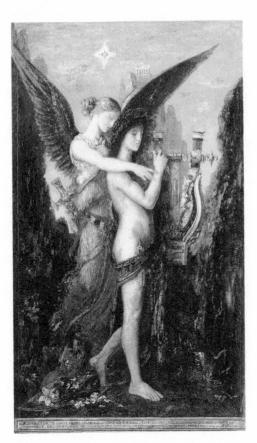

Gustave Moreau, Hesiod and the Muse, 1801

or to allow any but a few old friends in to inspect it. After the death of his mother in 1884, Moreau lived and worked alone at home on the rue Rochefoucauld with a simplicity, even austerity, that contrasted sharply with the style of his worldlier colleagues (Gérôme and Bonnat painted in formal tailcoats, Jacques-Emile Blanche had his palette and brushes presented by his valet each morning on a silver salver). In Rumour pictured him as something between an opium-eater and a modern Faust. His strange and increasingly narcissistic paintings were seldom seen, which made them correspondingly desirable. Coveted by collectors, hugely admired by fashionable aesthetes and literary Symbolists, they represented the high-water mark of advanced taste for those who still drew the line at Impressionism.

As a young man, Moreau had known Bizet and Baudelaire. Proust admired him. He was the friend of Edgar Degas and Odilon Redon, both of whom watched his gradual withdrawal into a private dream world with dismay. He was the sort of person who tucked in his toes for fear you might step on them, according to Degas, whose initial regard gave way to scorn for what he saw as Moreau's lack of moral courage. "A hermit who knew the train timetables" was another of Degas's tart comments. The young Henry James saw Moreau as the Gustave Flaubert of painting, "full of imagination and, if not of first-class power, at least of first-class subtlety." This subtlety—a rich, fluid ambivalence which diluted or dissolved other people's certainties—was one of his great gifts as a teacher. "He didn't set his pupils on the right road, he took them off it," said Matisse. "He made them uneasy." It

Moreau visited his official studio at the Ecole des Beaux-Arts twice a week, on Wednesdays and Saturdays, criticising the paintings offered for inspection more thoroughly but no less severely than his two colleagues. The only sign of eccentricity he showed at this stage was that, having corrected his students' work in the mornings, he accompanied them himself to the Louvre in the afternoons (the career-conscious pupils of Gérôme and Bonnat mostly copied casts in the Cours Yvon). In the galleries Moreau caught fire, moving from one painting to another among the Dutch and Italian masters, exploring each aloud in what became a process of discovery, or rediscovery, for both himself and his audience. His excitement was palpable. Georges Rouault (who was Moreau's favourite pupil) remembered "a spiritualist aura emanating from this small short man with the extraordinarily bright, kind and intelligent eyes, full of energy, a thinker and dreamer..." Old pupils fiercely defended their master against accusations of being too dry, overliterary, more attuned to the

head than the heart. "He didn't show us how to paint," said Matisse; "he roused our imagination in front of the life he found in those paintings." 109

It was the gift Matisse first got from the Goyas at Lille.

"I was a student of the galleries of the Louvre," said Matisse. IIO Between 1892 and 1898 Moreau's students fanned out through the galleries, setting up their easels, moving camp from one picture to another, breaking off alone or in groups for what Matisse called "a little session of comparative painting," was swapping notes, paying calls, collecting their friends and descending in a body to investigate any new arrival or any old hand with a fresh experiment in progress. Contemporary accounts of their comings and goings, their openness to new ideas, their mutual curiosity and the creative stimulus it generated, suggest an atmosphere closer to Sundays in Bohain—when the weavers left their looms and crowded into one another's houses to inspect the latest discoveries and developments—than to the studios' mechanical, factory-like reproduction, "made up and carried out like piecework," as Matisse said himself. II2

He was fascinated by the handling of paint: "You can say of any particular artist that his texture is like a velvet, or like a satin, or like a taffeta. The method ... you can't tell where it comes from. It's magic. It can't be taught." Like other pupils who followed Moreau through the galleries, Matisse did his best later to hand on what he had learned to younger students in a chain that continued up to and beyond Moreau's death in 1898, ending only with the last of them all, Charles Camoin, and another latecomer who joined the class in the autumn of 1897, a nineteen-year-old from St-Quentin called Maurice Boudot-Lamotte. "I was a student of the students of Gustave Moreau," said Boudot-Lamotte, who left vivid descriptions of the trouble his elders took to make the paintings come alive for him in the Louvre, teaching him to look beneath layers of dust, dirt and varnish, analysing technique, responding to colour, extolling Poussin over Monet or vice versa, each exploring in depth his own particular old master.

Matisse's was Chardin, who had imbued him as deeply as Goya at Lille with a sense of mystery and power, ¹¹⁵ and to whom he returned again and again as a student. He began with *The Pipe*, which was the first painting he ever copied in the Louvre, and which baffled him with an elusive blue on the padded lid of the box in the middle of the canvas: a blue that could look pink one day, green the next. Matisse tried everything he could think of to pin down the secret of this painting, using a magnifying glass, studying the texture, the grain of the canvas, the glazes, the objects themselves and the transitions from light to shade. He added more white at his friends'

suggestion ("I listened to everyone"). He even cut up his own preparatory oil sketch and stuck bits of it onto Chaudin's canvas, where each separate section was a perfect match, but when he put them together, there was no longer any correspondence at all. "It is a truly magical painting," he said, adding that this was the only copy he had in the end to abandon. ¹¹⁶

Matisse copied Chardin four times (the only other painter he copied more than once was Nicolas Poussin, to whom he returned three times). The hardest and most prolonged of his struggles was with *The Skate* (*La Raie*), a painting of dead fish and oysters on a kitchen slab, dominated by the rearing arched shape of a gutted skate which Proust compared, in a famous passage written round about this time, to the nave of a great polychrome cathedral. Matisse's confrontation with *The Skate* greatly impressed his fellow students, including Boudot-Lamotte, who had reached Paris in time to watch him slowly bringing to a close "this magisterial reinterpretation, which is at once a Chardin and a Matisse." It had taken six and a half years, almost exactly the same length of time as Matisse's apprenticeship to Moreau. It was a triumphant affirmation of Moreau's belief that the strength of a painting came from within and could not be applied from without:

Be sure to note one thing: which is that colour has to be *thought*, passed through the imagination. If you have no imagination, you will never produce beautiful colour. . . . The painting that will last is the one that has been thought out, dreamed over, reflected on, produced from the mind, and not solely by the hand's facility at dabbing on highlights with the tip of the brush. ¹¹⁹

This was the great lesson Matisse learned by precept from Moreau, and in practice from Chardin, in the years when he said he despaired of ever acquiring enough confidence to move on from still life to the human figure. His own paintings at the time were composed, like Chardin's, of everyday earthenware pots and kitchenware (he said that their vitality came from "a unifying affection, a feeling in my objects that gave them their quality"). He painted a plateful of apples to give to Léon Vassaux, for whom the canvas came to embody the emotions of the 1890s, when "I was a witness of the unfolding of your work." Vassaux called the painting his "little Chardin" and held on to it to the end of his life, long after he had been obliged to sell everything else, as the one painting from which he could never bear to be parted. [21]

It remained a cardinal point with Matisse ever afterwards that the life

of a painting comes not from the technical expertise brought to bear on it but from the steadiness and intensity of the painter's own emotional response, although neither he nor Moreau ever underestimated the skills needed to convey that response. The second painting Matisse copied in the Louvre in April 1893 was Jan Davidsz de Heem's Dessert: an opulent and fiendishly complex set piece designed to test everything he had ever learned about handling still life from textiles to glass, polished wood, porcelain and mother-of-pearl, gleaming silver, dull pewter, chased gold and beaten copper, not forgetting a profusion of exotic fruits with their contrasting colours, textures and blooms. The painting, selected by Moreau, was a shrewd choice for an ambitious young pupil who had just been forced to admit himself beaten. 122 Unlike Chardin's Pipe with its magical subtlety, simplicity and gravity, de Heem's Dessert called for the showiest skills to be deployed in the soberest manner. Invited to demonstrate the traditional virtuosity of his native region, Matisse rose to the challenge, retreating this time to the far side of the gallery and approaching the canvas as if he were working from nature. For Matisse, de Heem's Dessert always retained the character of a test piece. He would return to the theme three times, using it as the starting point for his battle with Impressionism in 1897, as the basis for a first foray into Abstraction in 1908, and again in 1915 for the closest he came to a direct skirmish with Cubism. 123

Matisse said it was ironic that Moreau sent his pupils to the Louvre expressly to save them from modern painting, which meant for him the art of the Salons. ¹²⁴ For Moreau, Bouguereau's Salon with its chalky colour and cheap trompe-l'oeil tricks spelt death: "I can't think of all that without bitterness," he told Henri Evenepoel, "it's the rape of the eye." ¹²⁵ Life for him lay in the loving reanimation of the art of the past to which he brought such generous enthusiasm that even his boldest pupils felt no need to look for nourishment elsewhere: "At the time of Moreau's death, none of his pupils—except perhaps Evenepoel—seems really yet to have discovered modern painting, as if the extraordinary ascendancy of their teacher had kept them from Cézanne, Seurat and Gauguin," wrote Moreau's historian, Pierre-Louis Mathieu. ¹²⁶

Moreau himself saw no future for Impressionism: "Among all the so-called new departures, impressionists, japanists, illusionists, etc., none of them will last, they are passing fads, they will all be swept away! Believe me!" In his gloomier moments they seemed to him a bunch of cynics setting out, with their commonplace street scenes, their dancers and barmaids, their sordid cafés reeking of stale tobacco and cheap wine, to degrade all that should be noble and lofty in art. He felt that the canons

fixed forever in Italy at the Renaissance had been betrayed twice in his lifetime by, on the one hand, the academics of the art establishment and, on the other, former friends like Degas and Redon. Brooding on this double defection, Moreau worked himself up into paroxysms of fury: "He could no longer contain himself," reported Evenepoel, who witnessed more than one of them. "You could sense all the revulsions he had endured, all the disgust, all the nightmares they had given him, and he ended up with an oddly expressive dumb show, his little eyes growing more brilliant than ever, the blood rushing to his face, which made his beard stand out whiter, his skullcap pushed back from his bald forehead by a sudden backwards thrust of the head, the whole of his little body starting out of his chair." 128

These outbursts were the obverse of his fiery exuberance. Matisse said that it took a strong character to stand up to Moreau, but that he always preferred those who did. 129 The students who interested him least were the careerists, doing time for the sake of accumulating medals and privileges, putting in the "ten years' pictorial and intellectual servitude" which was the minimum sentence for a Prix de Rome contender. 130 They tended to be as unenthusiastic about Moreau as he was about them. His unconventionality worried them, and they were frankly appalled by the dissatisfaction he fomented with the existing Beaux-Arts system. "He planted question marks in our minds," said Matisse. 131 His studio was divided roughly into three zones: an inner ring of favourites—serious and singleminded enthusiasts grouped around Rouault; an outer circle of what Matisse called independents, among whom he classed himself; and finally the rowdy or hooligan element, making an infernal racket, whistling, catcalling and slinging paint-tubes near the door. The acknowledged stars of the studio were Rouault himself—"a pale, skinny boy with red hair like flames," said Matisse¹³³ (who was two years older)—and a small, shy, generally silent prodigy called Albert Bussy. Both had been established members of the studio even before Moreau took it over. Rouault was already too senior, too close to Moreau and too intent on his own evolution to make any great impact on Matisse, who was chiefly struck by his ferocious contempt for anyone aiming at conventional success. Rouault set up his easel next to another potential highflier, Edgard Maxence, a future academician noted for his smooth finish and fine detail, in particular for the gleam he gave to an eye. "Rouault waited for that particular moment," said Matisse, "and just as Maxence was poised to place the highlight on the pupil, Rouault would jump up, yelling and stamping his feet, and Maxence was left with his brush in the air, saying softly: 'You annoy me, Rouault!' "134

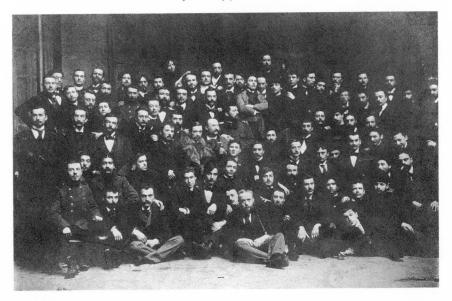

Moreau's students at the Ecole des Beaux-Arts, 1897, including Matisse (towards the back, on the left), Bussy in his fur coat, Martel, Marquet, Evenepoel, Flandrin, and Rouault in centre front row

Bussy (who later switched from Albert to his second name of Simon) would become a lifelong friend. Seven months younger than Matisse, he was, by the time they met, far ahead of him in experience and achievement. He had six years' studying in the capital behind him, having arrived in Paris with a scholarship from his hometown at the age of sixteen and passed the Beaux-Arts exam at his first try three years later. He and Rouault had been pacing each other as rivals ever since 1886, when the two sat next to one another on Bussy's first day at the Ecole des Arts Décoratifs. By 1893 Bussy was already exhibiting at the official Salon, and he would be picked the year after as one of two contenders (Rouault was the other) to represent Moreau's studio in the contest for the prestigious Prix Chenavard.

His technical accomplishment astonished his contemporaries. "Painting came easily to Bussy," wrote Eugène Martel, who shared digs with Bussy from 1892, when he first reached Paris as something of a prodigy himself from his native Provence. "His skill made me giddy.... I was stupefied to see him drawing with a knife's point, brushing in a huge canvas in no time at all, pinpointing as sharply as an engraver's tool the shine on the pupil of an eye or the reflection of a jewel. In short, he was already the complete Parisian painter, capable of producing the most spectacular 'demonstration piece' that could hold its own in point of technique with the very best, a Degas for example." Martel was both dazzled and paralysed by Bussy's prowess, which marked him for life with a sense of his

own inadequacy. As students, the two were inseparable, Martel always following two paces behind so that he seemed to be towed along in Bussy's wake (he guessed correctly that other people thought of him as "a sort of sub-Bussy"). He said he had learned as much from watching Bussy at work as from listening to Moreau or looking at the old masters in the Louvre. ¹³⁶

Martel was not the only one of Bussy's fellow students to be bowled over by him. Even the highly sophisticated Auguste Bréal-son of a distinguished philologist at the Collège de France, himself destined for a brilliant academic career until he threw it over to join Moreau's studio regarded Bussy's gifts with something like awe. 137 Bussy was short, slight, bright-eyed, black-haired and bullet-headed, reserved in public but phenomenally sure of himself and his judgement in private. He came from a small town called Dole in the Jura, where the Bussys had made their living as cobblers until Albert's father and uncles rose to be master boot-makers, expanding and developing the firm of Bussy Brothers into one of the town's biggest businesses. Born, like Matisse, into the rising provincial bourgeoisie, he too was the first in his family to look beyond the cramped confines of his hometown. He and Matisse shared the same stubborn selfreliance and resolve. But in these early years, it was Bussy-by far the more successful of the two, with a brilliant career confidently predicted ahead of him-who believed in and encouraged Matisse. He provided practical help, introducing his friend to older painters and recommending him to dealers. "I think our relationship was closer than most student friendships," Bussy wrote to Matisse, ¹³⁸ and it certainly proved a great deal more durable.

Their mutual respect was firmly anchored in regular, often daily visits to each other's studios. They first formed the habit of dropping in to assess work in progress in the 1890s, when Bussy lived with Martel at 41 quai de Bourbon on the Ile St-Louis, a short walk away from Matisse on the Left Bank. Forty years later, when their respective professional positions had long since been reversed, Matisse would still send for Bussy whenever he needed a critical assessment of his latest work. There was no trace in his attitude of the protective element that always coloured his feeling for Marquet: he looked for support and reassurance to Bussy, who had singled him out from the start and whose faith in him never wavered. At a low point in 1903, Matisse wrote to remind Bussy of "the days when you predicted, raising one sybilline finger at the quai de Bourbon, with a delicious smell rising from one of Martel's daubes flavoured by the aromatic herbs of his mountains, and with your legs propped up on the ash-can meant for emptying the stove, 'Matisse, one day you will earn a great

deal of money!' "139 This was a brave prophesy at a time when, for all his municipal subsidy and in spite of his Salon success, Bussy was almost as hard up as Matisse. He and Martel not only did their own cooking and housekeeping, they shared a single pair of respectable trousers, which meant that only one or the other could ever appear decently dressed in public. 140

In the summer of 1894 Matisse moved back to 19 quai St-Michel, a few hundred yards downstream from Bussy on the far side of the Ile St-Louis. These were quarters still inhabited by ordinary working people, clerks, dressmakers, laundresses, artisans and shopkeepers. The slums round Notre-Dame had recently been torn down as part of Baron Haussmann's grand schemes for urban clearance, but the poor and destitute still used the cathedral as a day shelter, coughing in the shadows of the nave, huddling round the great stove in winter, and giving off a rank smell that took you by the throat at the door. Bodies surfaced in the Seine, to be fished out and exposed each morning on slabs in the morgue behind Notre-Dame ("Just looking at the creatures that prowl the quais," wrote the young Evenepoel, who was sickened by the poverty he saw in Paris, "makes you wonder where they all live, and why more of them don't throw themselves off the bridges"). 142

The university district behind the quai St-Michel remained a warren of narrow streets reeking of inadequate sanitation, newly emptied garbage and close-packed humanity. To the end of his life Matisse knew by heart all the street cries of the Latin Quarter: he could intone the chants and the hoarse, ululating calls of the rag-picker, the old-clothes dealer, the knifegrinder and dog-clipper ("Je tonds les chiens, je coupe les chats"), the man selling fresh chickweed for cage-birds, and the glazier with his backpack of sheet glass for repairing smashed windows. ¹⁴³ If the streets at the back of his studio swarmed with life, the river in front teemed with traffic: boats hooting, whistles blaring, engines chugging, and a perpetual coming and going of soot-blackened tugs, ferries carrying people to and from work, barges discharging their loads with cranes at the quayside. This was the heart of Paris, and Matisse looked directly down on it from his window above the quai.

Simon Bussy, Self-portrait, c. 1895: the far more successful contemporary who believed in Matisse from the start, and remained a close friend to the end

No. 19 quai St-Michel was a massive stone building, put up in the early years of the century (when George Sand as a new arrival in Paris lived in three tiny rooms on the fifth floor at no. 29), let off and sublet into apartments so numerous it was more like a vertical village than a single dwelling. In Matisse's day it was full of small businesses-from the famous Symbolist bookseller Vannier, who published Verlaine on the ground floor, to tradesmen selling wallpaper and secondhand furniture together with a mixed bunch of artists. "There were artists on all the floors with studios in every corner, more or less well lit, opening off the landings of the many twisting staircases that split off or doubled back down to the quai, the inner courtyard or the rue Huchette."144 Cold running water came from communal taps on the long corridors. Everything else had to be carried up 102 stone stairs to Matisse's new studio on the fifth floor, into which he squeezed an easel, a cast-iron stove, a couch, a cupboard and a small table for still life arrangements. 145 This was the first studio of his own Matisse had ever possessed, and it marked a professional coming of age, or at any rate the point at which he finally achieved the ambition he had set himself in Croizé's drawing class: "When I opened my studio . . . I was painting just like anyone else."146

It was also the moment when he set up house with Camille Joblaud. "I returned to the quai St-Michel, where I had a studio with a view of the Seine," said Matisse. "There I got married." The couple had a second tiny room in the same building, looking out over the chimney stacks. 148 Pooling resources was the usual solution to intractable problems of domestic survival. Matisse and his friends made endless jokes about their antics as cooks and housekeepers, struggling with flimsy portable spiritstoves, fetching and heating buckets of water, washing their own dishes, blacking their own boots, making their own beds (or, in Matisse's case, leaving the sheets untouched until the time came to change them), emptying slop pails and ashpans (Matisse said he only ever emptied his when the layer of ashes and cinders spilling out round the stove became intolerable). 149 It was generally felt, even by their families back home, that a male student could not be expected to manage for long without the support of one of the smart, streetwise, freewheeling young working girls who provided the only female company available (apart from tarts and professional models) in the Latin Quarter.

Bussy had a marvellously stately mistress called Léona, whom he painted round about this time in a voluminous, voluptuous muslin blouse with leg-of-mutton sleeves. ¹⁵⁰ Emile Wéry, the painter who lived in the next studio on the same landing as Matisse, also had a girlfriend, who

made friends with Camille. Marriage in anything but name was not a practical possibility for any of them. Even if he had wanted to, Matisse could not legally have married without parental consent before his twenty-fifth birthday, nor could he have survived without his father's allowance on savings from even the most ruthless economising (Emile Jean recalled Matisse renting studio space at one point in a locksmith's workshop while somehow reducing his expenses to eighty francs a month). He had enrolled for a second year's evening classes at the Ecole des Arts Décoratifs, and in March 1894 he obtained the diploma that would qualify him to teach art in state schools. Otherwise there was no prospect at this stage of earning a living from painting.

Matisse's decision to put their relationship on a firmer footing came after Camille discovered that she was expecting a child. From the point of view of any respectable middle-class family, this should have been the signal to part. Even Camille Pissarro-the kindest and most generous of fathers as well as a practising anarchist—proposed paying off his son's girlfriend as soon as she became pregnant. Henri Evenepoel, whose mistress also bore him a child in 1894, faced the implacable wrath of a father who never forgave his son's determination to stand by mother and baby. Society allowed little room for manoeuvre to parents like Edmond Evenepoel and Hippolyte Henri Matisse, who saw an additional crushing burden about to drag down sons already hard put to keep their heads above water. Neither Evenepoel's father nor Matisse's could bring himself in the end to cut off supplies from home, but each saw it as his duty to obstruct further developments by all available means. Edmond Evenepoel tried threats and ostracism, defacing a lithograph of which Henri was particularly proud at one point, banishing him bodily to Algeria at another. 154 Hippolyte Henri Matisse responded by blocking the automatic right of his sons (and their putative descendants) to inherit, in a document drawn up by his lawyer and signed the day before the birth of his first grandchild. 155

Marguerite Emilienne Matisse was born on 31 August 1894. She would grow up sensitive and highly strung like her mother, with the same touching fragility and the same underlying resilience, the same delicate bone structure and the same deep, dark, odalisque's eyes. She had her father's passionate will, his courage and pride, his horror of compromise and his stubborn sense of duty. This first child inspired in Matisse what became one of the dearest and deepest attachments of his life. She was a studio child, born and bred among brushes and canvases, brought up with the smell of oil paints, accustomed from infancy to the constraints of posing

and watching her father paint. Her response to his work remained always intensely important to him; his art would become in the end the central supporting pillar of her life, the one certain good which never played her false, and to which she committed herself unconditionally.

Camille's love for her daughter was painfully ambivalent: Marguerite was too like her mother, and had cost her too much, for relations between them ever to be straightforward. It would be hard to exaggerate the moral stigma and the punitive practical sanctions imposed by a society that saw unmarried mothers as a threat to its fabric. A self-made girl managing to hold her own in the rootless urban world of the period nearly always found that pregnancy tipped the balance definitively against her. It meant she could expect to be sacked from her job and thrown out on the street by the concierge of even the humblest Parisian lodging-house. Camille described long afterwards the shock of finding herself pregnant, her shame and increasing desperation compounded by terror of the future. 156 She had no family in Paris to offer support or a safe house, nor could Matisse's relatives be asked to take her in. She gave birth to her daughter in the workhouse lying-in hospital at 89 rue d'Assas 157 (Jean Genet was born sixteen years later in the same establishment, and promptly handed over by his mother to the workhouse orphanage). 158 The child was registered under her mother's name by a couple of poor-law employees who did not even know how to spell it. After Camille returned to 19 quai St-Michel with her baby, the whole episode became a bad dream that would return to haunt her on her deathbed sixty years later.

At the time, she suppressed the memory with the gaiety and courage of youth. Stringent social taboos made it impossible for Matisse's family to acknowledge what had happened. It would have been unthinkable for Camille to visit Bohain, although she could be informally accepted in Paris by male relations like Henri's brother, his cousin Hippolyte, and another cousin, Adolphe Lancelle (Lancelle was the Bohain doctor's son, married himself by this time and living in Rouen). 159 She was known unofficially as Matisse's wife, and his friends remained hers. Chief among them was Léon Vassaux, who stood sponsor to Marguerite as his godchild, and who became the young couple's staunchest ally. They gave him one of Henri's two plaster medallions of Camille, signed and dated: "1894. For a good friend, Léon Vassaux." Henri Evenepoel, who greatly admired Matisse, was also charmed by both Camille and her baby. He painted his own small son having tea or playing with his building blocks in the studio, and he also painted Marguerite round about the same time as a grave, plump, curly-headed toddler of eighteen months. 161

1891-1895: PARIS

Henri Evenepoel, La Petite Matisse, 1896: Marguerite at eighteen months

The studio was Matisse's province. He filled it with his collection of lengths of fabric, embroidered cloths, chipped pieces of French faience, cracked china plates picked up cheap, all of which were gradually coated with dust and powdery grey ash from the stove. When Moreau came to visit two years later, he was struck by the comfortable way the whole interior revolved around the artist's easel: "It's magnificent, it's extraordinary: he has really organised his life for painting." Matisse was one of the rising stars of the studio himself by this time. Manguin and Marquet had both followed him to Moreau's, where both started painting under his

Matisse, Portrait Medallion 1, 1894: the first sculpture Matisse ever made, showing Camille's Egyptian profile (she kept this photograph to the end of her life)

wing, copying the same masters in the Louvre, sticking to the same low-key palette of greys, ruddy browns and earthy greens that Matisse had taken over from Jan Davidsz de Heem. Matisse himself took the Beaux-Arts entrance examination for the last time and passed in March 1895, doing brilliantly in anatomy and only slightly less well in the history of art (his scores in the more mechanical, formulaic areas of perspective and modelling remained negligible). ¹⁶³ In April he submitted his remaining portrait medallion of Camille to the Salon, which turned it down. ¹⁶⁴

But by the spring of 1895 Matisse was beginning for the first time to look beyond the horizons of the official Salon under the tutelage of Emile Wéry, a lively and able student of Bonnat with rather more advanced tastes than his young Flemish friend at this stage. Matisse responded immediately to the landscapes in a big Camille Corot exhibition that opened at the Palais Galliéra in May. His own first landscape, painted at the beginning of the summer, was dedicated to Wéry: a lowtoned, green and grey-brown view of the Seine with a broad, gleaming expanse of watery reflections at the bottom of the canvas, mirrored by an expanse of sky at the top, within a containing Corotesque framework of banks and foliage. He was moving on at last from still life, which had ranked at the bottom of the artistic hierarchy even in Chardin's day: "I was afraid I should never do figures, then I put figures into my still lifes." ¹⁶⁵

Figure painting—the depiction of contemporaries in their ordinary clothes as opposed to historical costume—was despised only slightly less than still life. Matisse recalled a general consensus among his elders that Corot spoiled the grandeur of his landscapes by including human figures. "I remember a big landscape with, in the foreground, the small figure of a young girl lying among the daisies, reading in a pretty white book. Many people said it was a shame you couldn't make the painting really good by cutting out that figure. . . . "166 Corot's girl reading haunted Matisse's pictorial imagination. The first figure he added to one of his still lifes was Camille reading (colour fig. 1), seated in a black dress in a dark interior with her back turned to the spectator so that light falls on the nape of her neck and on the white pages of her book. Matisse improvised a green flowered background from a favourite length of fabric which turns up often in paintings of the period. But the part of this canvas which his friends admired was the composition of vases, statuettes and ornamental oddments laid out behind the figure on a velvet cloth on top of the studio corner cupboard. In a second, smaller painting (colour fig. 2), Camille sits sewing, this time in a pale poppy-patterned dress with her face half turned to the spectator, alongside an altogether more experimental still

life which shows Matisse beginning at last to move away from traditional earth colours towards the lighter Impressionist palette favoured by up-to-date contemporaries like Wéry.

The first of these two portraits was started in the early summer of 1895 and finished off that winter. 167 Although the model was Camille, the impulse towards portraiture, like the first momentous revelation of the paint-box, originated with Matisse's mother. He described in a celebrated passage how he was doodling on a telegraph form while waiting for a telephone call one day in a post office in Picardy when he saw to his surprise that his mother's generous and firmly modelled features had materialised beneath his hand. He took it as a resurgence of the passionate instinctive urge that had been curbed and crushed by his Beaux-Arts training. This "revelation of the life in portraits" came from the deepest level of his being, channelled through his mother, and through Camille, who posed for the first in a long line of portraits—imbued always with particular depth and delicacy of feeling—which he made all his life of the women who meant most to him.

For the first time since he left home, Matisse's luck turned in 1896. He had five paintings accepted at the Salon de la Nationale in May, when his Woman Reading became the first of his works to be bought by the state. It was also singled out by the art critic of the Journal de St-Quentin as the work of a local lawyer's clerk who might be worth watching in future. The article diagnosed accurately enough that the young artist was ill at ease in the reach-me-down style he had worked so hard to master. It dismissed the two still lifes on show as altogether too old-fashioned ("Dear M. Matisse: . . . This sort of thing recalls the watercolours produced in the same manner by our great-grandmothers") and itemised various faults: overall grey tone, lack of conviction, inadequate contrasts, slack drawing. But its general conclusions must have caused satisfaction in Bohain: "Five small canvases worth as much as many larger ones. . . . He remains interesting all the same because one senses in him a true temperament." 169

This was the first and almost the last public recognition Matisse received in his lifetime from his native region. Its author was Elie Fleury, an energetic and ambitious journalist who would make a considerable mark in St-Quentin, ending up as both director of the *Journal de St-Quentin* and administrator of the Ecole de La Tour. He knew everyone in the town's art world, including both Jules Degrave and Emmanuel Croizé, probably also Maître Derieux, who had proved such a tolerant employer to the artist in question. If Fleury didn't know Matisse himself, he had certainly made enquiries from someone who filled him in on the background

THE UNKNOWN MATISSE

of Derieux's absconding clerk. "There are some lawyers with artistic leanings," wrote Fleury, "who may well allow their clerks to indulge themselves by opening a little window on the ideal." It would be interesting to know what lay behind the choice of this particular metaphor: whether it was coincidence, whether it came from Matisse himself, or whether on the contrary Fleury's article first suggested the image of a window opening onto another world that would exert such a powerful pull on Matisse's imagination.

CHAPTER FOUR

1895–1896: Belle-Ile-en-Mer

Matisse, photographed by Wéry on Belle-Ile

he first time Matisse painted a door or window opening from a darkened interior onto a brighter world beyond was in the summer of 1896, looking out through the wooden double door of a cottage in Brittany. For him this was a revolutionary painting: it contained no figure, no trace of still life, no landscape to speak of, only an austere geometrical arrangement of lines and angles framing the source of

The port of Le Palais, on the wild coast of Belle-Ile

light at the centre of the canvas. He painted it on Belle-Ile-en-Mer, a small island guarding the entrance to the Bay of Biscay off Brittany's Atlantic coast, where, in the course of three consecutive summers—1895, 1896 and 1897—he made drastic changes to both his life and work.

He first visited the island in 1895 on the advice of his Parisian neighbour, Emile Wéry, leaving Paris by train at the start of the summer holidays with a group that included Camille and the baby, Wéry and his girlfriend, as well as other painters and their models, who peeled off at earlier stops along the line.² The Belle-Ile party changed at Quimper, continuing on by train to the tip of the Quiberon peninsula, then by paddle steamer across a narrow stretch of water to the island. This was by his own account the first time Matisse had ever travelled beyond the inland plains of Flanders,³ and he had chosen for his first sight of the sea the wildest coastline in Europe. Visitors who began exploring Brittany in the 1850s and 1860s in search of the picturesque were amazed by the ferocious grandeur of the cliffs, the pounding waters, and the reefs ranging out to sea in rank upon rank of "dark jagged rocks fringed by foam, appearing like teeth starting from the deep to devour any hapless ships that may come within their reach..."

The people were as rugged as their landscape ("All skin and bone with craggy foreheads and limbs like dried sticks, our peasants have taken on the roughness of their own furze-bushes"). The Bretons were a self-sufficient race, subsisting on the produce of their fishing boats and their flinty farms, speaking their own Celtic language, living and dying almost

entirely cut off from the rest of France until the coming of the railway. They seemed strange, fierce and sombre—"wonderful to watch in their attitudes of mysterious savagery," like the inhabitants of Tahiti or Madagascar—to the first arrivals who poured in from the outside world by rail, spreading out as branch lines opened up throughout the 1890s. The Bretons shared their houses with their cows, pigs and poultry, eating meat rarely and such fish as they could catch to supplement a staple diet of gruel and coarse pancakes. Matisse, staying on a lonely headland in a cottage where the chickens ran in and out from the dung heap at the door, lived on pancakes, potatoes and buttermilk.

The peasants built their one-storey cottages or cabins from roughly hewn stone, slit by tiny unglazed windows and topped with thatch pulled down low like woollen bonnets. The interior was a single, long, dark, smoke-blackened room with a drainage channel in the beaten earth floor dividing human from animal living quarters. Matisse said he slept like his hosts in a box bed, a wooden sleeping cupboard with a door that could be fastened when the inmates climbed in at night. The only other furniture was a long table with benches and wooden chests or hutches for storing prized possessions: shoes, Sunday clothes and a supply of dark, durable bread loaves. Baskets, cradles, strings of onions, hams and salted meats hung from the rafters.

The women tied aprons over their voluminous skirts and pinned their hair back under white linen coiffes; the men wore theirs loose at shoulder-length with patched coats, baggy sailcloth breeches, and sabots stuffed with straw. Breton costume, habits, outlook and farming methods had barely changed since the Middle Ages. Parisians from Abelard in the twelfth century to Auguste Rodin in the nineteenth responded with dismay to the isolation, the dangers and the comfortless monotony of life on this desolate coast. "I am living in a barbaric country," Abelard wrote to Héloïse from his exile in Brittany, "where they speak a language unknown and horrible to me. I have no contact with anyone but these savage people; I walk beside the inaccessible shores of a turbulent sea. . . . Each day I undergo fresh perils; I expect to see at any moment a blade suspended above my head."

Matisse described much the same sensation on his first visit to Belle-Ile, when the sword dangling over his head was a pictorial one. "I was, like you, demoralised," he wrote a year later to Victor Roux-Champion, an ex-Moreau student whose traditional certainties were also beginning to disintegrate: "I imagined that all you had to do, on arrival in Brittany, was to set up your canvas and go to work as easily as you could do on the quays of

the Seine, or at the Ecole. So I produced nothing, or very little. I spent my time tearing my hair to force myself to work." Roux-Champion had been knocked off-balance by his first contact with modern art in the person of Paul Gauguin's disciple, Wladyslaw Slewinski, at Pont-Aven. It was Emile Wéry's approach to painting that worried Matisse far more than the wildness of the scenery (which he did not attempt to paint at this stage).

The son of an engraver from Reims, a competent but not outstanding Beaux-Arts student, Wéry was technically smoother, although only a year older than Matisse, and far more attuned to current fashion. Both of them had painted the Seine that spring, Matisse in a style that reminded Elie Fleury of his grandmother's watercolours. Wéry's comparatively stark, modernistic canvas was exhibited at the summer Salon just before they left for Belle-Ile under the title *Desperation*. It showed the stretch of the quai St-Michel directly beneath his and Matisse's studio windows, with Notre-Dame brilliantly illuminated by moonlight on the far bank, and the dark figure of a girl flinging herself into the water in the foreground. It was an up-to-the-minute version of a standard Salon subject (in George du Maurier's *Trilby*, the best-selling novel that made bohemian Paris all the rage in England in 1894, the heroine poses as a Spanish beauty in a mantilla, a

Emile-Auguste Wéry, Desperation, 1895: girl throwing herself into the Seine in front of the studio block occupied by Matisse and Wéry

peasant girl at the well, and "a starving dressmaker about to throw herself into the Seine"). 12

Wéry favoured melancholy moonlit, twilit or sunset scenes in realistic settings with mildly Symbolist overtones, and like most of the young artists who converged on Brittany each summer, he used the kind of toned-down Impressionist palette from which Moreau's pupils had been strictly sheltered. He had a particular admiration for Alfred Sisley, then nearing the end of an almost wholly unsuccessful career. Matisse had already heard of Sisley from his cousin Hippolyte, who regretted having paid the painter twenty francs for a painting that turned out to be unsaleable. Wéry squeezed his colours straight from the tube onto his palette ready for immediate use, an increasingly common practice by this time but so unsettling for Matisse that he took the boat back to the mainland. "After that I worked in Finistère at Beuzec-Cap-Sizun, separating myself from Wéry because we couldn't get on."

Before they parted, the two once again painted different versions of the same motif. Matisse's interior of a bar in Le Palais (Belle-Ile's chief port) was a genre scene in shades of grey, dimly lit and peopled with the huddled bucolic figures that came naturally to a student of the Flemish school. Roux-Champion painted a strikingly similar bar scene on Belle-Ile in 1896. Wéry's Interior of a Country Café was an altogether more colourful affair with light pouring in from the top left-hand corner of the canvas, silhouetting a customer perched high up at the bar and bouncing back off rows of gleaming red, orange and green bottles lined up behind the barman at the counter. The painting was a modest country tribute to Edouard Manet's A Bar at the Folies-Bergère, which had galvanised Paris thirteen years before. It may seem as unremarkable today as Slewinski's experiments in replacing form with colour, but for classically trained, Louvre-orientated Moreau students, any notion of a break with the past was hard to take. Roux-Champion said it sent him reeling. Matisse felt the ground shake under him on Belle-Ile. "I was so upset that I left after ten days. Everything seemed to me highly original, highly individual, but colossally difficult.... I remember how shocked and crushed I felt."15

Matisse retreated northwards, travelling via Quimper and Douarnenez by a brand-new branch line to Pont-Croix in Finistère, where he found a room above a patisserie kept by Mme Le Bars. ¹⁶ He had arrived at precisely the moment that this tiny, ancient market town—"totally forgotten at the end of the world on the great Cornish headland [Cap de Cornouaille]"¹⁷—roused itself from the sleep of centuries to start a new life as a tourist centre. Pont-Croix had a fine Romanesque church, a Catholic seminary, and a stepped stone street descending steeply from the single square to a sheltered inlet of the river Goyen. Summer visitors shuttled between these delights and the even smaller coastal village of Beuzec, which offered cliff walks and rough-sea bathing. Pont-Croix was the livelier of the two ("I found it very amusing," said Matisse). ¹⁸ People came from the whole surrounding region twice a month by rail on market days, when the town's three streets were jammed with cattle, every house on the square became a café, and the band played for dancing in the covered market or the newly erected dance hall behind the Hôtel des Voyageurs. The hotel, opened the year before in a converted granary, belonged to Mme Gloaguen, whose husband was the town's first stationmaster, and whose sister was Matisse's landlady, Mme Le Bars. ¹⁹

The two sisters were energetic, go-ahead young businesswomen, daughters of a successful local butcher, both starting out to build careers and rear families of their own. Painters and their models were accepted with comparatively few problems in this tough peasant society where women ran their own affairs on a more equal footing than would have been permissible in the censorious and puritanical industrial North. Mme Gloaguen had three small studios constructed above her dance hall to let out to the painters who filled her new hotel with their canvases. One of them decorated the dining room with a mural depicting four young artists with beards and broad-brimmed black hats, sprawling in the sun on a bench beneath the hotel windows, attended by the landlady's proprietorial dog, Limouzin. Matisse himself painted the hotel's long dining table decked with flowers, fruit and wineglasses in preparation for a fête. 20 One of the attractions of the hotels that sprung up with the railways all over Brittany was their easygoing holiday atmosphere. Expenses were low (Matisse paid sixty francs—about twelve dollars—a month for board and lodging) and morals loose.²¹ The painters left off their collars, cuffs and ties, wearing floppy coloured neck-scarves with open shirts and paintstained corduroys, some even changing their boots for country sabots. "More like wild beasts they looked than human beings," said the wife of the painter Mortimer Menpes, remembering her first visit to the Pension Gloanec at Pont-Aven at a time when she was the only respectable married woman, indeed practically the only woman of any sort, to stay there.22

Girls like Camille, highly prized and heavily outnumbered, enjoyed a freedom unthinkable in their urban winter lives. Whether or not she and the eleven-month-old Marguerite travelled with Henri to Belle-Ile, they were certainly with him in Finistère.²³ He remembered excursions to local

Holiday painters outside the Hôtel des Voyageurs at Pont-Croix in Brittany: mural (1897) by William Sylva, a student at the Académie Julian, in the hotel dining room which was drawn and painted by Matisse

beauty spots like the little fishing port of Audierne (one hour by train from Pont-Croix), then on by horse and cart to the Pointe du Raz: a gigantic rocky promontory overlooking the Baie des Trépassés (Shipwreck Bay), rearing eighty feet above the sea, reached by a bridge and pierced by a tunnel "through which the sea rushes with great violence so...terrible...that the noise has been compared to the distant roaring of wild beasts issuing from the depths of a forest."²⁴

Matisse also spent a night at Pont-Aven, which had served for the past decade and more as an unofficial open-air annex to the Académie Julian, swarming all summer with would-be academicians. "Wherever you may wander within a radius of fifteen miles," wrote Menpes's daughter Dorothy, "you cannot stop at some attractive prospect without hearing an impatient cough behind you, and, turning, finding yourself obstructing the view of a person in corduroys and flannel shirt, with a large felt hat, working, pipe aglow, at an enormous canvas." The pools, rocks and waterfalls of the gentle wooded slopes round Pont-Aven were endlessly reproduced in every Parisian style up to and including Impressionism, Symbolism and pointillisme. "There were the Dottists," wrote Dorothy Menpes, "who painted in a series of dots. There were also the Spottists—a sect of the Dottists whose differentiation was too subtle to be understood. Then there was the Bitumen school, a group of artists who never painted anything but white sunlit houses with bitumen shadows." 26

Matisse was no more attracted by the conformists of Pont-Aven than by its most ferocious nonconformist, Paul Gauguin, who had left several canvases and a dubious reputation at the Pension Gloanec after his last visit five years earlier. "I never saw Gauguin," said Matisse. "I recoiled instinctively from the theory he had already worked out, for I was a student of the galleries of the Louvre."²⁷ If Matisse belonged to any school at that stage, it was the Bitumenists. He extended his range methodically, painting Pont-Croix on its wooded hillside from the far bank of the river below the town, then moving on to the undramatic flat landscape inland from Beuzec, which stood on a headland with its back to the sea.

The church of St-Budoc, a Celtic bishop said to have reached Beuzec by boat from Great Britain, contained a lighthouse in its mediaeval bell tower which reappears several times in the background of Matisse's studies of a girl holding a pig on a string. She was the daughter of the peasant with whom he and Camille found lodgings. Breton pigs were members of the family, going everywhere with their owners, waiting tied up outside shops and bars, sleeping or rootling for garbage in the street. When the pig in the picture had its tail cut off that summer, it was Matisse who dressed the wound. He remembered with amusement and some affection the landlord warning them against a calf's head cooked in their honour by his wife: "You would do better to eat the potatoes because the veal has already gone off a bit."28 He also remembered the cow munching hay in one corner of the room while he painted its owner weaving in another (lengths of linen and woollen cloth for trousers, skirts, coiffes, shirts and sheets were made at home), noting with a knowledgeable eye that Breton weavers still used a far more primitive contraption than the Jacquard looms which had made Bohain's fortune.²⁹

The paintings Matisse brought back from Brittany in October 1895, and most of those he brought back the year after, were Flemish in tone and treatment: still lifes, genre figure studies, flat landscapes rendered in bistres and bitumens with low houses, stunted trees and stumpy windmills punctuating a canvas half or three-quarters filled with pearly, cloudscudded sky. Thinking back long afterwards to that summer at Beuzec, Camille wrote that, after the Wérys, their companions were two young Flemish artists, "Henri Hirk and Henri de Crosse." The first was Henri Huklenbrok (the surname was a simplified version of his family name of Huichlenbroich, which no one in Paris could either pronounce or spell), who had just completed two terms at the Académie Julian but was already, by instinct and inclination, an honorary Moreau student. An ardent and impetuous youth, son of a hat-manufacturer in Brussels, Huklenbrok had reacted to his first taste of being patronised as a provincial in Paris by becoming aggressively Belgian, a touchy, tightfisted beer-drinker with a guttural northern accent, determined not to let his gritty realism be overlaid by fancy French polish.31

"Henri de Crosse" was probably Camille's rendering of Henri de Groux (Pont-Croix in her spelling came out in the same letter as "Pont Croisse"), who was an altogether more formidable realist. Van Gogh had admired him (the feeling was unrequited), and he had caused a sensation in Paris in 1894 with his Christ aux outrages (Christ Jeered and Spat At): a violent, inventive, richly orchestrated mass of strained and pullulating bodies which owed as much to the horrors of contemporary industrialisation as to Bosch or Breughel. As brilliant as he was abrasive, with extravagant tastes that far outran his nonexistent income, de Groux at thirty was well on the way to becoming a professional outcast himself (he would end up in Provence between the two world wars as a ravaged, scabrous destitute, the French art world's contemporary Thersites).³²

He and Huklenbrok were thrusting young iconoclasts of a peculiarly northern brand, adamantly opposed to academicism, on the one hand, and to anything approaching pure aesthetics on the other. De Groux (who once picked a fight with Toulouse-Lautrec because he supported van Gogh) raised realism to a powerfully satirical and sometimes apocalyptic vision. Huklenbrok stuck to traditional subjects—Dutch or Belgian landscapes and figure studies—rendered in a range of lurid mauves and purples that struck Matisse's friend Henri Evenepoel as frankly obscene. Evenepoel knew both de Groux and Huklenbrok from home (all three had studied under the same master in Belgium, where Evenepoel's grandfather was a strong supporter of the young de Groux, Huklenbrok a protégé of one of the Evenepoels' family friends). No slouch himself when it came to keeping up with the artistic Joneses, even Evenepoel admitted that, compared to Huklenbrok's, his own work looked decidedly old-world.

Matisse's was still more so. The sober, silvery grey Breton landscapes and still lifes he worked on in his Paris studio in the winter of 1895–96 represented everything Evenepoel most admired: "works of poetic feeling and an infinite delicacy in colour and handling." The two were beginning in these months to build up the friendship which Matisse looked back on later as one of the best things in his life. They set up their easels with Marquet's on the middle ground in Moreau's studio, painting together along the quais in summer and meeting in the evenings to make music. Evenepoel, who had arrived in Paris with his piano, held open house on Monday nights for friends like Huklenbrok (on cello) and the young illustrator Charles Hoffbauer (who formed a trio with Matisse and their host one night in February 1897). Matisse fitted easily into Evenepoel's circle of music-loving Belgians, who felt themselves at home with a violinist from St-Quentin, which was the halfway station between

Henri Evenepoel, Self-portrait at the Easel, 1895: the brilliant young Belgian singled out with Matisse as one of the highfliers in Moreau's studio

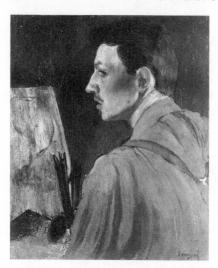

Brussels and Paris. Huklenbrok and Evenepoel once stopped off there to see the de La Tours on their way home, going out of their way afterwards to visit the museum at Lille, presumably at Matisse's suggestion.³⁸

Evenepoel came from a highly cultivated professional middleclass background. His mother had died soon after he was born, leaving him to be brought up by his stern, fond father—a senior civil servant who was also a passionate Wagnerian—and an indulgent,

art-loving grandfather. He was a precocious child, sweet-natured and appealing, used to being the centre of attention for large numbers of elderly relations. His health was fragile (a young aunt and uncle had both died, like his mother, of TB), but he made up in intensity for what he lacked in stamina and concentration. He grew up looking young for his age, with a surface charm and an underlying resolve beyond his years, both shadowed by a corrosive streak of pessimism. His teachers responded to his innate gifts as much as to his knack of pleasing. Disarmed by Evenepoel's ingenuous admiration, Moreau had a soft spot for this pupil who seemed to him to personify the weaknesses—as Matisse exemplified the strengths—of the Flemish temperament.

The difference between the Flemish and the French was a theme to which Moreau constantly returned. "You must understand that we belong to two countries with very different schools; we don't feel things the same way," he said when Evenepoel confronted him with fresh evidence of his incorrigible realism. Fascinated by the liveliness of the Parisian streets, Evenepoel found subjects everywhere: traders peddling milk or gutting chickens on the pavement, wrestlers stripping off for a fight, a corpse pulled from the river, a hatchet-faced old bawd (*La Vieille Maquerelle*) in dilapidated finery with her fag and carafe of cheap wine (this was the lithograph which so outraged Evenepoel's father that he returned it with the signature inked out). His aim was to reflect nature faithfully as it appeared to him. For Moreau, the artist's goal was to elevate and moralise ("yes, moralise"), which meant a perpetual fight against nature's coarseness and vulgarity. However hard Evenepoel tried to please, he never

attained the spiritual uplift without which a painting struck his master as irredeemably prosaic. "Looks like a man who has just got caught short in his pants," Moreau said briskly when Evenepoel showed him his Christ Crowned by Thorns: "Would you not have done better to represent him contemplating the sacrifice he is to undergo, fortified by his innocence, nobly facing his enemies as such a superior being, divine and mysterious, should do?" 42

Evenepoel's robust colour sense distressed Moreau if anything more than his insistence on painting only what he saw. "Moreau is not of our Flemish nature," Evenepoel wrote sadly, "being French and finding it hard to accommodate the vigour of the Flemish approach to colour." He started as he meant to go on by smacking the public in the eye with a swashbuckling, Whistlerian, very nearly life-size portrait of his friend Paul Baignières wearing a poppy-coloured suit which had been specially made for him at the artist's request. Exhibited in 1895, not at Bouguereau's Salon but at the galleries on the Champ-de-Mars belonging to the more liberal Société Nationale des Beaux-Arts, Evenepoel's *Man in Red* made his name. The national critics all picked up on it, Sarah Bernhardt stopped short in front of it, Jacques-Emile Blanche visited the young artist in his studio ("It impresses the concierge when people like that come to call," Evenepoel wrote home, impressed himself and anxious as always to placate his father. "That was my first carriage at the studio door").⁴⁴

By the early months of 1896 it was clear that, after a slow start, Matisse was also being groomed as one of Moreau's highfliers. The state confirmed its purchase of his copy of Annibale Carracci's The Hunt in February. In March Moreau not only approved his plan to apply, like Evenepoel, to the jury at the Champ-de-Mars but came himself to the quai St-Michel to inspect the work beforehand, a privilege reserved for few and favoured pupils. The visit took place on 11 March 1896, just over a week before entries had to be submitted. After some hesitation, Matisse decided that it was beyond him to clean up the carefully organised disorder in his studio. 45 Evenepoel, who had also been invited, found him pacing up and down outside the front door of no. 19. Already frail, crippled with shooting pains in his limbs and walking with difficulty, Moreau had to be helped up more than a hundred steep steps to the fifth floor. In one of the serial letters to his father that constitute a marvellously frank and graphic daily journal, Evenepoel described how Moreau first set his two nervous pupils at their ease, then relaxed in the warmth of their response:

At last we reached the little studio crammed with bits of tapestry and ornaments grey with dust. Moreau said to me: "We two will be the jury." He sat on a chair, with me beside him, and we spent an exquisite hour. He explained to us the whys and wherefores of all his likes and dislikes: Matisse showed his submission for the Champ-de-Mars, a dozen canvases, delicious in tone, nearly all still lifes, which provided the starting point for discussions of everything to do with art, including music. He [Moreau] has remained astonishingly youthful, he's not a professor, he hasn't the slightest trace of pedantry, he's a friend.⁴⁶

Neither Matisse nor Evenepoel ever forgot the intimacy of that encounter (nearly half a century later Matisse could not speak of it without tears in his eyes),47 which ended with Moreau asking how old they were: Evenepoel was twenty-three and a half years old, Matisse just twenty-five, Moreau a month short of his seventieth birthday. He talked about fathers, asking if Evenepoel's was managing to curb his impatience, and describing the way his own father had behaved to him—with uncompromising severity in artistic matters and sympathetic indulgence in all others—which was how he in turn approached his students. Moreau knew well enough that neither Evenepoel's father nor Matisse's could be counted on to follow his guidelines, although the work he and Evenepoel saw that afternoon gave grounds for hope. A few days later Matisse helped Evenepoel dismantle his biggest canvas, which they carried in a roll between them through the streets to the Champ-de-Mars, followed by the smaller paintings in a framer's cart. 48 Evenepoel made himself ill with nerves before the end of the week it took the jury to weed out almost two thirds of the three thousand entries. When he and Matisse were both accepted, he wrote to tell his father that he had cracked half a bottle of champagne with Huklenbrok to celebrate.⁴⁹

The news went down well in Bohain. Hippolyte Henri Matisse, who planned a trip to Paris for the Salon, was as anxious as Edmond Evenepoel to see his son compete for the Prix de Rome. The younger Evenepoel had wasted much time in a state of barely suppressed resentment, working through the qualifying stages at his father's urging the year before. "What makes the Prix de Rome detestable is the preparation for it, which is a machine designed to amputate the brain," said Matisse, who had Moreau's support in his bid to resist pressure from his own father. ⁵⁰ Evenepoel got no further than the preliminary round in 1895, when, to the indignation of his comrades, Georges Rouault was passed over in the final heat for a manifestly inferior candidate. "Moreau was furious, as were all those who

understood Rouault's worth," said Matisse. "Gustave Moreau was deeply affected by it."⁵¹

This setback seems to have marked a turning point for Moreau, whose allegiance to the Beaux-Arts system had already been severely tested when Rouault was turned down for the first time in 1893, and again in 1894, when his failure to win the Prix Chenevard had brought the rest of the studio so close to revolt that the jury had revoked its decision.⁵² Rouault in these years produced a series of small, strenuous, highly charged paintings encrusted with jewelled colour like condensed versions of Moreau's own richly decorated canvases. Samson at the Mill (1893), Coriolanus in the House of Tullius (1894), even Jesus Among the Doctors (1894): each features a sturdy but harassed and vulnerable youth attempting, like the painter himself, to comply with impossible demands. After the humiliating triple rejection of his best pupil, Moreau advised Rouault to forget the prize ("These are perilous exercises that wear you out")53 and leave the Beaux-Arts altogether. It was in this mood of disillusionment, verging on defiance, that Moreau told Hippolyte Henri Matisse that his son was too intelligent to compete for the Prix de Rome.⁵⁴ Matisse said long afterwards that nothing would convince his father that Moreau had not meant to mock him.55

Such loyalty as Moreau had ever possessed to the official Salon was largely eroded ("It's becoming pretty much a shop window," he said philosophically when Evenepoel defected to the rival outfit on the Champ-de-Mars).⁵⁶ The gulf opening between his studio and the others was increasingly obvious both inside and outside the Ecole. Already, two years earlier, Evenepoel had noted that his stock went up with Parisian intellectuals when they found he was a student of Moreau. By the summer of 1896 the challenge Moreau posed, in practice if not in theory, could no longer be ignored. To his colleagues, his tolerance looked like treachery. "You do realise, my friend," said Gérôme (who would be responsible with Bonnat for ensuring that none of Moreau's pupils ever won the Prix de Rome), "that you are landing your students in it up to the neck?" To others, Moreau's stance seemed positively heroic. "In the heart of the Ecole des Beaux-Arts a flame of revolt has been kindled," wrote the critic Roger Marx in a famous call to arms inserted into his review of the 1896 Salon du Champ-de-Mars. "All those who have risen up against routine, all those who believe in developing their own individuality, have grouped themselves under the shield of M. Moreau."58

Evenepoel reported that opposition was growing fast within the

Henri Evenepoel, The Cellar of the Soleil d'Or in the Latin Quarter, 1896:
Moreau risked his job by backing this portrayal of students and their girlfriends, which shocked his Beaux-Arts colleagues by its squalid realism

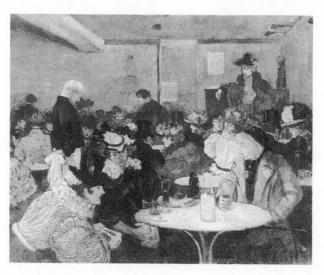

school, proclaiming his own intention to resist and proving it with a canvas that made Moreau blench. This was The Cellar of the Soleil d'Or in the Latin Quarter, a resolutely realistic rendering of the dim, squalid, smoke-filled basement packed with bodies and obscene graffiti on the corner of the quai St-Michel (headquarters on Saturday nights of the Symbolist review La Plume) where prostitutes and students met to drink, keep warm, play cards, make assignations and listen to songs notable even by student standards for lewdness and scurrility.⁵⁹ The canvas was as frank as Evenepoel had longed to be ever since the day when, as a new arrival at the Beaux-Arts, he had been reprimanded by Gérôme himself for trying to reproduce the reds and purples he saw reflected in the thighs of a nude model ("The tone's too bright, there's too much colour in it! It's brutal!").60 Evenepoel, who revered Moreau and took his criticisms seriously, had done his best to subdue his colours and curb his instinctive relish for the sights he saw around him. But The Cellar of the Soleil d'Or broke every polite Beaux-Arts taboo. Moreau responded with a mixture of delight and consternation: "It's very good, very good . . . but you can't show it . . . you'll get me killed!... And yet I absolutely insist you do it."61 His hesitations seemed comical to Evenepoel, but Moreau knew perfectly well that pledging his support to canvases like this one meant putting his whole future on the line.

Matisse, by contrast, provoked no qualms. With Rouault gone and Bussy also showing signs of striking out on his own, Matisse was rising up the lists Moreau jotted down on odd scraps of paper ranking his students in order of precedence. 62 Matisse's progress had been rapid, his achieve-

ments were impressive, his docility was not in question: "Moreau . . . scarcely had a student who worked more zealously or took more pains over . . . copying in the Louvre, who fell in more readily with his suggestions, who listened more attentively to his councils or better grasped their essence." Matisse raised great expectations untainted by the "modern tendencies"—the taste for low life, the inability to conform, above all the bright, strong colours—that were a source of chagrin in Evenepoel. When Matisse painted Paul Baignières, it was in a plain black suit. The painting, which depicted Baignières in Moreau's studio with the *massier* or head student Georges Desvallières and a nude model, clearly showed what Evenepoel meant when he called his friend "a delicate painter, master of the arts of *grey*." It was accepted at the Salon de la Nationale in 1896 (along with the portrait of Camille called *Woman Reading, The Pig-Minder* from Beuzec, and two still lifes) as a subtler and more serious declaration of intent than Evenepoel's eye-catching scarlet man of the year before.

The president of the Société Nationale, Puvis de Chavannes, was only too glad to field yet another escapee from the official Salon. He had founded the Société six years earlier, with Auguste Rodin and Eugène Carrière, in protest against Bouguereau's restrictive admissions policy, operating a relatively progressive regime at his breakaway salon on the Champ-de-Mars. Puvis himself belonged to the great French tradition of scorned and excoriated rejects who finally emerged triumphant to confound their critics. After years of disparagement and neglect, he found himself in his seventies hailed as the harbinger of a new dawn. He painted Victor Hugo Offering his Lyre to the City of Paris on the grand vaulted staircase of the Hôtel de Ville (Manet, who had offered to decorate the walls with Parisian street scenes, didn't even get an answer to his letter),66 and was greeted as a new Ingres with a dash of Claude Lorrain thrown in. Patriotic Frenchmen felt he had redeemed the nation's loftiest ideals: "It is France herself who smiles in the light of his skies, in the fecundity of his earth, presiding over his marvellous landscapes...."67 He seemed miraculously fresh and modern without the threatening or disruptive aspect of more radical departures. To the rising generation, he represented Olympian power and purity: "The younger French painters, among them Lautrec, Seurat and Gauguin, all revered Puvis...," wrote Will Rothenstein. "While profoundly influenced by both the Greeks and the early Italians, [he] brought a fresh vision to bear on the contemporary world....We were seeing the last of the heroes."68

Puvis and Moreau were contemporaries, old colleagues and long-term rivals. Unlike Moreau, who tucked in his toes for fear of contamination

from anything even faintly modern, Puvis welcomed the new wave of Symbolists and Impressionists, who in turn looked to him as their champion. Moreau could not always conceal the bitterness this reversal caused him (Matisse said it was obvious to everyone that whenever he talked about reputable artists painting drapery like bedsheets, Moreau meant Puvis). Puvis could afford to be magnanimous, and perhaps it gave him special pleasure to receive overtures year after year from Moreau's brightest pupils. At all events, it was Puvis who personally argued and won the case for Matisse to be elected an associate member of the Société Nationale, a notable accolade for someone who had never even exhibited before (Evenepoel would be made an associate the year after, but Bussy was turned down). It means guaranteed access, membership of the jury, the whole caboodle, wrote another Moreau student, Jules Flandrin, exulting in his own election two years later, with no small peace of mind to come, and no small honour. . . . "71"

Matisse now had the right to hang up to ten paintings at the annual Salon without further reference to the jury. He had also at last broken through the barriers to both official and unofficial patronage. Bouguereau's Salon had rejected his portrait medallion of Camille in 1805. but in June 1896 the state bought his picture of her reading for 800 francs (it would hang in the bedroom of Mme Félix Faure, the wife of the French President, at the Château de Rambouillet). He had sold a copy of Annibale Carracci's The Hunt earlier that year to the state purchasing committee, which would provide him with a small but useful income over the next decade and more. 72 It was Moreau's champion, the critic Roger Marx, who had advised Matisse to submit Woman Reading to the committee.⁷³ From now on he could count on support behind the scenes from Marx, who recalled Matisse's debut eight years later in the preface to his first one-man show: "In his twenty-seventh year, in 1896, Henri Matisse exhibited at the Champ-de-Mars with exceptional brilliance; his promotion to Associate went unchallenged, and his pictures swept into private and public collections with no interference."74

Matisse sent home a list of the nineteen new associates with his own name underlined. His parents already had the official offer of 600 francs for Carracci's *The Hunt*, endorsed on the back: "Letter about the sale of Henri's copy. The first he has sold." At least one of the paintings Matisse brought back from Brittany was finished off, sometime in the winter of 1895–96, on a visit to Bohain, where he also painted several still lifes. This was the first time he had returned home, or at any rate worked there, since he had left for Paris four years before, in 1891. His parents kept

him supplied—with sacks of rice, barrels of beer, the odd brace of pigeons—but the only relatives prepared in these years to welcome the renegade were a family of cousins of his own generation, who owned a substantial farm on the outskirts of Le Cateau. Ernest Gérard, Anna Matisse's second cousin, had married a wife only four years older than Henri himself. This was his Cousin Lucia, who had two small children by the early 1890s, when Matisse often fled Paris to replenish his energies at the farm. He repaid his cousins' hospitality at the end of each visit with a painting, noting sadly that even Lucia banished his pictures to the attic as soon as he was out of sight.⁷⁶

But the successes of 1896 went far to rehabilitate Matisse in the eyes of his family. Both parents came to Paris to see his work hanging at the Champ-de-Mars. His mother brought a present of fine wines.⁷⁷ His father roped in a distant cousin of his own, a Parisian textile-merchant called Jules Saulnier, who not only visited the Salon but bought one of the two still lifes on show (the other had already gone to a tradesman called Thénard).78 Saulnier produced luxury fabrics for the fashion trade, running a factory in Bohain and another a few miles outside it from imposing premises in the garment district behind the boulevard Poissonière (where Hippolyte Henri Matisse had once had lodgings as a shop assistant). He had married Marie Louise Jacqz, a Matisse relative from Le Cateau, where the Jacqzes were an ancient family of tanners like the Gérards. Henri spent a day at the Saulniers' apartment on the boulevard Magenta, basking for once in the approval of his cousins (whose fifteen-year-old son Raymond would grow up to become another of the twentieth century's great innovators, designing and producing planes for the world's first fighter squadrons). Apart from Père Thénard, Cousin Saulnier-who would remain a firm supporter to the end of his life-was Matisse's first collector.79

Another was his uncle and godfather, Emile Gérard, whose affairs had prospered to the point where he could afford to buy himself, in 1895, one of the grandest mansions in Le Cateau. This was no. 45 rue de la République, 80 a handsome eighteenth-century house near the old archbishop's palace, a stone's throw from the tiny Gérard cottage outside the mediaeval walls where Uncle Emile's only son—and Henri Matisse himself—were born within a few weeks of one another in the winter of 1869—70. There could have been no bolder statement of the family's rising expectations. The new house stood almost opposite the Gérard tannery, which had expanded to cover a large site on the riverbank with vats, tanning pits, rendering ovens, a margarine plant, warehouses, and stabling for

delivery carts. As the owner of one of the largest businesses in town, Emile Gérard had built up sizeable property holdings in the area, like his brother-in-law Hippolyte Henri Matisse (who stocked the agricultural fertiliser that was one of the tannery's by-products).

On the strength of his Parisian triumphs, young Henri was commissioned to design a decorative scheme for his uncle's elegant panelled dining room on the ground floor of no. 45. He painted the ceiling himself, picking out the plasterwork in gold, dark red and midnight blue.81 For the walls he made copies to fit the room's panelled embrasures of works by the Louvre's most urbane and graceful eighteenth-century masters: Boucher's Pastorale, Fragonard's The Music Lesson, Chardin's Pyramid of Fruits and Ribera's The Man with a Clubfoot. 82 The sober but sumptuous decorative effect was finished off with heavy, dark carved chairs and a table, based on designs from Gutenberg's house in Germany. It was an auspicious return for the prodigal who had left home so ignominiously five years earlier. Including Uncle Emile's copies, Cousin Saulnier's still life and the one bought by Père Thénard, the state's Woman Reading and The Hunt, Matisse had sold at least eight paintings in the first six months of 1896, and he could look forward to a broadening stream of further purchases and commissions. It was the first time in the nine years since his elementary-law exams that he had had anything to boast about from his family's point of view, and he itemised his successes in a jubilant letter to Adolphe Lancelle, the cousin with whom he had grown up on the same street in Bohain: "So you see, my dear friend, there are some paintings that bring in the money."83

Camille said that Henri presented her with a bunch of violets that spring each time he sold a picture.⁸⁴ The couple planned to spend the summer again in Brittany, and on 26 June, two weeks before they left, they gave a celebration dinner which Evenepoel described in a letter home:

Friday, yesterday, dined with Matisse, in the little room belonging to his wife, with his inseparable friend Vassaux. Great fun and very youthful, this little dinner for four, in a minuscule room under the roof looking out over the chimneys, laid out on a tiny little table, all our pleasure in being together sealed by the good wine his mother brought. How many splendid plans over the dessert, how many hopes, how much enthusiasm: one of the best meals of my life.⁸⁵

By the end of June the heat was stifling, especially for anyone living under the roof in a Parisian tenement block. Matisse took to rising before seven to join Evenepoel (who found his own top-floor studio so oppressive that he worked in his underpants) in the cool air on the riverbank below the quai: "The Seine is marvellous at that hour: a milky landscape, sky brimming with light, gilded, pink- and blue-tinted at the same time, the quais deserted!...From 7:30 we work until ten because at that hour the atmosphere changes, the enveloping morning mist clears: the sun beats straight down to grill us: we have to give way to it! So we go either to the Louvre or the Luxembourg, or to the school, till lunchtime!"86 They were preparing for the highly competitive end-of-year show put on by each of the three painting studios, when for the first time the students could compare and criticise the whole body of work produced over the past nine months. Evenepoel showed his portrait of his friend's baby daughter Marguerite or Margot, La Petite Matisse, along with eleven other paintings including The Cellar of the Soleil d'Or, for which Moreau warned him he would win no prizes. Matisse, however, took third prize for composition, the first and last official recognition he ever got from the Ecole des Beaux-Arts.87 It was an appropriate note on which to end an academic year that had set him squarely on the road to fame and fortune.

BUT EVEN BEFORE the Salon closed at the beginning of July, Matisse was talking about the need to get away from worldly distractions "to some isolated spot."88 Bussy, who had already left with a backpack for a walking tour that would last seven months, wrote anxiously from the Swiss Alps to ask if Matisse intended leaving Paris for good. His enthusiasm for Brittany was infectious ("It seems it is a marvellous place," reported Evenepoel: "a completely wild country where a storm is always round the corner, and where seas and skies make a drama out of every moment of the day!").89 On 15 July the Matisses left with the usual Brittany-bound band of summer painters, including this year Victor Roux-Champion (who diverged en route for Pont-Aven), Henri Huklenbrok and the Wérys, all of whom continued to Belle-Ile.90 However demoralised he had been the year before, something drew Matisse back to the island. He arrived characteristically well prepared with a tiny notebook into which he had copied eleven pages of practical information from a borrowed guidebook. 91 He noted the size of the island ("18 km long, between 4 and 10 km wide, 48 km in circumference"), its topography, its landmarks, its four ancient parishes and its contemporary tourist attractions (apart from a modern lighthouse and Maréchal Vauban's seventeenth-century fortifications at Le Palais, these consisted largely of cliffs, caves and rocks).

At the back of the notebook, he wrote out two poems from Les Fleurs

du mal by Charles Baudelaire, whose images reverberated in his own and his friends' imaginations, echoing in the background of Matisse's early paintings. One of the two poems he brought with him to Belle-Ile was "L'Idéal," a majestic rebuke to the febrile vapidity of Parisian Salon painting which was as pertinent in Matisse's day as in the poet's. The other was "Les Phares [The Lighthouses]," which invokes Baudelaire's masters— Rubens, Leonardo, Rembrandt, Michelangelo, Watteau, Goya, Delacroix—in a sonorous secular magnificat (which had not yet become, as it has done since, a standard art-historical roll call for French schoolchildren). The poem distilled for Matisse everything he had learned in the Louvre through Moreau. It proclaimed him a follower in the footsteps of his great predecessors—the lighthouses of Baudelaire's poem, signalling through darkness down the ages—among whom he was still modestly content to count himself a follower of Jan Davidsz de Heem, whose soft, clay-coloured palette of greys, greens and browns he had also brought with him on this second visit to the island.

The Matisses found lodgings in Le Palais above another patisserie at 13 place de l'Hôtel de Ville, beside the old church and the new town hall, with a view from their attic window at the back of the house looking down onto the quay and across the sheltered back harbour to Vauban's citadel. The sardine season was in full swing, with thousands of fishermen from all over Brittany crammed into the tiny port, sleeping at night in boats tied up to the quay, rising before dawn to leave on the morning tide, returning at noon with a catch to be salted the same day. The noise of men shouting, singing, swearing, loading and unloading, repairing or retarring their boats on the quayside below Matisse's window was compounded by hammering and sawing from the boatyards further along the harbour at the back and the cries of fishwives in the marketplace beside the town hall at the front. He painted several quiet, low-keyed studies of boats in the back port, but for a notoriously poor sleeper in search of isolation, conditions were less than ideal.

Matisse left Le Palais to settle for the summer with his family at Kervilahouen, a scattered hamlet six and a half kilometres away across flat, furze-covered scrubland on the far side of the island, where they stayed in the same house as the Wérys. They had an uninterrupted view out to sea from the top floor of a substantial, three-storeyed, stone "pilot's house" beside the track leading to the lighthouse (the pilots, without whom any boat heading for mainland France faced destruction, were the best-paid men on Belle-Ile). The great granite lighthouse rose 150 feet above the headland, barricaded in by knife- and axe-blade-shaped rocks rising from

a sea "more terrible," according to Octave Mirbeau, "than in any of the wild places of wildest Brittany, more impressive to the eye, more magnificent in its horror than the seas that lash against the black rocks of the Pointe de Raz." Anyone leaning out of the Matisses' window could see the lighthouse to the left. Its lantern, beaming through the dark at night, lit up their room like Baudelaire's symbolic beacons.

"Twenty-five yards from the most appalling coast you could imagine...you would find here a little room, very clean," Matisse wrote to Roux-Champion at Pont-Aven. "The landlady will do your cooking for nothing—all you would have to do is pay for provisions—eggs, milk, wine, fish, sometimes meat—and all this for thirty francs a month." The Matisses' own landlady was Mme Le Matelot, who ran a general store on the ground floor as well as letting out rooms under the roof of the capacious new house built three years before by her husband, the pilot Stanislas Le Matelot. Matisse, Wéry and Huklenbrok were part of a steady stream of painters drawn to Kervilahouen by "the Englishman's castle [le château de l'Anglais]," constructed ten years earlier on the clifftop a quarter of a mile away by the painter John Peter Russell. 97

Russell was in fact an Australian, the first outsider to settle on Belle-Ile (the second was Sarah Bernhardt, who established her summer quarters at the far end of the island in a blaze of publicity in 1895). The son of a Sydney iron-founder from whom he had inherited a substantial income at twenty-one, Russell had studied at the Slade School in London and at

Russell's house, known as "the Englishman's castle," above the creek at Goulphar, near the lighthouse beneath which Matisse found lodgings at Kervilahouen

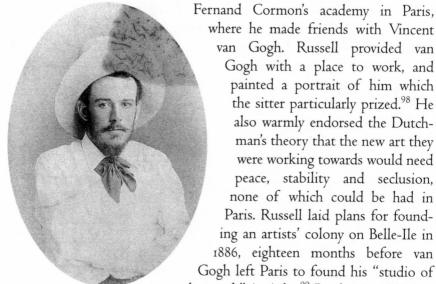

John Peter Russell. c. 1888

Gogh with a place to work, and painted a portrait of him which the sitter particularly prized.⁹⁸ He also warmly endorsed the Dutchman's theory that the new art they were working towards would need peace, stability and seclusion, none of which could be had in Paris. Russell laid plans for found-

ing an artists' colony on Belle-Ile in

1886, eighteen months before van Gogh left Paris to found his "studio of the south" in Arles. 99 By the time Matisse reached Belle-Ile ten years later, van Gogh's

experiment had ended in unconditional failure while Russell's continued to flourish.

He and his wife had established precisely the sort of setting van Gogh had in mind when he encouraged Russell to found his studio of the north: "One must have some settled base, like steady people, and not like decadents," van Gogh wrote in 1888 from Arles, describing the ideal artist's home on which he could afford to spend "fewer hundreds of francs than Russell, for instance, spends thousands."100 Russell lavished his thousands on a solid stone house above the sheltered inlet of Goulphar, with terraced gardens, tennis court, stables, cow-byre, and workshops on the hinterland behind, a slipway to the beach below, and spectacular views of the Atlantic in front, from the huge central studio round which the life of the household revolved. Besides a permanent retinue of children, maidservants, a coachman, tutors, governesses and gardeners, Russell attracted a floating population of visiting painters who either stayed at the big house or found lodgings, like Matisse and Wéry, at Kervilahouen. There was constant coming and going between the house and the village. The local girls worked for Mme Russell, younger children walked over each morning with baskets of fresh produce to leave at the Russells' kitchen door, the fishermen landing in Goulphar Creek sold the pick of their catch to Russell himself at dawn. One of Mme Le Matelot's sons married a girl employed in the big house, another carried easels for the artists who came each summer to paint on the rocks with "Milord Russell." ¹⁰¹

If Matisse found the wildness of the scenery appalling, he would not have been the only visitor to be equally appalled by the wildness of Russell himself. Autocratic, high-handed and hot-tempered, a red-bearded patriarch with a commanding presence and a carrying voice, Russell at thirtyeight was nothing if not conspicuous. He was a talented amateur boxer, said to be so powerful he could force a stray horse to its knees or lift a man off his feet with a single punch. 102 He fished, swam, sailed and rode round the island in all weathers. Auguste Rodin (who came to stay the year after Matisse's last visit to the island) called him "a triple Triton . . . frolicking among the caverns of Amphitrite, or rather of monsters of the deep." 103 Rodin was half dazzled, half petrified by the feats performed in his honour by his host before an audience of children, houseguests and local fishermen: spearing a gigantic tunny trapped in the creek below the house, wrestling by moonlight with a phosphorescent seven-foot conger eel, sailing his small boat (with an apprehensive Rodin aboard) over a pointed rock barely submerged even at high tide into an otherwise inaccessible cave mouth, where he stripped off and dived down to retrieve the boat's damaged keel from the sea bottom.

Frenchmen with a strict Catholic upbringing, a classical education and no sporting tradition were often mystified by Russell's outdoor Anglo-Saxon attitudes. Rodin, who liked him as a man, encouraged him as an artist, and regularly entertained the whole Russell family in his house at Meudon, clearly felt he was lucky to have returned alive from his only visit to Belle-Ile. ¹⁰⁴ In the neighbourhood of Goulphar, few could escape the Russells' lavish hospitality. Reluctant village boys from Kervilahouen were drafted to make up numbers for Russell cricket matches, and included with their parents in impromptu feasts with singing and dancing on the clifftop afterwards. There were regular boating or mussel-gathering parties, picnics, bonfires and excursions for the family and their friends.

Matisse's exuberant accounts of his own exploits on the island suggest the atmosphere of horseplay and high spirits recalled by the Russells' other visitors. He and Wéry borrowed a donkey cart from a local fisherman's wife for a disastrous shopping expedition to Le Palais during which the donkey refused to budge, so, being too tenderhearted to use the owner's goad, they beat it with furze branches, which proved useless. ¹⁰⁵ Asked what they would charge to repaint the cart, they roared with laughter and painted it for free, making a great joke of having found a new vocation as carriage painters. They built fires on the beach to cook freshly caught sardines and made painting expeditions to the same beauty spots Rodin later visited with the Russells. ¹⁰⁶ In the end the Matisses stayed

three months on this second visit to the island, instead of the one they had originally intended. 107

If the painters enjoyed themselves, so did their wives and girlfriends. Camille had nothing but happy memories of her summers on Belle-Ile: "She talked of the landscape, and the storms. It was the wildness of the place that impressed her." 108 She also responded to the artists' energetic communal life, which centred on the Russells. A model herself before she married, Mme Russell had none of the usual prejudice against irregular liaisons. She had presided over the wedding of at least one of the young artists who painted with her husband (this was the American Dodge MacKnight, who married the Russells' nursery governess and lived for several months in Kervilahouen before taking his French peasant wife back to Boston). 109 She got on famously with the painters' models, whose company amused her and whose troubles she listened to with more sympathy than most. Marianna Russell was Italian herself, the eldest daughter of a peasant family who had left home early with two of her brothers to make a living singing and playing on the streets of Paris. 110 She had lived with Russell since 1884, when she was nineteen, marrying him four years later after she had already borne him three children, two of whom died in infancy.

In eight years of marriage she had lost four more babies (the last was born on Belle-Ile and buried there at seven months old in February 1896). Her eldest child and only surviving daughter, who was nine years old in 1896, had three brothers aged six, five and three. Mme Russell had been dazzling as a girl. She was painted by the fashionable portraitist Carolus-Duran, and sculpted by Emmanuel Frémiet as a celebrated bronze equestrian Joan of Arc. She sat seven times for Rodin, who said she was the loveliest woman in Paris and used her as his model for Ceres, Minerva and Pallas Athene. III Time, grief and a turbulent married life had if anything matured her beauty as well as strengthening and steadying a naturally firm personality. She ran her large household of guests, servants and children with unobtrusive efficiency. Mme Russell dressed in rich, strong colours, had her clothes sent down from Paris, and produced an impression on all who knew her of majestic calm. She had a reputation among the islanders as the only person capable of controlling Russell, himself as famous for his violent mood swings as for his reckless exploits and princely generosity.

The people of Kervilahouen, who approached him with caution, liked and pitied her. They also had considerable respect for her kindness and consideration (when the Russells bought a cow from the butcher, the greater part of it would be distributed among local families who otherwise seldom ate meat from one year's end to the next). Mme Russell rode sidesaddle all over the island, visiting her neighbours in their houses, nursing them when they fell sick, delivering their babies and keeping in touch with their children. She knew everyone and everything that went on, and she accepted people's difficulties without the puritanical disapproval that made life so hard for girls like Camille on the mainland. The Matisses' daughter Margot had her second birthday that summer on Belle-Ile. Her mother could hardly have helped reflecting on the fairy-tale fate of another model whose face was her fortune, and who had ended up married to her lover with her own custom-built castle, a carriage and pair, a wardrobe full of Paris finery, and a whole island to treat her "like a queen."

Russell endlessly painted his wife and children, playing, swimming, walking, sitting on the beach and in the garden. He also painted the island and its people, its yellow gorse and purple heather, its slatey orange rocks, its purply green seas, and its flat-bottomed black fishing boats with square ochre-coloured sails (colour fig. 4). His painting methods were as dramatic as everything else about him, and their impact on conventionally trained, relatively unsophisticated young artists could be overwhelming. The Australian John Longstaff, who spent some months on the island as a newly fledged student in 1889, remembered all his life the spectacle of Russell on a promontory in a high wind dashing away at his roped-down canvases, "like ships in full sail, squeezing his colours straight from the tube, and laying them on without any addition of white. The effect upon his sea-scapes of pure ultramarine was, of course, brilliant and in those days breathtaking." 113

It had taken Matisse's breath away the year before when, whether or not he actually met Russell, he could hardly have helped hearing about him from Wéry. Matisse maintained later that the transformation of his palette—"the bistre-based palette of the old masters, especially the Dutch"^{II4}—came from watching Wéry squeeze out his colours, like Russell, in the order of the prism. "Working beside him I noticed that he was getting more luminous results with his primary colours than I could with my old-fashioned palette." He made a good story about how the two switched palettes, Matisse returning to Paris with a passion for all the colours of the rainbow, having bequeathed to Wéry his former love of bistre and bitumen. ^{II6}

But for the greater part of the summer he worked cautiously, turning his back on the spectacularly romantic coast within a few minutes' walk of his lodgings, concentrating instead on the same sort of humdrum motifs rendered in the same muted colours as the year before: the group of long, low whitewashed cottages opposite Mme Le Matelot's house, the peasants' outlying farms, their mills, their hay- and furze-stacks, and the nearby creek at Goulphar where they beached their boats. "Brittany has a soft and intimate aspect," he wrote to Roux-Champion at Pont-Aven, "which you have to be able to penetrate, and without which the landscape ranks below many richer, sleeker and more picturesque places. Its light is particularly silvery, and its skies are made of mother-of-pearl... A new country, when it is profoundly interesting, is often like a muddled manuscript that has to be decoded."

Apart from the landscape whose secrets he was beginning to decode, he painted at least one quintessentially Flemish still life (Lobster with Earthenware Jug) and a scene with a serving girl stooping over a table laid with bread, wine, fruit and a rumpled white cloth which became his parting tribute to the Dutch masters and to Chardin. Breton Serving Girl was painted on a trip a few miles up the coast to one of Belle-Ile's prime tourist sites, the Grotte de l'Apothicairerie: a vast cave at the foot of a slippery sheer cliff face, opening among foaming seas and perilous rocks like a nine-

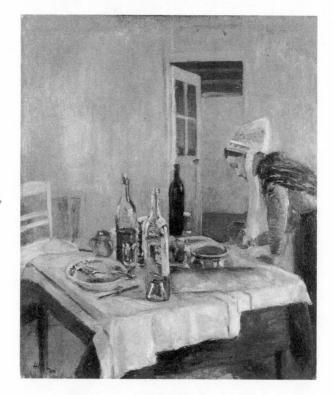

Matisse, Breton Serving Girl (Clotilde), 1896

1895-1896: BELLE-ILE-EN-MER

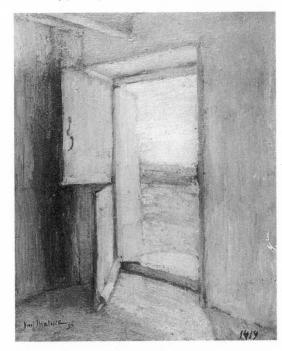

Matisse, The Open Door, Brittany, 1896, painted at Kervilahouen

teenth-century stage set. ¹¹⁸ Painters working on the motif (rendered by virtually every artist who ever set foot on Belle-Ile) stayed overnight at a rudimentary café, built in 1892 for the first visitors to an otherwise deserted headland by a farsighted wine merchant from Le Palais called Huchet.

A friend and supplier to the Russells, Père Huchet approved of the painters who were beginning to open up the island, and allowed them to sleep in the roof-space over his café, which they had to themselves in the evenings once the serving girls had gone home. The girl in Matisse's picture—who seems to be offering a drinking cup to a small child (almost invisible because the head was afterwards painted out)—was Clotilde, one of two sisters from Le Palais employed by the Huchets in the 1890s. Matisse worked in a small private room with a glass-panelled door off the main public saloon, faithfully rendering every detail of café life, from Clotilde's black apron and flat-topped coiffe with streamers (at a time when every Breton village possessed its own individual design, hers was the coiffe of Le Palais) to the disproportionately large soup tureen and the three opened wine bottles on a modest table set for two (Père Huchet threw in his wines free with the price of a meal).

But for all its Flemish realism, the canvas already shows the flood of

light, the bare luminous expanses, the loosening up of tone and texture evident in *The Open Door, Brittany* and the seascapes Matisse began painting that summer at Goulphar. A sense of release and liberation runs through the two letters he sent Victor Roux-Champion, who had written in a panic in mid-August from Pont-Aven. Two years younger than Matisse, Roux had been hit hard by Slewinski's painting experiments, and by one of Gauguin's canvases from Tahiti hanging at the Pension Gloanec ("After a month I grew frightened by my wild pictorial imaginings. I was losing my footing in that astonishing deluge of colour"). Matisse wrote back comfortingly in letters that echo the teachings he had already absorbed from Russell, whose son Alain—the youngest of the three boys and the nearest in age to Marguerite Matisse—remembered her father becoming his father's "virtual pupil" all through that summer and the next. 121

Matisse himself said that it was Russell who introduced him to the Impressionists' theories of light and colour, in particular to the innovations of Claude Monet, setting technical exercises to help him assimilate them in practice. However outmoded these sessions might have seemed to more fashion-conscious practitioners in Paris, they came as a shock to Moreau's students. "You tell me that 'I'm afraid of his [Gauguin's] influence, and yet I feel irresistibly attracted to this painting,' "Matisse wrote to Roux.

And what about *Impressionism* (dreadful word), what is Impressionism??? Corot is an Impressionist, Claude Monet is one too, both of them true artists, Corot has already made a mark, and in my opinion Monet will make his mark too.¹²³

This sounds like an attempt to set Matisse's own doubts at rest as much as to reassure Roux-Champion. Russell had never liked Gauguin, and obstinately resisted van Gogh's attempts to change his mind ("The Ignoble Savage. Mr Gogin" was the caption to a bony, mustachioed caricature in Russell's sketchbook, recognisably the master of Pont-Aven). 124 But he revered Monet—"I unhesitatingly place him as the most original painter of our century" 125—whom he had first met when they were both painting on Belle-Ile in 1886. Monet made a portrait of the Russells' handyman, a retired fisherman called Hippolyte Guillaume, or Père Polyte. Monet's paint-box on wheels (designed for working in all weathers) was still stored at the fishermen's inn in Kervilahouen, a stone's throw from Matisse's lodgings, and there was at least one Monet seascape in the collection of

some two hundred works by Russell and his contemporaries hanging in the house at Goulphar. 126

Russell also owned twelve drawings made specially for him by van Gogh, each representing a major canvas painted in the first season at Arles. 127 Russell had responded unconditionally in his late twenties to the stimulus of both van Gogh and Monet. In almost a decade of professional isolation since then, he had worked obsessively at the problem of colour, reaching his high point as a painter at roughly the same time as Matisse turned up on Belle-Ile. Russell was a forerunner and a facilitator, if not an innovator himself. As a teenager, visiting Japan and the Pacific Islands in a trading schooner based on Tahiti, he had collected Japanese prints long before they made an impact on European artists like van Gogh. 128 According to family legend, it was Russell who first suggested the idea of settling in the South Seas to Robert Louis Stevenson (some said he had sent Gauguin there as well). It was certainly Stevenson who was behind Russell's travels with a dogcart in Sicily, where, in the spring of 1887, he painted almond blossoms in the Japanese manner on canvases which confirmed van Gogh's determination to go south to paint orchards in bloom the year after. 129 Left to his own resources on Belle-Ile, Russell made no significant advance on the discoveries passed on by his peers ten years before, but he lost nothing of the passionate excitement which they had generated in him, and which he in turn now passed on to Matisse.

By August 1896 the younger artist had assimilated Russell's contempt for the picturesque packaging in vogue among the pictorial tourists who flocked to Brittany each summer: "You won't find an agreeable little port with fishing boats," Matisse wrote smugly to Roux-Champion. "Here it is the untamed wild in all its beauty and its emptiness." ¹³⁰ He posted "madly enthusiastic letters" to Bussy in the Alps, as well as to Roux, who was planning to join him that summer on the island ("You would be 21/2 minutes from the sea: the most beautiful corner of France and the most grandiose. You could produce masterpieces here"). 131 The qualities van Gogh had liked best in Russell were his gravity and strength, his vehemence ("Russell breaks out, he gets angry, he says something true, and that is what I need at times"), 132 and something he thought of as a countryman's innate soundness and sweetness. Matisse too responded to Russell's serious side. His Belle-Ile letters echo the twin principles—the primacy of colour and the need to be guided solely by individual feeling-which Russell himself had first worked out a decade earlier in student arguments with van Gogh in Paris. Matisse even caught the authentic Australian accent of bluntness and impatience: "We painters shouldn't be

galley slaves. So don't worry about your neighbour. Pay no attention to anything except what interests you (anything else would be impossible in any case). And enjoy working. Work with white, with blue, with red, paint with your feet if the whim takes you, and if anyone doesn't like it, send him packing." ¹³³

Russell had for years deliberately restricted his palette to six basic colours with a predilection in his Belle-Ile seascapes for cobalt blue combined with garance foncé, or deep purply crimson madder lake. ¹³⁴ Roux-Champion was so struck by the letter about galley slaves that he promptly set off for Belle-Ile, where Matisse found him lodgings at Envague, between Kervilahouen and the sea, suggesting they work separately without either inspecting the other's work so as to avoid any further upsets of the kind that had already knocked both sideways in Brittany. But at the end of the summer Matisse broke their pact, creeping up to inspect his friend's canvas in silence just before leaving Kervilahouen with his family. Roux, who had only ever known Matisse as an impeccably correct Flemish painter, subsequently tracked him down at his old room above the patisserie in Le Palais:

O surprise! I found him at his window, making a little study of the view along the harbour. His palette was now based on cobalt and garance: there was no trace left of the blended, restrained and sombre tones he had favoured up till then. The design was set about with pure colours. The radiance of Gauguin, filtered through Slewinski, then through me, had reached Matisse.... Matisse had set out intrepidly on the new road which had so frightened me. ¹³⁵

Matisse was working on one of several versions of *Port de Palais, End of the Season*, which showed a stretch of sloping roof with the quay beyond telescoped and blocked off by the neighbour's wall: a rich mix of colours with scattered crimsons and cobalts radiating vigorously out from the red splodge marking the door of the wooden customshouse in the centre of the canvas. He painted the view from his window at least three times, pairing the results long afterwards with an earlier clay-coloured view of the harbour marked: "Beginning of the season, compare with the other 'Port de Palais,' done at the end of the season, which heralds the influence of Impressionism" ¹³⁶ (colour figs. 3 and 5).

The painting itself embodied both Matisse's new red-white-and-blue formula, and the determination that went with it to send his critics pack-

ing. In three months on the island, Russell—with or without a helping hand from Gauguin—had set him on what would prove a collision course with Moreau. Matisse must have had some inkling of the consequences when he defined the core of his heretical philosophy to Roux as individuality and integrity:

You're interested in nature? Right? Why? Because of this or that. Put it into what you do. And you are already an original artist. That's the trick. But be personal above all, and for that you must be honest.

If you were as good as Holbein, you wouldn't exist yourself, you'd be nothing but his double. It would be better to paint a bit of water, a willow and a fine sky (like Corot) with feeling than to make yet another variation on the most beautiful Leonardo. 137

CHAPTER FIVE

1897–1898: Paris, Belle-Ile and London

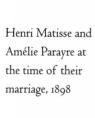

he works Matisse brought back towards the end of October 1896 were somewhat dubiously received in Paris. "I've seen Matisse," wrote Evenepoel, "who has returned from three months in Brittany, having done a great deal of work, and made genuine progress in his feeling for colour, but taken several steps backwards in technique!" Moreau suggested it was time for his star pupil to concentrate on producing a large-scale "masterpiece" in which he would put aside childish self-indulgence and demonstrate the genuine progress he had made in the last

five years. Matisse bought a canvas considerably bigger than anything he had tackled before, and set to work on a series of preliminary still lifes, in at least one of which the new canvas can be seen waiting, propped up against the studio wall in the background.

Bussy also returned to Paris after Christmas, full of energy and plans, with an impressive body of work from his travels, which had ended in Provence, where he spent the autumn with Martel. Matisse painted him in the studio at the quai St-Michel with what looks like a Belle-Ile seascape hanging on the wall behind him. In January the pair were approached, with Martel and Evenepoel, by an envoy bearing a proposition from Georges Petit, the ritziest and most fashion-conscious of all Paris dealers.² Petit's luxurious galleries off the boulevard Haussmann were frequented by everyone who was anyone, from Sarah Bernhardt and the Comtesse de Greffuhle to the top French and American collectors. Having started his career by making best-sellers out of Bouguereau, Gérôme and their peers, then moved on in the 1880s to poach Impressionists from their pioneering dealer Paul Durand-Ruel, Petit still liked to experiment from time to time with new young potential money-spinners. He proposed signing up the four friends for 5,000 francs over two years in return for enough work to fill his main gallery in a group show scheduled for 1899. The deal fell

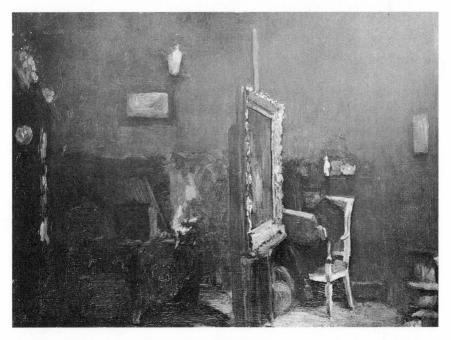

Matisse, Bussy Drawing in Matisse's Studio, c. 1897

through almost at once,³ but even the faintest ripple of interest from Petit left an impression in its wake.

Bussy, with Martel in tow, was snapped up by Durand-Ruel himself, who put on a two-man exhibition (Martel showed only drawings) in March at the premises on the rue Lafitte which had been for twenty years and more the Impressionists' home ground. Bussy was fêted, taken up and talked about all over Paris. There were plaudits from the critics, including the influential Octave Mirbeau, who electrified Bussy's friends by sitting waiting for him in a cab at the gallery door. The senior Impressionists rallied round. Rodin put in an appearance, Degas was complimentary, Pissarro presented the young artist to Renoir. Bussy himself, a virgin in this field like all Moreau's best students, was bowled over by the work he saw in their studios ("The discovery was a revelation to me"), especially by the painting of Monet and Degas. "It was a great success," he said of his show long afterwards, adding sadly, "the only one I ever had." 5

It seemed to Matisse and Marquet at the time that this first flush of success had gone to Bussy's head. He bought himself a fur coat, which did nothing to mollify their feelings. Overcoats were a sore point with poor students living on inadequate allowances in the sub-zero temperatures of a Paris winter. Evenepoel's was threadbare, and Marquet's had been stolen (which meant he had to go without until he could afford to buy another three years later). Matisse and Marquet never forgot the day when Bussy came to call in his fur coat, and proved too grand to climb the stairs, whistling instead beneath the studio windows on the quai St-Michel for them to come down to him. It caused a coldness between Matisse and Bussy, both proud, sensitive and easily wounded, with a readiness to take offence that brought them more than once in their long friendship to the brink of breaking off relations.

Matisse had reasons, both professional and personal, to feel edgy at this point. He had spent the winter months digesting Russell's teachings about individuality, originality and the artist's need for periodic retreat from corrupt commercial art-world networks, absorbing above all the approach to light and colour which eventually surfaced in the masterpiece he had told Roux-Champion would be incubated on Belle-Ile. *The Dinner Table (La Desserte)* (colour fig. 6) was intended, in compliment to Moreau and the Louvre, as a variation on the theme of plenty in de Heem's *Dessert.*⁸ The painting's actual starting point was a study Matisse had made the year before, in the Hôtel des Voyageurs at Pont-Croix, of the dining table set out for a party.⁹ This time the serving girl stooping over the table in his picture wore the little coiffe with distinctive flicked-back ends (la

penne sardine) belonging to the women of Pont-Croix. Matisse borrowed glass, china and chairs from the wife of a cousin (probably Marie-Louise Saulnier), ¹⁰ which explains the clash of lifestyles in his canvas. The expensive tableware of the well-heeled urban middle class mixes oddly with the simplicity of the girl in her country working clothes, the hotel's plain, green-painted dado, its long, uncurtained window, and the framed paintings by summer visitors on its walls.

He or Camille re-created a corner of the table setting, which was all there was room for on the little still-life table in his studio, using his cousin's porcelain, glasses, cutlery and starched napery (the bone-handled knives and the red-banded tablecloth turned up again all winter in his preparatory still-life studies). They bought fruit and flowers: this was the first but not the last time Matisse spent money he could ill afford on hothouse produce so that he could paint summer in a freezing Paris winter. 11 In order to make the costly fruit last as long as possible, he worked in overcoat and gloves in an unheated studio, while Camille took the pose of the serving girl in the masterpiece that was to have set the seal on his success at the 1897 Salon. But The Dinner Table, initially undertaken as a formal testimonial to Moreau, turned into an unofficial acknowledgement of Russell's influence. Matisse said he had started work on it using de Heem's traditional earth-coloured palette, and perhaps he was himself as surprised as any of his friends when the final result brought him closer to the description Russell had once given van Gogh of one of Monet's iridescent canvases: "Very fine in colour and light of a certain richness of envelop." 12

Evenepoel, who saw him working on *The Dinner Table* in early February, was horrified: "I am full of doubt and don't know which way to turn for the truth. Everything seems to be falling apart around me: Matisse, my friend, is at this moment doing Impressionism and swears only by Claude Monet, Huklenbrok defends him!!... What to believe, what to do, what to think, how to see? All this is worrying!... One doesn't really know where one is anymore!! All the painting you see, good or bad, starts dancing in front of your eyes, it's in turmoil!" A canvas which perturbed even the progressive Evenepoel stood no chance of acceptance by more conventional minds. Marquet took it in his stride, but Bussy could not stomach Matisse's new approach. Everyone who saw his painting in the studio that winter must have realised that it meant the end of any serious hope of sales or promotion.

Camille, by Matisse's own account, begged him not throw his career away. She wept, protested, pleaded, urged him to pull himself together, to make an effort, to do as other people did and take his work more seriously,

like his friends.¹⁵ Bussy was advancing from strength to strength that spring. Evenepoel had a London gallery in the offing, and a mixed show in Brussels scheduled for the autumn. Wéry, whom Camille had watched at close quarters tending his career for the last three years, was about to win his first medal at the official Salon on the strength of his prudent change of style. Matisse—intent on his new palette and increasingly obsessed by Monet—remained unmoved. Georges Petit's scheme was dropped at this point, and Camille was replaced as model by a wooden dummy.¹⁶

Bussy did what he could to spread his luck by arranging for Matisse to bring his work to the rue Lafitte to show to his new dealer, from whom the pair perhaps expected sympathy. But Durand-Ruel told Matisse sourly that there was no market for still life, advised him to stick to interiors with figures in them, and warned him above all to steer clear of anything to do with the unsaleable Paul Cézanne. When Bussy also introduced his friend to Camille Pissarro, Matisse had tears in his eyes. He said afterwards that Pissarro looked to him like one of the bearded prophets from the mediaeval "Moses Fountain" in Dijon, Perhaps because at this juncture it was Pissarro's prophetic strength and courage of which he stood most in need. Pissarro, who knew Russell, was characteristically perceptive, passing on to Russell's young protégé the encouragement he had himself received as a nervous youth showing his own work for the first time to Camille Corot: "Very good, my friend, you are gifted. Work, and don't listen to anything anyone tells you."

The two went together to the Luxembourg galleries to see Gustave Caillebotte's collection of Impressionist paintings. Bequeathed four years earlier to the nation, Caillebotte's legacy was accepted in part with a bad grace in a show that finally opened in February 1897 to howls of derision from the crowd and vituperative comments from Gérôme. "The idiot has made both himself and the Institute ridiculous...," Pissarro wrote philosophically. "Basically they may rage, but we are in the right; at least I for my part am convinced we are." Matisse can have seen comparatively little at this stage of Pissarro, who was working all that year against the clock, plagued by money worries, distracted by failing eyesight, by trouble with his teeth, and by increasing anxiety about two of his sons (both gravely ill in London, where the younger of the two finally died in November). But Matisse, who had been well prepared in tutorials with Russell on Belle-Ile, learned as fast as Pissarro could teach ("He was such a teacher that he could have taught stones to draw correctly," said Mary Cassatt). 22

Matisse had been taken by his cousin Hippolyte to see the Impressionist paintings owned by Degas's friend Henri Rouart, and he may or

may not have caught up with shows at Durand-Ruel, or with Ambroise Vollard's Cézanne retrospective in the winter of 1895. ²³ But he maintained that the first time he really saw the Impressionists was at the Caillebotte show with Pissarro, who had known them all, worked with most of them, and suffered greater material hardship for the sake of his art than any of the others. There were seven Pissarros on show together with three small Cézannes and eight Monets (including *Rocks on Belle-Ile*, which Matisse would

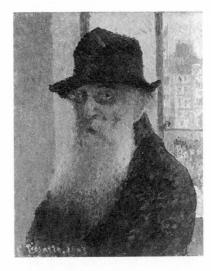

Camille Pissarro, Self-portrait, 1903

attempt to reconstruct on canvas that summer). Matisse learned a good deal about Cézanne from Pissarro later, but for the moment Monet occupied him to the exclusion of all else. He bought or borrowed a bicycle on which he rode out into the country to paint landscapes in the open air. Even nights out with Evenepoel and Huklenbrok at the Café d'Harcourt (another of the sleazy joints Evenepoel insisted on painting to his father's fury and Moreau's dismay) became Impressionist experiences: "We get carried away by enthusiasms for a red hat, or a black one, or a white one, or for certain harmonies which recall Degas, Claude Monet, Renoir, Goya..."

Matisse's visit to the Caillebotte show took place within a few days of the opening of the Salon de la Nationale on 24 April 1897, 26 when he needed all Pissarro's stoicism to face the reaction to his Dinner Table. The painting, humiliatingly badly placed by an outraged hanging committee, scandalised the Beaux-Arts authorities, who were already badly rattled by the Caillebotte offensive. Moreau, always protective of his rasher and more radical pupils, defended its experimental approach to light and colour, observing privately to Georges Desvallières that of all Matisse's paintings, he liked this one best. 27 But Moreau was virtually its sole supporter. Cousin Hippolyte was as upset as Camille and Evenepoel, expressing himself so forcibly that each visit became a misery to Matisse ("it knocked him flat for a week, without having the slightest effect on his resolution, or his vocation"). 28 In the end Matisse agreed to continue seeing his cousin only on condition that painting was never mentioned.

Matisse's father came up from Bohain, staying in the quai St-Michel studio where his son found him early one morning half-dressed, in shirt-

sleeves with his braces hanging down, contemplating a row of canvases which he had lined up against the wall.²⁹ These were Matisse's first tentative moves towards a looser and more impressionistic style; to his father they looked hopelessly sketchy and unfinished. At the Salon, Hippolyte Henri stationed himself beside *The Dinner Table* to watch people stopping in front of it to tell one another how bad it was. This second scandal—a replay of the first, when Matisse had been slung out of St-Quentin for tampering with the established rules six years before—confirmed his father's worst forebodings. Matisse dealt with his disappointment by echoing Pissarro: "I told him: 'It's me that's right.' "³⁰

Hippolyte Henri Matisse was not the only one filled with gloom by that year's Salon. Edmond Evenepoel did not attend at all, considering his son's The Cellar of the Soleil d'Or to be a family disgrace. 31 Joseph Huichlenbroich—a leading Belgian industrialist for whom an artist in the family was a source of rankling shame—bet his son over dinner at the elegant Restaurant Marguery in Paris that all his entries would be rejected by the jury. When two paintings were accepted, Huklenbrok blew his winnings (two hundred francs, or twice Matisse's monthly allowance) on a champagne dinner for the three Henris at the same table in the same restaurant ("Menu: Marennes oysters, bisque, fillets of sole in white wine, fillet steak with cèpes à la bordelaise, dessert, the whole washed down with two bottles of vieux Pommard!"").32 They finished the night at the Folies-Bergère, moving on at one in the morning to the Café Divan at the Grand Hôtel, dropping in at Les Halles for onion soup at four, and rolling home at half past six. Huklenbrok's extravagance echoed the mood of reckless defiance widespread among the student population in Paris in the 1890s. Matisse said that half Moreau's pupils were anarchists at a time when anarchy seemed the only route to a brave new world freed from tyranny and repression.³³

The undertow of desperation beneath the gaiety of the three Henris was more than justified. Evenepoel died young before his father could forgive him for his vocation as an artist. Huklenbrok's family destroyed his entire work after his death "for fear of seeing their name dishonoured." Matisse himself regretted to the end of his life that his own father had never brought himself to acknowledge that he had made good. The paternal view of art in general, and modern art in particular, as contaminating and contagious was common enough. In the last decade of the century, when cholera and typhoid were still endemic in great cities like Paris, and when the very idea of the recently discovered typhoid bacillus could spread panic, critics reported people catching smallpox in front of the

new *pointilliste* (or dottist) canvases, and nicknamed their perpetrators "the Bubonics [*les Bubonnistes*]." One of the complaints Hippolyte Henri Matisse reported back to his son from the 1897 Salon was that "people saw germs at the bottom of my decanters." 36

If attacks like these made Matisse feel like a moral typhoid carrier, he must have looked plague-stricken to Camille well before the Salon opened. On 10 February 1897—the week after a first sight of The Dinner Table had made Evenepoel feel sick and giddy-Matisse signed paternity papers, legally acknowledging Marguerite as his daughter. 37 She was baptised the same day, with Léon Vassaux standing godfather and without the knowledge of her father, who was a staunch atheist as well as anarchist at this stage. Marguerite maintained later that her baptism took place in secret at the instigation of her Matisse grandmother, whom she dearly loved.³⁸ It would have been inconceivable in those days for even the most liberal parent in Bohain to acknowledge a son's mistress openly, and it was scarcely less so to accept an illegitimate grandchild as Matisse's parents did. Official recognition by the father of a child born out of wedlock generally meant separation from its mother, and Matisse certainly moved out of the room he shared with Camille at this point, keeping his studio at 19 quai St-Michel but renting a separate room for himself above premises belonging to the Ecole des Arts Décoratifs at 10 rue de Seine. Their life together had degenerated into tears and scolding, on the one side, stubborn resistance on the other.³⁹ Camille could never get used to the gap between bohemian life in fiction, or on the stage of the Opéra-Comique, and the uncomfortable, disruptive, antisocial ways in which artists behave in fact.

By the end of May Matisse was in plaster and on crutches after a bicycle accident. 40 He and Camille made up their differences, fleeing together from a blistering heat wave that made Paris almost intolerable in June. 41 The couple spent the summer on Belle-Ile again (this time without Wéry, whose third-class medal—awarded for a Young Breton and a pensive sailor at sunset called The Last Rays—would be upgraded to second-class in 1898, with a national prize to follow in 1900). But anyone could see that the strange, bright, highly simplified paintings Matisse produced on the island in 1897 were frankly unsaleable. After The Dinner Table, Camille never apparently posed for him again. He painted the rocks and sea, more landscapes and the lighthouse, experimenting and exploring his new palette with mounting confidence.

Even the most mundane subjects took colour. The simple Breton mill, rendered two years before in an elegant gamut of greys, now became a conflagration of sharp cobalt and crimson, yellow and green brushstrokes

flickering like flames across a white ground. Canvases like this one have an urgency that would reappear in the work Matisse produced under a Mediterranean sun the following spring, when for the first time he attempted to grapple with van Gogh on canvas. Van Gogh had died five years before Matisse first reached Belle-Ile. Russell may well have owned a van Gogh painting as well as the twelve drawings sent from Arles, since the Dutchman had suggested exchanging canvases with him at least once. In a last letter to Russell, written in January 1890 from the asylum at St-Rémy, van Gogh explained that he had been overtaken by madness and delirium, and asked for one of his canvases to be included in an Impressionist collection Russell was putting together for Australia. 42

Van Gogh had sold a single painting before he shot himself at the age of thirty-seven in July 1890. Apart from a tiny memorial exhibition of sixteen canvases two years later, nothing had been shown or sold since then. In 1896 or 1897 the shock of his death was still raw, and his life offered a grim warning to another penniless young northerner starting out without support on the same uphill path to isolation and rejection. Whether or not Russell possessed any of van Gogh's paintings, he certainly talked about them to Matisse. At some point the Australian gave his young visitor one of his van Gogh drawings—something he had never done for anyone before, and would never do again, which suggests that he found in no one else the depth and strength of Matisse's response.⁴³

In his third summer on the island, Matisse was still chiefly concerned with Monet, whose Rocks on Belle-Ile he took apart and re-created much as he had once tried to do with Chardin's Pipe, setting up his easel at the same spot, painting the same jagged silhouette against the same shimmering seasurface with the same narrow band of sky across the top edge of the canvas. It was "the sumptuous melancholy, the grandeur and the solitude of the ocean" that had impressed Monet's friend Gustave Geffroy about this painting.44 A decade later Matisse's friends were struck in turn by the melancholy of his Belle-Ile seascapes, together with the force of the emotion they contained. The painter Jean Puy, who owned one of them, described it as "the most moving of the seascapes in its sadness, which becomes almost morbid by virtue of its truth: a drab grey sea, some phantom rocks drowned by the rain, a shapeless foreground of bleached lichens."45 The older Puy grew, the more powerfully this painting seemed to him to evoke not only Monet but the two poets who had presided over his youth, Verlaine and Baudelaire. He saw in Matisse's Rocks on Belle-Ile a combination of Verlaine's essential sadness—it was no accident that Verlaine, like Matisse, came from the North, whose sombre spirit shadows

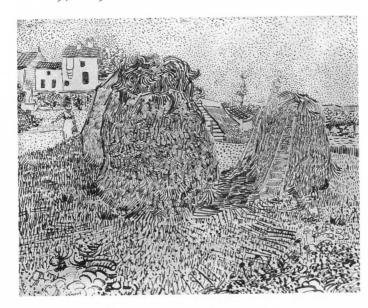

Vincent van Gogh, Haystacks, 1888: one of the twelve drawings van Gogh made for Russell, who gave it to Matisse

even his most frivolous Arcadias—with the moral complexities of *Les Fleurs du mal.* In a letter to Matisse written in 1945, Puy quoted Baudelaire's refrain about the consolations of the sea: "The sea, the vast bleak sea, and its moral chagrin beating against the cliffs of Belle-Ile, 'moesta et errabunda.' How poignant all this is..."

The summer of 1897 marked a decisive break in Matisse's life as in his work. He dated the onset of the insomnia that plagued him for the next half century to this turning point on Belle-Ile, 47 when he embarked as a painter on a course that spelt madness to his family and friends ("For two years now you have been working yourself more and more into a state," Evenepoel wrote in 1898. "where will it end? . . . in my view you are playing with your health").48 Matisse described a nightmare visitation in a Breton hovel on a deserted headland where he spent one of the worst nights even he ever experienced, lying awake listening to something unknown moving and scratching at the door: something that rustled and flapped, slithering to and fro, dragging along the ground, sometimes departing altogether, but always returning to slap at the door until dawn broke. When at last he steeled himself to rise from his bed of anguish and look outside, he found a sheet of paper—the heavy oiled paper used by butchers for wrapping meat—which had lain on the ground all night, borne to and fro on gusts of wind.49

For all the comic absurdity of this story, its undertext sounds like a return to the debilitating nervous crises of Matisse's adolescence. He told

the young Dominican monk Frère Rayssiguier, who kept a diary of conversations with Matisse after the Second World War, that "he had felt hunted all his life." What tormented him was "the misery of not painting like the others." He said he had been terrified of solitude when young: "He wouldn't have been able to stand it, because he was too continuously uneasy." One of the reproaches Camille laid against him was his inability, or refusal, to sleep at night and his corresponding failure to rise early, rested and refreshed for work, the next morning.

Her own nerves were increasingly on edge this summer. Herself a perfectionist, fastidious and highly critical, she had stood by Henri for five years, during which the couple would have been hard put to survive without her earnings. She had posed for the painting which brought his first Salon success, seen her patience handsomely rewarded, and watched him wantonly throw overboard everything he had worked so hard to gain. Before they left Paris, he had antagonised the authorities, thumbed his nose at dealers and collectors, chosen to behave like an irresponsible crackpot, in sharp contrast to the sagacious Wéry, who had long since outgrown his own juvenile excesses (earning himself, as Matisse said bitterly, "a nice little success in sales and decorations in the process"). 52 No wonder Camille implored him to change his mind, moving on to try coercion when he remained adamant. Everyone who knew her agreed that she had a sharp tongue and an authoritarian temper ("She could never allow herself to be contradicted. She hadn't the sort of character that bends easily").53 Matisse once said that her character was even stronger than his own, which made her constant opposition difficult to bear.⁵⁴

She became shriller and more desperate as she watched their relationship disintegrate that summer. She was fighting not only for her own future but for his: everyone from his teachers to his family and all his closest friends (except Marquet) foresaw disaster unless he could be brought to make some sort of compromise. Matisse said she made such perpetual scenes that in the end it became impossible to live with a neurotic. But it was Camille who finally decided she could no longer face a future which consisted of trying to make ends meet on a dwindling pittance in a tiny garret with a small child that had to be kept quiet for the sake of an obstinate insomniac who for almost twelve months had refused to listen to a word of reason. Mether she returned to Paris, or whether she remained on the island with the Russells, is impossible to say. Marianna Russell, who missed nothing that went on in Kervilahouen, must have known about and perhaps sympathised with a predicament that might once have been her own. She had borne her eleventh child at the beginning of 1897,

1897-1898: PARIS, BELLE-ILE AND LONDON

The rocks near Goulphar painted by Monet, Russell and Matisse

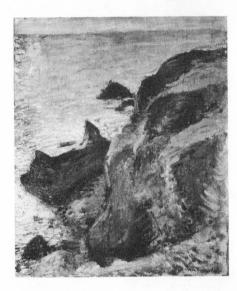

Matisse, Seascape,

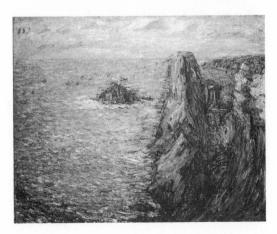

John Peter Russell, The Rocks at Belle-Ile, c. 1890

Camille

and could easily have found a place in her capacious and easygoing household for a companion who knew how to make herself useful, and who had all the latest Paris fashions at her fingertips. When Camille herself looked back afterwards, a golden glow suffused her life with artists on Belle-Ile as in the Latin Quarter. Nothing and no one in later years ever quite matched up to it. "She always regretted having left him: it had been the happiest time of her life." 57

Matisse returned to Paris without her in the middle of October for a wedding at which he was best man. The

bridegroom was Fernand Fontaine, an old school friend and son of the mayor of Bohain, who owned several of Matisse's paintings beginning with the chromo of a water mill copied from the lid of his mother's paint-box. 58 Matisse, who had already given Fontaine the Lobster with Earthenware Jug from Belle-Ile, gave him another relatively conventional still life as a wedding present.⁵⁹ But the seascapes he brought back to Paris from the island that autumn caused an uproar when he showed them to Moreau. "Matisse in a raging storm of youth overturned the teachings of Gustave Moreau's studio far more definitively and completely than Rouault," wrote Roux-Champion, half fearful, half admiring, of the older artist's daring. 60 Braver spirits in the studio were enthusiastic but Moreau himself was furious: "He let rip with bitter remonstrations—one could well use a stronger term—against the wretched students who had allowed themselves any liberties with the brush," wrote Jules Flandrin on 19 November. "The first to suffer was Matisse, who brought back an enormous holiday canvas, all impregnated with the country and fresh air...."61

One of the brightest and best-informed of Moreau's students, Flandrin came from a sophisticated and supportive family in Grenoble who had always felt at home with painting and painters. He had joined Moreau's studio in 1895, and begun experimenting with pure colour round about the same time as Matisse, who singled him out in retrospect as one of the leaders among his fellow students. Adventurous and inquisitive, attracted by all that was boldest and most radical in contemporary art, Flandrin offered support at a time of mounting pressure, when, according

to Maurice Boudot-Lamotte, Matisse said he spent the whole of his last year at odds with Moreau. Flandrin was often in trouble himself when the holiday paintings were unpacked each year at the beginning of the autumn ("Ah, Flandrin, no, I can't go along with you that far," Moreau said of a particularly audacious landscape in October 1896). Both earned themselves the kind of tongue-lashing described by Evenepoel, who once watched Moreau browbeat a pupil for twenty minutes, gibbering and gesticulating like an angry puppet on a string. Do you remember the time he made Matisse cry?" Marquet asked Manguin long afterwards.

But by October 1897, when Boudot-Lamotte joined Moreau's studio, Matisse had long since concealed any tendency to tears beneath a notoriously tough outer skin: "He was the studio comedian, a sort of Gascon of the North" (the people of Gascony in French popular myth were incorrigible clowns and show-offs). As a nervous schoolboy straight from St-Quentin, Boudot-Lamotte was both impressed and intimidated by his compatriot's seemingly boundless confidence, his devil-may-care attitude and his lusty rendering of the scurrilous anticlerical songs of their native region: "Matisse respected nobody and nothing." Matisse himself insisted that he had no choice. Years of trying and failing to please had finally forced him to make what capital he could out of his outcast status and increasing isolation.

In the autumn of 1897 most of his old friends were for one reason or another missing or preoccupied. Bussy, still estranged, was undergoing a radical reappraisal that ended with his changing his name to Simon, joining James Abbott McNeill Whistler's Parisian academy and being taken up by a set of English intellectuals from Bloomsbury in whose wake he moved to London. Manguin was deeply engrossed in courtship of the girl whom he would marry eighteen months later. Marquet remained close, already assuming the subversive and anarchic role ("At twenty I was ready to blow everything up")69 which he played ever afterwards in Matisse's life. "Marquet and I were the studio dropouts," said Matisse. 70 Evenepoel showed tubercular symptoms aggravated by trouble with his family that autumn. Passionately in love with an unhappily married cousin who had borne him a son three years before, he agonised over the future and over friction in the present with his father, who dispatched him to Algeria at the end of October. Both as a man and as a painter, he found himself obliged to retreat from the bold postures of his careless youth. It was an irony not lost on Matisse that just as he himself began at last to turn to colour, Evenepoel was moving in the opposite direction:

He had a great talent. Evenepoel's paintings were fresh, full of life and colour. . . . I admired them very much. Then he changed. He began painting in greys. I remember seeing an extraordinary thing: Evenepoel filling a tube with all the paint scrapings from his palette at the end of a painting session. He made a grey mix out of all those colours and packed them into a tube; and he used this grey tube to tone down his bright colours. It was dreadful.⁷¹

For Evenepoel this new sobriety represented the victory of French refinement and restraint over his native sense of colour, which he associated with coarse materialism. His problem was that he had come to share the dismissive French attitude summed up by Baudelaire, who said that "Flemish painting shines only through those qualities which are not intellectual—it has no *esprit* but it sometimes possesses a richness of colour, and almost always an astonishing sureness of hand." Evenepoel was no longer content to be, in Matisse's phrase, "the Franz Hals of the future." But however much he hankered after spiritual beauty, he could never entirely give up his kinship with other Flemish painters—"all those who have loved colour like a lover, who have *devoured* it so to speak" whose vigour and sensuousness ran in his blood.

Matisse, who was both French and Flemish, would combine the two traditions, bringing a lover's passionate feel for colour to the profoundly contemplative classicism central to French painting from Poussin to Cézanne. For him the influence of Russell, Monet and Pissarro was crucial but short-lived. They taught him a way of seeing: the first inklings of the pursuit of colour for its own sake that would draw in the end on his deepest emotional and imaginative resources. Impressionism came to seem too slack, too formless, too dependent on superficial accidents of time and place to satisfy his needs for long, but there was no turning back from the door that had opened for him on Belle-Ile.

Moreau, who had so unexpectedly supported *The Dinner Table*, could not tolerate the abstracted and reductive simplicity of the Belle-Ile seascapes. "He often told me off [*Il m'a engueulé souvent*]," said Matisse, who understood both Moreau's high hopes—"We were young, and he was proud of the qualities we might possess"—and his cloudy fears. ⁷⁵ Moreau had a growing sense of incubating monsters as one by one his brightest pupils moved towards the pictorial simplifications which seemed to him only a step from disintegration and decomposition. Matisse remembered his unaccountable enthusiasm for a Toulouse-Lautrec poster on the street, and his vain attempts to get the hang of Monet:

In front of a Claude Monet: "Ah, I see what it is: whipped egg white!" The canvas in question was painted with long brushes, shaved to a point like a knife blade, so as to avoid producing an impasto, so as not to disturb the layer of colour underneath when applying new dabs of colour on top, which produced an effect of feathers; it was the colouring [la teinte] which gave the impression, over the green water, of a white just barely tinged with pink and blue....⁷⁶

This was the central issue that divided Matisse from Moreau, for whom any notion of colour as an end in itself was ignoble dye-work ("C'est une teinture!").⁷⁷ Matisse in later life was often stigmatised as a dye-worker, a contemptuous term with the connotations of crudeness and vulgarity that always attended confrontations between the Beaux-Arts' assumption of spiritual superiority and the rich decorative heritage of Matisse's native North.

When he came to look back over his own life in his seventies, Matisse understood perhaps for the first time that Moreau too had been reviewing his past at seventy in the light of his young students' future. "He realised that he was not as gifted as he might have been. He had the greatest respect for true gifts. . . . He said of himself, I will be the bridge. . . . He could never satisfy himself, which was the reason for his great humility."

The students closest to him all remembered his magnanimity, his fellow feeling, the pains he took to atone for the rages and resentments generated as much by his own personal disappointment as by the prospect of a new art—the art of the future for which he had built the bridge—that would put an end to the pictorial world he knew. His complaint that Matisse was oversimplifying painting came with a disclaimer: "Don't listen to me. What I say doesn't matter. A teacher is nothing. Do what you want, that's the main thing. I like what you do for me much better than the work of others with whom I don't interfere."

Wax-pale by the autumn of 1897, emaciated, pitifully frail, already eaten up by the cancer that was killing him, Moreau frequently felt too weak to come to his Beaux-Arts studio. He paid a friend called Eugène Thirion to take the class for him, 80 and on the days when he came himself, he was often captious and hard to please. Matisse, preoccupied with his own struggles that autumn, was scathing at Thirion's expense and impatient with Moreau's advice to his students to do, when in doubt, whatever Leonardo would have done. "It was pernicious and false," Matisse said of a tyranny from which he himself had been set free by Russell on Belle-Ile.

"He implanted in the spirit of young people exorbitant demands that did not always correspond to their potential."⁸¹

The lash of Moreau's angry spirit—the inner dissatisfaction and gnawing sense of inadequacy which Matisse said destroyed weaker students—was probably, for those strong enough to take it, the greatest gift he had to give. It cut deep and drove hard. Matisse's life was shaped by it. So were the lives of Rouault, Marquet, Bussy and Martel. None had any financial resources beyond what they could earn from painting. All would have starved when young sooner than compromise their artistic principles ("Ah, those revolutionaries dying in their garrets," Bussy wrote nostalgically years later to Matisse. "Soon it'll only be members of the Institute who die in garrets. Still, that is no more than justice" All genuinely despised the worldly success that had come early to Bussy but eluded Matisse.

All faced an identity crisis in one form or another when the time came to leave Moreau's studio and launch themselves on the outside world. Rouault suffered a prolonged spiritual and nervous collapse beginning in 1898. Marquet survived by cutting himself off for good from any form of self-promotion, whether through dealers, galleries, museum officialdom or art-world politics. Bussy renounced the glittering prizes that had seemed within his grasp in favour of lifelong reclusion and withdrawal. Martel became a militant freethinker, retreating to his mountain village to work from now on in conditions of extreme hardship and almost total isolation ("a painter . . . who chose poverty without attempting to build a career rather than a career without producing works of art"). 83

Matisse had been the first to turn his back on the life of privilege and placement that would have been his if he had accepted the overtures of the official art world in 1896. "What a splendid career as a state functionary opened up before me," he said scornfully thirty years later. "I assure you there was no merit on my part in turning it down." But at the time, the decision cannot have been straightforward for a twenty-six-year-old with an unofficial wife and child to support. Camille's ambition was to see him rise up through the ranks of the artistic establishment. She was no different in this from Pissarro's wife, or from Mme Paul Cézanne, who told Matisse the only time they ever met that her husband was an old fool who understood nothing about art, and had never known what he was doing. Matisse said that uneducated peasant women like these two served their husbands according to their lights, treating them "as if they were simple carpenters who had taken it into their heads to construct tables with legs in the air." Their grumbling compliance suited him no better

than the fierce resistance he had to contend with from Camille (who was herself the daughter of a village carpenter).

André Gide described Matisse, Rouault, Bussy and other Moreau students as a breed of secular saints who shared "a fierce demanding intransigeance towards themselves, a disdain for facility, a contempt for material rewards, a quasi-austere harshness that makes them approach their art as if it were a kind of high priesthood." But celibacy played no part in even the sternest and most sacrificial secular vocation. The urgent pictorial problems Matisse faced in the autumn of 1897 posed at another level a human and personal dilemma, graphically illustrated by Vincent van Gogh, on the one hand, and John Peter Russell on the other. Van Gogh's attempts to live with other people—in particular his final scheme for setting up house in Arles with Gauguin—had always ended in catastrophe. By contrast, Russell's rock-solid marriage turned out to be more important even than his financial independence to his functioning as an artist.

Matisse took more than painting lessons on Belle-Ile, where he watched for the first time at first hand a painter working out a way of life dedicated solely to his art. The studio was the hub of all activity at Goulphar. Marianna Russell organised its daily running with apparently effortless ease, smoothing her husband's path, calming his outbursts, seeing to it that he was not distracted by his children. Russell, for all his forcefulness, depended absolutely on her unshakeable belief in him and in his work. "She is a treasure to me, all I could ask for and much more than I deserve," he wrote a few years after settling on Belle-Ile.87 They lived together for almost a quarter of a century, during which he painted steadily with little reference to, and virtually no support from, the outside world. Her death from cancer, at the age of forty-three in 1908, was a blow from which Russell never recovered. His house was sold, his canvases were scattered or destroyed, his children split up among relations and boarding schools in Australia and England.88 By the time he eventually brought himself to paint again, his work had lost a central impetus without which it faltered and petered out.

WHEN MATISSE LEFT Belle-Ile for the last time to be best man at the Fontaine wedding in Neuilly on 16 October 1897, he brought with him as his present to the groom a *Still Life with Apples*. He gave his next still life that autumn to the girl who had been the bride's maid of honour with the inscription: "To Mlle Amélie Parayre, 1897." The couple were placed next to one another at the marriage feast, which was a lavish and lively affair with wine flowing freely and the guests competing to see who could

catch and stow most bottles at his place beneath the table. By the end of the party Matisse had beaten all the rest. He never forgot the characteristically incisive gesture with which his neighbour stretched out her hand to him as she rose to go. He took the hand she offered, and whenever they met over the next few weeks, he presented Mlle Parayre with a bunch of violets. 90

For her part, she said long afterwards that she had sworn never to marry a redhead, or a man with a beard, let alone a painter, but that from the day they met she knew that she would break her vow in favour of Henri Matisse, who was all three. 91 She pressed the violets he gave her, and mounted them above her mantelshelf. It was Matisse's boldness that attracted her, the glint of devilry that overcame him all his life at moments when the lure of risk and danger compelled him to stake everything, both personally and professionally, on an uncertain future. She said ever afterwards that this first encounter hit her like a bolt from the blue. Each recognised and responded to the other at the deepest level. Matisse at this point was more isolated than he had ever been, infected by doubt and too continually uneasy to stand his own company for long. Beneath his tough exterior, he desperately needed someone to believe in him and—perhaps more important—in what he was doing. "Mademoiselle, I love you dearly," he declared, determined to avoid misunderstanding from the start, "but I shall always love painting more." 92 Nothing could have been better calculated to fire Amélie Parayre, who had spent much of her life searching for a cause in which she could put her faith.

She was twenty-five years old. Her nature was proud, impulsive and direct. Born in Toulouse in southwestern France, she had the dark good looks, the fire, dignity and reserve native to the women of her region. She also had a capacity for intense loyalty passed on by her mother, Catherine Parayre, who reminded Matisse of the black-eyed beauty in Corot's *Meditation* ("The portrait has her forehead, and her deep eyes"⁹³). Amélie and her younger sister Berthe had both inherited their mother's erect carriage, her firmly chiselled features and, even as girls, something of her regal presence: "All the women in that family looked like Spanish queens."⁹⁴ Matisse said he found Mlle Parayre absolutely ravishing. He was touched by the combination of shyness and stateliness in her bearing, and by "the mane of black hair which she put up in a charming style, especially at the nape of the neck. She had lovely breasts and very beautiful shoulders. She gave the impression, in spite of the fact that she was timid and reserved, of being a person of great goodness, power and sweetness."⁹⁵

She was also in her own eyes an adventurer and an idealist, proud of Corsair ancestry on her father's side, brought up in a Mediterranean fam-

ily with dramatic leanings and heroic expectations. "My sister is extremely courageous in time of crisis. All of us are in our family," wrote Berthe Parayre, adding in English: "We are a plucky people."96 The Parayres were an eloquent, witty and tempestuous clan who had migrated from Toulouse in a body to seek their fortunes in Paris when Amélie was a small child. Her father had been a schoolmaster in the village of Beauzelle, on the river Garonne just outside Toulouse, where she was born in 1872. She inherited from him her frankness and fearlessness together with her instinctive faith in radical innovation.

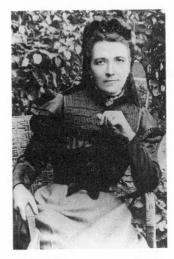

Catherine Parayre, Amélie's mother: "All those women looked like Spanish queens."

Armand Parayre belonged to an idealistic generation who saw education as a crucial factor in humanitarian reform. Conscripted straight from school into a crack foot regiment, the Chasseurs à Pied, he left the army to become a primary-school teacher in his early twenties, a volunteer in the educational shock troops sent out by the state to liberate the exploited and illiterate mass of French peasants and workers.⁹⁷ His obvious ability attracted the attention of the Republican député for Haute-Garonne, Gustave Humbert, a law professor at Toulouse University who was already increasingly involved in national politics. Humbert spent summers with his family in Beauzelle, where the young schoolmaster became his trusted disciple, and Latin tutor to his only son. Frédéric Humbert was fifteen years old in 1872, when Amélie was born. "Bravi feriae adventabunt [Hooray the holidays are coming]," he wrote that summer in a chatty Latin letter to his tutor from Versailles, where the parliamentary session was drawing to a close; "et ibimus primum Tolosam, et inde Vallicellam inventum dominum Parayrem, dominam Parayram, cum filiola suae [and we shall go first to Toulouse, then to Beauzelle to find M. Parayre, Mme Parayre and her little daughter]."98

All through the summers of Amélie's childhood in Beauzelle, her father and the ambitious local député met night after night in the Humberts' house beside the church to plot tactics for a political new dawn. These were heroic times for the Republican party, which fought titanic battles in the 1870s against monarchists, Bonapartists, congregationalists, opportunists, obscurantists and reactionaries of every stripe. Gustave Humbert was made a senator, or lifelong member of the parliamentary

THE UNKNOWN MATISSE

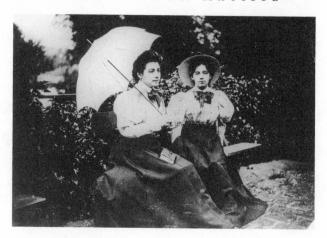

Amélie and Berthe Parayre

upper house, under the constitution of the Third Republic in 1875. He went on to hold the government's highest legal offices, eventually becoming Keeper of the Seals, or Minister of Justice, in 1882, at which point Parayre threw up his job and left for Paris in his master's train. Senator Humbert had impeccable Republican credentials. Son of a wine-merchant from Alsace-Lorraine who had been a volunteer in the Revolution of 1792, a veteran of the barricades himself in the glorious upheavals of 1848, he crowned his political career as Justice Minister by becoming one of the principal architects of the emergent Third Republic. Long after he left office, Senator Humbert was revered by the Left in France as an emblem of probity and disinterested endeavour. Contemporaries often made him sound more like a secular saint than a prince of the new Republican nobility. Humbert's vision of a free, equal and fraternal future remained ever afterwards the central inspiration of Armand Parayre's life. ¹⁰⁰

In 1882, the new Justice Minister's principal private secretary was his son, Frédéric Humbert, with Parayre still employed as his former pupil's chief adviser. The pair took over a radical campaigning newspaper based near Paris at Melun, L'Avenir de Seine et Marne, 101 through which Parayre masterminded the younger Humbert's election as a progressive left-wing député for Melun in 1885. Amélie was sent to boarding school in Melun, where for more than a decade her father was in his element as a crusading journalist. L'Avenir was one of a mass of proliferating political organs, like Georges Clemenceau's La Justice and Henri Rochefort's L'Intransigeant, hotly debating the democratic issues of the day—freedom of the press, the separation of church and state, the secularisation of schools, the empowerment of the thrusting middle and lower classes. Clemenceau himself was a

friend of Amélie's father, who knew and worked with many of the leading politicians of the day, from the popular Navy Minister, Camille Pelletan, to rising stars of the next generation like the young Socialist député Marcel Sembat.

From childhood on, Amélie
Parayre grew up surrounded by freedom fighters vowed to the cause of liberty, democracy and progress, perpetually
on the alert for treacherous new offensives

from the forces of reaction. In 1885, when she was thirteen, her father fought a duel in defence of press freedom against a right-wing journalist in Melun. ¹⁰² Parayre was permanently armed, like many citizens on the turbulent streets of Paris, and always quick on the draw with his revolver. He taught Amélie to shoot as well as to think for herself, to question authority, and never to follow orders blindly. Long afterwards she liked to tell the story of how, as a young conscript in the Chasseurs à Pied, Corporal Parayre was instructed to report for duty from Toulouse, in the southwest of France, to Vincennes, in the northeast, and confounded his superiors—in a regiment of famous marchers who bounded over the ground at prodigious speeds—by making the entire journey on foot. ¹⁰³

A keen reader of boys' adventure stories and romantic novels, Amélie flourished in an atmosphere of constant drama, lofty purpose and decisive action. Unlike her sister Berthe, who was from the start the quieter and more studious of the two girls, Amélie served her time at school in a state of simmering mutiny. One of her sharpest memories was of lying awake at night listening to the sentries patrolling the walls of the men's Central Prison in Melun, which was close enough for her to hear the tramp of feet and clink of arms. 104 Berthe, who had stayed behind in the south with her grandparents to attend the girls' lycée in Toulouse, went on to train as a teacher like her father, eventually becoming a pioneer in education for women in France. 105 Amélie, always the wild and reckless tearaway, defied her teachers in a series of confrontations over discipline which ended with her walking out for good at the age of sixteen in 1888. Having had her fill of lessons in deportment, social correctness and institutional conformity, she left school convinced that whatever destiny the future might hold, it would be worth waiting for. 106 The fate she dreaded above all was to be

Armand Parayre, Amélie's father, as a newspaper editor at Melun

THE UNKNOWN MATISSE

shut up for life within the stifling confines of a conventional bourgeois marriage.

She went home to her parents, whose marriage was a partnership of equals. If Amélie's father was Frédéric Humbert's mainstay, her mother fulfilled the same function for Frédéric's wife, Thérèse, a singular character in her own right who was now approaching the high point of a sensational career. Thérèse Humbert was heir to one of the greatest fortunes in France. She was also one of the most astute, extravagant and manipulative figures of the Third Republic. She kept considerable state in Paris, attended by a retinue of cabinet ministers, bankers and businessmen, as well as by leading members of the judiciary and the legal profession. The President of the Republic, Félix Faure, was a regular guest at her table. So were his two predecessors, Jean Casimir-Périer and Marie François Sadi-Carnot, together with a long line of prime ministers stretching back to Charles de Freycinet (whose cabinet had been distinguished by the appointment of Thérèse's father-in-law, Gustave Humbert, in 1882). The powerful prefect of the Paris police, Louis Lépine, and the leader of

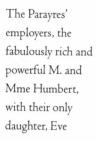

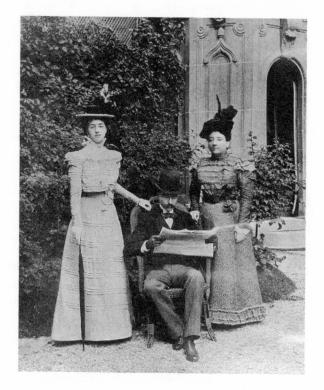

the Paris bar, Henri du Buit, were Mme Humbert's personal friends. ¹⁰⁷ From the late 1880s onwards, her goodwill was critical to "anyone seeking a place in the Republican sun," ¹⁰⁸ and the only access to her favours lay through her trusty second-in-command, Mme Parayre.

Amélie's mother presided over the gilded marble halls of the palatial Humbert mansion at 69 avenue de la Grande Armée (afterwards the headquarters of the Touring Club de France). She organised soirées, gala evenings and ceremonial dinner parties with a staff of twenty under her, and an annual budget said to amount to 200,000 francs. 109 The Parayres had their own private apartment in the house on the avenue de la Grande Armée, spending summers at the Humberts' château de Vives-Eaux, set in its own parkland with private lakes and hunting grounds in the forest of Fontainebleau. One of Armand Parayre's many titles was steward of Vives-Eaux, where he laid on hunting, shooting and riding parties for assorted Freycinets, Périers and Cunisset-Carnots. 110 Many of Amélie's relations on both sides of the family held key posts at the Humbert court. Her uncle Alexandre Parayre was steward of the Humberts' château de Celeyran, which stood in its own vineyards near Narbonne. A second, smaller estate, Orsonville near Melun, was run by another uncle, Jacques Boutiq (who had started his career by marrying Catherine Parayre's sister Noélie—Amélie's Aunt Nine—and succeeding Armand as schoolmaster at Beauzelle). A third uncle, Emile Thenier, was in charge of day-to-day administration at Vives-Eaux. III

All of them came initially from Toulouse. All belonged to the band of eager youths who had sat at the feet of "le bon Papa Humbert" in the 1870s and gone on to become his daughter-in-law's picked men. All prospered until a resurgence of conservative, monarchist and anti-Republican sentiment at the end of the 1880s brought a temporary slump in Humbert fortunes. In 1889 Frédéric Humbert lost his parliamentary seat to the archreactionary Comte de Greffuhle. Thérèse Humbert was twice threatened with a revolver in the next few years, first by the wife of a rival newspaper proprietor at Melun, then by a banker who blamed her for his impending bankruptcy and, having failed to kill her, went home to shoot himself. When L'Avenir folded in 1894 (the year after Clemenceau's La Justice), Parayre found himself unemployed with two marriageable daughters, aged twenty-two and eighteen, and no savings to fall back on. 113

Berthe took a job as a schoolteacher in 1895 in the village of Roquettes on the outskirts of Toulouse. It Amélie went to work for her Aunt Nine, who operated a successful business—the Grande Maison de Modes, sell-

ing wholesale and retail hats on the boulevard St-Denis—with nominal assistance from her husband, Jacques Boutiq, and from Armand Parayre's brother Alexandre. Tall, dark, handsome and imperious, Nine Boutiq combined the family's taste for high adventure (rumour said she had lost a fortune gambling on the horses) with its practical streak. Its She shared both aptitudes with her niece Amélie, a skilled needlewoman and embroiderer who now made and modelled hats for a clientele of fashionable Parisiennes.

The girls' father, who had neither found work nor received the compensation promised by his ex-employers, challenged Mme Humbert's brother and bodyguard, Romain Daurignac, to a duel. 117 They fought at Parayre's insistence with bare fists by English boxing rules until Daurignac-who was a notorious bully and fourteen years younger than his opponent-admitted himself beaten. Parayre next set sail at the age of fifty-one for Madagascar, newly appropriated by the French and already seething in a state of incipient revolt. He arrived in February 1896 to start work as an educator in the wake of the new governor, Hippolyte Laroche, another progressive député for Haute-Garonne who had been appointed to bring peace and French civilisation to the island. But the high hopes of the liberal contingent came to nothing. Laroche was replaced by a military commander, and Parayre had to be shipped home after barely three months on the island on account of his outspoken criticisms of the army's brutal methods of repression. II8 Pluck, as his daughter Berthe observed, was a family strong point. 119

Reinstated on his return from Madagascar as the Humberts' general factotum, Parayre himself defined his functions as those of "secretary, steward, administrator of the Rente Viagère and racing captain of the yacht." The yacht was *Le Lévrier*, Frédéric Humbert's pride and joy, moored below the château at Vives-Eaux on a system of private lakes and waterways descending to the Seine. The Rente Viagère was a savings bank, founded by the Humberts in 1893 and handed over four years later to Armand Parayre to run with a board consisting of his brother Alexandre and his two brothers-in-law, Jacques Boutiq and Emile Thenier. Il In 1898, the year after this sudden change of fortune, Berthe Parayre gave up her job as a village schoolmistress to enter the prestigious Ecole Normale Supérieure at Fontenay-les-Roses. Amélie Parayre married Henri Matisse.

The wedding took place on 10 January 1898, less than three months after the couple had first met. Henri marked the day in his pocket diary: "Vive la Liberté!" Amélie's wedding outfit came from Mme Humbert's

own dressmaker, Maison Worth, and the ceremony took place in the society church of St-Honoré-d'Eylau. 124 This was the Humberts' parish church, a bang up-to-date cast-iron structure in the Byzantine style with sumptuous decorations in polychrome and gold. It stood round the corner from their house on the avenue de la Grande Armée, which was itself an extension of the Champs-Elysées in the district radiating out from the Arc de Triomphe where the wealthy new industrialists and entrepreneurs of Baron Haussmann's Paris vied with one another in displays of conspicuous consumption. Matisse's new in-laws moved in circles quite unlike anything he or his painter friends had known before. Nothing could have gone down better in Bohain or Le Cateau. Henri's marriage witnesses were his two most prosperous and presentable relations, his uncle Emile Gérard and his father's cousin Jules Saulnier. Amélie's were Frédéric Humbert himself, and a close colleague from his days at the Ministry of Justice, Etienne Jacquin, councillor of state and secretary-general of the Légion d'Honneur.

A week later, on 18 January, the couple left Paris for London, travelling by train, Channel steamer and boat train to Charing Cross Station (Matisse made a note to remind himself to pronounce it "Tsharing"). They stayed at the Hôtel de Paris in Leicester Square ("Lesteur Squère"), opposite the back entrance of the National Gallery. They had picked their honeymoon destination expressly to take in the paintings of J. M. W. Turner, revered as a forerunner by both Russell and Pissarro. The new Mme Matisse began as she meant to go on, keeping faith with a family of visionaries who had passed on to her their belief in a glorious future to be achieved by hard work, dedication and self-sacrifice. Painting had played no part in her life up to this point, but Matisse's view of his vocation supplied the austere and exalted vision she had craved from girlhood. "I didn't know much about what he was doing," she said long afterwards, "but I knew that whatever he did could only be good." 127

The couple stayed two weeks in London, visiting the Victoria and Albert Museum as well as the National Gallery, which was so dimly lit that sometimes Matisse could barely make out the Turners he had come to see. ¹²⁸ Even, or perhaps especially in this wintry light, they dazzled him as they had a whole procession of Frenchmen making the same cross-Channel pilgrimage, starting with Monet and Pissarro a quarter of a century earlier. Turner had become an essential point of reference in Paris for the makers of modern art, and indeed for its opponents, like Moreau's celebrated supporter, the Symbolist J.-K. Huysmans:

Turner is stupefying at first sight. You find yourself confronting an absolute mishmash of pink and burnt sienna, of blue and white, rubbed with a rag, sometimes smeared round and round, sometimes dragged out in straight lines or forking in long zigzags.... It's like that in close-up... and from a distance, all is harmony. Before your disaffected eyes emerges a miraculous landscape, a fairy-tale scene, a radiant river flowing in iridescent sunlight. A pale sky stretches out of sight, lost in mother-of-pearl horizons, reflected in and merging with waters shimmering like soap bubbles in all the colours of the spectrum. Where do they come from . . . these wild burning clarities, these streams of daylight refracted in milky clouds, stained with red fire and streaked with violet, as if on a ground of precious opals? And yet these scenes are real: autumn landscapes, rust-coloured woods, running water, tall dishevelled forests: landscapes made volatile, dawns in an open sky: these are the sky and river festivals of nature sublimated, stripped down, rendered completely fluid by a great poet.129

For Matisse, as for Huysmans, Turner was a link between the present and the past, a way of reconciling the traditional realism of his native North with the lure of pure colour which already beckoned him so fiercely. He described Turner's impact nearly fifty years later, at a moment when his own recovery from a near-fatal operation had made the world once again look fresh and sparkling. It is Matisse's most brilliant evocation in words of a window opening on a new world, a period of radiant bliss after unhappiness and self-denial: "It is always a good thing to begin with renunciation, to impose a regime of abstinence on yourself from time to time. Turner lived in a cellar. Once a week he had the shutters suddenly flung open, and then what incandescence! what dazzlement! what jewels!" 130

Matisse spoke fondly ever afterwards of the city where he spent his honeymoon. After a fortnight the couple returned briefly to Paris before catching the train again to Amélie's native south, where they spent the next eighteen months. They sailed from Marseilles on 8 February for Corsica, ¹³¹ leaving the island in midsummer to visit Amélie's relations in Toulouse. Matisse now had a wife as capable, strong-minded and unconditionally loyal as Marianna Russell. He never returned to Belle-Ile, and never worked again in Moreau's studio. From now on he looked back with patronising pity to the timid Louvre copyist who had scarcely set foot,

1897-1898: PARIS, BELLE-ILE AND LONDON

either geographically or culturally, outside northern France. In Corsica in 1898 he painted the Mediterranean spring as Russell and van Gogh had done before him, launched at last on a course the Dutchman himself had foreseen ten years before, when he declared his belief that a new school of colourists would arise in the south: "The painter of the future will be such a colourist as has never yet been seen." ¹³²

CHAPTER SIX

1898–1899: Ajaccio and Toulouse

Gaston Vuillier. The Bay of Ajaccio: where Matisse first encountered the marvel of the south. The Villa de la Rocca (circled), where the Matisses stayed, stands between the large white Hospice Eugénie to the right and the old mill. which he painted with its factory chimney, on the left.

The steamer reached Ajaccio on the morning of Wednesday, 9 February, in brilliant sunshine. "The sea, powerfully blue and motionless as if set, as if hardened by the blazing light of the sun, stretched away beneath an infinite, almost exaggeratedly blue sky...," wrote Guy de Maupassant in his first novel, describing another young cou-

ple who made the long journey from the north by train and boat to start married life in Ajaccio. "At last they saw several pyramid-shaped rocks which the vessel soon rounded to enter a vast, calm bay, surrounded by a mass of high peaks. . . . As they advanced, the circle of mountains seemed to close up again behind the boat which swam slowly in an azure lake so transparent that at times you could see the bottom. And suddenly the town appeared, all white, in the depths of the gulf, on the edge of the waters, at the foot of the mountains." I Matisse said it was in Ajaccio that he first encountered the marvel of the south, and that he owed its discovery to his wife.

They were setting out together at her insistence on a life of stern and single-minded dedication to a cause whose worth neither ever doubted, then or later. But it was typical of Amélie that she chose to start her new life of renunciation and self-sacrifice in Ajaccio, where the heroine of Maupassant's *Une Vie* also embarked with the noblest aspirations on what turned out to be one of the most rapturously sensual honeymoons in literature. "Painting, even supposing it had been academic painting, could barely provide a living in those days. I was going to be forced to take up some other job," said Matisse, always the more prudent and level-headed of the two. "I decided to give myself a year off, without impediments, in which I would paint as I wanted to. I no longer worked for anyone but myself. I was saved."

If he had chosen it himself, he could hardly have picked a better spot for isolation and experiment. Ajaccio was a colonial outpost with no particular interest in or knowledge of art and, unlike Brittany, no tradition of visiting painters. Its first regular visitors from the outside were the hardy English followers of a doughty Scotswoman called Thomasina Campbell—"our very own Lord Brougham," the local paper fondly called her⁴—who had opened up the town in the 1870s much as wealthier and more fashionable Britons had already transformed Nice and Menton. Ajaccio by the late 1890s offered the elementary amenities of a cut-price Riviera. Life was simple, spartan and cheap ("a person can live, that is live as a gentleman," wrote one of Miss Campbell's English followers, "on half, or perhaps a third, of the income that would be regarded as a necessity by a gentleman at home"). The food was basic, comfort unheard of, and the spring climate as chancy as an English June, but the vegetation was subtropical and the scenery universally agreed to be stupendous.

Matisse maintained long afterwards that Corsica itself had taken him by surprise. "When he spoke of it, his eyes shone," said Marie-Dominique Roche, a native of Ajaccio who became the recipient, as a young museum curator in Nice, of Matisse's memories of the island. "He was truly moved. It had counted for much in his life. He hadn't come for the sake of either art or nature. He came in order to get away, to make a clean break. He found something he wasn't looking for. He said: 'And when I think of what I found! [Et qu'est-ce que j'ai découvert!]' "6 The five months or so that Matisse spent in Corsica came to seem to him in retrospect another of the pivotal points on which his whole life turned. He found himself jolted out of ways not only of seeing but also of thinking and feeling that had been second nature until now.

He was permanently affected by the clear southern light, so different from the cloudy, vaporous atmosphere that had conditioned him as a painter in Bohain, Paris and Brittany. On a human level, he was amazed by the Corsicans themselves. "That was his greatest shock," said Mlle Roche. "He discovered a whole new world of people of whom he knew nothing, and whose temperament intrigued him." They seemed astonishingly straightforward to a northerner born and bred in the teeming, grasping, overpopulated and furiously competitive world of industrial exploitation, where people habitually fenced themselves in and others out. Any concept of fencing was missing on the island. Beneath a skin-deep layer of French colonial bureaucracy, the Corsicans still belonged to an ancient, pastoral, largely pre-agrarian society where culture was essentially oral, and where money played as yet a minor part. Matisse liked their simplicity, their fierce directness, the sense of liberty they gave him in a place where there was no need to lock your door, or to ask permission before exploring the private gardens full of peach and pomegranate trees on the sunny sheltered slopes beyond the town. He responded above all to the generosity of a people who had virtually nothing to give but gave what little they had freely. He said he understood for the first time the saying "hospitable as a Corsican."

Other people before and since have prized the aesthetic quality of a way of life in some ways unchanged since the time of the Greeks and Romans. The broad avenues of Ajaccio—superimposed on the close-packed old town by Napoleon's decree in order to give it a classical new look more appropriate to an imperial birthplace—still ended abruptly, after at most two hundred yards, in the mountains or the sea. Shepherds still drove their flocks up the mountainside in spring. Fishermen sat down on the town's foreshore to mend nets slung between hand and toe. Women from the mountain villages laid out their wares on the ground: baskets of oranges, dried figs and apricots, jars of oil and honey, goat cheeses and packets of homegrown tobacco. Matisse encountered none of the wariness or suspicion other visitors reported in the inhabitants of Ajaccio,

who habitually treated French and English alike with polite reserve. Romantic legends of bandits and outlaws had been publicly confirmed by writers like Maupassant and Prosper Mérimée, to whom the Corsicans seemed as sombre, harsh and violent as their landscape. But Matisse, who had himself felt outlawed and rejected in the North, found acceptance in the south.

"He was seduced by that. He felt himself at home everywhere," said Mlle Roche. "The Corsicans appealed to him. They were the opposite of all those people who turn their backs on you. Everyone felt at home, even in someone else's house. That was what struck him." His sense of being made welcome reflected his own well-being that spring, and both owed much to a wife who was herself at home in the south. Amélie throve among a Mediterranean people whose pride, touchiness and passionate commitment matched her own. Matisse found in her company on her native ground a sense of liberation, an access of vigour and energy, a release from the restraints and coercions that had hemmed him in all his life both as a man and as a painter. In Corsica he and Amélie established a basic pattern that would barely change throughout their working lives together: a routine of work, rest, walks and modelling sessions into which she fitted the day-to-day practical running of her household whenever she had time or energy to spare. This was for both a period of conscious preparation. Both spoke of it afterwards with a high, almost Napoleonic sense of destiny.

After a few days in a hotel, they found lodgings in a villa just below Napoleon's Grotto, a rocky cave on the western outskirts of Ajaccio where the future emperor was said to have brooded as a boy on his own destiny. Theirs was the newest and last house in the "foreign quarter" established by Miss Campbell beyond the old town on wild scrubland, or maquis: the dense, prickly, aromatic mat of flowering arbutus, myrtle, broom, lavender, rosemary and rockroses that covered the island. For forty francs a month the Matisses rented two furnished rooms below the roof in the Villa de la Rocca, a capacious property built expressly for holidaymakers in the modern seaside style with roof terraces, turrets and a big bay window.8 The Matisses' tiny living room-cum-kitchen gave access by a tower stairway to a flat roof above the bay. Here Henri set up his easel to paint the nearest building (which was the local hospital) rather than the picturesque prospect looking westwards from his terrace, a view "infinitely more beautiful than from the environs of any town on the continent" according to the complacent Miss Campbell, who recommended February above all for spring blossom. "At Ajaccio the delicate pale pink flowers on

The Villa de la Rocca (on the left), where the Matisses spent their honeymoon

the leafless almond trees are succeeded by the masses of brilliant pink bloom of the peaches...."9

The Matisses' villa stood alone on a track running down through open scrub to the sea (now the southern intersection of the avenue Sylvestre Marcaggi and the rue Miss Campbell). Between it and the old town lay the hotels, newly built or still under construction, and several older, grander villas, including the four original "cottages" put up by Miss Campbell, whose own Tour d'Albion dominated the higher ground on the opposite side of the track. The whole area was bisected by the long, straight Cours Grandval, running uphill from the old town, past the English church and the teacher-training school for girls (Amélie's sister Berthe would become head of this institution in 1911), to the Napoleonic grotto below the wood where the English took their walks. The Villa de la Rocca combined easy access to the town with privacy and peace, all essential factors in the pattern the Matisses would re-create afterwards with minor variations wherever they went.

Ajaccio itself offered few distractions. Tourists generally reckoned a day or two sufficient to take in its two handsome palm-shaded squares, its single central shopping street, and its imposing statue of Napoleon flanked by his four brothers staring out to sea in togas. Two days after the Matisses' arrival, their landlord put on a pottery exhibition to entertain visitors on the ground floor of the Villa de la Rocca. Otherwise the town offered visitors a small library, an unremarkable cathedral, and the Fesch Museum, which housed a fine collection of Italian primitive paint-

ings, left behind as hopelessly unfashionable when Joseph Bonaparte plundered the Fesch holdings in the 1840s. Matisse was shocked to find the collection more or less abandoned with canvases coated in dust and grime, many of them stacked against the walls, many more missing altogether. The museum opened briefly twice weekly during the lunch hour. Otherwise the high spots of the week were the arrival of the packet boat from Marseilles twice a week, and a concert by the town band on Sunday afternoons, for all of which the entire population turned out. Matisse was struck both by the musicality of the Corsicans, who celebrated every event from birth to death with songs, and by the profound melancholy of their

singing. 12

Most travellers hired carriages or tough little island ponies to explore the spectacular coast and mountain scenery, but throughout their time on the island, the Matisses barely seem to have strayed beyond an area within easy walking distance of the Villa de la Rocca. They walked up the hill to the smallest and prettiest of Miss Campbell's holiday homes, La Maisonette (which Matisse painted), near Napoleon's Grotto. But mostly they walked along the coast road below their lodgings, bounded on one side by rocks and sea, on the other by luxuriant gardens laid out by the town's landowners, looking westwards towards the Iles Sanguinaires (supposedly so called because the setting sun stained their granite peaks blood red). "It is an Oriental fairyland that ravishes the spirit," wrote a local journalist, justly proud of the Route des Sanguinaires, which particularly impressed Matisse: "It would be impossible to imagine anything lovelier than this gently winding road which unrolls, at the foot of its green slopes, enticing and mysterious, dappled with light and shade, amid the scents of flowers, fruit and the maquis.... Lit by the first fires of dawn, still ablaze in the evening with the rays of the dying sun, it offers the dazzled eye a sublime panorama, showing the rocky outcrops of the Iles Sanguinaires in all the brilliance of their outline, their colouring and their savage poetry."13

This was a favourite evening promenade for the citizens of Ajaccio, who came to watch the sun go down behind the islands from vantage points like the little Chapel of the Greeks or, a mile or so further on, the chalet called Scudo, or le Scoud, which Matisse painted. He also recalled walks in the opposite direction, following the eastern curve of the bay past the saltworks to the newly built railway station, along a road lined with the scarlet and yellow flowers of the Barbary fig, or prickly pear. "For him it was the Orient," said Mlle Roche. This was the first time Matisse encountered the prickly pears, the palm trees and cactuses, the spiky

clumps of aloe and agave that would suit his decorative purposes admirably later, but for the moment he was no more interested in exotic plants than in the sea or the savage poetry of the scenery. He had brought with him two wooden crates packed with small- to medium-sized blank canvases, ¹⁴ and in just over five months on the island, he produced fifty-five paintings, nearly all done in or near his lodgings.

He painted the bedroom with his jacket hanging from the bedpost, his hat tossed down on the narrow wooden bedstead and a single canvas propped against the bare wall, as if to underline his stern devotion to his purpose. He painted still lifes in the little kitchen, where the usual subjects (including a characteristic pot-bellied, hoop-handled, short-spouted Corsican pot) started to decompose and discolour exactly as Moreau had predicted. He painted a delicate, impetuous, pink and green Peach Tree in Bloom 15 which suggests that if he hadn't seen van Gogh's paintings of Mediterranean spring blossoms, he had certainly seen Russell's. He painted a single sunset, a burst of explosive lemon yellow on a pinkstreaked green sky that clearly owes something to van Gogh and still more to Turner. But the approach is the opposite of the cool analytical enquiry in his Louvre studies. This is the work of a man emerging from a cellar, a man in the grip of the kind of urgent, instinctive, almost animal uprush of feeling Matisse described when he first held his mother's paint-box in his hands. He painted light, warmth, colour itself-van Gogh's rich, iridescent envelope—rather than the picturesque or scenic aspects of the island. "Soon there came to me, like a revelation, the love of materials for their own sake," he said, describing this year of liberty: "I felt growing within me a passion for colour."16

The passion can be seen growing in the three paintings he made of his wife in the first year of their marriage, beginning with a back view and gradually turning her to face him as his style became looser, less representational and more impressionistic. Amélie posed for him for the first time in a purple heliotrope-coloured dress with her hair pinned up, in the way he found so charming, with a big blond tortoiseshell comb. In this most conventional of the three canvases, she sits reading with her back turned and a still life laid out on a table to her left, in much the same arrangement as Camille had presided over two years earlier. In the next canvas she is seated sideways, sewing in profile at the kitchen table of the Villa de la Rocca: the dabs of pale blue and reddish pink which indicate her apron, or the sewing in her lap, intermingle in an unruly patchwork of brushstrokes with the pinky reds, yellows and blues on the tabletop (Matisse scholars have frequently mistaken this tabletop for a child's cradle, which

only goes to show how far the artist had already freed form and colour from their traditional realistic role). The Invalid (colour fig. 7) which was completed in January 1899 after the couple had left the island for Toulouse. Here Amélie lies in bed, reclining full face on her pillows, unrecognisable and off-centre, but unmistakably the focal point in a composition of glowing, semiliberated colours enveloping both the figure in the bed and the room itself, with its draperies and hangings, its padded orange chair, the bright shadows on the white cloth covering the bedside table, and the dabs of pink, deep blue, orange, yellow and green that might be a workbox or a rug at the right on the bottom of the canvas.

Matisse painted the view from his windows in the Villa de la Rocca, and from the terrace overlooking the only other building on this wild stretch of maquis. This was the Hospice Eugénie, the town's hospitalcum-almshouse standing in a clump of cypresses lower down the hill beside the sea. Matisse painted it five times, returning again and again to its red-tiled roof and its long whitewashed garden wall, which turned pink, blue and violet on his canvas. But he found his favourite motifs in the garden of the old mill, a few minutes' walk from the Villa de la Rocca across the maquis to the southwest. The garden was part of a great park owned by the président du Tribunal, Dominique Cuneo d'Ornano, a member of one of the four or five oldest families in Ajaccio, whose olive groves stretched from the Bois des Anglais at the top of the Cours Grandval to the sea below. The mill itself (demolished to make way for development in the 1930s on a site between what is now the boulevard Mme Mère and the boulevard Pugliesi Conti) was a traditional horse-driven olive press, a two-storey stone structure standing in a walled courtyard on a little knoll. Beside it was a factory chimney, one of the first in Ajaccio, belonging to a far more up-to-date coal-fired processing plant which employed fifteen workers in the manufacture of oil cake. The chimney (which belched fumes) figures in contemporary photographs, and in more than one of Matisse's paintings. 18

The park, open to all comers, contained groves of orange and mandarin, flowering orchards of peach, nectarine and almond, palm trees and shady alleys of ancient olives, as well as parterres and formal flower-beds. The Matisses must have spent many hours in this garden establishing what became another regular pattern, whereby he worked while she watched, sewed or meditated at his side. Alphonse Daudet described spending dreamy, dozy afternoons lapped by the swell and murmur of the bay a mile or so along the coast in another perfumed garden called Barbicaja:

"Above my head the orange trees, simultaneously in flower and fruit, burned their perfumed essences. From time to time a ripe orange, suddenly parting company with its branch, fell near me with a dull thud, producing no echo from the soft earth. They were superb fruits, reddish purple inside. Their taste seemed to me exquisite, and then the view of the horizon was so fine! Between the leaves the sea made spaces of dazzling blue like fragments of broken glass that glittered in the hazy air." ¹⁹

Matisse painted the gardens of the old mill—the building itself with its courtyard, its arched gateway, stone steps and open door, as well as the neighbouring chimney, the palm trees, the raked gravel and neatly tended flower-beds—at least fourteen times, probably more, since many of the olive trees he painted grew in these sheltered grounds. He explained to the collector Pierre Lévy more than forty years later that Fauvism had come initially from Corsica, especially from the Iles Sanguinaires: "It was there that he felt the first shock of what would become Fauvism, he told me so himself."²⁰ The shock erupted not in paintings of sunlit peaks or glittering blue sea, but rather in a dozen or more studies of the twisted, gnarled, grey olive trees, some as much as a century old, that grew in the ancient groves around the mill.

At some point during or soon after his year away from Paris, Matisse read and pondered on the preface to Maupassant's Pierre et Jean, in which the novelist expounds a theory of artistic originality based on lessons he had learned as a young man from Gustave Flaubert. Maupassant insisted that the artist must work solely from his own observation "without bias, without preconceived opinions, without academic ideas, with no allegiance whatsoever to any artistic group."21 Much of his argument served as a blueprint for the ideas Matisse himself developed, sometimes in almost the same words, in 1908 in his own "Notes of a Painter." Maupassant repudiated all attempts to correct or modify the artistic impulse according to established rules. Individual temperament and its expression were the sole sources of originality. "If you have any originality, he [Flaubert] said, it will have to be disentangled; if you have none, it will have to be acquired."22 Genuine originality could be achieved only by a patient, passionate, unremitting work schedule for which Maupassant gave practical instructions, including subjects for the young artist to practise on. Matisse said that he became obsessed with Maupassant's advice about capturing the essence of a cabman on the street (advice he put into practice on his return to Paris), and by this passage about fire and trees:

What you have to do is look at what you wish to express long enough and with enough attention to discover an aspect of it that has never been seen or described by anyone before. There is something unexplored in everything, because we have grown used to letting our eyes be conditioned by the memory of what others have thought before us about whatever we are looking at... To describe a blazing fire and a tree on a plain, we must stay put in front of that fire and that tree until for us they no longer resemble any other tree or any other fire. That is the way in which you will become original.²³

The motif to which Matisse returned more often than to any other on the island was a single olive tree, or group of trees, on a flat patch of ground: again and again his trees caught fire in a blaze of colour, becoming sometimes almost incandescent beneath his prodding, probing brushstrokes (colour fig. 8). This was the battle he began to fight alone and in seclusion on the island, the heroic battle which Turner and van Gogh had fought before him: the struggle to rid himself of even the memory of other people's ways of looking.

Most visitors to Corsica in the nineteenth century were astonished by the brilliance and variety of its colours, the almost spiritual purity and intensity of its light. "The sun which glitters on the foliage... takes on the iridescence of the mystical, fugitive, visionary colours of ancient stained-glass windows," wrote the engraver Gaston Vuillier.24 The island had been brilliantly captured by writers like Maupassant and Prosper Mérimée, by artists like Vuillier himself, and by Miss Campbell's friend Edward Lear (also, for that matter, by Whistler's friend Jean-François Peraldi, the keeper of the Fesch Museum, the state of which had horrified Matisse). But no one, not even Maupassant, saw what Matisse saw. Today, when time has long since accommodated the fundamental shift in perception brought about by Matisse and his peers, what he saw seems selfevident. The shift felt more like a dislocation or a fracture a century ago. Two English ladies, who rented a villa in the late 1860s on the same westfacing slopes as Matisse, described the view from their balcony at nightfall in terms of a high Victorian landscape painting:

On a fine clear evening the western hill stood out, dark and brown against a golden sky, while the mountains to the east were lighted up with tints of orange, yellow, blue, and at last deep crimson.

This glow would last for some minutes, the windows in the town being all illuminated, the sea reflecting every tint, and the whole landscape being one blaze of warm colour. Then the mountains would rapidly change to purple.... The beauty of these sunsets, which we witnessed day after day, cannot be described, and only those who are familiar with the bright colouring of southern skies can duly understand or conceive of them.²⁵

Nearly a hundred years later, another English lady, landing at Ajaccio in 1948, described another Corsican sunset according to a completely different set of painterly perceptions. This was the island's future historian, perhaps the subtlest and most perceptive of all its chroniclers, Dorothy Carrington, who combined a natural eye for landscape with the sophisticated, post-Fauve, Matisse-trained visual imagination of her English generation:

The sun was sinking as I toiled up the pinnacle.... And now all this world was being flooded with golden light, a light so laden with glittering particles that I felt it must surely lie heavy in my hand. Yet it was not a mist, confusing outlines; on the contrary, its action was to clarify.... The maquis, which all day long had looked tediously uniform, was now fragmented into gleaming tufts of vegetation growing from wells of shade; bushes assumed the dignity of forest trees. Colours, too, were transformed: grey rock turned pink and orange, slashed with deep sea blue; the stately peaks...soared, crimson, between vertical violet chasms. All that was normally dull and indefinite had become sharp, brilliant and solid: the change was not only of colour but of consistency.²⁶

In the spring of 1898, and for many years to come, Matisse's Corsican paintings were too disturbing to be shown to his contemporaries except in private. Evenepoel wrote reproachfully that they looked as if they had been done through gritted teeth: sketchy, crude, affected, wilfully extravagant, in short a shocking waste of a great talent ("The thing is that I consider you to be, of all of us, the most sensitive eye I know"). Matisse had posted him a package from the island containing two oil studies of flowering trees, a "man at the door," and what sounds like an early draft for *The Invalid*. Evenepoel said that this last made him feel old and irredeemably bourgeois ("Yes, I know you have to stand back seven or eight metres! Yes, but my studio is only five metres long, and all I can see is the tablecloth

with emerald green reflections, and a human figure green one side, and red the other, as if lit up by the glass bottles in a chemist's window!!"). ²⁸ It had taken Evenepoel a week to recover sufficiently from the shock of opening the parcel to be able to write calmly to his friend. But like many others after him, he found himself grudgingly forced to admit that, for all its absurd and primitive regression, Matisse's painting somehow managed to kill everything else in the vicinity stone-dead. "My bits of stuff, my ornaments, everything became grey, grey and neutral beside it! Your study struck the deep notes, sonorous and brilliant, of a resplendent stained-glass window!!" ²⁹

Matisse responded to this letter, dated 6 June 1898, by taking the train himself to Paris with a further batch of Corsican paintings. He had business to attend to, and no doubt he wanted to catch up with the Paris shows (Pissarro was showing at Durand-Ruel that June, and Monet at Georges Petit). He was also missing his friends as much as they missed him. He had left Paris without telling anyone about his precipitate courtship and marriage. Neither Marquet nor Evenepoel had yet met the new Mme Matisse. Evenepoel wrote wistfully as soon as he got back from his Algerian exile in May, begging Henri to intercede with her "so that she may take pity on your poor friends here in gloomy Paris, who would so much like to shake your hand!"30 Matisse needed to drum up funds, but more even than money, he needed reassurance and relief from a growing sense of disorientation. He said that after a few months he began to feel bored and lost in Corsica.³¹ He would report the same reaction on first reaching Morocco in 1911, Nice in 1916, and Tahiti in 1930: on each occasion a realignment taking place at the deepest level of his imagination filled his conscious mind with unease and foreboding. In Ajaccio in 1898, Matisse desperately needed a response to paintings that he warned Evenepoel in advance would strike him as "epileptic."32

Sure enough, the new work looked to Evenepoel as if it had been "painted by a mad and epileptic Impressionist!!" He felt that Matisse's career was over before it had properly begun ("It's crazy, he had such charming qualities as a painter!!"). His dismay echoed the remonstrances of Gustave Moreau, who had died in April while both Matisse and Evenepoel were out of Paris. There was now no older mentor to whom Matisse could turn apart from Pissarro, who was briefly in town for his show but who still scarcely knew his young admirer (he had used the Flemish form of his name—"Mathis"—when he wrote to Corsica in March to ask if he could rent the studio at 19 quai St-Michel for his son Georges). But not everyone was as despairing as Evenepoel. Matisse gave

two of his boldest studies of olive trees to Marquet, and a third to Jules Flandrin and his girlfriend, Jacqueline Marval, who was also a painter. Flandrin was so carried away by these Corsican canvases ("They were a real pleasure to see. They're so far from the picture-factories producing for the Salons")³⁵ that he did his best to reproduce their light in his own land-scapes that summer.

Matisse gave two more landscapes to Léon Vassaux, who hung one of them—*The Courtyard of the Old Mill*—over his bed so that he would see it first thing each morning when he opened his eyes. The other was a pathway lined with olive trees which Vassaux treasured to the end of his life, confessing as an old man to Matisse that he could never find the courage to part with it.³⁶ Matisse also had a visit from Père Thénard, the retired dairy wholesaler who had bought one of the still-life studies for *The Dinner Table* in 1896, and who had been made to suffer for it ever since by critical friends and relations. Thénard, whose taste often outran his courage, liked *The Invalid* but refused to buy it, even though Matisse offered to let it go for only 125 francs: "If I took it home, they'd have me up before a family tribunal!"³⁷

Matisse himself was reluctantly seduced that summer by a collection of exotic butterflies on display in the window of a postcard merchant opposite the Louvre on the rue de Rivoli. The butterflies, mounted behind glass on a plaster backing, included one with wings of the same blue as the sulphur flame with which he had first tried to create Mediterranean light as a schoolboy in his toy theatre in Bohain. Matisse gave a comical account of how his iron determination not to waste his money on anything so futile was undermined by this butterfly ("blue, but such a blue! It pierced my heart") for which, in spite of his best efforts at resistance, he paid fifty francs he could ill afford, salving his conscience by including it among the presents he brought back from Paris for his wife. 38 This was precisely the kind of daredevilry Amélie could never resist in her husband. The story of the blue butterfly became a family legend, standing for all the risks the pair had taken together when young. Jean Puy, who met the Matisses for the first time in 1900, was enchanted both by the butterfly itself and by their account of how they came by it.39

VISITORS TO CORSICA seldom stayed beyond midsummer, when the flowers faded and the island lay parched and scorched beneath the sun. Amélie was four months pregnant by the time the Matisses left in July⁴⁰ to spend the next six months visiting her relations in and around Toulouse. Her paternal grandfather was a merchant, Paul Parayre. His wife, Pauline

1898-1899: AJACCIO AND TOULOUSE

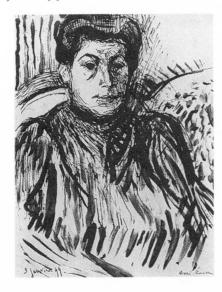

Matisse, Mme Matisse, 1899: drawn a few days before the birth of her son Jean

Pinson, counted among her ancestors the Pinson brothers, local heroes whose buccaneering exploits greatly appealed to Amélie. ⁴¹ Her other grandfather, Guillaume Fuzié, had worked as a bailiff in the village of Aussonne near Beauzelle, where she was born, nine or ten miles north of the city. Beauzelle itself was little more than a hamlet on a steep bluff above flat, fertile water meadows, which were cultivated by the villagers as market gardens and regularly flooded by the beautiful, swift and dangerous river Garonne.

Matisse swam (and once very nearly drowned)⁴² in the clear waters of the Garonne, threaded with whirlpools, running over treacherous, shifting

Vincent van Gogh, The Old Peasant, Patience Escalier, 1888: another of the drawings owned by Matisse

gravel banks and collecting in les Gourgues, great fishy pools shaded by majestic screens of poplar planted along the banks. He made bold, rapid, sometimes almost abstract colour sketches of the Gourgues that summer, rhyming the poplars with their reflections in confident homage to Monet. His drawings of his wife, and of the landscape round Toulouse, continued his vigorous dialogue with van Gogh. The name of Parayre carried great weight in both places, as well as in Toulouse, on account of the family connection with the Humberts, who, in this part of the highly politicised, radical south, supplied the nearest equivalent to a local aristocracy. The tomb of Senator Humbert, who had died in 1894, dominated the churchyard in Beauzelle. He was the first, and for a long time the only, celebrity the village had ever known, but even his prestige had been eclipsed by the fame of his daughter-in-law, Frédéric's wife, Thérèse Humbert.

The whole region was mesmerised by Mme Humbert, whom the villagers remembered as a simple local girl long before her spectacular transformation into a power in the land. Everyone had a tale to tell about "La Grande Thérèse," who was born Thérèse Daurignac in Aussonne in 1856. Her father was the self-styled lord of the manor, Guillaume Daurignac, a mysterious character generally regarded by the peasants as a necromancer or wizard. He was in fact a bastard—son of a priest and the wife of a Toulouse clock-maker—who had grown up nameless and unacknowledged, only later calling himself Daurignac (and, later still, the Comte d'Aurignac).43 The local people believed he had the power of prophecy as well as the ability to bewitch enemies, cast spells and call down thunderstorms to spoil their crops.⁴⁴ His wife, herself the illegitimate child of a wealthy farmer who set her up in a smart lingerie shop in Toulouse, died suddenly in 1867, when her eldest child Thérèse was eleven years old. 45 The Daurignacs, who had never been well off, hovered ever afterwards on the brink of bankruptcy. At the time of her mother's death, Thérèse started to talk of fabulous secrets, a locked coffer and a mysterious heritage.46

Stories began to circulate about her, at first in the surrounding villages, soon spreading to Toulouse. She galvanised the whole countryside with her strange history and wild escapades. Never beautiful, Thérèse had a neat figure when young, together with an air of naïve candour and a husky, hesitant lisp that people found irresistible. From the start she could wind anyone round her little finger. "You would have given her the good Lord without hearing her confession" was a local saying. The bailiff's daughter in Aussonne, Catherine Fuzié, was one of the first to fall under

the spell of this miraculous child, whose fantastic dreams and projects conjured up a richer, ampler and more stimulating world than anything on offer in Aussonne or Beauzelle. Catherine was eight years older than the motherless Thérèse. For the next forty years their relationship was conditioned by the older girl's desire to look after and protect the younger. "I practically brought her up," Mme Parayre said once in retrospect of Mme Humbert. 48

In 1871 Catherine Fuzié left Aussonne to marry Armand Parayre and move into the schoolhouse at Beauzelle. Amélie Parayre, born the year after her parents' marriage, was six years old when the village was turned upside down for the wedding of her father's pupil, Frédéric Humbert, to her mother's protégée, Thérèse Daurignac. Beauzelle had never seen anything like this wedding, which began with a carriage procession that had to be manoeuvred up the steep, narrow street under triumphal arches to the church, and ended with firework displays, guns going off and peasants streaming in from miles around to join the dancing. ⁴⁹ Afterwards the young Humberts moved to Paris, shortly followed by the Parayres, all four revolving round the rising star of Frédéric's father, Senator Humbert.

Soon after her arrival in the capital, Thérèse Humbert became the central figure in one of the most bizarre lawsuits of the nineteenth century, which dragged on for two decades through virtually every court in France, involving by the end many of the grandest lawyers in the land. Almost infinitely complex legal arguments turned on a fortune of 100 million francs in bearer bonds, left to the young Thérèse by an American millionaire called Robert Henry Crawford (rumoured to be her natural father) in a will which was contested by his two nephews.⁵⁰ The colossal stake at issue meant that each fresh court hearing was followed in the press like the latest instalment in a nationwide soap opera. As tension mounted, legends multiplied. The one that chiefly inflamed the public imagination concerned the strongbox containing the disputed Crawford bonds (whose value grew with every passing year), which was kept in a locked room on the third floor at 69 avenue de la Grande Armée, next to the Parayres' apartment. Amélie's mother, who kept the key, was said to dust and polish the strongbox herself once a week.⁵¹ Privileged visitors were occasionally allowed a peep at it, always under the personal supervision of Mme Parayre. Whenever the family left for Vives-Eaux, the bonds were ceremonially produced in a locked briefcase which had to be handcuffed for the journey to the wrist of Amélie's father. 52

Among the supplicants and social climbers who besieged the Humberts' door, Amélie's mother acquired a reputation for granite hardness

and implacability. She and her dragonlike deputy, Mme Gaubert (wife of an architect from Fenouillet, who had been another of Senator Humbert's followers), were known as the Caudine Forks of 69 avenue de la Grande Armée. She but in private, with people whom she trusted, Catherine Parayre showed the reverse of her forbidding public image. She was warm, open and profoundly unconventional. She made intuitive judgements and stuck to them no matter how difficult or unpopular they proved. She had been captivated as a girl by Thérèse's imaginative audacity. In later life, however impressed others might be by the dazzling performances Mme Humbert put on in public, Catherine Parayre understood the price that had to be paid privately afterwards in nervous and physical exhaustion. She shielded her mistress from intrusive or critical outsiders, and put up faithfully with her caprices. When they were both young, she had given her unconditional allegiance to Thérèse, and in the course of their subsequent, often stormy life together, it never occurred to her to take it back.

She and her daughter had much in common. Henri Matisse found in Mme Parayre the courage and constancy he prized in Amélie. Few mothers would have welcomed a son-in-law with no means of providing for a wife, no immediate prospect of earning even his own living, and no apparent future in his chosen profession. But both Parayres cordially endorsed Amélie's choice. Henri Matisse in later life treasured a watch chain given to him on his marriage by "my mother-in-law whom I dearly loved, and who understood me as she understood her daughter." He never forgot that Mme Parayre had accepted circumstances which his own family found hard to stomach in the years immediately before and after the turn of the century.

He also warmed to his far more expansive father-in-law. Armand Parayre was a typical southerner: short (just under five feet tall) and fierce with olive skin, brown eyes, and dark hair with chestnut lights. His impetuosity was captivating. Even stonyhearted Parisians were disarmed by "Parayre's fiery nature, and his Mediterranean verve." While his wife remained steady and inscrutable, he was dauntless and choleric, full of wild enthusiasms checked by an ironic sense of humour and a flashing wit: "Papa Parayre was quicksilver." He had a sharp and lucid mind ("Credidi legere literas Ciceronis Cyroni amico suo [I felt as if I were reading Cicero's letters to his friend Cyron]," wrote the young Frédéric Humbert on receiving a Latin letter from his tutor). His hot head was matched by a cool nerve, and he faced dangers that were real enough with considerable relish. Apart from the usual muggers or apaches on the streets of Paris, the Humberts' peculiar circumstances opened them to the attentions of every sort of

loan shark and crooked financier. They lived on a legal knife edge, assured of fabulous wealth if they ever got their rights, threatened daily in the meantime by hostile elements—always known as "the baddies [les méchants]" or "the enemies of Madame"—who sought by every means to bring them down. In a crisis, Parayre was the man they sent for to mount

guard with his gun over the strongbox.

He had brought up his daughters to believe in the power of the mind and the imagination, and to make light of material hardship. The whole family were used to great expectations with no security in either the present or the future. They lived like everyone else at 69 avenue de la Grande Armée in confident anticipation of the day when the Crawford case would finally be resolved in Mme Humbert's favour ("We spent ten years waiting anxiously for the glorious day when the strongbox would at last appear in showers of gold," said Mme Gaubert). 59 But during the waiting period, funds frequently ran low and confidence grew shaky. The magnificent Humbert façade was more make-believe than real, a front put up and maintained by Thérèse's indomitable will. She could not have kept it going without the courage and resourcefulness of the Parayres, who had committed Armand's small family inheritance to the Humbert cause, and who drew no salary themselves for twenty years (except for a nominal 500 francs a month to cover family expenses).60 Money played no real part in their calculations. A successful outcome to the lawsuit would mean a victory for truth and justice, the defeat of Madame's enemies, an opportunity to forward the greater cause of progress and democracy.

Armand Parayre belonged to a school of Voltairian rationalists and freethinkers who believed passionately in a new age of enlightenment. One of the greatest and most durable of all the reforms they fought for was to make education free, secular, and available to all, which meant removing it from the control of the Roman Catholic church. These were years of head-on confrontation between the French state and the church, which denounced any suggestion of power-sharing as the work of subversives, Protestants or Freemasons. Parayre, who belonged with Frédéric Humbert to a Masonic lodge in Toulouse, retaliated by instituting an anticlerical, Masonic column in the *Avenir* dedicated to "the struggle against fanaticism, ignorance and superstition." He published articles by Arthur Huc, another radical Freemason from Toulouse, who was Paris correspondent and art critic for the city's great socialist newspaper, *La Dépêche*. One of the *Avenir*'s fiery left-wing leader-writers in the early 1890s was the young Masonic député and future minister, Marcel Sembat. 63

To men like Parayre, Huc and Sembat (as to their friend and mentor,

the future prime minister of the Republic, Georges Clemenceau), it seemed self-evident that the democratic future would inevitably bring change on all fronts, not least in art. Huc spread alarm and despondency among the respectable citizens of Toulouse in the 1890s by commissioning posters for *La Dépêche* from Henri de Toulouse-Lautrec, and from another younger iconoclast called Maurice Denis. He included both in modern art exhibitions held at the paper's offices, and in 1902 he became one of the first genuine collectors (apart from relations and local tradesmen) to buy a canvas from Matisse. Sembat, another farsighted collector of contemporary painting, was probably Matisse's earliest and most active public supporter in France in the first decade of the century.

The open, tolerant, enquiring spirit Matisse encountered in his fatherin-law was part of the atmospheric change he found so congenial in the south after the restraints of his conservative and Catholic native region, where artists ranked along with Freemasons, Protestants, Jews and radicals of all sorts as social misfits. In the summer of 1898 he read three fighting articles published in La Revue Blanche by Paul Signac, 67 himself a socialist and anarchist for whom the liberation of painting marched hand in hand with the liberation of mankind. Signac's manifesto was aimed at young artists of his own generation (he was six years older than Matisse) who risked losing their way in the miasmas of Impressionism. He hoped to replace the Impressionists' legacy of shapelessness, muddle and hit-ormiss spontaneity with scientific rules which would set "an example of rigour and order."68 His argument was forceful, his style simple, clear and unpretentious. He explained basic colour theory, including the meaning of Divisionism and the optic mixture (essentially this meant that pure colours, each divided from but in harmony with its complementary colour, were to be applied to the canvas in separate dots or dabs of paint, unsullied by white, and mixed only on the retina of the observer's eye). Signac claimed to obtain by his methods a new brilliance and sumptuosity from the simplified palette Matisse had inherited from Russell.

As a teacher, Signac was strict but inspiring. His three essays—later published as a book, From Eugène Delacroix to Neo-Impressionism—constituted an encouraging, user-friendly, thoroughly modern manual along the lines of the do-it-yourself anarchist pamphlets put out at much the same time by Les Temps Nouveaux with covers by Signac and his friends. ⁶⁹ His presiding hero, the father of pure colour, first and greatest of all Neo-Impressionists, was Delacroix, whose sayings Signac appropriated in much the same spirit as later enthusiasts bandied the sayings of Chairman Mao in the 1960s. He began by quoting two texts that spelt death to the tradi-

1898-1899: AJACCIO AND TOULOUSE

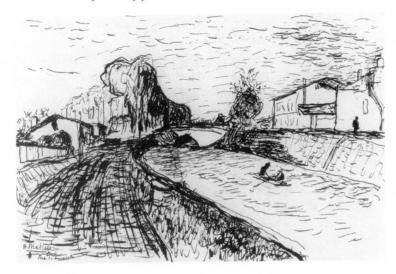

Matisse, Toulouse, Pont des Demoiselles, 1899: near the house of Amélie's grandparents, where she waited for the birth of her first child

tional palette: "Grey is the enemy of all painting!" and "Banish all earth colours!" With Delacroix to lend him historical legitimacy, Signac set out to analyse and regulate the explosion of colour Matisse had already experienced at first hand. Delacroix, in Signac's book, looked back to Turner and forward to the colourists of the future: "He urges them to dare all, to have no fear that their harmonies could ever be too full of colour."

This message could hardly have been more auspicious for Matisse. It offered a way of bringing his lucid, orderly intelligence to bear on the disorderly impulses of his imagination. Signac's three articles came out in the May and July numbers of La Revue Blanche, which Matisse read that summer and borrowed from Marquet to reread in December. 72 By this time he had already begun to explore the possibilities of Neo-Impressionism as vigorously as he had once tackled Impressionism itself in The Dinner Table, using the same vehicle of still life. He laid out classical compositions of his trusty standbys: glasses, bottles, a carafe, a knife and plate, a cup, a coffeepot and a fruit stand, replacing the usual apples with oranges which he had first seen growing in Ajaccio. "The fact is that orange is a special colour. It evokes light and reflected light with a unique directness," wrote Lawrence Gowing of these Toulouse still lifes: "Matisse made it his special property just as Turner took possession of yellow; oranges, which had been rare in painting before, became his chosen subject."73 All through the autumn and winter of 1898-99, Matisse worked out his response to this first encounter with the south in a set of variations on a theme of Delacroix, quoted by Baudelaire and reaffirmed by Signac: "Everyone

knows that yellow, orange and red inspire and represent ideas of joy, of riches, of glory and of love."⁷⁴

The Matisses moved to Toulouse that autumn to await the birth of their first child in the house of Amélie's grandparents at 14 rue des Abeilles on the edge of the old city near the Canal du Midi (which Henri drew and painted in the terse, expressive, calligraphic style he had inherited from Vincent van Gogh). Fan Gérard Matisse was born on 10 January 1899, twelve months almost to the day after his parents' marriage. His birth marked an end as well as a beginning, for now that he had a family to support, Matisse recognised that his time was up. The year in the south that had saved him as a painter ran out in January 1899. He would be thirty years old that year. "The period of studying was over," he said, looking back. "It was time to earn a living."

AT SOME POINT in February or March, he and Amélie left their baby with a wet nurse in Toulouse to travel north in search of work.⁷⁷ In the grey light and frigid temperatures of a Paris winter, Matisse embarked on what would become over the next months and years an increasingly disheartening round of job-hunting, visits to dealers, and unsuccessful attempts to interest buyers in his work. He had let his studio on the quai St-Michel in order to bump up his meagre income. In February he offered it once again to Pissarro, who declined on the grounds that he could not abandon the "battle with the Tuileries" which he was fighting on canvas from the window of a rented room on the rue de Rivoli.78 Pissarro, who had been as poor as Matisse in his youth, was still living in his seventieth year from hand to mouth, harassed by money worries, driving himself relentlessly, constantly anxious about his ability to meet the demands of a large and dependent grown-up family. Matisse fell into the habit of visiting him regularly that spring, conducting an increasingly companionable dialogue with the older artist about painting in general, Impressionism in particular, and—at any rate in its later stages—Cézanne above all.79

Matisse returned in search of a live model to the studio at the Ecole des Beaux-Arts, where Moreau had told him he would always be welcome. Most of his friends had left by this time. The conformists who remained had been relieved to find that they had nothing to fear from Moreau's replacement, Fernand Cormon ("His head is empty, quite empty!" Jules Flandrin wrote furiously. "Puts all his efforts into knocking up some sort of picture, and that's it! As for ever having given a moment's thought to what art itself might be, he's congenitally incapable of it!"). 80 Toulouse-Lautrec had studied in Cormon's studio fifteen years before with John

Peter Russell and Vincent van Gogh, who had ended up by trying to shoot the master after a showdown over painting styles. By 1899 Cormon was in his mid-fifties and had no intention of being set up by another half-cracked, red-bearded northerner. When Matisse produced one of the canvases that looked to Evenepoel like the work of a mad epileptic Impressionist, Cormon studied it uneasily in silence, then spoke not to Matisse but to the student in charge of running the studio: "Is he over thirty?" (Thirty was the official Beaux-Arts age limit.) "Yes." "Does he know what he's doing?" "Yes." "Then he'll have to go."

Nearly half a century later, Matisse could still repeat this scrap of dialogue word for word. It brought back all his old feelings of being morally contagious. "They were afraid the thing was catching," he explained. "It's not the one who pretends to have typhoid fever that's dangerous. It's the one who's got it." There was something far from reassuring about Matisse at this stage in his shabby corduroys with his southern suntan, his roll of crazy paintings under his arm, and his take-it-or-leave-it air. Younger boys felt it wise to keep their distance. Their elders were unenthusiastic when Matisse showed a drawing of the old mill outside Ajaccio at the Salon de la Nationale in May, together with four still lifes, presumably from Toulouse. The young Maurice Boudot-Lamotte, intimidated and impressed in equal measure by this tearaway from his hometown, reported rumours that Matisse had been slung out of his studio, and that he owed 4,000 francs to his colour-merchant for paints and canyas. The stage of the stage of the paints and canyas.

Matisse had sold nothing and found no work. On 16 May he put his name down at the Louvre for permission to copy works by Claude Lorrain and Luca Signorelli. He said bitterly afterwards that the purchasing committee only ever bought faithful copies made by the mothers, wives or daughters of the museum attendants, and that, hard though he tried, it was beyond him to run off the sort of copies which provided the mothers, wives and daughters with a nice little income on the side. His head was still full of his attempts to come to grips with Divisionism, and to absorb the impact of Turner and van Gogh. He had quoted van Gogh in Toulouse in a resplendent painting of sunflowers, and he would quote him again that summer in a brilliantly lit, unmistakably Flemish landscape with a single tree in the centre of the canvas, and a tiny church spire punctuating the horizon that divides the painting horizontally between blue and white bands of sky and a broader band of flat scarlet cornfields.

While Matisse copied Signorelli's Man with a Striped Sleeve in the Louvre, another former Moreau student was making a tremendous stir in the next

room, working on what was not so much a copy as a transposition of Paolo Uccello's fifteenth-century Battle in which the men came out scarlet, the standards black and the horses green. 88 The artist was the twenty-oneyear-old Georges Florentin Linaret, who seems to have been one of those wild boys, like Thomas Chatterton or Alfred Jarry, liable to take other people's breath away almost before they have left school by their natural gifts, their imaginative daring, their ability to anticipate whatever their contemporaries subsequently discover to be the latest thing. Linaret (who would die young) was the son of a bookseller from Montmartre. A large, spotty, impatient youth, he had startled his friend Boudot-Lamotte by announcing in the autumn of 1897 that for his part he shat upon the contents of the Salle Caillebotte, about which everyone else was kicking up such a fuss.89 Later he turned up at the studio with a couple of small Cézannes (a painting and a drawing he had saved up to buy from Ambroise Vollard's new gallery on the rue Lafitte), but his discovery fell flat since Cézanne meant nothing to Moreau, nor at that stage to Matisse.90

The radiant vistas to which Moreau once opened the door had dimmed by the spring of 1899: "drab and grey as a city pavement," wrote Paul Valéry,91 who was sadly disillusioned when the fabled treasure trove of Moreau's painting was finally exposed after his death to the inspection of his contemporaries. Matisse, like his new friend Linaret, was less interested in Moreau or the Louvre than in Vollard's tiny gallery, where everything seemed provisional, as if the owner were permanently in the middle of a move ("An unframed canvas on show in an otherwise empty window, a few canvases inside with their faces turned against the wall, and Vollard himself reluctant to bring out any paintings").92 Matisse tried and failed that spring to persuade his brother to buy van Gogh's L'Arlésienne from Vollard (Auguste Matisse spent his savings on a chainless bicycle instead).93 By the time he nerved himself to go back for the painting on his own account, the price had risen from 150 to 500 francs. Vollard explained that art was a buyer's market controlled by purses larger than anything dreamed of by a poor art student. Matisse returned a third time in May to buy van Gogh's Les Alyscamps, but before Vollard could even fetch out the canvas, he had lost his heart at sight to another, smaller painting hanging on the wall, beside which the van Gogh looked as tame as a print. 94

The painting (which for the moment he successfully resisted buying) was Cézanne's *Three Bathers*. Matisse had seen it before, for this was the Cézanne on which Linaret had spent more money than he could afford, and which had had to be returned to Vollard. 95 Before any further decision

1898-1899: AJACCIO AND TOULOUSE

could be taken, a telegram arrived from Toulouse, where the Matisses' five-month-old son Jean was gravely ill with enteritis. They travelled down at once and remained in the south for a month and a half until the child was out of danger. Staying with his in-laws and brooding on the hopelessness of his position in Paris, Matisse watched the local boys swimming in the river Garonne and thought of the consoling bathers in Cézanne's painting, with its yellow fall of sunlight and the blue and green volumes of its riverbank. 6 "Cézanne used blue to make his yellow tell, but he used it with the discrimination, as he did in all other cases, that no one else has shown," Matisse told his students in 1908, 7 by which time he had lived for nine years with the *Three Bathers*.

His resistance to the painting's strong and sober beauty had failed him as he walked beside the Garonne, and, mindful of Vollard's lesson about time and money, he had written to ask Marquet to make an immediate offer on his behalf. The clinching factor in making up his mind was his wife. Amélie knew nothing about Cézanne, but she had understood the affair of the blue butterfly the year before, and she was not a Parayre for nothing. The plan was to raise the down payment to Vollard on the *Three Bathers*—500 francs (or 100 dollars), a sum far beyond the young couple's

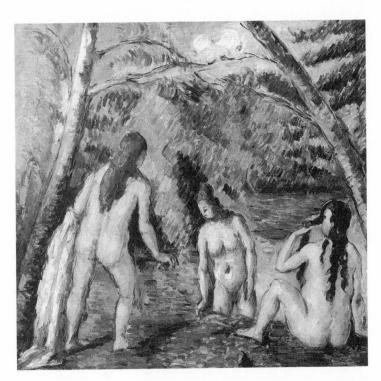

Paul Cézanne, Three Bathers, c. 1879–82

means—by pawning a magnificent emerald ring which had been a wedding present and was now one of Amélie's prize possessions. She never forgot the pang it cost her when her husband eventually returned to the pawnshop to redeem the ring only to find that his pawn ticket was out-of-date. She loved jewels, and she mourned the loss of this one all her life. ⁹⁹

But although it took many years before Cézanne's painting began to speak in its own voice to Amélie, she had caught an echo—or recognised the strength of her husband's response—and she understood in her bones the importance of this kind of sacrifice. Over the next three decades this small Cézanne canvas would exert a powerful pull over all the Matisses, representing to the parents an act of blind faith in the future, symbolising to the children everything they had been brought up to believe in, sustaining the whole family with a mysterious life of its own. Ioo "In the thirty-seven years I have owned this painting, I have come to know it fairly well, though I hope not entirely," wrote Matisse in a famous testimonial, when he finally presented the *Three Bathers* at his wife's suggestion in 1937 to the city of Paris. "It has supported me morally at critical moments in my venture as an artist; I have drawn from it my faith and my perseverance." Ioi

In 1899 there remained the immediate problem of an income. Henri's perennial solution, whenever the family's finances touched rock bottom over the next few years, was to abandon painting in favour of some more lucrative activity. Amélie countered with a plan to support the family herself. She proposed to start a hat-shop, always an obvious remedy for a Parayre in trouble. Business expertise, advice and contacts would come from her aunt and her two uncles at the Grande Maison de Modes, where she had worked before her marriage. 102 Returning with Henri and the baby to Paris at the end of June, just as the city was beginning to empty for the summer, she found a partner called Marguerite Dameron, and premises at no. 25 rue de Châteaudun in the ninth arrondissement, behind the Stock Exchange and the opera house planned by Haussmann as one of the hubs of his new Paris. 103 The rue de Châteaudun lay midway between Montmartre and the great new department stores in one of the capital's smartest shopping centres, on the edge of the textile and garment district where Cousin Saulnier had opened his elegant Art Nouveau showrooms in an area that had always been a Matisse family beat.

The street itself contained a mix of banking or financial offices and residential blocks with little luxury boutiques let out on the ground floor to modistes, couturiers, jewellers, and purveyors of high-class lingerie or shoes. This was Humbert territory, the commercial heart of an affluent society with new money to spend and new tastes to gratify. The next turn-

ing but one along from no. 25 rue de Châteaudun was the rue Lafitte, lined with dealers in art and antiques. Clients wanting paintings had wives who needed hats. Prospects looked hopeful for anyone starting out with the goodwill of Mme Humbert, whose hats turned heads wherever she went in a new creation of fruit, flowers or peacock feathers. She was said to run up bills of almost 20,000 francs a year with her favourite modiste, Mme Reboux of the avenue de l'Opéra. ¹⁰⁴

Several occupants of the rue de Châteaudun were suppliers or business associates of the Humberts. One was the banker M. Martin, at no. 55. Another was David Hadamard, a Jewish diamond-merchant installed with his family at no. 54, who was currently running through his admittedly ample resources in support of a son-in-law. 105 Hadamard's daughter Lucie was the wife of Captain Alfred Dreyfus, newly returned from Devil's Island in the summer of 1899 to face his second court-martial. Throughout the five years of his ordeal, 54 rue de Châteaudun had served as headquarters for the pro-Dreyfus campaign, with each fresh development marked by journalists collecting at the Hadamards' door. 106 Emile Zola had fled France in 1898 after publishing "J'accuse"; Dreyfus was brought back to France in June, 1899; and the affair reached its climax in September, when the army convicted him for the second time in a verdict which was immediately set aside by a free pardon from the President of the Republic. The issue split the art world, as it did the rest of France, into Dreyfusards (including anarchist sympathisers like Matisse and his friends) and their opponents, chief among them Edgar Degas. Degas lived on the rue Victor Massé, near the rue de Châteaudun and a few doors up from Berthe Weill (who would become Matisse's dealer two years later). When Mlle Weill filled the window of her gallery with a painting called Zola Jeered and Spat At (Zola aux outrages) (the artist was Henri de Groux), Degas turned his head away and sucked his spittle in disgust as they passed in the street. 107

The Matisses' next-door neighbours were the Electricity Company (closely connected with the Humberts) at no. 27 on one side, and, at no. 23 on the other, Thérèse Humbert's interior decorator and confidential minion, M. Boussac. ¹⁰⁸ A shortage of ready cash obliged Mme Humbert to operate an elaborate promissory system—barter, mutual favours, payment in kind in the form of recommendations for official honours, job placements, real estate—which probably explains how the Matisse boutique came to occupy the left-hand ground-floor showroom at no. 25 (the rental value for a space just over six metres square was 4,200 francs a year, seven times that of the Matisses' entire seed-store—house, shop, warehousing

and stables—in Bohain). Mme Humbert had accounts with the most exclusive hat-makers and couturiers of the day. She had a passion for precious stones, regularly commissioning magnificent pieces from the grandest jewellers—Roulina, Dumaret of the rue de la Paix, Haas of the boulevard Sebastopol—for herself, or to give away as marks of special favour. Her wedding present to the daughter of the Paris police chief, Louis Lépine, was a pouch of jewels, and she ordered dresses from her own couturier for the daughters of the barrister Henri du Buit. 110

She seems to have done the same for the daughter of her two oldest retainers: Amélie Matisse, too, had a wedding dress from Worth as well as a bag of diamond rings, bracelets, and brooches.^{III} Pawnable jewellery served as a routine substitute for ready money in the Humbert household. Mme Humbert paid regular weekly, sometimes daily, visits to the mont de piété (or pawnshop). The Parayres were said to be paid entirely in pawn tickets, 112 and in time of need Amélie herself would raise funds by pawning at least one of her rings. Her new boutique was scheduled to open in October 1899. The couple planned to live above the shop at no. 25, which had thirteen tiny servants' rooms on the fifth floor (the Matisses' attic was so small that when Mlle Weill finally came round to inspect his work, there was no space even with the door open for all three of them to squeeze in to see his pictures). 113 The scheme was for the sale of hats to keep the family going and buy Henri time to paint while he waited for collectors to find their way to him, as they had done in the end to the Impressionists.

At some point after his final return from Toulouse, Matisse rented a new and bigger studio with three tiny rooms attached on the fifth floor of 19 quai St-Michel.¹¹⁴ This was the studio with two windows above the Seine, one looking directly across to Notre-Dame and the Palais de Justice, the other upstream to the Pont St-Michel, views which Matisse painted constantly from now on. He celebrated the move by putting his name in the Paris commercial directory, or Bottin, under "Artists," 115 launching himself as a professional painter in a style that reflected the world of his in-laws rather than the hand-to-mouth way he had lived up till now. Of all his friends and fellow students at Moreau's, Matisse was the only one (apart from Jules Flandrin) whose name was on this list. It sat oddly alongside those of more worldly practitioners like his father-inlaw's employer, the former député Frédéric Humbert, who was a minor Salon artist in his spare time. Humbert had studied under Ferdinand Roybet, one of the grandest society painters of the day, and been rewarded with an official medal for a portrait of his father as Keeper of the Seals. 116

He had built up an impressive collection of recent paintings, ranging from Courbet, Delacroix, Manet, Renoir and Moreau to Benjamin Constant and Roybet himself.¹¹⁷ Amélie's mother looked after the picture gallery on the first floor at 69 avenue de la Grande Armée. She also personally supervised the running of Humbert's luxurious studio apartment, stuffed with exotic fabrics, objets d'art, and fancy dress for the models, on the place Vintimille, in the same studio block where Matisse had once visited Eugène Boudin.¹¹⁸

The first thing Matisse needed, after a studio, was access to a live model. Finding a model prepared to pose nude was always a problem, virtually insoluble in the country, not easy even in Paris for hard-up young artists (one of the last straws for Flandrin in Moreau's old studio had been the arrival, in February 1899, of a fully clothed model on the stand). ¹¹⁹ Ejected by Cormon, Matisse went back to Julian's academy in its original premises on the rue du Dragon, where he had started out as a run-away from St-Quentin eight years before. He enrolled on 9 July 1899, buying a whole month's tickets in advance, but left again as soon as he realised he was heading for the usual round of brutal baiting ("The boys straight out of school saw this thirty-year-old coming and started ganging up: 'Do you see what I see? . . . A nutcase. . . . We'll make him pay'"). ¹²⁰ Next he tried Julian's new premises near the Beaux-Arts on the rue Fontaine, where

the students were so disgusted by the strange way he drew the model—in loose, flowing, confident calligraphy quite unlike their own carefully rehearsed performances—that on the second or third morning, Matisse found someone had got there before him and scrawled all over his sketch. This time he left for good. "I was turned away from everywhere," he said long afterwards. ¹²¹

"Cold and glacial is the wind that blows from the north," wrote Evenepoel, 122 describing his own struggles with a father who refused with increasing bitterness to accept his son's work, his way of life, his love affair or his adored illegitimate

Frédéric Humbert in the studio run by Matisse's motherin-law

son, who was four years old. Matisse's relations were by no means easy with his parents, or with his daughter, who was also four years old when he returned to Paris in the summer of 1899. Marguerite had been left in the care of her mother, with weekly visits from her father whenever he was in town. Lodgings or a job would have been hard, if not impossible, for an unmarried mother to find except by concealing the existence of her child, or handing it over to be fostered (private fostering in the big cities was common and relatively inexpensive, but risky since children often failed to survive it). Marguerite remembered this as a time of misery, fear and frantic attempts to get back to her old life as it had been before her parents separated. Her years alone with her mother left vivid memories of tears and slaps. She never forgot a visit to 19 quai St-Michel when she was three years old which ended with her pulling away from her mother's hand to dart back across the road to her father, and being knocked down by a hansom cab. She described her father coming to see her in hospital and giving her his cane when the time came to leave because, as he said, "You know I never go anywhere without my cane."123

Matisse said long afterwards that his unwanted or neglected canvases inspired in him a special tenderness, "like you feel for a child when it is unhappy."124 Marguerite was always on his mind. When her mother left him in the summer of 1897, he described himself as a "single father [fils père]."125 The art critic Mécislas Golberg (who knew and worked with Matisse a few years later) used the same phrase to describe his own predicament when he too found himself abandoned in the 1890s by a girlfriend who left him to look after their infant son. 126 Golberg lived like a student all his life, earning a meagre living from essays and articles in fringe reviews, renting shabby furnished rooms when he could afford it in the poorest parts of Paris, sleeping otherwise on friends' floors or walking the streets all night. He said he kept his baby in a drawer wedged between the chest of drawers and the bed in a cheap hotel room, rocking it with his foot while he worked, and feeding it with milk collected at dawn each morning from the front doors of neighbouring apartment blocks. 127 This state of affairs, which acquired in retrospect in Golberg's memory the charm of an urban fairy tale, could hardly have lasted in practice for more than a few days. Child care was not a practical proposition at the end of the nineteenth century for a man on his own without a home or a woman to run it for him.

In the autumn of 1897, soon after he met Amélie Parayre, Matisse explained to her that there would be problems if they married because he already had a daughter. "That doesn't matter," replied Amélie, as uncon-

ventional and as sure of her own instinctive judgement as her mother. ¹²⁸ By the time she finally achieved a home of her own above the shop in the autumn of 1899, her son Jean was nine months old, and she herself was pregnant for the second time. Matisse had resumed regular visits to his daughter, but the child's unhappiness, her mother's resentment and his own divided loyalties made for constant strain between the two households. When tension stretched to the breaking point, it was once again Amélie who took decisive action. She announced that the child needed a family and offered to take her as a daughter, a proposal that Camille had no choice but to accept. A working girl without a protector could neither pass as a married woman nor continue for long to hide the fact that she had a child. Matisse, who acted as go-between for the two women, said that his wife's offer was a source of bitter grief to Camille, although she recognised it as the only viable solution. ¹²⁹

If losing her child was the price of a new life for Camille, Amélie, too, now put herself beyond the social pale by openly defying one of society's strictest taboos. Asked why she did it by Gertrude Stein long afterwards, Mme Matisse politely fobbed off her inquisitor by saying she had once read a romantic novel in which the heroine sacrificed her own reputation to bring up her husband's illegitimate child. 130 But if the Parayres had a history of striking heroic poses in noble causes, they also had a habit of making their dramatic gestures work in practical terms. Amélie Matisse meant what she said when she offered to be a mother to Marguerite. The child responded with passionate intensity. In the struggles and hardships of the early years of the century, Marguerite grew to be a lynchpin holding the whole family together: essential to her father's well-being, looked up to by her two younger half brothers (Pierre-born in the summer of 1900, soon after she joined the household—said that it was his sister who brought him up), 131 and profoundly attached to her adoptive mother. Amélie and Marguerite became and remained for the rest of their lives closer than most mothers and daughters, bound together by mutual affection, reliance and understanding in a relationship grounded from the first in their passionate mutual commitment to Matisse.

Amélie also learned to love her husband's painting by Cézanne. Haggling between Matisse and Vollard over this purchase seems to have gone on throughout the summer and autumn of 1899. The two were almost the same age. Both were gambling for high stakes at this stage in their careers, and neither ever felt comfortable with the other. Vollard, seldom entirely sure of his judgement with painters of his own generation, was especially uncertain about Matisse, whose work already showed signs of making

greater demands than that of his contemporaries. Vollard's resources of nerve and will had been largely staked over the past seven years on Cézanne, whose painting had struck him at first sight—as it did Matisse—"like a kick in the stomach." Cézanne trusted Vollard, who was the first dealer to believe in him without reservations.

By May 1899, when Matisse made his offer, Vollard's boldness was at last beginning to seem justified. Cézanne's prices had shot up in the Doria sale at Georges Petit's gallery at the beginning of the month, and they would rise again at Chocquet's sale in July. Vollard had charged Linaret 300 francs for the *Three Bathers* in 1898, buying it back the year after for 75. "Since he ought to have taken the canvas back for forty sous [two francs], he had made a profit of 223 francs as well as getting the picture back for nothing," wrote the indignant Boudot-Lamotte, who was as impressed by Vollard's ruthless opportunism as by Matisse's reckless bid to outflank it:

Vollard resold the Cézanne to Matisse for 1,500 francs, buying twelve canvases from him at the same time for 1,000 francs. In other words, he cleared another 1,500 francs on the Cézanne, which had already brought him 223, and he got twelve Matisses for nothing: that is how you build up a sales-house. Even so, Matisse didn't do too badly. 134

Matisse said that, for a down payment of 500 francs, he bought a plaster bust by Rodin as well as Cézanne's *Three Bathers*. ¹³⁵ Boudot-Lamotte's claim that the remaining 1,000 francs were paid in kind was probably right. Matisse certainly swapped one of his own canvases with Vollard for a painting by Gauguin, ¹³⁶ and it is hard to see how else he could have acquired a second van Gogh drawing at a time when he and Marquet were so hard up that they hired themselves out for a labourer's wage of just over one franc an hour.

Matisse had returned from the south to find his old friends almost all launching out in new and different directions. Bussy had moved in with Auguste Bréal's mother-in-law, who thought he was a genius and introduced him to her other lodger, an English Miss Strachey, whose own family in London would drastically reshape his life. Manguin, newly married in June, was busy setting up house half a mile from the rue de Châteaudun with his pregnant, nineteen-year-old bride. The new apartment at 61 rue Boursault had a small garden at the back, just big enough for Manguin to erect a collapsible studio which he shared that winter with

1898-1899: AJACCIO AND TOULOUSE

Matisse, Studio Interior, c. 1899

Matisse, Marquet and Jean Puy, all four painting the same model in brilliant synthetic colours applied in large, dabbing brushstrokes loosely based on Signac's theories.

Huklenbrok had gone home to his family in Brussels, where he shared a highly successful show with Evenepoel that autumn. ¹³⁹ Evenepoel himself was also planning to return to Belgium, where he meant to marry his recently divorced cousin and start a new life, free at last from dependence on his father. He came back to Paris full of hope and high spirits in mid-November to paint a portrait of Georges Clemenceau which was to have been the prelude to clearing out and closing down his studio for good. Instead he caught an infection and entered a nursing home on 8 December with what turned out to be typhoid fever. His father arrived two days later from Brussels, but Evenepoel died on 27 December. ¹⁴⁰ Matisse received the news with incredulity. "I climbed the stairs at 19 quai St-Michel . . . with the telegram in my hand, stopping every other minute, repeating in stupe-faction, 'Evenepoel is dead!' Marquet came up behind me. 'What's the matter?' 'Mon vieux, Evenepoel is dead.' 'Oh well,' said Albert, 'if people didn't die, they'd have to be killed.' "¹⁴¹ Matisse told this story later to

show that not even death could daunt Marquet. Savage Swiftian irony seemed the only response to a world in which Matisse came to feel more and more over the next few years that everyone was mad except Cézanne.

Huklenbrok—himself already heading for the breakdown that would cripple him both as a man and as an artist—said that Evenepoel's friends were haunted after his death by his sceptical, melancholy smile. ¹⁴² Matisse had lost one of his most supportive friends, who was also the last link with his youth as a Flemish painter. It was eight years since he had first reached the capital from St-Quentin with Louis van Cutsem, who gave up painting to go into business, and Jules Petit, who decided to stick it out as an artist. Petit died, after a short life of effort and disappointment, a few months before Evenepoel in 1899. Matisse at thirty had twice formed part of a trio of young northern painters who were ultimately defeated—by failure, poverty, disillusionment, or death itself—leaving him in each case to face the new century as the sole survivor.

On 7 December Matisse finally closed with Vollard for the *Three Bathers.* ¹⁴³ Cézanne had dominated the Paris art scene that autumn with two still lifes and a landscape at the Salon des Indépendants (which opened on 21 October 1899). "I can still hear old father Pissarro," said Matisse, "exclaiming at the Indépendants, in front of a very beautiful still life by Cézanne, representing a blue water pot of fluted glass in the style of Napoleon III, a harmony in blue: 'It's so like Ingres!' Once I got over my surprise, I found—and I still find—that he was right." ¹⁴⁴ The painting was presumably *The Blue Vase* (1889–90), which ultimately gave birth to Matisse's *The Blue Window* (1913). There was a second Cézanne show in November 1899, put on by Vollard, who remembered saying something in praise of Gustave Moreau as a teacher which so enraged Cézanne that he smashed his wineglass. Moreau, who had breathed life into the art of the past for Matisse and his contemporaries, represented for Cézanne a dead hand on the living art of the present and the future:

If everything painted by that distinguished aesthete looks hopelessly old-fashioned, it is because his dreams of art come not from his feeling for nature, but from what he has seen in museums and, even more, from a philosophical attitude based on knowing too much about the masters he admires. I wish I had the fellow under my thumb so as to drum into his head the idea—so sane, so comforting, the only true idea—of an art enriched by contact with nature. ¹⁴⁵

CHAPTER SEVEN

1900–1902: Paris

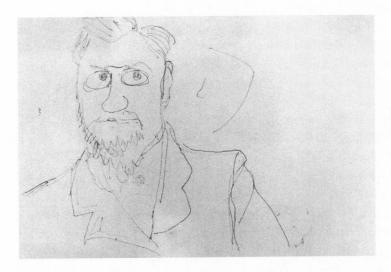

Matisse, Self-portrait, c. 1900

atisse by the turn of the century was already beginning to baffle and disturb people meeting him for the first time. Younger students who worked alongside him—Maurice Boudot-Lamotte, Jean Puy, Jean Biette, an English boy called Vernon Blake—all recalled the impression he gave of banked, smouldering, sometimes barely contained fires. "You were the Genie of the Lamp who releases sometimes demons, sometimes dancing girls," Puy wrote to Matisse forty years on. At the time, it was more often demons than dancing girls that rose up to haunt Matisse: demons of rejection, isolation, financial desperation, worst of all

the blind demons of custom and familiarity that fought him inch by inch in the long struggle to break through to a new way of seeing nature.

Matisse was by far the oldest and most forceful member of the academy he finally joined in Montparnasse on the rue de Rennes, where in more carefree days he had once wrecked a performance at the Gaîté. The school at no. 76 was run by an Italian ex-model called Giuseppe di Camillo, who provided a live model and, once or twice a week when funds permitted, correction sessions from Eugène Carrière, who lived round the corner.2 Carrière started teaching at Camillo's in 1899 in a class that never grew large enough to be commercially viable. Most of his pupils were impressionable and inexperienced, many of them recent school-leavers. In 1900 Puy himself was a timid twenty-three-year-old from the provinces, still smarting from the disillusionment of a first year in Paris spent studying (with Boudot-Lamotte and another silent, watchful member of Carrière's class, André Derain) under the academician Jean-Paul Laurens at Julian's academy.3 To Puy, Matisse's pride and confidence seemed unassailable: "He hardened himself against all the frailty and tenderness born of sentiment." Boudot-Lamotte came up against the same tough, dry, apparently unfeeling carapace. Vernon Blake (who went on to become head of the British School in Rome) remembered for the rest of his life the day Matisse first erupted like a cold draught or a stone flung into Carrière's peaceful little class sometime in the winter of 1899-1900.5

Blake, like Puy and Boudot-Lamotte, hugely admired Carrière, whose knowledge and sensitivity as a teacher matched what seemed to some of his most sophisticated contemporaries the incomparable subtlety of his work. In the thirty years since he had been expelled from the Ecole de La Tour at St-Quentin, Carrière had acquired an extraordinary reputation. Contemporaries ranked him with van Gogh and Seurat as one of the major prophets of the new age in art. Like Gauguin (who had been a close friend until he left for Tahiti), Carrière belonged to no school and worked largely in isolation from his fellow painters. His painting was veiled, reticent, opaque, reserving its disclosures beneath a sheen of swirling, silken brushstrokes in toneless browns and greys from which colour had been virtually eliminated. Carrière painted still lifes, figure compositions— Hope, Maternity, Old Age-and portraits as enigmatic and austere as the de La Tour pastels which had been the first pictures he (and Matisse for that matter) ever saw. Edmond de Goncourt said that Carrière's portrait of him, though a far from obvious likeness, was the only one that came close to depicting the brain that wrote his books.6 The two contemporary artists with whom he had most in common were the poet Stéphane Mal-

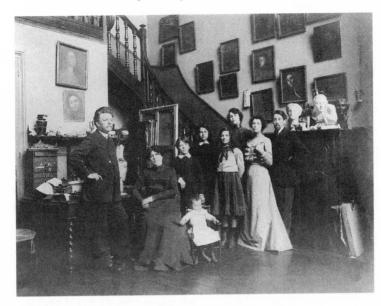

Eugène Carrière and his family, photographed by Dornac, c. 1901

larmé and the sculptor Auguste Rodin, who was not alone in rating Carrière the greatest of all living French painters.⁷

Carrière believed passionately in a free and equal future for humanity. When Matisse first met him, he had just founded a free school for the poor illiterate workers of Montparnasse to whom he explained the principles of socialism in night classes. He brought the same libertarian approach to his painting students, teaching those who wished to learn and respecting the others' right to ignore him with unfailing courtesy. The class was modest (seldom more than fifteen students), serious, highly motivated and self-contained, like its master. Matisse could hardly have found a greater contrast to Cormon's studio, or to the hooligan element at Julian's for which he had come prepared. Blake described the shock that ran through the class when the newcomer turned his easel to face the room from his position at the far end of the row furthest from the door, through which Carrière politely tried to slip away:

"Pardon me, M. Carrière," interposed Matisse, "but you have not corrected my study!" "Haven't I? I beg your pardon. Where is it?" pronounced a most obviously unhappy Carrière...[who] had been for some time casting uneasy glances in its direction. He placed himself before the astonishing medley of immense feet, and generally distorted representation of the pose in strong and, at that time, sombre strife of purple and carmine flesh-tones set off

by viridian greens. "Eh bien, mon ami, n'est-ce pas?"—Carrière was a nervous speaker and made great use of the palliative n'est-ce pas—"each of us has his own way of seeing Nature, n'est-ce pas? Your way of seeing Nature is not precisely the same as mine. Under the circumstances I really don't see how any remarks that I might have to make could be of any particular service to you, n'est-ce pas?" and with that he once more moved towards the door, took down his hat and went out.

The studies of nude models which preoccupied Matisse in Carrière's class in 1900 were unlike anything he had done before. Their distortions were literally stunning to conventionally trained boys like Blake, Puy and Boudot-Lamotte. Puy, along with most self-respecting art students, had read Signac's Neo-Impressionist manifesto by this time, but nothing had prepared him for the battle Matisse was fighting. The son of a prosperous manufacturer in Roanne, classically educated and destined by his parents for the civil service, he had left his lycée four years earlier in the usual state of pictorial illiteracy, "without ever having seen a real painting." Puy said that it would never have occurred to him as a star pupil in the school art class to do anything so eccentric as copy nature. He had come on fast and far enough since then for Matisse's experiments to seem at once attractive and repellent, but in either case impossible to follow.

Puy would admire Matisse's work with reservations from a safe distance to the end of his life. Years later he compared one of his friend's first paintings of goldfish in a bowl to the grave, sonorous and compelling notes of organ music. ¹² He re-created the bewildering impact of Matisse's early works—their dislocations, their apparent coldness, the sense they gave of coming from another world—by imagining Matisse himself as his own goldfish:

I can easily imagine a valiant goldfish who takes intense delight in the rainbow colours and forms visible through the distorting globe of his glass bowl, and who, if he could paint, would depict them without worrying about what they actually represent: female nudes, landscapes, still lifes, stripped of their material existence and meaning so that they no longer exist as anything but pleasing phantoms for his enchanted eye. ¹³

The lure of an enchanter—weird, disquieting, potentially disruptive—emanated from the place furthest from the door in Carrière's class.

"Matisse, who was over thirty, supplied the element that attracted and sustained our imaginative flights," wrote Puy. "We listened to and talked about his ideas and explanations with delight."14 He was once again the centre of a band of younger painters, as he had been a decade earlier in St-Quentin. He brought out his violin, sang his anticlerical North-country songs, told scurrilous stories about everything and everyone they had been taught to hold dear ("It was only by a hairsbreadth that Gustave Moreau himself escaped," wrote the gentle Boudot-Lamotte, always pained by Matisse's abrasive tongue). 15 He startled the others both by his daring and by his reliance on old-fashioned devices like the black glass (traditionally used for testing balance in a composition), the tape measure and chalk stick (for comparing and correcting the model's position on canvas and on the stand), and his faithful plumb line. 16 Matisse was never more rigorously scientific than in these months when, confronted daily at home by the essentially architectural power of Cézanne's Three Bathers, he struggled to penetrate for himself the secrets of light and mass.

Of all his companions in Carrière's class, the one who in the end owed and gave most to Matisse was André Derain. Boudot-Lamotte remembered Derain in those days as a big, broad-shouldered boy who kept to himself and seldom spoke. He was preoccupied with the beginnings of his own revolt, sparked off when he recognised with astonishment his old classmate from school, Georges Linaret, as the troublemaker copying Uccello's Battle in the Louvre. It was Linaret who introduced Derain to Matisse. "Derain was eighteen when I met him," said Matisse. "I was already over thirty.... I realised that Derain ... didn't work like the others. He interested me. Little by little we began to talk." Their dialogue was conducted on canvas as much as by word of mouth. Derain gave Matisse a little painting called The Funeral—done in his hometown of Chatou around the time they met-in which the effect of breezy, bright spring sunshine, produced by half filling one side of the canvas with clear pinky yellow brushstrokes, is sharpened by a vertical blue-grey band of shadow running up the other. Matisse would echo this device in 1905—the Fauve summer he spent painting the Mediterranean coast with Derain—in Le Port d'Abaill, which shows the foreshore at Collioure laid out beneath a radiant sun on a canvas divided horizontally by a similar shadow band (this time shimmering in pointilliste dabs of red, green and violet).

From the first, each responded to an answering boldness in the other. The Louvre, which had been their training ground, now became for both an experimental laboratory where they worked with Linaret on explosive new combinations and combustions. Derain's canvases so alarmed the

public that some demanded his expulsion from the galleries for an outrage against beauty (attentat à la beauté). 18 Others dropped by each afternoon to catch up on the latest development in his exuberant transformation of a fifteenth-century Italian Christ on the Road to Calvary. "Already he painted magnificently," said Matisse, who was himself transposing Philippe de Champaigne's Dead Christ in the style of Manet (he called it his marshmallow effort—"le Philippe de Champaigne guimauve"—and repainted it later in hopes of making a sale). "We got to know one another at the Louvre, where his copies appalled both the attendants and the museum visitors. My Derain couldn't have cared less. . . . "19 Derain was equally impressed by Matisse's refusal to allow his natural gifts to lead him along traditional paths, and by his readiness to destroy work as he went along so as to strike out in fresh directions. But Derain, whose imagination would react spectacularly to Matisse's five years later in Collioure, was chiefly absorbed at this stage in a set of parallel experiments, conducted at home in Chatou with a new friend, Maurice de Vlaminck, whom he met for the first time in the summer of 1900.

It was the observant Boudot-Lamotte who noted that year with something approaching awe the final completion of Matisse's copy of Chardin's The Skate ("Cézanne was behind it," said Matisse),20 which the state purchasing committee refused to buy. Puy watched him start on a strange black-and-white inversion of Delacroix's The Abduction of Rebecca "in which the values were reversed as in a photographic negative."21 For all his absorption in his private struggle, Matisse found time in the Louvre to pass on to Puy his love of Chardin, Vermeer, and the even more unfashionable Poussin.²² He went out of his way to help when Boudot-Lamotte's first offerings were rejected by the official Salon, recommending the Salon des Indépendants instead, and coming round himself to select paintings for submission.²³ The two younger boys found themselves caught up in the excitement of a call for sweeping change that neither saw any need to answer as a painter, then or later. Both remembered ever afterwards the ferocity of Matisse's attack, his harsh but miraculously harmonious colours, the slashing brushstrokes together with the solidity and balance of the nude studies he made in Carrière's class. These studies—"blazing with pure colour and coordinated by great strokes of ultramarine, the work of a superb colourist"—were for Boudot-Lamotte among the most stirring paintings Matisse ever made.24

By contrast, his *Storm*, *Belle-Ile*—painted in 1897 and brought out for Puy, who had reached Carrière's class in 1900 straight from a summer on the island²⁵—already seemed a masterpiece of classical authority. Matisse

RIGHT: 1. Matisse, Woman Reading, 1895.
Oil on wooden panel, 24½ × 18½" (61.5 × 48 cm).
Camille Joblaud in the studio at 19 quai
St-Michel, painted just as Matisse began to
move away from the sober low-keyed harmonies
of his native North towards the discovery of
light and colour. "I was afraid I should never do
figures," he said, "and then I put figures into my
still lifes."

Below: 2. Matisse, Camille with Lemons and Blue Jug, 1895. Oil on wooden panel, $8\% \times 11\%$ " (22 × 30.1 cm)

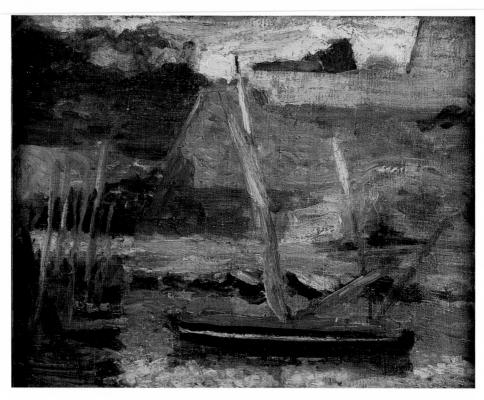

ABOVE: 3. Matisse, Belle-Ile (Le Port de Palais) (début de saison), 1896. Oil on canvas, $13 \times 16\frac{1}{9}$ " (33 × 41 cm) BELOW: 4. John Peter Russell, Red Sails, c. 1900. Oil on canvas, $20\frac{7}{9} \times 25$ " (53 × 63.5 cm)

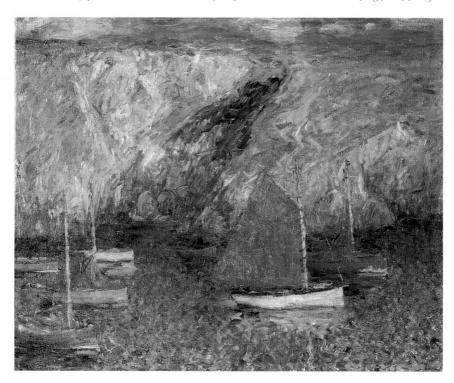

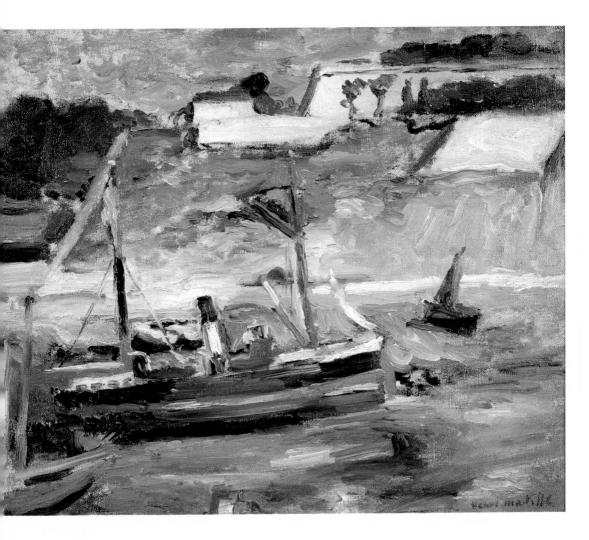

5. Matisse, Belle-Ile (Le Port de Palais) (fin de saison), 1896. Oil on canvas, $22 \times 25 \% 6''$ (55.9 × 64 cm). Matisse's two pictures of boats in the harbour were painted at the beginning and end of the summer during which, as a virtual pupil of John Peter Russell, he finally exchanged his traditional Flemish palette of earthy browns and clay greens for the rainbow colours of the Impressionists.

ABOVE: 6. Matisse, The Dinner Table, 1896–97. Oil on canvas, $39\frac{3}{8} \times 51\frac{1}{2}$ " (100 × 131 cm). The first in a long line of Matisse's works to outrage the public at the annual Paris salons; the other three canvases remained too disturbing to show to anyone except friends in private. RIGHT: 7. Matisse, The Invalid (Amélie Matisse), 1898–99. Oil on canvas, $18\frac{5}{16} \times 15\frac{1}{8}$ " (46.5 × 38.4 cm)

ABOVE: 8. Matisse, Corsican Landscape, 1898. Oil on canvas, $15 \times 18 \frac{18}{8}$ " (38×46 cm) BELOW: 9. Matisse, Swiss Interior (Jane Matisse), 1901. Oil on canvas, $14 \frac{1}{8} \times 18 \frac{7}{8}$ " (36×48 cm)

10. Matisse, Copper Beeches, c. 1900–2. Oil on canvas, $18\frac{1}{8} \times 15''$ (46 \times 38 cm). The picture bought by Bernard Berenson, painted in the park of the Humberts' château de Vives-Eaux.

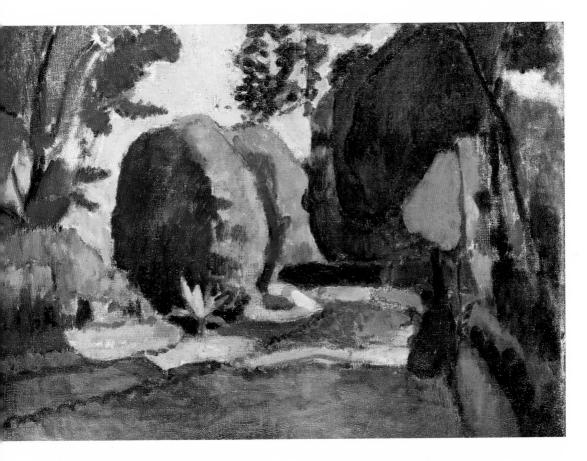

11. Matisse, The Luxembourg Gardens, c. 1900–2. Oil on canvas, $23\% \times 32''$ (59.5 \times 81.5 cm). Mme Matisse thought this too might well have been painted at Vives-Eaux.

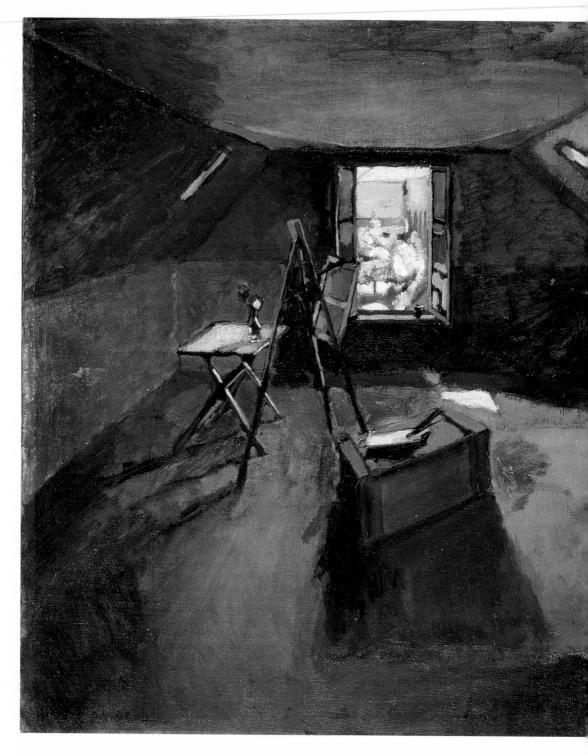

12. Matisse, Studio Under the Eaves, 1903. Oil on canvas, $21\frac{1}{2} \times 17\frac{1}{2}$ " (55 × 44.5 cm). Painted at 24 rue Fagard, Bohain, where Matisse and his family took refuge from public resentment and private humiliation in the grim months between the Humberts' arrest and their trial.

gave this painting to Puy, for whom it remained a touchstone all his life. Derain spent the following summer—his last before leaving for three years' military service in September—on Belle-Ile. Carrière himself was so struck by Matisse's painting hanging in Puy's studio that he too promptly left for the island (which proved to be his personal "road to Damascus," a turning point that radically revised his view of his whole life). Nearly half a century later, when one of Matisse's Belle-Ile seascapes resurfaced in an exhibition immediately after the Second World War, it poignantly evoked for his old friends the turbulence and grandeur of the struggles of their youth. "It's astonishing," Charles Camoin wrote of this canvas to

Matisse: "it's pure emotion."27

Camoin had been Moreau's last pupil in the few weeks before his death in 1898. Matisse was introduced to him by Marquet, and the three took to going about together, meeting in the crowded basement of the Soleil d'Or or in the quiet, shabby Café Procope—one of Verlaine's old haunts, now the working headquarters of the anarchist and decadent Mécislas Golberg—where you could sit and draw all evening for the price of a single coffee. They took the horse bus up to the Cirque Medrano and the rough, cheap music halls of Montmartre, which supplied them (as they would Picasso and his band a few years later) with sharply individualised live models. Matisse's work would be visited at intervals for the next thirty years and more by the chain of dancers leaping round the floor in the farandole at the Moulin de la Galette. The Moulin's proprietor urged them to attend his public auditions, held each afternoon at the Petit Casino on the passage de l'Opéra, where Matisse made hundreds of drawings of future music-hall stars, including Mistinguette, Paule Brébion and Gabrielle Lange.²⁸ For fifty centimes you could spend three hours sketching, with a bock or a cherry brandy thrown in, before being flung out of the Petit Casino. Concentrating against a background of hecklers, whistling and catcalls was not difficult for anyone who had served time at Moreau's. Alternatively, you could spend your fifty centimes on a twohour evening drawing session at the Académie Colarossi in Montparnasse, where the model took up a fresh pose every fifteen minutes while a pianist played Chopin or Beethoven.

In spring and summer Matisse and his friends patrolled the streets and parks with their sketchbooks, drawing cyclists, strollers, shoppers, cabmen and their horses, competing to see who could catch a likeness quickest. They followed the advice Flaubert had given Maupassant about how to catch in a single incisive gesture the whole moral and physical essence of any given hansom cab ("Show me, in a single word, what makes this cab

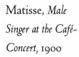

Matisse, Female Singer at the Café-Concert, 1900

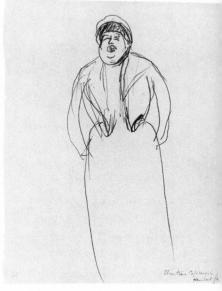

horse different from fifty others").²⁹ Matisse was still by his own account obsessed with Maupassant's essay on naturalism in the preface to *Pierre et Jean* (his two sons, born in 1899 and 1900, were called Jean and Pierre like the brothers in that book). Marquet dreamed of solving all his problems by becoming a cabdriver himself, perched high up under cover with a fine view, regular sums coming in and plenty of time for drawing between customers.³⁰ Camoin perfected a trick of tapping sharply on the pavement to make passersby turn round just long enough for a fast draw.³¹

They made a curious trio. Matisse's sturdy build, his greater weight of years, his neat professorial beard and gold-rimmed spectacles gave him an air of almost exaggerated sobriety in the company of the gnomelike Marquet and the even younger and no less waifish Camoin. Slight, shy, ingenuous, "part faun, part white-faced clown," Camoin at twenty, with his long nose and tentative moustaches, had an appeal that even confirmed misanthropes found hard to resist. All three were on their uppers—"Each bock was a problem," said Matisse — but all three were more streetwise than they looked. Camoin (whose father had died penniless when he was six) had learned self-reliance from a mother whom he adored, and who passed him throughout his childhood like a parcel round her relations in Marseilles. Marquet was still kept on a short string by his own mother. "Mon vieux, if your mother could see you now!" was his friends' regular

1900-1902: PARIS

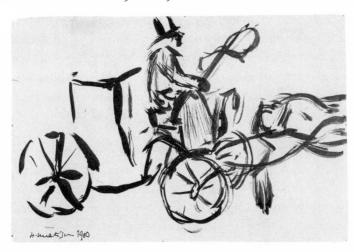

Matisse, The Cab,

refrain to Marquet, who was famous for making passes at every girl he met.³⁴ But Mme Marquet's button-shop on the rue Monge had not prospered in the ten years since she had moved with her son to Paris. A friend who dropped in at midday round about this time was shocked to find the pair of them sharing a dish of boiled lentils with neither bread nor wine to wash it down.³⁵

Marquet charged twenty sous, or one franc—less than the price of the cheapest meal—for a painting (even so, Matisse had to chase up at least one of their friends who fell behind on payment). Matisse, acting as his agent, once raised a lump sum of a hundred francs (twenty dollars) for a hundred canvases, forcing the purchaser to return the entire batch when Marquet's prices finally started rising. For the moment, all but the least fastidious collectors steered clear of this unprepossessing threesome.

Albert Marquet, The Handcart, 1900

Boudot-Lamotte remembered Matisse himself accepting five francs for three paintings from the owner of a junk-stall on the boulevard Raspail (when Matisse's prices also rose, well after Marquet's, the merchant paid him 300 francs apiece to sign his canvases).³⁷ If Matisse bought his paints on tick, Marquet restricted himself to the cheapest colours: white, umber and emerald green. It was a big day when Marquet could lash out at last on a tube of cadmium.³⁸

They wore the same shabby suits of corduroy summer and winter, year in, year out. Matisse regularly pawned his watch and overcoat (Marquet's had been stolen), and all three drew passersby or music-hall performers because even Camillo's or Colarossi's modest charges for a professional model were frequently beyond them. Matisse attended Carrière's class for nothing in return for performing the duties of *massier* (keeping the register, collecting the fees and tending the stove). They tried everything they could think of to raise money, including producing picturesque scenes to sell to foreign tourists on the rue de Rivoli. Matisse took this scheme seriously, sketching swans on the lake in the Bois de Boulogne and checking his observation against a specially purchased photograph, but the resulting canvas was another failure ("It didn't please me, and it didn't please anybody else").

Before he found out about Carrière's class in Montparnasse, he had signed on in desperation for a free municipal evening class on the rue Etienne Marcel, near the meat-market and not far from his wife's hatshop, where he copied a plaster cast of Antoine Louis Barye's Jaguar Devouring a Hare from the Louvre. 41 Almost exactly half a century earlier, Barye had taught the fifteen-year-old Rodin, who remembered him as a seedy little old man trying without success to flog his animal sculptures for two or three francs each in a dingy trinket-shop always on the verge of closure.42 His pupils despised him (Rodin repented bitterly later), and he was largely ignored by his contemporaries. By Matisse's day Barye had long since undergone the process of official secular consecration. Copying his works was now routine procedure in French art schools (casts of his Jaguar—and of Pierre Puget's flayed man which Matisse also copied—were standard studio equipment in du Maurier's novel Trilby). Matisse and the man at the next easel, who was an out-of-work sculptor, cooked up a moneymaking scheme to persuade the state to fund a statue of some consecrated genius who had not yet been commemorated in bronze. After poring together over a dictionary of great men, they fixed on the eighteenthcentury naturalist the Comte de Buffon; the only snag was that by the time

1900-1902: PARIS

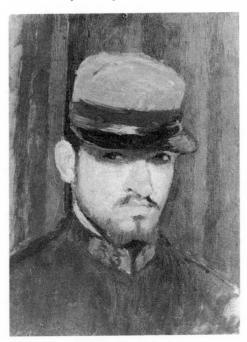

Charles Camoin, Self-portrait, 1901

the Buffon memorial won final approval, Matisse was so full of new ideas that his friend had to give the job of studio assistant to someone who could be trusted to enlarge the original maquette without incorporating changes or improvements of his own.⁴³

But Buffon had revived Matisse's interest in clay. He began modelling Barye's jaguar, wrestling with the clay all through the two crucial years, 1899 to 1901, during which he nerved himself to break through to a new art for the new century. He brought out his old peashooter from St-Quentin to shoot clay pellets at the floats of the fishermen on the barges strung out along the river beneath his studio window. These solid, peaceful Sunday fishermen came to stand for everything that blocked and thwarted the younger generation. Marquet, who had moved temporarily into a room in the same block as Matisse's studio, remembered shying stones from behind a tree in the Luxembourg Gardens at the artist Antonio de la Gandara, who specialised in highly saleable views of the balustrades and fountains. To hell with the Institute! was their war cry in these years. Long afterwards Marquet looked back wistfully to latenight conversations on the stairs at 19 quai St-Michel with "the Matisse of long ago, so alert, such a battler, always giving as good as he got." Each

relied at low points on the fighter in the other. The bitter note Marcelle Marquet detected in her husband's early street drawings—"a sort of vengeful rage" recurs in Matisse's account of their only successful attempt to find work as jobbing painters in a decorator's workshop.

This was the sort of workplace they would have ended up in if they had stuck it out in 1892 at the Ecole des Arts Décoratifs. They compiled a list of potential employers from the commercial directory and worked through it over several days, radiating out from the quai St-Michel by bus and on foot in ankle-deep mud and melted snow. They were finally taken on to help with preparations for the great Universal Exhibition of 1900 by Marcel Jambon, a well-known theatrical designer whose professional distinction contrasted sharply with conditions in his draughty workshop on the rue Sacrestan, high on the city's northern ramparts between la Villette and the Buttes Chaumont. Casual labourers worked a nine-hour day for one franc an hour, bent double, crouched over canvases spread out on the ground "as if they were breaking stones," spurred on when they faltered by kicks from their employer, whom nobody but Matisse dared answer back. 49

Matisse was put to work painting garlands of laurel leaves to decorate the halls of the brand new Grand Palais in a frieze one kilometre long. It was hard, mechanical, repetitive work, but what shocked him was the wretchedness of his fellow workers: unemployed waiters, errand boys and pavement-dwellers who taught him the basic rules of class warfare more efficiently than any socialist manual. This was the urban underclass: unskilled, unstable and short-lived. Matisse had grown up surrounded by men like this queueing to be taken on at factory doors in Bohain. Mécislas Golberg founded a paper for them called Sur le Trimard (Down and Out), published in the 1890s from the Café Procope. Matisse was appalled by the humiliation and the simmering anger of people whose only means of getting their own back on the system was to run up as many debts as possible at the local workmen's cafés before absconding with their wage packets intact. The men themselves were friendly and helpful, taking pity on his inexperience, explaining how to get through each day with the least effort and the longest breaks. They called him "Doctor" because his glasses made him look so serious: once they even fetched him to attend to an injured workmate.

Matisse developed a feverish head cold, always a response to strain in him since childhood. "Shut your mouth, Albert, or I'll kill you," he said when Marquet tried to cheer him up.⁵⁰ Jambon, who found Matisse's

brooding presence hard to stomach, sacked him after three weeks for truculence and insubordination. "When it came to earning a living," said Matisse, "we didn't know which way to throw ourselves." The contemporary painting section of the 1900 Universal Exhibition, opened in the Grand Palais on 1 June. The picture Matisse submitted was refused, although he could hardly have made a safer or less controversial choice. It was the *Woman Reading* of 1896—the first and almost the last of his canvases to have won professional approval—which he had fetched himself from the presidential residence at Rambouillet (being directed to the servants' entrance was a snub he never forgot). ⁵²

Matisse's Cousin Saulnier won a gold medal at the exhibition for his fashion fabrics from Bohain. Seguret et Thabut, one of the town's oldest and grandest textile houses, produced a silk commemorative banner showing a discarded lyre, an overturned classical bust, and a traditional artist's palette spurned by the gods, who offered their laurel wreaths instead in this opening year of the twentieth century to representatives from the modern world of innovation and experiment.⁵³ The exhibition brought a rich haul of gold and silver medals to Bohain's manufacturers, who drew crowds with their astonishing displays of silks and woollens, rich, vibrant, iridescent, shot through with strange lights (jaspées des éclats fauves), arranged in subtle harmonies or daring visual discords that exploited with unheardof brilliance every imaginable and unimaginable colour. By contrast the displays that attracted the biggest crowds for the lace-makers of St-Quentin were relatively academic: a fifteen-foot-long panel depicting the life of Joan of Arc in the Gothic style, an elaborate high Renaissance curtain, a meticulously accurate Louvre copy (of Murillo's Assumption), and a set of pastoral wall hangings which were—as the local paper put it—puvisdechavannesque.⁵⁴

Matisse returned with his wife to his triumphant hometown for the birth of their second child that summer. Pierre Louis Auguste Matisse was born on 13 June 1900 in the house of his Uncle Auguste, 55 who had taken over the seed-store and was himself planning an advantageous marriage the year after to the daughter of a grain-merchant from St-Quentin. Matisse's parents had retired across the road to 25 rue du Château, a handsome eighteenth-century town house backed by a long, narrow garden which both Matisse boys remembered later with affection. 66 Hippolyte Henri still drove the horses himself on delivery rounds all over the region, taking his elder grandson with him as soon as the child was old enough (one of Jean's happiest childhood memories was of sitting perched high

Jeanne Thiéry and her bridegroom, Henri's younger brother, Auguste Matisse, photographed at home in Bohain with his mother on the right and hers on the left

up above the glossy rumps of the great dray horses).⁵⁷ Anna Matisse loved her grandchildren and warmly welcomed a daughter-in-law who felt as strongly about Henri as even she could have wished.

But the Parisian Matisses did not stay long in Bohain. The contrast between Auguste's rising fortunes and the lamentable prospects of his elder brother was not lost on their neighbours. Henri's old friends were all doing nicely: Gustave Taquet was now in charge of his father's grocery shop, Louis Guilliaume in the process of setting up as the town photographer, Fernand Fontaine running a successful business in Paris. A gulf had opened between their world and Matisse's. The only one of his contemporaries to bridge the gap was Léon Vassaux, who had also moved away from Bohain for good. After qualifying as a doctor in 1898, Vassaux settled down to build a country practice at St-Saëns, near Rouen in Normandy, where he won the confidence of the poor subsistence farmers who came to him from miles around, paying his fees intermittently, often in the form of a pat of butter, some fresh eggs or a brace of pigeons. In later years one of Matisse's few remaining links with the world into which he was born would be the visits he exchanged with Vassaux, who made the most of life as a provincial bachelor, owning one of the first cars in rural Normandy, listening to concerts on an early wireless, and becoming a pillar of local

musical society, one of the region's pioneering Wagnerians as well as its first collector of Matisse's work (Vassaux owned seven paintings, including three canvases from Corsica and the *Still Life with Apples* which he called his little Chardin).⁵⁸

At some point in the summer of 1900, Henri and Amélie returned to face the broiling streets of Paris. Matisse said there was no money for summers in the country, although they visited Amélie's parents at least once that year at the Humberts' château de Vives-Eaux near Melun, where Henri painted the great trees in the park (colour figs 10 and 11).⁵⁹ Henri's friends liked Amélie. Those who knew little of his private life sometimes pitied a wife who now had two babies as well as a shop to look after, while her husband stayed out till all hours, shut up in his studio or visiting the Montmartre music halls. Jean Puy, whose family supported him in far greater comfort than anything the Matisses could manage, was charmed by the friendliness and simplicity of the little dinners for the three of them over which Mme Matisse presided. Henri's enthusiastic account of his researches was irresistible as always, but Puy was shocked to hear him say in front of his wife that he would have liked to live like a monk, alone in his cell, dedicated solely to his work.⁶⁰

It was the sort of heroic self-denial to which Amélie instinctively responded. Henri's driving sense of purpose, which drove hers, had been one of his great attractions from the day they met. Their marriage worked as a partnership, in which it was his business to paint while hers was to ensure that the smooth running of their daily lives freed him to concentrate on production. How she managed it at this stage is another matter. The attics where they lived above the hat-shop on the rue de Châteaudun

Dr. Léon Vassaux at the wheel of his de Dion Bouton, one of the first automobiles in rural Normandy

Matisse, Mme Matisse and Jean, 1901

were minute, and she had no help at home except for the six-year-old Marguerite. Amélie had left her first child as a baby of less than two months old with a wet nurse in Toulouse, and perhaps she found another for the second in the North. Pierre certainly grew up with fond memories of a nurse who had looked after him and his brother in the village of Busigny, halfway between Bohain and Le Cateau. Working wives in nineteenth-century France commonly entrusted children to their grandparents. Jean's mainstay as a small boy was his Matisse grandmother. Pierre, who spent much of his early childhood with his Parayre relations, formed a special attachment to his mother's sister Berthe.

The two boys were baptised in Bohain, with or without the knowledge of their stoutly anticlerical father, on 20 January 1901 at a ceremony attended by both sets of grandparents. Hippolyte Henri Matisse and Catherine Parayre stood sponsor to Jean, who was just two years old. Pierre, at seven months, had his Aunt Berthe and his Uncle Auguste as godparents. In Paris, Mlle Dameron at the hat-shop was given a Corsican landscape, perhaps for helping out at moments when the demands on Amélie as a mother threatened to conflict with her role as Matisse's partner. All that can be said for sure is that whatever the cost, then or later,

Amélie never allowed material hardship or domestic duty to assume greater importance in her scheme of things than she was prepared to give them.

The friends who knew her best admired and sometimes envied Henri for having secured so firm an anchor at the centre of his life. Amélie remained as retiring and discreet in company as her mother, but their friends' accounts give glimpses of her gentle, steadying presence, her determination and resourcefulness in face of each fresh setback. Albert Marquet (whose wedding present to the couple was the silver chocolate pot that figures in many of Matisse's early still lifes)64 painted his friend in the year of his marriage, looking tense in a blur with his features uncharacteristically indistinct. In 1900 Marquet celebrated the purchase of his first tubes of expensive coloured paints with a portrait of Amélie: a small, deceptively demure figure with head bowed, hands clasped, and feet planted firmly on the ground, looking the image of sober practicality except that the pink roses in her black hat and the animated blue shadows on her dark skirt have sparked off showers of pure colour in the background of the canvas. "The mauves, the oranges, the lemon yellows and April greens advance in crescendo...," wrote the Matisses' son-in-law, Georges Duthuit, who saw this painting as a herald of the Fauve canvases Marquet and Matisse would produce four years later: "The colours, exceptionally violent, have cleared a well-known path.... Everything has gone according to plan, as if expected. Everything except for the end result: a general effect that is, for Marquet, superb."65

Perhaps it was no accident that Mme Matisse set off this explosion. With Amélie's encouragement, Henri turned his back after the Jambon fiasco on the world that had rejected him, abandoning his search for work and treating his predicament as an absurd, elaborate joke. Once, with Amélie and Derain, he staged a dramatic scene for the benefit of passersby which ended with a body being hurled into the Seine (the victim was a dummy got up in the regalia of a Beaux-Arts professor). Another time they repaid the concierge whose disobliging manner infuriated Matisse ("Old mother Papillon was an intolerable woman") by throwing a party at 19 quai St-Michel for two hundred guests who arrived in a steady stream, each stopping to ask her for directions before disappearing up the stairs to Matisse's small studio, where they swapped hats and jackets, climbed out over the roof and in again through a friend's window on the fifth floor of the next-door building, then hurried downstairs to turn up once more as new arrivals at Mme Papillon's street door.

Matisse saw clearly enough in retrospect what lay behind these charades with their anarchic undertow of resentment, cold, hunger, want, and rage against the well-heeled bourgeoisie: "We were in a profession without hope. So we amused ourselves with nothing. . . . Joking, making up stories, sending everything up was all we could do. Painters? How were they supposed to know they would sell one day? There was only one way out: the Prix de Rome. Painters were lost souls."68 This was the period when Matisse saw most of his anarchist friend Maximilien Luce, who several times painted Notre-Dame from the window of the studio at 19 quai St-Michel.⁶⁹ Luce was a close friend of Camille Pissarro (for whom he had acted as middleman in 1898 in the negotiations that came to nothing over the lease of Matisse's studio). 70 Like Matisse, he had Picard blood: one of his great subjects was the splendour and misery of the northern industrial landscape with its fumes and flames, its belching chimneys, its looming slag heaps, its lurid purple and yellow night skies. Contemporaries saw his work as the pictorial equivalent of Emile Zola's literary naturalism. For a while in the 1890s, Luce became a Divisionist under the influence of Paul Signac, but he subscribed in the long term to no movement except anarchism, which had no subscribers.

The son of a Parisian railwayman, apprenticed on leaving school at thirteen to a wood engraver, largely self-taught as a painter, Luce retained all his life the habits, outlook and appearance of a fiercely independent workingman. "Glasses and a flat cap; below the glasses a short, straight, pointed nose, a little moustache and a wisp of greying beard; behind the glasses, two dark bright eyes with a piercing glance. The man...has no idea of getting himself liked. In his life as in his art, he never makes up to the customer."71 Luce's gruff speech and hangdog air were generally agreed to conceal a delicate sensibility, indomitable courage and a generous heart. He lived precariously, surviving from hand to mouth, sometimes with no fixed address, depending on his friends for studio space. He left (or was thrown out of) his lodgings in Montmartre in 1900, when Amélie Matisse said that he worked with her husband at 19 quai St-Michel.⁷² Although he was already in his forties, Père Luce fitted easily into Matisse's band of friends, who could count on support from no one but each other (they called one another "Père," meaning "Father"—Père Luce, Père Matisse, Père Marquet, Père Manguin—in ironic recognition of their total lack of status or success). He had a son midway in age between Marguerite and Jean Matisse, and he seems to have been regarded as almost a part of the family by the Matisse children.

Matisse, whose stories about Luce were ribald and affectionate, said that he had himself experimented with anarchism much as he explored possibilities—classical, other romantic, Impressionist-in his youth.⁷³ Practising anarchists among his friends included Mécislas Golberg (who had been officially expelled from France in the 1890s) as well as Luce (jailed for six weeks at the time of the great anarchist scare in 1894). Along with a great many other artists, Matisse contributed funds he could ill

Maximilien Luce, Self-portrait, c. 1910

afford to support prisoners and their families at a time when anarchists were under constant pressure from the French police. Each year he had a secret rendezvous with an anonymous contact to whom he handed over five francs for political escapees. As a young painter, he compared himself to one of Golberg's down-and-outs—"a vagrant [trimardeur] with only his legs to rely on, who trusts the road he travels"—in contrast to the "dilettante-butterflies" whose ample allowances allowed them to flit idly from flower to flower in the Louvre. Matisse said several times that having nothing to lose gave him a freedom not available to his more affluent contemporaries.

Certainly, of all Matisse's close friends, it was the two worst off—Marquet and Camoin—who felt as he did about Cézanne. Puy spoke for the majority when he said that, having seen the *Bathers*, he felt Cézanne would have been wiser to stick to painting tree trunks. He at Marquet (who had visited Vollard's pioneering show in 1895 with Evenepoel) assimilated Cézanne's influence in the early years of the century with the apparent ease and lack of fuss that characterised him as a painter all his life. Camoin was if anything even quicker off the mark. Born in a paint-pot, as he said himself (his family had been colour-merchants, decorators and art teachers in Marseilles), survivor of an upbringing in which art had often been the only stable factor, he had none of the prejudices or preconceptions that blocked his contemporaries' understanding of Cézanne: "I was

one of the few, with Matisse, to appreciate him; the others couldn't go that far, they preferred Renoir and the Impressionists." Posted at twenty-one in 1901 to his native south as a military conscript, Camoin tracked down van Gogh's painting of the local doctor which had been used to block a leaking henhouse in Arles. A few months later he made his way to Aix-en-Provence, where, of all the inquisitive young visitors trickling down from Paris at the turn of the century, it was Camoin in his corporal's uniform whose homage was most cordially received, and whose company most warmly cherished, by Cézanne. The other couldn't go

For Matisse, the upheaval set in motion by his acquisition of the *Three Bathers* was profound and painful. He said that he began each morning alone in front of it, rising early and padding into the studio on silent feet while his wife and daughter slept, so as to contemplate the painting by the first rays of the sun rising behind Notre-Dame. Matisse absorbed Cézanne—as he said Cézanne himself had absorbed Poussin minto his bloodstream at so deep a level that, though the underlying relationship is unmistakable, it is hard to pinpoint any specific visual resemblance. Cézanne represented reason, lucidity and logic: the principle of light that would impose order on the dark, formless conflicts of Matisse's own "naturally chaotic nature." He repeated again and again that an orderly canvas came from a well-ordered mind, and that the young painter must start by clarifying his responses. "There were always so many possibilities available to Cézanne that he needed more than most to put his brain in order," said Matisse, defining what became from now on his own first priority. Each of the said more in the said more into the said more i

Chaos and dissolution lapped at his heels in Carrière's class in 1900. The firmness of purpose he found in Cézanne marked the opposite extreme from Carrière's delicate, inconclusive searching, which looked like vacillation to Matisse. Carrière's work, always tentatively emerging from or tactfully retiring into a brown haze, supplied an easy target for disrespectful contemporaries ("They've been smoking in their room again," said Jean-Louis Forain of one of the crepuscular compositions for which Carrière's daughters posed).83 Cézanne himself remarked one day when the light suddenly darkened as he was painting Vollard's portrait: "Go for it! I suppose this is an answer to your prayers, Carrière!"84 But Matisse's jokes on the same theme, endlessly repeated later by his fellow students, were virulently personal. When the master's faithful pupils imitated his style, Matisse ordered the windows opened on the grounds that the stove was smoking. Boudot-Lamotte found him arrogant and heartless: "The boss won't be coming today," Matisse said on a morning of thick fog: "he's making the most of the weather to finish off his painting for the Salon."85

Whatever their ostensible target, the underlying butt of these jokes was Matisse himself, struggling to clear the fog from his own brain. What looked to others like aggression felt to him like rising panic. He could be patient with those who shared his own uncertainties, but he was merciless towards anyone showing signs of slickness, like the studio prodigy Pierre Laprade. Young Laprade was smart, ambitious, greatly gifted, already a clear favourite with the master. There are several accounts of Matisse prowling about behind him with edgy comments. "You need to start by losing your qualities," he advised through clenched teeth, according to Boudot-Lamotte (who conceded that Matisse was right: thirty years later Laprade was still painting the same thing, only worse).86 Derain remembered Matisse's malicious joke about one of Laprade's shadowy, streaky canvases: "Looks as if it's thawing."87 The joke became a boomerang when Laprade reaped the benefit of his qualities in a handsome deal with Ambroise Vollard, followed by a one-man show in 1903. "Looks as if it's thawing," he said smugly to Matisse⁸⁸ (who was six years older, and would be kept dangling for another year before he finally got his own one-man show at Vollard's).

Carrière himself held back, patiently refusing to rise to Matisse's crimson, green and purple confrontations save to say once that they looked to him like dye-work.⁸⁹ Another time he asked in exasperation: "And now, if you had a parrot to paint, what would you do?" To which Matisse replied, not without reason, "But I haven't got a parrot." His stint at Carrière's began badly and ended worse. Matisse said he left after about a year, when the class had to be abandoned for lack of pupils, but he also said that his approach had intimidated Carrière, who ended, like so many others, by sending him packing.91 Carrière understood well enough that his own role as a painter was transitional. He had been a co-founder in his youth of the breakaway Salon de la Nationale with Puvis de Chavannes, and in 1903 he astonished the Paris art world by throwing his considerable weight behind the new Salon d'Automne. In June 1904, when he was already dying slowly of throat cancer, he slipped into Vollard's to inspect Matisse's first show, which struck him as so badly hung that he offered to supervise the installation of the next himself. He sent for Matisse to confirm his offer, repeating "with great kindness" what he had said the first day they met: that he had never felt Matisse would care to take anything he had to give. 92 At the public banquet held that winter in Carrière's honour, Matisse was conspicuously absent, sending his wife instead to represent him with Marquet and Manguin.93 Carrière died in 1906. Nearing his own death almost half a century later, Matisse put a

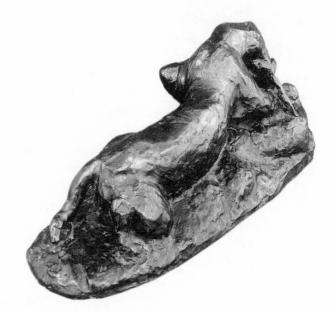

Matisse, Jaguar Devouring a Hare (after Antoine Louis Barye), 1899–1901

parrot at the focal point of one of his most beautiful, calm, orderly and brilliantly coloured cut-paper decorations.

BUT IN 1900 Matisse felt trapped and hunted, lost once again in the dark wood that had threatened to engulf him when he first reached Paris. Following what became a lifelong pattern whenever he found himself blocked as a painter, he turned to clay to organise and clarify his mind. The copy of Barye's Jaguar, recommended as a standard starting point in a municipal evening class, became over the next two years an exercise in selfdissection. Matisse's knowledge of anatomy was phenomenal. He had scored seventeen marks out of twenty in his Beaux-Arts anatomy paper in 1895 (he got no marks for architecture, three for perspective and four out of twenty for modelling).94 Nearly half a century later, after a major operation in 1941, he impressed the medical personnel from the surgeon on downwards by his anatomical expertise. 95 He had first acquired it at the popular lectures given for Beaux-Arts students by Professor Mathias Duval of the Sorbonne's medical faculty, whose course consisted of fourteen lectures on bones followed by an examination of the muscles in eleven dissection classes.⁹⁶

Duval's emphasis on minute observation coincided with Matisse's own need at this point to control conflicting impulses by scientific measurement. He worked blindfolded on the jaguar, using touch alone, with the help of a mounted skeleton of a cat supplied by the Beaux-Arts anatomy

room.⁹⁷ Duval, who inspired something like awe in Matisse from the start, encouraged his students to work by feel. He recommended practising on a flayed man, like the one Matisse copied, and on a wired-up skeleton ("In handling the bones, and experiencing the contact between their articulated surfaces, the purely descriptive aids of the articulated mechanism will take on a surprising reality, and remain forever engraved on the brain").⁹⁸ The professor was as clear as he was subtle, according to a Scots girl called Ottilie Maclaren who attended his lectures in 1900, noting that whenever he picked out an apparently insignificant detail, it "always develops into something which does not perhaps affect surface modelling, but affects movement."

Movement, rather than surface modelling, mesmerised Matisse. Barye had caught his jaguar with legs braced, belly flattened, back raked and furrowed by muscle-tracks like claw-marks, taut neck strung to clenched jaws in the act of snapping the spine of the hare, whose long, limp ears and dangling forepaws accentuate the ferocious concentration of the whole. But Matisse was not interested in the telling contrasts of Barye's elegant and alarming piece. He said he liked to finger his models so as to transmit his sensations directly through his fingertips to the clay. The sensation he transmitted to his jaguar, squirming spread-eagled on its formless prey, was of how it felt to be Matisse himself clawing what he wanted out of Barye's work.

He began work in 1900 on another sculpture, using the Italian male model he had painted to disquieting effect in Carrière's class. If his Jaguar is an image of devouring fury, this standing man—eventually called The Serf-ended up as an embodiment of stoical effort and endurance. The model, called Pignatelli and nicknamed Bevilacqua, was already famous as a favourite for more than twenty years with Rodin, who had based his St. John the Baptist on Pignatelli as a young man. Rodin described him at their first meeting as a gaunt, hungry peasant fresh from his village in the Abruzzi, grinning like a wolf, exuding a sense of danger, brute violence and almost mystic strength. Invited to pose nude, "he stood firmly rooted, his head raised, his torso straight, resting on both legs, which were open like a pair of callipers." Since then Pignatelli had posed for the celebrated Walking Man; for a skeletal burgher of Calais, Jean d'Acre; and for the cannibal Count Ugolino, who devoured his sons. In 1900 Rodin was recycling his Ugolino as Nebuchadnezzar, entrusting the work to his pupil Ottilie Maclaren, for whom Pignatelli posed at Rodin's expense that November. She was delighted by the "magnificent old chap," who assured her in his broken French that he would be her lucky mascot ("He tells me

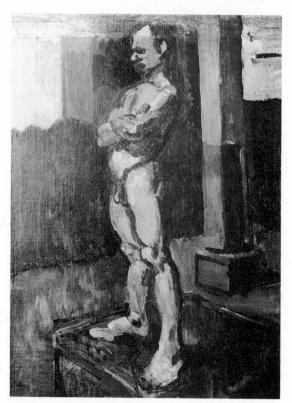

Matisse, Male Model (Bevilacqua), 1901

that he brings 'la chance. Tout le monde attraper la médaille quando travaillans con moi!' I think to 'attraper' a medal is a lovely idea"). ¹⁰¹

Pignatelli, or Bevilacqua, was also posing in the autumn of 1900 for Matisse, who drew, painted and modelled him over the next three years in well over a hundred sittings (sometimes he put the figure at three or five times as much). Various female models would absorb him at intervals in the future to the exclusion of all else, but this was the only time he ever subjected a male body to the same brooding and possessive scrutiny. Bevilacqua became a regular at 19 quai St-Michel, even pushing the handcart loaded with Matisse's and Marquet's canvases on fruitless forays to and from the salon. When circumstances forced Matisse to give up the studio and leave Paris, the first thing he did on a brief return to town was fix up sessions with Bevilacqua. Among the group of Carrière's ex-students who clubbed together to share a model after the class folded, it was Matisse who insisted on hiring Bevilacqua, to Jean Puy's disgust. Puy could never understand what either his friend or Rodin saw in a worn and aged model, more ape than man "with the face of an orang-outang, half-hidden in his

long hair and beard," "a sort of anthropoid" who seemed long since to have sunk to the bottom rung of his profession. 104

Soon after he started work on The Serf, Matisse called at Rodin's headquarters in the old royal stoneyards on the rue de l'Université, taking with him a batch of drawings on the advice of one of the master's assistants, Marie-Vitel Lagare, another ex-Moreau student who attended the same sculpture classes as Matisse in Montparnasse. 105 Rodin at sixty felt spurned and ostracised. Dismayed by the public outcry that had greeted his Balzac two years before, he had retaliated by erecting his own personal pavilion at the Universal Exhibition. When the public failed to flock to his pavilion, he retreated to the consoling company of his admirers, for whom he remained part god, part modern Michelangelo ("He sits

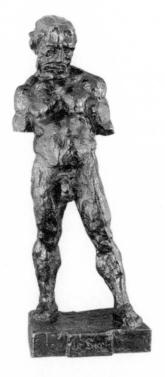

Matisse, *The Serf*, 1900–c. 1906

enthroned in their midst," wrote Henri de Groux in 1901, "convinced of his own worth, letting fall from time to time a monosyllable which he leaves them to interpret as if he were an oracle"). Rodin treated the young as a potential asset. "He looks on all his pupils simply as disciples of his creed," wrote the grateful Miss Maclaren, "who will in turn teach others so that his work will not cease with his death."

He went to some lengths in 1901 to encourage a smooth young operator called Gerald Kelly, who arrived with an introduction from Paul Durand-Ruel (Kelly would end up as president of the Royal Academy in London). But Rodin responded less enthusiastically to Matisse, who was shocked by the master's habit of working piecemeal on sculptures which he assembled, or dismantled and updated, like units on a factory production line (Rodin kept drawers full of severed hands, many of which had in fact been modelled by assistants like Ottilie Maclaren, or her predecessor Camille Claudel). Matisse was put off by the streak of mountebank in Rodin, and wounded when the master diagnosed in him the facility he had himself complained of in Laprade.

The artists and intellectuals who revered Rodin in France at this stage belonged chiefly to the generation before Matisse's. To younger sculptors he seemed more like a menace. Brancusi, Lipchitz and Maillol all turned their backs in the early years of the century on Rodin, whose massive presence blocked their light. Matisse, too, was beginning to look beyond the exuberantly inventive naturalism of Rodin's art to something broader and more sweeping. The job lot he had bought from Vollard included Rodin's plaster bust of the right-wing journalist Henri Rochefort: Matisse made what proved to be a seminal drawing from it in 1900, but his immediate goal lay elsewhere. "Already, for my part, I could only envisage a generalised architectural way of working, replacing descriptive detail by a living and suggestive synthesis. Here we come, in fact, to the antipodean opposite of the Rodinian creed." Rodin asked his young visitor to come back when he had learned to put more detail in his drawings, but Matisse never called on him again. The Serf, according to Jean Puy, who watched it growing, "started from a conception close to Rodin's but became something quite different, cruder and more formless, but exceedingly expressive." 110

Still in search of the teacher he said he needed and who was proving almost impossible to find, Matisse fell back on Rodin's senior assistant, Antoine Bourdelle, who ran the evening sculpture classes he attended with Lagare. III Bourdelle, only eight years older than Matisse, was himself approaching open revolt at this point, having taken all he could from a seven-year apprenticeship to the master ("I recognised myself as an ANTIDISCIPLE of Rodin. My syntheses are all directly opposed to the laws that govern his work"). 112 Matisse liked Bourdelle, who was the grandson of a goatherd, born near Montauban in the same region of southern France as Amélie Parayre. He was slight and sinewy, with a shock of black curly hair and the same impassioned openness that Matisse warmed to in Amélie's father. Sculpture was in his blood. He had grown up in the workshop of his father, a wood-carver and cabinet-maker, and been taught "to listen to the rock" by his uncle, who was a stone-cutter. 113 Encouraged by the village schoolteacher, trained at the art school in Montauban, he had reached Paris at the age of twenty-four in 1885, snorting and pawing the ground, as Rodin said, "like a little bull entering the arena." 114 Life in the capital meant years of extreme poverty, sickness and disorientation for the young Bourdelle. Rodin rescued him, but it was never easy for another sculptor to survive, let alone to grow, in Rodin's shadow.

Matisse probably made contact with Bourdelle in 1900 through Carrière, who was the sculptor's close friend and neighbour. The two lived next door to one another in a row of modest, one-storey studios on the impasse du Maine, backing onto the market gardens, cornfields and cow pastures that still lay on the far side of the boulevard du Montparnasse. Bourdelle took his first pupils in a teaching studio set up in the spring of

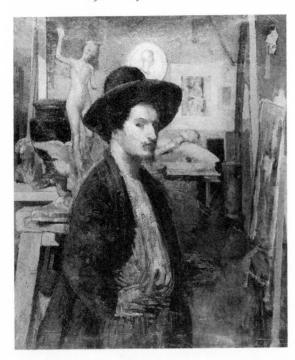

Antoine Bourdelle, Self-portrait in His Studio, n.d.: where Matisse became a sculptor

1900 by Rodin (who promptly abandoned his share of the teaching, keeping only Ottilie Maclaren and two other favoured female pupils). Classes were held in a studio block at 132 boulevard Montparnasse, where Matisse seems to have worked (he would make his Paris headquarters in the same building thirty years later) before Bourdelle moved his class to the new Académie de la Grande Chaumière, installed in a former dance hall a few hundred yards away on the far side of the boulevard. 115 Both were within easy walking distance of the impasse du Maine, where Bourdelle's studio opened into Carrière's. The pair tended to cast themselves with Rodin as beleaguered outlaws of the art world, standing shoulder to shoulder against officialdom alongside what Bourdelle called "all independent spirits, all those who have been scorned or rejected."116 When Carrière died in 1906, Rodin sought justice for his friend—and by implication for himself-by appealing over the heads of their contemporaries to the spirits of antiquity, of the great masters of the Renaissance, and of the new twentieth century.117

If Rodin marked the end of one epoch, Bourdelle saw himself as the start of another. He was brought up in the radical tradition of the Midi by a father who had been a passionate Communard, and whose livelihood never recovered after the Commune collapsed in 1871. The whole family

migrated northwards to live on next to nothing in the young Bourdelle's Montparnasse studio, which became a famously hospitable refuge for other exiles from the Midi. Bourdelle remained all his life, in Rodin's phrase, "a Greek from the south of France." His art at its best looked back beyond the artifice of Renaissance civilisation to the primitive simplicities of his ancestors beneath the harsh light of the Mediterranean. He spoke French with a heavy southern accent, and by his own account, he sculpted in his native language (which was also Amélie Matisse's), the langue d'oc.

When Matisse met him, he was groping towards his own individuality through his first major sculpture, a memorial to the Franco-Prussian war commissioned by his hometown. The Montauban Monument disrupted the heroic and naturalistic conventions of French nineteenth-century war memorials—"trumpet, standard-bearing woman, wounded soldier," wrote Mécislas Golberg laconically—in a way that caused consternation when it was finally unveiled at the Salon de la Nationale in 1902. For years

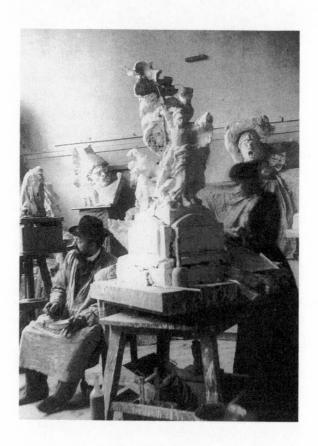

before that, Bourdelle's studio was littered with the monument's component parts, half-finished or waiting to be cast: distorted, howling heads, distended bodies, splayed hands like grappling claws—"gestures of desolation, rage and despair," wrote Golberg, who saw in this monument a distillation or abstraction of the brutality of war. "The foot soldier, like an avenging angel, seems to explode out of the marble; the cuirassier flings himself upon the living flesh, and the dying man wears a hideous last grimace." The citizens of Montauban were outraged, like the Parisian critics, by what seemed to them the deformation of Bourdelle's figures. By far the boldest of his inventions—the *Crouching Warrior with Sword*, completed in 1898—was reduced essentially to a foreshortened naked back on braced bent legs, with an abbreviated sword arm, bearing down on its prey in the same plunging movement as Matisse's *Jaguar*.

Matisse said he went from copying Barye's original as a routine exercise in the school on the rue Etienne Marcel to Bourdelle's correction class, where he continued work on the Jaguar and started on The Serf in 1900. In both works he moved away from anatomical naturalism (and from Rodin's elaboration of it) to a simpler, more abstract approach. Bourdelle's own sculpture always worked best when the wilder flights of his imagination were contained within severe geometrical constraints, as in the great jutting prow of his Rodin, or in the Herakles Archer that finally made his name in 1910. "You cannot have too much discipline," he said; "vou can never have enough." 120 He would end up ignoring his own advice, with disastrous consequences for his work, but in 1900, when he was still approaching his prime as a sculptor, it pointed in the direction Matisse himself was already taking. Bourdelle was a brilliant teacher. "The hand is never clumsy when thought is precise, when the spirit is not hesitant," he told his students. 121 "You must create, between yourself and your object, a stronger and stronger bond ... always remembering this truth, that the design is not to be found in the model but in ourselves. This sort of operation obviously cannot be forced, because it requires on our part (as well as intelligence) something that comes from the depths of the soul: emotion."122

These precepts echoed the teachings of Bourdelle's strange and charismatic friend Golberg (who was a year older than Matisse). Up until almost the end of the nineteenth century, Golberg had been a philosophical anarchist, a political and social thinker with a medical training and no particular interest in aesthetics. A Russian-Polish Jew twice deported for subversion by the French authorities, he was finally granted a provisional

Antoine Bourdelle, *Mécislas Golberg*, 1900: the prophet who called for a new art for the new century in Bourdelle's studio, where Matisse met him in 1900

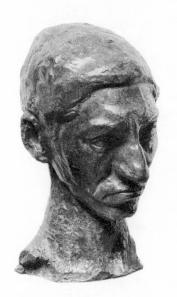

resident's permit in 1899 in return for an undertaking to abandon all political involvement. Instead he brought his subtle, searching, well-stocked mind and his extraordinarily refined sensibility to bear on the possibility of a new art for the new century. In 1900 Golberg sat for Bourdelle, whose experimental approach reinforced and stimulated his own ("Believe me, your works in marble and your plaster casts have given me strength in all my doubts"). 123

Between them they evolved a basis for radical innovation which they systematically explored over the next few years, Bourdelle as a practitioner in clay, Golberg as a critic and theoretician in successive

articles. "What is needed is an art based on feeling, on construction and on intelligence," he wrote in 1903. ¹²⁴ The aim of the stripped and streamlined modern art which Golberg confidently predicted would emerge from Bourdelle's studio was to express internal emotion, rather than to reproduce external reality. In the opening years of the twentieth century, Golberg was already examining the philosophical possibilities of abstraction. "The progress of art lies in the concentration of movement, in its visible simplification and its formal domination," he wrote. "The more completely the artist is in possession of his form, the more he depersonalises his feeling."

Similar themes would reappear in the "Notes of a Painter" which Matisse wrote for Golberg in 1907. The two certainly got to know one another in Bourdelle's studio, and perhaps they worked together as well, for in addition to his private sittings, Golberg posed naked for the entire sculpture class in 1900. This bizarre episode became a parable in Golberg's subsequent account, illustrating the gulf that yawned in Bourdelle's class between nineteenth- and twentieth-century attitudes to art. Destitute as always, emaciated by years of self-neglect and malnutrition, Golberg was already in the late stages of tuberculosis. He spat blood, struggled for breath and could no longer walk unaided. He was known affectionately by his admirers as the living skeleton ("le fameux cadavre ambulant . . . le plus bilare des cadavres"). The young disciples who propped him up, paid for his drinks and listened to his teachings in cafés like the Procope or the

Closerie des Lilas, saw in Golberg an heir to Hegel, Nietzsche and the great prophetic Russians, Bakunin, Tolstoy and Prince Kropotkin. They loved him for the gaiety and courage of a spirit that triumphed against the odds over physical disintegration, but even they were often appalled by the smell of the grave Golberg brought with him.

"His face was fearfully bony, almost corpselike, split by a great mouth, ravaged by scrofula and black as a vision of hell, with the eyes of an Oriental Jew brightened by the perpetual fever of tuberculosis." True to their Beaux-Arts training, Bourdelle's hard-boiled students arranged this living skeleton in the pose of a fighting gladiator. The lesson Bourdelle taught them—egged on by the sardonic Golberg, who treated his illness as a tormentor to be defied and derided in a series of macabre tricks like this one—was the novel concept of portraying the model in whatever pose came naturally. "Copy him as he slumps" was Bourdelle's instruction. "You will have a good drawing of a dying man in place of a bad drawing of a gladiator." 129

Matisse later passed on similar advice to his own students. It is probably impossible to sort out exactly what, or from whom, Matisse learned in Bourdelle's class. All that can be said for certain is that Golberg was working towards an underlying theory of modern art—"an aesthetic of reduction, of movement and of speed"130—on the basis of what he saw in Bourdelle's studio at the time when he and Matisse first met there. "He understood Henri Matisse," wrote André Salmon (who maintained that Golberg's influence on his own Parisian generation at the turn of the century was incalculable), "and he admired Bourdelle." I31 Golberg explored the possibilities of the new art both as critic and as editor of his occasional periodical, the Cahiers de Mécislas Golberg. His last act, before death finally caught up with him in December 1907, would be to plan a special issue of the Cahiers focussed on Matisse's art rather than Bourdelle's. Invited by Golberg to explain his position for this number, Matisse produced the first, the longest and by far the most carefully considered statement he ever made about his work. "Notes of a Painter" (which was eventually published elsewhere) originated as a response to the critic who had sensed the direction in which Matisse was moving almost before he did himself.132

As for Bourdelle, he was speedily overtaken by his former pupil in the first decade of the century. His bronze *Self-portrait* of 1908 has both arms sliced off and one foot thrust forward in a pose that owes much to Rodin's *Jean d'Acre* and to his *Walking Man*, but something perhaps also to *The Serf*,

which Matisse stripped down obsessively between 1900 and 1903. By the time he cut off its arms in or after 1908, The Serf had become in essence a powerfully concentrated self-portrait. Bourdelle had given Matisse what he most needed in 1900: backing for the discoveries he had made on his own account in the south. Bourdelle's work looked forward to the future. and back to a supposed primitivism which cut through the stranglehold of the Western classical tradition. Matisse responded by giving him one of the paintings that had bewildered his more conventional friends when he arrived back from the Midi: a brilliantly coloured landscape which the sculptor liked so much that he borrowed a second one to hang above his dining table, where he could study it while he ate. ¹³³ As a child, Bourdelle had watched a captive eagle sitting for many months hunched and immobilised on its perch until one day it slipped its chain, spread its wings and flew. He came to see the eagle as an image of himself, but everything he said about it applies as aptly to Matisse. "It is only after immense labour," Bourdelle told his students, "with ideas at last spread to their full extent, that the spirit of man can soar." 134

By 1900 Matisse had identified a central division in himself between, on the one hand, the lucid, orderly intelligence harnessed to a prodigious capacity for work and, on the other, the ravening imagination that had to be curbed and tamed before it could be allowed to soar freely. He painted two self-portraits that year. One depicts a workmanlike character with appraising eye and rolled-up sleeves, the researcher whom Puy remembered measuring everything that could be measured in Carrière's class. The canvas is filled with loosened, semiliberated colour: sunny yellows and warm ochres envelop the figure, a purple stripe bisects the white shirtfront, green splodges invade the forehead and left shoulder, crimson brushstrokes lick vigorously up the trouser legs. The second self-portrait shows why his contemporaries found Matisse so disturbing. Here the figure looms up as a dark, shadowy mass, threatened and threatening, against a turbulent purply blue and crimson ground. More than forty years later, when Matisse supervised the installation of the museum named for him in his birthplace of Le Cateau, he hung the drawing for this sombre selfportrait above the Jaguar, in which he said that he had "identified with the sensations of the wild beast [or fauve]."135

ON 15 MARCH 1901 the first van Gogh exhibition Paris had ever seen (apart from the memorial show of sixteen paintings put on after the painter's death) opened in Bernheim-Jeune's gallery on the rue Lafitte. Both Matisse and Vollard were impressed by a rough customer in a red

necktie who towered over everyone else in the tiny gallery, forcefully proclaiming his enthusiasm for pure colour. This was André Derain's friend, the twenty-four-year-old Maurice de Vlaminck, who said that he felt at their first encounter as if van Gogh had rushed out at him spoiling for a fight. Flemish by origin like Matisse, with no formal training and no art-world contacts, Vlaminck put the fierceness of his reaction to van Gogh down to their common northern origins. Matisse was introduced to him by Derain, who seemed still a little nervous of a companion he had met by chance the year before on a suburban train to Chatou, where both lived with their families. Derain's parents had forbidden him to associate with Vlaminck, who cultivated a reputation as the local bigmouth and bad hat. But the couple continued to meet secretly at Derain's house, where Vlaminck came to whistle beneath his friend's attic window and call up news of his latest pictorial breakthrough ("Listen, André, it's brilliant! I'm painting all in red!"). The painting all in red!").

Matisse told this story afterwards with relish, acting out the furtive exchanges between the two conspirators as Vlaminck lurked beneath the window at which Derain held up his canvases one by one, tilting them this way and that, for his friend's inspection. Vlaminck had plunged headlong into painting in his early twenties, treating it as a physical expression of anarchy and revolution. He painted as fearlessly as he boxed or cycled (Vlaminck, who already had a wife and two small children to support, scraped a living from amateur fistfights and cycle races as well as by giving drawing or music lessons, playing Gypsy numbers on his violin and turning out mildly pornographic novels which Derain illustrated). Lack of inhibition was his strong point, and he guarded it jealously, shunning all contact with museums or art schools, and glorying in the effect he produced on his own and Derain's parents as on all the other law-abiding shopkeepers of Chatou. "My paintings horrified everyone," he wrote with satisfaction. He wrote with satisfaction.

What he called his "clumsy violent colourations" had a spontaneity and attack unlike anything Derain had ever seen before. Time has mellowed the electric reds that astonished Vlaminck's contemporaries nearly a century ago: "You could see in the work of these two beginners an attempt to use vermilion as the Impressionists used ultramarine," wrote the painter Francis Jourdain, describing the impact of van Gogh at Chatou, "that is to say, more as a vibration than a tone." Vlaminck's temerity gave an edge to Derain's museum-based approach. When Matisse took the train to Chatou to see what the pair were up to, the results kept him awake all night and brought him back for a second look the next day. 142

In April 1901 Matisse showed for the first time at the Salon des Indépendants: a landscape, three still lifes, and three of the "superb nude studies" that so impressed Boudot-Lamotte. He also included a selection of his street and café-concert drawings: "airy flights from the tip of the pencil which seized on any blemish, ugliness or absurdity in the most irresistible way," wrote the critic Gustave Coquiot. "I remember a woman with a hooked nose, and another astonishing harridan sporting a great mane of hair like wood-shavings above the heroic jutting prow of her bust." ¹⁴³ But this was the last time Matisse ever showed the sort of satirical and sharply observant thumbnail sketches that reflected the dry, humorous, foot-on-the-ground side of his northern nature (he burned some hundreds of them later).

Deeper, darker impulses—the side of himself that identified with the wild beast, or *fauve*—were drawing him in a direction that frequently alarmed him. But once again, as in the crisis of his leaving home ten years before, he had gone too far to turn back. "So I charged forward, head down, working on the principle I had had drummed into me all through my childhood, expressed in the phrase: 'Get on with it!' . . . Like my parents, I got on with my work, driven by I don't know what, by a force which I realise now was alien to my normal life as a man. . . "144 Misgivings about his abnormality became one of the professional hazards Matisse learned to live with over the next decade and more. None of his pictures sold that spring at the Indépendants. Nor did any of Marquet's. Plodding home afterwards with Bevilacqua and the handcart full of their unwanted canvases, Marquet wished aloud that they might all be run over, which would at least have meant some hope of financial compensation. ¹⁴⁵

Marquet said that of all the exhibitors at the Indépendants, he and Matisse were the only ones to use pure colour in 1901. These were the years when the problems each posed as a painter, and the solutions they moved towards, coincided more closely than ever before or afterwards. Looking back later, Matisse said that considering how intensely they worked together, it was astonishing that each emerged with his artistic identity intact. They evolved an incisive, flowing, almost calligraphic style of drawing, and they used colour rather than modelling to compose in paint, taking their cue in each case from the Japanese ("When I look at Hokusai, I think of Marquet—and vice versa," Matisse said. "I don't mean imitation of Hokusai, I mean similarity with him"). Italiapanese prints, picked up from boxes of cheap engravings outside the art-shops on the rue de Seine, exerted a liberating and regenerative influence on Matisse's whole generation of French artists. He said that the patina of

wear and tear, together with the fading and discoloration of these low-grade reproductions, only added to the sense they gave of escaping from the tyranny of naturalism, which was what he was after at the time. ¹⁴⁹

After Carrière's class closed down, his more adventurous students continued to meet in the studio of Jean Biette on the rue Dutot, one of the newly built-up streets in what had until recently been open country beyond the boulevard du Montparnasse. Here Puy watched Matisse paint Bevilacqua on a dull wintry day made even duller by the grey-papered walls of Biette's studio:

But Matisse and, behind him, Derain represented this grey as a thick heavy blue and the forms of the model orange. It was striking but completely out of touch with reality.... Matisse at that moment did not hesitate to distance himself so far from reality that it verged on cruelty to the eye.¹⁵⁰

Matisse gave or sold this painting to Biette. Puy owned its almost equally powerful companion, painted a few months earlier in Carrière's studio, *Model in Pink Slippers*. But Puy's doubts and hesitations contrasted sharply with Marquet's lack of either. Matisse painted with Marquet from the studio windows on the quai St-Michel, out of doors in Parisian parks, and on expeditions to suburbs like Arcueil. If Matisse showed only a single landscape at the 1901 Indépendants, it was probably because the improvised colour harmonies of his experimental landscapes stood little chance of acceptance even by most other painters, let alone by the public at large.

He was learning to trust his instincts like Vlaminck, and like another painter whose debut caused a considerable commotion at the Indépendants in 1901, Jacqueline Marval. Impetuous, imperious, impossible to ignore, Mme Marval lived with Jules Flandrin in the rickety wooden warren of studios at 9 rue Campagne-Première opposite the Luxembourg Gardens, where the couple set up their easels with Matisse and Marquet. Marval was almost thirty when she became a painter in 1895, shortly before Vlaminck and with as little premeditation. Rumour said that, fed up with hearing about the claims and pretensions of Moreau's students, she dashed off a couple of landscapes on cigar-box lids "just to teach Flandrin how it should be done." The couple were in the thick of post-Moreau debates about what Flandrin called "the whole question of good and bad, the beautiful and the ugly," which invariably ended with everyone agreeing that the first aim of the true artist was to throw overboard everything he had been taught at school. Flandrin's bright, warm

colours and impressionistic technique broke established rules ("A few poppies and cornflowers in a jug on a piano gave him nightmares!" Flandrin wrote of one carping critic. "And I thought all I'd done was paint a bunch of flowers!"), ¹⁵⁴ but Marval's initiatives were bolder still.

She and Flandrin had been among the few to respond enthusiastically to the canvases brought back from Corsica in 1898 by Matisse, who presented the couple with one of them. 155 A sunset Marval painted in the Luxembourg Gardens provoked a stir. The tolerant amusement of Flandrin's friends began to give way to surprise and unexpected interest. Unhampered by an academic background, having no classical baggage to get rid of, Marval possessed an earthy directness as an artist that powerfully impressed her male contemporaries. "How many artists have found the scales fall from their eyes in front of Marval's paintings, which were so utterly without showiness and yet so cunningly constructed," wrote the painter Lucien Mainssieux (himself a protégé of Flandrin, newly arrived in Paris from their hometown of Grenoble in 1901). "Marquet, Flandrin, Matisse all awaited each work she produced with curiosity and emotion." 156

Marval had the looks as well as the temperament of a great beauty: a generous figure and strongly modelled features with an incisive nose, wide

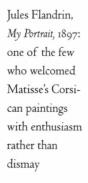

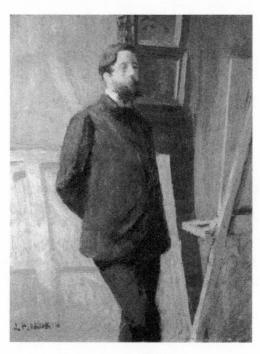

Jules Flandrin,
Marval Reading,
c. 1895: Jacqueline
Marval, whose
radicalism as a
painter astonished
and impressed her
male contempo-

mouth, high cheekbones, strange pale eyes like glass, and a mass of red hair bound in floating veils or crowned by an extravagant hat (which she made herself). In her prime as an artist—in the years immediately before and after the First World War, when she was stockpiled by Ambroise Vollard, fêted by Eugène Druet, and generally regarded as a reigning queen of the Paris art world—she would be dressed by Poiret and Paquin. But at the start of their parallel careers, when she and Flandrin sold little or nothing, she kept them both by sewing and embroidering waistcoats. Her reputation would suffer later (like Matisse's) from an association with the decorative or applied arts that was one of her strengths as a painter. She composed intuitively in colour, treating form like a sculptor (or a dress designer), "almost modelling the forms of her fleeting nuances, pummelling them brutally, then suddenly adding a note of black or intense gentian blue like a modiste finishing off a hat with a charming ribbon." 157

Marval's courage was indomitable. "Marquet and Matisse were bowled over by admiration for Marval's personality, as much as for her work," Marcelle Marquet said long afterwards. The circumstances of her early life would have sunk anyone less buoyant. Born Marie Vallet near Grenoble in 1866, and qualified as a village schoolmistress, she made a disastrous marriage from which she fled to Paris as a painter's model. She lived for thirty-five years with Flandrin, whose oaklike solidity and strength complemented her own imaginative drive. Marval's daring was as impressive as it was at times absurd. She turned her sex—which made it

far harder for her to be taken seriously than for any of the others—into a trump card. It was generally agreed that genius was Marval's prerogative while her male colleagues could aspire to no more than talent ("Homage from good taste to genius" ran the message on a joint postcard from Marquet and Henri Manguin to Marval in 1905). ¹⁵⁹

But their affectionate teasing was grounded in genuine respect. Marval—like Bourdelle, with whom she was often compared—cut through the stale atmosphere of the Paris salons, letting in great draughts of fresh air and light. Both were moving towards an essentially abstract art which would work primarily through rhythm, form and colour. "The lines talk, the colours sing, the whole is like good music perceived through the eye," wrote Jules Flandrin, ¹⁶⁰ who was by no means the only observer to be struck over the next few years by "Mme Marval and her influence on Matisse." ¹⁶¹ Marval's harsh and vibrant colours, her formal economy, the energy of her attack impressed painters from Georges Rouault to Kees van Dongen, as well as her close friends Marquet, Manguin and Matisse.

In the late spring or early summer of 1901, Matisse joined his family from Bohain in Switzerland, where he painted a series of small mountain landscapes ("one a day, as I might have done picture postcards"). He also painted his future sister-in-law, Jeanne Thiéry (afterwards known as Jane Matisse), seated with her back half-turned to the spectator at the writing table in her hotel room (colour fig. 9). The canvas is full of light and air, organised in animated blocks of colour: pinks, blues and greys with splashes of violet and lemon yellow against a darker ground. It is lit by the clear blue rectangle of a long window opening onto a verandah on the left, and balanced on the right by a basket chair, or rather by a shorthand notation of curving yellow and pink brushstrokes which aerates the whole canvas in a way that looks forward to the hotel paintings Matisse would make nearly twenty years later in Nice.

The picture was painted at Villars-sur-Ollon, a tourist resort just over the Swiss border to the east of Lake Geneva, set high above the Rhône Valley in a sunny, sheltered amphitheatre surrounded on three sides by the foothills of the Alps. ¹⁶⁴ Matisse painted the newly opened road linking Villars for the first time to the next village of Chesières. This was a prime site for the new century's leisure culture. Climbing was considered too strenuous and skiing was still unknown, but there were tearooms everywhere with striped awnings, wicker furniture and potted palms. Brandnew hotels with broad eaves and wooden verandahs, like the one in Matisse's picture, were shooting up all over the wooded plateau, dwarfing the peasants' huts, throwing out new wings and annexes, importing mod-

ern conveniences (telegraph, telephone, hot water, electric light, central heating) almost as soon as they were invented. People spent winter holidays in Nice, but they came to Villars between May and October for the sunshine, the pine-scented air, the gentle walks to spectacular viewpoints, and the restorative salt baths (Matisse's mother also took a fashionable mud cure nearer home at St-Amand-les-Eaux). The nearby town of Ollon even boasted its own artist, Frédéric Rouge, an almost exact Beaux-Arts contemporary of Matisse, who was already making a respectable living from paintings of mountain scenery, Alpine huntsmen, and pretty peasant girls in dirndl skirts and flat straw hats.

Matisse's pictures—cursory, abbreviated, full of flying colour—belonged to another world, or a new age. By the spring of 1901 it was clear that after studying for ten years in Paris, Henri was further than ever from achieving official recognition in his profession. It was also clear that the family business could not continue subsidising him forever at the rate of a hundred francs a month. The family gathering became a confrontation. July was the date set for Auguste's marriage to Mlle Thiéry, whose relations took a dim view of an unemployed, apparently unemployable brother-in-law imposing any further financial strain on the young couple's prospects as partners in the Bohain seed-store (which was about to be renamed "Matisse-Thiéry"). Justice required that Auguste's marriage por-

Matisse's mother (left foreground) taking a mud bath at the fashionable spa of St-Amandles-Eaux, photographed by Matisse's friend Louis Guilliaume, 1901 tion should match the 15,000 francs so far expended on training Henri. It was a substantial outlay, made worse by rumblings from Le Cateau, where their uncle Emile Gérard was about to be engulfed in scandal and ruin.

Complaints about the pestilential nature of the Gérard tallow works had been causing trouble for some time. The problem was that Emile Gérard had moved his tanning pits out of the tanners' quarter (where Matisse was born), traditionally located beyond the town walls because of the nauseating smell that hung over the whole area. He built new premises on a more convenient site opposite the house at 45 rue de la République which contained his nephew's painted ceiling, expanding the business from a simple tannery and abattoir (generations of Gérards in Le Cateau had been butchers and tanners) to a streamlined industrial processing plant, where carcasses could be skinned, dismembered, heated to obtain melted tallow, and mangled to extract any residual juices. These were a main ingredient in the manufacture of the animal margarine which made Emile Gérard's fortune (bread-and-marge became a staple diet for the poor of northern France, as it did elsewhere in Europe). 165 What remained was stored in wooden casks to be sold as fertiliser to local farmers. Neighbours complained that these processes made their houses uninhabitable. The unpaved street was thick with slippery tallow and decomposing animal matter. The air was foul with the stench of rotting flesh, smoke from the rendering ovens and caustic fumes from the tanning pits. The river Selle at the back of the premises ran with chemical and animal waste, while the wooden sheds and factory buildings were so saturated with grease that they posed a fire risk to the whole neighbourhood. 166

Gérard, condemned for flouting safety regulations by the public health inspector in the autumn of 1900, was exonerated on appeal in January by the superintendent of police. An immediate public outcry led to a departmental enquiry which called for the closure of the factory on 20 May 1901. By the time the damning departmental report was ratified by the prefect of the North on 10 June, Gérard faced prosecution as well as financial ruin. He was fifty-five years old. Within two years he would be dead, with his handsome house once more up for sale and his factory shut down. The shock had drastic repercussions on the whole family. Hippolyte Henri Matisse, who lent his brother-in-law 10,000 francs in an effort to stave off disaster, had to raise 25,000 francs in less than twelve months—more than four times the rental value of his seed-store—to cover both this loan and his younger son's marriage settlement. Whatever he may have made of that spring's offerings at the Salon des Indépendants, he had no choice but to cut off the allowance to his older son. 168

Matisse for his part saw no possibility of change or capitulation. A têtu, têtu et demi, as one of his admirers put it (meaning that a father obstinate as a mule produces a son half as obstinate again). Back in Paris, he attempted to make good the shortfall by applying for work backstage at the Opéra-Comique (1,200 francs a year—the exact amount of his lost allowance—was on offer for a watchman to mount guard over a ladder leading to the props-loft, from which a sceneshifter had recently fallen to his death). He failed to get this job, or any other. There was nothing for it but to make do on the proceeds of Amélie's hat-shop, without relying on his own wages from the sort of work that would in any case have been in her eyes a betrayal.

In the same week as his brother's marriage, which took place in the North on 8 July, Matisse's six-year-old daughter Marguerite fell ill in Paris with diphtheria or croup. She fought for breath in a struggle which became so acute that the doctor had to slit her throat in an emergency tracheotomy. Her father was obliged to hold her down for the operation on the kitchen table at no. 25 rue de Châteaudun. ¹⁷¹ Matisse's feeling for his daughter was deepened and darkened ever afterwards by memories of this traumatic episode. On 11 July 1901 Marguerite was admitted to the Hôpital Bretonneau in Montmartre, where she spent a week that stretched out interminably in her memory in retrospect.¹⁷² In her weakened state she contracted typhoid fever, like Evenepoel. Marguerite recovered, although she had from now on to wear a black ribbon round her neck to hide the three-inch scar, and she would be plagued by problems arising from a damaged larynx and trachea for much of the rest of her life. Matisse painted her for the first time that year, wearing a striped pinafore and looking directly at the spectator from cavernous black eyes set in a white face (colour fig. 13). It is a powerful portrait, simple and expressive as a child's painting, strangely combining the strength and directness of the sitter with a poignant adult sense of her extreme fragility. 173

At some stage in the autumn or winter of 1901, Matisse met Berthe Weill, who was on the verge of becoming—almost without knowing it, as she said herself—a dealer in modern art.¹⁷⁴ Mlle Weill was a profoundly unconventional woman determined to operate in a man's world, like Mme Marval, whose tactics were in almost every way the opposite of her own. Tiny, inconspicuous, bespectacled, Mlle Weill moved with little trotting steps like a mouse or mole until something excited her, when, as one of her admirers ruefully observed, the molehill erupted into a volcano.¹⁷⁵ For all her meek air and drab getup, she was as combative as she was stubborn and quixotic. "To struggle! To defend oneself!" she wrote in her memoirs.

"That is the story of my life!" ¹⁷⁶ Dealing was her delight, but she had no interest in profit, or not at any rate in material gain. Her casual attitude to money was both her strength and her undoing, since all the major modernists she discovered moved on as soon as they could to worldlier male dealers who did not expect their artists, or themselves, to live on air.

Matisse met Mlle Weill through Moreau's old champion, Roger Marx, at the moment when she finally succeeded at the age of thirty-six in striking out on her own in spite of her family's disapproval, her mother's attempts to marry her off, and the unanimous discouragement of her male colleagues on the rue Lafitte. The professional consensus was that good business meant sticking firmly to the past rather than meddling with the present or, trickier still, trying to predict the future. Weill's sole supporter was the widow of her former employer, Mme Meyer, who helped her open a little boutique—part gallery, part junk-shop—on the rue Victor Massé, where she sold everything she could lay her hands on: drawings, engravings, miniatures, old paintings, oddments of every sort, even in hard times the books off her own shelves. Soon she met an enterprising Spaniard called Père Manach who broadened her contacts, revamped her gallery and scouted out new talent (including his young and still unknown flat-mate, Pablo Picasso, whose first sales in Paris were three pastels bought by Mlle Weill). 177 In December 1901, on the strength of a small inheritance set aside by her mother for her dowry, Mlle Weill put on her first mixed show of contemporary artists. "We took the risk of going modern," she said. "It was what they call playing hookey." 178

The artists in her third show, which opened on 10 February 1902, were Matisse, Marquet, Marval, Flandrin and two others (the Divisionist Hippolyte Petitjean and a Mlle Krouglicoff). The only picture that sold from this exhibition was a snow scene by Marquet, bought for 50 francs by Francis Jourdain's father Frantz. But in April Mlle Weill sold one of Matisse's still lifes for 130 francs (the artist got 110) to Armand Parayre's fellow mason from Toulouse, the avant-garde collector and art critic Arthur Huc. Two months later she sold a smaller study by Matisse for 70 francs. ¹⁷⁹ These were his first professional sales (apart from whatever canvases he may have handed over in exchange for the Cézanne to Vollard) since he had given up trying to please anyone but himself five years before. He took part in June in another, distinctly more successful mixed show at Berthe Weill's, recapitulating the six she had already put on in her first six months. He had at last acquired both a gallery and a champion, who not only grasped what he was doing but asked nothing better than to fight for it.

Between the two Weill shows Matisse exhibited for the second time at the Indépendants in April—two still lifes, three flower pieces and another landscape—and was invited to join the hanging committee. "Young painters and writers began to congregate around Matisse," wrote Mlle Weill, "attracted by this creator, this renovator of painting who pulled the rug out from under the officials..."

180 His younger contemporaries were certainly impressed, if not entirely convinced as yet, either by his work or by the regular bulletins he gave them on the progress of his researches. "Matisse already acted like the head of a school," wrote Boudot-Lamotte, "laying down the law all the time in jest. Everyone got his comeuppance."181 But Matisse's urge to explain and justify what was happening on his canvases came at least in part from a pressing need for reassurance. He said the best thing about his visits to Derain and Vlaminck at Chatou was the comfort of knowing that two much younger men had independently reached the same point as himself. 182 His own paintings filled him with perturbation. At some point in 1901 or 1902 he slashed one of them with a palette knife (the canvas—a study of Notre-Dame—was subsequently repaired, and exchanged for Jean Biette's study of Bevilacqua). 183 His old enemy, insomnia, returned to plague him. He remembered sleepless nights that spring in a cheap hotel beside the Bois de Boulogne, where the professional battles he fought by day had to be paid for afterwards in nervous tension. 184 Amélie, his invariable companion on painting expeditions, established what became another regular pattern of their working life by reading to him in the small hours, continuing until either dawn broke or he fell asleep. Her mother also tried to help, doing her best to interest the great picture dealer Georges Petit who regularly did business with the Humberts. "The concierge talked to me from time to time about her son who painted," Petit said ruefully later, "but I never paid the faintest attention."

Matisse had weathered his father's withdrawal of funds the year before with his wife's support. The four years of their marriage had turned out to be the richest and most productive period of his artistic life. In the spring of 1902 he was painting with greater audacity and confidence than ever before. His colours had finally broken free from the constraints of naturalistic description, and were beginning to negotiate independently on their own terms. He had successfully resolved a long series of views of Notre-Dame, painted from his studio window, in which over the past seven years he moved from silvery grey naturalism to bold synthetic compositions of pure colour: turquoises, violets, tart greens and crimson pinks which function in relation to one another and to the whole, not so much evoking or describing morning or evening river light as producing a

pictorial equivalent. At the same time, he made a parallel set of small, vibrant, high-summer or autumnal landscapes. In one of them—painted either in the Luxembourg Gardens or in the park at Vives-Eaux where Amélie's parents spent their summers—the trees became patches of flat scarlet, or orange and purply blue, above jagged yellow streaks of sunlight on a pathway shadowed by indigo and pink (colour fig. 11). ¹⁸⁵ All the detonators for the Fauve explosion of 1905 were, as many commentators have pointed out, already present in Matisse's work by the end of 1901, or the beginning of 1902.

It was at this point that disaster struck. Amélie's parents, who had stood by the young couple throughout the difficult first years of their marriage, now found themselves overwhelmed by trouble of their own. Hostile elements were finally closing in on Mme Humbert. Two different lawsuits in October 1901 and February 1902 sparked off a series of steadily more virulent press attacks. ¹⁸⁶ The Humberts' creditors demanded their money back in increasing numbers. Amélie's father wore himself out in the spring of 1902 travelling in France and abroad, trying to rally former

The removal of the Humberts' safe on 9 May 1902: The newspapers reported ten thousand people waiting in the street to know what was found inside.

hangers-on and recruit new ones to the cause.¹⁸⁷ Mme Parayre remained at home, rocklike and imperturbable, to reassure sceptics and backsliders. "She told me it was no use paying attention to campaigns in the press," said one fainthearted creditor, who poured out his doubts to her that April.¹⁸⁸

Public anxiety tinged with panic began to turn to mass hysteria. On 6 May the president of the Civil Tribunal, sued to by a Humbert creditor, formally ordered the opening of the famous strongbox containing the bearer bonds that guaranteed fabulous wealth to their ultimate possessor. The date was set for 9 May. On the night of the seventh Armand Parayre, dining for what turned out to be the last time with his employers, drank a champagne toast to the downfall of Madame Humbert's enemies. 189 Two days later a crowd of several thousand spectators filled the broad avenue in front of 65 avenue de la Grande Armée. The prefect of police himself controlled operations on the street outside. Inside the man in charge was the procureur de la République (or public prosecutor). Journalists from the national and international press turned out in force. All France was agog. The Humberts were nowhere to be found, and neither of the Paravres could produce a key. After several hours of mounting tension, the procureur sent for a locksmith to break open the safe, which turned out to contain nothing but an old newspaper, an Italian coin and a trouser button, 190

CHAPTER EIGHT

1902–1903: Paris and Bohain

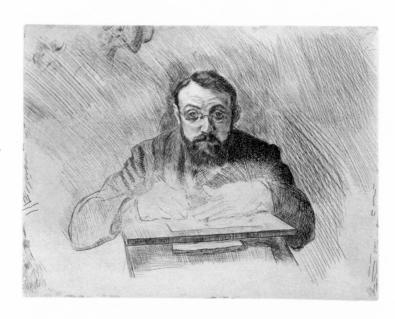

Matisse, Henri Matisse Etching, 1900–1903

he next two years have been officially labelled by art historians, starting with Alfred Barr in 1951, Matisse's "dark period." As a painter, he turned back on his tracks, abandoning his reckless experimental leaps almost in mid-flight, rediscovering the sober greys and earth tones of his original palette, tackling conventional subjects in the nearest he could get to a thoroughly conventional, or at any rate inoffensive and uncontroversial, manner. Matisse scholars have put the change

down to native prudence, failure of nerve, an innately bourgeois instinct to retrench rather than venture further into uncharted ground. In fact, for weeks and sometimes months on end during the period spanned by the Humbert scandal—from the beginning of May 1902 until the end of August 1903—Matisse was in no position to paint at all. His energies were absorbed by efforts to repair and limit the damage done to his own and his wife's families, which disintegrated round him.

Shock and incredulity gave way to despair as Amélie's parents surveyed the wreckage of their lives. They faced a bleak future, "without financial resources since they weren't offered so much as a parting gift; without hope since they are now too old to work; with no prospect in short except the workhouse or the street," wrote F. I. Mouthon, the journalist whose investigative campaigns in *Le Matin* had largely destroyed the Humberts, and whose heart was touched by the bewilderment of these two shipwrecked survivors: "Ruined and disabused, Armand Parayre today asks himself only how he is to eat tomorrow." The Humberts had disappeared without a trace, taking with them nearly 40,000 francs in cash (raised by the luckless Mme Parayre, who had pawned a consignment of jewels at the mont-de-piété as a final service for her mistress on 7 May).² While the police tried in vain to track down the fugitives, the press and public, cheated of anyone else to satisfy their curiosity or assuage their vengeful instincts, rounded on Armand Parayre.

All the national and local papers carried daily front-page reports on the Humbert Affair, backed up by interviews with and speculations about the part played by Parayre. Mouthon found him three days after the opening of the safe, looking shaken and exhausted, huddled in the back quarters of the otherwise deserted house on the avenue de la Grande Armée. His wife had taken to her bed, stupefied with grief and horror. "Blind, it's true, we were!" cried Parayre, breaking down in tears when the sympathetic Mouthon asked him point-blank why he had suspected nothing.³ The Humberts turned out to have made off with the pension funds from Parayre's savings bank, the Rente Viagère, which was promptly declared bankrupt. The furious lamentations of eleven thousand small investors, who had lost their life savings, added to the misery of the Parayres. Police searched their apartment on 14 May. Their daughter's hat-shop was searched five days later by a police squad who raided Matisse's studio on the quai St-Michel the same day.⁴

These first police raids triggered a wave of further disappearances, forced resignations, bankruptcies and suicides. All the leading lawyers who had harvested rich pickings from years of *Humbert v. Crawford* litiga-

tion now faced ruin. The Crawfords themselves—the long-dead American millionaire who had left a will in Thérèse Humbert's favour, and the two nephews who had so tenaciously contested it—turned out to have been figments of Mme Humbert's imagination. There were no Crawford millions, no will and no inheritance. The teams of lawyers hired to argue Mme Humbert's case in interminable proceedings up and down the land had been opposed by no less ingenious legal minds, who (although they did not know it) were also in her pay. On the rare occasions when the Crawford nephews put in a personal appearance to dupe a creditor or brief a lawyer, they had been impersonated by her brothers, Romain and Emile Daurignac.

For twenty years Thérèse Humbert had traded on the credulity—in some cases the willing complicity—of her creditors: bankers and speculative financiers who had supported her precarious empire by first advancing money, then clawing it back at exorbitant rates of interest. Mme Humbert was well known to offer the best monetary terms in France. She had helped precipitate her own downfall by suing a banker called Elie Cattui (who had charged her 63.49 percent interest on his loans) for usury. All her major creditors were open to the same charge. Smaller-scale private lenders merely looked ridiculous. For some, public humiliation was worse even than financial disaster. Mme Humbert's long-term defence counsel, Henri du Buit—a lofty legal eagle of fearsome probity and spotless reputation—tendered his resignation as leader of the Paris bar on 18 May ("What humiliation the man must have endured," wrote a former friend, "having passed for an eagle, to find that many now took him for a goose").5 The next day Etienne Jacquin-Mme Humbert's chief fixer, confidant and cavaliere servente, who had obliged his mistress by standing witness at Matisse's wedding—resigned his post as councillor of state.6

The Humbert crash left a wake of violence and mayhem, starting with a series of mysterious burglaries at Humbert properties all over France (many suspected an inside job when a Raphael and two Corots disappeared, along with other paintings, from the Château de Vives-Eaux two days after the Humberts' flight). A creditor called Müller killed himself in May, shortly followed by Mme Humbert's jeweller, M. Dumoret of the rue de la Paix (to whom she owed well over a million francs). When her own nephew, Frédéric Humbert, Jr., was found hanged in June, his family blamed a marauding Humbert creditor. These were by no means the first deaths to be laid at the Humberts' door. Thérèse herself boasted of keeping a suicide register, or *carnet de suicidés*, and there were persistent rumours that the more thuggish of her two brothers, Romain Daurignac,

had added at least two murders to his normal round of beatings, black-mail and extortion. IT Romain was one of the band of fugitives—together with Mme Humbert herself, her husband, her only child, Eve, her other brother, Emile, and their sister, Maria Daurignac—who seemed to have vanished off the face of the earth in May 1902.

In an age of sensational politico-criminal scandals, the Humbert Affair was not only one of the most colourful but potentially one of the most dangerous. Already in 1898 it had been described as "the greatest swindle of the century" by René Waldeck-Rousseau, who became Prime Minister of France the year after. But Waldeck-Rousseau's successful efforts to shut down another major scandal—by pardoning Captain Dreyfus in September 1899—left him no appetite for opening up the Humberts' can of worms. By 1902 too many top politicians, too many high-ranking civil servants, too many bankers and far too many members of the judiciary had traded favours with Mme Humbert for it to be in anybody's interest to spill her secrets. "The entire public administration of Paris turned pale at the sight of the Humbert dossier," reported Arthur Huc in La Dépêche of Toulouse. 13

The prestige of the Ministry of Justice, in the person of Etienne Jacquin, who had served under every Keeper of the Seals for more than twenty years, had been a key factor in sustaining Mme Humbert's credibility. Her close associates included the former public prosecutor of the Republic, M. Bulot; the presiding justice of the Court of Appeal, Frédéric Périer; and the celebrated police chief Louis Lépine, whose men were supposedly doing their best to find the Humberts (their signal lack of success in this direction was felt at the time to be no accident). There was a sustained attack in the press and Parliament on the left-wing demagogue and Navy Minister Camille Pelletan for accepting what looked like a Humbert payoff at the hands of Matisse's father-in-law. ¹⁴ No one could feel safe. Roll calls of Humbert creditors, published at intervals in the newspapers, pilloried the highest in the land, from the President's son, Paul Loubet, to Napoleon III's exiled Empress Eugénie. ¹⁵

Even those not personally involved feared for the honour of the Republic, not to mention the survival of the government. Although the original idea of the Crawford inheritance had come from Thérèse Humbert, it was widely assumed that the brains behind the original scam belonged to her father-in-law, the former Minister of Justice and pattern of Republican idealism Gustave Humbert. People said that the reason the Crawford fantasy turned out to be by far the most profitable of all Thérèse's tall stories was that it had been established by le bon Papa Hum-

bert on a sound and subtle legal footing, worked out in detail at Vives-Eaux in the summer of 1883, with the help of his son Frédéric (himself also a trained lawyer). The initial capital was thought to have been 2 million francs paid over by the Rothschild bank in return for ministerial favour (certainly the collapse of the Union Générale bank in 1882—for which many held Justice Minister Humbert responsible—had been highly convenient for the Rothschilds). From every point of view—historical, political, financial and judicial—the Humbert Affair was a menace to the Republican establishment. On 7 June 1902 Parliament appointed a new Prime Minister, Emile Combes, who ordered a cover-up at the highest level. The Scandal showed every sign of dying down that summer.

But Combes could not stop people from singing ribald anti-Humbert songs in the street, 18 or prevent the whole of fashionable Paris from flocking to Georges Petit's gallery to see the Humberts' picture collection sold off in June. The sale attracted more visitors than any of Petit's increasingly modish Impressionist shows. Spectators collected avidly in front of Frédéric Humbert's official portrait of his father, enthroned in ermine and representing the panoply of state ("The dead man contemplates the gallery-goers with stony eyes ...," wrote the academician Jules Claretie. "A forger dispensing justice! Here, once again, fiction is eclipsed by fact"). 19 But even Papa Humbert looked small beside Gustave Moreau's six-foot-high painting of King David as the embodiment of disinterested poetic genius, also enthroned, crowned, and venerated by a harp-holding angel at his feet. Ironies like these were not lost on contemporary witnesses. "Are these paintings plague-stricken?" asked Claretie, noting the gloating looks and spiteful comments of the crowd at Petit's. "They were decoys in their day."20

The pictures sold briskly to American collectors. Skilfully designed to flatter and reassure the Humberts' business clients, the collection was built round a base of nineteenth-century masters—Meissonier, Gervex, Isabey, Baron Gérard, Alfred Stevens—reinforced by reliable Salon performers like Ferdinand Roybet or Benjamin Constant, and piquantly topped off with a canvas apiece by Manet and Renoir. Columnists like Claretie and Arthur Huc (who bought his first Matisse in 1902) pointed out that these works had served their owners well: "The possession of a picture collection in Paris... is an excellent way of establishing your credit," wrote Claretie. "Your standing goes up—like a flotation on the Stock Exchange—as soon as you make an offer for a particular painting.... Buying pictures can also be a moral investment." 22

This was a lesson spelt out sharply to Matisse in the aftermath of the Humbert crash, when he tried to recapture the pictorial credit rating which he had once possessed, and which he had deliberately discarded in 1897. Georges Petit himself had been sufficiently impressed by Matisse's customer appeal at that stage to make advances to him. "All I need is for that facility to come back, so that I can start again," Matisse wrote four-teen months after the Humbert crash.

After all, painting does still sell. Henner, Roybet, Juana Romani, Caracollas et Cie can still keep the packers busy. I've forgotten Bouguereau! without meaning to. The trouble is that I sound like a good grocer (which one has to do a little, since nature has inflicted the same obligations on us all) only when I'm not backed up against a wall, in which case I can't answer for myself. What consoles me, as I said, is the thought that my intimate canvases gave pleasure before, and I did them by instinct—so that a good purge should get rid of all the good or bad weeds, foreign to my nature, that I've picked up over the last six years, and then I could present a calm smiling face to the crowd of collectors, who don't care for anyone anxious or tormented. 23

By July 1903, when he wrote this letter to Simon Bussy, Matisse had been trying for a year to please collectors. Throughout this period he was (apart from his young sister-in-law) the sole breadwinner for his wife, his three children and his wife's parents. Amélie Matisse's hat-shop foundered when her health gave way after the Humberts fled. There was no prospect of further help from her Aunt Nine, who ran the family hat business on the boulevard St-Denis, and who found herself faced overnight with two more ex-Humbert employees to support (Nine's husband, Jacques Boutiq, and her brother-in-law, Alexandre Parayre, had been stewards respectively of the Humbert properties of Orsonville and Celeyran). Amélie's business at 25 rue de Châteaudun was on the market towards the end of 1902, by which time the police had sealed off the house on the avenue de la Grande Armée, leaving her parents homeless as well as destitute. "Who would have believed it?" cried Mme Parayre in an uncharacteristic outburst of emotion. "Twenty years' salary vanished! And here we are on the street. If it weren't for our poor little daughter's wages, we'd be starving!"24

They had taken shelter with Berthe, who was a junior mistress teaching French and history at the girls' teacher-training college in Rouen. This was a plum posting for a newly qualified candidate (even a highflier like

Berthe could not have secured it without direct intervention from Mme Humbert's now discredited friend Etienne Jacquin),²⁵ but the starting salary of 2,200 francs a year was never intended to support more than one person. Berthe had a tiny house in a half-developed suburb called Boisguillaume on the outskirts of Rouen, which was one of the most virulently anti-Humbert towns in France. The name of Parayre had become a dirty word by this time among Humbert creditors and their families. Twenty-five million francs were owed to northern industrialists, who had been systematically targeted for loans by picked Humbert lawyers operating out of Rouen, Lille and Le Havre. The Humberts' retainer in Rouen, Maître Dumort (who claimed to have lost a personal fortune of 6 million francs), was physically attacked at the Gare de Lyon in the autumn of 1902 by the wife of a ruined investor.²⁶ Armand Parayre said that the townspeople treated him like a pariah, refusing to so much as rent him rooms as soon as they learned his name.²⁷ The local police kept him under permanent surveillance from a spy-post set up opposite his daughter's front door. Parayre retaliated by stationing himself with his revolver at an upper window from which he took potshots at the detectives who tormented him.28

The strain of constant abuse and humiliation exacerbated by their desperate financial plight bore down on the whole family. Both Berthe and Amélie collapsed in the end from nervous and physical exhaustion. When public pressure eased with the onset of the holidays, Matisse escaped to Switzerland for a week in August, recuperating—presumably at his parents' invitation-at Weber's Hotel in Villars-sur-Ollon. But a change of scenery could give no more than temporary relief. By September he was back in Paris, sick with worry, confined to his studio on doctor's orders.²⁹ For the first time in his life he tried painting standard academic subjects, studying Salon practice and dressing up his models in fancy costumes, like the earnest young Scotsman in du Maurier's Trilby, who proved himself an artist by hiring a guitar and a bullfighter's outfit to go with it ("His parents had intended that he should be a solicitor.... And here he was in Paris famous, painting toreadors!").30 Matisse painted two portraits of Bevilacqua incongruously kitted out as a toreador complete with guitar that autumn. He also painted Amélie dressed in white satin toreador pants, perched on a kitchen chair and strumming the guitar with an expression that struck Jean Puy as hardly human.³¹ Matisse never forgot the atmosphere of those sittings, which took place in a tension so great that at one point he kicked his easel down and she threw her guitar on top of the smashed wood, whereupon they both burst out laughing.³²

Matisse, Lucien
Guitry (as Cyrano),
1903: the only time
in his life that
Matisse tried the
Salon painters' trick
of hiring a professional costume
model to impersonate his subject

They had little else to laugh about that year or the next. Nothing if not thorough, Matisse paid a specialist Beaux-Arts "costume model" (as opposed to a nude model) to impersonate the actor Lucien Guitry playing Cyrano de Bergerac—Guitry's performance was one of the Paris theatre's star turns—and painted him in a false nose, leaning on his sword, wearing a musketeer's plumed hat, lace collar and floppy knee-high boots.³³ But even this piece of flamboyant fustian backfired. Unable to hit the correct note of lighthearted absurdity, Matisse turned his fake Cyrano into a notably uneasy, austere and sombre painting. Yet another elderly male model posed in a brown monk's habit in Jean Puy's studio for the two friends, who worked side by side on their respective versions for months on end. Matisse grew unexpectedly attached to his grey-haired, brownrobed, sad-faced monk, recalling him often afterwards in letters to Puy ("Do you remember...that old model dressed as a monk—what charm did he hold for us to be so devoted to him? Colour values, a grave expression . . . in order to express ourselves we were looking for a plastic, a purely plastic language without resorting to theories which abounded even in

Jean Puy, Self-portrait, c. 1908: a good friend to Matisse during his "dark period" after the Humbert scandal

those days.... Our attitude towards nature was like that of mystics awaiting a revelation").³⁴

Puy said that Matisse abandoned his experiments to become the slave of nature—more "submissive to reality" than ever before or after—at the end of 1902, when for several months he restricted himself to "painting in grey or muted colours." If Puy admired the robustness of his friend's Meditating Monk, so did Maurice Boudot-Lamotte, who considered Matisse's canvas more successful even than Corot's treatment of the same subject. Matisse drew close at this point to these two least adventurous of his friends, who welcomed the change in him with genuine enthusiasm. For Boudot-Lamotte the paintings of 1902–3—"What beautiful ripe fruits those Matisses were!"—represented a peak of achievement never matched again. Puy, whose monthly allowance made him relatively rich at twenty-five by comparison with Matisse, bought several canvases: a gesture of practical friendship that matched the delicacy of his responses as a painter.

Matisse produced a series of flower pieces this year, small, inexpensive bunches of chrysanthemums or yellow ranunculus or ragged sunflowers, arranged in improvised vases and painted in the drab tones of his youthful palette, only this time with a sharpness that gave a wholly contemporary twist to the intimations of loss and mortality traditionally explored by Flemish flower painters. Puy never forgot "a still life remarkable for its

nobility and bitterness: the portrait of a large metal coffeepot with some chrysanthemums just showing above the rim."³⁷ Inner disquiet, self-dissatisfaction, nervous strife were native to Puy's temperament. No one understood better than he did that this series of four or five small flower paintings, undertaken by Matisse in hopes of a quick sale, had become a meditation on the vanity of human wishes. "Another day when he came to my studio to work, he was profoundly moved by the sight of some flowers withering in a vase: their faded colours, their

Maurice Boudot-Lamotte, Self-portrait, 1903: a fellow northerner from St-Quentin half impressed, half intimidated by Matisse's boldness

melancholy grace touched something in him."³⁸ Matisse painted the dying purple tulip with its pale companions and dedicated them "affectionately to Puy," who pinpointed thirty years later the quality that made these works so difficult to sell: "The picture of flowers worked well from a photographic point of view, it was even very pretty. But as a painting the disruption of the tonal relationships made it very sad, even funereal."³⁹

Matisse found himself hoist with the petard of his own temperament. In his simplest efforts at photographic reality, banality eluded him. His more ambitious struggles to subdue reality, or rather to subdue his own reactions to it, were even more uncomfortable. "The disconcerting impression one gets from the best of these canvases springs from the fact that the signs of regression in them are so thoroughly interwoven with the signs of progress that the painter himself seems to get them confused...," wrote Pierre Schneider of Matisse in this dark period:

he had at all costs to persuade himself that his true temperament and instinct were opposed to experimentation. And this effort was simply unnatural, as everything that he painted in the years to come demonstrates: it went against his nature—a nature that, in a few canvases, like *Nude with a White Towel*, fought back with desperate violence, breaking up the planes, setting fire to the background and the outlines—exhausting and bewildering him.⁴⁰

Matisse's private battles were rudely interrupted on 20 December 1902, when the Parisian evening papers carried reports that the Humberts

had been discovered in hiding in Madrid, and taken into custody. The French police swooped down on Berthe Parayre's house in Rouen the same day to search the premises, confiscate papers and arrest her father. 41 On 21 December Armand Parayre was taken to Paris, where the crowd awaiting his arrival at the Gare de Lyon was so great that Amélie could not get near him. He was imprisoned in the Conciergerie on the Ile de la Cité, opposite Matisse's studio. "At sixty years old . . . the Conciergerie!" cried his weeping wife to a reporter. "It's appalling, monsieur! . . . Who could have imagined such a thing!"42 Her husband, "in a fearful state of excitation," declared his treatment an abomination, proclaimed himself innocent as a newborn babe, and swore to starve himself to death if not released at once.⁴³ He was formally charged with complicity in fraud and forgery. Alexandre Parayre and Jacques Boutiq, beside themselves with rage and indignation, poured out their feelings to reporters. Alexandre threatened to hold a public protest to vindicate his brother, who had said he could not afford to pay a lawyer. Boutiq called down curses on Mme Humbert ("Ah, la vieille scélérate!"). Both offered to defend Armand in court themselves, a suggestion promptly nipped in the bud by "Parayre's relations," who retained a professional defence lawyer instead.44

The "relation" in question could only have been Matisse, who was the sole male member of the family to keep his head at this point. From now on Matisse took charge. He sat in on an interview given to Le Matin by his wife, who, having been refused permission to see her father, answered questions with a calmness and restraint in sharp contrast to her uncles' lack of either. 45 When Le Matin printed a story about Parayre learning Spanish as a preliminary to joining the Humberts in Madrid, Matisse called on the editor the same day to refute the allegation in a lawyer's stamped affidavit ("Frequent contact with the Humberts seems to have given the whole family a mania for this style of communication," the editor noted drily).46 Amélie's father broke his hunger strike that day: PARAYRE A MANGÉ! ran the headline in Le Matin. On 24 December Matisse successfully applied to the examining magistrate in charge of the case for leave to visit his father-in-law, 47 after which there were no more hysterical outbursts, and no more rash pronouncements from Amélie's uncles. From now on Parayre regained his composure and his wit, emerging with dignity from a gruelling interrogation by the magistrate, who examined him almost daily throughout January. The most damaging charge against him was that he had organised the Crawfords' campaign of litigation in letters signed by their secretary, another purely fictional character by the name of Muller. Parayre firmly denied the accusation (it would be another three

months before handwriting experts were called to demonstrate that Muller's handwriting was the same as Frédéric Humbert's).⁴⁸

The Humberts themselves had reached Paris under heavy guard at the end of December, joining Parayre in solitary confinement at the Conciergerie, where Thérèse occupied a cell opposite the one that had once lodged Marie Antoinette. ⁴⁹ The press of Europe and America reported these goings-on with relish. Drawings, caricatures and photos of both Humberts and Parayres appeared on front pages all over France. Parisians whistled a catchy tune, "Le Noël des Humberts," and bought clockwork toys in which a miniature Mme Humbert leaped out of her window, pursued by the police and scattering a trail of tiny bank notes. ⁵⁰ There were Humbert dolls that collapsed, uttering a low, moaning gasp, when air was let out of a concealed bladder. But although the real Humberts may have looked to the public like deflatable rubber puppets, they loomed nightmarishly large to Armand Parayre, fighting for his life in January, and to his son-in-law, watching developments from his studio window overlooking the Palais de Justice and the Conciergerie.

A series of theatrical confrontations was staged at intervals throughout the month between the two couples, Humbert and Parayre. On 20 January Armand was brought face-to-face with his former pupil, for twenty years his employer, now the man whose ruthless greed, treachery and lies had landed them both in the dock. One or the other of the two had played the key role of Muller, and after "an extremely fierce exchange," it was Humbert who admitted himself beaten.⁵¹ Two days later, in an atmosphere like that of a prizefight, Parayre faced Thérèse Humbert. It was their first meeting since the day of the flight eight months before, and when he turned away contemptuously, refusing to take the hand she offered, Mme Humbert flushed dark red.⁵² On the last day of January, Parayre was provisionally released. He went straight to his brother's flat on the boulevard St-Denis, saying only to the crowd of reporters on his tail that he planned to take a shower and sleep between sheets for the first time in six weeks.⁵³

Matisse cracked up himself at this point. Reporters who made the most of the Parayres' Mediterranean brio and instinct for striking poses got no change out of "Parayre's son-in-law." But northern reserve, discretion and control exact a price. On 3 February Matisse wrote from Bohain to Henri Manguin to say that he was immobilised in the country, having been warned by three different doctors to take no more risks with a constitution dangerously undermined by overexertion. When Manguin sent a characteristically comforting reply ("Be serious about looking after your-

self, and come back to us as brave as ever"), Matisse explained that for three whole weeks he had not slept.⁵⁴ The doctors prescribed two months' total inactivity on a strict restorative diet, forbidding him to work or even to write letters. There was no question of an immediate return to Paris, apart from a brief foray to supervise the move out of the room above the shop on the rue de Châteaudun. Amélie had stayed behind in Paris in February to pack up their belongings, wind up her affairs and hand over the business to a modiste called Mme Cahey.⁵⁵ At some point that month or the next, the couple transported their possessions back to the studio on the quai St-Michel before retreating to spend the rest of the winter lying low in Bohain, holed up with their children in Matisse's parents' house.

Matisse could hardly have picked a worse moment to take refuge in his native region, where feeling ran higher against the Humberts than anywhere else in France (except Toulouse). Local papers carried sensational daily bulletins as the ramifications of the affair were systematically unravelled by the magistrate in Paris. It was borne in on the "creditors of the North," who had lost more than any other group of investors, that they had also made themselves a laughingstock with the rest of France.⁵⁶ The wealthy grain- and seed-merchants of Lille had suffered grievous losses. A M. Dumay of Cambrai, fifteen miles from Bohain, boasted of having successfully resisted attempts to touch him for a loan of 1,200,000 francs, but there were others in the town whose ingrained caution had proved no match for the Humberts' lure of easy money.⁵⁷ The whole area bore a grudge against anyone or anything connected with the affair. Armand Parayre's transparent honesty may have impressed the Parisian magistrate, but in the North his name was still a focus for the resentment, shame and anger aroused by the whole monstrous fiasco.

The citizens of Bohain did not take kindly to the return of a prodigal who had fulfilled the worst prophecies made at the time of his departure twelve years before, or to the fact that his wife was the daughter of the Humberts' right-hand man. Matisse's history spread round the town. Neighbours held him up as a warning to their children. Almost a century later, people in Bohain and St-Quentin still thought of him as a failure three times over (un triple raté): unfit to take over his father's business, unable to complete his training as a lawyer, lamentably inept by any conventional standard even as a painter. They called him "le sot Matisse" (sot was the word for fool or clown). Mocking stories circulated about his inability to produce lifelike pictures or paint a portrait anyone could recognise. Legend said long afterwards that he set up his easel in the street, painting whoever cared to sit for him for next to nothing on squares of

cardboard. People who had known him all his life called him a *gribouilleur* or *barbouilleur impuissant*, meaning someone who makes childishly feeble daubs or doodles. ⁵⁸ He said that even his cousins in Le Cateau, whose hospitality he had repaid with pictures, banished everything he painted to the attic. ⁵⁹

The Bohainois compared him unfavourably to the only other painter the town had as yet produced, Paul Dantan, who earned good money in Paris by supplying picture-dealers with faithful copies of old masters in the Louvre. "He was someone!" said one of Matisse's contemporaries, impressed as much by Dantan's skill as by his well-deserved success. "And what about his sister! Mademoiselle Dantan, who won a prize with her violin, and gave concerts abroad! They were real artists!...But Matisse? Le sot Matisse!...a poor creature! you won't get any good out of him!...He's got no future!"60 This grim forecast was delivered by the concierge of the cemetery in Bohain as a lesson to her nephew, Emile Flamant, who planned to go to Paris to be a painter in 1914. Young Flamant had grown up listening to his elders talk about le sot Matisse ("This was a phrase I heard constantly in those days, pronounced with a scornful laugh").61 He persevered, encouraged by Matisse himself in Paris, returning eventually after seven years at the Ecole des Beaux-Arts to spend the rest of his life two miles up the road from Bohain in the village of Fresnoy-le-Grand.

Flamant understood better than most what Matisse meant when he said that the whole world turned its back on him. Like their Bohain neighbours, the inhabitants of Fresnoy responded to a painter in their midst with at best indifference, at worst active hostility. Few people outside Paris or the big cities saw painting in those days as anything but futile or subversive. Artists who returned to live and work in their native region commonly described being treated like outsiders, or revenants from another world. Simon Bussy's friend Eugène Martel (whose herb-scented beef stews had comforted Matisse as a poor student) fought a lifelong losing battle in his Provençal birthplace against the feelings of isolation and rejection endemic among painters of his and Matisse's generation. Martel had no public outside his village, where most people wrote him off as "nothing but an agitator, later as a crackpot or a drifter." Even the relatively successful Jean Puy never entirely got over being despised by the solid, prosperous, philistine citizens of the town where he grew up. "What consternation this will cause among the people of Roanne," he wrote cheerfully to Matisse, reporting a substantial sale to Vollard in 1909, "which will be a joy to me; they have treated me like a clown for long enough. I should like to do a scalp dance on their stomachs in hobnailed boots." 63

Puy's violence was not unusual in his day. People on both sides of the Beaux-Arts debate spoke and wrote with a ferocity bordering on frenzy. In March 1903 Zola's collection of Impressionist paintings, on show at the Hôtel Drouot in Paris, seemed a national outrage to the right-wing journalist Henri Rochefort (whose bust by Rodin Matisse had bought at the same time that he bought Cézanne's *Three Bathers*). "Had the unfortunate fellow never seen a Rembrandt, a Velásquez, a Rubens or a Goya?" Rochefort asked, discussing Zola in *L'Intransigeant*. "For if Cézanne is right, then all those great painters were wrong. Watteau, Boucher, Fragonard and Prud'hon no longer exist, and nothing remains as the supreme symbol of the art dear to Zola but to set fire to the Louvre." Matisse drew the opposite conclusion, reversing Rochefort's formula in the fighting slogan that sustained him in these years when he came closer than ever before or after to outright defeat: "If Cézanne is right, then I am right. And I knew that Cézanne had made no mistake."

Whether or not Matisse read the article in which Rochefort denounced both Cézanne and Zola as diseased minds, traitors to their country, lovers of physical and moral filth, it gave satisfaction in conservative households all over France. It was especially appreciated in Cézanne's hometown of Aix-en-Provence, where three hundred extra copies of this particular issue of L'Intransigeant were ordered, many of them to be stuffed through the doors of Cézanne's supposed friends and supporters. Cézanne himself—in his sixties, already ill and nearing death—found copies on his mat each morning with abusive messages and advice to leave "the city that he was dishonouring." The young English painter Gerald Kelly, calling on Cézanne soon afterwards as part of his grand tour of the artistic sights of Europe, was disturbed both by the paintings and by a horrible feeling that the old man had been afraid of answering the door. Matisse, who never wished to meet Cézanne himself, drew strength at times like this from the Three Bathers.

THE SPRING OF 1903 marked his low point. He wrote to Marquet in March, vividly describing the state of misery and emotional numbness to which insomnia had reduced him, and which he feared might end in total disintegration. He told Marquet that he had lost all desire to paint, repeating to Bussy that he had almost decided to give up as a painter. For once, Amélie, whose health worried her husband more than his own, could not lift his discouragement about work, or about money. Efforts to sell his

paintings locally found no takers. Auguste Matisse bought nothing (forty years later Henri reminded Auguste gently that he could have been a rich man if he had seized his chance when his brother was practically on his knees). Henri's old school friend Gustave Taquet claimed long afterwards to have refused an offer of two Matisse canvases, with a couple of Cézannes and a Renoir thrown in, for one hundred francs. It was the moment when we were both trying to launch ourselves, him as a painter, me as a grocer, Taquet explained. In needed my 100 francs for buying mustard. Marguerite Matisse was sent to sit for another old classmate, the photographer Louis Guilliaume (whose studio was opposite the seedstore on the rue du Château), because, as her father said sardonically, at least his, Guilliaume's, portraits look like her.

Matisse escaped from Bohain in mid-March to spend a few days in Paris helping to install the nineteenth Salon des Indépendants (for which he was on the hanging committee). He also stayed with his sister-in-law in Rouen, giving her address to Bussy in a letter in which he reckoned he would need at least another two months convalescing in the country.⁷¹ Berthe was jumpy and unsettled, like Amélie, suffering from lung prob-

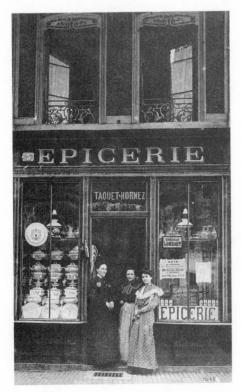

Mme Taquet, wife of Matisse's friend Gustave, in the doorway of their grocery shop in Bohain (according to local rumour, the painting in the window on the right was a Matisse for sale)

lems diagnosed as the early symptoms of tuberculosis.⁷² The authorities at her training college had supported her through the protracted exposure of the Humbert Affair, but she longed to leave the cold, wet, hostile climate of Rouen for a posting in the south. Amélie herself was so rundown that her doctor made her drop a plan to go back to Paris with a job as a tapestry-restorer in the autumn.⁷³ Both sisters were worn out after months of watching their mother and father pilloried in public and seeing details of their private lives splashed all over the newspapers. The preliminary investigations in Paris looked as if they would drag on into the summer, and the trial itself was still to come.

Matisse said that for weeks on end in 1903 he found it almost impossible to paint. He had not worked in Bohain since he met his wife and made the discovery of southern light: almost the last canvas painted in his parents' house was the still life dedicated in 1897 "To Mademoiselle Amélie Parayre." He showed seven canvases (including a male *Guitarist*) at the Indépendants, which opened on 25 March, and two more new works—*Tulips* and *The Skein-winder from Picardy*—at the first Salon d'Automne in October. The skein-winder was Old Mother Massé, who had lived on the rue Peu d'Aise opposite his father's seed-store when he was a

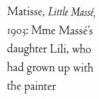

boy. The painted her at her spinning wheel, the only attempt he ever made at a genuine Flemish genre scene (apart from the *Breton Weaver*, also painted in Bohain seven or eight years earlier). He painted her grandson, a dark, round-headed boy known as *Young Capella*, and he made two paintings of her handsome brawny daughter, his own contemporary Lili Massé, who worked at a local textile mill. Matisse had made his first communion in 1881 with a Massé and a Capella. Their family had known his from the beginning: he paid them ten centimes an hour to pose for him, and their matter-of-fact acceptance was easier to take than "everlasting bourgeois' complaints about the portraits he produced, so far from any realistic likeness." He painted a couple of peasant girls in the fields, and two views of the Blasted Oak beneath which he had played as a boy, where his own children now played.

The roughness and brutality of a way of life their father had grown up with came as a shock to the Matisse children. Marguerite recalled Zolaesque scenes on the streets of Bohain, where existence was a daily grind of poverty, violence and alcoholism with skinny children and long lines of gaunt, white-faced men queueing for work or wage packets. Pierre's northern images in later life were no less harsh: drowning kittens, a rat cornered in a trap, the squelchy, rotting beets that stank and littered the streets in winter. Of the three children, the only one who felt at home in the North was Jean, who spent more time there than either of the others, and who had fond memories of his grandmother taking him into bed on freezing winter nights, and of driving out on the dray-carts with his grandfather. Jean remembered shining well-fed dray horses: Pierre's memories were of the wretched bony beasts tied up for sale in the horse-market.

At some point in the spring of 1903, Matisse moved his family out of his parents' house opposite the seed-store on the rue du Château to a vacant property owned by his father at 24 rue Fagard, a few doors along from the town hall and the Taquets' grocery shop on the central square. The house was tall and narrow, two storeys high with a front door opening onto the street. Its chief advantage was an attic floor beneath the sloping roof, poky and dark, lit by tiny skylights and a north-facing casement window looking out over a yard at the back to the red-brick wall of the factory alongside. This became Matisse's studio. Here he painted a handful of drooping purple dahlias in a wineglass on a folding bamboo table, and a view of the attic itself—Studio Under the Eaves (colour fig. 12)—which showed work in progress on the easel, with the artist's palette on a packing case beside the folding table and its vase of dahlias.

Matisse scholars have found nightmarish overtones in the confined and sombre space of Studio Under the Eaves: a sense of claustrophobia heightened by the rectangle of preternaturally bright light beyond the window, which is the painting's focal point. For Alfred Barr, the canvas was "as original in conception as it is disconsolate in atmosphere."82 Pierre Schneider saw it as a reflection of the painter's sense of being imprisoned: "The room is low, stifling, dark, almost a cell..."83 To Jack D. Flam it seemed "like something seen in a bad dream." 84 But for Matisse himself, this work and its pendant, Bouquet on a Bamboo Table, remained in retrospect two of his best paintings. His only regret was that "at a transitional stage between values and colours," he had been obliged to stick to low-key colouring in order to bring out the tonal values. "The values got the better of it in that one—what depths and suppleness in the shadows...," he wrote to his son Pierre, discussing Bouquet on a Bamboo Table in 1942: "What became of the studio where it was painted? forty years ago! You were still small. I can see you now in a little striped blue suit your mother made for you out of Vichy cloth. You were already sweetnatured."85

This was the first time the Matisses had lived together as a family under their own roof without having to confide one or other of the children to grandparents or wet nurses. But pleasure in his children's company was overshadowed for their father by misgivings about their future. Of all his friends, Matisse was the only one to have saddled himself with children (apart from Manguin, who had a small but safe inheritance; even so, Matisse was frankly appalled to learn in August that the Manguins were expecting a third child).86 His congratulations on Bussy's marriage in March were accompanied by a word of warning about the anxiety and expense of children.⁸⁷ His own, aged two, four and eight years in the spring of 1903, constituted one of the responsibilities that looked like putting a stop to his career more effectively than abuse or ridicule. "We are in great trouble," he wrote in July to Bussy. "The various problems, great and small, more great than small, of which—though I'm not all that old—life has given me a fair share, the responsibilities I've made up my mind to shoulder with courage, all this, coupled with the meagre sums brought in by our profession, practically decided me to give up painting altogether for a quite different job, insipid but sufficiently lucrative to live on."88

Pierre Matisse, who had his third birthday in June 1903, remembered talk of his father taking work as a colourist in a rug factory.⁸⁹ Specialist

designers were in constant demand in Bohain. One or another of the Matisses' neighbours could have fixed him up at a local textile factory, or he could have turned to his old teacher Emmanuel Croizé, still surviving as an assistant at the art school in St-Quentin. Croizé eked out his inadequate salary by teaching a weekly design class for poor weavers, grudgingly laid on and abominably paid by the municipality of Bohain in a back room at the town hall. His career was a bleak reminder of high hopes that came to nothing. Matisse brooded that summer on a warning given him twelve years before by "a man well acquainted with the underside of the artist's life," who must surely have been Croizé: "If you are to paint, you have to be unable to do anything else." "

The studio under the eaves provided refuge from the neighbours' pointing fingers and the family's blank incomprehension. His relatives were another of the problems Matisse described on 15 July to Bussy. "As for me, I'm in Bohain...among my family, with whom unfortunately I can't always agree, something that constantly disrupts my work, for which I need very great calm and an evenness of temper, among the people I live with, that I'm far from finding here."92 Matisse's parents had taken him in when he most needed it, but their courage and generosity had been severely tested in the process. His mother's belief in her son was unconditional, but his father's initial doubts had proved only too well founded. Hippolyte Henri was sixty-three years old in 1903. His achievements, his position in the town, the respect he had earned for the name of Matisse, were being undermined through no fault of his own by derisive laughter. "My father told me a few days ago, very angry and humiliated, that everyone took me for an imbecile, and yet I wasn't one," Matisse wrote to Jean Biette on 31 July. "The worst of it is that he held me responsible." The conflict between the two had reached crisis point. More than forty years later, as an old man in his eighties, Matisse could be moved to tears by memories of his father, "to whom he had caused great suffering, and who had never had confidence in him."94 But as a young man, he could neither stand back calmly nor follow his instinct to put his head down and charge. Like the hero of Pearl Buck's novel The Patriot, with whom Matisse identified, his feelings were ambivalent:

He felt the depths of his father's disappointment, and that now he needed comfort.... But...he could not forget that his father was the same man he had always been, and that if he did not like a thing he could not comprehend it, however good and right it

was.... His father whom he had thought of as being a proud man, satisfied and able to have anything he liked, he now saw was neither proud nor satisfied, nor had what he wanted.⁹⁵

Matisse and his father confronted one another with mutual bitterness and frustration, each conscious of the other's distress but unable to ease it by shifting his own position. It was the kind of standoff Matisse would re-create with his own sons long afterwards, when he looked back ruefully to the past ("I don't know if you'll be able to understand what I'm saying yet," he wrote to Pierre in 1938; "perhaps you'll need a few more years for where your father can't make you understand, your children will often succeed"). 96 In 1903 the upshot was flight. Matisse could not go on forever occupying premises normally let out to paying tenants in a town where his very presence brought shame on his relations. In July he found a house eight miles away on a bluff above the river Oise in the village of Lesquielles St-Germain, where he planned to settle with his wife and children. To the gossips of Bohain this move looked like outright victory for Hippolyte Henri Matisse. They still talked more than ten years later of "the poor holiday tenant of the Oise Valley, when his terrible father as good as threw him out."97

The rent of the new house was twenty-eight francs a month⁹⁸ (just over five dollars, half or two thirds the amount the studio on the quai St-Michel would have brought in if Matisse had found another tenant). Lesquielles was an ancient weavers' village, hugely swollen in response to industrial demand by a sprawl of one-storey brick hovels housing two thousand factory workers, who commuted night and morning by cheap trains to the neighbouring town of Guise. Matisse proposed to live and paint here for a year with his wife and children on an income even more uncertain than a casual labourer's wage. It was a dire solution to a desperate predicament. "I have by now exhausted my family, who are frankly and purely bourgeois, and I can't count on them any longer," Matisse explained on 31 July in a letter from Lesquielles to Bussy. ⁹⁹

His hope was that Amélie (whose health began to mend as soon as they left Bohain) would regain her strength over the next year, during which the family would scrape by on whatever could be raised by selling pictures. According to Jean Puy, Matisse had made 1,200 francs at the end of 1902 from the sale of five or six studies (including the chrysanthemums in the coffeepot) to Vollard, who approved of his new, subdued and sober style. ¹⁰⁰ More sales might follow, but Vollard's cat-and-mouse tactics as a dealer meant that no one, least of all anyone as hard-pressed as Matisse,

could pin much faith on his hints and half promises. Berthe Weill was rich in loyalty and enthusiasm but as short of ready money as her artists. A base in the country ruled out the usual standby of Louvre copies. Matisse had written in May to the ever generous Puy (already installed for the summer on Belle-Ile), describing his dream of persuading three or four collectors to guarantee him an income by taking his work on a regular basis, sight unseen, and stumping up another 1,200 francs a year between them. ¹⁰¹

By July the scheme had become considerably more ambitious. The capital sum had doubled and the number of hypothetical collectors risen to twelve, each of whom was to pay an annual 200 francs (forty dollars), in return for which Matisse would supply two paintings apiece, or twenty-four in all. "I already have three participants," he explained to Bussy, outlining the proposed syndicate with a confidence that faltered and seeped away as he contemplated potential drawbacks, "and I think I could get others quite quickly if I were setting up the scheme for the benefit of someone else, because an affair like this can't be put forward on one's own account, and in any case I haven't any contacts, you know I'm always rather an outsider, but all the same I couldn't get far on my own. I'm already ashamed to talk about it to someone who I know is a genuine friend." 102

Bussy in 1903 was still far more successful than Matisse, whom he had scarcely seen in the six years since they broke with one another on artistic grounds. But Matisse's misfortunes, as a bystander caught up in the Humbert scandal, made even estranged friends rally to his side. Bussy had written in March from London to propose a truce ("Let us say as little as possible about our work"), blaming himself for their differences and suggesting a meeting in April, when he meant to be in Paris with his English bride (she was Lytton Strachey's sister, Dorothy, who had been Bussy's drawing pupil). 103 Matisse responded with intense relief and pleasure. He poured out his feelings in July in two long letters, which became a running debate with himself about his life and work, and the difficulty of reconciling his need to paint with his family's need for survival (which the syndicate was designed to solve). "I realise too late that I've written you a business letter almost, when all I meant to do was talk to you as a friend about peaceful and pleasant things," he wrote on 15 July, adding sadly, "but it's so long since I knew any peace or rest that I think you'll forgive me a little...."104

Bussy offered to act as go-between with his friend Auguste Bréal, a born fixer of great charm, generosity and wide contacts, always less interested in furthering his own career than in promoting other people's.

Matisse, Charles Guérin (?), Auguste Bréal and unknown friend, photographed at Emma Guieysse's house at Saint-Prix

Matisse replied optimistically enough on 31 July, describing his hope of turning into a perfectly acceptable Salon artist—"I'm not such a fool as to think myself indispensable to the advance of painting, and my only wish at present is to earn my living"—with a scribbled rider in the margin: "Balzac says necessity is the midwife of genius; the trouble is I'm not a genius. And if I were, from a pecuniary point of view, it probably wouldn't make much difference." He was already installed at Lesquielles by this time. The weather was rainy and grey, the three takers for his scheme had not materialised, and desperation was getting the upper hand. "I've replied at once so you could do what you can if there's a way—as soon as possible, for the anxiety often becomes agonising, both for me and for my wife, and we're growing thin with worry. Forgive me, dear Bussy, for exposing myself like this. . . ." ¹⁰⁶

Matisse often treated Bussy as a kind and supportive elder brother, rather than a slightly younger contemporary who had troubles of his own. The two had missed one another in Paris in the spring (when Bussy was on his way south to start married life at Roquebrune, beyond Nice on the far southeastern coast of France), but their exchange of letters marked the renewal of what became one of the great sustaining friendships of Matisse's life. Of the two, Bussy was the first to discover the Mediterranean (when he spent the winter of 1896 with Martel in Nice), and the first to settle there, as he had been the first to meet Pissarro in 1897. Matisse had caught up late but with accelerating momentum, moving on

from the Impressionists via van Gogh to Cézanne, opening up a gulf between his work and Bussy's that would never close again. From now on Bussy gradually withdrew into reclusion as an artist, maintaining a low, eventually nonexistent public profile and keeping his work for a handful of his more perceptive friends ("The work of Simon Bussy speaks only to those prepared to explore it," wrote André Gide, "but to them, however long their contemplation, it never ceases to give up its secrets"). Long after their professional reputations had been spectacularly reversed, the relationship between Matisse and Bussy retained traces of its origins in respect on one side and reassurance on the other. Well into their sixties, Bussy—familiar for so long with the doubts and inner perturbations that plagued his friend—always had a calming effect on Matisse, who for his part set immense store to the end by Bussy's good opinion.

The tone of probing, sometimes painful intimacy Matisse adopted when he wrote to Bussy was quite different from the lighthearted absurdity of his letters to Manguin and Marquet, who spent the summer of 1903 together at the Manguins' family house beside the sea in Normandy. Matisse consoled himself amid the rigours of his native region by picturing the pair of them—"I think of you often and follow you in my imagination, strolling along the coast, paint-box in hand, screwing up one eye to see which is paler, sea or sky"-and begging them to send him news, painting tips, accounts of work in progress, even a sketch of Manguin's house. 108 They invited him to stay by return of post, Marquet offering a half share of his own room, which Matisse regretfully declined. He contrasted their contentment, the undoubted brilliance of their output and the quietness of Manguin's children with his own sad state that summer. Where he had reported serious progress in his work to Bussy, he lamented the opposite to Manguin and Marquet ("I haven't produced anything worthwhile. Everything I do makes me cry aloud more and more loudly my impotence"). 109 When he finally consulted them about his syndicate in August, it was with a casual offhand jokiness that made it clear he hardly counted on any practical response.

Asking for help did not come easily to Matisse, who much preferred to give it. He described his syndicate tentatively to Jean Biette, apologising for bothering him, worrying about whom to approach and how, begging him not to tell the prodigious Pierre Laprade ("At any rate, I'd never dare"), 110 who had his own show at Vollard's that summer. Help looked more likely to come from Antoine Bourdelle, who had liked the landscape Matisse gave him enough to ask for a second one: "But I still wouldn't dare

propose my scheme to him. I'm a fool because I daren't ask when I know people won't agree to take part, and I dare even less when I know they'll feel themselves obliged to agree."^{III}

Matisse's scheme would almost certainly have worked if he had managed to put it into practice. The paintings were to have been exhibited and sold off after two or three years, by which time he calculated that Vollard would have established his reputation sufficiently for them to make a profit for their owners. It was probably no accident that Matisse's plan bore a striking likeness to another art-buying syndicate, the eminently successful Peau de l'Ours, set up in 1903 by André Level, the enterprising young manager of the Marseilles dock company. Level had been a fairly conventional collector until his discovery of modern art galvanised him into persuading a dozen friends to club together, each contributing 250 francs a year along the lines Matisse envisaged, to build up a collection that was eventually dispersed at a now legendary sale in 1914. Ten of Matisse's canvases were included in this sale. Matisse himself did not meet Level until the winter of 1903-4, just after the launching of the Peau de l'Ours, but rumours could easily have reached him at the planning stage through their mutual friend René Piot (who introduced Matisse to Level), 112 or from someone else who knew how urgently he needed money. Bands of private patrons operating on an ad hoc basis provided the only available subsidy for the arts (apart from official state commissions). Bourdelle—who proved encouraging, but too hard up to help, when Matisse finally contacted him in August 1903—had himself set up a committee of subscribers earlier that year to support the sick and destitute Mécislas Golberg. 113

Matisse's problem was timing. He was forced to rely exclusively on friends, mostly as impecunious as himself, because of the two devastating blows that had almost simultaneously destroyed his chances of making other contacts. Members of his northern family might have helped him if it had not been for the scandal that closed the Gérard margarine factory in Le Cateau: Matisse's Uncle Emile (who had commissioned work from his nephew in the past) died prematurely, apparently from the shock of this disaster, in 1903. In Paris, the Humbert scandal made it impossible for Matisse to approach the far more sophisticated circle of potential backers accessible through Armand Parayre, who knew Arthur Huc, Marcel Sembat and Georges Clemenceau.

In the event, the only firm subscriber to Matisse's syndicate was his father's cousin, Jules Saulnier, 114 the mill-owner who had been (with Emile

Gérard) one of his two marriage witnesses in 1898. Saulnier was the proprietor of the handsome little eighteenth-century château de Bohéries, which stood on a tributary of the Oise a mile or two southwest of Lesquielles, in walled parkland with its own water mill, farm buildings, and a stone stable block that was the sole remainder of a considerably grander mediaeval abbey. Just over six hundred people lived in Bohéries, mostly working for Saulnier in the textile factory whose tall brick chimney reared up directly alongside the château. The rest worked in another textile mill and a sugar refinery, also grouped along the river. Saulnier himself owned a second textile factory in Bohain, and a second country house on the Oise at Pont St-Maxence, to which he had by now largely retired because, as one of his family observed, living beside the factory tended to give the workers wrong ideas. 115

Cousin Saulnier joined Matisse's syndicate with alacrity. "He jumped at it with both feet," Matisse said tartly, explaining that the scheme enabled his cousin to acquire two views of his property at the bargain price of 200 francs the pair, instead of the 150 each Matisse would otherwise have charged. This piece of sharp practice naturally bred ill feeling. But Saulnier, who had been almost the first person ever to buy a painting from Matisse, was the only one of his relations prepared to brave family feeling at this point by taking his work seriously and backing his commitment with a commission. He was not otherwise interested in art, and it is not even certain if he took delivery, for he too died prematurely in 1903. If he had already received Matisse's two views of Bohéries, they were probably destroyed with the château by fire in 1907.

Matisse's spirits soon lifted at Lesquielles. "My house, which touches the church, is perched on the hill that dominates this valley, and my dearest wish goes no further at the moment than to be able to stay here for a year," he wrote to Bussy on 31 July, declaring on the same day to Jean Biette: "This place suits my wife, and as for me, I see an unlimited succession of paintings to be done—everything would be for the best if it weren't for this damnable want of cash." The Matisses' house had a garden, and a magnificent view south over rolling chalk downs to the mediaeval stronghold of the Ducs de Guise. Even the beet fields glinted green in summer. Matisse painted a landscape from the foot of the hill at the bottom of the steep village street, showing his house below the church spire in the distance. For the first time in his life he painted the domestic life around him in his own house and garden as he would do so often in the future: a table laid for a meal out of doors; a warm-toned, Cézannesque

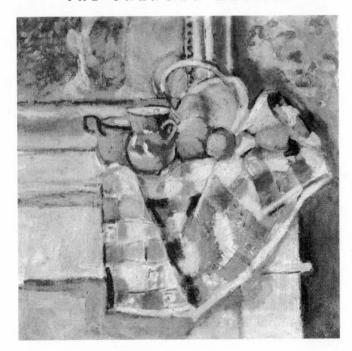

Matisse, Still Life with Red Checked Tablecloth, 1903

still life of apples on a rumpled, red-and-white-checked cloth; and a summer posy of yellow and purple pansies, which had none of the melancholy

gravity that had touched his flower pieces the year before.

Some mornings he set off with his knapsack to work in or around the park at Bohéries. This was where the bare, deforested landscape of the Ardennes met the luxuriant, green, well-watered pastures of the Thiérache. People came from miles around to fish in the pools, streams, rivers and canals that were the glory of Lesquielles and Bohéries. The gently winding road that linked the two passed a clear spring, where travellers could drink and gather watercress. There was also a shortcut through the woods, a precipitous ten-minute scramble starting just below Matisse's lodgings in Lesquielles and coming out near the railway station at the foot of the hill in St-Germain, where a footbridge crossed a small canal that ran parallel to the Oise. He set up his easel between the two watercourses at this point, looking back towards the village half-hidden in trees, and upstream along the broad, reflective surface of the river to the pink millhouse on the right. 120

He painted the play of light and shadow in two more of these lowtoned, leafy, watery landscapes. One shows the lock on a raised section of the main canal at Vadencourt, which flowed along the back of Saulnier's

1902-1903: PARIS AND BOHAIN

Matisse, Path Beside the Stream, 1903: running along the park wall of Cousin Saulnier's château at Bohéries

property and could be reached by a gate in his boundary wall (a tiny protuberance on the top of the green mound to the right of this canvas marks the spire of Lesquielles church in the distance). Another shows the shady walk, l'Allée de la Rivière, between the park wall and the tree-lined riverbank at the front of Saulnier's château. Matisse avoided the house itself, with its twenty-four identical windows lined up along a symmetrical façade, in favour of his cousin's flower borders, shrubberies and the tall trees in the garden. In all, he brought back at least seven paintings from the six or eight weeks, which was the most he finally spent at Lesquielles (the previous six months at Bohain had produced only a dozen canvases).

Matisse reluctantly dropped his plan for a syndicate, and with it his dream of a year in the country, after a trip to Paris in mid-August, when Bourdelle and Vollard between them changed his mind. Bourdelle failed to put forward a single candidate to fill the eleven vacant places on Matisse's committee of collectors. Vollard—or "fifi wleur [Fifi the thief]," as Matisse rudely called him to Manguin and Marquet—bought more

paintings and offered to put on a show that winter. Matisse accepted, although the offer made him wish once again that he had chosen a different profession altogether. "I guess he'd give me a dirty look if I were to abandon the penal servitude they call the artist's life," he wrote grimly; "that would be the first great joy of my life as a bourgeois." ¹²³

Matisse had gone up to town for the Humbert trial, which finally opened in the assize courts of the Seine on 6 August. The house was packed for what *Le Matin* called "one of the most fantastic and most rivet-

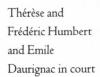

ing judicial spectacles you could hope to see." 124 Disappointed crowds had to be turned away. "The presence of Maître du Buit, and above all of Parayre, caused a stir," wrote a reporter on the first day. 125 Captain Dreyfus's celebrated lawyer, Maître Labori, starred as Mme Humbert's defence counsel. But the Humberts themselves, bedraggled and universally despised, seemed more than ever like burst balloons. People rubbed their eyes and stared, like bystanders in a fairy story when the gold turns out to be dry leaves. A procession of bankers, lawyers and businessmen (including the gallery-owner Georges Petit)¹²⁶ followed one another onto the witness stand, marvelling aloud that they had ever been bewitched or hypnotised into believing in the whole preposterous farrago. Mme Humbert herself—pale, feverish, heaving with emotion, raking the courtroom with blazing glances from dilated eyes, sometimes cursing her tormentors, sometimes talking at random in a voice "like a death rattle" 127—struck more than one reporter as a hunted beast. The whole world watched with incredulity as she was cornered and brought down. "There is not a paper on the surface of the globe which does not feel in honour-bound to give

her pride of place," wrote the *Télé-gramme* of Toulouse with a flash of local pride. ¹²⁸

M. and Mme Parayre were called as witnesses in the second week of the trial, when Matisse came up from the country for three days on a cheap excursion ticket. Their evidence passed off, without drama or revelations, so quietly that their son-in-law seized his chance to fit in a couple of sittings with Bevilacqua ("The session...at the assize court... was a waste of time compared to the one with Bevilacqua," he wrote to Manguin and Marquet on 27 August). 129 No further suspicion attached to either Parayre or his wife.

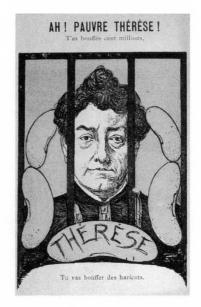

"Ah, poor Thérèse! You've gobbled up 100 millions. Now you'll have to live by gobbling beans."

They were unanimously agreed to have been innocent stooges, "purest of the pure" like Maître du Buit, or the even more wretched Maître Dumort of Rouen, people whose integrity and genuine conviction had provided essential cover for the Humberts. Jules Claretie called them moral dupes. "What the Humberts set out to do was to create a décor, to provide themselves with references...," wrote Arthur Huc, whose family had known both Humberts and Daurignacs from their beginnings in Toulouse twenty years before. "The Humberts surrounded themselves with extras rather than accomplices." Islandon to have been innocent stooges, "purest of the pure" like Maître Dumort of Rouen, people whose integrity and genuine conviction had provided essential cover for the Humberts. Jules Claretie called them moral dupes. "Islandon to have been innocent stooges, "purest of the pure stooges, pure stooges,

Thérèse Humbert and her husband were each sentenced on 21 August to five years' solitary confinement with hard labour, her brothers Romain and Emile Daurignac to three and two years respectively (no charges had been brought against Mme Humbert's sister or daughter). They were generally considered to have been let off lightly. So were a great many more important people who might have found themselves in trouble if proceedings at the trial had been anything like as wide-ranging as the preliminary investigation. A collective sigh of relief went up all over France. The affair had uncovered a depth of cynical corruption best not thought about again. Mme Humbert served her sentence in the women's prison at Rennes. Her husband Frédéric was sent to Melun, scene of his own and Parayre's former triumphs, to spend his five years in the Central Prison (a barracks within earshot of the boarding school where Amélie Matisse had once lain in bed at night, listening to the changing of the guard). Nothing

Matisse, Profile of a Child (Marguerite),

more was ever heard of either after their release in 1908. 132

The Parayres moved back into Berthe's house at Rouen. Her mother never apparently recovered from the destruction of her faith in Thérèse Humbert, which had been for almost thirty years the core of her faith in herself. She died, at the age of sixty, a few weeks before Thérèse was released from prison. Armand Parayre, who had rapidly regained spirits, energy and humour, lived to a ripe old age at the centre of his younger daughter's house-

hold, radiating intellectual curiosity, reading, writing, learning languages, much loved by Berthe's pupils and by his Matisse grandchildren. The Matisses themselves returned to Paris in the autumn of 1903. They left their sons in the North, Jean with the grandmother he loved in Bohain, Pierre in Rouen with his other grandparents and Berthe, who adored him.

Marguerite moved back, as she had always longed to do, to take up her old life again as a studio child at 19 quai St-Michel. She was nine years old that autumn, and already beginning to be indispensable. She could sit quietly, watch carefully, and look after the tiny studio apartment when her mother went out to work (the ordeals of the last sixteen months had drawn the two so close that both seem long since to have forgotten that Marguerite was in fact Amélie's adoptive daughter). Matisse marked the end of almost two years' disruption by modelling Marguerite's profile in clay bas-relief; from now on his daughter would become scarcely less important to him as a model than his wife herself.

Amélie had gone back to her old job, working as a modiste for her Aunt Nine at the Grande Maison des Modes. ¹³³ Matisse, too, was hunting for work that autumn. Word of his situation went round among his friends, who did what they could to urge him on. "Heaven knows, not a day passes but I think of you," Jean Puy wrote, sending fervent wishes for Matisse's peace of mind and future prospects, "and as I work, I think of your example and of your advice. When my painting flags and I can only sit on my backside, the memory of your determination, and your breadth

Left to right: Pippa Strachey, Hermann Dick (?), Pernel Strachey, Hermine Bréal, Emma Guieysse (seated), Michel Bréal, Dorothy Strachey and Simon Bussy; at Saint-Prix, 1899

of vision, drives me on like a searing and reviving whiplash!"¹³⁴ By far the most effective practical encouragement came from Auguste Bréal, who began by buying two of the Lesquielles canvases for the princely sum of 400 francs (or double the price paid by Saulnier). "The money came in the nick of time for me," Matisse reported to Bussy: "high time, and more than time, for it vanished in a flash."¹³⁵

Bréal was the renegade son of Parisian intellectuals, closely connected through his wife with the English Strachey family (who treated the couple as the French end of what later became the Bloomsbury intelligentsia in London). Brilliant, erudite, infinitely resourceful, he had begun by following in the footsteps of his father, the distinguished philologist Michel Bréal, who said stoically on learning that his son had given up studying Oriental languages at Cambridge University: "Bah! Since Auguste can't seem to get his teeth into Hindustani, why shouldn't he paint? He'll have to find some way to pass the time." Bréal offered to fix Matisse up with drawing pupils as he had done two years earlier in London for Simon Bussy (whose new wife, Dorothy Strachey, had been one of the students drummed up by Bréal). Bréal's wife Louise made a point of inviting the Matisses to dinner—"We must ask them round for a square meal"—while their eight-year-old daughter Hermine, another studio child, was detailed to play with Marguerite (whose shyness and stiffness, the natural consequence of her truncated childhood, made games difficult). 138

Bréal next roped in his younger brother Henri, a lawyer who had once played the violin with Henri Evenepoel, and who now pulled strings behind the scenes to get Matisse appointed contrôleur du Droit des Pauvres: a grand title for a shabby job which consisted of making nightly rounds of theatres and music halls to collect a levy on box-office takings destined to fund the Paris workhouse. The job's advantage was that it would bring in 1,200 francs a year while leaving daytimes free for painting. But Matisse had, as he said himself, nothing on his plate but trouble. He failed to get the post, and at some point in October or November, word came that his son Pierre was ill with bronchial pneumonia in Rouen. Survival was always problematic for sick children in northern winters, when mortality rates rose steeply, and Matisse was not hopeful. The very much afraid this may end badly, he wrote to Bussy towards the end of that dreadful year. My wife . . . has just left for Rouen to nurse little Pierre, who is my last-born. He is three years old.

This was the second time in two years that the Matisses came close to losing a child. When Pierre pulled through, Amélie brought him back to convalesce at the quai St-Michel, where she could keep him under her eve. and where it became one of Marguerite's jobs to look after him. He took a rooted dislike that winter to his father's Italian model, Carmelina, who tried her best without success to win him over. It In the end Matisse painted Pierre, too, standing beside the studio still-life table and clutching his wooden horse called Bidouille (colour fig. 14). 142 Life was not easy for a small boy who had to learn to be seen but not heard in the cramped confines of a studio apartment designed for a bachelor artist, or for his older sister, who was responsible for keeping him quiet. The Bréal and Manguin children had separate living quarters, and nursemaids to take care of them. Even so, Lucile Manguin (who was five years younger than Pierre Matisse) remembered her earliest feeling for her father as a mixture of fear and awe: "Attracted by the magic of the white canvas putting on little by little its colored robe, I couldn't go near it; those were the orders." 143 However wistfully Pierre looked back at the time to his fond aunt at Rouen, and to his even more indulgent nurse at Busigny, he was, like his sister and Lucile, dazzled then and afterwards by the magic of the creative process. In the early years of the century, until Pierre was sent away to school, he and Marguerite were the children at home. They never lost their closeness, or their unconditional commitment to their father's art.

In the winter of 1903–4 it was the children's Aunt Berthe who collapsed next. She had carried on teaching, paying no attention to her growing exhaustion or her difficulties in breathing, ignoring the threat of suspected TB, and returning to work too soon after a brief sick leave. Her health gave way in the New Year so completely that her doctor predicted, wrongly, that she would never return to teaching. Her renewed sick

leave stretched into the autumn, when her application on health grounds for a transfer to Toulouse was turned down, because the authorities felt her connection with the Humberts made it unwise for her ever to return to the town where she grew up. She was posted instead even further south to Perpignan, where she settled with her parents, a move that would have crucial repercussions on Matisse's life and work.

On 31 October 1903 the Salon d'Automne put on its first exhibition. Matisse, Marquet and Manguin had been planning strategy and preparing their submissions to the jury for a month or more beforehand. The new venture, intended to pioneer a more liberal exhibition policy than either the official Salon or the increasingly repressive Salon de la Nationale, had been organised by a group of older artists led by the architect Frantz Jourdain (designer of the Samaritaine, the department store on which Zola based Le Bonheur des dames). Jourdain saw himself as a cross between Robinson Crusoe and the hero of a Fenimore Cooper adventure story, or alternatively as a Trojan horse attempting to breach establishment defences. 145 Arrangements for the new salon, organised by well-meaning amateurs on a shoestring from a café on the place Blanche, had been touch-and-go to the last minute. It finally opened, on a bitterly cold night in the unheated basement of the Petit Palais, in the teeth of hostile manoeuvres by the Beaux-Arts lobby, and even more vociferous opposition from former champions of liberty at the Salon de la Nationale.

Jourdain's heroic venture would shortly be attacked from the opposite direction, for being altogether too timid, by Matisse and others of his younger generation. Frantz Jourdain's son Francis saw his father's cronies as a bunch of discontented greybeards who would have been only too happy to settle for conventional success: "The worthies of the place Blanche [les justes de la Place Blanche] did not so much want to drive evildoers out of the Temple. Their ambition was to occupy a part of the Temple themselves for a few weeks." In fact, the new salon was a halfway house. Eugène Carrière was its honorary president (his defection was considered an unspeakable betrayal by his former colleagues at the Salon de la Nationale). Matisse's old companion from Belle-Ile, Emile Wéry, organised the painting section. From the point of view of more audacious artists, familiar with experimental developments in studios all over Montmartre and Montparnasse, the work on show at the first Salon d'Automne clung firmly to the middle of the road.

But for even the least hidebound gallery-goer, the effect was electric. "It was a revelation to me," André Level wrote of this salon. "There was a boldness and youthfulness there which cut through the monotony and

THE UNKNOWN MATISSE

predictability of the grand annual salons.... I saw canvases there which seemed to me, without the slightest shadow of a doubt, to be the authentic art of our own age, and of the immediate future. I believed in it, I had faith." Matisse was represented by his *Tulips* and by his *Skein-winder from Picardy*, the Flemish interior painted in a style which had looked wilfully lumpy and unlifelike to the citizens of Bohain, but which seemed already sadly out-of-date in Paris. In the early months of 1904, it was high time, and more than time, for Matisse to turn again to the art of the present and the future.

CHAPTER NINE

1904: St-Tropez

how I we mis his content et je in rapporte zen Infai on a le soute d'al défai que. from se lost her, mon gone Paris auss is a bonong change separat grider in. South gur pour un come je n'or per en de charce. que l'ai du feire me demande trop tout et que pe a'éla per port in he liste des condidate et que per courignel come n'ilail per prépaté. molgre ale je It's peal the day de so peier our margare a the traver they will be a some some expert. I repose gui an mettre men nom i le guesse el que , il vote le l'arque on up gum feign in france to me que perge l'i't avai, to one John et je remerge gran la ge was pris open tout ce grelle de land. a har ugurder elle est affecte & in oragine the e quille a to voi gonne je dois the promble a population an is now I pen retourne a Peris hautit sera -ce rous I pour ou does 15? how com were 50 fr. a cheese i'm from you it was cute to parte - Paris a y arriver au unt her vieny Distantinos amitica to fume. I wime ne en a me charge worce of go the ke sais for gone je liviris man I comme depend A trups infini ells me rebuce de cutte aportrople: I con a mangini. Le raygon qu'elle sol unime de I four restricuents a vote is and one author to frame y to your pour non - of to a serve amiculand

Letter from
Matisse to Manguin, September
1904, showing the
St-Tropez caféowner who dismayed Matisse
by turning ugly

ou talk of my going south to the Midi," Matisse wrote to Bussy, who was settling into his new villa on the Mediterranean above the Bay of Menton: "it is, alas, my dearest dream; but, mon cher, without money, what can you do? I think I should work twice as hard there as in the North, where the winter light is so poor—that will be for later, perhaps."

At some point in the winter of 1903–4, Matisse met Paul Signac, who had a villa at St-Tropez in the Midi and made a point of encouraging younger artists to join him there for painting trips. Signac was vice president of the Société des Artistes Indépendants. He had been a founding member in 1884 at the age of twenty-one, and remained all his life a passionate advocate of the Indépendants, which, unlike any of the other salons, never settled down into a conservative old age. Scruffy, flexible, down at heel, more or less nomadic, the society was riding high in 1904 on the strength of its recent move into the Grandes Serres on the Seine, spacious light-filled glass houses put up on a temporary basis to hold the horticultural section of the 1900 Universal Exhibition.

The Indépendants was the only salon to have abolished the competitive and hierarchical system, which was a philosophical approach as much as an administrative convenience in France. Exhibitors were neither selected beforehand nor rewarded afterwards with individual accolades: "Sans jury ni récompense" became the Indépendants' battle cry. The result was a democratic free-for-all that could degenerate into a scrum. "It matters to me to exhibit as much as possible at the Indépendants...," wrote another founding member, Signac's friend Henri Edmond Cross, insisting in February 1904 that even after twenty years the struggle must go on. "Besides, I like the style of the Indépendants, combative outsiders, kicked around from the right and from the left, crushed by every kind of material hardship, and indestructible all the same, standing up against all setbacks."²

It was a style that suited Matisse, too, in 1904. He had served his time on the hanging committee and been successfully nominated as one of Signac's deputies by Marquet and Manguin,³ who took their turn that year at putting up the pictures. They had 2,395 works to hang before the show could open on 21 February (Signac, away in Italy for the opening, was sad but not surprised to hear that their hanging was deplorable).⁴ There were

six canvases each from Matisse, Manguin and Charles Camoin, five from Marquet. The last two sold all their paintings and left in triumph for the Midi on the proceeds.⁵ Matisse, singled out for praise by Moreau's old ally, Roger Marx, found buyers for a flower piece and an interior (although not for his *Meditating Monk*).⁶

In the same week that the Indépendants opened, André Level officially signed the document that empowered him to set about forming the collection called the Peau de l'Ours, through which he hoped "to give young collectors a taste for the work of painters as young as themselves." Level at forty was older than the other members of his syndicate: bankers and businessmen (including his three brothers and a cousin) mostly near the start of their careers, many of them in their twenties. Matisse said that the group, which met regularly to play cards, had been persuaded to hand over their winnings to Level for him to invest in paintings.8 His buying committee consisted of two other members—"my bodyguards"—who could prevent his making acquisitions but not force him to buy. One of his first acts was to climb the 102 stairs to Matisse's studio at 19 quai St-Michel. His two bodyguards were the manager of the Paris Gas Company, Maurice Ellissen and his brother Robert, neither of whom raised any objection to the canvases Level picked out: Still Life with Eggs, painted in Bohain in 1896, and a more recent landscape showing the Pont St-Michel under snow. "It made a strong impression, stronger even than when I first saw it. That is the way with all your paintings," Level wrote of this snow scene, in a letter agreeing on 18 March to the price of 550 francs for both pictures.9 Forty years later Matisse's memory of being paid for his still life retained the clarity of a dream. "He gave me 400 francs. I found myself holding four bills for one hundred francs in my hand! I couldn't get over it." Before he could start worrying as to whether or not he had overcharged, an old friend from Moreau's studio, Charles Guérin, tapped on the door to ask how he was doing:

I placed a one-hundred-franc bill on the floor. I stepped back one metre. I put down the second bill. Another metre. I put down the third. And then, one metre further back, the fourth. And Charles Guérin touched the bills with his foot, before asking me uneasily: "Have you killed someone?" ¹⁰

Level, who had been shocked to learn from René Piot of Matisse's financial plight, tried without success to interest a friend in a bigger and even more expensive canvas, only to find to his surprise that the friend

(probably one of the Ellissens, who became regular clients later) started buying Matisses on his own account within twelve months. It Matisse was bitter about collectors who congratulated him on his work, assuring him of their interest and generally raising his hopes, while waiting callously to buy until he was no longer in urgent need of money. But these particular collectors were still learning their trade. Level, who regarded the triangular contest between artist, collector and dealer as a refined game of nerve and skill, came to enjoy the slow, step-by-step advances of his personal experiment in visual education. He bought a third Matisse, two Picassos and a Gauguin for the Peau de l'Ours in its first year, noting that his friends were always happier with early work (like Matisse's still life) than with his latest acquisitions, "because it was so difficult to miss out any of the rungs, to skip or overshoot a stage." Is

Level recognised time as a prime factor in retraining the eye and the imagination. So did Ambroise Vollard. Although he had offered Matisse a show in the summer of 1903, when it looked at least possible that the syndicate might release him from the power of dealers, Vollard made no further move. Matisse hung about the gallery on the rue Lafitte, half exasperated, half fascinated by the dealer's inexhaustible fund of stories. As a raconteur, Matisse met his match in Vollard, whose drowsy lisp and heavy, brooding presence he mimicked ever afterwards with a relish equalled only in his imitations of Bouguereau.¹³ When Vollard finally invited himself to dinner at 19 quai St-Michel, Matisse prepared a stack of paintings while his wife cooked an elaborate meal. Their guest ate heartily, then fell asleep-Matisse said that after meals he looked "like a replete python"14—snoring soundly until it was time to go at eleven o'clock, when he insisted on inspecting the apartment, poking about and wanting to know if there was a back door (Matisse realised afterwards that he had been trying to locate Cézanne's Three Bathers). 15 One evening he asked the Matisses round, with a couple of other guests, only to drop off again: "Vollard left us gaping at the round table covered with an ancient oilcloth, beneath a faded orange lampshade blackened by fly droppings. I had the impression he was pretending to be asleep in order to make fools of us."16

People not personally involved often found something magical about Vollard's strange tactics of somnolence and evasion, his habit of stonewalling customers, his extreme reluctance ever to part with a painting, or even to show up for an appointment with a collector in his half-empty shop with its stacks of canvases turned to face the wall. "Sitting in a corner a man with a huge misshapen head and a swarthy skin seemed to

1904: ST-TROPEZ

Paul Cézanne, Portrait of Ambroise Vollard, 1899

be asleep...," wrote André Billy, describing Vollard's gallery on the rue Lafitte in the early years of the century. "You saw him standing behind his open door... watching the movement on the boulevard with an air of such boredom that you felt sorry for him. Dreaming and sleeping like this, alone in his shop, Vollard was wasting no time.... Month by month, in solitude and silence, the prices of his pictures rose." 17

Matisse and his friends took part in a second mixed show at Berthe Weill's gallery in April 1904. Weill, a year or so older than Vollard, was still operating from hand to mouth, subsidising her regular mixed bags of modern painters by alternating them with shows of graphic work from more established artists. She had recently enlarged and refurbished her gallery on the strength of 10,000 francs paid over in compensation for a serious railway accident. People still stopped in front of her window to laugh and point ("It was a c—— who painted that for sure! But even more of a c—— who buys it!"), and it was a red-letter day when the sales of any given exhibition covered its costs. Weill's attitude to time was the opposite of Vollard's. She liked to keep on the move, selling fast and cheaply, mesmerised by turnover, temperamentally unable either to hold on to her stock or, on the rare occasions when she had any, to put money

aside. Dealing meant for her the speed, action and exhilaration of perpetual change. Although virtually all the major modern artists in Paris passed through her hands, none of them stayed for long.

Vollard dealt in patience and concentration. Matisse had calculated correctly that Vollard, if anyone, would establish his reputation. The two circled one another in their mid-thirties, each wary of the heavyweight in the other. Like Matisse, Vollard had started out at twenty as a law student, shipped back to Paris by his parents from the French colonial island of Réunion, off the coast of Madagascar. His passion for pictures had brought him as close to destitution as Matisse, and left him as unsentimental. He said that even in his worst moments as a young dealer in the early 1890s—cold, hungry, often sick, going whole days without bread, and whole winters without an overcoat—he still refused to sell the paintings he had half starved himself to buy. Once he walked all the way from his rented room in Montmartre in the north of Paris to Bercy in the south, where he hoped to sell a drawing by Forain to an art-loving winemerchant, who offered him twenty francs short of his asking price. "You're haggling over my Forain," I said to my client. "Very well! It isn't 120 francs anymore, I want 150."20 The obduracy and the secretiveness ingrained in those days never left him. "I'm always afraid all that will start again," Vollard once told Vlaminck.21

The trouble between the two great gamblers, Matisse and Vollard, was that neither could give the other the secure base each had to have at this stage in order for his gamble to come off. Matisse, who needed guaranteed backing, sensed in Vollard the lack of confidence he dreaded in his own father. Vollard for his part seems to have treated the young Matisse as, in avant-garde terms, not much better than a potboiler: a safe hand whose thoroughly acceptable still lifes and landscapes could be relied on to keep the gallery ticking over while its owner waited for more serious stock to rise. No one, except those who had explored the studio on the quai St-Michel, had yet seen anything that might have made Matisse seem a riskier proposition. For public exhibitions, he was still drawing on a store of unsold work going back to Bohain and Belle-Ile in the mid-1890s. In 1904 he began for the first time to show canvases from his Corsican honeymoon, but not the pointilliste studies that followed, or the series of coloursaturated still lifes he had begun in Toulouse. When Vollard finally named a date for his show (which ran from 1 to 18 June 1904), Matisse selected forty-five paintings, all but eight of which were either landscapes or still lifes. They ranged from The Dinner Table, which had looked all set to make his fortune in 1896, to the costume studies of six years later—a couple of

guitarists, the monk and the musketeer—and a clutch of landscapes from Lesquielles. All (except for the Corsican paintings) stuck to the traditional palette of which he had long been master: what Vollard called "his greys

that appealed so strongly to the customers."22

Matisse installed his paintings himself, arranging them in order of interest as he would have done for friends to inspect them in the studio, or at the informal, end-of-term student shows at Moreau's. Looking back later, he agreed with Eugène Carrière that the show had been abominably hung.²³ Carrière's support, expressed in a characteristically practical offer to help hang the next show, was a comfort to Matisse. So was the general feeling that this retrospective had confirmed his standing as a senior member of the rising generation. Even so, he resented the way Vollard used his pictures as decoys to entice collectors, shamelessly bringing out Cézannes and Renoirs in the middle of the private view.²⁴ Nor did he care for being told to mind the shop when Vollard, who was expecting a major collector anxious to buy a painting by Gauguin, planned as usual to be out. The disappointed client was Hugo von Tschudi of the Imperial Museum in Berlin, the only major European museum director collecting Post-Impressionists at this date: Matisse, acting on Vollard's instructions, showed him an exceptionally fine Tahitian nude by Gauguin²⁵ (and perhaps he showed him his own paintings, too, for Tschudi commissioned a still life from Matisse six years later).

The show was a reasonable, if not a resounding, success. The solidity of Matisse's achievement and the steadiness of his eye were praised by sympathetic critics following the lead of Roger Marx, the museums inspector who had been the first to predict great things for Moreau's students in 1896, and had remained their consistent champion ever since. For ten years Marx had followed their progress, chronicling their achievements in the press, smoothing their paths behind the scenes, intervening with the purchasing committee on behalf of their Louvre copies, welcoming them to his office or on Sunday mornings at home, where he had an impressive art collection of his own. To young painters who lost their way in the corridors of artistic power, Marx was an unexpectedly reassuring figure, bearded and balding, with a high forehead, hooded eyes and a forceful, questing nose ("an enormous nose which puts half his face in shadow," wrote Henri Evenepoel, who, like Matisse, had had reason to be grateful for Marx's encouragement).²⁶

Marx's courage and discernment were rare, if not unique, among Beaux-Arts civil servants. It was Marx who had been responsible for including Cézanne and the Impressionists in the grand Centennale show

put on to celebrate the last hundred years of French art at the Universal Exhibition of 1900 (Impressionists were banned from the official Décennale, covering the previous decade). He had watched over Matisse's career from its beginning, arranging his first sale (Woman Reading) to the state in 1896, introducing him to Berthe Weill in 1901, and drawing public attention to all three chances to see his work in the first six months of 1904. He wrote about Matisse at length in his review of the Indépendants ("M. Henri Matisse won our hearts long ago, and the path to a rapid success lay open to him after his first exhibition at the Champ-de-Mars..."), 27 as well as in catalogue prefaces for both Weill's and Vollard's shows. Although none of Matisse's friends ever mentioned the Humbert Affair in print, their tacit sympathy may be gauged from the essay Marx wrote for Vollard's catalogue, which was not so much an interpretation of the work on show, more a moral testimonial to the painter's firmness of purpose, fortitude in adversity and readiness to make sacrifices for his art.

Matisse seemed once again to be heading for the professional acceptance which had been within his grasp eight years before, and which he had deliberately thrown away by exhibiting *The Dinner Table* at the Salon de la Nationale. For the first time since those days, he was starting to make a living for himself and his family from the sale of paintings. Vollard did not buy up the contents of his studio, as he would do in the next few years for many of Matisse's friends (among them Henri Manguin, Jean Puy and André Derain). But he sold a canvas to the collector Olivier Sainsère, and bought *The Dinner Table* on his own account for his usual price of 200 francs (promptly reselling it for 1,500 to a German collector). Vollard's show made Matisse look like a paying proposition to other dealers, one of whom agreed to take all the academic still lifes he could supply for 400 francs apiece. The only snag was that, having managed for so long without a regular income, Matisse now found himself unwilling, if not unable, to make the compromises expected of him in return:

One day, I had just finished one of these [still life] pictures. It was as good as the previous one, and very much like it. I knew that on delivery I would get the money that I sorely needed. There was a temptation to deliver it, but I knew that if I yielded it would be my artistic death. Looking back, I realise that it required courage to destroy that picture, particularly since the hands of the butcher and the baker were outstretched waiting for the money. But I did destroy it. I count my emancipation from that day.²⁹

Canvases being expensive and funds short, Matisse's wife and daughter were set to scrub or scrape off the surface of the painting, which was followed by others as his destructive fury grew. Marguerite remembered ever afterwards scrubbing with aching arms and heart at more and more pictures, which had to be obliterated for fear her father's resolution might weaken when the dealer called the next day.³⁰ It was a more violent replay of Matisse's revulsion against the tyranny of tradition in 1896. Once again he felt that he had swung too far in the direction of order and control. He had spent the six weeks before the opening of his show at Vollard's copying with Manguin and Marquet in the Louvre. This was the first time he had worked in the galleries since the fine, careless rapture of his experiments with Derain, and now he made a copy of Raphael's portrait of Balthazar Castiglione which was meticulously accurate, from the slashed brim of Castiglione's big black hat to his white linen shirt and puffed velvet sleeves.31 Even Jean Puy thought that Matisse was overdoing his subjugation to reality, a phase from which Puy said his friend was rescued by Paul Signac.³²

Matisse had written in early May to Signac in St-Tropez, asking for advice about finding a place to rent that summer. Signac warned him that the seaside landladies of St-Tropez were likely to charge more than three times as much as he had paid the year before in the industrial North (100 francs a month, as against 28 in Lesquielles). In the end Signac found him a place for 50 francs: a tiny cottage called "La Ramade"—two rooms up, two down—which was too small for the whole family (the landlady in any case charged extra for children).33 Marquet, who had planned to spend this summer with the Matisses as he had spent the last with Manguin's family in Normandy, dropped out at the last moment, pleading poverty and pressure of work (he was illustrating a low-life Parisian novel, Bubu de Montparnasse, for his friend Charles-Louis Philippe). "I am working myself into the ground, as hard as I can, at a job I loathe," he wrote to Matisse from his sweltering studio on the quai des Augustins; "meanwhile there are some—and you know all about them—who wallow beside a beautiful blue sea, beneath a clear sky among the trees etc.—lucky devils!"34

The Matisses left Paris on 12 July,³⁵ accompanied only by the four-year-old Pierre, whose delicate state of health needed sea air (Jean was presumably still in Bohain, and perhaps Marguerite went to Amélie's sister for the holidays, or back to her own mother). In the haste of packing up, Matisse forgot to submit his Raphael copy to the Beaux-Arts purchasing committee, a slip that would cause endless trouble all summer.³⁶ "Our

friend Matisse is here," Signac wrote from St-Tropez to Henri Edmond Cross, "a very good sort, intelligent and a real painter—but yet another victim of the copy—if a cloud changes shape, it puts him on the spot and leaves him helpless. I haven't seen his painting yet. He talks to me about his plumb line, *chambre claire*, with all the colours, ochre, white and black . . . that make up his range."³⁷

St-Tropez in 1904 was readily accessible only by boat. Arriving by train as the Matisses did meant an interminable journey from Paris, followed by a ride along the coastal railway as far as the next port of St-Raphaël, from which it could take up to half a day by branch line through wild and isolated country to reach St-Tropez itself. The town was an almost impregnable citadel at the heart of a region of fortified hilltop villages that had for centuries fought off Saracen invaders. It was set into the curve of a deep circular bay: a cluster of tall houses, washed in faded ochre, pink and yellow, protected by water and cut off from the interior by a range of mountains known after their Moorish attackers as Les Maures. When Maupassant visited St-Tropez in the 1880s, it seemed to him like a marine outcrop: "one of those modest little towns, growing in the sea like a shell, nourished by fish and sea air, and producing sailors. . . . You smell fishing and boiling tar, brine and the hulls of boats; you see sardine scales, like pearls, on the cobbled streets, and harbour walls peopled by old sailors, limping and half-paralysed, sunning themselves on the stone benches."38

Unlike Nice, Marseilles or Toulon, St-Tropez faced north rather than south, catching the sun all afternoon and enjoying spectacular sunsets. For visitors from Paris, the sun could be a problem. The Matisses arrived at the hottest point of the whole year, when contemporary visitors normally fled the Côte d'Azur: "The excessive heat stopped us sleeping at night and crushed us by day," Matisse wrote to Manguin, describing how he had forced himself to work in spite of the risk of sunstroke.³⁹ Ribald speculation as to whether his lead plumb line would or wouldn't melt greatly entertained his friends in Paris, while Matisse wrestled with his pictorial problems that summer. 40 As always in a new place under a new light which would eventually bring about a profound visual and imaginative readjustment, he was overwhelmed by frustration and inertia. He wrote despairing letters to Marquet and Manguin, blaming his guardian demon ("I have never had a guardian angel"), complaining about his work ("I fear painting will drive me mad, so I'm going to try to give it up as soon as possible"), and longing to see what they were doing. 41 Isolation added to the miseries that oppressed him. Apart from fishermen, wine-growers and a local

Théo van Rysselberghe, *Signac on His Boat*, 1896

painter called Pégurier, there was no one for company but Signac himself.⁴²

Signac was master of St-Tropez, which he had discovered from the sea twelve years before (he was an intrepid yachtsman, never without a boat in which to pilot his friends out to sea or ferry them along the coast). He had built himself a house, called La Hune (Crows' Nest), above the town with a wild, jungly garden and a commanding view. He picked for his house "the site which, failing the citadel itself, a captain would have chosen to defend the town.... No new arrival escaped this sailor: no drama, fête or holiday: a storm from the east, the blaze of the setting sun, a sail, a scheme afoot, nothing could remain hidden from the painter."43 Signac was by temperament almost the opposite of Matisse: expansive, sanguine, categorical, immensely sure of himself and of his aims. He had something of the vigour and vehemence, the high temper and robust appetite for life of his Australian contemporary John Peter Russell (the two had been neighbours in the same studio complex on the impasse Hélène in Paris in the 1880s, when they both kept sailing boats on the Seine and shared at least one mutual friend in Vincent van Gogh).44 Both preached the gospel of pure colour (colour fig. 15). Both brought to painting boundless vitality, conviction and physical attack. For the second time in his life Matisse found himself marooned on an island or "almost-island" (St-Tropez stood on a peninsula, or presqu'ile) with a passionate proselytising colourist whose message was precisely what he needed as an artist at that particular juncture.

Signac was the fiercest, the most partisan, the most unequivocally convinced of all the Neo-Impressionists, or Neos. For him, the Neos' tech-

nique of Divisionism—pure colours built up, according to the law of contrasts, in separate or divided brushstrokes to produce a peculiarly brilliant luminosity—had developed philosophical, even quasi-religious overtones. "I feel myself in this philosophy free, full of feeling, strong and happy as a lark," Signac wrote to his friend and fellow Neo, Théo van Rysselberghe. Signac's exuberant creative power flourished within the close confines of Divisionism, which provided him with an essential discipline, like rhyme for poets ("Far from hampering their inspiration, it helps give their work a severe and poetic quality"). He rejoiced in the prospect of a new and still unknown art of the future for which the Neo-Impressionists had prepared the ground. "And if there has not yet appeared among them the artist who, by his genius, will be able to exploit their technique to the full, they will at least have helped to simplify his task. This triumphant colourist has only to show himself: his palette has been prepared for him."

Signac published his prophecy in the manifesto From Eugène Delacroix to Neo-Impressionism, which had launched Matisse on his first encounter with Divisionism in 1898. The book was Signac's successful bid to rally his fellow Neos after a series of disasters—professional defections, critical hostility, public indifference—that followed the premature death of the movement's cofounder, Georges Seurat, in 1891. Devastated by the loss of Seurat, Signac retreated to regroup in St-Tropez, emerging seven years later with the book that decisively turned the tide in the Neo-Impressionists' favour. Signac had always been the movement's keenest propagandist. As a young man in his early twenties, he had enlisted both van Gogh and Pissarro (van Gogh proved at best a partial convert: Pissarro's recantation after five years as a Divisionist was regarded by Signac as rank treachery). There was nothing Signac liked better than a new recruit to what he called his "joyous polychrome battalions," but his approach was neither crude nor overbearing. "Drawn to systemisation, he did not preach," wrote Francis Jourdain: "he reflected."48

By the time of his meeting with Matisse, Signac had made himself, as his friend Félix Fénéon observed, the Claude Lorrain of Neo-Impressionism to Seurat's Poussin. ⁴⁹ Signac built up his colour effects on the same system as Seurat, except that "he used a mosaic brushstroke that was much bigger and more authoritarian, as befits his character." ⁵⁰ He began by working from nature in impromptu impressionistic water-colours, but unlike the despised, hit-or-miss Impressionists, Signac aimed to eliminate chance by reasserting the artist's sole control over the creative process. His watercolour sketches of scenes and motifs provided no more

than tactical input for the real wars, which were fought out in the studio. Signac treated each canvas like a battlefield, drawing up a preliminary strategic plan in charcoal, massing and deploying his colour troops, attacking from all sides, establishing bridgeheads and frontiers, bringing up reinforcements and encircling obstacles until, in a final sweeping movement, he occupied the last remaining white spot on the canvas and brought his campaign to a victorious close. ⁵¹

Matisse's Divisionist experiments of five years before had been relatively academic, conducted at second hand on the purely theoretic basis supplied by Signac's manual. What had initially drawn him to the system was the certainty it offered ("Painting had at last been reduced to a scientific formula").⁵² In St-Tropez, he could see at first hand how much energy and emotion were contained within that formulaic discipline. Fellow painters were always welcome in Signac's 45-foot-long studio above the sea. "The azure light floods in from the vast bay," wrote his friend and pupil Lucie Cousturier (whom Matisse met that summer, probably in the studio at La Hune), "abolishing the materiality, the volume of objects, reducing them to subtly differentiated patches against the great pale walls. Signac places his canvas, so to speak, on the sky to paint his colours, and as he works, he conducts a continuous dialogue with space."⁵³

Signac liked to break off this dialogue at intervals for an exchange with a friend, in person or on canvas (he owned works by Cézanne, Renoir, Pissarro and van Gogh—a still life of two salt herrings, wrapped in paper on a plate, which the artist had given him in Arles—as well as by fellow Neos like Henri Edmond Cross).⁵⁴ Signac thought of the paintings in his collection as his personal trainers, and hung them at strategic points around the house for regular consultation. Like John Peter Russell, he had inherited a comfortable income from a father who died early, enabling his son to gratify the genial instincts of an active and outgoing nature. He liked speed, movement, fast cars (he took delivery of one of the first Peugeots in Marseilles in the autumn of 1904),⁵⁵ and people round him. He married young and kept a hospitable table, ahead of his time—in cooking as in painting—in his dislike of anything fussy or overelaborate, preferring simple, elegant, clear-cut food which retained its shapes and colours.⁵⁶

MATISSE READILY RESPONDED to his host's liberating modernism. He set to work on the local motifs in St-Tropez, painting boats in the harbour, the place des Lices and the seventeenth-century chapel of St. Anne, built above the town with a view over the rooftops, which he also painted. He began to advance cautiously for the second time towards Divisionism

itself, making two versions of a *Still Life with Purro*, one of which was a Divisionist transposition of the other.⁵⁷ The singing colours once again released by his return to the south made him place less emphasis on his subject, and more on the decorative surface of his canvas. He read Signac's copy of an article by Emile Bernard on Paul Cézanne which included copious quotations from the master, many of them confirming the Neos' revolutionary approach to colour and the creative process ("Painting is classifying one's sensations of colour... Drawing and colour are not separate at all; insofar as you paint, you draw... Penetrate what is before you, and persevere in expressing it as logically as possible").⁵⁸

The breadth of Signac's knowledge was impressive. His generosity acted as a stimulant, and his work opened up dazzling possibilities. But there was a peremptory and abrasive side to his personality that often grated on the sensibilities of others ("He did not stop to think if the consequences of his pronouncements cut across their familiar prejudices, or undermined the comfortable opinions with which they felt at home," wrote Lucie Cousturier). 59 Signac's assertiveness exacerbated Matisse's already painful state of trepidation. He painted The Gate to Signac's Studio in large, pale, loosely impressionistic patches of flat colour. He also painted the narrow terrace in front of Signac's boathouse, with steps leading down to the sea and Amélie sitting sewing on a stool in the shade cast by the boathouse wall. The Terrace, St-Tropez (colour fig. 18) distilled the flowery, light-filled essence of all the terraces Matisse would ever paint, but his method fell far short of strict Divisionist regulations. When Signac criticised his large brushstrokes, the younger painter felt so crushed and angry that his wife had to take him for a walk to calm him down. 60

Matisse's guardian demon took charge of what started out that afternoon as a family walk beside the sea. When Amélie sat down to give their small son his tea, Matisse dashed off a watercolour of the pair of them seated on the beach opposite a tall Scots pine beside the shining yellow, orange and scarlet path of the setting sun. Afterwards he worked up his preliminary sketch in an oil painting called *The Gulf of St-Tropez* (colour fig. 16): "Since I got here, I have produced only one canvas, size 15, painted at sunset, which gives me a little satisfaction," he wrote to Manguin in September 1904, "and I still can't believe it was me who did it, although I've carried on working on it in a dozen sessions—it seems to me that it was by accident I got my result." "61

The showdown with Signac over *The Terrace* supplied the explosive force Matisse needed periodically to break through, or in his own words kick down, the successive barriers that blocked his way forward as a

painter. In *The Gulf of St-Tropez* he reached a junction between, on the one hand, drawing spontaneously in colour like Cézanne and, on the other, using Signac's tightly formulated notation. He chose the second path on his return to Paris that autumn for *Luxe*, calme et volupté (colour fig. 17), a canvas based directly on *The Gulf*, which was interpreted by both critics and fellow painters as Matisse's formal declaration of Divisionist allegiance. Divisionism provided logical grounds for separating the ultimate goal of painting—order, harmony, emotional stability achieved through rhythmic compositions of form and colour—from its traditional dependence on the subject. This was a separation which in the end Signac could never quite bring himself to complete, although he led many younger painters to the brink from which they could leap—as Matisse himself would do in the summer of 1905—into a pictorial new world.

If Matisse's discouragement was lost on Signac in St-Tropez, it was immediately apparent to Signac's neighbour, Henri Edmond Cross, who had spent the summer of 1904 in Paris, arriving back in the south only at the end of August. Cross had guardian demons of his own. He came over from his house a few miles along the coast to pay his respects in St-Tropez in the first week of September, when he described meeting "the anxious, the madly anxious Matisse" in a letter to Théo van Rysselberghe: "You will easily understand that I was as happy to talk to him as I was delighted to see the self-confidence of our friend Signac...."62 A northerner himself, considerably older than either Signac or Matisse, Cross had been forced to settle permanently in the Midi because of a rheumatic condition that was steadily disabling him. He lived with his wife in a tiny hamlet called St-Clair on the edge of the sea, just over a mile from the nearest fishing village of Le Lavandou, which was itself too small to appear on maps. As a painter, he loved and needed solitude. Starved of company as a man, he developed an extraordinary sensitivity towards other people. Lucie Cousturier was one of the many friends who could never have enough of Cross:

He captured them, on their visits to the coast, absorbing everything, indiscriminately, their stories, their laughter, their gestures, without criticism or preference: he had the knack of making them unfold by his grace of manner, his pleasure in their presence, his unconditional goodwill. He... listened not to what they said, but to what they would have liked to say. In Cross's company, confidence made the shyest and most reserved as cheerful and talkative as children... he never laughed aloud, not simply from a natural

Maximilien Luce, Portrait of Henri Edmond Cross, 1898

taste for restraint, but because of an ingrained insecurity in pleasure. In the presence of suffering or contemplation, he took on a particular gravity, and the brevity of his words made them the more highly prized. ⁶³

Matisse confided in Cross with a freedom he rarely, if ever, showed to another older painter. There were just over thirteen years between them, but the gap seemed wider because Cross had been aged by illness. Prematurely white-haired, fair-skinned with pale blue eyes, he had gnarled hands, stiff joints and brittle limbs like a wind-whipped tree. The two men dined together at a little pension, Chez Maille, on the harbour front at Cavalière, midway between St-Clair and St-Tropez,64 where they discussed life and art and Matisse's decision to turn his back on professional success in favour of hardship and renunciation. "I know well that the question of money for survival is disturbing, and constantly gets in the way of the other, higher question," Cross wrote a year later to Matisse. "But, as you told me, you chose long ago the path of independence, the only noble path."65 In some ways Matisse was following closely in Cross's own footsteps. Like Signac, Cross had private means, but as he explained gently to Matisse, want of money was not the only or necessarily the worst tyranny an artist might have to face.

Henri Edmond Cross, Portrait of Mme Cross, c. 1901

The only son of a French father and an English mother, born thirty miles north of Bohain in the industrial coal-mining town of Douai and brought up, like Matisse, in textile country, Cross educated himself as a painter at the museum in Lille before completing his studies in Paris. ⁶⁶ He was dogged from the start by family and health problems as well as by agonising self-doubt. Like Matisse, he mastered their native Flemish palette, painting sombre interiors, still lifes and portraits, and looking set throughout his twenties to became a follower of the minor Dutch masters. Slow, methodical, reflective, he spent seven years pondering the merits of Divisionism before making a dramatic public conversion in the form of a grand full-length portrait of his wife, which was exhibited at the Indépendants in 1891.

Equally important for his development as a painter was his move to the Midi in the same year. It was Cross who persuaded Signac to settle in St-Tropez. "In summer... the light streaming profusely down on everything attracts you, stupefies you, drives you mad," he wrote after ten years in the south.⁶⁷ Throughout that period he had struggled to render the brilliant explosion of Mediterranean light and colour on a northern retina by means of an analytic Divisionist technique. He was perpetually torn between realism, or truth to nature, and the desire to control, organise and clarify his responses to it. Signac's enviable confidence was as unattainable

for him as for Matisse. "To reach any knowledge of oneself is a rare and precious bonus," Cross wrote to another painter, Charles Angrand, in the week he met Matisse in St-Tropez. "Most people live to the end in doubt and uncertainty. What torment! It's not a matter of finding the right path, but of finding one's own path, as Nietzsche said, 'Become who you are.' Alas! for one moment of certainty, how many hours of doubt!" 68

The Matisses visited the Crosses in their pink house at St-Clair, set among vineyards and orchards at the foot of the mountains called les Maures. Mme Cross, who made much of her husband's friends, welcomed all three Matisses with especial warmth. Irma Cross was on the face of it an odd wife for her ascetic husband. She had been a worldly, stylish Parisienne with nothing like Cross's educational or social background, but once the couple married and left Paris, she threw herself wholeheartedly into their new life of seclusion, watching over her husband, supporting him through gruelling courses of "electrical treatment" in Paris, making his enforced retreat at St-Clair not only tolerable but productive. To many of Cross's friends, it seemed that he could not have survived without her. Others (including Signac) dismissed her as frivolous and shallow, regarding her as a burden her husband bore with stoicism, and blaming her for his gradual withdrawal from normal life. In their patronising company, Mme Cross was made to feel uneducated and inadequate.

Amélie Matisse (who would encounter similar problems herself later with some of her own husband's more supercilious friends) understood what it meant to live with a man driven daily to the brink of desperation by inner tension, insomnia, the paralysing demons of frustration and selfdoubt: troubles "that would set even a navvy's nerves on edge," as Mme Cross wrote to Henri Matisse, "and my Henri has the nerves of an artist."69 The two wives got on well, like their husbands. Irma Cross responded to Amélie's impulsive and dramatic nature: "so charming, so spontaneous," she wrote to Matisse, sending fond wishes to his wife. Over the next year and more, she grew increasingly to trust and depend on Matisse's feeling for her husband, both as a man and as a fellow painter, and she lost her heart to Pierre, who was the only child that summer among six adults (both the Crosses and the Signacs were childless). Pierre was an adorable infant. "I can still see the pensive little boy you used to be," wrote his Aunt Berthe, reliving memories of that period nearly thirty years later, "the child in a pink shirt . . . with big black eyes and golden curls and a gravity that gave an air of mystery."70 A raconteur like his father, Pierre could always make the grown-ups laugh. They called him little Tartine (literally Jam Sandwich, with an underlying impression of

someone who tells stories), and surrounded him that summer with an affectionate warmth that went some way perhaps to make up for the chill shadow cast by the Humbert Affair over almost half of his short life.

The two men talked about the work which was often a misery to them both. Matisse took comfort from Cross's assurance that it would be virtually impossible to suffer worse torments than he did himself.⁷¹ The younger painter swore aloud at his easel, the elder groaned as if crushed by his loaded brush. Each felt himself the helpless prisoner of an obsession he could not have borne to be without. "As you once said to me," Cross wrote ruefully to Matisse, "this confounded Painting takes all our time." 72 They compared and analysed one another's achievements, exploring old canvases and exchanging ideas for new ones. Both were acutely aware that new ways of painting could come only from new ways of thinking and seeing. In September 1904 Cross had just completed a course of treatment in Paris and was enjoying one of the periods of temporary respite in which he lived with redoubled intensity to make up for months of debility and pain. He painted the wooded slopes above his house, descending to the sea in a tumbled mass of pines and cork oaks, punctuated by the dark spires of cypress. He also painted the shady recesses of his garden, layer upon layer of greenery growing so densely that the visitor had to part curtains of weeping willow and push past screens of flowering eucalyptus or mimosa to reach the house, itself in a riot of scarlet geraniums, sky-blue aloes and pink roses.⁷³ "What does nature offer us?" asked Cross.

Disorder, chaos, gaping holes. Yet we go into ecstasies before this chaos, and cry "How beautiful!" A work of art can be plucked from this. It is here that you must "organise your sensations." Offset this disorder, this chance, these holes with order and profusion. From the very fact that we experience sensual emotion, we may conclude that there is something here for us. How to proceed from a practical point of view in order to express this emotion? Select fragments or details of the beauty on offer. Impose order on these fragments, always bearing in mind the end result. At this moment, we make a work of art. We transform, we transpose, we assert power.⁷⁴

This was the nub of the discussions begun at St-Clair or St-Tropez, and continued by post after Matisse had returned to Paris. By 1904 Cross, at the age of forty-eight, had finally reached what he felt fairly confident was his own path. Divisionism, which had been for him a harsh geometric

Paul Signac, The Age of Harmony, 1893–95, 1902

discipline of calculation, equation and deduction, was beginning to offer him the freedom it gave Signac. Cross's friend the poet Emile Verhaeren noted that the cold, stiff, cerebral character of the early work had at last given way to sensual richness and harmony: "Today, formal composition still makes imperious demands on you, but they are no longer rendered sterile by effort and exhaustion.... I am violently in love with those of your canvases in which the leafy, close-packed, even obstructive vegetation excites every one of the senses. Sight, smell, touch, taste are all invoked; the whole is suffused with something close to a pantheistic ardour..."

Both Cross and Signac were preparing in the autumn of 1904 for successive one-man shows at Eugène Druet's new gallery in Paris. For both, this was a period of energetic reassessment, of reconsidering old canvases and rapidly completing new ones. Matisse could hardly have asked for a more intensive refresher course on Neo-Impressionist theory and practice. Cross gave him a painting, The Farm, Evening, which was a pair to one he had given Signac, The Farm, Morning. They had been painted ten years earlier in response to Signac's The Age of Anarchy (later tactfully retitled The Age of Harmony), a grand politico-cum-Divisionist manifesto designed to celebrate a personal and professional fresh start at a moment when Signac and Cross, both newly married, were both embarking on new lives in the south.

Signac's painting showed various handsome half-naked men playing bowls, reading, or plucking fruit with a woman presiding over a picnic in the foreground, while two couples—a pair of lovers and an artist with his model—occupy the centre of the canvas against a background of busy peasants (including a dozen harvesters dancing a wild farandole). Berthe Signac posed for the women, and nearly all the men had her husband's features. The setting was a composite version of the seashore, pine woods and meadows of St-Tropez, and the caption ran: "The golden age is not in the past, but in the future."

The anarchist ideal of freedom, justice and beauty—spread throughout France from Russia via Kropotkin, Tolstoy and Bakunin—appealed to all that was noblest and most optimistic in Signac's generation, especially among painters. "What a generous and powerful philosophy!" Cross wrote of Kropotkin's paper, La Révolte, to his friend and Matisse's, Maximilien Luce. Anarchy proposed a future in which human beings, freed at last from the tyrannies of industrial exploitation and political or military repression, would dwell together in peace and plenty. "He [Signac] embodied the element of pastoral dream in the innocent anarchy which the young all ecstatically professed in those days, with no thought of the consequences, in a big picture, an Arcadia...," wrote Gustave Kahn of Signac's The Age of Anarchy, which Matisse almost certainly saw that summer at St-Tropez. "This fine painting was a sign of the times in which it was painted." Signac and Cross, both lifelong anarchists, confined themselves largely to pictorial support—illustrating pamphlets, painting magazine covers, exploring the anarchists' Arcadia on canvas—for a cause in which several of their friends were actively involved.

Luce himself was arrested twice in the 1890s during the anarchist terror that engulfed Paris in a wave of demonstrations, student riots and bomb explosions culminating in the assassination of President Sadi-Carnot, and countered by widespread police searches, summary trials and guillotinings. The last of the bombs intended to blow apart a corrupt bourgeois society was planted in April 1894 by the art critic Félix Fénéon, who was another of Signac's close friends. Fénéon was imprisoned and tried (although not in the end convicted) in August at the notorious "Trial of the Thirty," after which the anarchist panic gradually died down. In the summer of 1904 Fénéon and his wife were among Signac's visitors at St-Tropez with Matisse, who would paint an Arcadian dream of his own that autumn, followed by another the year after ("The description you sent me of your 'Arcadia' is alluring," Cross wrote, discussing Matisse's Bonheur de vivre in the winter of 1905–6). 81

Henri Edmond Cross, *The Evening Breeze*, 1893–94

For Signac, modern art was inextricably bound up with a political new dawn. If he no longer painted gasometers and workers' housing, it was because he had come to see the liberation of painting as part of a grander revolution that would free the toiling masses (who could be counted on, in a state of anarchy, to respond instinctively to all the latest trends in art). Signac's friends, less convinced of Divisionism's political content, nonetheless shared his belief that it was up to them to invent an art for the new century that would be the contemporary flat-dweller's equivalent of Delacroix's or Puvis de Chavannes's grand decorative wall paintings. Signac's definition of the new painting supplied a blueprint from which Matisse worked for the rest of his life. "These canvases which restore light to the walls of our urban apartments, which enclose pure colour within rhythmic lines, which share the charm of Oriental carpets, mosaics and tapestries: are they not also decorations?" "82"

Part of the attraction of the Midi was that it enabled contemporary painters to locate their futuristic golden age in the landscape that had played host to the classical idylls of the ancient world. Cross, who had tried but failed to paint scenes of contemporary social deprivation, settled instead for previewing a future in which "the moral and physical beauty of humanity would, through happiness, be such that the satirical masks drawn by artists like Daumier would have completely disappeared." ⁸³ It was this anarchist vision, achieved through an explosion of Mediterranean

light and colour, that had rescued Cross as a painter from the mundane and satirical northern tradition which Matisse, too, had fled south to escape. "I've just sketched the *patronne* of the café, who struck me as very pretty up till now," Matisse wrote disgustedly to Manguin from St-Tropez, "but I realise that in drawing her I've picked out only her ugly points—if you look hard at her, she's hideous. . . . You see how impossible I must be to live with at the moment."

In less than twelve months Matisse's pictorial experiments would reach a pitch at which colour itself felt to him like dynamite. For the moment he was content to explore Cross's gentler vision of an earthly paradise in which moral and physical ugliness would melt away of their own accord rather than having to be blown apart. This meant in practice painting lightly draped or naked nymphs, reclining, picnicking, bathing or brushing their hair beside the sea in canvases that owed something to Puvis, something also to Poussin, but quite as much to a northerner's excitement on discovering the Mediterranean. "There are any number of charming and secluded spots alongside the grander aspects, at once fairytale and decorative," Cross had written soon after his arrival in the south to Signac: "yes, these two epithets best convey the sensations I feel here."85 Fairy-tale and decorative elements swiftly invaded the charming and secluded spot Matisse painted a little further along the same coast in The Gulf of St-Tropez. Back in Paris in the autumn of 1904, he began preparations for a far more elaborate version of this canvas in which Mme Matisse, still wearing her fashionable hat and walking costume, presided over a picnic laid out on the beach for a boatload of naked nymphs who seem to have sailed in from another world.

Luxe, calme et volupté was the only Divisionist work in which Matisse attempted to combine realistic details—the figure of his wife, the teacups and the tablecloth, the Scots pine and the bay of St-Tropez—with imaginary beings in a synthetic whole. This head-on confrontation with Divisionism was by far his largest and most ambitious work since he had grappled with Impressionism in *The Dinner Table* eight years before. Like that earlier Salon piece, this one took a whole winter's planning (the watercolour sketches from St-Tropez were followed by a series of preparatory oil paintings, nude studio studies and a full-scale cartoon or charcoal drawing that had to be transferred to canvas by Matisse's wife and daughter, using the traditional Beaux-Arts technique of pouncing). Matisse underlined the painting's Neo-Impressionist affinities with a title taken from one of his and Signac's favourite poets. "Là, tout n'est qu'ordre et

beauté,/Luxe, calme et volupté [There all is order and beauty,/Luxuriant, voluptuous and calm]" is the refrain from "L'Invitation au voyage" in Baudelaire's Les Fleurs du mal.

But at the time there was no telling the destination of the voyage Matisse had embarked on in this strange, vibrant, uneasy painting, bulging with an energy that strained Signac's rules to the limit and beyond. Luxe, calme et volupté is full of the flagrant irregularities which had made Cross predict, even before his friend left St-Tropez, that Matisse would not be restrained by Divisionism for long.⁸⁷ He had taken from it practical lessons about the primacy of colour, together with the underlying belief in art as a stabilising force powerful enough to contain the fiercest and most explosive emotions. He had watched Signac assert, in practice as well as theory, the creative autonomy of the individual, which marked a major shift between the nineteenth- and the twentieth-century artist. Signac himself, looking back later on that summer at St-Tropez, described Matisse in the act of taking power, selecting, transforming and transposing elements from nature as Cross had prescribed:

Matisse in front of the motif traces a line round his feet on the ground, as a model does in the studio so as to be able to resume exactly the same pose. He holds a plumb line in his hand in order to pinpoint the slightest change in the rhythm of the verticals. He contemplates at length the many branches of the green flowering eucalyptus in front of him. Then he searches patiently on his palette for the colour that will fill in the contours outlined according to the forms he has discovered. And from this leafy tree, suppressing branches and foliage, he makes a bare cylinder, in no way resembling what nature offered him. But when you see the work again later, far from the exact reality, it manifests an unexpected grandeur. 88

Matisse, dissatisfied and restless at the end of his St-Tropez summer, planned nonetheless to return to the Mediterranean the year after. He used a spare railway ticket given to him by Fénéon for a three-day trip with his wife east along the coast to Agay, Cannes, Nice, Monaco, and Menton (where Bussy lived), almost as far as the Italian border. Busy Later Amélie set off alone in the opposite direction to visit her sister Berthe, who had moved south to take up a new post that autumn at the teacher-training school for girls in Perpignan. It was on this visit that Amélie, continuing her journey westwards in search of a cheap, unspoilt place to stay, fetched

up just short of the border with Spain at the foot of the French Pyrenees in the fishing port of Collioure. O Apart from Signac, who had landed there on his first painting trip to the Midi twelve years before, no painter had yet occupied Collioure, where the Matisses planned to settle for the summer of 1905.

By mid-September 1904 they were down to their last fifty francs, with another fifty left for their return to Paris. 91 Thanks to the combined efforts of Marquet and Roger Marx, the copy of Raphael's Balthazar Castiglione which Matisse had forgotten to submit to the Beaux-Arts committee was included at the last moment on the official list of purchases.92 Matisse accepted 300 francs for it at the beginning of October from Marx himself, who had recently been appointed one of the Beaux-Arts commissioners responsible for buying work from the second Salon d'Automne, which opened on 15 October. 93 Matisse showed fourteen canvases, all relatively conservative by comparison with the work he had brought back from St-Tropez: four interiors, four still lifes, two flower pieces, two guitarists, a Bois de Boulogne landscape and the Blasted Oak from Bohain. Marx saw to it that the state paid 400 francs for a painting that was forwarded to the museum at Montpellier ("one of the most charming of Matisse's early works, a still life silvery as a Chardin," wrote a municipal employee, describing how he rescued it many years later from the back room in the town hall to which it had been consigned in disgust by that ungrateful town).94 Matisse was picked out by Marx's follower, the journalist Louis Vauxcelles, in Gil Blas as the strongest in his group—the others were Marquet, Manguin and Camoin-and the one who came closest to Cézanne.95

The four of them worked that autumn with Jean Puy in Manguin's collapsible studio behind the apartment on the rue Boursault. Marquet and Manguin responded once again to Matisse's renewed Divisionist enthusiasm: all three painted each other and their nude model with a gaiety and gusto that owed more to Luce's slapdash style as a Divisionist (some said he used a sieve to speed up the process of covering his canvas evenly with coloured dots)⁹⁶ than to Signac's rigour. Winter was the season of intrigue, cabals and furious lobbying behind the scenes as different art-world factions drummed up support on the various committees that would control who showed what and how at next year's exhibitions. Charles Guérin enlisted Matisse in December for the Salon d'Automne's planning meeting, instructing him to bring Manguin, Marquet and any other sympathisers he could muster. PRené Piot urged Manguin to come early to the Indépendants' General Assembly, accompanied by enough

friends armed with lists of candidates to pack the front rows and make their presence vigorously felt ("It will be a great struggle," Piot wrote. "It is essential to write to people, to go and see them, and to make them come"). In the event, Matisse was co-opted by both the leading breakaway salons, remaining secrétaire-adjoint at the Indépendants and becoming a member of the Salon d'Automne's selection committee.

As Signac's adjutant, Matisse helped organise the first official exhibition ever held, in France or elsewhere, of the work of Vincent van Gogh. This was a retrospective of forty-five works put on as part of the Salon des Indépendants in March 1905, for which Matisse borrowed paintings as well as lending the drawings he had himself acquired from Russell and Vollard. The collector Maurice Fabre of Narbonne sent four canvases, including *The Round of Prisoners*, which he asked Matisse to touch up or have restored for him ("If you think it needs doing, I put myself entirely in your hands"). Whether or not Matisse performed this practical homage to the northern painter who had done most to point him towards the light and colour of the south, he certainly looked hard at van Gogh's work. He said that when Divisionist regulations began to make him feel unbearably constricted, it was van Gogh who with Gauguin enabled him to cut loose that summer. Too

In avant-garde circles at home and abroad, Matisse at thirty-five carried increasing weight. His work had been reproduced by the young Sergei Diaghilev at the end of 1904 in the pioneering Russian art magazine *Mir Iskusstva*. ¹⁰¹ In Paris, Ambroise Vollard relied implicitly on Matisse's judgement in dealings with their contemporaries. Vollard invested heavily in both Marquet and Manguin at this point, as well as buying up the contents of Jean Puy's studio on Matisse's instructions. ¹⁰² When Matisse took him by cab to Chatou to call on André Derain, newly returned that autumn from three years' military service, Vollard bought everything the unknown young painter had for sale (delivering a second batch of paintings later, Derain found the first still unopened in a corner of the gallery on the rue Lafitte). ¹⁰³

The public, which had got into the habit of treating modern painting as a freak show, responded with relish to the 1905 Indépendants: "From one end of the hall to the other you still heard intemperate laughter, and sarcasms rising to open contempt," wrote Berthe Weill (who put on her own mixed show of Matisse, Marquet, Manguin and Camoin in April). Derain and Vlaminck were exhibiting for the first time, roped in by Matisse and received by Signac with the gruffness of a sergeant major signing on two raw recruits. Matisse himself showed eight paintings,

Albert Marquet, Matisse Painting in Manguin's Studio, 1904–5

headed by Luxe, calme et volupté, which caused a considerable stir. He was warmly welcomed by the Neos as the movement's most prestigious convert since Pissarro. Signac expressed his pride and joy by purchasing Matisse's canvas himself later that summer. ¹⁰⁶

The state bought a *View of St-Tropez*,¹⁰⁷ and the critics, if not uniformly enthusiastic, were markedly respectful. "This young painter—another dissident from Moreau's studio who has mounted freely to the heights of Cézanne—now takes on, whether he likes it or not, the position of chef d'école," wrote Louis Vauxcelles. Older and more established painters grumbled among themselves ("When a boy scrawls shit on a wall, he may be expressing the state of his soul," said Paul Sérusier, discussing Matisse that spring with Maurice Denis, "but it's not a work of art"). The younger generation had no such reservations. "It was for me the greatest revelation," said Raoul Dufy, who was twenty-six when he saw *Luxe*, calme et volupté in 1905: "I understood instantly the mechanics of the new painting."

CHAPTER TEN

1905: Collioure

The port of Collioure, photographed by Matisse

In May 1905, as soon as the Indépendants and the show at Berthe Weill's closed, Matisse and his friends headed south. The Manguins left for St-Tropez, where they had taken a villa for the summer on Signac's recommendation. Marquet and Camoin followed them. The Matisses continued westwards along the coast to visit Amélie's family at

Perpignan. Berthe, whose health and spirits had recovered rapidly in the south, shared a small house with her parents in which the Matisse children—les petits Matissous—were always welcome.² The two little boys stayed on in Perpignan (Marguerite had been left behind with their Matisse grandparents in Bohain).³ On 16 May Matisse completed the last leg of his journey, another fifteen miles along the coastal railway skirting the edge of the eastern Pyrenees where they ran down to meet the sea in Catalonia, a harsh, vivid mountain country, long disputed and finally divided between France and Spain. "All of a sudden as you emerge on the crest of a hill from a rocky corridor, Collioure! Radiant with light on the curve of a small bay, hemmed in by the last burnt foothills of the mountains, a blaze of reds and ochres," wrote a contemporary taking the train from Perpignan. "Is this still France, or already Africa, with its clumps of agave, and its palm trees dotted here and there among the gardens?"⁴

This stretch of the Catalan coast was the point at which France came closest to North Africa. Coastal steamers from Collioure's neighbouring deep-sea ports, Port-Vendres and Banyuls-sur-Mer, traded along the African shore, and Port-Vendres already had a regular ferry service to Algeria. Traces of the Moors were everywhere in Collioure, from the construction of the houses—dark, dank, almost lightless caverns shuttered against the sun—to the crumbling fortifications that had once enclosed the town, and the watchtowers that still surmounted neighbouring hill-tops. The military barracks in the centre of the bay was a Templars' castle dating back to the Crusades. The tall orangey pink bell tower (instantly recognisable in so many of Matisse's paintings) was a converted lighthouse, originally built according to legend by the Arabs.

Banana and date palms flourished alongside native figs, oranges and lemons. In spring, pomegranate, peach and cherry trees blossomed in sheltered hollows round the town. A lush green growth of vines covered the terraced slopes, and flowering asphodel grew on the hills beyond. The town itself lay like an amphitheatre between the mountains and the sea. Its first historian, the Abbé Falguère, found he could hardly tear himself away from "the spectacle of the magnificent sea, its surf sometimes gently heaving, more often choppy and agitated, glittering beneath long shafts of brilliant clear sunlight." The houses lining the bay were lime-washed in deep, soft bluish pink, watermelon red and saffron yellow. Visitors were rare in Collioure, but the few who came agreed with the inhabitants that the town's secret lay in its light and colour: "It is this intense light, this perpetual dazzlement, that gives a northerner the impression of a new world...," wrote a local wine-grower, Paul Soulier, whose guidebook was

published three years before Matisse arrived. "One is struck above all by the bright light, and by colours so strong and so harmonious that they possess you like an enchantment."

Soulier became Matisse's friend, remaining for the next decade his staunchest supporter in the town. He was a keen amateur photographer, and he celebrated in words the colours he could not catch on film. For Soulier, the open-air market at Collioure was a symbol of nature's abundance and painterly generosity: "In the cool of the morning, beneath the shade of the big trees ... there are great hampers of cherries, pyramids of pears, tumbled masses of apricots; the sharp red of tomatoes and the pale yellow of cucumbers add their brilliant notes to this pleasing picture.... Carts full of oranges pour their contents out into baskets of every shape, and the golden globes that roll free mingle with white and purple aubergines, like the mighty eggs of some unknown bird." Matisse's Interior with Aubergines (1911)—one of the strangest and most sumptuous paintings of the period when he took more risks than ever before or after in his career—was based on three aubergines from Collioure market. Bonheur de vivre, in which the discoveries of his first summer in Collioure were explored in retrospect on canvas, took its title from the local Catalan proverb: "A Cotllioure fa bon viure! [The living is good at Collioure]."8

A few years later, when Matisse's friends and followers were beginning to trickle down from Paris, staying in Collioure and paying visits to Picasso, established with his band sixteen miles away at Céret, Charles Camoin said that he found spilt pigment on the ground at all the town's best painting sites. Even Jean Puy, briefly forsaking his beloved Belle-Ile, found himself reluctantly impressed ("Where is the Breton sea with its scudding clouds of wild and ardent pirates? Still, it's not half bad, Collioure"). But in 1905 Matisse was the first painter ever to set foot in Collioure's single hotel. His only predecessor was Signac, who had arrived by boat thirteen years before and rented rooms above a grocer for a brief exploratory foray before beating a prudent retreat to St-Tropez. Outsiders were not welcomed by the local people, who spoke Catalan, earned their living from the sea, and had known small contact with the world beyond the mountains until the coming of the railway. Signac told Matisse that he had narrowly escaped arrest in Port-Vendres as a spy.

Matisse himself automatically aroused suspicion at the Hôtel de la Gare, a barnlike building just outside the station, run by a landlady who shared the general mistrust of strangers. But the Widow Paré, always known as Dame Rousette, made an exception for Matisse. She liked his air of respectability, his evident seriousness, and his easy dealings with

local bigwigs like Paul Soulier (who lived in a new house a little further along the avenue de la Gare). Matisse whittled a bit of wood into a likeness of Rousette, the carved equivalent of his lightning sketches of Parisian street life: "It shows a stubborn, bony face, the face of a nightbird on the neck of a tortoise, bound in a Catalan coiffe," wrote a native of Collioure, the novelist François Bernardi, who heard the story of Matisse's visit long afterwards from Dame Rousette's hotel potboy, Mathieu Muxart. It was partly thanks to Muxart that Rousette had agreed to take in the strange-looking, fair-skinned, red-haired northerner who stepped off the train one day for no known reason with his palette and his easel. Muxart was fifteen years old in 1905. An intelligent and observant boy who was not a native of Collioure (people said he had been abandoned by a train of muleteers from the mountains), he sympathised with "Monsieur Henri" as an outsider like himself.

Young Muxart had made himself indispensable to the practical running of the hotel, which was not much more than a large saloon with a bar and a kitchen beyond, a vegetable plot at the side, and a yard at the back for keeping chickens and hutch-rabbits. Three or four small rooms above the tavern were reserved for people passing through on business, mostly fishmongers or railwaymen working on the line. Within a few days of his arrival, Monsieur Henri had not only moved in himself but arranged to fetch his family from Perpignan and install them upstairs as well. Rousette charged him roughly 150 francs a month for board and lodging for all four of them. "The living is therefore very cheap, and in my view quite adequate," Matisse wrote to Manguin, urging him to bring his family on a visit. "Of course, you would be coming to a village where people don't expect strangers. So it's important not to make too many difficulties." 15

Life in Collioure was very different from Ajaccio, with its foreign-tourist quarter, or St-Tropez, where painters operated within Signac's hospitable orbit. Collioure made few concessions to the modern world. Women still dressed entirely in black, men in faded blue sailcloth, and anyone of either sex who wore a hat—as opposed to the loose Phrygian bonnets or flat caps of the fishermen, and the coiffes worn by their wives—stuck out from the ordinary people as *un notable*, one of a handful of small landowners like Soulier headed by the doctor, the schoolmaster and the priest. Matisse belonged in neither camp. The irregular life of bohemian Paris, in some ways unimaginably strange, might have seemed in others curiously familiar to the fishermen, who worked by night and slept by day, and whose earnings fluctuated wildly according to the caprices of wind, tide, weather, the size of the catch and the state of the market.

Most people in Collioure lived from hand to mouth, like the Matisses, who had been held up for several days in Perpignan waiting for a payment that failed to materialise from Berthe Weill. Matisse's share of the proceeds from the sale of one of his paintings to Olivier Sainsère was 150 francs, urgently needed to pay for oils and other painting materials, as well as for the family's baggage, which had followed them down by slow goods train from Paris. 17 Correspondence between Matisse and Weill in these years consisted of increasingly exasperated protests on his part, answered by scrappy apologetic notes on hers, pleading the need to chase up purchasers, to buy in stock, to travel abroad prospecting for new outlets. In May 1905 Matisse appealed in desperation to Manguin, who sent one hundred francs by return of post. Money worries, in particular Matisse's problems with repayment, nagged at both painters on and off throughout the summer ("When shall we ever feel easy, at any rate on that score?" Manguin asked Matisse ruefully in August). 18 Camoin, whose work was at last beginning to sell, also sent money to tide the Matisses over. 19 Weill stumped up fifty francs on account on 19 June. An offer from the state for another of Matisse's canvases had arrived at the same time as Manguin's loan, but payment was as usual indefinitely delayed.²⁰

Even comparatively small windfalls like these represented serious purchasing power in Collioure, where a fisherman's earnings had dropped by 1905 to an unprecedented low of about one franc a day (a stonemason in Perpignan normally made four times as much).²¹ Collioure was still one of the busiest ports on the Mediterranean, with roughly 120 fishing boats and a virtual monopoly in the production of anchovies and sardines preserved in oil or brine. The fish landed each morning were gutted and salted the same day in dozens of small family businesses around the port (one of the things that deterred casual visitors was the stench of rotting fish-heads and other debris from these saltings).²² But the fishing fleet, which had expanded to meet the new markets opened up by rail in the 1870s, found itself having to compete with suppliers from as far afield as Brittany and Algeria. The profit each man could expect to clear in the six-month fishing season shrank from an average of 6,000 to 7,000 francs to something more like 800. The slump in prices hit the town at a point when local vines were only just beginning to recover from the ravages of phylloxera, which had devastated the French wine trade in the 1880s. Collioure never fully recovered from the catastrophic impact of this double blow.

Matisse's arrival coincided with the end of an ancient self-sufficiency based on fishing and tending vines. Mounting tension among people on the brink of destitution all over the south of France would erupt two years later in a mass uprising, led by the fiery Catalans of Perpignan, Montpellier and Narbonne. But Matisse, working in Collioure that summer, had no direct contact with the peasants, and had in any case long since outgrown his youthful anarchism. The ends attainable through political commitment, or for that matter by direct political action, came to seem to him relatively short-term, chancy and of dubious value. The paintings he produced or incubated at Collioure in the years leading up to the First World War responded on a different level to the explosive forces of breakup and destruction at work in the new century.

One of Matisse's first moves in Collioure in May 1905 was to rent a room to work in above the Café Olo, overlooking the Port d'Avall.²³ This was the most outlying of the town's three beaches, on the far side of the castle, beyond the old port grouped with its church and bell tower along the foreshore called the Boramar (Catalan for bord de la mer, or seashore). Matisse used the Catalan form of Port d'Avall as the title for a Divisionist painting, called Le Port d'Abaill²⁴ and based on drawings he made in May and June from his room above the Café Olo. He was preparing the ground, with a meticulousness Signac would have approved, for what turned out to be his final and most frustrating confrontation with Divisionism. Many of his sketches—of boats leaving the harbour, the shadow line cast by the sun behind the houses, women mending nets, and men heaving at a capstan on the beach—would be transferred straight onto the canvas when he came to work on Le Port d'Abaill in his Paris studio that autumn.

All the life of the port took place on the beach, where the population turned out each morning to watch the fleet return and to size up the catch. The fish market was a noisy, quarrelsome daily drama performed in the open air on the seafront, after which the fishermen dispersed to get ready

Matisse, study for *Le Port d'Abaill*, 1905–6: from the window of his room above the *Café* Olo

Matisse, notebook sketch of a sailing boat, 1905

for the next night's work beneath Matisse's window. He drew the boats lined up with sails hanging from the yardarm to dry, and he drew them again later in the day with furled sails. He drew them leaving the harbour towards evening, their graceful triangular sails skimming and looping over the surface of the water, or reduced to barely visible points above the horizon as the fleet approached its fishing grounds. He drew the nets laid out to dry after the night's fishing, and a few hours later he drew the owner of the nets carrying them rolled up in a bundle on his shoulders as he set off home to bed. The observation in Matisse's drawings and paintings is so accurate that a fisherman can tell the time of day, sometimes even the precise hour, when each was made. Carrying pots on their heads or stopping to gossip at street corners, were all dashed down with a precision Matisse had practised from his boyhood on the rue Peu d'Aise in Bohain.

The beach and street scenes of his Collioure notebooks record the daily round of a people who had lived and worked on the seashore since antiquity. Matisse told his son-in-law long afterwards that these ancient patterns gave him energy for the *Dance*, the huge frieze of leaping scarlet figures on a flat blue and green ground which caused an uproar in the Paris art world in 1910. "When Matisse was working on the *Dance*... he found himself crouching, ready to leap as he had done a few years before, one night on the beach at Collioure, in a round of Catalan fishermen far more

violent in movement and appearance than the *sardane*."²⁶ This ancestral dance was the heart and soul of Catalonia, according to the sculptor Aristide Maillol—himself a Catalan from Banyuls—who said that he recognised its whirling rhythms, and the beautiful diabolical music of the pipes, when he paid his first visit to Greece in 1908.²⁷

Collioure gave Matisse direct contact with the primitive world on which he and other painters—above all the honorary Catalan, Picasso would draw increasingly over the next decade. It also gave him the sense of liberation, both as a painter and as a man, which he had first encountered in Ajaccio. There were no censorious pointing fingers to contend with in Collioure, no preconceived opinions about painting, and none of the emergent middle-class susceptibilities that had been outraged by his work in Bohain. "Don't forget it's only a village that is not used to regular tourists," Matisse wrote to the Manguins, "except for a few of the lower middle-class from Perpignan, and even they are very rare."28 The family settled into a routine, revolving as always around work, but including a daily swim from a pebbly cove called l'Ouille half an hour's walk away (bathing could be tricky in the harbour, which received not only the fishheads and guts voided daily from the saltings, but the contents of the whole town's chamberpots, borne down to the beach on the heads of the women and emptied nightly into the sea).²⁹

Matisse wore a straw hat and shirtsleeves with his trouser legs rolled up. Amélie posed barefoot in her Japanese kimono on the rocks at l'Ouille.³⁰ The whole family exchanged their shoes for rope-soled espadrilles made by a sandal-maker on the Port d'Avall (these sandals were such a success that Signac sent his own and his wife's measurements so that Matisse could order them a pair each).³¹ The hills in which Matisse walked every day beside the shore recur constantly in his paintings. So does the sheltered bathing beach of l'Ouille, a perfect curve overhung with greenery which became the setting for *Bonheur de vivre*.³² When heat drove him indoors, he painted the view out to sea from the window of a room above the sandal-maker. *The Open Window, Collioure* (colour fig. 19)³³ is perhaps the richest and most radiant expression of Matisse's sense that painting gave access to another world: a mystery, glimpsed through an open door or window, which he had first contemplated as a boy in a dark northern law office in Bohain.

If the adults felt liberated in Collioure, so did the two boys. Jean and Pierre were allowed to run wild, fishing, climbing, exploring the rocks and pools, playing games (Pierre at five had graduated from his wooden horse to a passion for cowboys and Indians) with their contemporaries from the

Matisse, Mme Matisse, Rocks, 1905

village. Their companions were fishermen's sons, making the most of their own brief freedom before each grew old enough to go to sea as a cabin boy at eleven or twelve. "Ragged urchins with shaven heads and bare feet, slippy, quick as lizards, insatiable marauders," wrote François Bernardi, himself the son and grandson of Collioure fishermen. "The first fruits, peas, tomatoes, beans were always theirs. They knew already how to watch life at the bottom of the sea, where to find fish lurking beneath the smallest pebble. They were free, permanently on holiday." Memories of Collioure meant freedom and the joy of life for the Matisse children ever afterwards.

Their parents worked as hard and lived almost as frugally as the fishermen and their wives. Monsieur Henri was "always out of doors, from morning to night," said Mathieu Muxart; "he scarcely took time off to eat." He drew and painted his wife strolling beneath her parasol in the olive groves, or standing on the bastion above the town with a view across the bay to three rocky headlands (which would reappear two years later in the background to *Le Luxe*): en Pujol, del Mitg and Cap Gros. Her strong profile materialised on his drawing pad beneath a sketchier impression of the landscape. She posed for him standing among the trees with bare shoulders and bare arms, wrapped in nothing but a towel or a shift (a costume that would have been unthinkable in any more conventional seaside resort).

Amélie's presence, so tentative in his paintings seven years earlier in Corsica, presides emphatically at the centre of the work done this summer in Collioure. The images she inspired grew progressively more challenging. She became the key structural element in a semiabstract composition

of colours—orange and violet, turquoise-green and red—her head surmounted by a blue-black mass of hair, her face bisected by the broad green stripe that supplied the painting's title, *The Green Line* (colour fig. 20). This portrait of his wife shocked Matisse's contemporaries. "He teaches you to see her in a strange and terrible aspect," wrote an American journalist, Gelett Burgess in 1910. ³⁷ Almost a century later, the strangeness and terror have given way to a powerful serenity embodied in the subject's steady gaze, the incisive curve of her eyebrows, the firm set of her chin, even the high-piled chignon that crowns her head.

"Matisse knew how to elicit from her a passion for his work," said Lydia Delectorskaya, who became Matisse's model and secretary in the last two decades of his life. "He knew how to take possession of people and make them believe they were indispensable. It was like that for me, and it was like that for Mme Matisse." As the pace of his pictorial experiments accelerated in the summer of 1905 until he seemed to himself to be losing all control over what he painted, Matisse needed his wife more than he had ever done before. The three and a half months he spent in Collioure in 1905 developed into an ordeal on which he looked back afterwards with horror and amazement. "Ah, how wretched I was down there," he said wryly a few years later, when one of his students asked about his struggles. At the time, he felt himself cracking up. Sleep became impossible. If Amélie Matisse glows in these Collioure canvases with the courage and confidence her husband gave her, she in turn became a bulwark against his own mounting perturbation.

Not that his troubles started right away. The summer began innocuously enough with a round of hospitality from the painters of the region, who were few, widely scattered and as avid for news from Paris as their compatriots were indifferent or averse. First on the scene was Etienne Terrus, who thought nothing of walking the seven miles from his native village of Elne to call on his friend Paul Soulier in Collioure. Terrus would become over the next ten years the most companionable of all the friends the Matisses made in Catalonia. The three explored the Pyrenees together, and Terrus grew especially fond of Amélie, whose generosity and stubbornness belonged, like his, to this hard, dry, tough landscape with its dazzling play of light and colour. The two men exchanged paintings. In the professional crises that lay ahead, Matisse (who was twelve years younger) would come to rely on sound advice and unconditional support from Terrus.

Blunt, stocky and square-headed, Terrus wore the cloth cap, work-man's jacket, loose, shabby trousers and stout shoes of a local wine-grower

Etienne Terrus, Collioure Bell Tower, 1899

(he had inherited a plot of vines in Elne, handing them over for cultivation to his brother). People often said he looked as if he had sprung from his own red earth. Others compared him to a classical god, more Silenus than Apollo by this stage. His neighbour Aristide Maillol celebrated his rocklike presence in a massive bust. "The powerful head makes you think of a wild boar," wrote Maillol's biographer, "while the forehead, and the deep-set eyes, speak of the intelligence, the thought and observation of a man of nature." Terrus was the senior member of a small band of "Artistes Roussillonais," who exhibited most years in Perpignan. He had started out as a youth of phenomenal brilliance and determination, leaving Elne in 1874 at the age of seventeen to study under Alexandre Cabanel at the Ecole des Beaux-Arts in Paris. Returning home a confirmed anarchist ten years later, he turned his back for good on the Beaux-Arts system, thereby ensuring for himself a lifetime of professional isolation, neglect and poverty.

Matisse admired Terrus as an artist.⁴³ By the time they met, the older painter had apparently accepted the bitterness of his fate with something approaching equanimity. Over the last twenty years he had become a familiar figure in the landscape, planted on his camp stool, working in watercolour on paintings in which, as Maillol said, each note sang with Mozartian delicacy and strength.⁴⁴ Largely despised by his own people

1905: COLLIOURE

Etienne Terrus

and ignored by the world beyond, he painted the rocks and valleys, the mountain villages, the flat-topped towers and red-roofed farmhouses round Elne together with the cliffs and creeks along the coast. He exhibited nothing outside Perpignan until the spring of 1905, when he showed three paintings with the other Roussillon artists in Barcelona and sent another eight to the Indépendants in Paris. The Indépendants' anarchic rabble of dropouts, dissidents and unpretentious revolutionaries like himself suited Terrus, who continued to show there until 1914.

He was an old friend and contemporary of Maximilien Luce, whom Matisse had left in charge of the studio at 19 quai St-Michel in the summer of 1905. ⁴⁵ Perhaps on the strength of their mutual liking for Luce, or perhaps at Soulier's introduction, Matisse responded immediately to the warmth of Terrus's welcome. He was a bachelor, living austerely as a lodger in his brother's house and entertaining other painters to convivial lunches on the terrace in front of his studio at Elne. Over the next few years the Matisses and their friends became regular visitors in this light-filled, whitewashed studio, which had awnings above the table and a garden alongside full of birdsong, flowers and fruit trees. The studio itself was set high into the town's Roman ramparts with views stretching to the sea, on one side, and to the mountain of Canigou on the other. Matisse drew the mountain's great, sprawling, snow-capped summit from Terrus's

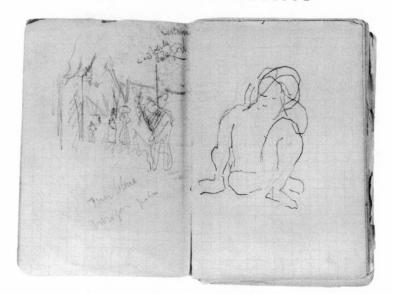

Matisse, sketch of a crouching figure, 1905: probably done in Maillol's studio at Banyuls

eyrie ("Have you ever seen the peak of Canigou in spring, bathed in the sun's red reflections?" he once asked a journalist to whom he was trying to describe the glimmer of light on white). ⁴⁶ The whole range of the eastern Pyrenees, from Elne to Port-Bou on the Spanish border, was dominated by Canigou, endlessly celebrated in poetry and paint by the Catalan artists to whom Terrus now set about introducing his new friend.

The first trip they made was to Banyuls, two stops along the railway from Collioure, where Aristide Maillol gave a lunch party in Matisse's honour on 22 May.⁴⁷ Maillol still lived in the pink house where he was born above the port, with a stone terrace shaded by great pine trees, and a garden of tangled tropical vegetation falling steeply away below. Banyuls, like Collioure, reminded travellers of an African oasis set with the spiky growth of palms, agaves and prickly pears. Maillol's father had been a sea captain—"handsome as the Jupiter of Phidias," said his son⁴⁸—who plied the coast of Africa. One of his aunts kept a textile trading post at Mascara in Algeria. He himself had followed Terrus to Paris in 1882 to train as a painter under Cabanel, an experience which had left him, too, with a permanent abhorrence of academic values. "We were so close we could not have managed without one another," Maillol said of Terrus.⁴⁹ Both were short, thickset men burnt brown by the sun with fierce eyebrows and bushy beards.

Maillol not only looked as if he had stepped down from the pediment of a Greek temple but dressed the part in thick-soled espadrilles like clas-

1905: COLLIOURE

Aristide Maillol, La Méditerranée, 1905

sical buskins and a rustic cloak ("I can still see him in his ancient shepherd's cloak, bought in Perpignan," said Matisse. "It had lost all suppleness and colour. It stood up by itself as if made of roofing felt"). Maillol gloried in Banyuls' classical past, which he found all round him, in Roman vases dug up on the seashore, and in the living forms of the Catalan girls he sculpted. Like Terrus, he reminded Parisians of a wild animal down from the hills. "With his sharp features, his keen and constantly moving eye, his pointed, questing nose, his supple, loose and wary movements, he resembles a young wolf...," wrote the critic Octave Mirbeau. "He talks with a southern accent, picturesque and pleasant, and what he says is simple, strong, fair-minded, pungent and apt to stick in the mind." 51

He worked in the deep, cool cellar underneath his house, built into the hillside below the terrace with an orange tree bearing fruit above the doorway. On the day Matisse and Terrus came to lunch, Maillol was struggling with an ambitious scheme for enlarging a small clay female nude into a life-size plaster figure that could be cast in bronze. Maillol's contemporaries were often disconcerted by his hit-or-miss, sometimes brilliant, sometimes crazily impractical experiments (he insisted on starting from first principles, whether it meant colouring his tapestries with homemade plant dyes or printing a deluxe edition of Virgil's *Ecloques* on paper he produced himself by boiling rags). Sa a sculptor with no technical training, he built a kiln to his own design, dug up clay from the garden (sometimes

with the earthworms and snails left in), and tried modelling his large, solid, deep-breasted and broad-hipped nudes as a potter raises a clay pot, instead of using a traditional supportive armature. It was one of these nudes that was giving him trouble when Matisse arrived with Terrus. Matisse drew the little crouching figure in his notebook and lent his host a hand with moulding the full-scale version of what ultimately became La Méditerranée: A marvellously balanced, stable and streamlined composition which seemed to the boldest spirits at the Salon d'Automne in October 1905 to revolutionise sculpture much as Matisse himself was revolutionising painting.

Matisse later firmly repudiated any suggestion that he was responsible for making a sculptor out of Maillol. It was true that the Catalan had only recently begun to work in clay, but the crucial imperative had come for him—as for Matisse—from Antoine Bourdelle, whose Montauban War Memorial opened up a new world at the turn of the century. "There was the thunder of god in it," said Maillol.⁵⁵ Bourdelle's studio on the impasse du Maine became a second home for Maillol and his young wife in their first years of poverty in Paris. Clotilde Maillol had been an enchantingly pretty needlewoman in the small tapestry workshop set up by her future husband in Banyuls. She followed him to Paris after the business failed, bearing him a son in 1895 in wretched lodgings on the rue St-Jacques (Matisse had just moved back round the corner to the quai St-Michel). Maillol was blinded for six months in 1900 by a rheumatic inflammation, exacerbated by the effect of the harsh northern climate on a constitution already weakened by overwork and malnutrition. It was this final blow that forced him to abandon painting and tapestry design for sculpture.⁵⁶

Mme Maillol, sturdily supporting her husband through his many tribulations, came close to embodying a turn-of-the-century ideal of the artist's wife as muse and model. Patient, self-effacing and resourceful, she betrayed little trace in public of the asperity often noted in Mmes Pissarro and Cézanne. Maillol astonished the young painter Gerald Kelly by sending for his wife to demonstrate a point about remaining true to nature. "He stooped and picked up her skirt, he just tranquilly raised it up above her head, and there you saw her admirable legs, of a massive construction, covered with hand-knitted stockings, which stopped a little above the knee with great garters, and then above that there rose her red, mottled, splendid thighs. And then he said this beautiful thing, 'Et je retrouve la marbre—I find the marble again.' "57 Clotilde Maillol and her husband were both in their forties by 1905. Their marriage was grounded

1905: COLLIOURE

Aristide Maillol and his wife, Clotilde, photographed by Count Harry Kessler, 1907

on one side in a passivity wholly foreign to Amélie Matisse's nature and, on the other, in a composure Henri Matisse could never equal. "Whenever I spend two hours with Maillol," a nervous painter once told Octave Mirbeau, "I go away completely reassured, carrying with me a confidence and serenity which last me several days." ⁵⁸

The older couple gave generous encouragement that summer to the younger. Amélie took lessons from Clotilde in the technique devised by her husband for his tapestry panels (which were worked in petit point with a long, flat flexible stitch). Matisse made a compact little clay nude that clearly owed something to what he had seen at Banyuls. But his subsequent figurines of kneeling or seated women have a tension wholly foreign to Maillol, who triumphantly achieved his aim of re-creating as a twentieth-century Frenchman the tactile poise and harmony of the Greeks. "Maillol's sculpture has the ripeness of a plump fruit which makes me want to reach out and touch it," said Matisse, describing an art at the furthest remove from his own nervous and aggressive use of clay. "We never discussed sculpture. For we could not understand one another. Maillol worked in masses like the ancients, and I worked in arabesques like the Renaissance sculptors. Maillol didn't like taking risks, and I couldn't resist them."

Risk beckoned him on his first visit to Banyuls in May. One of Maillol's lunch guests was Daniel de Monfreid, the painter who more than any other had supported Paul Gauguin in Tahiti, receiving shipments of work right up to the artist's death in 1903, and continuing to act afterwards as his unofficial agent. It was Monfreid who gradually disseminated Gauguin's ideas to a wider public, starting with the little band of art-lovers Matisse met in and around Collioure. Monfreid had marked his friend's death by setting out his revolutionary aesthetic in an open letter to the local press. Its central tenets—all of which would reappear in Matisse's thinking—were Gauguin's rejection of traditional dogma, his insistence that art should be in essence the communication of emotion, and his emphasis on its decorative rather than imitative purpose ("Nobody in the art schools ever told us that the decorative aspect should be the base of all plastic art. Is it not the Salons which have created this absurd distinction between 'the picture' and 'the decorative panel'? Doesn't painting primarily consist in using colour and design to decorate a surface?"). 62

Monfreid's letter was addressed to Louis Bausil, a painter from Perpignan who was another of Maillol's guests on 22 May. Matisse was sufficiently impressed to invite them all to inspect his work in Collioure on 2 June. A week later they met again for a long weekend on Monfreid's estate of St-Clément, just outside the village of Corneilla-de-Conflent at the foot of Canigou. The house party included Bausil and a couple of local collectors, the banker Fernand Dumas from Perpignan, and a dentist from Béziers called Calmel, who was one of Gauguin's earliest French patrons. Matisse and Terrus, arriving to join the others for the day on Monday, 12 June, found their host waiting with his bicycle at the station to walk them back the last mile or so through the fields to his house, where lunch was laid out on the terrace. They sat talking the whole afternoon, adjourning only to the studio at the top of the house to examine Monfreid's work and Gauguin's.

Matisse already knew Gauguin's paintings, as he knew van Gogh's, from Vollard, who had sold him one of them six years before. Monfreid's Gauguin canvases were in any case kept in storage with friends in Paris. The only works of his at St-Clément were a group of carved and painted wooden pieces, which had arrived four years earlier in a crate shipped direct to the station at Villefranche-de-Conflent, with a note from Gauguin: "It would give me great pleasure if you would accept... all the sculpture in wood from Tahiti." No one outside Monfreid's Catalan circle had yet seen the contents of this crate. The very existence of Gauguin's wooden sculpture remained unknown at least until the end of 1906, when the retrospective of his work at the Salon d'Automne provided a first viewing for other artists (including Picasso). Nothing could have pre-

pared Matisse for the impact of these carvings in 1905. Gaudy, primitive and barbaric, they represented the most extreme of all Gauguin's attempts to repudiate Greek refinement. They pointed in the opposite direction from Maillol. No other European had yet imagined anything like them.

Monfreid said nothing in his diary about the newcomers' reaction, noting only that Matisse and Terrus found it so hard to tear themselves away that in the end they stayed the night, sleeping on his floor and rising at dawn with Calmel to catch the earliest train home. Matisse himself said later that he had been astounded by his first sight of Gauguin's wood carvings at this point. 66 He may have been thinking of this house party at St-Clément, or of his encounters with Monfreid's friend Gustave Fayet, whose apartment Matisse had already visited in Paris, and whom he visited again this summer in the south with Monfreid and Maillol.⁶⁷ The first and greatest of all Gauguin collectors, Fayet was a prosperous winegrower and maker of liqueurs, based thirty miles from Perpignan at Béziers. In the early years of the century, he was already organising modern art shows at Béziers with his friend Maurice Fabre of Narbonne, whose van Goghs Matisse had borrowed for the 1905 Indépendants. The pair would return Matisse's visit a year later, calling on him together at Collioure in the summer of 1906.⁶⁸ Fayet and Fabre, Monfreid and his friends round Perpignan belonged with others whom Matisse already knew—Arthur Huc of Toulouse and Marcel Sembat of Grenoble—to a remarkable generation of independent patrons and painters in the south of France, whose progressive outlook put them streets ahead of the Parisian art establishment.

The radical boldness and openness he found in the south were always tonic for Matisse. Signac sent him a friendly letter on 18 June, reiterating his admiration for Luxe, calme et volupté, reporting that rainstorms had prevented Manguin and Marquet from working in St-Tropez, and poking gentle fun at them for insisting on painting out of doors instead of confronting nature under controlled conditions in the studio. "The quickest method of notation is still the best," he wrote, meaning the Divisionist system of preliminary watercolours and line drawings. "It provides you with the most varied input, and at the same time gives you more freedom to 'create' afterwards." But Signac's admonitions came too late. Matisse was already flouting orthodox Divisionist practice in small oil paintings, jabbing them down on oblong bits of card, drawing the cliffs, the rocks and sea in a choppy, tumbling mass of coloured brushstrokes, which had broken loose at last from both Divisionist and naturalistic restrictions.

A CRISIS WAS APPROACHING. Matisse, too uneasy as always to relish the prospect of facing it alone, had already written to his old painting companions in St-Tropez—Manguin, Marquet and Camoin—asking each of them to join him in Collioure. 70 None accepted his invitation. On 25 June he sent a nervous and peremptory postcard to André Derain: "I cannot insist too strongly that a stay here is absolutely necessary for your work-you would find yourself in the best possible conditions and you would reap pecuniary advantages from the work you could do here. I am certain that if you take my advice you will be glad of it. That is why I say to you again, come."71 Derain, who had reached the end of what he could learn from Vlaminck, responded at once. He was twenty-five years old that month. He owed much to Matisse, who had regularly visited his studio at Chatou, brought friends to inspect his work, and helped him through the worst of his military service. It was thanks to Matisse that he had exhibited at the Indépendants and sold the contents of his studio to Vollard. Before leaving Paris, Matisse had travelled down once again to Chatou, bringing Amélie with him at Derain's request. Carefully disguised as a bourgeois couple of impeccable respectability, the pair successfully persuaded Derain's parents against their better judgement to accept André's choice of painting as a profession. Mme Derain remained unconvinced, but her husband, impressed by their son's success at the Indépendants, handed over 1,000 francs, on the strength of which Derain now packed up and headed for Collioure.⁷²

He arrived on 7 or 8 July,⁷³ looking like a Left Bank dandy down from Paris and causing consternation at the Hôtel de la Gare, which had scarcely been prepared by Matisse's relatively discreet infiltration for the appearance of his friend. "An apparition," said Mathieu Muxart, "a sort of giant, thin, dressed all in white, with a long fine moustache, cat's eyes and a red peaked cap on his head." Dame Rousette flatly refused to have anything to do with this young show-off in his clownish costume, telling Muxart in Catalan to throw him out. Muxart, disarmed by the stranger's courtesy ("he spoke nicely, and he called me 'vous'"), once again stood up to his employer, arguing that she could not insult Monsieur Henri by rejecting his friend, and threatening to leave the hotel himself if she did so. Rousette capitulated, dispatching Muxart to fetch Monsieur André's luggage the next day from the station. "He had the whole handcart filled to overflowing with trunks, suitcases and a parasol bigger than a customs officer's umbrella."

Like other travellers visiting Collioure for the first time, Derain was

bowled over by the colours. "In effect, this place, its people with bronzed faces, skin colours of chrome yellow, orange, deeply tanned; blue-black beards," he wrote, jotting down impressions pell-mell for Vlaminck. "Its women, with splendid gestures, in black jackets and mantles; pottery in red, green and grey, donkeys, boats, white sails, multicoloured barks. But it's the light, a pale gilded light, that suppresses shadows. The work to be done is fearful. Everything I've done up till now strikes me as stupid." Over the next two months Derain sent Vlaminck a stream of letters, vividly conveying his own and Matisse's gathering excitement over the supremacy of light, the elimination of shadow, the surrender to colour for colour's sake.

The two inspected Monfreid's Gauguin carvings and made a trip with Amélie across the border into Spain, where they were all astonished by the pottery and carvings of Spanish Catalonia ("Churches with wooden sculptures that would make even Vlaminck turn pale," wrote Derain).76 Matisse posed for Derain beside a folding table piled with brightly coloured waterpots, which could be picked up for next to nothing in the Spanish village of Llansa. He even decorated one of them himself, a green-glazed, fat-bellied, spouted jar which he presented to Paul Soulier's daughter for her birthday.⁷⁷ Soulier introduced Matisse and Derain to another of Collioure's notables, Joseph Berge (a relation of the town's most famous son, Napoleon's Baron Berge), who drove them about in one of the first motorcars in the entire department.⁷⁸ They rowed out to sea with Terrus, who owned a boat and a little hut on the shore near Collioure at Racou.⁷⁹ Derain made a double portrait of Terrus and Matisse, "two solid fellows, sunburned and bearded," stationed in front of the Collioure bell tower. 80 Matisse drew Terrus in one notebook, and Derain in another, curled up with a book against a bulkhead, looking decidedly uncomfortable beneath his enormous beach umbrella. He also drew Derain at his easel, where he seemed altogether happier in his peaked cap with a pipe clamped jauntily between his teeth.

The hotel stood beside the railway in relative isolation, on scrubland below the mountains and above the town, at the top of the broad, new, sparsely built-up avenue de la Gare, as far away as it was possible to get from the din and animation of the port. The two painters worked furiously, often side by side at favourite motifs, stationed above the town looking out over the roofs, or on the rocks at l'Ouille (where Derain drew Amélie posing for her husband). They carried on working at the hotel in the evenings, among the regulars in the public saloon, painting portraits of one another and of the town water-carrier, Palile. They took over the

THE UNKNOWN MATISSE

Matisse, Derain Beneath His Beach Umbrella, 1905

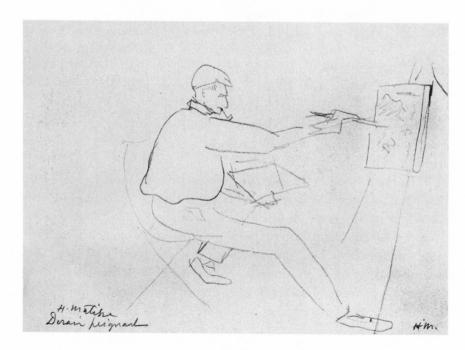

Matisse, Derain Painting, 1905

attic of the house next door to store their painting materials (Matisse later appropriated it altogether as a studio). Derain painted a hotel signboard in hopes of mollifying Dame Rousette, who indignantly rejected it as nothing but a mess of colours (Muxart hid the sign on top of the rabbit cages in the yard, "so that Monsieur André should not have the pain of seeing it in the ditch"). Be Forty-five years later Matisse celebrated the exhilaration of their first weeks together in a drawing called *Le Bonheur des peintres*, sketching the hotel in an album belonging to two old friends from Collioure, and decorating it with a sign of his own: "Grande Auberge ROSETTE. IET AUBERGE du PAYS [Grand Hotel ROSETTE. Best INN in the COUNTRY]."

Derain's absurd sense of humour, his energy and dash, his sudden switches from moodiness to gaiety made him difficult to resist. Missing Paris himself, above all missing the Parisiennes (for whom he found no substitute among the beautiful, voluptuous, unavailable girls of Collioure), he captivated the whole Matisse family that summer. His presence was, as one of their friends remarked, a great comfort to them all. Matisse drew up a reckoning, at the back of one of his notebooks, of expenses to be shared with Derain for pipes filled and beers drunk on convivial evenings at the hotel. Derain designed tapestry patterns for Amélie, who liked him best of all the young painters congregating in these years

Matisse. Le bonheur des peintres, 1950: Dame Rousette's Hôtel de la Gare, showing the attic next door where Matisse and Derain stored their gear, and which subsequently became a studio. (When Matisse made this drawing four decades later in the album of his old friends from Collioure, René and Jojo Pous, he was a year out on the date.)

round her husband.⁸⁵ He swam, told stories and amused the boys. Pierre, who adored him, rode everywhere on Derain's shoulders.⁸⁶ Derain's despondency was obvious to Muxart when the Matisses moved out of the Hôtel de la Gare in July.

They had rented the upper part of Paul Soulier's capacious old family house, overlooking the port on the Boramar, at the heart of Collioure as the quai St-Michel was at the heart of Paris.⁸⁷ The Boramar was noisier and more rackety even than the Port d'Avall in the mornings, when several hundred fishermen landed with their catch, which was weighed and sold at auction immediately below Matisse's studio. "The bustle and crush of people at that time can no longer be imagined today," wrote François Bernardi.⁸⁸ Derain, bored and lonely at the hotel after his friends' departure, joined Matisse to work in his studio. Many of the paintings they produced that summer look out through the open window across the balcony with its pillared balustrade to the view beyond, either straight out to sea or down onto the corner of the harbour with its ancient bell tower on the left. The heat was sweltering. Amélie, who now had two painters to keep happy, compared notes with Jeanne Manguin at St-Tropez, who had three (even after Marquet left the Manguins' house to join Camoin at his hotel, the trio met most nights over dinner on the port, or at Jeanne's table). "My husband is working steadily with Derain, in spite of the heat," Amélie reported with satisfaction on 15 July. 89

Matisse wrote the same day to Simon Bussy, saying he felt fairly confident that the pictures he was producing would find favour, even with the state purchasing committee. He had been working with Derain for a week.

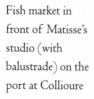

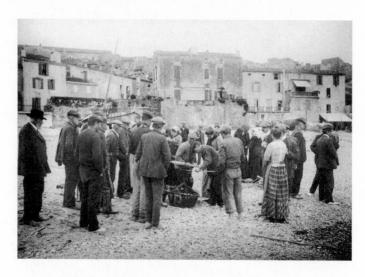

The younger artist's fresh eye and painterly intelligence were pushing him once again, as they had done three years earlier in the Louvre, fast and far in dangerous directions. Matisse wrote uneasily to Signac, envying him his pictorial certainties, worrying about the unresolved conflicts in Luxe, calme et volupté, and contemplating with misgiving his own preparations for another Divisionist canvas, Le Port d'Abaill. The very idea of this painting produced an unconvincing note of caution ("In spite of myself, I must consult the views of dealers so as to return to Paris with some saleable merchandise in hand").90 Matisse's letter raised the problem of rebellious colour, and his own inability to comply with the rules devised by Signac for mastering unruly elements. "He loved rough seas and raging winds," wrote Francis Jourdain, defining Signac's temperament both as a painter and a sailor. "He loved no less the rigorous accord of sail and rudder, or the precision of an engine."91 Matisse's letter made it clear that, much as he liked and admired Signac, he was preparing not only to chuck the regulatory machinery overboard but to jump after it himself into the raging sea.

Derain, rasher and far less profoundly disturbed than Matisse, leapt first. By the end of July he was congratulating himself on having—unlike Matisse—eradicated all trace of Divisionism from his work. "The night is radiant, the day is powerful, ferocious and all-conquering," he wrote on I August. "The light throws up on all sides its vast and clamorous shout of victory." Confronting this light on canvas, both painters found themselves by turns victorious and vanquished. Derain described his alternating joy and gloom to Vlaminck. Matisse asked Signac to send him Cézanne's reassuring words about reconciling line and colour (from the article by Bernard which he had read at St-Tropez the year before). By the time the passage came, copied out in Signac's hand on a postcard dated 14 August, it must have seemed as if Cézanne himself endorsed what was happening in Collioure: "Line and colour are not distinct. . . . When colour is at its richest, form takes on its fullest expression."

Matisse's crisis lasted throughout the summer. In these final stages of a struggle he had once hoped Divisionism would solve, he turned, not to Signac, but to Henri Cross, who had long predicted that the solution Matisse was looking for lay in himself. In 1905 Cross (like Maillol before him) faced the threat of blindness. The rheumatism that had already endangered his left eye flared up again that spring in an excruciatingly painful inflammation of the iris. In April Matisse gave Cross (who was under treatment in Paris) one of his old Jardin du Luxembourg land-scapes, 94 and received a bunch of parrot tulips in return. Warned by Mar-

quet in late May that Cross was confined on doctor's orders to a darkened room at St-Clair, Matisse promptly offered him his purple, gold and crimson painting of the tulips. ⁹⁵ Irma Cross, writing on behalf of her husband, who could no longer see to hold a pen, thanked him for this delicate attention, which greatly touched them both.

In June Signac described to Matisse an atrocious day spent at St-Clair witnessing Cross's sufferings. 96 In August Manguin reported that Cross's state was so dreadful he hadn't the courage to face going back alone.97 Matisse responded to these horrifying bulletins by writing steadily to Cross and his distracted wife. "Dear painter! friend!" she replied in an emotional letter, full of gratitude and affection on 20 June. 98 She followed it on 2 July with an appeal to Matisse to help her husband, whose condition was unchanged, and whose stoical endurance was showing signs of strain. "Tell my Henri about your work, it consoles him for not being able to work himself. One painter will know how to rouse another painter, for his wife . . . can do nothing to lift his painterly discouragement. You, the Painter friend, talking about art, will help him to accept the regime of resignation which I preach."99 The Crosses admired Matisse for his dogged courage as an artist. But they loved him for the speed and sensitivity with which he responded to their predicament in spite of his own turmoil that summer. As his colours raged and flamed, emitting a strange light of their own all through July and August, Matisse sent accounts of work in progress at Collioure to the sightless Cross, blindfolded at St-Clair.

In retrospect, Matisse saw the conflagration that consumed himself and Derain as something awesome, even demonic. He told Bussy that colour had released an energy which seemed to come from witchcraft. 100 His subsequent accounts emphasise the element of reckless defiance and deliberate destruction. "We were at that point like children before nature, and we let our temperaments speak.... I spoiled everything on principle, and worked as I felt, only by colour." But at the time, his faith in his own liberating instinct was at best provisional. His descriptions and sketches of Le Port d'Abaill had an agitated undertow, to which Cross responded in soothing messages dictated to his wife. At the end of August the patient was permitted to remove his eye patch. Still weak and unable to see properly, Cross wrote shakily himself for the first time to thank Matisse for his letters, promising to respond more fully as soon as he could ("I don't forget that in one of them your anxious thoughts raised a grave and interesting artistic question"). 102 Cross's first impulse, on recovering his sight that autumn, was to reassure Matisse. He urged him to believe in himself and not to feel he had betrayed his former friends ("It

was precisely my great love, my great desire for liberty that made me tell you last year 'that you would soon leave Divisionism behind' "). He had still not seen—and acknowledged that he could not imagine—the work Matisse produced at Collioure, but he grasped its revolutionary nature, maintaining that he had anticipated something of the sort as soon as he saw Luxe, calme et volupté:

I said to myself then—here is a painter who is going to investigate the laws of the optic mixture [the essential Divisionist principle whereby the eye itself activates and mixes pure colours, which remain physically distinct on canvas], not in order to submit to them, but so as to take from them whatever suits his temperament, and to use it freely to express his intentions. Knowledge does no harm, and I think that one can contravene the rules all the more easily for understanding them better. ¹⁰⁴

The anarchic joy of breaking laws—the laws governing not only Divisionism but the whole Renaissance tradition in which both Matisse and Derain had schooled themselves so meticulously and for so long—was riddled with anxiety for them both. Forty years later Derain told Matisse's son-in-law, Georges Duthuit, that the wholesale smashing of taboos in Collioure had been, for him as for Matisse, an ordeal by fire. "There was no longer any way we could stand back far enough to see things clearly, and bring about our transposition at leisure. Colours became sticks of dynamite. They were primed to discharge light." 105 Derain's profoundly ambivalent nature precluded the unclouded confidence of Vlaminck or Signac. His letters were full of self-disgust. His clothes, his manners, the way he spoke French, even the fact that he was easily the tallest person in the village, made him feel increasingly conspicuous. He was known as despenja figues, the fig-picker, because of his height. 106 He took to spending more and more time alone at the hotel, where Dame Rousette relented sufficiently to allow him to pin up his paintings in the saloon. "Look, Mathieu, at least they make a better effect than calendars," 107 he said to Muxart, who remembered a banquet in July at which the guests, baffled by the works on the walls, were egged on to make fun of them by Derain himself: "He mocked his own pictures more even than the others did." Long after the end of the party, he sat on alone at the deserted table with an unlit pipe, staring sombrely at his work, seeming "so tired and sad" that Muxart did not dare say anything: "I pitied him that night." ¹⁰⁸

On 4 August a ferocious storm kept the whole town indoors. Dame

Rousette, taking pity like Muxart on her guest, gave permission for him to paint a picture on the saloon door, finding herself torn between criticism and helpless laughter as she watched him do it. The subject Derain chose was Don Quixote and Sancho Panza, two crackpots who set out to do battle against imaginary obstacles. "A yellow moon in a green sky!" said Muxart. "No one had seen anything like it! Wherever did he get hold of these things, Monsieur André? How he made us laugh, *la patronne*, me, and everyone else who saw that door!" Derain wrote to Vlaminck the next day, describing his alienation, his feeling that painters were not men but eunuchs, his sense of belonging nowhere and serving no purpose. "I am a stupid artist, placed outside the law, outside other people, outside the world, a hybrid being. I'm beginning to regret the soldier I was last year, who set his boots on the route according to precise instructions." 110

Matisse painted Derain at Collioure, a delicate centrifugal composition of sharp spring colours—lemon yellow, turquoise, cherry red and chalky blue-exploding outwards from the bony, tentative young face with its blank black eyes and drooping black moustache (colour fig. 22). Derain in his turn painted Matisse at least three times. He gave Amélie the most solidly constructed of these portraits, an impression, relatively conventional in colour (apart from the green shadow spreading like a bruise around one eye), of the kind and knowledgeable older man Derain learned from and looked up to: the dependable, bespectacled, pipesmoking character who inspired confidence in people like Derain's parents. But Derain also knew and painted a far more unsettling aspect of his friend that summer. A second portrait—so lightly drawn that the ghostly body scarcely emerges from the bare canvas—catches Matisse red-handed, clutching a paintbrush dipped in red, white-faced with a red splodge encircling his neck, more like a ligature than a beard (colour fig. 21). Matisse kept this image of a man possessed, or blown out of his mind, to the end of his life.

More than forty years later, Georges Duthuit described the state in which his father-in-law approached the act of painting, a tension so extreme that those closest to him risked being sucked in with him to the verge of breakdown or vertigo. "The obvious forebodings experienced by the painter—who is at the same time so prudent and so orderly that people call him 'the Doctor'—made him tremble. During the few years when he was able to endure this vision, Matisse spent whole nights without sleep, nights of desperation and panic." From now on Matisse would never again be free from the insomnia that had first attacked him on Belle-Ile. Amélie helped him through the interminable nights by reading to him,

RIGHT: 13. Matisse, Marguerite, 1901 (formerly dated 1906). Oil on canvas, $30 \times 21''$ (71.1 $\times 53.3$ cm). Matisse painted his daughter for the first time in the aftermath of the emergency operation which she only narrowly survived; the portrait of Pierre as a studio child dates from the winter when he, too, nearly died of pneumonia.

BELOW: 14. Matisse, Pierre Matisse with Bidouille, 1904. Oil on canvas, $29 \times 23^{1/4}$ " (73.7 × 59 cm)

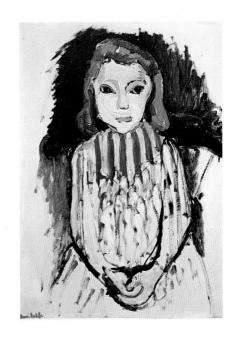

LEFT: 15. Paul Signac, The Red Buoy, St-Tropez, 1895. Oil on canvas, $31\% \times 25\%''$ (81 × 65 cm)

BELOW: 16. Matisse, *The Gulf of St-Tropez*, 1904. Oil on canvas, $25\frac{1}{2} \times 19\frac{7}{8}$ (65 × 50.5 cm)

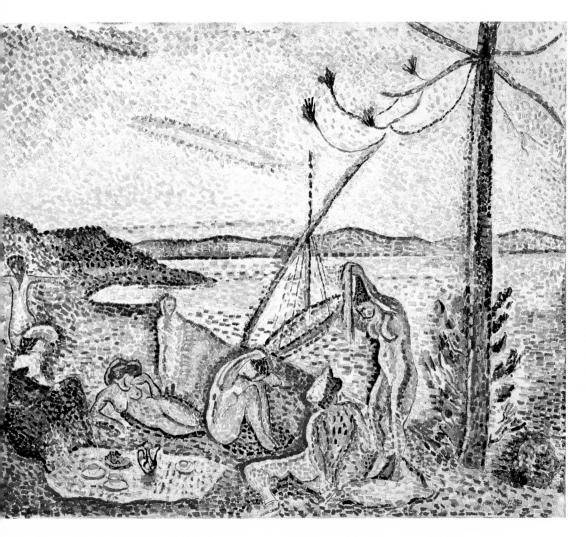

17. Matisse, Luxe, calme et volupté, 1904–5. Oil on canvas, $38\frac{1}{2} \times 46\frac{1}{2}$ " (98.5 × 118 cm). Paul Signac led Matisse to the brink from which he would leap into a pictorial new world. "It was for me the greatest revelation," Raoul Dufy said of this canvas. "I understood instantly the mechanics of the new painting."

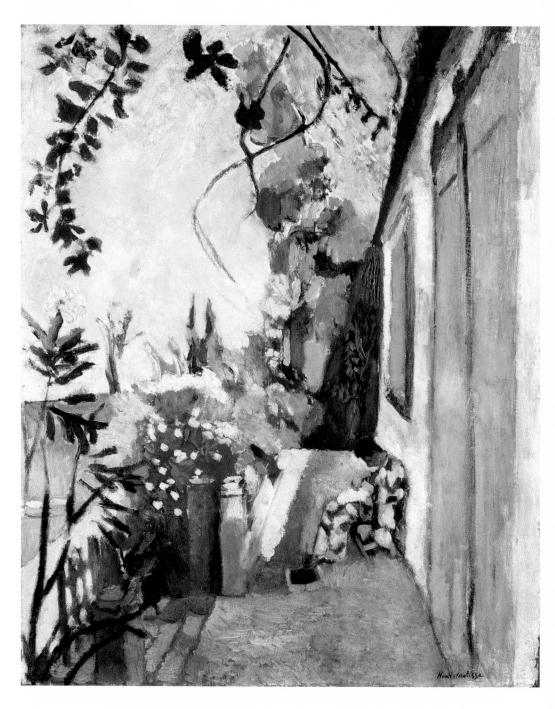

18. Matisse, The Terrace, St-Tropez, 1904. Oil on canvas, $28\frac{1}{4} \times 22\frac{3}{4}$ " (72×58 cm). It was Signac's harsh criticism of this painting that gave Matisse the strength to "kick down the door," or break through to a new phase in his development as a painter.

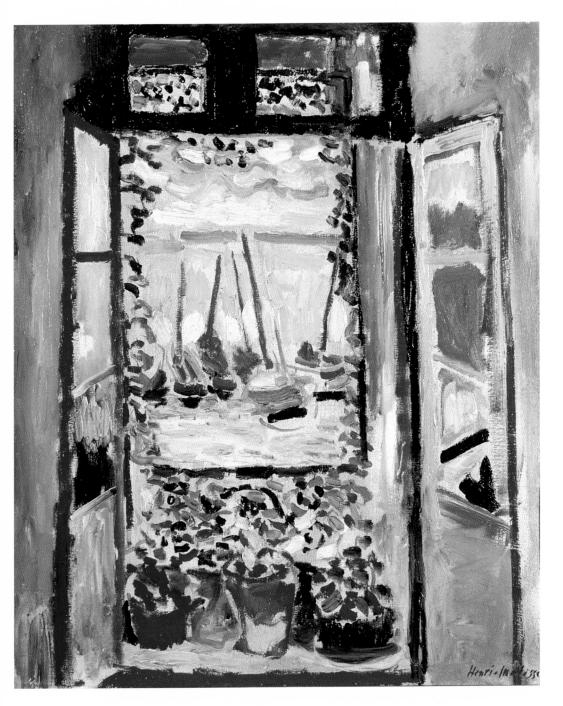

19. Matisse, The Open Window, Collioure, 1905. Oil on canvas, $21\% \times 18\%$ (55.2 × 46 cm). A motif that haunted Matisse from the days when he first glimpsed another world through the half-open glass door of the northern lawyer's office where he worked as a clerk: "This is what I find so particularly expressive, an open door like this, in all its mystery."

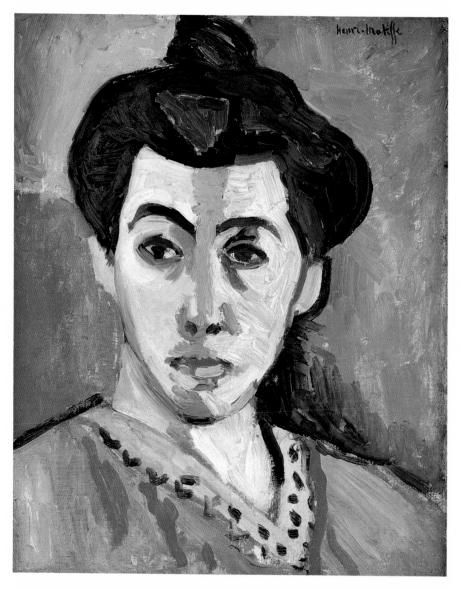

20. Matisse, Portrait of Mme Matisse (The Green Line), 1905. Oil on canvas, 16 × 127/8" (40.5 × 32.5 cm). "He makes you see her in a strange and terrible aspect," wrote an American journalist of Matisse's portrait of his wife presiding over the explosion of colour at Collioure in 1905, which made the two perpetrators feel like dynamiters or terrorist bombers.

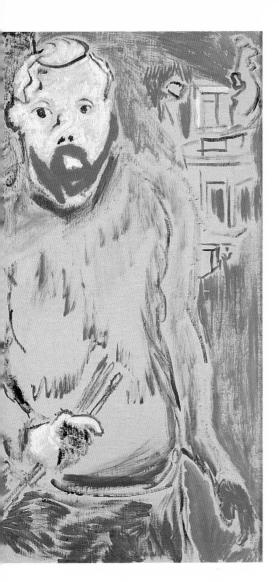

ABOVE LEFT: 21. André Derain, Portrait of Henri Matisse, 1905. Oil on canvas, $36\% \times 20\%$ " $(93 \times 52.5 \text{ cm})$ ABOVE RIGHT: 22. Matisse, André Derain, 1905. Oil on canvas, $15\frac{1}{2} \times 11\frac{3}{8}$ " $(39.4 \times 28.9 \text{ cm})$ RIGHT: 23. Matisse, Self-portrait, 1906. Oil on canvas, $21\% \times 18\frac{1}{8}$ " $(55 \times 46 \text{ cm})$. Gertrude Stein felt this painting stripped its subject too bare for anyone to feel comfortable with it hanging on the wall.

24. Matisse, Woman in a Hat, 1905. Oil on canvas, $3t^3\!\!/4 \times 23^{1\!\!/2}\!\!/''$ (80.6 × 59.7 cm). "I'm in my element when the house burns down," said Amélie Matisse, looking back at the end of her life to the pictorial conflagration that had struck contemporaries as the work of a dangerous lunatic.

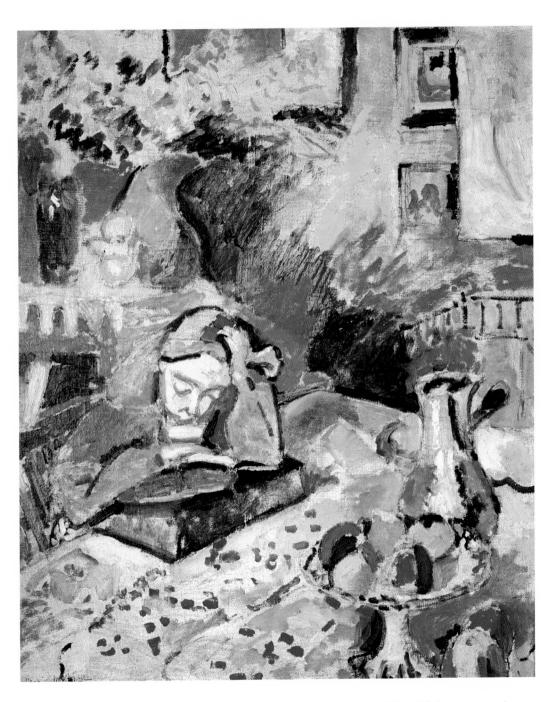

25. Matisse, Interior with a Young Girl (Girl Reading), 1906. Oil on canvas, $28\% \times 23\%$ " (72.7 × 59.4 cm)

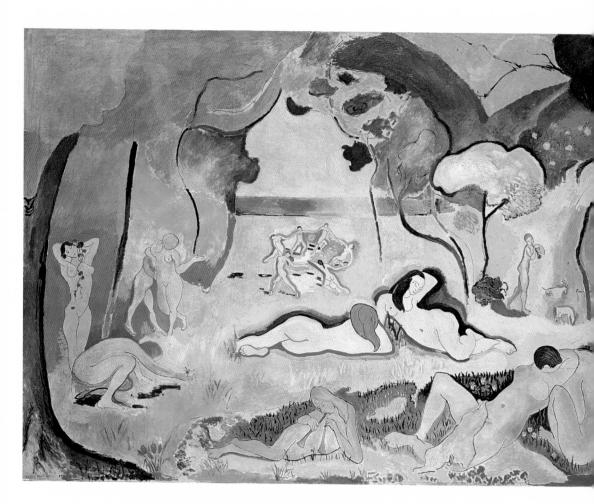

26. Matisse, *Le Bonheur de vivre*, 1905–6. Oil on canvas, 69½ × 94½" (175 × 241 cm). "Parisians who can still remember the event say that from the doorway, as they arrived at the salon, they heard shouts and were guided by them to an uproar of jeers, angry babble and screaming laughter, rising from the crowd that was milling in derision around the painter's passionate view of joy."

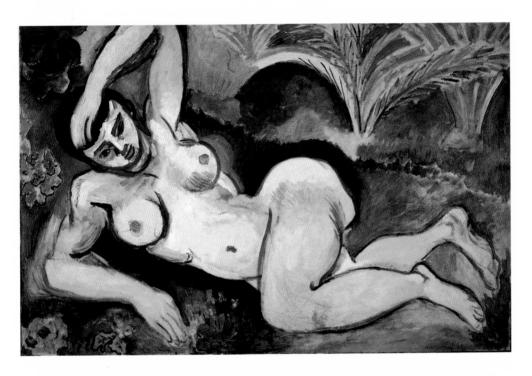

27. Matisse, Blue Nude: Memory of Biskra, 1907. Oil on canvas, 36½ × 55½" (92.1 × 140.4 cm). Bernard Berenson called this painting the toad ("If you can ever convince me of any beauty in that toad, I'll believe in Matisse"); Pablo Picasso's response was to work with renewed energy on the Demoiselles d'Avignon.

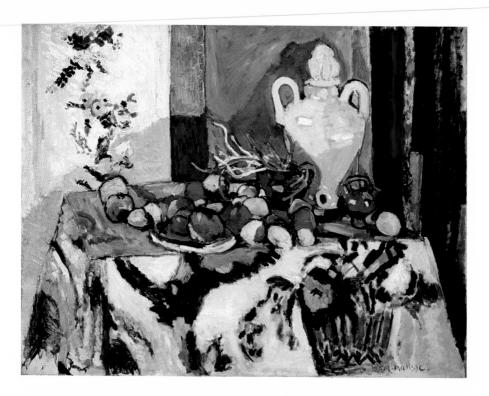

ABOVE: 28. Matisse, Blue Still Life, 1907–8. Oil on canvas, $35\frac{1}{4} \times 45\frac{7}{8}$ " (89.5 × 116.5 cm) BELOW: 29. Matisse, Still Life with Red Rug, 1906. Oil on canvas, $35 \times 45\frac{7}{8}$ " (89 × 116.5 cm)

ABOVE LEFT: 30. Matisse, The Young Sailor (II), 1906. Oil on canvas, $40 \times 32^{3}/4''$ (101.5 \times 83 cm) ABOVE RIGHT: 31. Matisse, Portrait of Greta Moll, 1908. Oil on canvas, $36^{1}/2 \times 29''$ (93 \times 73.5 cm) BELOW: 32. Matisse, Pink Onions, 1907. Oil on canvas, $18^{1}/8 \times 21^{5}/8''$ (46×55 cm)

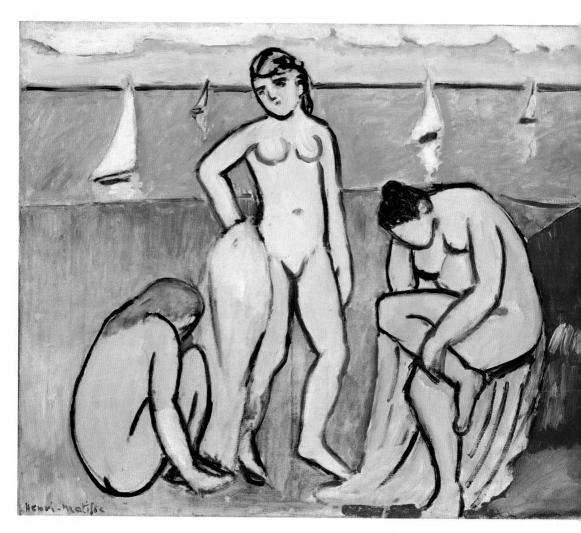

33. Matisse, *Three Bathers*, 1907. Oil on canvas, $24 \times 29''$ (61×73.7 cm). The smallest of the strange, highly simplified canvases produced under the impact of early Italian fresco painting, which would lead to the great decorative wall panels Matisse made for the Russian collector Sergei Shchukin.

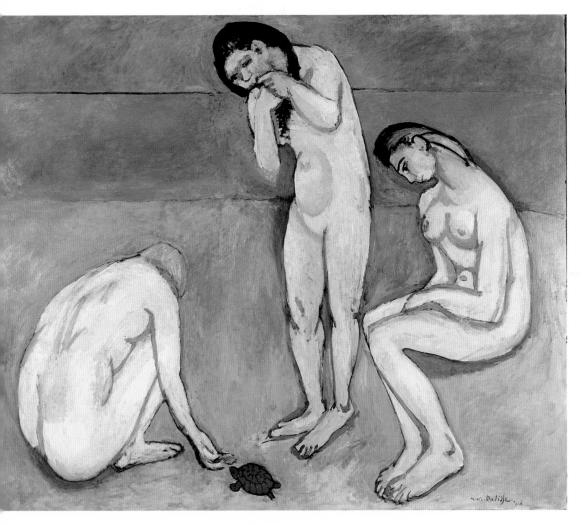

34. Matisse, Bathers with a Turtle, 1908. Oil on canvas, $70\frac{1}{2} \times 87\frac{3}{4}$ " (179.1 × 220.3 cm). First sight of this canvas drove Shchukin wild with longing: "I see the painting all the time before my eyes. I can feel that freshness, that majesty of the ocean, that sense of sadness and melancholy."

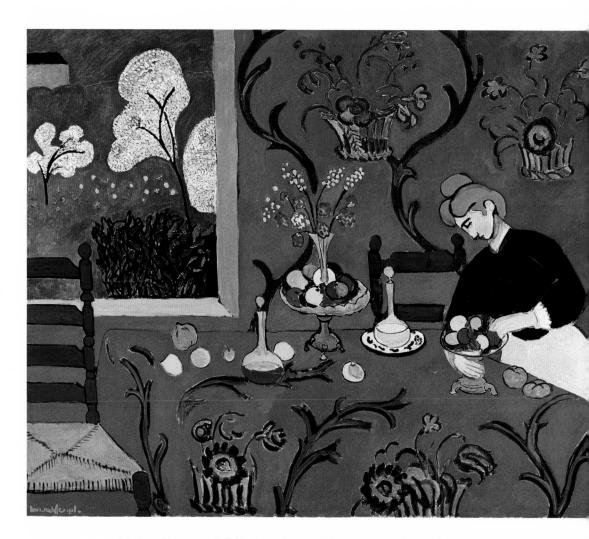

35. Matisse, Harmony in Red (La Desserte), 1908. Oil on canvas, 70% × 86%" (180 × 220 cm). "Suddenly I stood in front of a wall that sang, no screamed, colour and radiated light," wrote the young artist Isaac Grünewald, confronted by this painting at the 1908 Salon d'Automne, "something completely new and ruthless in its unbridled freedom."

sometimes until dawn. The novel Matisse remembered reading in 1905 was Alexander Kuprine's *Yama*, an account of life in a provincial Russian brothel which deeply disturbed him. ¹¹² In fact, he could not have read this particular book (which was not published in French until 1923): it was a freak of Matisse's imagination that transposed Kuprine's powerful images of brutality and exploitation in a nocturnal underworld back to the summer at Collioure, when the stable, familiar daytime appearance of normality seemed to be blown apart before his eyes.

It is not easy to understand today how paintings of light and colour, mediated through scenes of simple seaside domesticity—a view of fishing boats above pots of scarlet geraniums on the studio windowsill, Amélie wrapped in a towel or seated barefoot on the rocks—could have seemed at the time, both to their perpetrator and to his public, an assault that threatened to undermine civilisation as they knew it. But Matisse was not simply discarding perspective, abolishing shadows, repudiating the academic distinction between line and colour. He was attempting to overturn a way of seeing evolved and accepted by the Western world for centuries, going back to painters like Michelangelo and Leonardo, and before them to the Greek and Roman masters of antiquity. He was substituting for their illusion of objectivity a conscious subjectivity, a twentieth-century art that would draw its validity essentially from the painter's own visual and emotional responses.

He did it by following clues that were already present in the first painting he ever made as a lawyer's clerk in Bohain. "I found myself or my artistic personality by considering my early works. I discovered in them something constant which I took at first for monotonous repetition. It was the sign of my personality, which came out the same no matter what different moods I passed through."113 Matisse's fierce, unrelenting interrogation of his own darkest moods and instincts felt at times like madness. It took all his resources of nerve and imagination to impose a previously unimagined equilibrium on what seemed the fevered images of a disordered brain. Sometimes he feared that the blazing colours he had let loose would end by making him go blind, like Cross. After their two hectic months in Collioure, he never worked again with Derain. In a sense, it probably would not have mattered which of his friends answered the calls he sent out at the beginning of the summer. Derain brought youth, strength, boldness, a deep and cultivated understanding of the rules he and Matisse set out to break. Above all he gave, and took, the courage each needed from the other for the final passage that had to be made alone on canvas from the old world to the new.

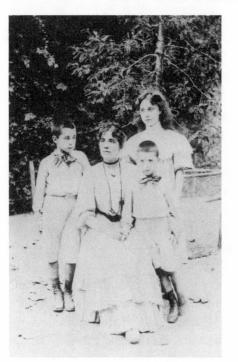

Jean, Marguerite and Pierre Matisse with their aunt Berthe at Perpignan

When the time came to return to Paris at the end of August, Derain's luggage, even more voluminous than on arrival, included thirty finished canvases, twenty drawings, fifty sketches and several Catalan waterpots tied up in straw ("I've always wondered what he did with them," said Muxart). 114 The many works he left behind, pinned up in the hotel saloon, were thrown out by Dame Rousette without protest from Muxart ("No one told me they were worth more than calendars," he said ruefully years later, when word of his mistake trickled back from Paris). 115 The Matisses also left for home

at the beginning of September, stopping off on the way with the Parayres at Perpignan. The two households had set up what became over the next decade and more a regular summer pattern of visits, Berthe accompanied by her pupils or her parents coming by rail to spend the day at the seaside in Collioure, the Matisse children travelling with or without their parents in the opposite direction. When the family finally returned to Paris, they left Pierre with his grandparents and his aunt.

Pierre, who was asthmatic, would spend the winter in Perpignan so as to avoid the risk of another bout of pneumonia in Paris. A newborn cousin, Auguste Matisse's first child, André, had lived for only three months that spring (André Matisse, who died on 6 June 1905, was the ninth baby to die in Bohain in those three months, a toll representing the town's appalling rate of infant mortality rather than any particular epidemic). The health of the eleven-year-old Marguerite was also causing anxiety. She had needed prolonged treatment from the family doctor after an accident in the spring, which perhaps explains why she was left behind in Bohain (where her grandmother seized the opportunity to have her prepared for her first communion along with all the other children of her age). The damaged larynx made her particularly vulnerable, and both

parents were still seriously worried about her condition in the autumn of 1905.

When Marguerite moved back to the quai St-Michel in Paris, Jean took her place with their grandmother at Bohain. Anna Matisse kept the household at the quai supplied with baskets of fresh produce and provisions from the shop, sent up on the train to Paris twice a month. Hippolyte Henri had long since accepted defeat in the battle to retain his elder son. Matisse reported that communication with his father had shrunk to little more than brief exchanges when he arrived for a visit, or left afterwards: "Things going alright in Paris, are they? 'Yes.' And that was all. They drank a glass of something (cognac or whisky in those days). Then they went to bed. And when he left again, his father, driving the horse and cart, would grumble: 'When are you coming back?' "¹¹⁸

But without steady support, material as well as moral, from both sets of parents-in-law, the painter's family could scarcely have survived these years of poverty and dispersal. The Parayres not only looked after Pierre; they also kept a store of Matisse's paintings in Perpignan to show to potential buyers, who included in November Terrus's and Maillol's friend from Perpignan, Louis Bausil. Gustave Fayet showed interest as well. Visiting him that winter in his Paris apartment, Matisse was advised to bring out the brilliance of his colours with boiling wax, a method Fayet himself practised on his Gauguins. Matisse never forgot being shown by Fayet's valet how to warm a canvas overnight to make it more absorbent and, once the surface cooled, how to buff it with a furniture brush to produce a glossy finish (the horror of this revelation was brought home six years later in Moscow, where Matisse found the paint flaking on Fayet's Gauguins, which had by then been sold to the Russian collector Sergei Shchukin). Sergei Shchukin).

MATISSE BROUGHT BACK with him from Collioure fifteen canvases, forty watercolours and a hundred drawings to show his friends on the usual autumn round of inspection visits. ¹²¹ "Matisse and Derain have done some stunning things," Marquet reported on 8 September to Manguin (who had stayed on in St-Tropez). ¹²² On 13 September Matisse received a visit from Signac's friend Félix Fénéon, reputed to possess the most discerning and disinterested eye for modern art in Paris. Fénéon's history of championing new talent went back to 1884, when, at the age of twenty-three, he had discovered Georges Seurat and the Neo-Impressionists (the word was his own invention). ¹²³ As editor of various

avant-garde organs, he was responsible for publishing key texts like Rimbaud's Les Illuminations, Lautréamont's Chants de Maldoror, Gauguin's Noa-Noa and Mallarmé's Divagations. For years he also wrote a national newspaper column, consisting entirely of more or less offbeat items collected from the press and retailed with a terse, disconcerting wit which raised the news roundup to a proto-Surrealist art form.

He was profoundly ironic, subversive, and a lover of Jane Austen (arrested in 1894 as a suspected anarchist, Fénéon spent his time in prison translating *Northanger Abbey*). Tall, desiccated, austerely elegant, with an aquiline profile and a wispy goatee beard, he looked like a cross between Uncle Sam and the boneless music-hall performer Valentin le Désossé, whose silhouette was made famous on posters by Toulouse-Lautrec. Fénéon was discreet to vanishing point (his responsibility for planting the last of the anarchist bombs which exploded in 1894 was not finally established until nearly fifty years after his death). ¹²⁴ By 1905 he had abandoned art criticism as altogether too flamboyant and was proposing to pursue his commitment to modern painting by trying his hand at dealing. "He'll be the only dealer who knows what's what in painting," Signac reported joyfully to Théo van Rysselberghe, "as well as being fastidious, kind, intelligent, already well known." ¹²⁵

Fénéon had bought a Matisse still life from Eugène Druet in August, and would go on to acquire among other works a Breton seascape, a view of Notre-Dame and a flower piece (the non-Divisionist version of Cross's Parrot Tulips). 126 He was already negotiating that autumn to open a modern branch of the prestigious Bernheim-Jeune gallery. In due course he would become the only dealer by whom Matisse never felt let down. "Fénéon, as a good anarchist, planted Matisses among the bourgeoisie from the back room at Bernheim-Jeune as he might have planted bombs," wrote Maurice Boudot-Lamotte (who mourned Matisse's defection to modernity in 1905 as a heavy loss to French painting). 127 Fénéon arranged for Matisse to meet the powerful Octave Mirbeau on 21 October—the week in which the Salon d'Automne opened—as a preliminary move in a series of more or less oblique approaches to the Bernheims (with whom Matisse finally signed a contract ingeniously drawn up by Fénéon four years later). 128

Matisse's financial situation had once more touched rock bottom. He had accepted a proposal from Eugène Druet for a second one-man show in the spring of 1906, but Druet at this stage was scarcely more prosperous than Berthe Weill. No immediate offer came from Vollard (who paid 3,300 francs to Derain that autumn¹²⁹ and continued steadily acquiring work

from Manguin and Marquet). All Matisse's good intentions of bringing back saleable merchandise from Collioure had gone for nothing. For the past three years he had been living largely on a dwindling store of old work. But now that his relationship with tradition had finally been dislocated, he could no longer replenish his stock of relatively conventional landscapes, flower pieces and still lifes (six of them were shown by Weill at a mixed show in November). The position was so desperate that on a black day—jour de défaite—in the autumn of 1905 Matisse even contemplated selling Cézanne's *Three Bathers*. One of the purposes of the meeting set up by Fénéon was to sound out Mirbeau about a possible deal with the Bernheims (who declined to buy, on the grounds that the 10,000 francs at which Matisse valued his Cézanne was hopelessly unrealistic). ¹³⁰

Matisse's go-between in this affair was his new friend Aristide Maillol, who had returned from Banyuls to take up winter quarters at Marly-le-Roi just outside Paris. When Matisse called on Maillol at Marly, the sculptor was wrestling with yet another of his intractable nudes. This would become L'Action Enchaîné, Maillol's first official commission, ordered by Georges Clemenceau (now Minister of the Interior) as a memorial to the Republican agitator Auguste Blanqui. Maillol envisaged a titanic female, with splendid gartered thighs not unlike Mme Maillol's, and hands tied behind her back to symbolise the impotence of the noblest aspirations. He had reached the point of abandoning the whole scheme as impractical when once again Matisse's intervention saved the day. "Momentarily discouraged, he [Maillol] flung down the enormous effigy he had constructed, far larger than life-size, and proposed handing over the commission to Henri Matisse; then, taking up his statue again with a rush of energy, he remoulded it on a smaller scale, at a single session, in a towering rage." 132

Few of Matisse's friends were in any position to offer practical help. The exception was Signac, who responded to the younger artist's worries about Divisionism by buying Luxe, calme et volupté in September for a handsome 1,000 francs. "What sumptuous meals we shall have now . . . even if the menu itself is meagre," Signac wrote jubilantly to Manguin, explaining that he meant to hang the painting next to an old favourite by Cross in the refurbished dining room at La Hune. "The Camoin has been moved to the drawing room. . . . I like it less and less whereas I like the Matisse more and more. The one is a poem—the other is a news item, admittedly well written." Still a nominal Divisionist, Matisse set to work in earnest on Le Port d'Abaill, the canvas planned since the beginning of the summer, which took him so long to paint that he had to apply for special permis-

sion to deliver it late to the Salon d'Automne. "I'm doing it in petit point," he wrote to Bussy, "which makes slow work, especially since it doesn't always work the first time." ¹³⁴

The Divisionists' use of dots, or points, which twelve months before had seemed to promise a glorious liberation from academic orthodoxy, had come to feel to Matisse by this time like repetitive, laborious handstitching, doggedly pursued according to fixed rules to a prearranged conclusion. The finished painting has its own subdued but golden light, together with a disarming comicality, as if the tiny figures turning the capstan or mending nets were only too well aware of the absurdity of their creator's plight. Developments in his painting were moving almost too fast for Matisse himself to keep up with them. Years later André Level described how he had been buttonholed for forty-five minutes in the autumn of 1904 by Matisse, newly returned from St-Tropez as a fervent convert to Divisionism. "Eloquent, indeed besotted about his subject, he convinced me utterly that the dot [le point] alone could enable the painter to raise his colour tones to maximum intensity." A year later Level was perplexed to find no vestige of Divisionism in Matisse's work. "I timidly reminded him of our conversation, or rather of his profession of faith the previous autumn, to which he replied immediately without embarrassment: 'Why ever should I use the dot when I can, as you see, obtain such intensely luminous results without it?' And he convinced me for the second time."135

Work on *Le Port d'Abaill* dragged on too long for it to be included in the 1905 Salon d'Automne. Matisse exhibited it instead the following spring at Druet's, then took it home to Bohain to show his mother, who had started him off as a painter, and whose instinctive judgement he still trusted. Anna Matisse was not impressed. Her seven-year-old grandson, Jean, reported a tense scene in which she dismissed the work that had cost months of anxious toil—"That's not painting"—whereupon Matisse took a knife and slashed the canvas. ¹³⁶ *Le Port d'Abaill* was the field on which Divisionist theory had fought and lost him. His mother's verdict was as much a release as a rejection. Forty years later Matisse remembered painting another picture for her and "putting into it, out of tenderness for her, everything that theory could not give him." ¹³⁷

The painting which he completed at top speed and showed at the Salon d'Automne in place of *Le Port d'Abaill* was *Woman in a Hat* (colour fig. 24). It looked to contemporaries like a crude piece of graffiti brutally slashed or smeared across the canvas. People who knew that the painter's wife had posed for it were frankly shocked. The public doubled up with

laughter in front of it. The critics used the same insults in public—barbouillage, gribouillage, bariolages informes¹³⁸—that the people of Bohain uttered behind Matisse's back. Even young artists eager to identify themselves with everything that was new and forward-looking found this latest work hard to take. One of them was the writer Francis Carco, a friend of the twenty-four-year-old Pablo Picasso, whose reputation was already gaining ground in Montmartre in spite of the fact that hardly anyone had seen his work. Carco, hanging out at Picasso's local, the Lapin Agile, could make no sense at all of the Spaniard's pronouncements on modern art:

And I was starting to ask myself if, in spite of his astonishing powers of persuasion, Picasso was not getting more pleasure from mystifying us than he was from actually painting, when the notorious *Woman in a Hat* taught me more in an instant than all his paradoxes. . . . Nothing about it was physically human. You had the impression that the artist had been much more preoccupied by his own personality than he was with the model's. . . . Nonetheless there emanated from this singular work—with its outlines like charcoal scrawled on a wall balancing the cold tones which you would have thought were put on with a stencil—such an evidently conscious fixity of purpose that, after an interval of more than thirty years, I still have not forgotten it. 139

Matisse's painting became the Salon's star turn that year for spectators, who treated the whole show as a circus. The Salon's apprehensive president, Frantz Jourdain, who had done all he could beforehand to persuade the jury to turn it down, found himself overruled by Matisse's supporters on the jury, led by Roger Marx, René Piot and another of Moreau's old henchmen, Jourdain's vice president, Georges Desvallières. 140 Level maintained that the prestige of the Salon d'Automne in its early years was largely due to Desvallières's energy, authority and disinterested determination to pick out what was good and genuine regardless of the consequences. 141 Desvallières was certainly responsible for grouping Matisse with his friends-Derain, Vlaminck, Marquet, Manguin, Camoin—in what became the notorious Salle VII. Cross, who was also included on the original list, prudently cried off at the last minute ("I would prefer my submission, which belongs with the softer harmonies this year, to be separated from yours," he wrote to Matisse, "in a place that favours calm where it can hold its own, rather than being made to look even paler, which would certainly happen anywhere near you.")142

Matisse had approached the opening with high hopes. For once he felt that he had expressed something of what he wanted in his work, which he looked forward with modest confidence to putting before the public. 143 Others, like Jourdain, expected trouble. Arriving to inspect the Salon before it opened, Louis Vauxcelles noticed a couple of academic sculptures placed incongruously in the middle of Salle VII and made what became a famous wisecrack to Matisse: "a Donatello among the wild beasts [fauves]." When Vauxcelles recycled the image in his article in Gil Blas on 17 October, it was the public who became wild beasts, in a Roman circus with Matisse cast as a luckless Christian martyr. The more sophisticated critics (including Vauxcelles) took no part in the popular hue and cry, but as it approached its height a couple of weeks later, they found their wary tributes picked up out of context and published on 4 November in L'Illustration, alongside reproductions of the Salon's most provoking works. 145

L'Illustration was a fashionable magazine read all over Paris and in provincial cafés throughout France. Matisse's Woman in a Hat and The Open Window dominated its double-page spread, which polarised opinion as battle lines were drawn up on both sides. Matisse's old friend Jules Flandrin (who was at last beginning to find a market for his work) felt half thankful, half aggrieved to have been passed over. "They didn't count me worth including," he wrote wryly to his mother, "but out of ten artists, eight are friends of mine, and I know the other two!!" Simon Bussy was not included either. Exhibiting for the first time at the Salon d'Automne, he had sent five paintings from London with a note confiding his nervousness to Matisse, who rightly told him not to worry. 147

But Bussy's success with the critics did his reputation no good what-soever in the long run. The art establishment, heroically resisting change as always, came to look back on its eventual, enforced capitulation as its finest hour. The official line in retrospect was that the 1905 Salon d'Automne had witnessed a glorious reversal, with Salle VII "invaded every evening by long lines of revolutionaries, pouring down from Montmartre...much as a century earlier streams of rioters from the faubourg Antoine descended on the National Convention." Certainly, the regulars at the Lapin Agile, like Francis Carco, were powerfully impressed. Picasso (who had not yet met Matisse) felt he had been decisively outflanked. He Matisse himself cheerfully admitted to Carco afterwards that even the derogatory nickname had done no harm at all ("Frankly, it was admirable. The name of Fauve could hardly have been better suited to our frame of mind"). 150

But at the time, the whole affair was a dreadful replay, acted out in the full glare of national publicity, of the jeers and pointing fingers Matisse had endured for years in Bohain. He had dreamed as a child of growing up to be a clown, and now the dream had turned into a nightmare. "The good public saw in him the incarnation of Disorder, of a savage wholesale rupture with tradition," wrote Marcel Sembat, "a sort of con man in a silly hat, half anarchist, half charlatan!" It was widely felt that the artists exhibiting in Salle VII, especially Matisse, were attempting to get the better of the public in a monstrous confidence trick. The accusation reinforced the private doubts Matisse poured out in a despairing letter to Cross, who responded with characteristic generosity:

But my dear uneasy friend, I was delighted with your letter in the sense that it increased the great respect I already have for you. I understand your uneasiness and your sensitivity so well! I like them, too, for (failing that fine serenity which is undoubtedly the most enviable state to be in) I am convinced that they are painful but useful qualities for the artist. Believe in yourself for what you are, and if you are satisfied with your Collioure canvases, it is because they are good. There is only one judge of your work, and that is yourself; to hell with those who don't understand!¹⁵²

The charge of confidence trickery had painful reverberations for anyone who had already endured the public humiliations of the Humbert Affair. In spite of his best resolutions not to go, Matisse found himself constantly drawn back to the Salon, and to the sound of baying laughter inspired by his pictures in Salle VII. Amélie, who never visited the exhibition herself, urged him to keep away: "Why torture yourself by going there?"153 She had learned at her mother's knee to pay no attention to hate campaigns in the press. She stayed at home, as imperturbable as Mme Parayre before her, sewing tranquilly and posing for her husband. A week before the Salon closed, a telegram arrived during one of these posing sessions, containing an offer for Woman in a Hat of 300 francs, which was 200 francs less than the asking price. Nothing else had sold. Morale was lower and money tighter than ever before. It was typical of both parties that, whereas Henri's impulse was to accept, Amélie insisted on sticking out for the full amount. The story became another of the family legends circulated among their friends, one of whom described what happened next. "Oh no, said Mme Matisse, if these people are interested enough to make an offer they are interested enough to pay the price you asked, and she added, the difference would make winter clothes for Margot." After several days of mounting tension, the original terms were accepted in a second telegram, which Matisse opened and read with such a strange expression that his wife was terrified. "I was winking at you, he said, to tell you, because I was so moved I could not speak." ¹⁵⁴

The buyers were two Americans, a brother and sister, Leo and Gertrude Stein. They made a conspicuous pair—one tall and thin, the other short and stout—in their flat sandals and matching bright brown corduroy suits. They were already beginning to be familiar in and around the rue Lafitte, where Berthe Weill had tried in vain to bring them to the point of buying ("Matisse interested them... they didn't dare. 'Believe me, buy Matisse,' I told them... but the paintings weren't quite ripe yet"). In fact, it was the couple's sister-in-law, Sarah Stein, who with her husband Michael finally persuaded the dubious Leo to make up his mind about Matisse's painting. "I remember everybody standing in front of it," wrote an American girl who was staying with Sarah and Michael Stein. "The young painters were just laughing themselves sick about it. And there stood Leo, Mike and Sally [Sarah] Stein, very impressed and solemn about it." It was agreed between them that Leo would pay for the picture, which the other two could not afford.

Several witnesses reported the two odd Stein couples returning regularly over the next few weeks, accompanied by relays of more or less perplexed companions, to contemplate the Salon's craziest painting. Gertrude's friend Claribel Cone was stunned on the opening day by what sounds like the most conventional of Derain's three images of Matisse. "We stood in front of a portrait," wrote Dr. Cone. "It was that of a man, bearded, brooding, tense, fiercely elemental in colour with green eyes (if I remember correctly), blue beard, pink and yellow complexion. It seemed to me grotesque. We asked ourselves, are these things to be taken seriously?" ¹⁵⁷

The Steins' decision came in the nick of time for the Matisses, whose financial situation was beginning to alarm their friends. The champion fixer René Piot exchanged anxious letters that autumn with Georgette Agutte, a fellow painter and former hanger-on at Moreau's, now married to the Socialist deputy Marcel Sembat (who would eventually take on the role of chief defence counsel for the Fauves). Sembat had already arranged a cheap rail pass for the Matisses to and from Collioure. Socialists of addresses for business circulars ("It's very hard work and abominably paid—but if the need is too pressing, Marcel could always get it for

him"). ¹⁵⁹ The week after the show opened, Sembat lobbied the art minister himself on Matisse's behalf, extracting the assurance of an emergency handout of 250 francs. ¹⁶⁰ This payment still had not been made by the second half of November, when the Steins plucked up courage to make their offer only to have it turned down by Amélie. ¹⁶¹ However demure Matisse's wife might have seemed in public, in private their partnership was already closer to an active collaboration than the unequal relationship between artist and muse promoted as the ideal of their generation. Amélie's recklessness matched and at times outdid her husband's. "As for me," she said with reason in old age, "I'm in my element when the house burns down."

Woman in a Hat is among other things a portrait of Amélie's courage, her will and her passionate, exacting faith in the painter. When Picasso made a famously totemic portrait of Gertrude Stein in 1906, he said, in answer to protests that the sitter did not look like his image of her: "She will." The same thing happened with Matisse's paintings of his wife, which had seemed chillingly inhuman at first sight to contemporaries like Carco. People who knew Amélie not only recognised her resemblance to her early portraits but insisted that the older she grew, the more striking the likeness became. "When I myself met Mme Matisse for the first time," wrote Pierre Schneider, "I immediately recognised the woman who, forty-five years earlier, had sat for *The Green Line*." She is beautiful and dauntless as ever," Simon Bussy's daughter wrote in 1957, when Amélie was an eighty-five-year-old widow. "She still looks astonishingly like her portraits of the Fauve years." 165

In the winter of 1905–6 Matisse painted a third Fauve portrait, *Interior with a Young Girl (Girl Reading)* (colour fig. 25), a painting of his daughter which was also a picture of the burning house that brought out the best in his wife: the house of art going up in flames along with its traditional fixtures and fittings. "The interior and its furnishings cease to be identifiable, like a log veiled by the fire it feeds...," Pierre Schneider wrote of this painting (which was bought by Fénéon). "These colours are all... adamant in their refusal of modelling, shading, perspective, shadows, highlights and reflections, and tonal values." Hard Marguerite posed at the still centre of this conflagration, as Amélie had done for *The Green Line*. The canvas shows the child in her working pinafore, absorbed in a book, with her head propped on one hand, at the table with Marquet's chocolate pot and the fruit stand familiar from innumerable still lifes, in the studio at the quai St-Michel.

Marguerite was already the third pole around which the life of the stu-

dio and the household revolved. Brave, resolute and uncompromising, she could be (and was for the rest of her life) relied on absolutely by her parents and her brothers in small things and large. Even as a little girl, she took over routine domestic chores like shopping, cleaning, looking after the boys, all the offices that would have been performed in a less hard-up household by a maid of all work. It was Marguerite who ensured that Amélie was free to pose, or rest after staying up into the small hours reading to her husband. As a child, Marguerite was nicknamed "the Doctor," like her father. Her life was shaped, as his was, by the pull of duty. The fracture that had split her world when she was three made her turn outwards, locating her sense of security and self-respect in concern for other people. Her father's studio represented, more perhaps for Marguerite than for any of the others, a human and imaginative refuge from the long series of ordeals that had shaken, and very nearly shattered, the Matisse family at the beginning of the century.

They survived by closing ranks for mutual protection and defence. Throughout the next decade, the years in which Matisse took the greatest risks of his career, the support system which made it possible for him to function as an artist came from his family. His wife's determination never failed him. His children prided themselves on being Fauve children. When the sixteen-year-old Marguerite saw her first painting by Puvis de Chavannes, she was bewildered by its overall pallor, its ghostly figures and its "muted, sad, dismal colour." All the young Matisses responded to the paintings in the studio frankly and directly. They were taught from their earliest years to look closely and to describe their responses clearly to their father, who learned from what they saw in his paintings as much as from what he found in theirs.

As a very small boy, Pierre copied one of his father's paintings and sold it for fifty centimes to Berthe Weill (he would grow up to become an immensely influential dealer in modern art). ¹⁶⁹ At home from infancy with Fauvism and Cubism, he would be well into his twenties before he began to be curious about the art of the past. ¹⁷⁰ Matisse's painting provided not only the context of Pierre's childhood but its meaning. Like Marguerite, he recognised in their father's work a source of cohesion and emotional stability for the whole family. "I know the place your paintings occupy in our family," he wrote to his father after he left home. "Each of them represents a period, a fresh enrichment for all of us, each one takes a place whose importance you don't fully realise until after it has disappeared." ¹⁷¹

Matisse's children grew up, as he himself had done before them, watching their parents engaged day in, day out, in unremitting labour. Work was

the family watchword, a defence and panacea against all ills. "A slowing down in sales or even a full stop doesn't mean all is lost," Matisse wrote to Henri Manguin in 1906, looking back at the storms he himself had weathered the year before, in a long, comforting letter full of practical advice:

On the contrary, if you lose your nerve and stop working, you justify your detractors, and compromise your own future.... All you have to do is work. If you're in trouble, it's through work that you will get out of it. If you know clearly where you're going, if your ideas are solidly based, it's through work that you will make them succeed. Forget everything except what I say in these last two lines, and don't hold the rest against me. It's the advice of a true friend. 172

In October 1905 Matisse exchanged the cramped working conditions of the quai St-Michel for a larger room, rented cheaply in an abandoned convent, the Couvent des Oiseaux on the corner of the rue de Sèvres and the boulevard Montparnasse. He needed more space to work on a portrait of Mme Signac, 173 which was ironic, since the canvas that preoccupied him above all else in his new studio precipitated what turned out to be a final showdown with her husband. This was Le Bonheur de vivre (Joy of Life) (colour fig. 26), the painting Matisse called "my Arcadia." It marked a decisive victory in the lifelong battle which was, as Matisse ruefully acknowledged, a struggle with himself—an attempt to lay to rest his own perturbed spirit—as much as with an outworn pictorial language. In this new canvas he broke through to the realm of sensuous and luxuriant calm that had eluded him in Luxe, calme et volupté. He had finally moved on from the strenuous Neo-Impressionist disquiet which preceded the pictorial upheaval of the previous summer in Collioure. Matisse himself explained his aim in characteristically low-key and pragmatic terms: "I tried to replace the vibrato with a more responsive, more direct harmony, simple and frank enough to provide me with a restful surface."175

Nothing could be simpler, franker or more restful than *Bonheur de vivre* with its Arcadian personnel of nymphs and lovers—embracing, dancing, making music or relaxing beside the sea—treated as decorative elements in a rhythmic pattern of flat areas of plain colour. Signac, who was one of the first to see the painting on a visit to Matisse's new studio, was appalled. "Matisse . . . seems to have gone to the dogs," he wrote to a fellow Neo on 14 January 1906. "Upon a canvas of two and a half metres he has surrounded some strange characters with a line as thick as your thumb. Then

he has covered the whole thing with flat, well-defined tints which—pure though they may be—strike me as disgusting."¹⁷⁶

Having however reluctantly tolerated Matisse's aberrations at the Salon d'Automne, Signac saw this new painting two months later as a public betrayal. From the point of view of artistic power politics, he was right: the loss of Matisse meant for all practical purposes the end of Neo-Impressionism as anything more than a private faith (Cross was already moving towards more intuitive principles of composition, Luce made up his own rules as he went along, even the faithful Rysselberghe would be denounced by Signac three years later for a heretical use of brown). Signac staged a recriminatory scene with Matisse that spring in the café that had become an unofficial annexe to the Indépendants, after which relations between the two painters came to a full stop. 178

In *Le Bonheur de vivre*, more than in any other single canvas, Matisse mastered the lesson he had set himself in his first summer at Collioure: "how to make my colours sing." The painting took its title from the town's Catalan motto, and its setting from the beach at l'Ouille. The ring of dancers in the middle ground looks back to the ancestral round dance of Collioure fishermen, and forward to the barbaric modernism of Matisse's own *Dance* in 1909. The colour is as exalted as only he could make it, and as earthy as the fruit and vegetables his friend Paul Soulier described in Collioure market: "You will rarely find another such image of abundance, of the ease of living, of well-being within everybody's reach." ¹⁸⁰

This was the democratic concept of luxury Matisse had imbibed in infancy from the silk-weavers of Bohain. At the end of his life he came to feel that his entire career might be construed as a flight from the dark, narrow and constricted world of his northern upbringing. He recognised clearly enough the inner pressures that demanded and denied him rest. Already, in the early years of the century, Matisse set himself to achieve through art a stability that would counter the chaotic flux of the modern world. He pursued this vision with stern, even inhuman tenacity because, although the dream first came within his grasp under a Mediterranean sun, he remained to the day he died a man of the North. His art is grounded in the northern sensibility that gave him, on the one hand, his matter-of-factness, his obstinacy, his perseverance and, on the other, the austere, concentrated feeling he shared with the great Flemish masters: a spiritual intensity released again and again at crucial points in his development as a painter by the light and colour of the south.

CHAPTER ELEVEN

1906–1907: Paris, Algeria and Collioure

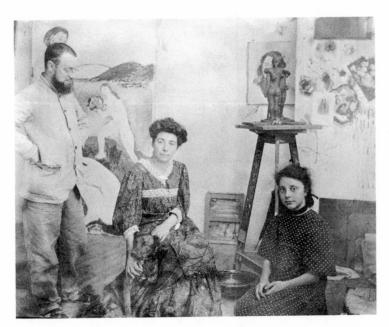

Matisse with Amélie and Marguerite in the studio at Collioure, 1907

e Bonheur de vivre was Matisse's only submission to the Salon des Indépendants in March 1906, a gesture of courage and defiance that caused even more excitement than Woman in a Hat. "Henri Matisse had the greatest success of his career in terms of hilarity that year, I think," wrote Berthe Weill. Fifty years later the memory had not faded. "Parisians who can still remember the event say that from the doorway, as

they arrived at the salon, they heard shouts and were guided by them to an uproar of jeers, angry babble and screaming laughter, rising from the crowd that was milling in derision around the painter's passionate view of joy." For the second time in less than six months Matisse had been turned into a cabaret act or circus turn. One of the imaginative young jokers who hung out at the Lapin Agile in Montmartre had the bright idea of defacing a set of posters designed to warn against the toxic properties of lead paint, so that handbills stuck up outside the local urinals now read: "Painters, stay away from Matisse!" "Matisse has caused more harm in a year than an epidemic!" "Matisse drives you mad!"

The popular press weighed in with relish. More responsible critics were baffled or sardonic. Many hedged their bets by repeating variations on the view that Matisse had allowed theory and dogma to stifle his undoubted talent. This case had been eloquently argued the year before by the young André Gide, echoing his friend the painter Maurice Denis.4 Gide was already making waves as a literary iconoclast himself, and Denis, too, had a reputation for radical innovation. A teenage scourge of Bouguereau and the Beaux-Arts system, Denis had published a Symbolist manifesto preaching the gospel of Gauguin and van Gogh long before Matisse (who was the older of the two by almost a year) had so much as opened his first paint-box. But by 1905 Denis had exhausted his capacity to detect or respond to originality. Matisse's work struck him as arid, empty, artificially constructed and utterly devoid of intuition or feeling. The last charge was so patently absurd that Matisse, marching his tormentor up to a recent canvas, forced him to admit that the tonal relations could only have been reached by instinct, rather than worked out by scientific calculation.5 Denis had a good enough eye to take the point at surface level, but Matisse's underlying purpose was beyond him.

Coarser minds, following the lead of Gide and Denis, endorsed the vaudeville atmosphere that made it hard to look clearly at Matisse's second one-man show: a carefully chosen retrospective of some sixty works from the past decade which opened on 19 March, the day before the Indépendants, at Eugène Druet's enterprising and unexpectedly successful little gallery on the faubourg St-Honoré. Matisse had painted a cheerful placard with gaily coloured sailing boats bobbing about beneath a beaming sun to hang in Druet's window, but the only reviewer to notice the exhibition warned the public not to be taken in by the tricks of a meretricious showman. "The Organiser of the Henri Matisse Exhibition, Galerie Druet, Faubourg St. Honoré" received a one-line missive from an advo-

cate at the Paris bar: "Sir: Kindly note my name and address in order to avoid sending me any more of your obscenities."

Druet had a cool head and a sharp nose for business. His response to outrage among potential clients was to lay in a stock of Matisse's latest work, for which he paid 2,000 francs in April.7 The painter grumbled that the original agreement had been for half as much again, but Druet's confidence was worth having. An ex-barkeeper with no aesthetic pretensions or qualifications beyond a spontaneous liking for the artists who had once been regulars at his bar, Druet was the first after Berthe Weill to specialise in young contemporaries of Matisse's generation (Marquet, Manguin, Marval and Camoin all showed with him). Competition stirred Vollard at last to snap up 2,200 francs' worth of Matisse's early work in the same month as Druet.8 Both were inspired salesmen. Both worked intuitively (like Matisse). Both could sense that a tide was on the turn well before the swell alerted other people. Signs of impending change were small but discernible that spring. Matisse had shown the previous autumn with a little band of provincial pioneers at Troyes,9 and he showed again in May with the Modern Art Circle of Le Havre (newly founded by a local housepainter and decorator, Charles Braque, whose son Georges had already joined up as a Fauve in Paris). A trickle of similar invitations followed scattered droplets rather than a steady stream at this stage—as friends and supporters among Matisse's contemporaries slowly wrested control of local art groups in towns and cities all over France. He took part for the first time that May in an international avant-garde exhibition, the Libre Esthéthique in Brussels, and he sent four canvases to a travelling German show described by the alert young Wassily Kandinsky as a bomb going off in the heart of Munich.10

Le Bonheur de vivre meanwhile made two crucial conquests. The first was the Russian textile magnate Sergei Ivanovich Shchukin, who visited the Indépendants accompanied by his eldest son, a twenty-one-year-old student from Moscow University as mystified as he was impressed by his father's intent response to this particular painting. Something about it transfixed Shchukin. He had been collecting modern art for the past eight years, starting with the Impressionists (he owned a dozen Monets as well as a roomful of Renoirs) before working his way via van Gogh and Cézanne steadily towards the present day. Shchukin looked to paintings as other men do to women for risk, challenge, the excitement of the chase and the lure of the unknown. His relationship with an artist's work went through successive stages: speculative interest, growing absorption, even-

tual satisfaction as each in turn disclosed its secrets, leaving him free to move on to the next. He was currently involved with Gauguin, whose work he kept discreetly hidden from prurient visitors to his Moscow mansion. He was a short, shy man with a head too big for his body and a stutter that made him hard to understand at times. "A m-m-madman painted it," he said, bringing out his first Gauguin to show to a friend at home, "and a m-m-madman bought it."

By 1906 the Russian had already acquired a handful of early Matisses, though none had so far claimed his full attention. Now he asked Vollard for an introduction to the painter and paid a call which, as Shchukin's first biographer observed, changed the lives of both men. ¹³ Matisse would gain from Shchukin not only the unconditional financial backing he could get nowhere else but also—at a time when he desperately needed both—a pictorial courage and ambition as exacting as his own. "If there are painters whose eyes never deceive them, he had such eyes, although he was not a painter but an industrialist," Nina Kandinsky said of Shchukin, ¹⁴ a judgement borne out by his dealings with Matisse perhaps more than with any other painter. As for Shchukin himself, his passion for Matisse's work would give him back purpose and meaning at a time when his life had largely lost both.

But that point lay in the future. For the moment, he did no more than pick a canvas to take away, explaining that he needed to test it out for a few days ("If I find I can stand it, and if it still interests me, I'll keep it"). The picture was *Dishes on a Table* from 1900: an early but audacious still life, chiefly startling at that date because of a large area of flat paint with no convincing naturalistic alibi—it might have been the tablecloth, or the back of another painting propped against the table—filling one third of the canvas with rich, dense, animated red and purply brown brushstrokes. Shchukin paid up ("I was lucky that he turned out to be able to stand that first ordeal with no problem," Matisse said cheerfully) 16 and disappeared with the painting back to Moscow.

The second major consequence of the Indépendants was still more encouraging. When the salon closed on 30 April, *Le Bonheur de vivre* went home with Leo Stein, who had disliked it intensely at first sight, announcing only after several weeks' deliberation that "the big painting was the most important done in our time." Leo was visually self-taught, like Shchukin, and had arrived a little earlier at the same destination by a quite different route. His art education had begun in Italy with the primitive church painters of the fourteenth century, whose formal rigour and severity had made it possible for him to appreciate Cézanne, who in turn pre-

pared him for Matisse. "It was what I was unknowingly waiting for," he wrote of Woman in a Hat, explaining why it had taken time to make up his mind the year before, "and I would have snatched at it at once, if I had not needed a few days to get over the unpleasantness of the putting on of paint."18 By any standards Leo's reactions were phenomenally fast. Posterity has backed his assessment of Le Bonheur de vivre, but Leo was apparently the only person who fully grasped its importance as soon as it was painted.

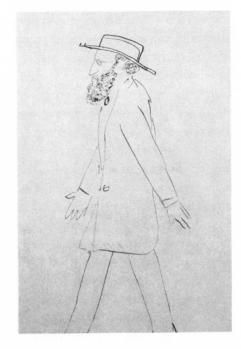

Pablo Picasso, Leo Stein Walking, 1905

Leo was thirty-four years old in 1906, a whole generation

younger than Shchukin, who was fifty-six. Each often felt uneasy with his contemporaries, each was to some extent an outsider in his own country, but otherwise the two could hardly have been more unlike. Leo, who had inherited at nineteen a small but adequate income based on California streetcar stock, never earned a penny in his life. He had a speculative, original and incisive mind, but no long-term application whatsoever. At Harvard he had successively abandoned degree courses in zoology and law to write a book on the Florentine fresco painter Andrea Mantegna, which came to nothing, whereupon he decided to become a painter himself instead. This project was almost immediately overtaken in 1903 by his discovery of Cézanne, 19 and two years later of Matisse. Leo felt the ground shift beneath his feet. Thinking and talking about the seismic pictorial upheaval going on around him became from now on a full-time occupation. Leo, who tended to strike other men as touchy, boastful and contentious, had always had a gift for explaining difficult things simply and clearly, especially to women or girls, and most of all to his younger sister Gertrude.

The two had grown up in San Francisco, the last in a family of five children born to German Jewish immigrants whose premature deaths left their offspring—as Leo proclaimed with relish—financially, socially and emotionally self-sufficient. Early disaster, which in some sense stunted or

withered his moral stamina, only strengthened hers. Intellectually and aesthetically, the pair were not so much arrogant as righteous in the biblical sense. Neither seems to have been surprised when the unlikely prophecies to which each pinned his or her faith in the opening decade of the century duly came to pass. Gertrude had realised very young that what she wanted most was glory, but for thirty years and more she remained content to function as Leo's sidekick, tailing him everywhere as a child, later following him to Harvard, joining him on sightseeing trips to Europe, even setting up house with him in Paris against her own inclinations in 1903. Their seedy ground-floor studio apartment on the Left Bank would become a prime attraction on the avant-garde tourist trail between the two world wars, largely thanks to Gertrude, whose celebrity grew in direct proportion to the difficulty of reading, understanding or indeed obtaining her rarely published works.

But the reputation of the apartment at 27 rue de Fleurus came also from the legendary picture collection it contained, which had been handpicked by Leo. People who knew them from the first in Paris remembered Gertrude as a genial but often silent presence, at any rate in the company of the French, whose language she hardly spoke. Leo in those days was by far the more impressive of the two. "Gertrude didn't count for very much...," said an American visitor who had been flabbergasted as a girl by Leo's pictures. "Gertrude was not responsible for their collection. Of course she had nothing to do with it."20 The couple were still inseparable. Gertrude followed her brother faithfully, accompanying him on rounds of dealers in and around the rue Lafitte, pooling her funds with his and endorsing his decisions as she always had. On the one recorded occasion when she objected to his choice, Leo went ahead and bought it all the same. For the moment, the two remained at one, but their aims were beginning to diverge. Gertrude valued pictures as an adjunct—an extension of herself, her world, her will-whereas for Leo their value was intrinsic. Left to herself, before and after the years she spent with Leo. Gertrude's taste was at best commonplace. Matisse himself said she never understood Fauvism.²¹ Even Vollard, who was enchanted by everything to do with Mlle Gertrude, never credited her with any particular pictorial flair.

What delighted Vollard was a perspicacity, a self-assurance, a subversiveness so ingrained that he could not be sure whether it was conscious or not. Appearances were as misleading in her case as in his own. "To see her in her robe of coarse cotton cord," he wrote appreciatively, "with her leather-strap sandals and general air of being slightly simple-minded, you

might have taken her for a housewife whose horizon was limited to her dealings with the milkman, the grocer and the greengrocer."²² Aliens from the land of Emerson and Thoreau, Gertrude and her brother took simplicity and lack of guile to lengths that stupefied the French, who rarely saw Americans, let alone Americans like these, whose looks and lifestyle flew in the face of reason, custom and politeness. It was the Steins' strong point as collectors. Reasonable people did not live frugally, dress shabbily and do without all but basic amenities in order to get their kicks from patronising disreputable, disruptive, semidestitute young painters.

Leo said that the very first picture he ever bought (a small item by the mildest of English sub-Impressionists, Philip Wilson Steer) made him feel like a desperado.²³ He acquired his first two works by French contemporaries (one was a nude by Henri Manguin) at the 1905 Indépendants, moving on that autumn to buy his first Matisse within weeks, perhaps days, of his first Picasso. The sums he disbursed from then on were never large. When Matisse's prices rose beyond a few hundred francs (largely thanks to Shchukin's intervention), Leo dropped out of the running. But for eighteen crucial months, with no encouragement and no funds to speak of, the Steins could and did buy nearly all the masterpieces Matisse produced. "In later years people often said to me that they wished they were able to buy such things for such prices," Leo wrote wryly nearly half a century later, "and I had to remind them that they also were in Paris then, and had more money than I had."²⁴

Leo's logic was as usual unimpeachable. It was one of the most irritating things about his uningratiating character. "Leo Stein was long and skinny with a wispy beard and an aspect more or less severe," wrote a French observer, adding unsympathetically: "Perhaps his favourite drink was water?" Gertrude's expansive nature complemented her brother's austerity. She was as adroit as he was clumsy when it came to other people, and the painters Leo brought home responded with relief to her hospitable humorous presence ("She had a laugh like a beefsteak"). The first was Henri Manguin. The Steins met and made friends with Manguin on the strength of buying a canvas from him in the spring of 1905, an experience new enough to be a pleasant shock to both parties. Manguin's cordiality and readiness to talk endeared him to Leo, who became steadily more involved with the world opened up by his new guide.

When Leo nerved himself to buy his next contemporary work that autumn, it was Manguin who arranged for him to meet the artist. "Matisse was really intelligent," wrote Leo,²⁷ a unique accolade from one who often had difficulty finding painters prepared to submit their work to

the sort of severe critical analysis he enjoyed giving. Some were downright ungrateful, unlike Matisse, whose rampant self-doubt made him desperate to know what sympathetic observers thought about his work. Matisse respected Leo's judgement, and shared his serious, single-minded absorption in the subject. Leo's eminently rational approach appealed to the orderly side of Matisse's nature, even if in practice he found it difficult to bear. He remembered that it was a grey day with a low light when, after many visits and much agonising delay, Leo finally made up his mind about *Le Bonbeur de vivre.*²⁸

It was also the day before news reached Paris of the earthquake that devastated San Francisco on 18 April 1906, leaving many dead, fires everywhere and large areas of the city reduced to rubble. No one knew how much or how little had survived. "The Steins may well find themselves almost ruined," Matisse wrote sombrely to Manguin. He readily agreed that the painting should be hung in the studio at rue de Fleurus, whether or not it could be paid for ("Mlle Stein told me: if our situation turns out to be unchanged, we'll take it").29 By the day of its installation in early May, Matisse's agitation was so painful that the combined efforts of Leo, Gertrude, Amélie and Etienne Terrus (up from his native Roussillon for the Indépendants) failed to reassure him. "Stein decided that it went very well, much better than at the Indépendants," he wrote to Manguin, "and that it didn't war with anything else, even that it looked good with the things he has at home. His sister agrees with him. Terrus, whom I took along, also thinks it looks fine, my wife too. For myself, I daren't form an opinion on the matter, though I will admit between ourselves that I was glad to see it hung."30 It was exactly twelve months since the Steins had come back from their first foray into contemporary painting with Manguin's Standing Nude. Over the next few years their walls would fill with paintings, hung at first in a single line at eye level, later two deep, eventually frame to frame from floor to ceiling with as many as five canvases ranged one above another.

Painters were fascinated by this unprecedented, unpredictable, constantly updated display. Gertrude and Leo—who never took the simple life so far as to do without a good French cook—gave lunch parties for the artists and their wives, at one of which Matisse noted that his hostess had amused herself by seating each guest opposite his own production. Taking his cue from *Woman in a Hat*, he presented her with a drawing of his wife in the act of putting on one of her big black hats ("Gertrude Stein always liked the way she pinned her hat to her head...," Alice Toklas wrote of Amélie Matisse. "She always placed a large black hat-pin well in the mid-

dle of the hat and the middle of the top of her head and then with a large firm gesture, down it came").³¹

It was a witty gift, and characteristic of the giver, who noted more than once the shrewdness of Gertrude's psychological perceptions and the private games she liked to play with other people. Gertrude's friendliness would decline, coming close to hostility in the end, partly because she found Matisse noticed too much for comfort. But although she turned against him, and Leo's interest in his pictures—like all Leo's other interests—eventually faded, Matisse never minimised the debt he owed the Steins. Their belief in him at crisis point had meant as much as their financial backing. In public statements about his past, he placed them ever afterwards firmly at the head of his list of benefactors.

In private he made no bones about the fact that the Stein who mattered most to him, both professionally and personally, was neither Leo nor Gertrude but their brother Michael's wife, Sarah. Matisse always held Sarah personally responsible for the initial purchase of *Woman in a Hat.* She

Matisse, Nude Before a Screen, 1905

certainly picked out a second picture, painted at the same time using the same palette, which she and her husband bought that autumn on their own account. This was the tough little *Nude Before a Screen*, identified ever afterwards in the Matisse family as "the Steins' first purchase" (presumably because the bigger payment for the larger canvas took longer to be handed over). Never one to do things by halves, Sarah went on the same winter to acquire *The Green Line*, the first portrait Matisse had made of his wife that summer, widely held to be as demented as the second. Within months she and Michael would buy from Druet the first landscape sketch and the final study for *Le Bonheur de vivre* together with *The Gypsy*, a newly finished canvas full of the sense of release and confidence Matisse felt in his loosened, liberated colour.

Sarah was as fearless as Gertrude, and she had an eye as fine as Leo's. She delighted in the side of Matisse that struck others as wildest and most barbaric. Her instinct, especially in the radical discoveries and experiments of 1906–7, was always for the riskiest, least reassuring canvases. Thirty years later Gertrude would drastically revise the history of the Stein family collections by exaggerating her own role at the expense of her brother's, and in the public wrangling that followed, Sarah's part was written out altogether. Unlike Gertrude, she had no public platform, and she did not attempt, as Leo did, to set the record straight. It was Matisse who insisted angrily, when other people ignored or denigrated her, that Sarah was the most genuinely intelligent of the Steins, the most sensitive, "the one who had the instinct in that group."

He also said that she held a key to Leo's clenched and inward-looking nature, "because she possessed a sensibility which unlocked the same thing in him." Sarah had nothing in her background to compare with Leo's scholarly history of reading and gallery-going, but she had a natural authority he could not match. "She had always been accustomed to rule," wrote Gertrude, who learned much in those early years from her redoubtable sister-in-law, "and her family had been afraid of her and all men bowed before her." Sarah's reactions were generous, her actions swift and decisive. Where Leo had to contend with private qualms, Sarah's only constraint as a collector was money. She and Michael, living economically with their small son in a modest rented apartment, could not always lay hands at short notice on even the relatively small sums required at this stage for Matisse's major paintings.

Born Sarah Samuels, the second child of a moderately successful San Francisco lawyer, she was the only one of the four Steins with no income of her own. The freedoms available to Gertrude and her brother—further

education, foreign travel, the capacity to choose where and how to live—had never been on the cards for her. Like other bright, frustrated Jewish girls in the conformist, money-conscious world of second-generation San Francisco immigrants, Sarah took art classes, which provided the accepted outlet for unconventional or bohemian aspirations. As a gesture of defiance, its scope was strictly limited. The girls drew plaster casts or copied their favourite works by Dutch and Italian old masters onto bits of china. Their knowledge of art came from popular reproductions and a small cross section of mostly minor French Salon works generously eked out by copies. The arrival in town of Jean-François Millet's *Man with a Hoe* knocked the local intelligentsia sideways. "We talked about nothing else for days," wrote Sarah's future brother-in-law, Leo Stein, whose memoirs feelingly convey the almost total lack of cultural or visual stimulation on offer in his and Sarah's youth.³⁷

The city boomed, spreading upwards and outwards, shooting up sky-scrapers from its rocky heights, throwing suburbs out over scrubland to the ocean. Ships and railroads poured in with goods from east and west. Markets multiplied. Speculation thrived. So did energy and initiative, which were the penniless Sarah Samuels' stock-in-trade. It was generally felt to be a fair deal when she married a rising young businessman called Michael Stein in 1894, the year after he had triumphantly pulled off the integration of the city's streetcar system, shortly afterwards becoming company vice president. Michael built an apartment block—the first flats ever seen in San Francisco—where he lived with his dashing bride. Sarah furnished their rooms competitively in the fashionable cool, pale Whistlerian style with Japanese prints, Chinese vases and Oriental textiles. The bazaars of Chinatown were San Francisco's answer to secondhand or second-rate European cultural reach-me-downs, and Sarah made the most of them. Her son Allan was born in 1895, when she was twenty-five.

She got up an artistic salon, entertained the local amateurs, dabbled in painting at the kind of art class that copied copies. Sarah had always set a cracking pace for restless, ambitious younger girls like her friend Harriet Levy and Michael's sister Gertrude, but it was hard to see how even she could reach much further beyond the confines of child-rearing and home-decorating. Several of Sarah's women friends left autobiographical accounts, looking back on the stultifying constriction of their lives in a world where only men managed money and only money mattered. "To have money was to be somebody, to have none was to be nobody...," wrote Harriet Levy. "To have little, but to be on the path to acquire more, was to be ambitious and praiseworthy; to have much with a prospect of

acquiring much more was importance and distinction." Sarah and Michael were well on the way to both the latter at the turn of the century in a society where only misfits and mischief-makers dreamed of escape. Gertrude and Leo had by this time got as far as Baltimore ("Baltimore Jewish society... would in a short time stunt anything from a sensitive plant to a Sequoia," said Leo). Friends who left for Europe in these years included Isadora Duncan and her brother Raymond, Pablo Casals (who stayed for two months in Sarah and Michael's apartment after an accident on a concert tour in 1901), finally Leo and Gertrude, too.

Sarah was thirty-three when, after nine years of marriage, Michael was persuaded to review his resources, throw up his job, rent out the apartment, fire the staff and sail with his wife and son for Paris, where Leo had just discovered Cézanne. Efficient, practical, laconic, Michael welcomed or complied with this plan as placidly as he generally fell in with the schemes of his wife and siblings. From now on he shone with his usual mild glow in the supporting role of their enabler and provider, running the family finances with exemplary smoothness. Leo became Sarah's mentor, and he could not have had a more eager pupil. Sarah might be brash and bossy. People were often misled by her frizzy hair, thickening figure and motherly expression ("Her appearance suggested comfort," wrote a disillusioned friend from home: "a good San Francisco bourgeoise; in fact, not a trace of modishness or Parisian chic"). 40 But Sarah's homeliness, like Gertrude's, was skin-deep. When she arrived in Paris in December 1903, she brought with her the gift of the New World to the Old: voracious, semistarved cultural appetites, freedom from an enfeebled and contaminated tradition, the native vigour of a rootless race of outsiders accustomed from earliest years to consult and act on their own powerful intuitive responses.

It was the quality of her intuition that mattered to Matisse, who said he had himself been so tormented by provincial narrowness in his youth that he charged headlong at the prospect of escape, like an animal plunging towards the thing it loves. After her first impetuous encounter with Woman in a Hat, Sarah wasted no more time. The full force of a magnetic personality went into furthering Matisse's cause. Many thought her stupid, if not insane. Others found her eloquence difficult to withstand. From the start her backing was as practical as it was powerful. Within three months of their first meeting, she called at Matisse's studio, bringing a family friend from Baltimore, Etta Cone, whose sister Claribel had been baffled the year before by Derain's blue-bearded portrait of Matisse. Etta bought a drawing and a watercolour. When she and her sister took up

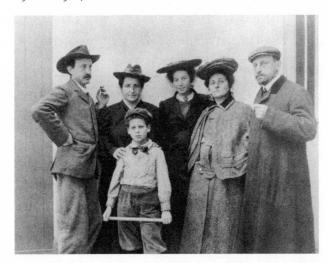

Leo, Gertrude, Allan, Sarah and Michael Stein with Allan's *au pair*, Therese Ehrman (in the middle at the back), in Paris

serious collecting in the 1920s, they would build on this modest foundation one of the richest and most comprehensive Matisse collections in America.

Etta had taken rooms for the winter of 1905-6 in a pension near the Luxembourg Gardens, round the corner from the rue de Fleurus, at 58 rue Madame. Sarah and Michael lived immediately below in a large, sunny first-floor apartment furnished, like Gertrude's and Leo's, in what was for Paris in those days an exceedingly strange way. The premises consisted of two small bedrooms, a kitchen and a spacious hall or loft, forty-five feet long by forty wide, attached to a Lutheran church built thirty years before in the plainest and most functional fake-Gothic.⁴² Divided by a row of columns, heated by a studio stove, and lit by three west-facing double windows, the room had high white-painted walls for hanging pictures and bare wooden floors dotted with Persian rugs. Here the family lived, ate and entertained their friends (the American girl who looked after tenyear-old Allan also slept in the living room on a couch). There were heavy dark chairs and two massive refectory tables picked up on summer holidays in Italy, as well as Oriental porcelain, a bronze Chinese warrior, two scroll paintings and other decorative pieces shipped from San Francisco.

"Michael and Sarah Stein had an important collection of Chinese art," said Matisse, describing the beginnings of their friendship. "They were interested in my painting, and bought one or two canvases which they regarded at first as objects, or curios, because of their exotic appearance." Their response was hardly surprising, given that the first paintings they bought from him were so unlike anything painted in the West before.

The Green Line and Nude Before a Screen caused consternation when their owners arrived with them in San Francisco in the spring of 1906. Michael and Sarah had sailed for home after the earthquake to investigate what, if anything, could be salvaged from the family's property investments, and Sarah described with glee to Gertrude the effect of her paintings on a generation that still counted Millet's Hoe a major landmark of its youth. People flocked to see them, and their comments—"horrors," "gross unaesthetic monster," "a far cry from the nude painting in our life class"—were a measure of how far the Steins had travelled imaginatively and geographically.⁴⁴

"It was grotesque," wrote a young visitor called Annette Rosenshine, who found herself literally struck dumb by Matisse's painting of his wife. "To me, with my training at Mark Hopkins Institute of Art in San Francisco, it seemed a demented caricature of a portrait." But no one, however affronted, could deny that the paintings spat and crackled with life. The sequel was bizarre. Annette Rosenshine was invited by the Steins to sail back with them to Paris, where she soon became an eager if small-scale Matisse collector in her own right. So did Harriet Levy. Ninety years later, thanks to Sarah Stein and her circle, San Francisco possesses unusually rich holdings of Matisse's experimental early work. 46

Before they left France in 1906, Michael and Sarah had stored the rest of their canvases at the rue de Fleurus. Leo wrote cheerfully to Manguin about the "exhibition of marvellous pictures" he planned to leave for his American holiday tenants. "Green is moving in for the summer, and I can't tell if they'll end up hostile to, or manage to come to terms with, these latest manifestations of the French spirit."⁴⁷ As it turned out, Andrew Green disliked the paintings, complaining indignantly afterwards that they had spoiled forever the pleasure he used to take in more conventional art. ⁴⁸ No wonder he was upset. His living room contained not only the two works by Matisse that had caused mayhem at successive salons but Picasso's looming, life-size, seven-foot-high *Boy Leading a Horse*.

The two artists had been introduced by the Steins at or around the time of the Indépendants. Picasso, who was twenty-five years old, had moved three years earlier from Barcelona to Paris, where he had still not found a dealer. Parisians were impressed by this short, stocky, silent Spaniard, who struck even the unromantic Leo as being "more real than most people while doing nothing about it." To Picasso and his Montmartre supporters, Matisse seemed at this point far older than his thirty-six years: sleek, well groomed, enviably fluent, "the image of an established master." On top of which, his was already a household name all over Paris (that was the point of scribbling it on posters in Montmartre: the

joke would have fallen flat if "Matisse" had been replaced by an utterly unknown name like "Picasso"). Gertrude had been posing almost daily for Picasso all through the winter and spring of 1906 when the Steins took Matisse with his eleven-year-old daughter, Marguerite, to see the portrait. Ficasso was on his uppers. He worked, lived and slept with his mistress and a large dog in a cold, humid, barely furnished room in a block of Montmartre tenements, let out to impoverished artists for next to nothing and nicknamed the Bateau Lavoir.

Neither Marguerite nor her father can have been surprised by Picasso's studio with its chaotic clutter of easels, canvases, paints and brushes interspersed with heaps of ash and unemptied clinker from the stove. Marguerite had been brought up in just such a studio. After fifteen years of living from hand to mouth in Paris, Matisse knew all there was to know about squalor, privation, want of coal, food and oil paints. He had survived on handouts, windfalls and dead-end jobs, like the Bateau Lavoir artists, wearing the same cheap practical workmen's clothing as they did until circumstances forced him to exchange his shabby corduroys for a conventional suit. "Matisse used to dress as carelessly as Picasso," said Lydia Delectorskaya. "It was Mme Matisse who rebelled, and insisted that he dress correctly." In the years when his wife's family faced disgrace and

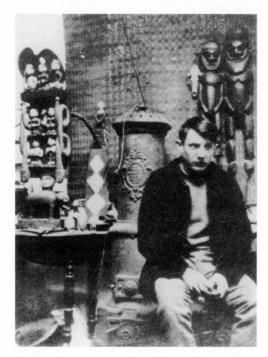

Picasso in his studio at the Bateau Lavoir, 1908

ruin, Matisse—dealing willy-nilly with the police, with truculent crime reporters and intrusive newspaper editors, with prison jailers, lawyers and court officials—had had no choice but to assume responsibility, and the trappings that went with it.

In March 1906 his finances were still shaky. It was barely four months since his friends had been scrabbling about for 200 francs (40 dollars) to tide him through the winter. "I couldn't be more pleased, for he certainly had it owing to him," Jean Puy wrote when Manguin tipped him off about Matisse's sales to Druet and Vollard in April.⁵³ A week later Leo sent Matisse word that Picasso, too, had sold more than two dozen early canvases to Vollard ("enough to give him a respite for the summer, even perhaps a little longer").⁵⁴ Neither would ever sink back to the lower depths of poverty and insecurity. As his income slowly stabilised over the next few years, Matisse, who always passed on to younger artists any luck that came his way, shared his good fortune with Picasso.⁵⁵

Still barely able to speak French himself, Picasso tended to go along with whatever the older artist said because, as he explained to Leo, "Matisse talks and talks. I can't talk, so I just said oui, oui, oui. . . . "56 Picasso had been shaken by Woman in a Hat, and seriously perturbed by Le Bonheur de vivre. A glance at the Steins' walls was enough to make his own most ambitious work to date look relatively wan, even derivative. Whether or not each recognised from the start (as Picasso later claimed) that theirs was a two-man race, Leo certainly encouraged them to think so. He had singled them out as usual well before anybody else. "Stein can see at the moment only through the eyes of two painters, Matisse and Picasso," an apprentice art critic jotted down on his Indépendants catalogue.⁵⁷ The critic was Guillaume Apollinaire, who would lose no time in acting on the opinion of a judge whose rulings already carried weight with dealers as well as critics. But Leo's accolade was also a challenge. The two stars of his summer picture show can hardly have been unaware that when they returned to Paris at the end of the summer, they would find Leo eagerly awaiting their respective next moves.

ON THE STRENGTH of Vollard's payment, both painters left Paris in May for Catalonia, Matisse heading back to Collioure, Picasso to Gósol, seventy miles away in the mountains on the Spanish side of the border. Picasso would be greatly impressed that summer by a twelfth-century Madonna in the church at Gósol, made by one of the Catalan wood-carvers whose work had excited Derain on trips into the Spanish Pyrenees with Matisse the year before. Matisse himself had been looking at African

tribal masks and wooden figures, souvenirs sent back from the French colonies that were beginning to fetch up in the windows of Parisian curio shops. He broke his journey across France at Marseilles to see a trade exhibition from the colonies, which had stirred unexpected interest among Parisian artists (both Derain and Charles Camoin were fascinated by the live dancing girls included among its exhibits). On 10 May—after spending some days with his in-laws at Perpignan, and before settling down for the summer in Collioure—Matisse boarded the ferry for North Africa.

He insisted afterwards that this was a working trip ("It wasn't holiday travel, it was a relocation of work"). See Ever since Delacroix, French painters had flocked to Morocco and Algeria in search of the picturesque, a concept that meant nothing to Matisse, who was less interested at this stage in Oriental bazaars, harems or fretwork mosques than in Africa itself. Algeria offered the nearest available access to the homelands of primitive or tribal art. It was probably not until the autumn that Matisse bought his first little wooden figure from the Congo, but he already knew Gauguin's "Maori" carvings (which had still not been exhibited in public) through Daniel de Monfreid and Gustave Fayet. Practical encouragement for the Algerian expedition seems to have come from Fayet, who began buying Matisse's work on the same scale as Stein and Shchukin in 1906, and who visited Algeria himself more than once that year on business connected with the wine trade. So

Fayet had finally abandoned plans to turn his native Béziers into France's leading avant-garde showcase, moving instead to Paris, where Matisse was one of the first to inspect the extraordinary collection in his new apartment on the rue de Bellechasse. Up to a hundred Gauguin canvases passed through Fayet's hands, together with several of the "marvellous wood carvings" which took pride of place in an installation he had himself designed as "a sort of chapel." Gauguin had made two, if not three, of these carvings specifically for Fayet. It was probably Matisse who sent the Steins to the rue de Bellechasse, and he certainly accompanied Fayet on a return visit with his friend Maurice Fabre to the rue de Fleurus in February. Fayet was a large man in every sense, tall, forceful and expansive, a visionary with a flowing black beard and impressive business acumen. Like Leo Stein, he was a failed painter whose collection supplied an outlet for his own prodigious pent-up creativity.

He had the southerner's love of bold and brilliant effects. "Colour has absolute power over Fayet," wrote André Suarès. "He is possessed by colour; it intoxicates him, it is his delight..." He shared the belief in overall design so passionately argued by Gauguin (who had dreamed in the

Gustave Fayet in his study (with his daughter), surrounded by van Goghs and Gauguins, facing the installation he designed for Gauguin's wood carvings, 1910

last months of his life of returning to France to settle near this miraculously keen new patron in Béziers).⁶³ Fayet was a close friend of the painter Odilon Redon, with whom he would work a few years later on a project to turn the abandoned Cistercian abbey of Fontfroide, just outside Narbonne, into a rich decorative ensemble of wall painting, wood carving, ceramics and stained glass. When Redon eventually persuaded Fayet himself to return to creating rather than collecting art, it was as a carpet designer (Fayet's carpets caused a considerable stir when they were first exhibited in Paris in 1924). In January 1906 he bought four Fauve watercolours and a recent drawing from Matisse on a single day, acquiring a Still Life with Lemon the same week from Druet, followed by another still life in April.64 Fayet's whirlwind enthusiasms could be overwhelming. He shocked Matisse by showing him how to brighten up his still lifes with boiling beeswax. But he also provided access to Gauguin's wood blocks for Noa-Noa, which he owned, and from which both Matisse and Derain pulled prints in 1906 (Fayet asked Matisse for lessons so that he could print from them himself as well).65

Derain had spent the first part of the year in London, returning for the opening of the Indépendants in a blaze of colour, kitted out by an English tailor whose heart must have sunk when he heard what his French customer had in mind. "It couldn't have been more English," Derain recalled with pride, "except that I had added an element of Fauvism to tailoring. I had a green suit, a red waistcoat and the yellowest of yellow shoes." But Derain's six weeks in London had not been wholly frivolous. He used the time to stand back and look more clearly at the direction in which he and Matisse had been moving the previous summer in Collioure. He toured the public galleries, conducting an energetic reassessment which meant discarding anything not directly useful as a weapon against naturalism. The Renaissance masters in the National Gallery left him cold. He told Matisse that the three things which chiefly struck him were Turner ("Turner authorises us to create forms that go beyond conventional reality"); primitive art ("With the primitives I feel totally at home"); and the ancestral Maori carvings from New Zealand in the British Museum. These last defied description, and he promised Matisse to bring sketches back instead.

Clearly the two had talked along these lines before. Their friendship had been museum-based from its beginnings in the Louvre six years earlier, when each had spurred the other on to bolder and more extreme experiments. Exploring another great museum alone in London, Derain continued on paper the kind of conversation the two had conducted faceto-face in Paris. He had no need to spell out for Matisse the properties of light which had negated shadow on their canvases the year before. In the chill mists of a London winter, Derain dreamed of the noble, sensual faces of southern women, the women of Collioure, "made for moving in full sun." The "alarmingly expressive" carvings he copied for Matisse in the museum fed his longing for escape: "These are forms born of the open air in full sun, forms called into being by strong sunlight."68 The lure of the south, and of the sun, was always tonic for Matisse. Time and again in the years ahead, he would take off southwards-heading for Seville, Morocco, Nice, Tahiti-after a period of great emotional strain or exertion, such as the cumulative ordeals of the past seven months had been for him in Paris.

Matisse took the early-morning train on 10 May from Perpignan, travelling westwards along the coast via Collioure to Port-Vendres, where the ferry left for Algeria. The crossing took twenty-four hours, followed by a day to recover, after which first impressions were disappointing (as they invariably would be for Matisse on this kind of regenerative journey in the future). The heat was torrid, the people demoralised, the casbah full of predatory whores. Algiers itself was an infinitely dispiriting version of the worst aspects of Paris: "a filthy stinking Paris that has been inadequately

cleaned for years," Matisse wrote to Manguin.⁶⁹ Henri Evenepoel, landing in Algiers eleven years before, had been appalled even then by the effect of unchecked industrial pollution from the factories of the coastal plain ("The French! How they have ruined this country! You can't imagine what a foul, squalid, miserable place it has become!").⁷⁰

Trains were slow and unreliable, stopping at every halt along the way so that it took twelve or fourteen hours to make the journey from Algiers to Constantine through mountains that had defeated both the Romans and the Turks, falling finally to French railway engineers after the conquest of 1847. Matisse said that at least half his fortnight in Algeria was spent travelling. Constantine did not impress him. The town clung to a clifftop, a spectacular natural fortress protected on three sides by a sheer drop which meant that the tourists crowding in to peer down at birds of prey circling in the gorge below became easy prey for the child beggars who swarmed all over them like flies. "Nice place! But the heat!" Matisse wrote in a postcard to Derain. "I shall have to get the hell out of here without having managed to do anything!"⁷¹

Looking back at the end of his life on this first trip to Africa, Matisse recalled whole days from which he got absolutely nothing: "but it has to be said also that the advantage of time spent being bored is that it enables you to penetrate a little into the spirit of the country, quite unconsciously."72 He followed the tourist trail through copper-coloured mountains and dazzling white salt lakes to Batna, a journey chiefly memorable for an encounter on the train: "I lunched opposite a magnificent Arab, a sort of Arab prince, fair-skinned with wavy hair and fine blue eyes, and a remarkable purity of expression."73 The line ended at Biskra, fabled gateway to the Sahara, but Matisse got off a stop before to catch the stupendous view from El Kantara (where travellers stayed overnight at a hotel run by the same landlady for fifty years as a French country inn, with caravans of camels tethered beneath the windows). Matisse arrived in drenching rain. He was oppressed by the inhumanity and immensity of the African landscape. When he finally saw the desert, it looked to him like a vast, shimmering sandy beach unbounded even by the sea. "Because of the sun—and it's nearly always like that—the light is blinding."74

Biskra itself astonished visitors with its 150,000 date palms, watered by irrigation canals and rising from a tangled mass of fresh green vegetation. Matisse visited one of the famous oasis gardens, which struck him as too rich and strange to paint. "It is delicious to dream in the shade of the palm trees, their greeny blond foliage heightened by blue reflections and looking even duller and more matt by contrast with the sharp vivid green

of the fig trees...," wrote the Dutch painter Philippe Zilcken, who visited Algeria a year or two after Matisse. "There is nothing to be heard except for running water and rustling palms; the silence is broken only by the cry of a rare bird, the flight of an insect, or the melancholy bleating of little black goats herded by an Arab boy who plays a few sweet repetitive notes on his reed flute."⁷⁵

Flute-playing was a speciality with the men of the desert tribe of Ouled-Nails, whose sisters and daughters worked in Biskra as belly dancers. The only unveiled women in Algeria, famous for their muscular bodies, their barbaric rhythms and general air of being tougher, fiercer and harsher than the Moorish women of the north, they made the town a sexual tourist trap whose reputation inflamed the imagination of the male population in France. Pierre Loti fuelled the legend, and so did André Gide, who had sent Oscar Wilde and Lord Alfred Douglas there a decade earlier in search of Arab boys. Whether or not Matisse had read Gide's beautiful ambivalent descriptions of Biskra in *The Immoralist*, he certainly sampled a substandard belly dance ("The famous Ouled-Nails, what a joke!" he wrote to Manguin. "You could see a hundred times better at the exhibition")."

Biskra's other claim to fame was carpets. Boldly patterned in red, black, white and yellow, woven on rudimentary handlooms on the desert sand, they were sold in the covered arcades of the souk by merchants squatting over their wares all day, each with his bowl of goldfish set beside him on the ground. Textiles were paramount in a country rendered largely colourless by the bleaching effect of light. "In the blazing sunshine the crowds form combinations of astonishing colours, intense reds, turquoise greens, yellows of rare distinction, against the different whites of their burnouses and their haiks," wrote Zilcken, whose chief memories were of the sun and the beauty of the stuffs, especially the faded carpets, tattered silks, and scraps of threadbare brocade with which the poorest people produced effects "infinitely richer than anything you could make with fresh and gaudy new materials." Matisse, born and bred among weavers, always a passionate and subtle lover of textiles, added several Biskran prayer mats to the collection he had started as a student haunting the junk-stalls of Notre-Dame.

Apart from these rugs and some pieces of local pottery, he brought back little that was immediately useful to him as a painter. He said that much of his time passed in a daze. "I went from one surprise to the next—without being able to tell if my amazement came from the strange customs, or the new types of human being I was seeing, or from purely pictorial emotions." He painted a single unpretentious street corner in

Biskra: "You can't just take your palette and your method and apply them," he explained to Manguin, echoing his own words a decade earlier on Belle-Ile. But he also said that though a fortnight was too short to acclimatise himself or his imagination to the country, it was long enough to leave him with a store of images that would last a lifetime.

Some of them—the flute-player, the goldfish, the princely Arab—would surface later in his work. At the time, he was preoccupied with the blinding light, and how to paint it. He discussed the problem with a friend in Algiers, an art-lover called Capitaine le Glay—probably one of Fayet's contacts—who lived with his family in the fort of the casbah. Le Glay and his wife made much of Matisse, inviting him to meals, offering to house his trophies, laying on a feast for him on his last day. "Come back soon," Le Glay wrote prophetically in June. "Oriental painting may be in fashion, but except for one or two, we have strictly speaking no artists here who know how to paint with light. Given the temperament I recognised in you, there can be no doubt that you will succeed on a grand scale." ⁸⁰

Matisse returned with renewed vigour to Collioure. "Before I left for Africa I had found it slightly insipid, but as soon as I got back it gave me a furious urge to paint." He got out his comfortable rope-soled sandals and plunged back into painting, immersing himself in nature, turning his back on the arguments and counterarguments of the past few months, and breaking off contact with Derain, whose endless theorising distracted him. He needed to regroup, to bring together and organise his impressions, to find out where he was going, and where he had come from ("I think constantly of the work I've done over the past ten years, and I tell myself that the main thing is to be yourself").

Above all he needed the support of other people. When Amélie joined him with all three children at Dame Rousette's hotel beside the station, the family was reunited for the first time since their summer in Lesquielles three years before. Matisse sketched them all on a postcard for Sarah and Michael Stein: Amélie looking notably young, stern and resolute; himself peering out with a rather more quizzical expression from behind thin-rimmed spectacles above a bushy beard; Marguerite prepared to pose, serious and sedate in a pinafore and puffed sleeves with a ribbon in her hair; Jean and Pierre (with the caption "the naughtiest of them all") ready for anything with jug ears and shaven heads. On 6 June the two boys enrolled at the local primary school, where Pierre's attendance over the next two months was irregular but Jean made steady progress, winning praise for his special skill in drawing.⁸²

Matisse told Picasso it was round about this time that he began to pay attention to the boldness and spontaneity of his children's artwork.83 Pierre copied his father's painting of a rose in a pottery jug brought back from Biskra. He also invented a new colour, and remembered all his life how crushed he felt when his father pointed out that there was no such thing.⁸⁴ Matisse was harassed as usual by professional and money worries ("Our children are with us," he wrote, contemplating the spiralling financial responsibilities he saw no prospect of meeting, "our three children. It's not up to them to lift their father's spirits when he's depressed").85 Playing among the boats on the port that summer, Pierre was already learning to mend nets, splice ropes and tie knots like a professional. He planned to go to sea himself with his classmates as soon as he was old enough (the two fishermen's sons listed next to him on the register, both born like him in 1900, left school at twelve and fourteen respectively to become cabin boys). Twenty years later Matisse still felt a pang at having dismissed his son's ambition to be a sailor as curtly as his father had once opposed his own desire to paint.86

The family resumed its routine of swimming, walks and work. Matisse spent much time drawing in the garden of the Villa Palma, a luxuriant jungle filled with huge eucalyptus and magnolia trees, carobs, jujubes, pepper plants, rare citrus fruit and pomegranates, garlanded with flowering creepers and festooned with sweet-scented old roses. The garden had been laid out on experimental lines in the 1870s by Napoleon III's gardener, the botanist Charles Naudin, who collected exotic specimens from China, New Zealand, Africa and South America to plant on sheltered and well-watered ground bounded by the main road, the railway line linking France with Spain, and the little river Douy, where the women of Collioure washed their clothes.⁸⁷ He included a pond and a magnificent alley of coconut, date and banana palms leading to the house. No matter how fierce the heat in the town or on the port, anyone stepping through the wrought-iron gates into the walled garden of the Villa Palma entered another world, cool, moist and shady even at midday. By 1906 Naudin had been gone for nearly thirty years. His garden was overgrown, and his house was let furnished to a schoolteacher from Perpignan, Ernest Py, who gave Matisse space to store his gear in the attics but refused to have a painter in the house for fear of compromising the reputation of his two young unmarried sisters.⁸⁸ The fact that the artist in question was a family man with a wife and three small children weighed nothing against the Catalan code of honour.

Matisse, Standing Nude Undressing (Rosa Arpino), 1906

Amélie and Marguerite posed in the studio, or on the outskirts of the town. The Matisses had brought with them an Italian model from one of the Paris art schools, Rosa Arpino, who had modelled for all the female figures in Le Bonheur de vivre the previous winter.89 Something about her cheerfulness and vigour, her pert, beaky profile and sinewy body stimulated Matisse, and amused his wife. Everyone liked Rosa. She posed with Marguerite for studies of a standing or stooping nude washing or being dried in a tin tub, and with Amélie for a series of women at their toilet. Rosa was the first in a long line of models to be adopted as honorary members of the family by the Matisses. But posing nude was a problem even for a professional model in a place like Collioure, which preserved a Spanish severity in morals ("I shall never

get over not having been able to see the bodies of the women of my country," said Maillol, complaining that he had to draw the Catalan village girls fully dressed, and undress them mentally afterwards: "You can see their legs, which are admirable. What might the rest be like?"). 90

Manguin, who had taken a summer villa at Cavalière near St-Tropez, corresponded gloomily with Matisse in May and June about their chances of being able to paint nudes in a landscape. Jeanne Manguin, posing for her husband beside the sea, could never be sure of finding a spot sufficiently secluded to be safe from the attentions of local men fishing from the rocks. She had run naked in the shady garden of another rented villa at St-Tropez the year before, when rumour among the envious bachelor painters on the port said that she did her housekeeping with nothing on, getting dressed only once a day when the postman called (Marquet and Camoin had to make do with sailors' tarts as models in the harbour bars).

1906-1907: PARIS, ALGERIA AND COLLIOURE

Matisse, Marguerite Reading, 1906–7

The Matisses worked out a way for Amélie to pose, too, by rising early each morning, leaving the Hôtel de la Gare at six and walking through the railway tunnel as soon as the Paris/Barcelona express had passed, after which the couple climbed up into the woods on the mountain slopes beyond. "We've been there a dozen times, and we have never been disturbed," Matisse explained to Manguin. "But it means an hour's walk, and you have to come back at ten or eleven in the great heat, which is hard." He painted Amélie with another naked nymph (presumably Rosa) and two small boys, one playing a pipe like an Algerian goatherd or a stray reveller from *Le Bonheur de vivre*. He painted her seated in a clearing, curled up on the grass or washing her feet in a stream in the classical pose of Watteau's *Diana*, blocking in her shape and her surroundings with swift, impromptu brushstrokes in flat, swirling pools and patches of synthetic colour.

He also painted Marguerite, clutching her hat and veil in a high wind on the fort above the town. The child posed for whole days at a time during her first summer at Collioure, reading in the studio in a high-necked lace-collared dress until the light failed, when she took off her clothes and pinned up her hair to pose for a *Standing Nude* in clay. Sculpture once again became a testing ground. Everything about the little figure of his daughter—its symmetrical stance, large head, long arms, short legs, prominent buttocks and belly—suggests how fast Matisse was moving away from anatomical construction towards the radical reinvention of the human body that impressed him in African or Egyptian sculpture. At the

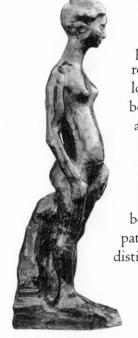

Matisse, Standing Nude, 1907

end of the summer he made a set of variations on the theme of his standing nude, pushing it to the limit in opposite directions: in one, the figure was pared down to a classically regular, smoothly rounded torso, armless and headless with legs lopped off above the knee; in another, the clay has been roughed up and gouged out, the hollows of armpit, crotch and belly button set off against the sharpened protuberances of buttocks, breasts and pinched-off arm-tops.

The original statuette provided a solid, defining presence in one of the still lifes that were beginning to dissolve like the landscapes, forming patterns which had less and less to do with traditional distinctions between form and content, foreground and

background, horizontal or vertical surfaces. This dissolution had its threatening aspect for the painter as well as for his public. In the still lifes of the next few years Matisse often included one or other of his little clay models of the

human figure alongside the two-handled vase or the pottery jug from Biskra, the flowers, fruit and vegetables from Collioure market, which challenged him to impersonal confrontations he found steadily more daunting. "I feel a fear of starting work in face of objects whose animation has to come from me, from my own feelings," he would write to his son Pierre in 1940, when the anxieties of war made it almost impossible for him to concentrate on fruit and flowers. Even in his seventies, Matisse still needed human models to soften the harshness of his daily struggles on canvas. "They keep me there in the middle of my flowers and my fruit, with which I manage to make contact little by little almost without realising. . . . Then all I have to do is wait for the inspiration that cannot help but follow."

Inspiration—the phrase Matisse used was coup de foudre (thunderclap), which generally means love at first sight in French—came in 1906 from the Algerian rugs which invaded his canvases that summer. This was the first but not the last time textiles conspired in his painting to disrupt the traditional canons of volume, form and perspective. Something similar was beginning to happen with other stuffs, especially the toile de Jouy with which the painter had fallen in love a few years earlier. Matisse told Louis Aragon that he had spotted this particular length of cloth from the top of

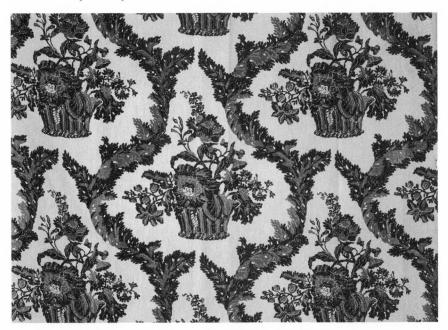

The toile de Jouy
Matisse fell in love
with in 1903, and
which became his
trusty ally ever
afterwards in the
battle against
perspective

a horse-drawn bus in a shopwindow on the carrefour Buci,⁹⁵ then a notorious haunt of prostitutes, junk-merchants and secondhand-clothes dealers in the warren of little streets between the river, the boulevard St-Michel and the boulevard St-Germain.

The toile to which Matisse lost his heart was a piece of pale blue glazed cotton, printed with a stylised pattern of leafy arabesques and baskets of flowers in darker blue. It first turns up as a conventional wall hanging in canvases like the male *Guitarist*, painted in 1903 in the aftermath of the Humbert Affair, and the portrait of Pierre clutching his wooden horse the following year. It recurs after that as the back cloth in a series of increasingly animated still lifes. In *Still Life with Blue Tablecloth* (1905–6), the cloth's overhanging skirts seem to rear up, while its forking blue arabesques start to infiltrate the objects on the table, licking up the stem of the china fruit stand, outlining the rim of the water jug, collecting in a pool of blue beneath a saucer, finally spilling right off the edge of the table as a vivid blue streak in the sombre patchwork of colours filling the upper part of the canvas, which no longer makes any serious pretence at rendering a realistic interior.

The subversive ghost of an Algerian prayer mat lurks in the background of this painting. In *Still Life with Red Rug* (colour fig. 29), painted in Collioure in 1906, the carpet hanging on the wall joins forces with two

lengths of red and green material arranged in front of it to overwhelm the standard still-life arrangement of plate, pan, book, fruit bowl and watermelon, which ends up as no more than incidental detail in a sumptuous decorative whole. Marcel Sembat bought *Les Tapis rouges* (he also bought *Marguerite Reading* from the same year), counting it ever afterwards among the jewels of

the majestic Blue Still Life (colour fig. 28), based on the toile de Jouy which belonged to

his collection: a companion piece to

Michael and Sarah Stein, and which Sembat called *Les Tapis bleus*. "All the canvases of this period are ablaze with the joyous triumph of colour. Captivating blues, as in the Steins' *tapis*, powerful reds heightened by blacks and yellows! And in the portrait of Marguerite reading, a light worthy of Velázquez! On the back of her hand an audacious green! What strength and simplicity in the lines of her face!" By the time Sembat wrote this in 1920, the Fauve conflagration had lost its air of menace, beginning to seem in retrospect more like a contained and warming glow.

But in the summer of 1906 Matisse suffered as much as anyone from what Manguin called the "pictorial disquiet [inquiétude picturale]" which neither cared to face alone. In the second week of July the Manguins packed up and set off for Collioure. Matisse had found them a house on the port with bedrooms for everybody, a terrace and a superb view of sea and mountains, all for the knockdown price of less than one hundred francs a month.⁹⁷ The two families had lived at close quarters before, when both were starting out on married life in Paris in 1899. Amélie Matisse got on well with Jeanne Manguin, and their children had grown up together. Matisse had modelled a tiny head of the Manguins' second son Pierre as a baby in 1903, a year or more before he made any of the clay heads of his own children-each no more than a few inches high-which served him as familiar reminders of ordinary life in the years when his art seemed both to himself and to others increasingly abnormal. He modelled his own son Pierre in 1904, and Marguerite in 1906 wearing her pinafore and hair ribbon, an almost exaggeratedly naturalistic pendant to the Standing Nude he was working on at the same time. Jean sat the year after for a leathery, wizened, grinning Head of a Faun, in which any parent will

recognise the mixed feelings inspired on a bad day by even the most beloved offspring.

By the summer of 1906 Jean Matisse was seven years old; his brother Pierre was six; so was Claude Manguin; and Claude's little brother, also Pierre, was four. The boys played together, the women talked or posed, the two painters examined and analysed one another's work with the companionable frankness that had seen them through the setbacks and upheavals of the past fifteen years.

Henri Manguin, Self-portrait, 1904

For all his leonine head, spade-shaped beard and air of unassailable confidence, Manguin was the gentlest of the Fauves. He had, as Matisse pointed out, an innate sense of colour harmony and balance together with emotional directness ("a passionate tenderness of feeling... that is particularly yours"), 98 but little of the urge for change that drove his friends. Though he continued to fight loyally at their side, he had already reached his own boldest point as a painter by the time of the public outcry in 1905 ("Fauvism for him was like being skinned alive," wrote Pierre Cabanne). Manguin exasperated the others in September 1906 by failing to reach Paris in time to take his turn on the Salon d'Automne selection committee. "It's infuriating to let slip this sort of fighting chance, which we ought to leap at in a struggle like ours," wrote Matisse, whose hopes of another one-man show with Druet depended on a serious showing at the Salon. "Oh well, too bad. We can pick up the pieces after the battle—if only it weren't for the money!" 100

Shortage of funds, together with anxiety over where to turn for fresh supplies, remained a pressing problem at the end of the summer for a father of three with no regular income. The Manguins had always been better off than the Matisses, with a measure of financial security which made sales of secondary importance. Hospitable and outgoing, they kept open house for other painters, writers and musicians. Of all his friends, Manguin was the only one with whom Matisse shared his sense of the family as crucial for support, if not survival, as a painter. Both households revolved around the studio. Married at nineteen, mother of her first child at twenty, Jeanne Manguin provided all her life the stable context of her husband's work, as well as being for many years its central subject. Man-

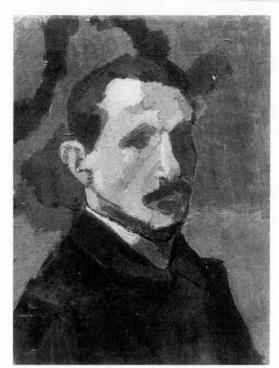

Matisse, Albert Marquet, 1903

guin painted her reading, sleeping, doing her hair, sprawled on her bed or on the grass in summer, paddling, bathing, swinging in a hammock, dressed up as a mandolinist or a bacchante, undressed as a naiad, fauness or one of the three Graces. Matisse drew her, too, in 1906, looking comparatively matronly (she was pregnant at twenty-six with her last child).

"Manguin is the only one who is happy with what he's done, more than happy," Matisse wrote in a roll call of friends whose work had run into difficulties by midsummer. Iol Jean Puy sent long, despairing letters describing a crippling depression which Matisse's replies could not lift ("The encouragement you give me is invaluable, and I was very touched by it. . . . I reread your letter and was deeply moved by the depth of friendship in it. But your letter can't, alas, dispel the state of apathy in which I find myself"). Marquet, whose father had died and whose mother had been ill, was flitting disconsolately in search of a fresh start from one port to the next along the Norman coast. Derain was more perplexed than ever—"everything I do seems frivolous to me, for I should so like to produce something stable, fixed and precise" and even Manguin's satisfaction did not last. "I think you might be better off with a calmer and more down-to-earth approach," Matisse wrote reassuringly in a long, affection-

ate letter that explored Manguin's strengths and weaknesses in detail before concluding that audacity had never been his strong point as a painter. ¹⁰⁴ It was the kind of just and generous assessment Matisse himself had received from Henri Cross the year before, and it came as a relief to Manguin, who readily agreed to stop straining after a radicalism for which he himself felt no intrinsic call.

Matisse himself planned to avoid any repetition of the previous winter's tensions by keeping away from Paris. Amélie left on 10 September to travel back with the children for the start of the school term. The premises at 19 quai St-Michel had been redecorated ("You will be moving in, and making the most of M. Matisse's absence to get your new room organised," wrote Jeanne Manguin, urging Amélie to ask the Manguins' maid, Julie, for help). Matisse remained alone in Collioure with Etienne Terrus for company. The two saw one another almost daily, working together in Terrus's studio at Elne, attending performances by a local theatre group for which Terrus designed and painted sets ("the *Grand Théâtre Moderne* of Collioure... on a makeshift stage, stalls 25 cents, gallery 15 cents," Matisse wrote cheerfully to Manguin. "Count X goes without shoes in spite of being in formal court dress.... In short, mon vieux, we make do with any amusement we can get"). 106

Matisse was painting, modelling in clay and experimenting with glazed pottery, which he had persuaded a local factory to fire for him. To When he returned briefly to Paris for the autumn Salon, he left Terrus in charge of overseeing his ceramics and moistening the cloths round a half-finished clay figure to prevent it from drying out. He also begged for an analysis of a still life—perhaps the opulent Dishes and Fruit on a Red and Black Carpet—left hanging on the studio wall. "I like it more and more," wrote Terrus. "You were wrong not to take it with you, for you would probably have sold it. I've tried to think of criticisms but I couldn't find any. Its equilibrium is perfect; it is perhaps the best thing you've done this season." To But I with the season." To But I with you, for you would probably have sold it. I've tried to think of criticisms but I couldn't find any. Its equilibrium is perfect; it is perhaps the best thing you've done this season."

EVEN BEFORE he arrived himself in October, word had reached Paris of Matisse's work in progress, spread by Manguin, or by Gustave Fayet who had paid a visit to Collioure with Fabre in August. ¹⁰⁹ Vollard, primed by Leo Stein, wrote to ask for the right to a first viewing, only to find himself forestalled by Druet ("Druet has heard talk of your things, and asks constantly when you're arriving...," Marquet reported. "He'll be waiting for you at the station to prevent any speedier competitor from snatching your canvases from him"). ¹¹⁰ The five canvases Matisse submitted to the

Salon jury were not only accepted but sold on 4 October—the day before the private viewing—to Druet, who passed them on immediately to Fayet. III

The Parisian gallery scene was shifting and expanding. Painters feared there might soon be more dealers than collectors: "so much the better." Druet told Matisse, "the more attention paid to painting, the better it will sell." The contemporary market was beginning to interest professionals like the Bernheim-Jeune brothers with whom the previous generation of hit-or-miss, bric-a-brac merchants could not compete. Berthe Weill would soon be forced to recognise that her time was up ("You're wrong, a thousand times wrong," Raoul Dufy assured her passionately. "You must support us, all of us whom you've already shown, the whole gang... or someone else will take your place, and that must not happen. You must believe that you have in Matisse, Vlaminck, Derain...the painters of tomorrow"). II3 For the first time in the autumn of 1906 collectors competed for Matisse's work. Leo Stein found that only two of the Collioure landscapes he would have liked were still available. Marcel Sembat announced to the press his intention of buying another two of Matisse's canvases, without apparently realising that they had already been snapped up by Fayet (Sembat would acquire both two years later for considerably more from Bernheim-Jeune).114

The critics, led by Louis Vauxcelles, congratulated Matisse warmly on having had the sense to abandon the perverse experiments of the immediate past. Only Maurice Denis abandoned his customary tone of pitying reproof for a full frontal attack, which was also a personal recantation. Denis had realised too late that the pictorial revolution so enthusiastically endorsed by himself and his friends nearly twenty years before would stop at nothing short of wholesale destruction. "The mistake of the various factions, the mistake we all made, was to pursue light above all," he wrote in December, calling wistfully for a return to the values of the Venetian high Renaissance. Matisse's latest canvases seemed to him to point to decadence and decay. "All they give us in the way of sunlight is trouble with the retina, an optical shudder, the painful sensation of dizziness, the vertigo you get in high summer from a white wall or esplanade. Their theory of aesthetics sanctions their attempt to blind us. There is no crudity of lighting from which they shy away and, in order to convey it, no cruelty of colour."115

Matisse, accused at the beginning of the year of driving people mad, ended it on a charge of blinding them as well. The tides of opinion had begun to flow so fast that many found it difficult to keep up. The sensa-

tion of the autumn Salon was its retrospective showing of Denis's former mentor, Paul Gauguin, now adopted as their hero by a whole new generation of young painters. Matisse dropped in at Druet's gallery to find Sergei Shchukin in the act of buying eleven Gauguins, most of them from Fayet, who replaced them with eleven Matisses which he would sell in turn at a profit. Much as he loved his pictures, Fayet loved even more to see them on the move. "It was impossible to say no," he explained a few years later when Monfreid remonstrated over the vast profits accruing from the sale of Gauguins. "Just think of it: my collection will have cost me nothing."

The death of Cézanne on 22 October was widely seen as the passing of a modern master. "At the Salon d'Automne of 1905 people laughed themselves into hysterics before his pictures," wrote Leo Stein, "in 1906 they were respectful, and in 1907 they were reverent." Artists who had never looked at, sometimes barely even heard of, Cézanne turned out to be fervent admirers. A craze for blue swept the easels of Montmartre and Montparnasse. Groups of massive bathers or blue nudes cropped up on all sides. Twelve months almost to the day after Cézanne's death, Jacques-Emile Blanche described to André Gide an encounter with a former Beaux-Arts stalwart called Alexis Axilotte: "I met... the poor old Prix-de-Rome Axilotte, who, at the age of fifty-three, has now seen the light, put his family on dry bread, dreams only of Cézanne, and claims to be more revolutionary than Matisse."

Sometime in the autumn of 1906 Matisse met Picasso at the Steins'

studio on the rue de Fleurus, bringing with him the little Congolese Vili figure which would powerfully affect both painters. 120 Matisse had just bought it round the corner on the rue de Rennes from a shopkeeper called Emile Heymann, known as "le Père Sauvage," who was the first and for a long time the only Parisian dealer in carvings brought back from Africa by settlers or sailors, and stocked strictly for their curiosity value. Picasso reacted fast. He dined with the Matisses, refusing to be parted all evening from the statue, and staying up afterwards in his studio at the Bateau Lavoir, where Max Jacob found him next morning surrounded by drawings of a one-eyed, foureared, square-mouthed monster which he claimed was the image of his mistress. 121 Derain had acquired a Fang mask from Gabon round about this time or a

The Congolese Vili figure, which Matisse bought from le Père Sauvage in 1906

little earlier, paying fifty francs for it to Vlaminck, who had picked it up in a suburban bar. The mask dominated the display in Derain's studio of Fauve landscapes, which seemed to his friends to look like nothing on earth. Over the next few years, as the triple impact of Gauguin, Cézanne and African art finally unseated the old gods of custom, decorum and academic propriety, this sort of unearthliness would become a prime criterion for the new art.

In the short term, primitivism solved Picasso's problem with the portrait of Gertrude Stein, which he had abandoned without a face after ninety sittings at the beginning of the summer. He completed it in the sitter's absence by painting in the masklike features which, as he rightly said, she soon came to resemble. Matisse for his part painted his African figure only once, as part of a still life which he never finished. Gertrude Stein said that he absorbed the essence of African art (as he had assimilated the influence of Cézanne) internally rather than through his eyes: "Matisse through it was effected more in his imagination than in his vision. Picasso more in his vision than in his imagination."

Matisse returned south alone in November, stopping off for a week in l'Estaque to see a bunch of competitive young Fauves, including Derain, with whom he laid a bet as to which of the two could produce the finer blue nude. Matisse settled for the winter in Collioure, where his wife and daughter joined him. Marguerite had fallen ill again in Paris, as she was apt to do at the onset of winter. We were so sorry the other day to find her sick, wrote Marcel Sembat's wife Georgette, whose little niece was also ill. How wretched you must have felt!... All our best wishes—she was charming in her bed, your little daughter, so gentle and so good—give her a kiss from me. The Sembats' niece had caught typhoid fever, which she only narrowly survived. Marguerite had the flu, but she too had nearly died of typhoid five years earlier. Sooner than run any further risk, her parents decided to take her south with them, even if it meant keeping her out of school.

Marguerite remembered that when she and her mother finally reached Collioure, the new painting hanging on the wall to greet them with its paint still wet was the sombre, sculptural *Standing Nude* (*Nu au linge*). ¹²⁶ In his few weeks without a model, Matisse had copied the pose from a book of photographs of naked girls called *Mes Modèles*. He took subjects several times that winter—especially for sculpture—from this and similar books, copying them for disciplinary reasons as a corrective or antidote to the old masters he had once copied in the Louvre. He used every available distancing device—photographs, tribal images, children's art—in the struggle to

break free from the past. The scale and speed of Matisse's experimentation at this stage baffled more cautious practitioners like Manguin and Jean Biette, who mistook the means for an end in itself. "I found Biette ten or eleven years later, still copying photographs," Matisse said ruefully. "He said when he saw my latest things, 'I can't keep up, I've stuck with the painting and drawing we were doing at Carrière's.' "127"

Matisse painted himself at Collioure with harsh, jabbing brushstrokes, his head outlined in black and blue, greens scudding across his face like storm clouds (colour fig. 23). It was a self-portrait that seemed to his contemporaries to strip him bare emotionally as well as physically. When Sarah Stein bought it, Gertrude remarked "that she felt it was 'too intime' to be casually hanging upon one's wall." 128 Matisse persuaded a reluctant sailor to sit for a portrait that used the same smudged colour and scratchy, abbreviated drawing. The slumped body and straddled legs of this young sailor, his drooping head, thick nose, full lips, the red and green shadows bruising his forehead and chin, all forcefully convey physical constraint, the difficulty of holding still, perhaps the painter's own buried memory of how it felt to be a captive adolescent. Young Sailor (II) (colour fig. 30) is a graceful, debonair, rhythmically condensed transposition of the first. Matisse also painted a still life, Pink Onions, which, like the Sailors, has the directness of a child's painting (colour fig. 32). The drastic simplification of these canvases made him so uneasy that he passed them off to friends in Paris as the work of the local postman ("You're lying, Matisse," said Jean Puy as soon as he saw Pink Onions, "you painted it yourself").129

Matisse, Reclining Nude (I)/Aurora, 1906–7 could be enclosed within a perfect square, my *France* fits inside an acute triangle." ¹³⁰ Barely contained within the compass of her rectangular plinth, Matisse's figure exudes energy from the crown of her jutting hairdo through the sharply articulated twists of shoulder, hip and thigh to the ball of her thrusting foot. He worked on this clay figure for weeks in the house on the port which the Matisses had taken over after the Manguins left. It absorbed him to the exclusion of all else. Once he missed an appointment with Maillol in Banyuls because, although he constantly consulted the clock on the church tower outside his window to be sure of leaving in good time for the station, the sculpture drew him so compulsively that in the end he missed both the morning trains. ¹³¹

Catastrophe overtook Reclining Nude (I) Aurora in early January. Amélie, alerted by a crash followed by cries from the room above, rushed upstairs to find that the figure had slipped and smashed to pieces on the floor. 132 Her solution was to remove her husband bodily from the scene of disaster. She took him for a walk as she had done two years earlier, when he was beside himself over a similar setback in St-Tropez. Once again the crisis seems to have cleared a mental blockage or, in Matisse's phrase, kicked the door down. The next morning, even before he set about picking up the clay pieces, he recaptured the essence of his figure with heightened confidence on canvas. This was the Blue Nude: Memory of Biskra (colour fig. 27). The central figure combines the globular weight and fullness of African art with the equilibrium of Cézanne, against a flat, decorative frieze of fan palms (included, according to the painter, to remind him of Biskra). 133 For all its compact, writhing pose, the clay Reclining Nude remains the naked body of a woman of the period with neat chignon and nipped-in waist. The Blue Nude is by comparison inhuman. It seemed prodigiously ugly and misshapen to Matisse's contemporaries. "Matisse distorted more than he wanted to distort ...," wrote Leo Stein. "He told me that at every beginning of a picture he hoped that he could end without any distortion that would offend the public, but that he could not succeed." 134

By the beginning of February the *Blue Nude* was finished, or sufficiently near completion, for Matisse to ask Manguin to find an antique frame for it. ¹³⁵ At this point work was suspended for a round of excursions with Terrus to call on the other artists of the Roussillon. They began by taking the train from Perpignan up the Têt Valley to the Pyrenean town of Prades, where the Catalan sculptor Gustave Violet had his studio. ¹³⁶ Matisse moved on a few days later to visit Fayet and Fabre in Narbonne. ¹³⁷ By 12 February he was back in the Pyrenees with Amélie and Terrus at Vernet-les-Bains, two or three miles from Monfreid's house at

the foot of Canigou, where snow lay eight feet deep. ¹³⁸ The Monfreids were so pleased with the Matisses that they planned to move their whole household, including the painter Louis Bausil, to Collioure for the summer. Matisse for his part warmed to these free-spirited and supportive Catalans, especially to Terrus, whose judgement he trusted both as a man and an artist. Terrus's encouragement was all the more worth having because it came from one whose own depressions could be bitter, and who was himself struggling in these years to come to terms with isolation and critical indifference ("The newspapers have not been kind to you, but still it's a good thing they give you space," he told Matisse, sending an enormous box of Spanish sweetmeats with several bottles of wine at Christmas 1905, "for anything is better than silence"). ¹³⁹ The company of friends like these must have been a comfort at a time when Matisse was preparing to face a fresh round of public abuse in Paris.

Sarah Stein wrote from the capital to announce her return from San Francisco in January 1907, an event she celebrated by exchanging a painting by Maurice Denis, together with two other unwanted canvases, for six Matisses. 140 "I am delighted (so I am told is Père Druet), and I look forward with pleasure to your return. We shall be very happy to know what you think of our big room, and our Japanese objets d'art—and we hope also to add more of your latest works to our collection to complete the installation." The family fortunes had survived the earthquake intact, which meant that Leo and Gertrude could pay for *Le Bonheur de vivre* at last as well as plan new acquisitions of their own. "We count on you to see that we view your works before the monstrous dealers gobble you up entirely," wrote Leo, already nipped and jostled by competitors he had done more than anyone to stimulate. 141

Manguin wrote on 12 February to warn Matisse to keep his prices up, "for Druet, Vollard and perhaps Fénéon will be haggling over your canvases." Ten days later Fénéon offered a one-man show with Bernheim-Jeune. He followed his letter with a visit to the studio as soon as Matisse reached Paris, buying three paintings on 1 March and proposing an arrangement whereby Bernheim-Jeune would purchase the bulk of all production in return for prior rights over other dealers. Daniel Kahnweiler had reached Paris the week before, setting up shop in time to buy from Marquet, Camoin, Puy, Derain, Vlaminck and Braque. Kahnweiler would in due course sign up Picasso, too, but when it came to Matisse, the most he could afford was a single drawing from the Indépendants. 144

Blue Nude: Memory of Biskra was the only canvas Matisse showed at the 1907 Indépendants in March. For the third time in eighteen months, he

scandalised the public, bewildered the critics (who described the new work as indecent, atrocious or reptilian), and stopped the art world in its tracks. Rumour said that Derain destroyed his own painting of post-Cézanne bathers or blue nudes after seeing Matisse's. ¹⁴⁵ For the third time, the canvas that caused greatest outrage at the salon was bought by Leo and Gertrude Stein, who were learning to gauge the success of their collection by their friends' consternation. A twenty-three-year-old New Yorker called Walter Pach, fresh from three years at art school in Manhattan, visited the rue de Fleurus for the first time that year and found himself faced with the *Blue Nude*:

"Does that interest you?" asked Picasso. "In a way, yes . . . it interests me like a blow between the eyes. I don't understand what he is thinking." "Neither do I," said Picasso. "If he wants to make a woman, let him make a woman. If he wants to make a design, let him make a design. This is between the two." 146

CHAPTER TWELVE

1907–1908: Paris, Collioure, Italy and Germany

Bevilacqua posing for Matisse's class with Sarah Stein in the middle standing next to, from left to right, Hans Purrmann, Matisse and Patrick Henry Bruce arah Stein bought the little clay *Reclining Nude* as well as the self-portrait which seemed to her sister-in-law too disturbing to hang in the house. She also bought *Pink Onions*, and the more challenging of the two *Sailors* for which Matisse disclaimed responsibility even to close friends. He was acutely aware of the incomprehension and disgust that cut him off from other painters. The more sensitive and highly trained the eye, the more it was repelled by his latest work. Young Walter Pach found reassuring echoes of El Greco and Toulouse-Lautrec in the Picassos he saw hanging at the rue de Fleurus, and he recognised the logical conclusion of a venerable tradition in van Gogh and Cézanne. "All three men were therefore easily connected with what I already knew," wrote Pach. "Matisse was of the present, and I fought it in my mind...." Coming to terms with Matisse meant jettisoning everything Pach had learned at art school as well as in the great museums of Europe, and the battle lasted a whole year.

It took almost as long for another of the Steins' friends, Hans Purrmann, a German three years older than Pach who had studied in Munich under the same teacher as Kandinsky and Paul Klee.² Purrmann knew Paul Cassirer, whose Berlin gallery was described by Vollard as an extension of the rue Lafitte (Matisse would show eight drawings in a show put on by the Berlin Secession at Cassirer's gallery in the autumn of 1907). Passionately committed to the future, an ardent convert to Manet and Cézanne, Purrmann had left Germany in 1905 expressly to catch up on the latest developments in Paris, only to find everything he held dear called into question by *Woman in a Hat.* Many months later he saw the painting for the second time at the Steins'. "It was like a blow to the head; how could a collector have chosen this painting! And paid good money for it! Only now did I begin to awaken."

When Pach and Purrmann were introduced by Leo Stein to the painter who had made them feel so queasy, both became family friends and tireless supporters of his work. Neither was troubled by the complex undertones that coloured their French contemporaries' defensive reaction to Matisse. "We called him 'the Professor,' said one of Picasso's hangerson, the painter Félix Jourdain, "because he had gold-rimmed spectacles and a beard which he trimmed neatly." It wasn't only for his beard and glasses that Matisse stood out in gatherings of ambitious youths centred

round Picasso at the Bateau Lavoir. "In the world of 'independent' artists, Matisse was already an *ancien*," wrote Vlaminck, using "ancien" to mean "senior" with overtones of "has-been." Vlaminck himself was only too happy to entertain his juniors with wilder and wilder stories about his and Derain's heroic exploits at Chatou (Vlaminck would end up claiming not only to have discovered Negro art but to have invented Fauvism as well). The worrying thing about Matisse at this point was not so much his age, or his air of respectability, as the fact that even the most iconoclastic youth could not make head or tail of his fearsomely subversive paintings.

Picasso himself had gone to ground in the spring of 1907, shut up in his studio, largely unavailable even to his most faithful followers. He had been working for months on a response to Le Bonheur de vivre, which became after the opening of the Indépendants an even more urgent answer to the Blue Nude. Few people saw Picasso's work in progress, which would not be officially known as Les Demoiselles d'Avignon until it was finally shown in public almost a decade later. Those invited to a viewing found it as baffling as the stuff Matisse was currently producing. Picasso's three closest friends-the writers Guillaume Apollinaire, Max Jacob and André Salmon—were noncommittal. Kahnweiler considered the painting a failure, and Leo Stein burst out laughing when he saw it.6 Picasso, unlike Matisse, offered no explanations. Jokiness became his refuge from the kind of universal blankness which drove Matisse in the opposite direction, towards ever more elaborate efforts to make himself intelligible. "As for Professor Matisse... as you know, he doesn't go in for fun!" said Félix Jourdain, describing an evening with Salmon and the others in a Left Bank café. "And then, every sort of bullshit you care to think of, he solemnly brought it all out. He said for instance: 'I've never known how to paint! One day, when I was watching my son painting'—the son was five years old at the time—'he made a portrait in profile, and put two eyes both facing outwards. At that moment, I understood painting!" "7

Picasso, who had instantly seized the point of African art the year before, seems to have been the only painter to take this new interest in children's painting as seriously as Matisse himself. When the two exchanged canvases in 1907, Picasso picked a portrait of Matisse's daughter painted with a child's expressive force and flatness, down to the name MARGUERITE printed across the top in shaky capitals. Friends like Salmon assumed that their leader's choice was part of the everyday routine of sending up Matisse. "We played practical jokes on him," he explained. "Jokes from a respectful distance." One of their first tricks—apparently dreamed up by Apollinaire—had been to write Matisse's name on govern-

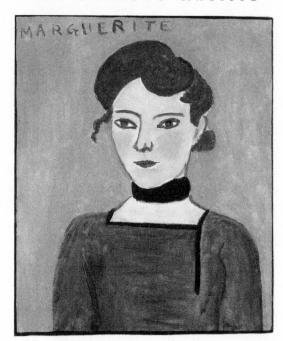

Matisse, Marguerite, 1907: the painting Picasso's gang used for target practice

ment health warnings ("Matisse is more dangerous than alcohol!" "Matisse has done more harm than war!").9

Another was to use the portrait of his daughter as a target for games of darts in Picasso's studio. "A hit! One in the eye for Marguerite!" "Another hit on the cheek!" cried Salmon and his friends (their darts were toy ones, with suction pads instead of steel tips, so that the players could relieve their feelings without leaving lasting wounds). Marguerite Matisse was thirteen years old in 1907. Her confidence, damaged in her early childhood and patiently rebuilt by her second mother, was bound up in her role as her father's model-cum-studio assistant. She would have been a familiar figure to anyone visiting Matisse, as Picasso regularly did at this time, turning his famously rapacious gaze on each fresh development, even going so far as to adopt a thirteen-year-old "daughter" himself in May 1907 (this was the orphan called Raymonde who had to be sent back to her orphanage four months later, when Picasso showed signs of the wrong sort of interest as a foster parent). II

There was an element of schoolboy thuggery in Picasso's bande, or gang, of acolytes, mostly in their early or mid-twenties, all more or less hard up and on the make. The price of acceptance as an insider was being whipped into line by the merciless mockery that marginalised outsiders. "As for those who did not join in the chorus...," Vlaminck wrote grimly

later, "needless to say they were accused of hopelessly ingrained pomposity [indécrottable pompiérisme], afflicted in the eyes of all by a total lack of artistic imagination." Matisse had come up against this kind of collective pressure all his life. Stigmatised at home as a disgrace to his family and the world he came from, he was now accused of being irredeemably bourgeois by a younger generation that knew nothing of his past, or the public scandal that had taught him to attach overwhelming importance to discretion. The gnawing anxiety about his painting, for which Matisse sought constant reassurance from other people, was no concern of theirs. They saw him as a humourless bore, more like a lawyer than an artist, endlessly pleading the cause of his own work.

Matisse himself did nothing to contradict the impression built up at the time and repeated later in the memoirs of writers like Salmon, Jourdain and Francis Carco. When Gertrude Stein published her wonderfully persuasive account of bohemian Paris in *The Autobiography of Alice B. Toklas*, Matisse's protests at its inaccuracies and distortions only served to reinforce the book's view of his stuffiness. The image of an invincibly correct Matisse—the "grand bourgeois cossu" of Carco's memoirs 13—became (and has remained) entrenched in legend. Admittedly Matisse encouraged it himself. On a human level, he had had more than enough by this time of exposure. As an artist, the destructive aspect of his work frightened him in some moods as much as anyone else. His response was to adopt a front of disarming rationality which suited one side of his nature and provided cover for the other. From now on Matisse buried the implacable wild beast, or fauve, deep within himself.

One of the few outside his family who understood the price he paid in terms of inner trepidation was Sarah Stein. She had lost her heart to Matisse's painting—she told him that the *Woman in a Hat* had been an enchantment at first sight—and from now on she could never feel at home without his canvases hanging on her walls. ¹⁴ Matisse said that Sarah's certainty sustained him in "my passionate years of work, turmoil and anxiety" up to and including the First World War. ¹⁵ Their friendship took root after the Steins' return from San Francisco. Far from being deterred by the American reaction to Matisse's paintings, Sarah made up her mind to collect nothing else, a proposal cordially seconded by her husband ("Michael had confidence in Sarah's judgement," wrote Harriet Levy, who knew them both throughout their marriage, "and thought that . . . if she thought the paintings were good, they probably were good"). ¹⁶ Sarah spent the early months of 1907 weeding out their collection, selling or swapping work by other painters, and acquiring a dozen of Matisse's most

recent paintings. Besides the two major canvases brought back from Collioure, she also purchased four of the bold little nude studies painted on early-morning excursions into the woods above the town.¹⁷

The character of her collection was already very different from the cautious, balanced retrospectives with which Matisse had done his best to reassure potential customers at Druet's, or a few years earlier at Vollard's. Sarah's display reflected the love of danger shared by artist and collector. She and Michael acquired in the end more than forty paintings and at least half a dozen bronzes, mostly dating from 1905-8, the years in which the Steins could take their pick of Matisse's canvases "even before they were dry"18 (this state of affairs stopped once Bernheim-Jeune started reckoning prices in thousands rather than hundreds of francs). Sarah also bought or borrowed from Leo and Gertrude The Serf, the Woman in a Hat and the Blue Nude. 19 Apart from Matisse's latest work, the only other period that interested her was the fiercely experimental phase cut short by the Humbert scandal. She owned at least nine canvases from 1900 to 1902. Matisse himself went to considerable trouble in 1907 to secure for her the grandest of all his studies of Bevilacqua, persuading Jean Biette to part with it in exchange for the Notre-Dame from the same period which had been slashed by its creator and subsequently repaired.²⁰

Matisse was intrigued by a collector who could keep pace with his boldest leaps into the unknown. Scarcely a week passed without her visiting his studio, or his bringing something new to show her. "She was the one who fascinated him," said Therese Ehrman, the Steins' au pair. "He'd come with bundles of pictures under each arm, and Sarah would tell him what she thought of things, sometimes rather bluntly. He'd seem to always listen and always argue about it...."21 Therese's successor, Annette Rosenshine, also remembered Matisse calling at the apartment on the rue Madame—"There he found solace in unburdening his latest problems and uncertainties to Sarah Stein"22—whenever he was struggling to break through a barrier in his work. Several of Sarah's friends described these sessions and recognised her role as touchstone. "Over the years Matisse came to her for encouragement and assurance," wrote Harriet Levy, who followed the Steins to Paris from San Francisco in 1907.²³ He showed Sarah his canvases, as he showed them to his family in the studio, newly finished, with the paint still wet, at the point when he most needed to know how they looked to other eyes. Sarah, who had known his work from its turbulent early stages, prized above all the nobility and grandeur of Matisse's paintings, their purity, distinction and serenity: "qualities which are yours par excellence," she wrote to him in 1926.24

1907-1908: PARIS, COLLIOURE, ITALY AND GERMANY

Her criticism meant as much to him as her admiration. If she did not like a painting—if something in it struck her as discordant or incomplete—she said so. Once, walking with Sarah in the rain in Paris, Matisse broke the arm off a little clay nude as he took it from his pocket to show her.²⁵ He never forgot how she calmed the feelings of suffocating fury that overwhelmed him in disaster, successfully persuading him not to destroy the armless figure which had its own value, like The Serf. Matisse trusted her at the deepest level. He valued the rational exegesis at which Leo excelled, but Sarah gave him the gift he had first had from his mother, that passionate understanding which was for him the ultimate goal of art. "It penetrated my spirit and my heart at a single glance," she wrote to him in 1911 of a canvas which both sensed would turn out to mark a major advance. "In looking at it, I felt that emotional completeness which convinces me of the reality of a work of art without the need to analyse it." ²⁶ For three decades Matisse relied on Sarah's judgement, which grew, as he said, from "an exceptional sensibility and a complete knowledge of the road I've trav-

Apartment of Sarah and Michael Stein at 58 rue Madame. Matisse's works (from top to bottom, left to right) are: The Gypsy; Corsican Landscape; Self-portrait; sketch for Le Bonheur de vivre; Reclining Nude; La Coiffure; Collioure Landscape; Still Life with Chocolate Pot; Pont St. Michel, Paris; a second Corsican Landscape; Nude Before a Screen; The Serf.

elled."²⁷ When she finally returned to America in 1935, he wrote sadly: "It seems to me that the best part of my audience has gone with you."²⁸

Their relationship, based firmly on Matisse's work, spilled out from the start to include their families. The male Steins shared riding lessons with the Matisses, and all of them took seaside holidays together as well as exchanging regular visits at home in Paris. Allan Stein, who was a year younger than Marguerite, grew up with the Matisse children and with their father's paintings. The huge white-painted living room on the rue Madame held more canvases than the biggest studio. Sarah took her visitors' breath away by hanging as many as twelve major Matisses on a single wall. "Whether you wanted to or not," wrote Jean Puy, always suspicious of his own instinctive pleasure in his old friend's work, "you couldn't help but give in and let yourself be carried away by the magic of the colours on that enchanted wall." "I had never before seen such glowing colour, such living colour," wrote Harriet Levy. "People came from all over the world to see them. This was the only place where one could see them." "

Like Leo and Gertrude, Sarah and Michael were at home one night a week to streams of inquisitive visitors—mostly young, nearly all foreigners in Paris—who came to inspect what was widely held to be a freak show. Reclining on a couch, dressed in Oriental robes and antique jewellery, Sarah was as fluent in her commanding and expansive style as Leo in his dry one. Leo's expositions were models of clarity and logic. Invited to provide someone who could explain his work to a group of other painters, Matisse asked Leo, because, "he said there was no one else to do it" (Leo refused on the grounds that lecturing Frenchmen in their own language on one of their compatriots was too much, even for him).³¹

Leo taught by precept and explanation, Sarah by imaginative osmosis. She held that Matisse's painting opened the way to a new world that could be perceived only by a fundamental shift of vision. The best account comes from Harriet Levy, who was a professional journalist just turned forty when she experienced Sarah's methods at first hand. Harriet had crossed the Atlantic with an equally tough-minded travelling companion, Alice Toklas, both in full flight from the provincialism of their hometown. Even so, the impact of paintings that violated every canon of moral and artistic decency was staggering ("The pictures were so strange that one quite instinctively looked at anything rather than look at them just at first," wrote Alice primly).³²

Harriet found the *Blue Nude*, with its bulbous breasts, protruding belly, flaunting buttocks and muscular thighs, vulgar to the point of obscenity. The scales fell from her eyes one night alone with Sarah, who was reading

Rabindranath Tagore. "Something happened to the painting... It moved me as I had never before been moved by the extent of its grandeur, its beauty.... Now I was understanding Matisse.... It gave me a key to all his paintings." Harriet took her cue from Sarah in applying the vocabulary of religious experience to an aesthetic conversion of superlative intensity: "It was a realisation of power, of abstract power, beyond any I had ever seen expressed in natural figures or even in a tree. In fact I saw that the artist was searching within himself for the emotion of which he was not yet fully aware." This account comes so close to the terms in which Matisse described his creative practice at the time that Harriet must have had it either directly from the artist or indirectly through Sarah. Over the next few years Harriet built up under the Steins' guidance a small but choice collection of Matisse's oils, watercolours and early bronzes.

Sarah's conviction was mesmeric at close quarters. It radicalised even Alice Toklas's painfully timid and conventional cousin, Annette Rosenshine, the girl who had accepted the Steins' invitation to come to Paris to look after Allan in spite of her qualms about their paintings. Like many of her romantic generation, Annette arrived on the Left Bank with expectations raised by George du Maurier's Trilby. Matisse seemed to her lamentably tame and fatherly compared to the art students she saw on walks with Allan in the Luxembourg Gardens ("With their wide baggy velveteen trousers, berets and flowing ties, they certainly would have qualified much better for the title of les Fauves").34 But after a short spell in Sarah's hands, Annette too found that other painters' work looked "flat and meaningless" beside Matisse's. Soon she was spending her pocket money on pictures to brighten up her poky bedroom in the pension on the floor above the Steins. She bought three Matisses (he charged her thirty dollars for a small oil) with the money which she saved, at Michael's shrewd suggestion, by buying a chocolate croissant every afternoon instead of patronising expensive American tea-shops.³⁵ Slender, self-possessed and elegantly groomed with a diffident manner and expressive eyes, Annette was surprised but not displeased when Matisse asked if he might paint her portrait. He said it was the eyes that appealed to him, but he was firmly turned down by Sarah, who knew the effect his proposal was likely to produce on a respectable Jewish matron like Mrs. Rosenshine.³⁶

Annette at twenty-seven was still as docile as a child. She had been crushed enough at home to enjoy the sense of righteousness conferred by association with the Steins ("The pose was, if you don't admire these daubs, I am sorry for you," wrote a disgruntled Mary Cassatt, describing evenings at the rue de Fleurus. "You are not of the chosen few").³⁷ One

fine day in the spring of 1907 Annette set out with the landlady from her boardinghouse on a boat trip to visit another former lodger, now living a few miles down the Seine at Sèvres. Annette's friend was a German, Gabriele Münter, who had been one of Kandinsky's pupils in Munich and was now living with her teacher (whose own breakthrough as an artist still lay in the future). "The Fräulein and Kandinsky were working in a very large atelier," wrote Annette, adding smugly, "It needed to be sizeable to meet the dimensions of Kandinsky's representational canvases that I saw that day, painted in drab colours similar to those I had been accustomed to in San Francisco. . . . I felt quite superior in recognising how far removed his work was from the avant garde art I was seeing at the Steins'." "

Competition and one-upmanship were strategic weapons in the campaign to establish a new world vision. "Visitors felt the lash of Sarah's scorn," wrote Harriet, who watched a whole procession of rich Americans reluctantly succumb over the next few years to the spell of their hostess at the rue Madame. "When they were with Mrs. Stein they were hypnotised and ready to buy Matisses. When they left her, demesmerised, they did not understand or have confidence in them.... They were afraid of the brilliant canvases. They couldn't bear the violence of them. They were afraid to buy them, they were afraid not to buy them. Afraid they would turn out to be the important paintings the Steins said they were." 39 Of all Sarah's conquests, perhaps the most spectacular was Leo's friend the connoisseur Bernard Berenson, who found the Blue Nude so repulsive that he nicknamed it "the toad." "Berenson said to Sarah: 'If you can ever convince me of any beauty in that toad, I'll believe in Matisse.' "40 By the end of 1908, after an evening to which Sarah invited both parties, Berenson was writing to the New York press to champion Matisse in no uncertain terms. The year after that he bought a Matisse painting of his own.

The Steins' converts commonly burned with missionary zeal when they returned to their own countries. Young Pach would be one of the organisers of the Armory show in New York, which introduced Matisse and his French contemporaries to America in 1913. Young Purrmann would help to put on Matisse's first German exhibition at Cassirer's Berlin gallery in 1908. Already at the beginning of 1907, Purrmann was bandying Matisse's name with Baron von Tschudi, the director of Berlin's Imperial Museum, and Count Kessler, whose patronage made Maillol's fortune in these years. ⁴¹ He was also acting as a go-between for another enterprising young German collector, Karl Ernst Osthaus, who gave Matisse his first commission since he had decorated the dining room of his Uncle Emile's ill-fated house in Le Cateau in 1895. Osthaus ordered a *Nymph and Satyr*,

painted on a set of three wall panels made of enamelled ceramic tiles, to adorn his own new house at Hagen in Westphalia. Purrmann wrote glowingly to Osthaus about the "wonderful colours" of Matisse's first test tile, fired in February at a kiln in Asnières.⁴²

The workshop belonged to André Metthey, a brilliant, self-taught potter who had set himself virtually single-handed to rescue French ceramics at the beginning of the century from the stranglehold of the Sèvres porcelain factory. Metthey was determined to find an alternative to the mechanical production line—the ceramic equivalent of academic painting-whose cold and lifeless products filled him with "a terrified repulsion, a real physical horror."43 In 1906 he hit on the idea of recruiting the Fauves, who had liberated painting the year before, to help him do the same for pottery. Matisse joined friends in Asnières—Derain, Vlaminck, Puy, Rouault and others-who were already working on plain white faience pots and plates provided by Metthey. "For the love of colour, he surrounded himself with painters," wrote Marcel Sembat, who collected Metthey's work as eagerly as the Fauves'. "We hared down to Asnières every fortnight in those days for the prodigious surprises of the kilnopenings. . . . What firings! an orgy of splendid plates, of vases, of platters, of great gleaming bowls.... Colour was triumphant. It was queen of this violent creation, which opened out in all directions, here barbaric and wild, there all elegance and coquetry."44

Matisse responded with enthusiasm to the opportunities on offer at Asnières. He had experimented with local pottery at Collioure the year before, using richly coloured glazes like the Catalans whose work he and

Derain had bought for next to nothing across the Spanish border in Llansa. Metthey worked in the same medium of humble earthenware, using the excellent clays round Paris to produce altogether more sophisticated effects. Matisse gave Sarah Stein the first tile he successfully fired in Metthey's kiln. He decorated his pieces sparsely and with the utmost simplicity, restricting himself to a few loosely brushed and highly stylised motifs—flowers, dancers, portrait heads—disposed at intervals on a white ground within the circular rim of a plate, or on the curving surface of a vase. In the still lifes of the next few years, these highly recognisable pots would take their place alongside his textiles and

Matisse, Large Covered Jar, c. 1907: one of the pots made by André Metthey and decorated by Matisse

Matisse, Statuette and Vase on an Oriental Carpet, 1908

clay figurines in the little band of familiars Matisse used to help him disrupt and reassemble established pictorial conventions of form and space.

He worked at Asnières in March, and he would return at the end of the summer, experimenting with an absorption that matched the potter's own. Metthey, who was two years younger than Matisse, was already in the grip of the tuberculosis that would eventually kill him. He had the pallor, the feverish glance and restless hands Matisse knew from the weavers of Bohain. Sembat said that Metthey lived under threat for twenty years, perpetually summoning the energies left over from his illness as if to fling them with his pots into the kiln. "That studio at Asnières, how he suffered there, and what happiness he knew there too! What a radiant expression on his face when he came towards you, eyes shining, holding in his hands his latest masterpiece . . ."⁴⁶ On 21 April 1907, just as he was leaving Paris, Matisse contributed his share (twenty francs with an offer of more) to an artists' whip-round for Metthey, who had suffered one of the periodic collapses that only made him stoke his fires higher as soon as he could leave his bed. ⁴⁷

Matisse hurried back to the Midi with his wife and daughter even before the Salon closed on 30 April ("You're country people, like our-

1907-1908: PARIS, COLLIOURE, ITALY AND GERMANY

Matisse, La Coiffure,

selves," Georgette Sembat wrote approvingly, "and you didn't hang about on the Paris pavements").⁴⁸ He had been working in Collioure with three brief interruptions for a whole year by this time, and he planned to put in at least another six months' solid work. The boys stayed behind to finish the school term with their grandparents in Bohain. At the beginning of May one of Matisse's cousins—Germaine Thieuleux, a nineteen-year-old orphan who had been gravely ill-was sent down by his mother to spend the summer convalescing in the sun and sea air that had done so much for Marguerite and Pierre. 49 The daughter of Anna Matisse's youngest sister, Sydalise, Germaine was the child of a broken home. Both her Gérard grandparents were already dead before she was born, her parents had divorced (a scandal from which no family easily recovered in those days), and her mother had died young, after which she seems to have been taken in by her Aunt Anna, Matisse's mother, who had no daughter of her own. This young cousin was the first member of his northern family with whom Matisse shared his discovery of the south.

He began work on a series of figure studies-Music, La Coiffure,

Germaine Thieuleux

basis for unexpected developments in his work over the next few years. He was experimenting with people, suppressing their individuality, heightening their expressive force, reducing them to large, flat, simplified shapes within an overall design. He drew on the studies of women at their toilet for which Amélie and Marguerite had posed with Rosa Arpino the year before. La Coiffure shows Amélie with another woman pinning a flower in her hair. Ger-

Flemish style of the Gérards, quite unlike the fineboned delicacy of Marguerite or Amélie's dramatic southern looks. Perhaps she took turns as a model with her cousin's wife and daughter. If so, perhaps she supplied the starting point for the stocky, round-faced girl flanked by two others in Three Bathers (colour fig. 33), a strange painting

maine Thieuleux was handsome in the sturdy

which would exert a powerful pull on Matisse's imagination.

The peaceful routines of summer at Collioure did not last long. Within ten days of her arrival, Germaine suffered a sudden, brutal relapse. 50 She deteriorated rapidly over the next week, losing strength, becoming paralysed, drifting in and out of consciousness. Amélie nursed her. Matisse watched in horror. His mother, who was sixty-three years old, made the long journey across France alone in sweltering heat to find that Germaine had died of a brain tumour, barely three weeks after leaving home. After a hurried funeral service, the coffin was already on its way back to Bohain by train. Amélie was exhausted. So was her mother-in-law, who, like Henri, found it impossible to sleep in time of crisis. Matisse himself was sick for a month after his cousin died. It was Amélie who accompanied Anna Matisse-both women in black with mourning veils-back to the North, where, after a second interminable funeral in the dark church Matisse had hated as a child, Germaine was buried in the Matisses' family tomb. When Amélie finally returned to Collioure, bringing her two sons with her in early June, she collapsed herself.⁵¹ "I don't think there is such a thing as real tranquillity," Matisse wrote on 20 June, attempting to come to terms with what had happened in a long, grimly detailed account to Manguin. "I have been pretty much shattered by the

sight of my poor cousin." His only consolation was that the children had witnessed nothing (the boys were away, and Marguerite must have been sent to the Parayres in Berthe's house in Perpignan).

Throughout the Matisses' private drama, the countryside around them had been in an uproar. Simmering unrest among subsistence farmers, whose livelihood had dwindled to starvation level, flared up that summer all over the Midi. On 19 May 180,000 peasant wine-growers attended a demonstration in Perpignan. There were 250,000 at Carcassonne on 26 May, the day Matisse first sent word of his cousin's death to Manguin. In the first week of June, when Amélie travelled back to Collioure with the boys, protesters clashed repeatedly with the police at Perpignan railway station. More than half a million gathered at Narbonne on 9 June to deliver an ultimatum to the government. Clemenceau sent in the troops the next day. The peasants' leaders were arrested. Strikes broke out, and rioting was feared, in towns all along the coast. Troops mutinied at Béziers. On 18 June, after more trouble at the station, strikers sacked the prefecture in Perpignan. Armand Parayre's lifelong radicalism had taken on sour overtones after its exploitation by the Humberts. But his former

Mme Matisse mère

colleagues from Toulouse—the journalist Arthur Huc, and the Socialist deputy Albert Sarraut (both of whom had bought paintings by Matisse)—championed the strikers' cause. Clemenceau's ruthless suppression of the spontaneous, nonviolent uprising that became known as the Wine-growers' Revolt was part of an increasingly authoritarian approach, which turned former supporters like Marcel Sembat against him. To casual observers caught up on the spot in the strikers' protests, the affair was a clear signal of government incompetence and callous indifference.

It confirmed the futility of political solutions to anyone who, like Matisse, had had anarchist instincts in his youth. "I have seen too much of human misery," Matisse wrote in his letter of 20 June to Manguin. Henri Cross, writing to commiserate on the death of Matisse's cousin, tried to cheer him up with a catalogue of their friends' woes. The Manguins at St-Tropez had gone down with scarlet fever; Mme Signac had enteritis; Mme Cross was laid up with bronchitis; Luce had gone to Holland, where the wind made it impossible to work; and Cross himself (although he did not say so) had endured another of his terrifying bouts of blindness. "Decidedly the painters of the Midi are going through a sticky patch," he wrote genially.⁵³

The annual summer show of the "Artists of the Roussillon" opened in Perpignan the week after the attack on the prefecture. Two of the artists in question—Daniel de Monfreid and Louis Bausil—were spending the summer as neighbours of the Matisses in Collioure, where a third—Etienne Terrus—regularly joined them for boating, fishing and mussel suppers. On 24 June the whole party celebrated the feast of St. John the Baptist in the traditional way with a bonfire on the beach. Jean and Pierre Matisse had gone back to the village school for the last two months of the term. Amélie was regaining health and spirits. Matisse found himself able to paint again. When Michael and Sarah Stein arrived for a visit with their son, all of them went swimming from a dinghy in the bay. Matisse painted Allan with a butterfly net provided by his Uncle Leo to amuse him on Italian holidays, when he was the only child among four adults. St

The Matisses had been persuaded by Leo to visit him in Florence, where he spent summers with his sister. They left on 14 July, dropping Marguerite off with her aunt in Perpignan, and travelling at a leisurely pace along the coast, making a round of studio visits on the way. They started with the Manguins at St-Tropez and the Crosses at St-Clair, going on to spend a week with Derain at Cassis within easy reach of Braque and Friesz at La Ciotat. ⁵⁶ Matisse had parcelled up three or four paintings the

1907-1908: PARIS, COLLIOURE, ITALY AND GERMANY

Sarah Stein and her family bathing with the Matisses at Collioure

day before he left to send to Fénéon in Paris ("I trust the firm of Bernheim will prove the definitive solution for the modern school," he wrote with no great optimism to Manguin, "and Fénéon its picture vendor"). The photos he took with him amazed his friends. "It's brilliant—I believe he's crossed the threshold of the seventh garden, the garden of delight," Derain reported to Vlaminck, adding on a more characteristic note in a second letter: "He's getting younger. He's happy as a lark, and has the air of being ready for anything. I'm very fed up." ⁵⁸

The Italian journey was planned as a treat for Amélie (Matisse told his son-in-law long afterwards that he went there chiefly to please his wife). ⁵⁹ Bernheim-Jeune had sent a payment of 18,000 francs two days before they left, so for the first time since their honeymoon, they travelled in style. ⁶⁰ Their hotel in Florence was the comfortable and convenient Hôtel d'Italie, on the right bank of the Arno in the best part of town, handy for shops and sightseeing, and practically next door to the church of Ognissanti with its crucifixion by Giotto. ⁶¹ Amélie told Gertrude Stein that for her this trip was a girlhood dream come true. "She said, I say to myself all the time, I am in Italy. And I say it to Henri all the time and he is very sweet about it, but he says, what of it." Matisse himself was dis-

tracted rather than stimulated by the riches of the Uffizi galleries and the Pitti Palace. He found it hard to remain patient with Leo, who, having spent the past seven summers perfecting his knowledge of Florentine art, had laid on a highly specialised programme few tour guides could match.⁶³

Leo's helpful comparisons and didactic tips were admirable for opening the eyes of inquisitive young art students. But Matisse had been looking at pictures as intently as Leo for a great deal longer, and with a ruthlessly professional eye. Travelling was for him essentially a solitary experience. He said that the last thing he needed was Leo buzzing at his back, allowing him a short pause in front of each new masterpiece before darting forward to solicit his impressions. Matisse became exasperated, Leo felt hurt and disappointed. There had been tension between the two in Paris when Leo, who had started painting again himself, asked for and got Matisse's frank opinion of his work. There was no actual breach, but although he would take home several paintings on approval, Leo never bought another canvas from Matisse after this Florentine encounter.

The Steins' rented villa was in the hills above the town near the Berensons' I Tatti. It was Berenson who had presided over Leo's first exploratory trips to Florence, offering the run of his library, rating him highly as a budding connoisseur, and subsequently deploring his decision "to set up as a prophet and painter in Montparnasse."66 By 1907 Berenson himself was beginning to move away from pure connoisseurship onto more dubious ground. He started work this year for the tycoon Joseph Duveen, embarking on what Roger Fry called "the game of grab," auctioning his services to the highest bidder and trading one multimillionaire off against the next. Fry himself had just completed a whirlwind picture tour with Pierpont Morgan, "rushing over Italy in a closed automobile, the biggest, heaviest, swiftest, strongest ever built," wrote Mrs. Berenson, noting sardonically how much Morgan enjoyed being fawned on by "the crowds of dealers who line the passages in every hotel he goes to."67 Although the Steins did not bring Berenson and Matisse together on this visit, it would have been hard to miss the atmosphere of venality and greed emanating from I Tatti.

Matisse's own experience of dealers had not been encouraging, and the corruption he saw or glimpsed in Italy filled him with revulsion. A vision of materialism went with him to Venice, which held nothing for him in his current stern and uncompromising frame of mind. "In Venice, in front of the great Titians, the Veroneses, in short all those we have quite improperly agreed to call the masters of the Renaissance, I saw superb fabrics, created for their wealthy clients by those great pleasure-

loving artists, inclined more to physical than spiritual concerns." When Matisse spoke afterwards of this confrontation with the Italian high Renaissance, it was in terms of artifice and sensual excess. He told the poet Guillaume Apollinaire a few months later that he felt himself at a crossroads for painting. The Venetians gave him a sense of uneasiness and equivocation. He found their work fatally contaminated by the corrupt princes of church and state for whom it was produced. "Yes, that comes from my soul: manufactured for the rich. The artist sinks to the same base level as his patron."

He received the opposite impression from the primitive painters of an earlier age, who seem to have spoken deeply and directly to Matisse for the first time on this visit. Leo took him for the day to Arezzo to see the frescoes of Piero della Francesca. There were trips to Padua for Giotto's interior of the Arena Chapel ("Giotto is the height of my desire," Matisse wrote to Pierre Bonnard long afterwards), and to Siena for Duccio's Christ in Majesty ("less powerful in volume but more so in spirit," Matisse told Apollinaire). Matisse responded to the structure rather than the detail of these frescoes, the abstract beauty of design, the strong and subtle harmonies of colour. "When I see Giotto's frescoes in Padua, I don't worry about knowing which particular scene of the Life of Christ I have before my eyes," he wrote in "Notes of a Painter" (on which he would start work almost as soon as he got back from Italy), "but I immediately grasp the feeling that comes from it, for that is in the lines of the composition, in the colour, and the title can only confirm my first impression."

It was what Matisse saw in Padua and Siena that spoilt his appetite for Venice. Walter Pach, who met him for the first time while staying with the Steins in 1907, remembered the mood of exaltation in which Matisse returned from Padua. Thirty years later, when Matisse himself seemed to many to have tilted the balance of his own work in the direction of luxuriant sensuality, Pach looked back to that summer in Italy: "Sooner or later...his seriousness drives him back to memories of the romantic, expressive art that utters its deep cry in such a work as Giotto's *Death of St. Francis of Assisi.* It was such a tone again as came from the throats of the 'wild beasts,' as Matisse... and the others were nicknamed."⁷⁵

Back in Collioure by mid-August, Matisse resumed his experiments, working this time on a larger scale than ever before. There are echoes of Botticelli's Florentine *Birth of Venus* in the seven-foot-high canvas called *Le Luxe*, which sets Matisse's own notably austere concept of luxury against the earthly delights of the Venetian Renaissance. The allegorical or anecdotal meaning of *Le Luxe*—a slender, dark-haired, long-necked

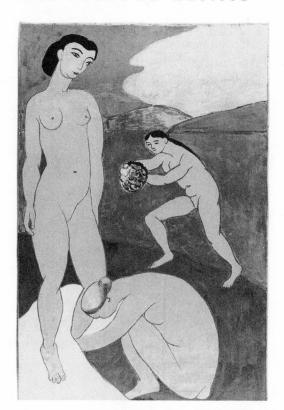

Matisse, Le Luxe II,

woman with one attendant bringing her flowers while another bends to dry her feet—presumably signified no more to its creator than the plot of Giotto's *Life of Christ*. He set the painting on the heights above Collioure, looking across to the rounded hills on the far side of the bay (faithfully observed, even down to the faint pink penumbra, which is a local trick of the light at certain times of day). Its point lies in the interaction of the figures with their background, made up of horizontal bands or waves of colour like an Italian fresco. In a second version of *Le Luxe*, Matisse heightened the fresco effect by experimenting with his paints, mixing them with glue according to a recipe used by Terrus to give a soft glow to his theatrical backdrops. When the first of these two huge canvases went on show at the Salon d'Automne, even the few sympathetic critics complained that it was too sketchy, disappointing in detail, and effective only from a distance.

In the ten years since he first showed signs of dissatisfaction with conventional procedure in *The Dinner Table*, Matisse had arrived at an alternative style of extreme individuality and expressive force, combining

elements from wildly discrepant sources. He listed some of them for Apollinaire that autumn: the ancient art of the Egyptians, the Greeks and the Peruvians; Cambodian stone carving; and African tribal figures (he might have added Algerian pottery and textiles).⁷⁹ He said he had taken what he wanted from the Western tradition, citing the Italian primitives and Rembrandt. He saw himself and his generation as heirs to the kingdom of European painting, which stretched from the perfumed gardens lapped by the Mediterranean to the mighty seas of the continent's northern coast. He felt that painting had reached an intersection where the artist could only find which route to take by trusting his own instincts.

He knew well enough that the visible results of this programme were liable to provoke his public beyond bearing. In his own "Notes of a Painter," as well as in interviews given at much the same time to other people, Matisse defended himself stoically against charges of crudity, aggression and gross indecency. He insisted that all he was trying to do was construct a new plastic language free from the maddening constraints of outdated grammar and syntax; and that the message he hoped to convey in this new language was the opposite of destructive. He would be questioned over the next few months by Apollinaire, Walter Pach, an American journalist called Gelett Burgess, and Michel Puy (the brother of his friend Jean, and the only one of the four who was at all familiar with the new language). All four were struck by the overriding importance Matisse attached to clarity and calm. "Nothing is stranger," wrote Puy, "in an artist so impassioned, so vehement and so tormented, than this longing for tranquillity."

The publicity surrounding Matisse in the autumn of 1907 was sparked by a letter he had found waiting for him on his return from Italy that summer. It came from his old friend Mécislas Golberg, who recalled their time together six years earlier in Antoine Bourdelle's studio and explained that he had followed Matisse's subsequent career with admiration. The Cahiers de Mécislas Golberg had recently been revived as an art review. Its editor proposed to devote an entire number to Matisse: "Would you let me have for the September issue two or three pages—as many as you like for that matter—explaining your aesthetic—defending it, and justifying it with reproductions of your works, and those of Friesz and the others who follow you—does that appeal to you?"⁸¹ Matisse wrote back immediately. In answer to his qualms about seeming arrogant or spurious, Golberg insisted that, on the contrary, any guidance he might give "would be useful to the critical nitwits, and could open new horizons for younger artists trying to find their way. It's not a question of art criticism,

but of annotating the work . . . —which is not the same thing, I promise you—please do it." 82

This was apparently the first time anyone had asked Matisse to provide a written statement, and he could not—as Golberg modestly pointed out—have found more disinterested intellectual auspices under which to publish it. The Cahiers were read by radical thinkers in Paris, London, Weimar, Berlin, even New York, circulating probably in single copies from hand to hand. Golberg wrote nothing that was not intelligent, as André Salmon said in his portrait of the legendary living skeleton who had turned the cafés and pavements of the boulevard St-Michel into a Socratic school for a whole generation of young poets and painters.83 One of Matisse's friends in Moreau's class, André Rouveyre, had been captivated for life as a student by the beauty, humanity and generosity of Golberg's ideas.84 By 1907 the master had finally lost his race with death (he had spent much of the past two years in a sanatorium near Fontainebleau, paid for by Rouveyre). He was well aware that this new number of his Cahiers would be the last. Apollinaire said that people visited Golberg at Fontainebleau as once they had made the pilgrimage to Ferney to see Voltaire. 85

In fact, apart from Rouveyre, Golberg saw virtually no one, because, as he said himself, even genuine friends could no longer stand the spectacle of his physical decomposition. "As for meeting you, my poor friend," he wrote to Matisse, "insofar as I exist at all there is nothing left of me but the head! Consumption has killed off the rest. For two years, I have survived without legs, without a voice—with only my brain, and a little energy, and the will to endure."86 Golberg warned Matisse that it took a strong stomach to visit the deathbed on which he lay, offering to send someone to discuss the article in his place. "But if one day you find yourself passing through Fontainebleau, come and lunch or dine with me—in which case you will need courage for the macabre." Golberg's envoy was Apollinaire, who received instructions on 20 August to be ready to call at 19 quai St-Michel. 87 Matisse's response to Golberg's letter was to abandon plans to stay on alone in Collioure after his wife had returned to Paris with the children. He visited Fontainebleau on 10 September, taking his notes with him. Golberg chose three photographs of recent work as illustrations and dispatched the notes straight to the printer.88

Publication was postponed for a month to coincide with the Salon d'Automne, scheduled to open on 1 October. A revised plan for this autumn issue now included an interview with the painter by Apollinaire, whose knowledge of painting was rudimentary, and whose art criticism

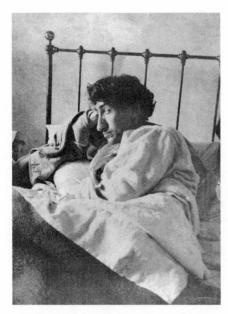

Mécislas Golberg on his sickbed, c. 1903

had so far largely consisted of gossipy stories and puffs for his friends (chiefly Picasso). Golberg explained to Apollinaire that he had gone to some trouble to persuade Matisse to see him ("I've sung the praises of your style of criticism"). He summoned Apollinaire to Fontainebleau for a day's briefing and told him to look through Matisse's notes beforehand ("Agreed about the Matisse, but don't interfere with what he writes—let his notes remain unpolished, and without a commentary"). Golberg also intended to contribute an essay of his own on contemporary artists, which would have singled out Matisse, Picasso and Derain, but this scheme proved too ambitious. Time and strength were running out. "What is all this prevarication?" he wrote when Apollinaire failed to produce his text by mid-October. "For pity's sake, my dear Guillaume, if you're having second thoughts, I beg you, reassure me about my Matisse, and explain what's going on." 10 points of the produce his text by mid-October. "For pity's sake, my dear Guillaume, if you're having second thoughts, I beg you, reassure me about my Matisse, and explain what's going on."

This was Golberg's last letter. By November he had sunk too low to function in or even contact the outside world. Apollinaire, who had still not got round to finalising his interview, was galvanised into action only by the publication of Michel Puy's essay, "Les Fauves," in *La Phalange* on 15 November. *La Phalange* was a literary review of exemplary modernity, newly founded by the poet Jean Royère, who wrote to Matisse declaring himself a keen admirer. His was a far more prestigious outfit than anything Apollinaire had yet written for, and perhaps it was Royère who

Pablo Picasso, Apollinaire as an Academician, 1905

approached his fellow poet at this point. At all events, Apollinaire arranged to polish off his interview over a hasty dinner with Matisse ("Don't forget your press cuttings") on 19 November. His article, published in the next issue of *La Phalange*, reads like a more or less direct transcription of Matisse's answers to questions initially suggested by Golberg. "There is nothing else so sensible, so fair, and so totally unenthusiastic in all Apollinaire's writings" was the verdict of Louis Aragon. Hospitalian and so totally unenthusiastic in all Apollinaire's writings was the verdict of Louis Aragon.

Apollinaire himself described the article as "a timorous effort [un essai craintif]." He published on the same day—15 December—what amounted to a fulsome if premature obituary of Golberg, 95 who lived just long enough to see his Matisse interview finally appear in a rival paper, before dying at Fontainebleau on 28 December. The last posthumous issue of his Cahiers in January contained a single View of Collioure supplied by Matisse, but not the painter's notes. Although Apollinaire's subsequent prestige as an art critic rested largely on this early scoop, he never acknowledged the extent to which he owed his discovery of Matisse to Golberg. Matisse's

contempt for the poet's abilities as an art critic (shared by many other painters, including Picasso and Georges Braque) seems to have been compounded by memories of this shabby episode.⁹⁶

Puy's long, lucid and authoritative article situated Matisse at the head of the movement which had replaced Impressionism. It established him as a serious, dedicated, and above all disciplined worker with nothing in the least savage or bestial about him. Puy concentrated on Matisse's evolution and achievements, bringing in the other Fauves more or less as an after-thought at the end. He said that however unpolished Matisse's latest paintings might seem, he found (like his brother Jean) that he could not look away: their presence was so vivid and demanding that it drained the life from all other contemporary work at the autumn Salon. Puy faithfully reported Matisse's view of himself and his work, emphasising the artist's restrained and sober side while making it quite clear that there was another: "He heads for his goal so furiously, he's so full of his subject, that he loses sight of everything else. In his passion for decoration, he risks becoming obsessed with decorative themes. The danger for him is to lose touch with moderation. . . . "97

Matisse's contribution to the 1907 Salon consisted of two landscapes, two drawings and three of his new figure paintings: Le Luxe I, Music (Sketch) and a brilliantly decorative portrait of Amélie called Woman in a Red Madras Robe. Apollinaire, reverting happily to his role as gossip columnist, reported a last-ditch offensive by the Salon's president, Frantz Jourdain, who had managed to browbeat his committee into rejecting La Coiffure (the painter never forgot Jourdain's clinching shot: "Those who vote for Matisse—for that thing—are no friends of his"). The ceramics which Matisse had made at Metthey's in September were also on show, in a large glass display case devoted to the Asnières pottery. When Sarah and Michael Stein bought Music and the portrait of Amélie, Matisse gave them Le Luxe as well on loan. 99

He sold two more paintings to an enthusiastic German couple, a painter called Oskar Moll and his young wife Greta, who had been her husband's pupil at art school until he married her the year before. ¹⁰⁰ Moll, a member of the Berlin Secession who had already shared a show at Cassirer's with Edvard Munch, was one of the many ardent devotees of van Gogh, Gauguin and Cézanne beginning to converge each year on Paris for the latest autumn crop of work at the Salon. The Molls had travelled via Hagen, where they were astonished by Osthaus's French paintings, especially by his latest acquisition, Matisse's *Still Life with Asphodels* (painted that summer in Collioure). ¹⁰¹ Osthaus also headed for Paris for the Salon. The

Molls took furnished rooms in Montparnasse, not far from Colarossi's academy, where a striking figure could be seen drawing near the door most afternoons: "Enveloped in a black sheepskin coat, turned wool side out, with a square-cut red beard, strong features and large shining eyes—a sight you couldn't overlook—that was Henri Matisse." The Molls were taken by their friend Hans Purrmann to 19 quai St-Michel, where they fell in love at sight with the bright, clear colours—red, yellow and blue—of *Three Bathers*, a small canvas so powerful that it looked to Greta much bigger than it actually was. They bought it on the spot, together with the painting of Allan Stein and two small sculptures, a foundation on which they would go on to build one of the finest Matisse collections of its time in Europe.

The pace of pictorial change was accelerating faster than ever. A fundamental shift of vision could be seen taking place in 1907 at the autumn Salon's grand retrospective exhibition of Cézanne's paintings. "Without studying any single one, and standing between the two great halls, you can feel their presence gathering into a colossal reality," wrote the poet Rainer Maria Rilke, who belonged to the same group of purposeful young Germans as Hans Purrmann and the Molls. "It is as if these colours took away all your indecisions forever and ever." 104 Rilke, who spent much time with the Cézannes, pinpointed the reactions of the opposing factions: on the one hand, the general public, perplexed and dismayed, the men loudly asserting their refusal to be taken in, the women checking their own reflections in the glass doors in response to Cézanne's portraits of his wife; on the other, the impassive cognoscenti, for whom Cézanne was already an old master ("In this salon he is every bit as alone as he was in real life, and even the painters, the younger ones, go quickly past him because they see the dealers at his side. . . . "). 105

Among the succeeding generation, Matisse was generally singled out by critics as being in a different class from his contemporaries. Apollinaire called him the Fauve of Fauves. ¹⁰⁶ He was even interviewed for a popular New York paper by Walter Pach. Still puzzling over what Matisse was driving at, Pach managed to put together an article which, by his own account, might have been published if he hadn't also submitted illustrations ("Once the editor got his eye on those, he decided very sharply that such insanities were 'unavailable'—even for the sensation-loving pages of a Hearst Sunday supplement"). ¹⁰⁷ The Salon was awash with genuine and fake Fauves: imitators who aimed at reproducing Matisse's style without, as he said, the faintest notion of its underlying structure or logic. Greta Moll remembered a canvas by a Russian woman painter "which showed a

squatting man sinking sharp teeth into his own leg—you could clearly see the blood running down." Works like this one drove the Fauve of Fauves to desperation. "Matisse was painfully affected by such followers," Frau Moll wrote indignantly, "for he saw how often and how evidently his own way had been misunderstood." He said that his self-styled supporters reminded him of the no less literal-minded attackers who had accused *The Dinner Table* ten years earlier of harbouring TB microbes.

At some point that autumn, Matisse went to the Bateau Lavoir to see Les Demoiselles d'Avignon, which affected him in much the same way as the Russian cannibal painting. 109 It struck him as a mockery of everything for which he had fought so long and hard. This seems to have been more or less the view of everyone who saw Picasso's canvas at that time. Georges Braque said it made him feel as if he had eaten tow or swallowed petrol. 110 Derain predicted gloomily that Picasso would end by stringing himself up in the studio behind his own Demoiselles. III Both Braque and Derain rapidly revised their initial impressions. Over the next six months both would transfer their allegiance from Fauvism to the new and still nameless countermovement led by Picasso. Twenty-five years later Picasso's girlfriend, Fernande Olivier, reported that Matisse swore to get his own back on the Spaniard and make him beg for mercy. II2 Fernande, who liked and admired Matisse, can only have heard this threat at second hand, probably from Gertrude Stein, or one of Picasso's gang (who habitually talked in terms of getting even, paying people out, and settling one another's hash).

Whatever he actually said, Matisse's disquiet was plain to see. He complained in the spring of 1908 to Gelett Burgess about the defection of Derain and Braque (Burgess proved more persistent than Pach; even so, it took him two years to find an outlet for his interview, which eventually appeared in New York's Architectural Record in May 1910). 113 By this time the most powerful propagandists for the modern school in Paris were beginning to split their support. Leo and Gertrude Stein had ceded most of their Matisses to Sarah and Michael, and Gertrude at least had thrown her weight massively behind Picasso. Matisse had disappointed her even more than he had Leo (she told Annette Rosenshine that she had hoped he would paint her portrait, like Picasso; she found his insight into her own manipulative ploys annoyingly acute; and she did not care at all for his increasingly appreciative attachment to her sister-in-law). 114 From now on Gertrude began to speak of Matisseites and Picassoites. "They became two camps in the art world of Paris," wrote Harriet Levy, who was too much in awe of Sarah to be anything but a Matisseite. 115

Pablo Picasso,

Dance with Veils

(Nude with Drapery),
1907

The two artists had embarked on what would become a lifelong dialogue on canvas, a dialogue that was also a duel. By the spring of 1908 Matisse had evidently seen the *Nude with Drapery*, Picasso's majestic retort, at once visceral and severely geometric, to the *Blue Nude*. Based on studies for the *Demoiselles d'Avignon*, Picasso's *Nude* hung in the same room as Matisse's at 27 rue de Fleurus. Matisse must have had this rival *Nude* in mind when he described to Burgess how his ideas were being pirated and perverted:

Poor, patient Matisse.... He may say, perhaps: "To my mind, the equilateral triangle is a symbol and manifestation of the absolute. If one could get that absolute quality into a painting, it would be a work of art." Whereat, little madcap Picasso, keen as a whip, spirited as a devil, mad as a hatter, runs to his studio and contrives a huge nude woman composed entirely of triangles and presents it in triumph. 116

Forty years later, looking back companionably with Picasso over their parallel careers, Matisse would compare his own slow process of assimilation with the enviable speed of Picasso's lightning raids. 117 Matisse insisted that, whereas all ways were open to Picasso (who protested that he had fought against this facility all his life), for him there had only ever been one possible path. The polarity between the two, defined and fostered by the Steins, bred a rivalry that proved one of the richest and most productive in the history of Western art. Each pursued a goal that was the opposite of the other's. Matisse, hounded all his life by the fear of rejection and exposure, sought peace and stability above all in his work. Picasso, surrounded from earliest years by admiration and approval, taught the world to speak a new plastic language based on disruption and disintegration. On a human level, Matisse longed for a sobriety at the furthest extreme from his detractors' taunts of clown and charlatan. Clowning, initially adopted as a protective measure, became Picasso's second nature. "He's turning his back on his own reality," Matisse said shrewdly in 1951, when he was eighty-one and Picasso just seventy: "he's naturally refined; but he wants to be a peasant, a breaker of clods in heavy working boots."118

In the autumn of 1907 Matisse's response to the kind of backhanded homage that disturbed him quite as much as outright derision was to redouble his attempts at explanation. He kept open house in his studio at 19 quai St-Michel one afternoon a week, when he would bring out his old work to show to visitors, explaining where he had come from and answering questions about where he was going. Anyone was welcome, but those who turned up seem to have been mostly foreign art students from Colarossi's. The small group of Matisseites who attended Colarossi's drawing class and drank afterwards at the Café du Dôme ranged from professionals like Purrmann and the Molls to Sunday painters like Annette Rosenshine (Annette came with Leo Stein, who shocked her by whispering, as they got out their drawing boards, that what he liked best was imagining the model's body before she took off her clothes). Purrmann also worked with Sarah Stein, sharing a model with her at home in the living room on the rue Madame.

Sarah had started painting seriously, and with considerably more encouragement from Matisse than Leo ("Matisse was delighted," wrote Harriet Levy. "He gave her great praise"). Purrmann's most advanced painting in 1907 was a *Standing Nude in the Studio*, heavily influenced by Matisse at his most Cézannian in works like *The Serf* (which was hardly surprising, since Purrmann worked for much of that year with *The Serf*

before his eyes in Sarah's studio). Matisse inspected Sarah's work informally from time to time, and at the end of the year, she showed him Purrmann's, too. It was at this point that the pair asked Matisse if he would consider taking on a small class on a regular basis. ¹²⁴ He agreed on one condition, which was that they come to him rather than expecting him to come to them. Greta Moll, who with her husband was an enthusiastic founding member of Matisse's class, attributed this willingness directly to his shock at the freaks and mutants he had unwittingly let loose on the autumn Salon. ¹²⁵

All that remained was to find premises, buy a stove and drum up pupils. Sarah roped in Leo and Annette, Purrmann recruited Max Weber, an American from Colarossi's who got nowhere when he tried to interest other members of the American Art Club in Montparnasse ("They would not hear of it and I was even ridiculed for making such efforts"). 126 With funds supplied by Michael Stein, the prospective pupils hired a room in the Couvent des Oiseaux where Matisse had had a studio for the past two years. By this time they had been joined by a second American, Patrick Bruce; Matisse's old friend Jean Biette; a Dutch girl called de Ward; and a German, Fräulein Knierim. Apart from Biette (who soon left), the Steins and Oskar Moll, all were in their twenties. 127 Purrmann was appointed massier, or student in charge of collecting money for the rent, hiring models, seeing the stove lit and the floor swept. Matisse inspected their work once a week, giving his services free (he had to start charging later, for fear of being overrun by students who had heard there were no fees to pay).

"The atmosphere of the first three days before Matisse's visit was tense with anticipation and fear," wrote Max Weber, "but with joy and pride as well, for we felt that a rising master was coming to bring us light and lead us out of chaos towards the right path..."

The messianic imagery probably came from Sarah Stein, who imbued the whole class with her own belief in a pictorial new dawn. "The students in the Matisse class were deadly serious and worked at white heat," wrote Annette Rosenshine, who had never known anything like it in any other art class. "On the days that Matisse would appear for criticism, the anxiety and tension were at breaking point." Legend said afterwards that Matisse had been so appalled to find his students lined up waiting for him on that first day, with their canvases already daubed in crude, clashing colours, that he rushed straight back to his studio to fetch a cast of the Apollo Belvedere for them to copy. But this story and others like it belong to a later period, when the school attracted growing numbers of brash young painters in

search of shortcuts to a sensational modernism ("We want your colour," said one of two American girls hoping to study under Matisse, who replied shortly: "If you haven't brought your own colour, you will never get mine"). The first students were better informed, which was what made them so nervous. The school began in any case as a drawing class, and its students did not move on to painting for several months. ¹³¹

Most of them already knew Matisse as well as his work. Purrmann became a family friend, like the Steins. So did the Molls, who knew Purrmann and quickly got to know the Steins, growing especially fond of the kind, quiet and self-effacing Michael, whose satisfaction came from solving problems and making other people's schemes run smoothly. Greta felt at home from the day she and Oskar met the Matisses. She was charmed by Mme Matisses's friendliness, and by the two studio children, Marguerite and Pierre (Jean had gone back to school with his grandmother in Bohain). Greta was, as she said, the youngest member of the class, still in some ways a child herself (Matisse could not believe she was out of her teens, although she was in fact twenty-three years old in 1907). In December she made a special German Christmas tree complete with tinsel, silver balls and candles for the little Matisses. ¹³³

This was their first Christmas in a new family home. After fifteen years on one or another floor at 19 quai St-Michel, Matisse finally moved out in early December 1907. The tenants of the Couvent des Oiseaux had received notice to quit, and Matisse found both working and living space in a second empty convent nearby (all religious houses had been forcibly closed down and appropriated by the government in 1904 as part of the Third Republic's programme for secularising the French state). Marquet (whose mother had died the previous summer) took over the old apartment on the quay from the Matisses, who spent much of December transporting their belongings, together with the contents of both studios, to the new quarters at 33 boulevard des Invalides. This was the convent of the Sacré-Coeur, which stood in its own park on the corner of the boulevard des Invalides and the rue de Babylone. Matisse turned the huge, high, whitewashed refectory into his studio, dividing the space with a partition so that he could install his students next door.

He also rented rooms on the ground floor of a handsome eighteenth-century building for his family, who had never lived anywhere in Paris except over the shop or in two tiny rooms designed for a bachelor artist behind the studio. Jean came back from Bohain, becoming part of his family on an everyday basis for the first time since he was born. They could hang up paintings and put out ornaments crammed for years into or

on top of dusty studio cupboards. They gave celebratory dinners for friends like the Steins and Molls with dishes cooked by Amélie, wines chosen by Vollard, and on special occasions the Italian model, Bevilacqua, dressed in a borrowed suit to wait at table. The parlour used by the nuns for receiving guests became Amélie's salon, eighteen feet long with tall windows looking out across the tangled garden to the Hôtel Biron (then occupied by Auguste Rodin, and now the Musée Rodin). The place swarmed with impecunious artists and writers. Rilke lived there at one point, and so did Jean Cocteau. Purrmann and Bruce moved in on the floor above the Matisses. Later two more of Matisse's students, a couple of Russian girls, would find lodgings in the attics.

Matisse started his class off, as he had himself been started, by making them copy classical plaster casts. The students clubbed together on his instructions to buy a copy of the Borghese gladiator from the Louvre. Greta Moll remembered sitting for a whole week—"seven long days on the same drawing, each day for three or four hours"—in front of that severe geometric masterpiece. 137 Matisse was a daunting and demanding critic. "Matisse thinks like a painter...," Purrmann wrote. "There was nothing of the teacher in him, he nearly always remained a student like us."138 The advice he gave, based always on experience, involved him in what came close at times to a review of his own past: contemplating his problems, reexamining his solutions, assessing the dangers he had faced and the risks still to be taken. The process was as exhilarating as it was nerve-racking for his students. Even the oldest of them—Sarah Stein was the same age as Matisse, Leo and Oskar Moll respectively two and five years younger-could not begin to match his artistic weight. Much of what he told them echoed the preoccupations of the "Notes of a Painter," which he had put together for Golberg. He urged his students to analyse form, to search for harmony, to trust their instincts, to concentrate on conveying the essence rather than the incidental detail of any given subject. "When, for instance, you are painting a landscape," he said to Greta Moll, "don't end up with rain when you started out in sunshine." 139

All his students agreed that he was at his most helpful and constructive when he was most practical. He made drawing seem as simple and inevitable as breathing. "One must always search for the desire of the line, where it wishes to enter and where to die away." His sense of composition was musical, and he expressed his conclusions in clear and cogent metaphors. "Good colour sings," he would say. "It is melodious, aromalike, never overbaked." Painting was like carpentry, or constructing a house: "You can see the colours of the skirting slabs, the cornice, the walls

and shutters that build a unity, a living unity, which is what a painting needs."¹⁴² Sarah Stein wrote down what Matisse said, paying particular attention to his anatomical observations, which take on a poetic delicacy and concision in her transcriptions.

"You may consider this Negro model as a cathedral, built up of parts which form a solid, noble, towering construction—and as a lobster, because of the shell-like, tense, muscular parts which fit so accurately and evidently into one another, with joints only large enough to hold their bones," Matisse said, adding a characteristically practical rider: "But from time to time it is very necessary for you to remember that he is a Negro and not lose him and yourself in your construction." Much of this was hard advice for young artists. Matisse made no concessions to their inexperience, and they listened in silence to his teaching. "I can never forget it," Mlle de Ward wrote to Matisse after she left Paris, explaining that if she had made no sign at the time, it was not because she failed to grasp the truth of what he said: "At all events I know that it has put me on the right track forever." 144

Matisse took his students step by step through the stages he himself had passed, beginning by sending them to the Louvre on Saturdays. He explained the colour theory of the Impressionists and Neo-Impressionists. On special days—"veritably festive afternoon hours," recalled Max Weber 145—he invited them into his own studio next door. Here, in front of his current work in progress, he explained his concept of decorative abstraction, and the use he made of archaic or Oriental sources. He took down his collection of small, slender African batons and tribal figures, handling them one by one to demonstrate their sculptural quality, "the supple palpitating fullness of form and equilibrium in them."146 He also showed his students "with great pride and loving care" the works he owned by his contemporaries. Weber remembered figure drawings by Maillol, black-and-whites by Rouault, and van Gogh's beautiful ink drawings (Matisse had added another two or three to the original drawing given him on Belle-Ile by John Peter Russell). The high point was Cézanne's Three Bathers. "His silence before it was more evocative and eloquent than words. A spirit of elation and awe pervaded the studio at such times."147

It was this kind of thing that made Gertrude Stein and others refer sneeringly to Matisse as "cher Maître," or CM, behind his back. The initial closeness and intensity lasted only so long as the class consisted of no more than eight or ten people (Leo Stein dropped out fairly soon, and so did Annette Rosenshine, who returned to the United States), when it

functioned in some ways more like an extended family than an academic school. Matisse always worked best with his family around him. Most of his students were Germans, or Americans of German origin, and they instituted their own version of the musical evenings Matisse had known as a student himself with Henri Evenepoel and his Belgian friends. Max Weber sang Handel arias and Schubert songs to the accompaniment of Mlle de Ward, who was a fine pianist. Matisse himself performed in his new studio on a tiny mechanical organ, using music rolls which needed "strong lungs and strenuous pedalling with the feet." ¹⁴⁸

Once he played the whole of Beethoven's Fifth Symphony, becoming so exhausted halfway through that his audience feared a collapse, but he rallied and continued to the end. "Then he would rise slowly, straighten out his shoulders, take a few steps, and convey the feeling of great satisfaction," wrote Max Weber. "His happy mood and sparkling eyes gave proof that the strenuous effort, the sweating and pumping, was worthwhile." This congenial atmosphere lasted through the summer and early autumn. Later, as word spread and new students enrolled, the school inevitably lost both its intimacy and its exaltation: "Never again was Matisse so open," wrote Greta Moll, "so overflowing with willingness to share his knowledge and experience, so stimulating in his clever teaching methods and his talk about art, artists and our own work, as in those first happy months!" 149

Matisse offered to paint Greta, whose blue eyes, subtle colouring and golden hair made him think of honey or ripe corn. Both parties left accounts of the sittings for this first commissioned portrait. Greta remembered Matisse adding liquid wax to the turpentine with which he mixed his oils so that the finished canvas could be polished (like Gustave Fayet's Gauguins) to take on a silken sheen. She posed daily for three hours, during which she watched the painter intently, gaining a strong sense of what she called the logic of his work. He forbade her to inspect the canvas, but before she left on the tenth day, she sneaked a glimpse. Both artist and model agreed that at this stage the portrait was strikingly like, and very beautiful. "In spite of my best efforts... I had got no further than the charming features which were not lacking in my model," wrote Matisse, "but I had not managed to catch her statuesque aspect." 152

His dissatisfaction crystallised around the memory of a painting by Veronese whose richness had dismayed him the year before in Venice. The portrait that bothered him was *La Bella Nani* in the Louvre, a stately, fair-haired, pink-cheeked girl in gold-embroidered, pearl-encrusted blue velvet ("The proportions of the model were almost the same as Mme O. Moll"). At the end of the tenth sitting, Matisse set off for the long gallery

at the Louvre to check up on the painting, hurrying home to lock himself in his studio the same evening for a final showdown with Venetian sumptuosity. "Abandoning all caution, I worked on it for an hour, perhaps two, ending up with the feeling that I had been most satisfactorily delivered." Matisse explained afterwards to his sitter that what he wanted in his own painting was the grandeur of Veronese's. His procedure was remorseless. In the finished portrait (colour fig. 31), colour has been simplified, detail suppressed and design flattened so that the coarse features and massive forearms of the model rhyme with the blown-up arabesques of the *toile de Jouy* in the background. When Mme Moll came for her sitting the next day, Matisse showed her the canvas. "She was appalled by the result and asked permission to fetch her husband. I saw them completely devastated by the results of my work, which struck them as disastrous. They lamented all the golden curls and the varied colouring of the portrait."

The episode shows what Matisse meant when he said that if you make a landscape, you must paint both sun and rain. Other sitters in similar circumstances later would burst into tears, or flatly decline to accept the portrait. The Molls passed their test with flying colours. Matisse had proposed from the start to charge them at the top of his price range—1,000 francs, "pretty steep for us," said Greta—with the proviso that they need not buy the portrait if it failed to please. After two whole days spent considering their position, the Molls sent word with heavy hearts by Purrmann that they would keep their bargain. "The painting became ours, and we loved it more and more. . . . It is one of Matisse's most beautiful and powerful works," Greta wrote half a century later, quoting with satisfaction André Salmon's reaction to her portrait: "I could kill the man who owns it in order to call it mine." ¹⁵³

Greta Moll had posed in front of a huge canvas, nearly six feet high by over seven feet wide, bigger even than *Le Luxe*. This was the newly finished *Bathers with a Turtle* (colour fig. 34). Matisse had started work on it before leaving the Couvent des Oiseaux, finishing it at the Sacré-Coeur in February 1908, by which time it was already coveted by the Steins (who hesitated for lack of wall space) and by the German Karl Ernst Osthaus (whose ceramic panels were finally dispatched that month to Hagen). ¹⁵⁴ Egged on by Purrmann, Osthaus made up his mind to buy *Bathers with a Turtle* in March. In April, at the Salon des Indépendants, Matisse (who was showing nothing for the first time in six years) once again encountered the Russian collector Sergei Shchukin. At their last meeting eighteen months before, Shchukin had been buying Gauguins. Now he was ready for a fresh engagement, and had already rediscovered *Le Bonheur de vivre* at the Steins'

on the rue de Fleurus. Greta Moll remembered him arriving at 33 boulevard des Invalides to inspect the contents of the studio with his fellow Muscovite, Ivan Morosov. The two Russians each owned a single Matisse canvas from the year before (when Morosov had paid 1,000 francs for a flower piece). Bathers with a Turtle impressed them both, especially Shchukin, who tried in vain to persuade Matisse to reopen the bidding. "Your picture nearly drove the Russian crazy," Purrmann reported to Osthaus. "He kept talking about the colour, and he wanted a duplicate but Matisse refused to paint one." 157

Before Shchukin left for Moscow at the end of April, Matisse had agreed to paint a smaller picture for him on the same theme as the *Bathers* using a similar palette of soft, clear blues and greens. The painting that drove Shchukin wild with longing was perhaps the strangest work Matisse had undertaken since *Le Bonheur de vivre*. It shows three stylised, almost lifesize figures contemplating a small turtle—in fact a common Mediterranean tortoise—which provides the focal point at bottom centre of a canvas divided into three horizontal bands of colour representing grass, water and sky. The painting's allegorical overtones are intensified by the presence of the tortoise (which may be a symbol of persistence and fertility, a borrowing from Maillol's strikingly similar *Woman with a Crab*, or simply a reminder that tortoises were familiar studio and family pets in Paris at the time).

It was the austere and sombre grandeur of this enigmatic canvas that appealed to Shchukin. In the spring of 1908 the Russian was at a cross-roads in his private life much as Matisse had reached a turning point in painting. Outwardly as composed and sober as Matisse himself, Shchukin's inner balance had been destroyed by a succession of violent blows over the past three years (the suicide of his youngest son in 1905 had been followed just over a year later by his wife's sudden death, and finally by a second suicide when his younger brother shot himself in Paris in January 1908). He felt that he had lost everything that mattered in his old life, and that his efforts to fill the void by throwing himself into travel, philanthropy or business had come to nothing. In Paris he haunted the galleries in the Louvre filled with Egyptian funerary art. He told Matisse, who also loved the Egyptian galleries, that he found there the same concentrated force as in Cézanne's paintings. ¹⁶⁰

In his desolation after his wife's death, Shchukin had travelled to Egypt himself, staying in a monastery at Wadi el Der in the Sinai Desert, where he found a reproduction of one of Matisse's paintings pinned to the cell wall of a young monk, who was trying to copy it with homemade paints.¹⁶¹ This story passed into Matisse family legend. The two men rapidly established a relationship of mutual respect and trust, based initially on the intensity of Shchukin's response to *Bathers with a Turtle.* The painting is a drastically condensed and simplified version of *Three Bathers*, the canvas Matisse had been working on in Collioure when his own life was disrupted by his cousin's death the year before. "I think all the time of your ravishing *Sea*," Shchukin wrote to Matisse after his return to Moscow. "I see the painting all the time before my eyes. I can feel that freshness, that majesty of the ocean, that sense of sadness and melancholy." ¹⁶²

Matisse had produced relatively little in the winter of 1907-8, when his energies went into moving house and setting up his school. But Shchukin's visit in April was followed by a prolonged burst of activity. Matisse started work immediately on a third sea painting, once again setting three vertical bathers against flat horizontal strips of green grass, blue sky and bluer sea. This time the figures were boys playing bowls (a theme variously interpreted by critics as a symbolic game of life and death, a folkloric trio interrogating fate, or three "demiurges setting the heavenly bodies in motion"). 163 The Game of Bowls was painted lightly and fast. "Matisse has finished it, and it is very good,' Purrmann reported to Osthaus in May, "but he has no intention of parting with it." 164 Although Shchukin was often impatient, he never protested at the artist's need to reconsider or rework any given canvas. Before leaving Paris that spring, he had commissioned two further paintings, a decorative panel the same size as Bathers with a Turtle to hang in his dining room, and a second, smaller painting on the theme of Osthaus's Nymph and Satyr. 165

He had also embarked on what looked to Purrmann like a rampage, "buying up everything by Matisse he can find in Paris." Shchukin's purchases in 1908 included a Collioure landscape from Bernheim-Jeune, a still life from Berthe Weill, three canvases from Druet and two more from the Salon d'Automne. The Paris art world was stupefied by a collector prepared to shell out for artists of the modern school prices approaching those reserved for Salon painters. The sums spiralled as rumours multiplied. Even artists who did not write the Russian off as a buffoon or lunatic marked him down as a source of easy pickings. But although his patronage would transform Matisse's life from a material point of view, theirs was always an imaginative rather than a strictly commercial partnership. No other collector ever nerved Matisse to such efforts as Shchukin

did from the start. The three canvases which the artist agreed to paint for him that spring would mark a major advance after a period of consolidation and reassessment.

For the first time since he had plunged headlong into painting at the age of twenty, Matisse had found time in the past eight months to raise his eyes from the immediate struggle long enough to look back at the ground he had already covered, and forward to the unknown territory ahead. The stocktaking precipitated by his students formed part of a process begun when Mécislas Golberg had written to ask him in the summer of 1907 for a "speech for the defence" which would be elaborated over the next few months in journalistic interviews. "Notes of a Painter" would be published in its final form at the end of 1908. The essay set out his theoretical position with clarity and confidence. Matisse declared his presence in practice the same year by exhibiting in London ("Impressionism ... reaches its second childhood ... with M. Matisse, motif and treatment alike are infantile," reported the critic of the Burlington Magazine); 167 New York ("The French painter is clever, diabolically clever. . . . With three furious scratches he can give you a female animal in all her shame and horror");168 and Moscow (where bewildered Russian art-lovers reacted, as Prince Sergei Shcherbatov nicely put it, "like Eskimos to a gramophone"). 169

Shchukin's visit to Matisse's studio in April 1908 could hardly have been better timed for either of them. The Russian, who had been methodically preparing himself for years, had at last found a living painter in whose future he could believe implicitly. Matisse for his part had acquired a patron—as three years earlier he had found the Steins—at precisely the moment when his work showed signs of becoming once again unsaleable. Ever since his encounter with quattrocento fresco painting in Italy in 1907, he had been increasingly preoccupied with the decorative panels which were not only the largest but the most ambitious works he had yet attempted. His close friends found them almost impossible to judge by the standards of the time. Even Sarah Stein had hesitated over the vast, flat, daunting expanse of colour in Bathers with a Turtle. Osthaus, who had launched the series with his commission for a six-foot-wide set of painted tiles, seems to have been happier with the notably conventional treatment of the ceramic Nymph and Satyr than with Matisse's rigorous new manner. At all events, although he bought one more flower painting, and there was talk of his commissioning a stained-glass decoration as late as 1911, he took no more risks with Matisse after Bathers with a Turtle. 170

Shchukin had not only desired this canvas passionately at first sight but, when he found he could not have it, immediately commissioned another on the same grand scale. This second decorative panel was to be predominantly blue in order to hold its own against the glowing yellows of the sixteen Gauguins which hung frame to frame in Shchukin's Moscow dining room. The painting would test Matisse's powers to the limit, and for it he returned to the subject he had chosen a decade earlier, when Gustave Moreau had also demanded a test piece: The Dinner Table (La Desserte). All the old motifs reappear in the new Desserte: the window, the upright chairs, the tabletop filling the bottom section of the canvas, the napery, the fruit and flowers, the decanters of red and white wine, the maid in her dark dress and white apron. But this time the subject or essential fabric of the painting is the tablecloth itself, none other than the length of toile de Jouy which had already imparted its energy to several still lifes as well as to the newly finished portrait of Greta Moll. Posing for that painting had been a lesson in colour composition for the sitter, who sensed rather than saw her white blouse turn green on canvas one day, and blue the next, as a living harmony of colour grew beneath the painter's hand. 171 The blue ground of the toile de Jouy, with its pattern of arabesques and flowerbaskets, still contained within the confines of a backcloth in the portrait, overflowed to cover almost the entire surface of the canvas in the new Desserte, or Harmony in Blue.

Matisse worked on what he called his "big still life" on and off throughout the summer of 1908. The family pattern of migration southwards was disrupted that year by the illness of Amélie's mother, who grew steadily weaker, nursed by her two daughters in Berthe's tiny house in Perpignan. Matisse stayed behind in his new studio in Paris to complete the commissions for Shchukin. Intense concentration alternated with fits of unrest. For once he could not fall back on Marquet, always a safe companion in Matisse's flights from the demons of doubt and dissatisfaction. Still devastated by the death of his own mother, Marquet had fled Paris to join the Manguins, who were travelling through Italy. Matisse, escaping briefly from the city streets to Dieppe, concocted a series of saucy seaside postcards designed to test the conjugal complacency of the faithful Manguin. "Out of sight, out of mind. Adèle" ran the caption beneath a luscious bathing beauty dispatched to Manguin c/o the Steins in Florence. 172 Another, addressed to Marquet, showed two plump young bathers, all breasts and buttocks, with a curt message on the back: "Kindly exchange this card for the one sent today in error to Monsieur Henri." Manguin's card pictured yet another smiling young woman with a swarm of babies at her back, and the warning: "This is what awaits you if you come back to France without having learned more sense."

Matisse always needed urgently to be distracted in the wake of great exertion. When the school closed for the summer, he set off for a quick trip to Germany with Purrmann, ending up in the latter's hometown of Speyer. "The beer is good, and so are the cigars but the wines!!!" he wrote plaintively to Manguin on 12 June. "It's been very amusing and very exhausting. It hasn't exactly been a grand ducal tour but it's been fun all the same. . . . The best part was that we managed to put in some serious drinking." Purrmann welcomed Matisse to his old studio at the Munich art school, finding a model for him to draw, and moving on with him to Nuremberg to see the old town and the German National Museum before meeting the Molls at Heidelberg, where Matisse decorated three vases at a local pottery. ¹⁷³

Back in Paris by the middle of the month, Matisse completed his *Harmony in Blue*, which was approved by Vollard and photographed on 6 July by Eugène Druet.¹⁷⁴ In the course of the next month the whole painting was repainted red (colour fig. 35). As the grandson and great-grandson of weavers who tried out their designs as a matter of course in first one colour, then another, Matisse insisted this was perfectly normal procedure, explaining to his old friend Henri Cross that colour was the driving force in his experiments at this stage. Cross replied that he dared not venture an opinion on the strength of Druet's photograph ("Rumour says the dominant colour is a powerful red?!"), adding cautiously that he got "the strong sense of a highly ornamental tapestry."¹⁷⁵ When a visitor to the studio observed that the re-working had produced a different painting, Matisse said testily: "He doesn't understand a thing. It's not a different painting. I am seeking forces, and a balance of forces."¹⁷⁶

Almost the entire surface of the canvas, more than forty square feet, was now saturated in red paint: an even, unaccentuated red seeping like a dye from the flattened tabletop to the wall beyond it, the whole bound together by an overall design in which everyday objects—apples, oranges, lemons, decanters, the elaborate epergne, even the maid fiddling with the fruit stand—submerge their individuality like instruments in an orchestra within the looping rhythms of the cloth's blue arabesques. Textiles in Matisse's native region went hand in hand with radical innovation. Harmony in Red used the richly decorative tradition into which Matisse was born as a means of overturning the Beaux-Arts ethic which, from his first days at art school, had sought to demean and diminish his commitment to pure colour. "With him it's not colour," André Derain would repeat sourly in middle age, by which time he had long since repudiated his old

partner and the discoveries they had made together at Collioure: "it's dyework, they used to call him the dye-worker (*le teinturier*)." ¹⁷⁷

When Shchukin saw his eagerly awaited Harmony in Blue for the first time in Paris that autumn, he had no problem with the fact that it had become a Harmony in Red. His acceptance was put down at the time and since to his being a Russian, rash, uncouth, ill educated, "familiar with the bloodred of the old Russian icons." ¹⁷⁸ But Shchukin was also by trade, as Matisse said himself, "a Moscow importer of Oriental textiles." ¹⁷⁹ He had inherited from his father in 1890 a thriving business dealing in wool and cotton goods, which had grown under his management into a textile empire, one of the leading industrial concerns in Russia. Trained in European textile centres, a regular visitor to the annual trade fair with the Orient at Nizhni Novgorod, he had quartered India and Asia in search of new ideas and outlets. In Moscow he was accustomed to select fabrics and to supervise in person the teams of artists and designers employed by I. V. Shchukin & Sons. 180 Shchukin understood instinctively the syntax of the new pictorial language Matisse was evolving. Freshness and nobility were the qualities he prized most highly in Matisse's work in the summer of 1908. When the still life that was to have complemented the Gauguins in his dining room threatened to overwhelm them altogether, he hung it in an anteroom instead, explaining to visitors that he liked to imagine its blue lines careering off the edges of the canvas across his walls and on into infinity beyond. ^{ISI}

Looking back as soon as he emerged from his absorption in *Harmony in Red*, Matisse said that the painting seemed to have swallowed up the summer. "I see with horror that the Salon d'Automne is looming," he wrote to Shchukin on 6 August, "for I haven't got, and shan't have, all I meant to be able to show there, the big still life has taken up so much of my time; but since I am content with the outcome, I tell myself one can't hope to be fast as well as good." ¹⁸² Shchukin's commissions brought the two men close both professionally and personally. Matisse's laconic letters, reporting progress and setbacks, were punctuated by bad news from Perpignan, where his mother-in-law lay hovering between life and death all through May and June. He was wrestling with the transposition from blue to red when she died in late July. The idiom of loss and grief was another language Shchukin understood. "My wife, who is still in the period of moral turmoil that comes of losing her mother, whom she dearly loved, is very touched by your message," Matisse wrote at the end of his August letter.

The death of Mme Parayre drew a line beneath the Humbert scandal, which had fatally damaged her belief in herself and come close to destroy-

Amélie Matisse in mourning for her mother

ing her family. The affair was never again voluntarily mentioned by Matisse's friends or relations, but its legacy ran deep, leaving to succeeding generations a residue of loathing and contempt for anything that could be construed as an invasion of privacy. Mme Parayre's defiance of her tormentors in the press lived on in her descendants. So did her proud policy of silence, discretion and inscrutability, which came in the long run to seem more like bourgeois tightness to a world that had no inkling of anything hidden below the surface of the past. Matisse, like his wife, had loved his parents-in-law, and done everything in his power to protect them in time of need. But the private trauma round which the family closed ranks in self-defence would insidiously damage his public reputation. The traditional view that acknowledges Matisse's greatness as a painter while simultaneously belittling him as a human being—representing him as self-regarding, coldhearted and mean-spirited—goes back largely to a collective urge for concealment so strong that when Mme Parayre went to her grave, her secret remained buried with her for another ninety years.

In August 1908 the Matisses returned to Paris. Work resumed in the studio on submissions for the Salon d'Automne. Matisse broke off at intervals for jaunts with Marquet to see an American dance troupe, the Darlings, at the Bal Tabarin, or snatch a breath of country air outside Paris at Poissy or Fontainebleau. In September it was his turn and Marquet's for jury service at the Salon. Georges Braque, about to embark on a partnership with Picasso that would change the ground rules for all other artists, had every one of his canvases rejected. Matisse, attempting to describe one of them to the critic Louis Vauxcelles, sketched an arrangement of converging straight lines and crossbars: "It's made of little cubes," he said in a phrase history never forgot. 183

At the end of the month, with the jury's deliberations over, Matisse and Marquet made a brief dash southwards to Biarritz and over the border into Spain. "En route for Madrid," Matisse wrote to Manguin on 20 September from San Sebastián: "Toros, Grecos, Velasquezos y Goya-os. Amitieros—H. Matissos." This was wishful thinking for in fact the pair took the train back to Bordeaux, where Marquet had been born, and where his mother now lay buried. It was typical of them both to enliven this melancholy visit with a fresh volley of postcards boasting of still wilder schemes to set sail for Dakar and Zanzibar, where Manguin was cordially invited to join them. "Bring old father Signac with you, and we'll feed him to the cannibals." ¹⁸⁴

Signac could forgive neither the depth of treachery laid bare in the work of his former friends nor the speed with which Fauvism had eclipsed Neo-Impressionism as the latest rage in Paris. The Salon d'Automne opened on 1 October. Urged on by his friends, Matisse had exercised his right as a jury member to unlimited showing, putting together what amounted to his third one-man exhibition: eleven paintings, thirteen sculptures and seven drawings. All but two or three canvases represented his latest work. The centrepiece was *Harmony in Red*, exhibited as *Decorative Panel for a Dining Room*. "Suddenly I stood in front of a wall that sang, no, screamed, colour and radiated light," wrote a young Scandinavian, Isaac Grünewald, encountering Matisse's work for the first time (he enrolled immediately at the Matisse school), "something completely new and ruthless in its unbridled freedom..."

Matisse's detractors had for the moment lost their bite and vim. Most, more or less reluctantly, conceded his preeminence. Bernard Berenson, invited by Sarah Stein to meet the artist, sent his wife a rapturous description of the evening they spent together at 58 rue Madame. "He talks as if he had never done anything but look and reflect. I cannot tell you how

startlingly like to mine all his faculties and principles are, with the great advantage on his side of an infinitely more experienced and detached feeling for design. One felt in contact with a being of astonishing vigour, entirely absorbed in art."¹⁸⁶ A month later Berenson publicly announced his conversion in a letter defending Matisse in the New York *Nation.*¹⁸⁷ It was a triumph for Sarah's strategic skills. If Leo and Gertrude had reintroduced Shchukin to *Le Bonheur de vivre*, it was Sarah who pointed the way as a Matisse collector. Shchukin's early letters to the painter are peppered with references to Mme Stein's pictures, and to his desire to match her collection. Shchukin owned in the end thirty-seven Matisses, almost exactly the same number as passed through Sarah's hands. His great house in Moscow, thrown open to the public on a regular basis, would offer in the years before the Revolution the world's richest and most comprehensive display not only of Matisse but of the modern school of Paris.

It was Matisse who took Shchukin in the autumn of 1008 to inspect Picasso's Les Demoiselles d'Avignon at the Bateau Lavoir. 188 Initially appalled by what he saw, Shchukin would become—as Picasso's Cubism grew harsher and more exacting over the next few years—one of his few dependable collectors. Although their dealings never took on the warmth of his relations with Matisse, Shchukin set himself to grasp and penetrate Picasso's work. The initial introduction was typical of Matisse's habitual generosity. His correspondence with friends and acquaintances is full of small, unpublicised acts of support: he helped to guide their submissions past the Salon jury, offered to hang or sell their work, frequently arrived himself in their studios with encouragement, and, especially in the precarious early years, made a point of persuading his own potential patrons to come with him to look at the work of struggling younger artists. Manguin, Marquet, Puy and Derain himself all owed their success with Vollard in the first instance to Matisse, who watched over the careers of painters as different from himself as Jean Biette, Maurice Boudot-Lamotte and Picasso's friend, the Spaniard Francisco Iturrino. 189

The Matisses' own circumstances were easier by this time, although still far from secure. Relative affluence had not changed the family priorities. Matisse had bought a Renoir from Druet in August, and on 26 October Vollard sold him six watercolours by Cézanne. In the excitement of Shchukin's first purchases, Amélie Matisse confided to Greta Moll that she had bought bedsheets for her household at the Bon Marché department store. Matisse had also set off for town in the opposite direction on the same day: a wonderful Persian carpet had been too much for him.

He couldn't get the pattern out of his head. 'What a beauty! so beautiful!' "¹⁹¹ After living for twenty-four hours with this refrain, Amélie, who knew as well as her husband that their budget would not stretch to cover both sheets and carpet, returned her purchase and claimed a refund. It was the story of the blue butterfly all over again. Amélie's commitment to her husband's work remained as absolute as his own. Matisse got his magic carpet. Greta remembered him sitting in front of it for a whole evening, puffing contentedly on a cigar, contemplating the colours and patterns which he would shortly transmute on canvas into the beautiful *Still Life in Venetian Red*.

The old charges of fairground trickery and clowning surfaced again that autumn in a diatribe against Matisse by Joséphin Péladan. ¹⁹² Known as "the Sâr," an orator and self-styled mage, part genuine aesthete, part theatrical mountebank, Péladan enjoyed performing arcane rituals in crimson brocaded robes with lilies, bells and candles. Vollard remembered sitting spellbound at a lecture given by Péladan in Nîmes which began: "Citizens of Nîmes, all I have to do is pronounce a certain formula for the ground to open and engulf you all..." Péladan reproached the Fauves for wearing conventional dark suits like so many department-store floorwalkers. "Does genius depend on so little?" wrote Matisse. "If it's me he's worried about, M. Péladan may rest easy. I will call myself Sâr tomorrow, and dress up like a necromancer." ¹⁹⁴

Péladan's article appeared in the Revue Hebdomadaire on 17 October. It still rankled two months later when Matisse tacked his reply onto the end of the revised "Notes of a Painter," scheduled for publication at last in the prestigious Grande Revue. Matisse's essay was preceded by a sympathetic preface from the paper's new arts editor, Georges Desvallières, Moreau's old friend who had defended Matisse for years as second-in-command to Jourdain at the Salon d'Automne. The "Notes" appeared on 25 December 1908. For the second year running, Matisse was spending Christmas with the Molls, this time in Berlin, where he had arrived at the last minute with Purrmann in hopes of resolving a row over his proposed showing at Cassirer's gallery. 195 This was to have been a compromise solution to the deadlock that arose when Matisse's name was struck off a list drawn up by Purrman for a Berlin Secession exhibition of contemporary French art. But neither Cassirer nor his associates were prepared for what they found when they unpacked the crates dispatched from Paris (the selection centred round the Blue Nude together with Shchukin's Harmony in Red, making its last stop in western Europe on the way to its permanent home in Russia). Banished to an annexe, Matisse's work sickened and dismayed even the doughtiest of Post-Impressionist supporters. Private indignation spilled over into outrage in the press.

Matisse told Purrmann that the whole episode brought back bitter memories of hostilities in Paris eleven years earlier, the worst time of his life, an ordeal he hoped had been put behind him for good ("How many attacks from every side would still have to be beaten back!"). ¹⁹⁶ Strategic planning was needed to win over critical opinion, and Greta Moll set to work immediately on a German translation of "Notes of a Painter." She and her husband organised a consoling Christmas dinner (their guests included a leader-writer from the *Blaubuch*, himself facing a prison sentence for sedition), which got off to a sticky start on account of Matisse's evident perturbation, and inability to speak the language. But with sympathy, affection, rich food, good wines and simultaneous translation all round the table, he relaxed sufficiently for the whole party to take him to their hearts. ¹⁹⁷

Matisse was a week short of his fortieth year. For the first time in the two decades since he had become a painter, he could propose a tentative toast to the future. However much abuse he still had to endure at the hands of the press, the public and the art establishment, he could count as always on his family, especially his wife and daughter. He had the support of a small but vigorous band of activists headed by Sarah Stein, Purrmann and the Molls. He already knew that Shchukin's backing would open the inner doors of his creative energy. Perhaps even more important, he had found in Picasso a rival whose phenomenally swift reactions and implacably demanding eye would challenge him to the limit. Above all, he had learned to contain and channel in his work the chaotic, choking surges of ungovernable emotion that had made him a painter in the first place.

"If there is order and clarity in the picture," Matisse explained, paying tribute to Cézanne in "Notes of a Painter," "it means that from the outset this same order and clarity existed in the mind of the painter, or that the painter was conscious of their necessity." This is the core of the rigorous theory of abstraction formulated in the "Notes," explored in practice in the portrait of Greta Moll, and taken further still in *Harmony in Red.* "I try to put serenity into my pictures, and to rework them as long as I have not succeeded in doing so," wrote Matisse.

Suppose I want to paint a woman's body: first of all, I imbue it with grace and charm, but I know that I must give it something more. I will concentrate the meaning of this body by seeking its

essential lines. The charm will be less obvious at first glance, but it must eventually emerge from the new image I have obtained, which will have a broader meaning, and one more fully human.... A rapid rendering of a landscape represents only one moment of its existence. I prefer, by insisting on its essential character, to risk losing charm in order to obtain greater stability. 199

At the beginning of a century of unprecedented disruption and dispersal, Matisse dreamed of "an art of balance, purity and tranquillity, free from any nagging or disturbing element," an art that would offer his contemporaries an antidote to the tensions of the workplace or the office.²⁰⁰ He said that art should be as soothing as a good armchair, a metaphor that has done him more harm ever since than any other image he might have chosen. In fact, this passage reflects its obverse-Matisse's intimate acquaintance with violence and destruction, a sense of human misery sharpened by years of humiliation, rejection and exposure—which could be neutralised only by the serene power and stable weight of art. In Harmony in Red—and yet more in its immediate successors, Dance and Music of 1909—Matisse's work approaches the emotional intensity and purity of music. By the time European painting reached this point again, his three canvases had been dispatched to Russia, where history would ensure that they spent the central decades of the twentieth century shut up in a Soviet cellar. The grand scale, and underlying stillness, of Matisse's decorative panels would be fully matched only in the brilliantly coloured cut-paper decorations he made at the end of his life; and perhaps also in the great meditative canvases produced by the American Abstract Expressionist Mark Rothko, at much the same time in the 1940s and 1950s. It would take longer still for the inner logic of Matisse's living colour to be grasped and understood intuitively by the public, as he had always hoped it would be.

KEY TO NOTES

ABBREVIATIONS

Archives de l'Ecole des Beaux-Arts, Paris ADN Archives Départementales du Nord, Lille AM Amélie Matisse AMP Archives Matisse, Paris AN Archives Nationales, Paris Armand Paravre ASM L'Avenir de Seine et Marne, Melun DT La Dépêche, Toulouse GC Getty Center for the History of Art, Santa Monica, California GT Gazette des Tribunaux, Paris HM Henri Matisse JPM Archives Jean-Pierre Manguin, Avignon IR Journal de Rouen ISO Journal de St-Quentin MNAM Musée National d'Art Moderne, Paris MoMA Museum of Modern Art, New York MP Le Matin, Paris PMF Pierre Matisse Gallery Archives, Pierpont Morgan Library, New York TT Le Télégramme, Toulouse

SHORTENED REFERENCES
TO BOOKS, EXHIBITION
CATALOGUES, ARTICLES,
TAPE RECORDINGS AND
UNPUBLISHED MANUSCRIPTS

Aragon 1 & 2 Henri Matisse: A Novel by Louis
Aragon. Vols. 1 and 2. Translated by Jean Stewart.
London, 1972.

Ardouin 18, 19 & 37 Voyage en France by Victor Ardouin-Dumazet. 18e série, Région du Nord I: Flandre et le littoral du Nord; 19e série, Région du Nord II: Artois, Cambrésis et Hainaut; 37e série, Le Golfe de Lion. Paris and Nancy, 1899 and 1904.

Aubéry Mécislas Golberg: Anarchiste et décadent, 1868–1907. Biographie intellectuelle suivie de fragments inédits de son journal by Pierre Aubéry. Paris, 1978.

Bacou Odilon Redon by Roseline Bacou. Vol. 1. Geneva, 1956.

Bailly-Herzberg Correspondance de Camille Pissarro. Vol. 4, 1895–1898. Edited by Janine Bailly-Herzberg. Paris, 1989.

Bantens Eugène Carrière: The Symbol of Creation by Robert James Bantens. New York, 1990.

Barou Matisse, ou Le Miracle de Collioure by Jean-Pierre Barou. Montpellier, 1997.

Barr Matisse: His Art and His Public by Alfred H. Barr, Jr. New York, 1951.

Benjamin Matisse's "Notes of a Painter": Criticism, Theory and Context, 1891–1908 by Roger Benjamin. Ann Arbor, Michigan, 1987.

Bernardi Matisse et Derain à Collioure, été 1905 by François Bernardi. Musée de Collioure, 1989.

Bernier tapes "Conversations with Pierre Matisse." Tape-recorded by Rosamond Bernier in 1986.

Besson Marquet by Georges Besson. Paris, 1920. Billy La Terrasse du Luxembourg by André Billy. Paris, 1945.

Blake *The Art and Craft of Drawing* by Vernon Blake. London, 1927.

Bock Henri Matisse and Neo-Impressionism, 1898–1908 by Catherine C. Bock. Ann Arbor, Michigan, 1981 (1977).

Boudot-Lamotte 1 "Souvenirs sur Henri Matisse" by Maurice Boudot-Lamotte. *Revue Palladienne*, no. 13 (Dec.–Jan. 1950–51).

Boudot-Lamotte 2 "Souvenirs, 1897–1902" by Maurice Boudot-Lamotte. Unpublished memoir, 1950, Archives Marie-Thérèse Laurenge, Paris. Boudot-Lamotte 1979 Hommage à Maurite Boudot-Lamotte (1878–1958): Peintre et collectionneur by Marie-Madeleine Aubrun. Ex. cat., Musée Départementale de l'Oise, Beauvais, 1979.

Brunt "Auguste Bréal" by Martin Brunt. Unpublished biographical documentation, Brunt archives, London.

Buck The Patriot by Pearl Buck. London, 1937.
Bury Palliser Brittany and Its Byways by Mrs. Bury
Palliser. London, 1869.

Bussy Unpublished letters from HM to Simon Bussy, Musée du Louvre, Paris (photocopies in Courtauld Institute, London).

Bussy 1996 Simon Bussy (1870–1954): L'Esprit du trait, du 200 à la gentry by Philippe Loisel. Ex. cat., Musée Départementale de l'Oise, Beauvais, 1996.

Bussy, J. S. "A Great Man" by Jane Simone Bussy.

Burlington Magazine, vol. 128, no. 995 (Feb. 1986).

Cachin Paul Signat by Françoise Cachin. Paris, 1971.
Caillebotte Gustave Caillebotte, 1848–1894 by Anne
Distel et al. Ex. cat., Grand Palais, Paris, and Art
Institute of Chicago, 1994–95.

Carco L'Ami des peintres by Francis Carco. Paris,

Carrière 1970 Eugène Carrière, 1849–1906. Ex. cat., Marlborough Fine Art, London, 1970.

Carrière 1996 Eugène Carrière 1849–1906 by Rodolphe Rapetti. Ex. cat., Musées de Strasbourg, 1996.

Cavailhon La Fascination magnétique by Edouard Cavailhon. Preface by Donato. Paris, 1882.

Cazeau Maximilien Luce by Philippe Cazeau. Paris, 1982.

Cerf Essai sur l'histoire de Bohain et ses seigneurs by Adalbert Cerf. Bohain, 1902.

Cézanne 1995 Cézanne by Françoise Cachin et al. Ex. cat., Grand Palais, Paris, Tate Gallery, London, and Philadelphia Museum of Art, 1995–96.

Cladel Aristide Maillol: Sa Vie, son oeuvre, ses idées by Judith Cladel. Paris, 1937.

Claretie La Vie à Paris, 1901–3 by Jules Claretie. Paris, 1904.

Collectors Morozov and Shehukin: The Collectors by Georg-W Költzsch. Ex. cat., Museum Folkwang, Essen, 1993; Pushkin Museum, Moscow, and Hermitage, St. Petersburg, 1994.

Combeau "Anecdotes et souvenirs" by Paul Combeau. Société Agricole, Scientifique et Littéraire des Pyrénées-Orientales (Perpignan), no. 75 (1960).

Compin Henri Edmond Cross by Isabelle Compin. Paris, 1964.

Coquio Mécislas Golberg (1869–1907): Passant de la pensée. Une Anthropologie politique et poétique au début du siècle. Edited by Catherine Coquio. Paris, 1994.

Courthion "Conversations avec Henri Matisse" by Pierre Courthion. Unpublished ts., Getty Center for the History of Art, Santa Monica,

Cousturier 1 Paul Signac by Lucie C. Cousturier. Paris, 1922.

Cousturier 2 Henri Edmond Cross by Lucie C. Cousturier. Paris, 1932.

Couturier La Chapelle de Vence: Journal d'une création by Henri Matisse, M. A. Couturier and L. B. Rayssiguier. Paris, 1993.

Cowart "Ecoliers" to "Fauves": Matisse, Marquet, Manguin. Drawings, 1890–1906 by J. W. Cowart. Ann Arbor, Michigan, 1972.

Crespellé Montmartre Vivant by J. Crespellé. Paris, 1964.

Dagen Pour ou contre le fauvisme: Textes de peintres, d'écrivains et de journalistes. Edited by Philippe Dagen. Paris, 1994.

Denis Théories by Maurice Denis. Paris, 1920 (1913).

Derain Lettres à Vlaminek by André Derain. Edited by Philippe Dagen. Paris, 1994 (1955).

Derain 1994 André Derain: Le Peintre du "trouble moderne" by Suzanne Pagé et al. Ex. cat., Musée d'Art Moderne de la Ville de Paris, 1994.

Devigne "Le Peintre Henri Matisse" by Arthur Devigne. St-Quentin Soir, July 1931.

Diehl Henri Matisse by Gaston Diehl. Paris, 1954. Dodeman Trois conférences sur la ville de Bohain by E. Dodeman. Bohain, 1899.

Duthuit Les Fauves by Georges Duthuit. Geneva, 1949.

Escholier *Matisse, ce vivant* by Raymond Escholier. Paris, 1956.

Evenepoel 1 & 2 Lettres à mon père by Henri Evenepoel. Vol. 1, 1892–1895, and vol. 2, 1896–1899. Edited by Danielle Derrey-Capon. Brussels, 1994.

Falguère Nos Villes maritimes. Collioure: Notice historique by l'Abbé Joseph Falguère. Perpignan, 1898.

Fauve Landscape The Fauve Landscape by Judi Freeman. Ex. cat., Los Angeles County Museum of Art, 1990.

Flam 1 Matisse: The Man and his Art, 1869–1918 by Jack D. Flam. London, 1986.

Flam 2 Matisse on Art by Jack D. Flam. University of California Press, 1995 (1973).

Flam 3 Matisse: A Retrospective. New York, 1988.
Flamant 1 "Le Peintre Henri Matisse" by Emile Flamant. Bulletin de Documentation Municipal (Bohain), May 1965 and February 1967.

Flamant 2 "Croquis fresnoysiens" by Emile Flamant. Ms. memoirs (some published in the Bulletin Municipal de Fresnoy), Archives Municipales, Fresnoy-le-Grand.

Flandrin Jules Flandrin (1871–1947): Un Élève de Gustave Moreau témoin de son temps by Georges Flandrin and François Roussier. Paris, 1992.

- Fosca Simon Bussy by Francis Fosca. Paris, 1930.
 Four Americans Four Americans in Paris: The Collections of Gertrude Stein and her Family by Margaret Potter. Ex. cat., MoMA, 1970.
- Fourcade Henri Matisse: Ecrits et propos sur l'art. Edited by Dominique Fourcade. Paris, 1972.
- Galbally The Art of John Peter Russell by Ann Galbally. Melbourne, 1977.
- Garnett "Early Work of Simon Bussy" by Oliver Garnett. Unpublished thesis, Courtauld Institute, London, 1980.
- Gautherie-Kampka Les Allemands du Dôme: La Colonie allemande de Montparnasse dans les années 1903–14 by Annette Gautherie-Kampka. Bern, 1995.
- Giraudy Camoin: Sa vie, son oeuvre by Danielle Giraudy. Paris, 1972.
- Goupil Manuel général et complet de la peinture à l'huile by Frédéric Goupil. St-Quentin, 1884 (1877).
- Gowing Matisse by Lawrence Gowing. London, 1979.
- Grammont Correspondance entre Charles Camoin et Henri Matisse. Edited by Claudine Grammont. Lausanne, 1997.
- Grunfeld Rodin by Frederic V. Grunfeld. London, 1988.
- Halperin Felix Fénéon: Aesthete and Anarchist in Fin-de-Siècle Paris by Joan Ungersma Halperin. Yale University Press, 1988.
- Hanotaux Mon temps I: De l'Empire à la République by Gabriel Hanotaux. Paris, 1933.
- Hudson For Love of Painting: The Life of Sir Gerald Kelly, KCVO, PRA by Derek Hudson. London, 1975.
- Humbert Thérèse intime: Souvenirs de Mme X, anon. Paris, 1903.
- Jelenko "Reminiscences" by Thérèse Jelenko. ts, Bancroft Library, University of California, Berkelev.
- Jourdain Sans remords ni rancune by Francis Jourdain. Paris, 1953.
- Kean French Painters, Russian Collectors: The Merchant Patrons of Modern Art in Pre-Revolutionary Russia by Beverly Whitney Kean. London, 1994 [revised ed. of All the Empty Palaces, London, 1983].
- Klüver Kiki's Paris: Artists and Lovers, 1900–1930 by Billy Klüver and Julie Martin. New York, 1994 (1989).
- Kostenevich Collecting Matisse by Albert
 Kostenevich and Natalya Semyonova. Paris, 1993.
- Lavrillier Bourdelle et la critique de son temps by Carol Marc Lavrillier and Michel Dufet. Paris, 1979.
- Lemire "Le Souvenir de Matisse à St-Quentin." Interview with Gaston Lemire. L'Aisne Nouvelle, 16 Nov. 1954.
- Level Souvenirs d'un collectionneur by André Level. Paris, 1959.

- Lévy Des Artistes et un collectionneur by Pierre Lévy. Paris, 1976.
- Levy H "Reminiscences" by Harriet Levy. ts, Bancroft Library, University of California, Berkeley.
- Maclaren Ottilie Maclaren Papers, National Library of Scotland, Edinburgh.
- Mainssieux *Lucien Mainssieux*, 1885–1958 by Isabelle Experton and François Roussier. Grenoble, 1985.
- Manguin Henri Manguin: Catalogue raisonné de l'oeuvre peint by Marie-Caroline Sainsaulieu. Neuchatel, 1080.
- Manguin 1983 Manguin parmi les fauves by Pierre Gassier. Ex. cat., Fondation Pierre Gianadda, Martigny, 1983.
- Manguin 1988 Henri Manguin, 1874–1949. Ex. cat., Musée Marmottan, Paris, 1988.
- Marquet Marquet by Marcelle Marquet. Paris, 1952.
- Marquet 1975 Albert Marquet, 1875–1947. Ex. cat., Galerie des Beaux-Arts, Bordeaux, and Musée de l'Orangerie, Paris, 1975–76.
- Martel 1991 Eugène Martel, 1869–1947: Redécouverte d'un peintre moderne by Geneviève Colomb and Pierre Martel. Ex. cat., Musée Louis Vouland, Avignon, 1991.
- Martin The Hypocrisy of Justice in the Belle Epoque by Benjamin F. Martin. Louisiana, 1984.
- Marval Jacqueline Marval (1866–1932): A Retrospective. Ex. cat., Crane Kalman Gallery, London, 1989.
- Mathieu Tout l'oeuvre peint de Gustave Moreau by Pierre-Louis Mathieu. Paris, 1991.
- Matisse Sculpture Matisse: Catalogue raisonné de l'oeuvre sculpté by Claude Duthuit with the collaboration of Wanda de Guébriant. Paris, 1997.
- Matisse 1970 Henri Matisse: Exposition du centenaire by Pierre Schneider. Ex. cat., Grand Palais, Paris,
- Matisse 1988 Matisse und seine deutschen Schuler by Gisela Fiedler-Bender. Ex. cat., Pfalzgalerie, Kaiserslautern, Germany, 1988.
- Matisse 1992 Henri Matisse: A Retrospective by John Elderfield. Ex. cat., MoMA, New York, 1992.
- Matisse 1993 Henri Matisse, 1904–1917 by Dominique Fourcade and Isabelle Monod-Fontaine. Ex. cat., MNAM, Paris, 1993.
- Maupassant Pierre et Jean by Guy de Maupassant. Paris, 1888.
- Menpes Brittany by Mortimer Menpes. London, 1905.
- Mirbeau Aristide Maillol by Octave Mirbeau. Paris, 1921.
- Moll "Erinnerungen an Henri Matisse" by Margarete Moll. In Matisse 1988, pp. 41–6.

Moreau Gustave Moreau, sa vie, son oeuvre: Catalogue raisonné de l'oeuvre achevée by Pierre-Louis Mathieu. Fribourg, 1976.

Murdoch Portrait of Sir John Longstaff When Young by Nina Murdoch. Sydney and London, 1948.

Neff "Matisse and Decoration, 1906–1914: Studies of the Ceramics and the Commissions for Paintings and Stained Glass" by John Hallmark Neff, ts thesis, Harvard University, April 1974.

Olivier *Picasso et ses amis* by Fernande Olivier. Paris, 1973 (1933).

Onfray Russell, ou La Lumière en héritage by Claude-Guy Onfray. Paris, 1995.

Ozenfant Mémoires, 1886–1962 by Amédée Ozenfant. Paris, 1968.

Pach Queer Thing Painting: Forty Years in the World of Art by Walter Pach. New York, 1938.

Pétréaux Notice sur la ville de Bohain by Joseph Pétréaux. Paris, 1900 (1897); reprinted 1993.

Picard Résumé d'étude sur la ville de St-Quentin, son commerce et ses industries by C. Picard. St-Quentin, 1880.

Plouchard Le Département de l'Aisne à l'Exposition Universelle de Paris en 1900 by Eugène Plouchard. JSQ, publication locale no. 10, 1901.

Poncin Promenades dans Ajaccio: Spassighjati in Aiacciu by Lucette Poncin. Ajaccio, 1995.

Puy "Souvenirs" by Jean Puy. Le Point, July 1939.Puy 1988 Retrospective Jean Puy. Ex. cat., Musée Déchelette, Roanne, 1088.

Richardson 1 and 2 A Life of Picasso: Volume 1, 1881–1906 and Vol. 2, The Painter of Modern Life, 1907–1917 by John Richardson. London and New York, 1991 and 1996.

Rosenshine "Life's Not a Paragraph" by Annette Rosenshine. ts, Bancroft Library, University of California, Berkeley.

Rothenstein Men and Memories: Recollections of William Rothenstein, 1872–1900. London, 1931.

Roux-Champion 1991 V.J. Roux-Champion, 1872–1953 by C. Puget. Ex. cat., Musée de Pont-Aven, 1991.

Russell "John Peter Russell" by Dorothy Stobart Russell. Unpublished memoir, Russell archive.

Russell 1997 John Peter Russell: Un Impressionniste australien by Patrick Jourdan. Ex. cat., Musée des Jacobins, Morlaix, 1997.

St-Quentin 1988 St-Quentin et ses artistes du 19e siècle by Christine Debrie. Ex. cat., Musée Antoine Lecuyer, St-Quentin, 1988.

Salmon 1 and 2 Souvenirs sans fin: Première Époque (1903–1908) and Deuxième Epoque (1908–1920) by André Salmon. Paris, 1955 and 1956. Salter The Lost Impressionist: A Biography of John Peter Russell by Elizabeth Salter. London, 1976.

Schneider Matisse by Pierre Schneider. Translated by Michael Taylor and Bridget Strevens Romer. London, 1984.

Séverin L'Ecole de La Tour: Ecole royale gratuite de dessin fondée à St-Quentin par Maurice Quentin de La Tour, 1782–1975 by Monique Séverin. St-Quentin, 1993.

Signac D'Eugène Delacroix au néo-impressionisme by Paul Signac. Edited by Françoise Cachin. 1978 (1964).

Signac 1992 Signac et St-Tropez, 1892–1913. Ex. cat., Musée de l'Annonciade, St-Tropez, 1992.

Signac 1997 Signac et la libération de la couleur: De Matisse à Mondrian. Edited by Erich Franz. Ex. cat., Musée de Grenoble, 1997.

Simon Mignet, Michelet, Henri Martin by Jules Simon. Paris, 1890.

Slatkin Aristide Maillol in the 1890s by Wendy Slatkin. Ann Arbor, Michigan, 1976.

Soulier Etudes sur Collioure et ses environs by Dr. Sériziat and Paul Soulier. Perpignan, 1902.

Stein The Autobiography of Alice B. Toklas by Gertrude Stein. Penguin Modern Classics, London, 1966 (1933).

Stein L Appreciations: Painting, Poetry & Prose by Leo Stein. New York, 1947.

Tabarant Maximilien Luce by A. Tabarant. Paris, 1028.

Terrus 1994 Terrus by Madeleine Raynal. Ex. cat., Musée Terrus, Elne, 1994.

Tisserands 1993 Tisserands de légende: Chanel et le tissage en Picardie Ex. cat., Abbaye de Royallieu, Compiègne, 1993.

Vachon William Bouguereau by Marius Vachon. Paris, 1900.

van Gogh Further Letters of Vincent Van Gogh. Edited by Joanna Bonger. London, 1929.

Varenne Bourdelle par lui-même. Edited by G. Varenne. Paris, 1937.

Vlaminck Portraits avant décès by Maurice de Vlaminck. Paris, 1942.

Vollard Souvenirs d'un marchand de peinture by Ambroise Vollard. Paris, 1984 (1937).

Weber "On Matisse's School" by Max Weber. Lecture text, MoMA, New York, 1951. In Flam 3, pp. 90–103.

 Weill Pan! Dans l'oeil! by Berthe Weill. Paris, 1933.
 Wineapple Sister Brother Gertrude and Leo Stein by Brenda Wineapple. London, 1996.

Zola Le Bonheur des dames by Emile Zola. Paris, 1980 (1883).

NOTES

~

CHAPTER ONE

- 1. Couturier, p. 128.
- 2. HM to Maurice Guillot, interview by M. Parent, Nord-Matin, 8 Nov. 1952. It is not easy to clear up the mystery surrounding HM's birthplace, which was one of a row of identical weavers' cottages on the part of the rue du Chêne Arnaud (now rue de la République) then called the place du Rejet (now place du Commandant Vignolle). The house belonged to his maternal grandfather, Benoît Elie Gérard (register of births, Le Cateau), and HM said it was demolished after the 1914-18 war (when the whole area was reconstructed and the numbering changed). A matrice cadastrale, or land register, of 1825 shows the painter's paternal grandfather, Jean Baptiste Henri Matisse, as the owner of no. 2 rue du Chêne Arnaud. According to later cadastres, and to the will of HM's maternal grandfather (succession B. E. Gérard, 1870, ADN), nos. 1, 3, 5, 7 and 13 rue du Chêne Arnaud (there were no even numbers) belonged to the Gérards; HM's Gérard grandmother lived at no. 13 in 1870. More than a century after his birth, some claim HM's birthplace as the corner house (now no. 1), others as no. 5 (now reconstructed with the old no. 3 thrown in). All that can be said for certain is that the painter was born in a house that no longer exists (possibly on the site of what is now no. 5), which changed hands probably round about 1869—the year of his parents' marriage and his birth—from his father's to his mother's family.
- 3. See Charles Marandu, "La Mulquinerie en Cambrésis à l'époque révolutionnaire," Jadis en Cambrésis (Cambrai), no. 47 (July 1990). My account of the family history has been pieced

- together from local records (chiefly land and parish registers of Le Cateau and its surrounding hamlets in the North, Bohain and its neighbouring villages in l'Aisne) in the Archives Municipales of Le Cateau, Bohain and St-Quentin, and the Archives Départementales du Nord at Lille, and de l'Aisne at Laon; also from baptismal and marriage registers in the Archives de l'Archevêché de Cambrai; and from directories: Bottin Départemental du Nord, 1869, Annuaire de Commerce et de l'Industrie du Département du Nord, 1887 (including Le Cateau), and Annuaire de St-Quentin, 1880 and 1891 (including Bohain). A basic genealogy was kindly established for me by Colonel Claude Moreau ("L'Ascendance du peintre Henri Matisse," Association généalogique Flandre-Hainaut, bulletin no. 39 [Sept. 1993]; see also Joseph Valynseele and Denis Grando A la découverte de leurs racines [Paris, 1988], pp. 166-67).
- 4. HM's father is referred to as "Henri Matisse" in contemporary documents, but to avoid confusion, he will be "Hippolyte Henri" in this book (spellings vary, from "Hypolite" on his own birth certificate and "Hyppolite" on his son's, to the classical "Hippolyte" on his marriage contract). He was a shop-boy, or garçon de magasin, in his father's will (succession Jean Bpte. Henri Matisse, 1866), but had risen to assistant buyer, or commis négociant, living at 7 boulevard Poissonnière, Paris, by the time of his marriage settlement (25 Jan. 1869); his wife gave her occupation as hat-maker, or ouvrière modiste.
- 5. According to family tradition (Schneider, p. 715), he worked first for the Cour Batave, then for the Grande Maison de Blancs. Both are listed under "Lingerie" in the 1869 Paris Bottin, the first as Hébert, Laignel et Cie, 41 boulevard Sébastopol (see W. Szambien, "Cour Batave, Bvd.

- Sébastopol," in *Paris-Haussmann*, ex. cat. [Paris: Pavillon de l'Arsenal, 1991], p. 253); the second as Ch. Meunier et Cie, "spécialité pour trousseaux et layettes, grande maison de blanc," 6 boulevard des Capucines (part of the Grand Hôtel complex on the new place de l'Opéra).
- 6. Fourcade, pp. 177-78; Flam 2, p. 151.
- 7. There has been repeated misunderstanding about when and why the Matisses moved over the departmental border to Bohain, and a basic misconception about the house in which the painter grew up. The seed-store at 26 rue du Château, initially leased and subsequently bought by his parents, has been confused with another, smaller Matisse property at 24 rue Fagard (not Fayard, as the name is generally misspelt), which HM occupied in 1903 (see chap. 8). His parents moved on their retirement across the road to no. 27 rue du Château, by which time they also owned adjacent properties at 25 rue du Château and 2 rue Peu d'Aise (all these houses still stand). HM said in a letter to Jean Biette, 7 July 1903 (AMP), that his parents took him to Bohain at the age of eight days; their domicile is given as Paris on the registration at Le Cateau of their marriage on 26 January 1869, and their son's birth on 31 December 1869.
- See note 2 above; the painter's paternal grandfather—Jean Baptiste Henri Auguste Matisse, or Mathis, foreman and later barkeeper (contremaître and cabaretier), 1800–1865—lived in the family house on rue du Chêne Arnaud but died at 2 rue Genty, or Gentil (succession J. B. H. Matisse, 1866).
- 9. Ardouin 19, p. 180.
- 10. Ibid., p. 171; Pétréaux, pp. 167-70; Picard, pp. 151-55.
- 11. Information from Lydia Delectorskaya, Paris, 1993. See also Ardouin 19, pp. 106, 181, 226.
- 12. Aragon 1, pp. 181, 246.
- 13. Courthion, p. 61.
- 14. Cerf, pp. 6-7.
- 15. Couturier, p. 145.
- L. Vassaux/HM, 6 July 1943 and 31 Sept. 1944, AMP.
- 17. Information from Claude Duthuit.
- Pétréaux, pp. 174–75; Ardouin 19, pp. 20–26;
 Hanotaux, p. 175.
- 19. Hanotaux, p. 176; see also Pétréaux, pp. 174-80.
- 20. Moll, p. 46.
- 21. Information from Lydia Delectorskaya.
- 22. Pétréaux, p. 180.
- 23. Ibid., pp. 174-75.
- 24. Hanotaux, pp. 155-56.
- 25. Cavailhon, pp. 290, 310; Bussy, J. S., p. 32.
- 26. Pétréaux, p. 179.
- 27. Cannoneers' chorus in Cerf, flyleaf; anti-Prussian slogans in Ardouin 19, p. 24.

- 28. Information from Lydia Delectorskaya; Pétréaux, p. 239.
- 29. Information from Lydia Delectorskaya.
- 30. Ozenfant, p. 29.
- 31. Simon, p. 318.
- 32. Thérèse Pousin/HM, 5 Nov. 1952, AMP.
- 33. HM/P. Matisse, 27 Aug. 1946, PMF.
- 34. Ibid., 3 Nov. 1945.
- 35. Information from Claude Duthuit.
- 36. Information from Gérard Matisse.
- 37. Courthion, p. 59; information from Marie-Gaetana Matisse.
- 38. Information from Lydia Delectorskaya; Bussy, J. S., p. 80.
- 39. The painter's father was baptised on 11 May 1840 under the name "Mathisse," a spelling regularly used for the three previous generations in parish records. Camille Pissarro and Aristide Maillol both spelt HM's name "Mathis" in correspondence, AMP.
- 40. Information from Claude Duthuit.
- 41. Hanotaux, p. 2.
- 42. Ibid., p. 79.
- 43. HM/P. Matisse, 1 Feb. 1927 et passim, PMF.
- 44. Couturier, p. 34.
- 45. Ibid., p. 144.
- 46. Information from Paule Martin.
- 47. See chap. 10, p. 330.
- 48. F. Vallotton, *La Vie Meurtrière*, Paris, 1946, pp. 39–40.
- 49. Schneider, p. 715; Flora Groult, *Marie Laurencin* (Paris, 1987), p. 50.
- 50. Information from Marie Matisse.
- st. Ibid.
- 52. Courthion, p. 118; Couturier, p. 79.
- 53. Billy, p. 43.
- 54. Information from Lydia Delectorskaya; HM/L. Vassaux, 30 July 1949, AMP.
- 55. Note by Auguste Matisse on *Nature morte*, Bohain, 1896, AMP.
- L. Vassaux/HM, 26 Sept. 1945 and 28 Nov. 1945, AMP.
- 57. Ozenfant, p. 18.
- 58. Ibid.
- Information from Lydia Delectorskaya; see also Aragon 1, pp. 116, 132.
- 60. Courthion, p. 135.
- 61. Aragon 1, p. 76.
- 62. Information from Claude Duthuit.
- 63. Flamant 2.
- 64. L. Vassaux/HM, 4 May 1952 and 19 June 1943, AMP.
- 65. The Skein-winder from Picardy (La Dévideuse picarde). The sitter, identified as "la Mère Massé" in a note by Auguste Matisse, AMP, was Octavie Massé, or Masset (the family were illiterate

NOTES TO PAGES 18-27

- Belgian immigrants whose name was variously spelt Massé, Macé, Masset or Massez), née Darmotte, mother of Marie Félicie (Lili) Massé (b. Bohain 5 Dec. 1870), who was herself painted by HM as *La Petite Massé*, 1903. Lili's father, Jean Baptiste Massé, seems to have been employed by the Matisses. See also chap. 8, n. 75.
- 66. L. Vassaux/HM, 15 Apr. 1950, AMP.
- 67. Ibid., 31 Sept. 1944 (the Bohain commercial directory for 1891 lists Nobécourt, rue Fagard, and Morlet, or Melot, rue du Château) and 1 Aug. 1942.
- 68. Dr. Léon Vassaux, 1872–1958 (the Vassaux family owned both 24 rue du Château and 2 rue Peu d'Aise, later sold to Auguste Matisse).
- 69. L. Vassaux/HM, n.d. [Nov. 1949], AMP.
- 70. Ibid., and 4 May 1952, AMP.
- 71. L. Vassaux, 25 Sept. 1942 and 4 May 1952, AMP.
- 72. I am grateful for information about Gustave Taquet (b. Bohain 25 Apr. 1870), and his relationship with the Matisses, to his granddaughter, Mme Jacqueline Joncourt.
- 73. Flamant 1; Louis Joseph Guilliaume (b. Grougis 4 Mar. 1880; photographer at 23 rue du Château; d. 1957) was Flamant's chief source for memories of HM.
- 74. Vassaux et Cie, Caisse Agricole, was founded by Calixte Vassaux (1807–1880), whose sons Alfred (Léon's father) and Arthur resigned in 1874; Léon's maternal aunt, Marie Edmondine Delafaix, married Dr. Adolphe Hardy and was the dedicatee of HM's copy of Prud'hon's Crusifixion ("A Mme Hardy: Souvenir respectueux. H. Matisse, 1893").
- 75. There has been as much confusion about HM's schooling as about his birthplace and his background. No previous account has noted that he attended the Ecole des Garçons, Bohain (for which no records survive), like Taquet and Guillaume (Flamant 1), or that he began his secondary education at the Collège du Cateau (see note 84 below); and few have realised that the Lycée de St-Quentin, where he completed his studies, was the same establishment as the Lycée Henri Martin (see chap. 2, p. 34).
- 76. Académie du Nord, Collège du Cateau, Années classiques, 1852–53 and 1857–58, ADN.
- 77. L. Vassaux/HM, 2 July 1949, AMP; information from Lydia Delectorskaya; Pechy's salary was 1,500 francs per annum, as opposed to 1,800 for the commissaire de police (and 880 for the town vet), Pétréaux, p. 226.
- 78. Bernier tape.
- 79. HM/P. Matisse, 15 Feb. 1940 et passim, PMF.
- 80. Pétréaux, p. 178.
- 81. Bernier tape; Devigne.

- 82. Information from Gérard Matisse.
- Couturier, pp. 132, 433; baptised 7 Jan. 1870, first communion 26 June 1881, Archives de l'Archevêché de Cambrai.
- 84. HM talked about his time at the Collège to Madeleine Vincent (interviewed Paris, 1992), and to old boys like Maurice Guillot (Parent interview, Nord-Matin, 8 Nov. 1952) and Charles Pousin (Thérèse Pousin/HM, 5 Nov. 1952, AMP).
- 85. Thérèse Pousin/HM, 5 Nov. 1952, AMP.
- 86. Diehl, p. 5; Joseph Francq (b. 1833) became principal in 1880, and HM's grandmother, Joséphine Gérard, left Le Cateau in 1882 for Bohain (where she died in 1883), which suggests that HM attended the Collège between 1880 and 1882.
- 87. Proviseur du Collège du Cateau/recteur, 18 Jan. 1854, Archives du Rectorat, Académie de Douai; rectoral circular, autumn 1855; reports on the Collège, 1867 and 1881, all AND.
- 88. Information from Claude Duthuit (a daily dram was stipulated by the employment contract).
- 89. Ardouin 19, p. 15; Flamant 2.
- 90. JSQ, 4 Jan. 1884. For the industrial background, see Jadis en Cambrésis (Cambrai), no. 6 (Aug. 1986) ("Le Conseil des prud'hommes du Cateau dans la seconde moitié du 19e siècle" by L. Durin); no. 17 (Sept. 1982) ("L'Industrie sucrière dans le Cambrésis" by M.-T. Pertriaux); no. 30 (Dec. 1985) ("La Vie quotidienne des tisseurs à la fin du 19e siècle: Le Cambrésis et l'agglomération lilloise" by Jean Tordoit); and no. 51 (Oct. 1991) ("L'Industrialisation du Cateau-Cambrésis au 19e siècle" by L. Durin).
- 91. Couturier, p. 429; and P. Matisse/HM, 19 Nov. 1952, PMF.
- 92. Flamant 2.
- 93. Courthion, p. 9. See also Pétréaux, pp. 161-63.
- 94. Picard, p. 157.
- François Calame, "Cachemire et betterave: La Haute Fantaisie en Picardie," Tisserands 1993, p. 19.
- 96. Ibid., p. 17; Pétréaux, pp. 159, 164-66.
- 97. Vachon, pp. 312-13.
- 98. Information from Suzanne Manesse-Nambruide, whose grandfather, Eugène Nambruide (1859–1927), compagnon de France en tissage, presides as the doyen of Bohain's skilled silkweavers over Emile Flamant's civic frieze in the town hall.
- 99. Plouchard, p. 154.
- 100. Harmony in Red/La Desserte, 1908, originally Harmony in Blue, is the most famous example (others include La Réverie, 1911, and La Table de marbre rose, 1916); colour relations in Interior with a Dog/The Magnolia Branch, 1934, were worked out

NOTES TO PAGES 27-40

- with a paper pattern, HM/P. Matisse, 28 Mar. 1934, PMF.
- 101. Aragon 1, p. 240.
- 102. Pétréaux, p. 191.
- 103. Ibid., pp. 154, 184; Dodeman, pp. 185–86.
- 104. "Ebauche pour Le Bonheur des dames," Zola, p. 551.
- 105. Ibid., p. 561.
- 106. Schneider, p. 715.
- 107. Couturier, p. 420.
- 108. Information from Claude Duthuit.
- 109. Couturier, p. 225.
- 110. Ibid., p. 128.
- III. L. Vassaux/HM, 5 Oct. 1952, AMP ("Petit Quinquin"—or "Tiot Quinquin"—was written by the greatest of all local songwriters, Alexandre Desrousseaux of Lille).
- 112. HM/P. Matisse, Feb. 1943, PMF.
- 113. Boudot-Lamotte 2 (for a brilliant analysis of these songs, see William M. Reddy, *The Rise and Fall of Market Culture: The Textile Trade and French Society*, 1750–1900 [London, 1984], chap. 9; see also Ardouin 18, pp. 103–4).
- 114. Glaneur de St-Quentin, 29 and 30 Apr. and 1 May 1884.
- 115. Cavailhon, pp. 24, 27, 32.
- 116. Ibid., p. 173.
- 117. Glaneur, 3 July 1884.
- 118. JSQ, 29 June 1884 and 4 July 1884; *Glaneur*, 29 June 1884 and 3 July 1884.
- II9. I am grateful to M. André Alcabour (whose uncle witnessed Donato's performance) and to Mme Fernande Blondiaux, former proprietress of the Lion d'Or, for the following reminiscences.
- 120. Bussy, J. S., p. 82 (HM described the same events to both Lydia Delectorskaya and Paule Martin).
- 121. Cavailhon, p. 38.

CHAPTER TWO

- 1. Hanotaux, p. 105.
- 2. Courthion, p. 5.
- 3. Billy, p. 33.
- 4. Prospectus, Lycée de St-Quentin, 1885.
- Hanotaux, pp. 108, 129; proviseur's report, 30 July 1886, Lycée Henri Martin, St-Quentin, Académie de Douai, 2T 1681, ADN.
- 6. Hanotaux, pp. 127, 132.
- 7. Ibid., p. 135.
- 8. Cowart, pp. 55-56, n. 33.
- 9. Lycée Henri Martin, report on Ancelet, Année classique, 1888–89, ADN.
- 10. Hanotaux, p. 130.

- II. Correspondence and annual reports on Anthéaume, 1881–87, Lycée Henri Martin, ADN. Further information from Almanach-Annuaire de St-Quentin, 1880; Paris Bottin, 1869; and St-Quentin press reports on the annual "Amis des Arts" salon.
- Proviseur's weekly reports, 1882–87, Lycée Henri Martin, ADN.
- 13. Courthion, p. 7.
- 14. Ibid. Emile Jean (b. 4 Jan. 1869) was the son of the headmaster of the Theillier-Desjardins primary school (Archives Municipales, St-Quentin).
- 15. Courthion, p. 8.
- Séverin, p. 159; Délibérations du Conseil de St-Quentin, Archives Municipales.
- 17. Fourcade, pp. 319-20.
- 18. P. Matisse/HM, 27 Sept. 1921, PMF.
- Bureau d'Administration du Lycée de St-Quentin, 24 June 1882 and Dec. 1886, ADN.
- 20. Report on Ancelet, 1888–89, Lycée Henri Martin, ADN.
- Proviseur's report, 21 May 1887, Lycée Henri Martin, ADN.
- 22. Ibid., 15 July 1887.
- 23. Information from Paule Martin, Paris, 1994.
- 24. Courthion, p. 8.
- Ibid., p. 6; information from Lydia Delectorskaya (and see note 55 below).
- 26. L. Vassaux/HM, 1 Feb. 1853, AMP.
- 27. Elie Faure, André Derain (Paris, 1923), p. 10.
- 28. 19 Apr. 1885, Lycée Henri Martin, ADN (see note 55 below).
- 29. Prize certificate, 1 Aug. 1885, Archives Léon Bouvier.
- 30. Couturier, p. 132.
- 31. Information from Lydia Delectorskaya.
- 32. Paul Flayelle, Sr. (b. Le Cateau 1849) kept a chemist's shop at 43 rue St-Martin, St-Quentin, which was later inherited by his son, Paul Flayelle, Jr. (1870–1962; obit. in La Voix du Nord, 17 Aug. 1962). Further information from M. and Mme André Flayelle de Xandrin; Monique Séverin; Robert Dufour; and Archives Municipales, St-Quentin.
- 33. Courthion, p. 6; "Henri Matisse," Nord-Matin, 8 Nov. 1952.
- 34. P. Matisse/HM, 10 Jan. 1938, PMF.
- Couturier, pp. 96, 186; I have been unable to identify Matisse's "Cousin Hippolyte" from public or private archives.
- 36. HM's account of the initial calm followed by mass panic is confirmed by other eyewitness accounts reported in "L'Incendie de l'Opéra-Comique," Glaneur de St-Quentin, 29 May 1887 and 1 June 1887.

NOTES TO PAGES 40-48

- 37. Courthion, p. 6. All previous accounts have placed this first work experience in St-Quentin, although HM specifically said it took place during the holidays (presumably Easter or summer 1887). His employer was identified as Maître Dezoteux by Mme Richard-Cousteix (in a letter to Georges Bourgeois, Mar. 1996), daughter of Maître Michel Cousteix, who took over from Dezoteux as the Matisses' legal adviser in Bohain after the First World War. See also notes 46 and 76 below.
- 38. Date and place identified by Wanda de Guébriant. Henri Benoît Gérard (b. Le Cateau 1850) married Maria Watremez and set up as a photographer on the Grand-Place, Ath, Belgium, in 1873 (Archives de la Ville d'Ath), becoming three years later the first photographer in Ypres, where, by 1887, he was established at 9 rue de l'Étoile: "Maison H. Gérard-Watremez, Photographie Artistique et Industrielle—Portraits, Monuments, Intérieurs"; in 1888 he won a Diplôme d'Honneur at the International Photography Exhibition, Louvain (advertisements in L'Avenir [Ypres], 20 May 1888, and Le Progrès, 3 Feb. 1892, kindly supplied by Georges Bourgeois).
- 39. Courthion, p. 6.
- 40. Ibid.
- 41. Information from Gérard Matisse.
- 42. Fourcade, p. 319.
- 43. Courthion, p. 6.
- 44. Ibid., p. 7; certificat de capacité en droit, Faculté de Droit de Paris, 7 Aug. 1888, AMP.
- 45. Ibid., pp. 6-7.
- 46. Successive commentators have considerably increased the confusion surrounding HM's brief legal career. In fact, he worked over a period of four years for three different lawyers, of whom the first was Maître Dezoteux in Bohain (see note 37 above). The second was Maître Duconseil, remembered as HM's employer by several contemporaries, including Gustave Taquet (information from Mme Joncourt), Gaston Lemire (see Lemire), and Duconseil's cousin, the painter Gabriel Venet (1884–1954), himself the son of a St-Quentin lawyer (Diehl, p. 6; information from Monique Séverin). The third was Maître Derieux (see note 76 below).
- 47. Devigne.
- 48. Ozenfant, p. 19.
- 49. Information from Jacqueline Matisse Monnier.
- Information from Mme Suzanne Manesse-Nambruide and M. Emile Bourdeville in Bohain, and from Mme Joncourt.
- 51. Flamant 1 (Marie Clément, b. Bohain 24 Mar. 1870, was three months younger than HM).

- 52. Weavers' notebooks, Archives G. Bourgeois, Bohain; song sheets (e.g., "Naidja": "Au café chantant de Tanger/Devant un public d'étrangers/Une danseuse, légère et charmeuse,/Troublait chacun par sa beauté voluptueuse . . . ") kindly shown to me by E. Bourdeville, Bohain.
- 53. Flamant 2.
- 54. Billy, p. 41.
- 55. HM's mysterious incapacity, which has provoked much ingenious speculation, was diagnosed by the medical tribunal in 1889 as a hernia in the right groin (hernie inguinale à droit); he was therefore excused from active service but placed on the auxiliary list in 1891, in reserve from 1893, and in the territorial army from 1903. Archives, Château de Vincennes, conscription register, no. 1711 (information kindly supplied by Mlle Magalie Redon; see also note 25 above).
- 56. Hanotaux, p. 135.
- 57. HM/P Matisse, 1 Feb. 1927, PMF.
- 58. Ibid., 15 Feb. 1940.
- 59. Simon, p. 303.
- 60. Hanotaux, p. 200.
- 61. Courthion, p. 8; HM's long convalescence took place at home, but he told Lydia Delectorskaya that he was hospitalised at this point.
- 62. Ibid. For the identification of HM's painting friend with Léon Bouvier, see Hilary Spurling, "How Matisse Became a Painter," Burlington Magazine, vol. 135, no. 1084 (July 1993): pp. 463–70; information about Léon Bouvier comes from his grandson, Pierre Bouvier; HM's definition of painting is in Flam 2, p. 42, and Fourcade, p. 50.
- 63. Information from Mme Jacqueline Joncourt.
- 64. Courthion, p. 8.
- 65. Ibid.; the publisher of Goupil's Manuel général et complet de la peinture à l'huile (1877; revised 1884) was J. Moreau & Fils of St-Quentin (former employers of Eugène Carrière).
- 66. Goupil, p. 1.
- 67. Ibid., p. 82.
- 68. Ibid., pp. 2, 70.
- 69. HM exhibited his first two paintings, Still Life with Books and Still Life with Newspaper, at Bernheim-Jeune in 1920 as Mon premier tableau and Mon deuxième tableau. Identical copies of the former still surviving in Bohain and elsewhere suggest that it was based on a chromo, a supposition confirmed by the signature "Essitam" (information from Suzanne Nambruide and Wanda de Guébriant).
- 70. Courthion, p. 10.
- 71. Walter Pach, ts. note on HM, 1920; P. Matisse/HM, 12 Dec. 1953, PMF.
- 72. Courthion, p. 10.

- 73. Carrière 1970, p. 27.
- 74. Flam 2, p. 220, and Fourcade, p. 175.
- 75. Couturier, p. 401.
- 76. Devigne. HM said he enrolled at the Ecole de La Tour while working for Derieux (HM/F. Campaux, 4 Apr. 1946), and described what happened next to P. Courthion, pp. 9–10. Maître Didier-Jean, cited by various authorities as yet another of HM's employers, was in fact the lawyer who took over Derieux's practice after HM had left St-Quentin (Annuaire de St-Quentin, 1910).
- 77. Séverin, p. 89.
- 78. HM/François Campaux, 15 Apr. 1946.
- 79. Séverin, p. 148, and further information from Mme Séverin; Courthion, p. 24.
- 80. Detailed report on the school by Marius Vachon, JSQ, 21 and 22 Sept. 1897.
- 81. Régistre de l'Ecole de La Tour, no. 6, 1900–1911, Archives Municipales, St-Quentin.
- 82. Ozenfant, p. 42 (see Hanotaux, p. 130, for the casual way de La Tour's pictures were treated before the arrival of Degrave).
- 83. Ibid.
- 84. Albert Boime, The Academy and French Painting in the Nineteenth Century (London, 1971), p. 109. For the later career of J. Degrave (1844–1932), see Séverin, pp. 83, 103, 140; and St-Quentin 1988, p. 15.
- 85. Archives Municipales, St-Quentin; St-Quentin 1988, pp. 45–46.
- 86. Séverin, p. 88.
- 87. Ardouin 19, pp. 12-14.
- 88. Plouchard, pp. 154-55.
- 89. Paul Delcroix, 19 July 1887, in Séverin, p. 87.
- Régistre de l'Ecole de La Tour, no. 6, 1900–1911, Archives Municipales, St-Quentin; information from the school's late director Dr. R. Haye.
- 91. For E. Croizé (1859–1930), see correspondence, AJ 52 256, ABA, AN; and St-Quentin 1988, p. 16.
- 92. Lycée Henri Martin, dossier Paul Marie, 1890–95, 2T 399, ADN.
- 93. Ardouin 19, p. 287.
- 94. Letter from Croizé and Marie, JSQ, 19 Dec. 1890.
- 95. Ibid., and Devigne.
- 96. Annuaire de St-Quentin, 1891 (I am grateful to the occupant for a tour of 11 rue Thiers).
- 97. Lemire.
- 98. Devigne.
- 99. Lemire (for Gaston Lemire, 1874–1957, see St-Quentin 1988, p. 41, and Séverin, p. 157).
- 100. Devigne, and Courthion, p. 10 (L. P. Couturier, generally assumed to be "the teacher at the school" whose encouragement HM remembered, had in fact no connection with the Ecole de La Tour).

- 101. Bernier tape.
- 102. Courthion, p. 9; Devigne.
- 103. Information from Claude Duthuit.
- 104. Flam 2, p. 171, and Fourcade, p. 235; Courthion, p. 10; Escholier, p. 17.
- 105. Courthion, p. 10.
- 106. Ibid., p. 12.
- 107. Adrien Villart, "Les Salons," JSQ, 19 June 1896; Boudot-Lamotte 2 (Maurice Boudot-Lamotte was Couturier's pupil in St-Quentin in 1896). For P. L. Couturier (1823–1901), see JSQ, 28 June 1902 and 8 June 1906; obit. in Guetteur de St-Quentin, 1 Dec. 1901; and St-Quentin 1988, p. 31.
- 108. "L'Exposition des Amis des Arts," JSQ, 13 Sept. 1880.
- 109. Devigne.
- 110. Boudot-Lamotte 2.
- 111. Diehl, p. 7; Flam 2, p. 200, and Fourcade, p. 113.
- 112. P. L. Couturier, Millet, Corot (St-Quentin, 1902), pp. 14, 15, 17, 30.
- 113. Interview with Croizé in "Une Visite à l'Ecole Quentin de La Tour," Guetteur de l'Aisne, suppl., 22 Nov. 1924.
- 114. Catalogue illustré des peintures du Salon National des Artistes Français, 1897, 1898, 1900, 1901, 1903, 1905 and 1910.
- 115. Guetteur de l'Aisne, 26 Apr. 1930.
- 116. C. Poette, Promenades dans les environs de St-Quentin (St-Quentin, 1891), vol. 2, pp. 385–86.
- 117. Devigne.
- 118. Weather reports, JSQ, Jan.-May 1891.
- 119. Evenepoel 1, p. 28.
- 120. Devigne.
- 121. AJ 52 256, ABA, p. 241; Lycée Henri Martin, report on P. Marie, 1891, ADN.
- 122. Reports on Croizé's teaching, 1905 and 1909, Régistre de l'Ecole de La Tour, no. 6, 1900–1911, Archives Municipales, St-Quentin; Séverin, p. 109.
- 123. Information from Croizé's last pupil, Dr. R. Haye, St-Quentin, 1993.
- 124. Fernand Frizon (1869–1944), painter and town councillor; Henri Caron was killed in the 1914–18 war; Paul Petit (1873–1950) ran a textile business.
- 125. Devigne. Further details on Louis Jules van Cutsem (b. 1871) and Jules Louis Petit (1873–1899, no relation of Paul Petit) from birth and death certificates, Archives Municipales, St-Quentin.
- 126. Lycée Henri Martin, St-Quentin, report on P. Marie, 1891; and Collège d'Abbéville, reports on P. Marie, 1892–94, and correspondence, 1895, ADN.
- 127. Courthion, p. 9.
- 128. Devigne (Arthur Devigne was born in 1880 in Bohain, where he grew up, later moving to St-

NOTES TO PAGES 59-73

Quentin to become an accountant, like HM's friend Louis van Cutsem).

120. Courthion, p. 10.

130. Eyewitness report from Auguste Matisse's contemporary, later the Matisse family doctor, Dr. Léon Tamboise of Le Cateau, cited in Diehl, p. 7.
131. Carco, p. 223.

132. To Charles Camoin, 3 Feb. 1902, Paul Cézanne Correspondance, ed. John Rewald (Grasset, 1978), p. 281.

133. Courthion, p. 10.

134. Lemire.

135. HM/P. Matisse, 22 May 1941, PMF.

136. Buck, pp. 56-58.

137. "Une Visite à l'Ecole Quentin de La Tour," Guetteur de l'Aisne, 22 Nov. 1924.

138. Escholier, p. 17.

139. Flam 2, p. 200, and Fourcade, p. 113.

140. Couturier, Millet, Corot (see note 112 above), p. 32.

141. Diehl, p. 7.

142. L. Vassaux/HM, 26 Sept. 1945, AMP.

143. Flam 1, p. 29.

144. Bernier tape.

145. Courthion, p. 9.

146. Ibid.

CHAPTER THREE

1. Courthion, p. 37.

 He married Louise Lahaye, April 1899, Archives Municipales, St-Quentin.

3. For HM on J. Petit, see Courthion, p. 12; he joined Moreau's atelier on 16 March 1893, and was officially accepted by the Beaux-Arts on 29 June 1895, AJ 52 248, ABA; exhibited at Salon 1896 and 1897; for his death, on 17 February 1899, see Devigne and JSQ, 21 Feb. 1899.

4. Couturier, p. 98.

5. Vachon, p. 81.

6. Klüver, p. 17.

7. Vachon, p. 133.

8. Ibid., p. 96.

9. Evenepoel 1, p. 110.

10. Fourcade, p. 114, and Flam 2, p. 200; Courthion, p. 13. I am grateful to Gerald D. Ackerman for pointing out that HM may possibly have confused *Le Guêpier* (of which no known copies exist) with a similar painting, *L'Innocence* (1893), which was copied in Bouguereau's studio.

11. Lettres de Degas, ed. Marcel Guérin (Paris, 1931),

12. Vachon, p. 141.

13. Bussy, J. S.

14. Courthion, p. 13.

15. Date established in Flam 1, p. 484, n. 15; see Flam 2, p. 78, and Fourcade, p. 79.

16. Courthion, p. 13; George Moore, Confessions of a Young Man (London, 1928 [1886]), p. 18.

17. Report by W. Bouguereau, Délibérations du Conseil, 20 Mar. 1891, Archives Municipales, St-Quentin; Courthion, p. 13; Flam 2, p. 78, and Fourcade, p. 79.

18. Courthion, p. 20.

19. Fourcade, p. 115, and Flam 2, p. 201.

20. Bernier tape.

21. Vachon, p. 24.

22. Ibid., pp. 107, 15.

23. Ibid., pp. 11, 14, 20.

24. Vachon, p. 110.

25. A. Marquet/H. Manguin, 20 Aug. 1904, JPM; A. Marquet/HM, July 1904 and 2 June 1905, AMP.

 Couturier, p. 113; Gérard Matisse told me that HM still used his much-ridiculed plumb line in the 1950s.

27. Courthion, p. 13.

28. Ibid., p. 14.

29. Ibid., and p. 20; Flam 2, p. 78, and Fourcade, p. 79.

30. Rothenstein, pp. 36, 40.

31. Couturier, p. 75.

32. Ibid., p. 152.

I am grateful to Jack Flam for this information.

34. Courthion, p. 14.

35. Journal, July 1952, Couturier, p. 429.

36. Evenepoel 1, pp. 129-30.

37. Courthion, p. 14; Ardouin 18, p. 72.

38. Couturier, p. 376.

39. Courthion, p. 73; the paintings were Le Temps, ou Les Vieilles, 1808–12, and La Lettre, ou Les Jeunes, 1814–19; see Karl Baedeker, Northern France (Leipzig, 1909), for their location.

40. Courthion, p. 14.

41. Ibid., p. 21.

42. Bernier tape.

43. Courthion, p. 15.

44. Archives, Musée Gustave Moreau, Paris.

45. Courthion, p. 21.

46. Ibid., p. 14.

47. 32 rue des Ecoles (given as a hotel in the Paris

Bottin in 1887) was HM's address in the Académie

Julian register, 5 Sept. 1891 (information from

Jack Flam), and ABA, Feb. 1892.

48. Evenepoel 1, pp. 136, 342-43.

49. Courthion, pp. 14-15.

50. Courthion, p. 12; 12 rue du Maine was the address HM gave on his visiting card that spring (see note 44 above), and to the military authorities on 18 June 1892, Archives, Château de Vincennes.

51. Courthion, p. 36.

- 52. L. Vassaux/HM, 31 Sept. 1944 and 25 Sept. 1942,
- 53. Courthion, unnumbered page.
- 54. Ibid., p. 36.
- 55. John Rewald, *The Ordeal of Paul Cézanne* (London, 1950), p. 18; Rothenstein, p. 100; Julia Frey, *Toulouse-Lautree: A Life* (London, 1994), p. 252.
- 56. L. Vassaux/HM, 10 Sept. 1949; for Louis Alphonse Watbot (1876–1936), see St-Quentin 1988, p. 54.
- 57. Boudot-Lamotte 1 (Maurice Boudot-Lamotte, 1878–1958, son of a well-established St-Quentin family, became while still a schoolboy a favoured pupil of P. L. Couturier, who sent him to Paris with an introduction to Moreau in October 1897. A friend of HM, Marquet, Signac and Maurice Denis, Boudot-Lamotte became a delicate, intimist painter of landscape, portraits and still life, a lifelong collector, and the author of vivid, detailed, as yet unpublished memoirs, kindly made available to me by his granddaughter, Marie-Thérèse Laurenge).
- 58. Courthion, p. 36.
- 59. Schneider, p. 720.
- 60. Escholier, p. 224; Evenepoel 1, pp. 109–10; for violent ragging at Moreau's, see Evenepoel 1, pp. 83, 140, 143, 235–36.
- 61. Evenepoel 2, pp. 183-84.
- 62. HM/P. Matisse, 15 Feb. 1940, PMF; for initial slovenliness and unpunctuality, see chap. 11, p. 353 and n. 52, and Carco, p. 231.
- 63. Courthion, p. 12. For the various rooms HM occupied successively in this building, see note 145 below.
- 64. Ibid., p. 13; 350 rue St-Jacques was the original address HM gave on 10 September 1892 in the register of the Ecole des Arts Décoratifs, AJ 53 177, AN.
- 65. Billy, p. 186.
- 66. HM/P. Matisse, 15 Feb. 1940, PMF (for Verlaine's addresses, see Joanna Richardson, *Verlaine* [London, 1971], pp. 290, 322).
- 67. Courthion, p. 13; 39 rue Claude Bernard was written in above HM's rue St-Jacques address (see note 64 above).
- 68. L. Vassaux/HM, 19 July 1943 and 22 Mar. 1944, AMP; Courthion, p. 131; and information from Pierre Bouvier.
- 69. L. Vassaux/HM, 5 Sept. 1952, AMP.
- 70. Ibid., 16 June 1952.
- 71. Courthion, p. 67; Mathieu 1, p. 272. (I am grateful to Guy Issanjou and M. J. Brun at the Ecole des Beaux-Arts de Lyon for confirming that Georges Eugène Lorgeoux served as director of the Ecole Municipale de Dessin du Petit Collège at Lyon, 1920–38.)

- 72. Caroline Joblaud, 1873–1954. The account which follows has been pieced together principally from parish records, Parisian municipal archives, HM's reported comments, and the memories of people who knew her after she left Paris to spend the last twenty-five years of her life at Concarneau in Brittany (a retirement which presumably accounts for the false but widespread assumption that she came from Brittany; see note 80 below).
- 73. Information from Wanda de Guébriant, who had it from Marguerite Matisse.
- 74. Saying repeated by C. Joblaud, whose Parisian reminiscences, confided to her friend Mme Richard, were preserved and passed on to me by Mme Richard's grandson, Michel Gueguen. 75. Ibid.
- 76. HM/A. Rouveyre, 8 Dec. 1941.
- 77. To John Rewald, 29 Aug. 1950, ms. interview, Barr Papers, MoMA.
- 78. Information from Lydia Delectorskaya.
- Information from Mme Marie-Louise Coppa (herself a couturiere, who inherited C. Joblaud's dressmaker's dummy, or mannequin) and her sister, Mme Jeanne Donnerd.
- 80. Her father, Pierre Joblaud (1843–1880), was born in the neighbouring village of Aniay-le-Château, as was his father, Léonard Joblaud, taillandier (edge-tool maker); her mother was Jeanne Dorlet (b. c. 1842). Archives, Mairies du Veurdre and de Concarneau.
- 81. HM said she attended an Ursuline convent (information from Madeleine Vincent).
- 82. Courthion, p. 58.
- 83. Paule Martin, Paris, 1994.
- 84. Aragon 1, p. 240.
- 85. Ibid., p. 68.
- 86. Escholier, p. 25.
- 87. Courthion, p. 64.
- 88. Ibid.
- 89. Draft letter, undated but written in the spring of 1893 (Moreau stated in it that HM had been his student for a year—ten months crossed out—and replied to an invitation to the funeral of Eugène Baudouin, d. 1893, on the back of the sheet), Archives, Musée Gustave Moreau, Paris.
- 90. Register, AJ 53 176-77, AN.
- 91. Pierre Courthion, Georges Rouault (London, 1962), p. 15; Cowart, pp. 67–73.
- 92. Marquet, p. 21; Escholier, pp. 29, 33.
- 93. Marquet, p. 36.
- 94. Ibid., p. 21.
- 95. Manguin 1980, p. 15; information from Jean-Pierre Manguin.
- 96. Boudot-Lamotte 1, p. 86.
- 97. Besson, p. 20, and Georges Besson, Albert Marquet (Paris, 1929), p. 57.

NOTES TO PAGES 81-94

- 98. Marquet, p. 79.
- 99. Schneider, p. 135, n. 17.
- 100. Manguin 1988, p. 17.
- 101. HM/H. Manguin, 15 Aug. 1906, JPM.
- 102. Marquet, p. 24.
- 103. For their technical training, see Cowart, p. 81 et passim.
- 104. Ozenfant, p. 49.
- 105. Mathieu, p. 5; for Moreau's relations with his students and with the academic establishment, see Philip Hotchkiss Walsh, "Los alumnos, obra académica," in Gustave Moreau y su legado, ex. cat., ed. Roberto R. Littman (Centro Cultural Arte Contemporaneo, Mexico City, 1994), pp. 288-308.
- 106. Henry James, Parisian Sketches (New York, 1957), pp. 153, 176.
- 107. Courthion, p. 19.
- 108. Mathieu, p. 12.
- 109. Courthion, p. 16.
- 110. Escholier, p. 35.
- III. Courthion, p. 33.
- 112. Ibid., p. 20; Maurice Boudot-Lamotte and Auguste Bréal's friend Ellen Heath both left unpublished accounts of copying in the Louvre, c. 1900, for which I am indebted to Marie-Thérèse Laurenge and Martin Brunt respectively.
- 113. Courthion, p. 18.
- 114. Boudot-Lamotte 2 (see note 57 above).
- 115. Georges Duthuit, Barr Papers, MoMA; HM passed on his love of Chardin to both Boudot-Lamotte and Jean Puy, see chap. 7, p. 196.
- 116. Courthion, pp. 17-19 (the painting was La Tabagie, dit "Pipe et vase à boire").
- 117. La Pipe, La Raie, Le Buffet, Nature morte (Cowart, p. 147, n. 12, also gives Le Chat dans la garde à manger; but I am grateful to Wanda de Guébriant for pointing out that this was almost certainly La
- 118. Boudot-Lamotte 1, p. 83; Proust's response is in Pierre Rosenberg, Chardin, 1699-1779, ex. cat. (Grand Palais, 1979), p. 118.
- 119. Evenepoel 1, p. 197.
- 120. Aragon 1, p. 142.
- 121. L. Vassaux/HM, 5 Jan. 1953 and 4 July 1945, AMP; information from P. Bouvier; the painting (private collection) is inscribed "A L. Vassaux, mon ami. HM 1896."
- 122. Courthion, p. 17.
- 123. The Dinner Table (La Desserte), 1897, see chap. 4; Harmony in Red/La Desserte, 1908; and Still Life after J. de Heem's "La Desserte," 1915 (MoMA).
- 124. Courthion, p. 33.
- 125. Evenepoel 1, p. 197.
- 126. Moreau, p. 222.
- 127. Evenepoel 1, p. 312.

- 129. Courthion, pp. 16, 22.
- 130. Flandrin, p. 28.
- 131. Courthion, p. 33.
- 132. Ibid., p. 19.
- 133. Ibid.
- 134. Ibid., p. 20.
- 135. Fosca, p. 4; see also Garnett.
- 135. Martel 1991, p. 26.
- 136. Ibid., p. 24.
- 137. Ellen Heath/Edward Garnett, 1898, in Brunt; by far the fullest biographical account of Simon Bussy (1870-1954) to have appeared so far is in Bussy 1996, pp. 21-42.
- 138. S. Bussy/HM, June 1898, AMP.
- 139. HM/S. Bussy, 15 July 1903, in Bussy.
- 140. Bussy 1996, p. 24.
- 141. C. Boulindraud/M. Duthuit, 5 Dec. 1949, AMP: Courthion, p. 13; and see note 145 below.
- 142. Evenepoel 1, pp. 122-23; see also ibid., p. 93.
- 143. Information from Claude Duthuit.
- 144. Marquet, p. 37.
- 145. Courthion, p. 24. Much confusion has arisen from the fact that HM occupied four successive studios in the same building: the fifth-floor studio into which he moved in 1894 was larger than the sixth-floor roof-space he had shared with Jules Petit two years before (see note 63 above), but smaller than the studio with two windows (and three other rooms attached), also on the fifth floor, where he lived from 1898 to 1909 (see chap. 6, p. 184 and n. 114); he moved back into a studio apartment on the fourth floor in the winter of 1913-14.
- 146. Flam 2, p. 51.
- 147. Courthion, p. 13.
- 148. Evenepoel 2, p. 60.
- 149. Courthion, p. 24.
- 150. Bussy 1996, pp. 45, 47.
- 151. P. Matisse/HM, 2 Oct. 1921, PMF.
- 152. Diploma dated 23 Mar. 1894, AMP.
- 153. Bailly-Herzberg, p. 85.
- 154. Evenepoel 2, pp. 5, 7, 161, 232-33.
- 155. Donation de E. H. H. Matisse, 30 Aug. 1894, Archives Dezoteux, Bohain.
- 156. Information from Soeur Jeanne Bohan, who nursed Caroline Joblaud on her deathbed in Concarneau in 1954.
- 157. Acte de naissance, 3 Sept. 1894, Archives de la Seine, 6e.
- 158. Edmund White, Jean Genet (London, 1993), pp.
- 159. Couturier, p. 168; HM/A. Lancelle, 9 June 1896, in Arts, no. 371 (7 Aug. 1952); the recipient of this letter was Adolphe Charles Constant Lancelle, b. 1865, son of Edouard Lancelle, 1837-1880,

Hippolyte Henri Matisse's second cousin, who ran a general practice on the rue Peu d'Aise and served as secretary to the mayor of Bohain).

160. Information from Claude Duthuit; see chap. 5, p. 137 and n. 38.

161. La Petite Matisse, 1896, and Le Petit Charles, 1896, both reproduced in Hommage à Henri Evenepoel, 1872–1899, ex. cat. (Brussels: Musées Royaux des Beaux-Arts de Belgique, 1972).

162. Courthion, p. 24.

163. AJ 52 60, ABA, AN; see chap. 7, p. 212 and n. 94.

164. Couturier, p. 168.

165. Aragon 1, p. 142.

166. Courthion, pp. 75-76.

167. HM/A. Lancelle, 9 June 1896 (see note 159 above).

168. Flam, p. 221; Fourcade, p. 177.

169. Adrian Villart [pseud. of Elie Fleury], "Les Artistes de l'Aisne aux Salons," JSQ, 19 June 1896.

CHAPTER FOUR

- 1. The Open Door, Brittany, 1896, was painted at Kervilahouen, Belle-Ile-en-Mer, AMP.
- 2. C. Boulindraud/M. Duthuit, 5 Dec. 1949, AMP.

3. Courthion, p. 114.

- 4. C. R. Weld, A Vacation in Brittany (London, 1856), pp. 188–89.
- Charles Géniaux, La Bretagne vivante (Paris, 1912),
 p. 13.
- 6. Roger Marx, "Paul Gauguin," Maîtres d'hier et aujourd'hui (Paris, 1914), p. 328.
- 7. Information from C. Duthuit.
- 8. Ibid.
- 9. Bury Palliser, p. 193.
- 10. HM/V. J. Roux-Champion, Belle-Ile, n.d. [summer 1896], one of two letters first published by Daniel Morane in Roux-Champion 1991, p. 6.
- 11. Désespérance, reproduced in Catalogue illustré de peinture et sculpture du Salon National des Artistes Français (Paris, 1895). The painting, subsequently in the Musée des Beaux-Arts, Reims, was destroyed during the First World War.
- 12. Trilby (London, 1894), p. 88.
- Interview with HM by John Rewald, Barr Papers, MoMA; Fourcade, p. 115, and Flam 2, p. 201.
- 14. Escholier, p. 34.
- 15. Roux-Champion 1991, pp. 6-8.
- 16. Ibid. The building (now the Crédit Agricole), at the angle of the rue Louis Pasteur and rue des Marronniers, was kindly identified for me in October 1994 by Françoise Decourchelles, to

- whose knowledge of local history—and especially of the painters of Pont-Croix—I am greatly indebted.
- 17. Albert Robida, La Vieille France: Bretagne (Paris, 1891), p. 212.
- 18. Roux-Champion 1991, p. 6.
- 19. I am grateful for much information about the Hôtel des Voyageurs, its proprietress, Mme Gloaguen, and her sister, Mme Le Bars, to Mme Gloaguen's grandson, M. Pierre-François Gloaguen of Pont-Croix.
- 20. See chap. 5, p. 132. The mural painter was an American from Julian's Academy, William Sylva; other artists working in Pont-Croix in the 1890s included Charles Cottet, Georges Lacombe, Emile Dezaunay, Louis Roy, Eric Forbes-Robertson, Lucien Simon and Edmond Aman-Jean.
- 21. Evenepoel 2, p. 37.
- 22. Menpes, p. 141.
- 23. C. Boulindraud/M. Duthuit, 5 Dec. 1949, AMP.
- 24. Bury Palliser, p. 272. For HM's excursions, see Escholier, p. 34, and Roux-Champion 1991, p. 6.
- 25. Menpes, p. 155.
- 26. Ibid., p. 138.
- 27. Escholier, pp. 35-36.
- 28. Information from Lydia Delectorskaya, who had it from HM.
- 29. Courthion, p. 9; the painting was Le Tisserand breton, 1896, MNAM.
- 30. C. Boulindraud/M. Duthuit, 5 Dec. 1949, AMP.
- 31. Evenepoel 1, p. 431. Henri Huklenbrok (1871–1942) was the third of the eight children of Joseph Huichlenbroich, founder of la Fabrique Belge de Matières Premières pour la Chapellerie in Brussels. I am grateful to Danielle Derrey-Capon of the Centre Internationale pour l'Etude du XIXe Siècle, Brussels, for much supplementary information on Huklenbrok, and especially for material from the family archives supplied by the painter's nephew, Dr. Léon Hucklenbroich.
- 32. Henri de Groux (1866–1930), who came from an old Breton family, was invited by Léon Bloy to visit Brittany in the summer of 1895 but apparently refused on grounds of destitution, spending at least part of the summer squatting with his family in the municipal casino at Spa (Correspondance Léon Bloy et Henri de Groux, ed. M. Vaussard [Paris, 1947], p. 186; Emile Baumann, La Vie terrible d'Henri de Groux [Paris, 1936], p. 116). He was, however, notoriously unreliable, a flitter and bolter all his life, so, failing further documentary evidence, there seems no way of establishing whether or not he painted that summer with HM (the two had mutual friends in Paris and Brussels,

- and both became protégés of Puvis de Chavannes, later sharing a dealer in Berthe Weill).
- 33. Evenepoel 1, p. 431 and p. 433, n. 2. List of works shown by Huklenbrok, exhibiting with Evenepoel at the Cercle Artistique de Bruxelles, 4–13 November 1899, kindly supplied by Mme Derrey-Capon.
- 34. Their teacher in Brussels was Ernest Blanc-Garin (see Evenepoel 1, pp. 35, 177, 431; and Evenepoel 2, pp. 352, 467).
- 35. Evenepoel 1, p. 431.
- 36. Evenepoel 2, p. 36, n. 1.
- 37. Ibid., p. 106.
- 38. Ibid., p. 82.
- 39. Evenepoel 1, p. 293.
- 40. Evenepoel 2, p. 7 (La Vieille Maquerelle is reproduced in Evenepoel 1, p. 504). D. Derrey-Capon's Catalogue raisonné de l'oeuvre peint and her invaluable essay, "Henri Evenepoel, 1872–1899," are in Monographie Henri Evenepoel (Brussels, 1994); there is some interesting biographical material, more discreetly handled but based on firsthand information, in Paul Lambotte, Henri Evenepoel (Brussels, 1908).
- 41. Moreau, p. 217.
- 42. Evenepoel 1, p. 293.
- 43. Ibid., pp. 270, 272.
- 44. Ibid., p. 454.
- 45. Courthion, p. 24.
- 46. Evenepoel 2, pp. 34-36.
- 47. Courthion, p. 24.
- 48. Evenepoel 2, p. 37.
- 49. Ibid., pp. 40, 41.
- 50. Courthion, p. 22.
- 51. Ibid. (the winner of the Prix de Rome in 1895 was a student of Bonnat, Antoine Marc Gaston Larée).
- 52. Evenepoel 1, p. 371.
- 53. Moreau 1, p. 230.
- 54. Couturier, p. 79.
- 55. Information from Lydia Delectorskaya.
- 56. Evenepoel 1, p. 453.
- 57. Evenepoel 2, p. 66 (see also Evenepoel 1, p. 309).
- 58. The passage from Marx's review, published in La Revue Encyclopédique, 25 Apr. 1896, was quoted by Evenepoel in his own fighting report two months later for a Brussels paper (Evenepoel 2, p. 53, n. 4).
- 59. Evenepoel 1, pp. 436-37.
- 60. Ibid., p. 85.
- 61. Evenepoel 2, p. 66.
- 62. Archives, Musée Gustave Moreau, Paris.
- 63. Diehl, p. 8.
- 64. Evenepoel 2, pp. 35–36; the painting of Baignières and others, identified in R. Escholier, Matisse from the Life (London, 1960), p. 30, was presumably L'Atelier de G. Moreau/Intérieur d'atelier, c. 1895.

- 65. HM submitted twelve canvases, of which four were listed in the catalogue but five were hung (Adrian Villart, "Les Artistes de l'Aisne au Salon" JSQ, 20 June 1896).
- 66. Beth Archer Brombert, Edouard Manet: Rebel in a Frock Coat (Little, Brown, 1996), p. 407.
- 67. Marius Vachon, Un Maître de ce temps: Puvis de Chavannes (Paris, 1900), p. 83.
- 68. Rothenstein, p. 72.
- 69. Courthion, p. 22.
- 70. Escholier, p. 39.
- 71. Flandrin, p. 43.
- 72. Carracci sale in Benjamin, p. 36 and p. 247, n. 94. Woman Reading in ibid., p. 56 and p. 258, n. 42.
- 73. Courthion, unnumbered page.
- 74. Barr, p. 45. (Marx thought HM was twentyseven but in fact his twenty-seventh birthday was not until 31 December 1896.)
- 75. 6 Feb. 1896, AMP. List of associates, 19 Sept. 1896, ibid.
- 76. Guillot interview, Nord-Matin, 8 Nov. 1952 (the Gérard farm at 107 rue Landrecies is here confused with a smaller Matisse property on the faubourg de Landrécies). I am grateful for these memories of HM to Jean Gérard, grandson of Ernest Gérard, 1855–1915 (whose greatgrandfather—Charles Gérard, 1751–1785—was also Anna Matisse's), and Lucia Gauguier, 1865–1940; nothing now remains of their original farm except a barn big enough to hold 700 to 800 sheep; HM's paintings were destroyed in a fire before the 1914–18 war.
- 77. Evenepoel 2, p. 60.
- 78. HM said that he sold his first picture, Nature morte au couteau noir, for one hundred francs to Père Thénard (Courthion, p. 37); the sale of a second still life to Jules Saulnier is mentioned in a letter to his parents, 29 June 1896, AMP.
- 79. Jules Saulnier (1850–1903) took over and modernised in the 1890s an old Bohain firm, Létu, Saulnier et Maguin (later Saulnier et Fils), with Paris headquarters at 15 boulevard Poissonnière and 2 rue d'Uzès, Paris 2e; his home address was 40 boulevard Magenta. I am grateful to M. André Alcabour for information about the Bohain factory (built in 1896 by his grandfather, Eugène Alcabour), and to M. Serge Saulnier for family details (see also chap. 8). For HM's inventor cousin, Raymond Saulnier, see Gérard Maoui, Morane-Saulnier, 1911–91: 80 ans de technologie aéronautique (Paris, 1990).
- 80. There has been considerable confusion about this house, often supposed to have belonged to HM's grandparents, whom he is said to have visited there as a child. In fact, he stayed with his grandmother on the rue du Chêne Arnaud (see

chap. 1, p. 23 and n. 86); both Gérard grandparents died long before HM's uncle bought 45 rue de la République in 1895 (land register, Archives Municipales, Le Cateau; information kindly supplied by M. Lucien Durin). For E. Gérard's business affairs, see chap. 8.

81. Diehl, p. 6.

82. AMP (the last three remained at no. 45 rue de la République, encased in the panelling, until they were finally removed in 1969: HM's copy of de Heem's Dessert also hung there, and it seems likely that so did Watteau's Le Concert champêtre). See also Schneider, p. 718.

83. HM/A. Lancelle, 9 June 1896, in *Arts*, no. 371 (7 Aug. 1952); see chap. 3, n. 159.

84. Information from Michel Gueguen.

85. Evenepoel 2, p. 60.

86. Ibid., p. 65.

87. Dossier H. Matisse, AJ 52 283, AN.

88. S. Bussy/HM, June 1896, in Evenepoel 2, p. 55.

89. Evenepoel 2, p. 63.

90. Roux-Champion 1991, p. 8; AMP.

gr. AMP.

92. Kindly identified for me by Louis Garans, président de la Société Historique de Belle-Ileen-Mer, to whom I am grateful for much information about the island and its past.

93. Information from Lydia Delectorskaya.

- 94. A note at the back of HM's Belle-Ile notebook identifies the house's owner as "Tanis," and I am grateful to Mme Thierry at the Hôtel de Ville, Bangor, Belle-Ile, great-granddaughter of Stanislas (Tanis) Le Matelot, for identifying him, and to his granddaughters, Mme Guillerme and her cousin, for a tour of the house (including the painters' attics) and for many recollections of visiting artists.
- 95. Mirbeau on Kervilahouen in La Revue Indépendante, Jan. 1887.

96. Roux-Champion 1991, p. 8.

97. John Peter Russell, 1858–1930. The account which follows owes much to members of Russell's family, especially to his grandson, the late John Russell of Torr na Fhaire, who kept the family archive, and to the archivist of the other side of the family, Claude-Guy Onfray (see note 110 below); to islanders' memories; and to help from Kerry Sullivan, Manuscripts Section, State Library of New South Wales. For studies of Russell, see Key to Notes under Galbally, Onfray and Salter.

98. V. van Gogh/Théo van Gogh, in Salter, p. 83 (the portrait is in the Rijksmuseum, Amsterdam). Russell gave van Gogh free run of his Paris studio on the impasse Hélène (A. S. Hartrick, A Painter's Pilgrimage Through Fifty Years [Cambridge, 1939], p. 79).

99. J. P. Russell/T. Roberts, 5 July 1887, in Galbally, p. 90.

100. V. van Gogh/T. van Gogh, in van Gogh, p. 193 (Russell's income was £3,000 per annum [Onfray, p. 44]); details of the Belle-Ile house from Russell, and from Dorothy S. Russell, *Spindrift* (London, 1948); sketch plan in Onfray, p. 60.

101. Information from Mme Guillerme.

102. Jeanne Guénégou, "John Peter Russell: Souvenirs de son cocher racontés par la fille du cocher," Belle-Ile Histoire: Revue de la Société Historique de Belle-Ile-en-Mer, no. 4 (Apr. 1992); Onfray, p. 26.

103. A. Rodin/J. P. Russell, 21 May 1904, Archives, Musée Rodin, Paris.

104. Ibid., 2 Jan. 1903.

105. Courthion, p. 131.

106. Information from Lydia Delectorskaya.

107. Evenepoel 2, pp. 63, 153.

108. Information from Michel Guegen.

109. Murdoch, p. 100.

- 110. Marianna Mattiocco (1865–1908), daughter of Pasquale Mattiocco, gardener, Monte Cassino, married Russell on 8 Feb. 1888 (marriage certificate in Onfray, p. 34). I am grateful for many family details to Claude-Guy Onfray, greatgrandson of Marianna Russell's brother, Serafino Mattiocco.
- III. List of works for which she modelled in Onfray, pp. 185–86 (for documentary evidence that she first met Rodin when she modelled for the bust commissioned by her husband to mark their marriage in 1888, see ibid., pp. 110–11).

112. Guénégou, "John Peter Russell" (see note 102 above); and Russell.

113. Murdoch, p. 99. Other painters working on Belle-Ile in the 1890s and early 1900s included Dodge MacKnight, Henry Moret, Achille Cesbron, Maxime Maufra, Hippolyte Berteaux, Lionel Crashaw (all friends of the Russells), Charles Cottet, Francis Aubertin and Jean Puy; see Henri Belbéoch and Florence Clifford, Belle-Ile-en-Art (St-Brieuc, 1991), and Les Peintres de Belle-Ile-en-Mer, ex. cat. (Morlaix: Musée des Jacobins, 1994).

114. Courthion, p. 125.

115. Flam 2, p. 201, Fourcade, p. 115.

116. Courthion, p. 125.

117. Roux-Champion 1991, p. 6.

118. See Hilary Spurling, "Matisse on Belle-Ile," Burlington Magazine, vol. 137, no. 1111 (Oct. 1995).

119. Information from M. Huchet's granddaughter, the last proprietress of the subsequently muchenlarged Hôtel de l'Apothicairerie, Mlle Annie Maillard, who identified for me both the setting of La Serveuse bretonne and its subject (previously assumed to be Caroline Joblaud, who may well have taken the pose when the painting was

NOTES TO PAGES 126-135

worked up in Paris that winter). Pierre Schneider's identification of the half-obliterated child with HM's daughter (Schneider, p. 318) was emphatically denied to Wanda de Guébriant by Marguerite Matisse.

120. V. J. Roux-Champion, "De Gustave Moreau à l'ecole des fauves et au cubisme," Cahiers du Haut-Marnais, no. 39 (1954), in Roux-Champion 1991, p. 6.

121. Russell.

122. Escholier, p. 34, Galbally, p. 68.

123. Roux-Champion 1991, p. 8.

124. Notebook, Russell archive.

125. J. P. Russell/T. Roberts, n.d. [1890–91], in Galbally, p. 94. For an excellent analysis of Russell's relations with Monet, see Galbally, pp. 51–55, 68–77.

126. Russell was building up an Impressionist collection intended for Australia, but apart from references in his own and van Gogh's correspondence to paintings bought from or exchanged with contemporaries, there is no way of documenting this collection, which was, according to family tradition, sold or given away when the household broke up in 1908.

127. Letters nos. 516, 517 and 518, Aug. 1888, in van Gogh, pp. 129, 131, 132.

128. Salter, pp. 20, 25.

129. V. van Gogh/J. P. Russell, Feb. 1888, in Salter, p. 104; for Russell's *Amandiers en fleurs*, Sicily, 1887, see Russell 1997, pp. 3, 48.

130. Roux-Champion 1991, p. 8.

131. Ibid., p. 8; HM/S. Bussy, 15 July 1903, in Bussy. 132. V. van Gogh/T. van Gogh, 1 Feb. 1890, in van Gogh, p. 434.

133. Roux-Champion 1991, p. 8.

134. For Russell's account of his "six-color palette" with its three supplementaries ("Cad. deep, Cad. pale, Vermilion Chinese, White, Garance foncé, Cobalt, Ultramarine, Vert émeraud, Paolo Veronese") together with a detailed analysis, especially of the cobalt/garance combination, see Galbally, pp. 70–71, 91.

135. Roux-Champion 1991, p. 6.

136. AMP. The earlier painting was Belle-Ile, Port de Palais, 1896 (Musée de St-Etienne), which was one of a clutch of similar canvases; see Spurling, "Matisse on Belle-Ile" (see note 118 above).
137. Roux-Champion 1991, p. 8.

CHAPTER FIVE

31 Oct. 1896, in Evenepoel 2, p. 74.
 19 Jan. 1897, in ibid., p. 92.

3. 2 Feb. 1897, in ibid., p. 98.

4. Dorothy Bussy/A. Gide, cited in Martel 1991, p. 12.

5. Fosca, p. 5.

6. Evenepoel 2, p. 19, and Marquet, p. 27.

7. Information from Lydia Delectorskaya.

8. Escholier, p. 29.

9. I am grateful to Françoise Decourchelles for this identification, which was first spotted by the late Pierre Poupon, proprietor of the Hôtel Poupon, Pont-Croix, and confirmed to me by Pierre François Gloaguen, grandson of the proprietress of the Hôtel des Voyageurs in HM's day. See Hilary Spurling, "Matisse on Belle-Ile," Burlington Magazine, vol. 137, no. 1111 (Oct. 1995).

10. Couturier, p. 185.

11. Stein, p. 43.

12. J. P. Russell/V. van Gogh, 22 July 1888, in Galbally, p. 72.

13. 2 Feb. 1897, in Evenepoel 2, pp. 97-98.

14. S. Bussy/HM, June 1898, AMP.

 Information from Claude Duthuit, based on his mother's recollections.

16. 2 Feb. 1897, in Evenepoel 2, p. 98, and Couturier, p. 184.

17. Bussy's recollections in Fosca, p. 6; HM's in Fourcade, p. 197, and Flam 2, p. 158. C. Bock speculates that both refer to the same occasion (Bock, p. 38), and I think she is right.

18. Fosca, p. 6; Courthion, p. 74. I am grateful to Richard Shone for confirming Pissarro's resemblance to the figure of Isaiah ("or just possibly Zacharias") on Claus Sluter's Moses Fountain in Dijon.

19. Courthion, p. 75.

20. C. Pissarro/Lucien Pissarro, 10 Mar. 1897, in Bailly-Herzberg, p. 334.

21. Pissarro's correspondence makes it clear that he left Paris on 6 October 1896, returning 9–18 December; in 1897 he was at the Hôtel Garnier, 111 rue St-Lazare, from 10 January to the end of April, visiting the Caillebotte show between 17 and 29 April (Bailly-Herzberg, pp. 348, 352). Otherwise he was in Paris only briefly at the end of July, and again 29 September–6 October and 8–22 November. Matisse married and left Paris in January 1898. See chap. 6, p. 178 and n. 79.

22. John Rewald, *The History of Impressionism*, 4th ed. (London, 1980), p. 406.

23. Courthion, p. 75.

24. List of works accepted by the state in Caillebotte, pp. 34–71. HM said he first saw the Impressionists at this show (Fourcade, p. 81, and Flam 2, p. 79), but subsequently modified this claim in response to a specific question from A. Barr (note by P. Matisse on letter from Barr, 1 Aug. 1950, Barr Papers, MoMA).

NOTES TO PAGES 135-145

- 25. 18 June 1897, in Evenepoel 2, p. 131.
- 26. See note 21 above.
- 27. Couturier, p. 185. For Moreau's response, see Fourcade, p. 82, and Flam 2, pp. 79–80; for an analysis of *The Dinner Table's* mixed Flemish and Impressionist ancestry, see Bock, pp. 4–5.
- 28. Couturier, pp. 167-68.
- 29. Information from Lydia Delectorskaya.
- 30. Schneider, p. 71, n. 74.
- 31. Evenepoel 2, pp. 7, 10, 87 et passim.
- 32. 5 Apr. 1897, in ibid., p. 117.
- 33. Quentin Bell, *Elders and Betters* (London, 1995), p. 158.
- 34. Evenepoel 1, p. 433.
- John Rewald, Post-Impressionism (London, 1979),
 pp. 430–32; and David Sweetman, The Love of Many Things: A Life of Vincent van Gogh (London, 1990),
 p. 315.
- 36. Couturier, p. 185; Fourcade, p. 82, and Flam 2, p. 79.
- 37. Acte de reconnaissance, Mairie du 6e, Archives de la Ville de Paris.
- 38. Information from Claude Duthuit; date in list of first communions at Bohain, 25 June 1905, Archives de l'Archévêché de Cambrai (out of sixty-five girls, Marguerite Matisse was the only one not baptised at birth).
- 39. Information from Lydia Delectorskaya; HM gave his address on the acte de reconnaissance as 10 rue de Seine, where Léon Vassaux visited him (L. Vassaux/HM, 31 Sept. 1944, AMP).
- 40. 26 May 1897, in Evenepoel 2, p. 122 (HM said he was cycling out to the country to paint landscapes [Fourcade, p. 306, and Flam 2, p. 163]).
- 41. C. Boulindraud/M. Duthuit, 5 Dec. 1949, AMP.
- 42. Onfray, p. 79; see chap. 4, n. 126, for the fate of this collection.
- 43. The tradition that HM bought two van Gogh drawings from Russell seems to be mistaken on both counts. Specifically questioned on this point by his son Pierre, HM himself maintained that Russell had given (not sold) him a single drawing (P. Matisse/A. Barr, 12 Sept. 1950, Barr Papers, MoMA); Russell family tradition supports this claim; and it is in any case hard to imagine what sort of price for a virtually unsaleable drawing could have been negotiated with a poor young artist by the rich and famously openhanded Russell. HM eventually owned three van Gogh drawings, all dating from Arles in 1888: Haystacks (Les Meules) (no. 1427 in J. B. de la Faille's Catalogue raisonnée [Paris, 1928]), which came from Russell (see Flam 1, p. 485, n. 13); The Harvest (La Moisson) (Faille no. 1491) and The Old Peasant Patience Escalier (Faille no. 1461), of which at least one was acquired from Vollard, see chap. 6, p. 180 (PMF).

- Caillebotte, p. 44. For a discussion of the relationship between Monet's painting and Matisse's Seascape, Belle-Ile, see Bock, p. 9.
- Puy, p. 16, n. 1 (the painting was Tempête à Belle-Ile, 1897). For the equally powerful effect of these seascapes on others, see chap. 5, p. 138.
- 46. J. Puy/HM, 15 Sept. 1945, AMP (the reference is to the poem "Moesta et errabunda" in Les Fleurs du mal); Puy found "une peine verlainienne" in the same painting in another letter, Nov. 1944, AMP.
- 47. Couturier, p. 79.
- 48. H. Evenepoel/HM, 6 June 1898, AMP.
- 49. Story from Claude Duthuit, who had it from HM.
- 50. Couturier, pp. 73, 75.
- 51. Ibid., p. 151.
- 52. Courthion, p. 125.
- 53. Michel Gueguen.
- To Marguerite Duthuit (information from Wanda de Guébriant).
- 55. Information from Lydia Delectorskaya.
- Information from Michel Gueguen, confirmed by Soeur Jeanne Bohan.
- 57. Michel Gueguen.
- 58. Courthion, p. 8 (the picture disappeared in the upheavals of 1914–18); see note 90 below for the Fontaine wedding.
- 59. Still Life with Apples, 1897, AMP.
- 60. V. J. Roux-Champion, "Gustave Moreau," *Cahiers Haut-Marnais*, no. 39 (1954): p. 200.
- 61. Flandrin, p. 40.
- 62. Courthion, p. 23.
- 63. Boudot-Lamotte 1, p. 85.
- 64. Flandrin, p. 35.
- 65. Evenepoel 1, p. 102.
- 66. Manguin p. 15.
- 67. Boudot-Lamotte 1, p. 86.
- 68. Boudot-Lamotte 2.
- 69. Marquet, p. 19.
- 70. HM to G. Duthuit, ts. notes, AMP.
- 71. Courthion, p. 23.
- Mary Anne Stevens, Impressionism to Symbolism: The Belgian Avant-Garde, 1880–1900, ex. cat. (London: Royal Academy, 1994), pp. 17, 29.
- 73. HM/E. Martel, 22 Aug. 1897, in Martel 1991, p. 88.
- 74. Evenepoel 2, p. 80.
- 75. Courthion, p. 22; G. Duthuit, ts. notes, Archives Duthuit, Paris.
- HM to G. Duthuit, Archives Duthuit, Paris. For Toulouse-Lautrec, see Escholier, p. 22.
- 77. Evenepoel 1, p. 167; see also p. 170.
- 78. Courthion, pp. 24-25.
- Ibid., p. 22; see also Couturier, p. 398 (Moreau accused both Rouault and Evenepoel of simplifying painting).

- Boudot-Lamotte 2 (Eugène Thirion, 1839–1910, did not deserve HM's mockery, in Boudot-Lamotte's opinion).
- 81. Courthion, p. 22.
- 82. S. Bussy/HM, 12 Sept. 1910, AMP.
- 83. Martel, p. 87.
- 84. Fourcade, p. 82, and Flam 2, p. 80.
- 85. Fourcade, p. 193; for Mme Cézanne's complaint, see Couturier, p. 398.
- 86. Bussy 1996, p. 130.
- 87. J. P. Russell/T. Roberts, n.d. [1890–91], in Galbally, p. 93.
- 88. Information from the late John Russell, whose grandfather, according to family tradition, burned virtually all his paintings of his wife at this point. See Onfray, p. 185, for the twenty-five works left by Russell's daughter Jeanne to the nation (moved in 1997 from the Musée Rodin, Paris, to the Musée des Jacobins, Morlaix, Brittany), and pp. 187–95 for a list of all works in public collections.
- 89. Still Life with Bottle, Jug and Fruit (private collection), AMP.
- 90. HM's account of this wedding and its consequences was passed on to me by Lydia Delectorskaya; Pierre Matisse's memory of AM's account came from Marie-Gaetana Matisse, and from Rosamond Bernier (Bernier tapes). Fernand Fontaine (b. Bohain 1870) married Juliette Apolline Collet of Neuilly-sur-Seine on 16 October 1897 (Archives de la Ville de Paris); Fernand Fontaine was an old school friend, confirmed with Matisse in Bohain in 1881 (Archives de l'Archevêché de Cambrai).
- 91. Information from Claude Duthuit.
- 92. Information from Lydia Delectorskaya.
- 93. HM/P. Matisse, 15 Mar. 1927, PMF (I am grateful to Michael Clarke, keeper of the National Gallery of Scotland, for identifying this picture as no. 387 in Robart's catalogue of Corot's work).
- 94. Claude Duthuit.
- 95. "Testimony Against Gertrude Stein," *Transition*, vol. 23, no. 1 (Feb. 1935).
- 96. B. Parayre/Alexina Matisse, 16 Dec. 1937, PMF.
- 97. Armand Parayre (1844–1922) served with the 16e Bataillon, Chasseurs à Pied (army paybook, AMP); brevet de capacité pour l'enseignement primaire, 1864 (AMP); village schoolmaster at Aussonville in 1867, and at Beauzelle, Haute-Garonne in 1868–82 (Annuaire de la Haute-Garonne, Toulouse).
- 98. F. Humbert/Armand Parayre, 9 July 1872, AMP. 99. MP, 13 May 1902; TT, 16 June 1902.
- 100. "La Leçon de Papa" (profile of G. Humbert), ASM, 27 Sept. 1985.

- 101. ASM ran from 25 Jan. 1882 to 18 Feb. 1894, with A. Parayre signing his first leader as editor on 2 Dec. 1883 (he later became managing director). See also *Histoire de la presse française*, ed. C. Bellinger (Paris, 1972), p. 360.
- 102. ASM, 16 Sept. 1885.
- 103. Information from Claude Duthuit.
- 104. Ibid.
- 105. Berthe Parayre (1876–1945) was considered by her superiors an outstanding director of teacher-training colleges for women (toles normales) in Cahors (1910), Ajaccio (1911–23), Agen (1923), Pau (1924–27) and Aix-en-Provence (1927–33) (Dossier B. Parayre, F17 24321, AN).
- 106. Information from Claude Duthuit.
- 107. Martin, p. 89; Humbert, pp. 8, 118, 147.
- 108. TT, 25 May 1902.
- 109. H. Vonoven, *La Belle Affaire* (Paris, 1925), p. 185. 110. Humbert, pp. 8, 86.
- III. Probably the clearest list of Humbert property and its various managers is in GT, 9 Aug. 1903; for Jacques Boutiq at Beauzelle, 1882–84, see Annuaire de la Haute-Garonne; Emile Thenier, or Thenière, was Frédéric Humbert's cousin (through his mother, Mme Gustave Humbert, née Marie Emilie Thenier), and either an actual or honorary uncle by marriage to the Parayre girls (GT, 14 Aug. 1903).
- 112. TG, 17 Aug. 1903; DT, 23 Nov. 1902.
- 113. MP, 31 May 1902.
- 114. Annuaire de la Haute-Garonne, Toulouse, 1895.
- 115. Information from Claude Duthuit; for the hatshop at 15 boulevard St-Denis, see MP, 21 Dec. 1902; GT, 9 Aug. 1903; and Paris Bottin, 1903.
- 116. Information from Mme Montagnac (Beauzelle, 1993), who had it from her father-in-law, himself the frère de lait, or foster brother, of Amélie Parayre.
- 117. MP, 31 May 1902.
- 118. Information from Claude Duthuit; GT, 9 Aug. 1903; see also le Colonel XXX, "La Vérité sur la guerre de Madagascar" (Toulouse, 1896), in 30 ans d'histoire by Lieutenant Colonel C. Rousset (Paris, 1912), vol. 3, pp. 193–94; and Stephen Ellis, The Rising of the Red Shawls: A Revolt in Madagascar, 1895–1899 (Cambridge, 1985), pp. 76, 102–5.
- 119. B. Parayre/Alexina Matisse, 16 Dec. 1937, PMF. 120. MP, 13 May 1902.
- 121. DT, 11 May 1902; Martin, p. 97.
- 122. Dossier B. Parayre, F17 24321, AN.
- 123. AMP.
- 124. Registre des actes de mariage, Archives de St-Honoré-d'Eylau; provenance of the wedding dress from Claude Duthuit (Mme Humbert owed Worth 30,000 francs by 1902 [TT, 7 Aug. 1903]).

- 125. Pocket diary, AMP.
- 126. Courthion, p. 114; Galbally, p. 91.
- 127. Information from Claude Duthuit.
- 128. Courthion, p. 14. I am grateful to Rémi Labrusse for the information that HM recalled visiting the V&A in subsequent correspondence with his family.
- 129. Review of Turner landscapes, 1887, in J.-K. Huysmans, *Certains* (Paris, 1908), pp. 201–2.
- 130. Escholier, p. 208.
- 131. Pocket diary, AMP; I am grateful to Jacques Poncin for pointing out that "M. et Mme Matisse" are listed among the passengers disembarking at Ajaccio next day in the *Union Républi*caine, Ajaccio, 9 Feb. 1808.
- 132. Van Gogh, p. 49.

CHAPTER SIX

- Guy de Maupassant, Une Vie (Paris, 1883), chap. 5.
 Escholier, p. 40. Previous accounts have assumed that the Matisses chose Ajaccio because Amélie's sister was head of the local teacher-training
- sister was head of the local teacher-training college for girls, but Berthe Parayre (only twentyone in 1898 and still in her first job as a village schoolmistress at Roquettes) did not reach this position until 1911.
- 3. Fourcade, p. 83, and Flam 2, p. 80.
- 4. Le Colombo (Ajaccio), 2 July 1919.
- 5. John Warner Barry, Studies in Corsica (London, 1893), p. 143.
- 6. Mlle Roche in conversation with the author, Ajaccio, Mar. 1995; HM himself told his friends that he was dazzled by the country, especially by its light (HM/A. Marquet, 28 Feb. 1898, Wildenstein Institute, Paris; and HM/Salvetti d'Esdra, Spring 1898, AMP).
- 7. Ibid. Matisse's sister-in-law, Berthe Parayre, analysed the same openness, simplicity and directness in an unpublished psychological study, "L'Ecole Normale d'Institutrices d'Ajaccio et 'le Village' " F17 24321, AN.
- 8. Letters from Marquet, Pissarro, and Evenepoel to HM in Ajaccio (AMP) were addressed to the Villa de la Rocca (which still stands, although under threat of imminent demolition). I am grateful to John Spurling for identifying the building; to Lucette Poncin for confirming that it was put up c. 1883 by Antoine de la Rocca (Registre des Hypothèques, 1886, and matrices cadastrales, Archives Départementales, Ajaccio); and to Jacques Poncin for locating the Matisses' apartment and for photographing the views HM painted from its terrace and windows. For

- furnished rooms to let in the Villa de la Rocca, see Edouard Bosc, Guide de l'étranger et du tourisme à Ajaccio (Ajaccio, 1894), p. 31; for the "quartier des étrangers" in the 1890s, see Poncin, and J. M. Chapman, Corsica: An Island of Rest (London, 1908), p. 61. The Matisses stayed initially at the Hôtel de France on the Place de Diamant. L'Union Républicaine, 9 Feb. 1898.
- Thomasina M. A. E. Campbell, Notes on the Island of Corsica (London, 1868), pp. 25, 33.
- 10. *La République*, Ajaccio, 11 Feb. 1898 (cutting kindly supplied by Jacques and Lucette Poncin).
- 11. Matisse told Mlle Roche (herself a subsequent curator of the Fesch Museum) that the pictures he remembered best were *The Adoration of the Magi* from Rimini, c. 1300; *The Holy Family* by Domenico Puligo (c. 1492–1527); and *The Martyrdom of St. Lawrence* by Corrado Giaquinto (1703–1765).
- 12. Information from Mlle Roche.
- 13. Max Roger, "La Route des Sanguinaires," L'Union Républicaine, 17 Jan. 1912; HM described his own response to Salvetti (see note 6 above) and in Lévy, pp. 93–98.
- 14. Standard sizes 8 and 10 (46 by 33 centimetres and 55 by 33 centimetres), according to a note by AM, AMP; most of the Corsican works are still in private collections.
- Dated 1899 in Flam 1, p. 63, but a note by AM, AMP, corrects this firmly to Ajaccio, 1898.
- 16. Fourcade, p. 83, and Flam 2, p. 80.
- 17. E.g. Schneider, p. 113; and Ajaccio-Toulouse, 1898–1899: Une Saison de peinture, Cahier Henri Matisse 4, Musée Matisse, Nice, 1986, p. 90; but a note by AM (AMP) confirms that this canvas was painted in the kitchen of the Villa de la Rocca at least six months before her first child was born.
- 18. I am grateful to Lucette Poncin for identifying the mill together with its adjacent factory (matrices cadastrales 1882 and 1911, and report to the Ministry of Commerce, 26 Feb. 1894, Archives Départementales, Ajaccio). The mill, the factory and the surrounding gardens were vividly described to me in Ajaccio by M. J. Pettrochi, who remembered having visited them as a small boy.
- 19. Alphonse Daudet, Lettres de mon moulin (Paris, 1884).
- 20. Lévy, pp. 93, 98.
- 21. Maupassant, p. 2.
- 22. Ibid., p. 22.
- 23. Ibid. See also Aragon 1, pp. 132, 242.
- 24. Gaston Vuillier, Les Iles oubliées (Paris, 1893), p. 222.
- 25. Two Ladies, A Winter in Corsica (London, 1868),
- Dorothy Carrington, Granite Island: A Portrait of Corsica (London, 1971), p. 149.

NOTES TO PAGES 168-179

- 27. H. Evenepoel/HM, 30 May 1898, AMP.
- 28. H. Evenepoel/HM, 6 June 1898, AMP.
- 20. Ibid.
- 30. H. Evenepoel/HM, 30 May 1898, AMP; and HM/A. Marquet, 28 Feb. 1898, Wildenstein Institute, Paris.
- 31. Courthion, p. 59.
- 32. H. Evenepoel/HM 6 June 1898, AMP.
- 33. H. Evenepoel/E. Evenepoel, 15 June 1898, in Evenepoel 2, p. 248.
- 34. C. Pissarro/HM, 24 Mar. 1898, AMP. The studio was rented out until 19 July (Bailly-Herzberg, p. 466), so presumably the changeover of tenants was one of the things HM returned to Paris to arrange.
- 35. In Flandrin, 29 June 1898, p. 43 and p. 61, n. 62.
- L. Vassaux/HM, 4 Apr. 1945 and 19 June 1950, AMP.
- 37. Courthion, p. 38.
- 38. Ibid., p. 59.
- 39. Puy, p. 20.
- 40. Note by AM, AMP.
- 41. 16 Feb. 1872. Information from Claude Duthuit; Archives Municipales, Toulouse; and AMP.
- 42. Information from Claude Duthuit; and from Beauzelle's former mayor, M. Lafarge.
- 43. DT, 19 May 1902; Humbert, p. 21; JR, 9 Aug.
- 44. DT, 2 June 1902.
- 45. Some said she was sixteen on her mother's death in 1871 (JR, 9 Aug. 1903), others that she had appropriated the birth certificate of an older sister who died young (Humbert, p. 29); for her mother's history, see DT, 9 May 1902 and 23 Dec. 1902; GT, 9 Aug. 1903.
- 46. TT, 19 Aug. 1903.
- 47. Humbert, p. 67.
- 48. JR, 21 Dec. 1902; DT, 18 May 1902; and 2 June 1902.
- 49. Humbert, p. 29.
- 50. Probably the clearest summary of the essential basis of the case, and its subsequent development, is in Martin, pp. 86–90.
- 51. TT, 16 June 1902.
- 52. MP, 13 May 1902; Humbert, p. 180.
- 53. MP, 9 May 1902.
- 54. Humbert, pp. 80, 88.
- 55. HM/P. Matisse, 23 Nov. 1939, PMF.
- 56. MP, 1 Jan. 1903.
- 57. Information from Claude Duthuit.
- 58. F. Humbert/A. Parayre, 9 July 1872, AMP.
- 59. TT, 16 June 1902.
- 60. MP, 13 May 1902.
- 61. ASM, 3 Feb. 1893 (the column was signed "Frère" and decorated with a tiny black caricature of a priest); AP's certificate as Master Mason (third

- degree), Grand Orient de France, Toulouse, 1879, AMP (he was initiated with Frédéric Humbert and Romain Daurignac by M. Bulot, procureur général de France [TT, 28 June 1902]).
- 62. ASM, 27 Apr. 1889 (Huc's column under the pseudonym "Pierre et Paul" was syndicated from DT). Arthur Huc (1854–1932), son of Etienne Huc, who had taught law at Toulouse University with Gustave Humbert, belonged to the same Masonic lodge as AP and Frédéric Humbert. See Henri Lerner, La Dépêche: Journal de la démocratie (Toulouse, 1978), vol. 1, pp. 97–108.
- 63. ASM, 13 Jan. 1893 and regularly thereafter.
- 64. 1900: Toulouse et l'art moderne, ex. cat. (Toulouse: Musée Paul Dupuy, 1990).
- 65. Nature morte, 1899, bought from the Galerie Weill for 125 francs (note by AM, AMP); and Carco p. 231. It seems likely that this purchase had something to do with the fact that Huc wrote for HM's father-in-law, whom he had known from his youth in Toulouse.
- See Marcel Sembat, "Henri Matisse," Cabiers d'aujourd'hui, no. 4. (Apr. 1913), expanded as Henri Matisse (Paris, 1920).
- 67. La Revue Blanche (Paris), 1 and 15 May and 1 July 1808.
- 68. Signac, p. 22.
- 69. Signac, Maximilien Luce, Henri Edmond Cross and Théo van Rysselberghe all designed covers for a series of pamphlets edited by Jean Grave on anarchist thinkers like Kropotkin and Elysée Reclus (Compin, p. 52).
- 70. Signac, p. 37.
- 71. Ibid., p. 83.
- 72. HM/A. Marquet, 29 Dec. 1898, Wildenstein Institute, Paris.
- 73. Gowing, p. 27.
- 74. Signac, p. 52.
- 75. I have found this address given as 7 or 12 rue des Abeilles, but it is no. 14 on letters to and from HM. AMP.
- 76. Courthion, p. 31.
- 77. Ibid., p. 47.
- 78. C. Pissarro/HM, 7 Feb. 1899, AMP.
- 79. HM said these visits took place in the hotel on the rue de Rivoli (Duthuit, p. 169, n. 1), which puts the date in 1899, since Pissarro was staying at a hotel on the rue St-Lazare in 1897 when the two first met (see chap. 5, n. 21).
- 80. Flandrin, p. 51.
- 81. Salter, p. 82.
- 82. Courthion, pp. 25–26 (Benjamin, p. 266, n. 1, points out that HM was not strictly speaking thirty until 31 December, but HM often exaggerated his age in retrospect).
- 83. Courthion, p. 26.

- 84. Benjamin, pp. 64, 67, and p. 264, n. 97.
- 85. Boudot-Lamotte 2.
- Débarquement de Cléopâtre en Corse and Fragment d'une composition (Man with a Striped Sleeve) respectively; for HM on Signorelli, see Couturier, p. 217.
- 87. Flam 2, p. 201, and Fourcade, p. 114.
- Escholier, p. 27; Linaret introduced HM to Derain, whose account of this painting is in "Quelques Souvenirs," Comoedia, 20 June 1942.
- 89. Boudot-Lamotte 2. Georges Florentin Linaret (1878–1905) officially studied under J. Blanc at the Ecole des Beaux-Arts, but Boudot-Lamotte recalls him frequenting Moreau's studio from October 1897.
- Boudot-Lamotte 1, p. 86; HM placed this incident at Moreau's (Barr, p. 530, n. 4), but Boudot-Lamotte recalled it happening the year after at Camillo's.
- 91. Mathieu, p. 12.
- 92. Rosenshine.
- 93. Courthion, p. 46.
- 94. Ibid., p. 47
- 95. Boudot-Lamotte 2.
- 96. Courthion, p. 47.
- 97. "Notes of Sarah Stein," 1908, in Flam 2, p. 52, and Fourcade, p. 72.
- 98. Courthion, p. 47.
- 99. The story of the ring (a sapphire in Schneider, p. 725) comes from Claude Duthuit, who had it from AM.
- 100. P. Matisse/HM, 8 Feb. 1927, PMF.
- 101. Fourcade, p. 134, and Flam 2, p. 124.
- 102. AM's shop seems to have been a subsidiary of her Aunt Nine's Grande Maison de Modes at 15 boulevard St-Denis (MP, 21 Dec. 1902; and see chap. 5, p. 154 and n. 115).
- 103. Business card, AMP.
- 104. JR, 18 Aug. 1903, and Humbert, p. 93.
- 105. "Liste des collaborateurs financiers," DT, 8 May 1902; MP, 4 Feb. 1903; DT, 26 Dec. 1902.
- 106. Michael Burns, Dreyfus: A Family Affair,
- 1789–1945 (London, 1992), pp. 79, 145, 237, 401. 107. Weill, p. 55.
- 108. TT, 2 June 1902; Paris *Bottin* 1902; JR, 18 Aug. 1903.
- 109. Révision cadastrale, 1900, calepin de propriétés bâties, Archives de la Ville de Paris (property values were assessed in terms of annual rental value, which was 600 francs in the 1880s for no. 26 rue du Château, Bohain).
- 110. Humbert, p. 93, and DT, 26 Dec. 1902.
- 111. List of jewels in HM's pocket diary, July 1898, AMP; for the wedding dress, see chap. 5, n. 124.
- 112. MP, 22 Dec. 1902.
- Weill, p. 78; révision cadastrale; Courthion,
 p. 26.

- 114. Courthion, p. 27; a note by Marguerite Matisse, AMP, confirms that HM moved into a second, larger studio in 1900 (see chap. 3, n. 145); for descriptions of the new apartment, taken over by Marquet in 1908, see Marquet, p. 38, and Flandrin, p. 21.
- 115. "Peintres artistes," Paris Bottin, 1903.
- 116. GT, 9 Aug. 1903; TT, 6 June 1902.
- 117. Lists of artists collected by F. Humbert (his Moreau was the ambitious *King David* of 1878) in MP, 17 June 1902; TT, 20 May 1902; JR, 29 May 1902; and Claretie, p. 95.
- 118. Humbert, p. 55 (Humbert's pseudonym as a painter was Henri Lelong, and his studio at 11 place Vintimille backed onto 56 rue Douai).
- 119. Flandrin, p. 45.
- 120. Courthion, p. 26, and unnumbered supplementary page; date in Flam 1, p. 486, n. 35.
- 121. Carco, p. 229.
- 122. Evenepoel 2, p. 273.
- 123. Information from Claude Duthuit (it is not easy to date these childhood memories with any precision: the only record of Marguerite Matisse having been admitted to a Paris hospital was in 1901 [see chap. 7, n. 172], so unless there was an earlier hospitalisation of which no official record survives, either she was put to bed at home or this visit took place three years later).
- 124. Escholier, p. 88.
- 125. Information from Madeleine Vincent, Paris,
- 126. Aubéry, p. 132.
- 127. Salmon, pp. 95-96.
- 128. Information from Lydia Delectorskaya, who had it from HM.
- 129. Ibid.; Marguerite was certainly living with the family at 19 quai St-Michel by the winter of 1899—1900, when HM worked for Marcel Jambon (Escholier, p. 51), and at 25 rue de Châteaudun when she was admitted to hospital in July 1901 (see chap. 7, n. 172).
- 130. Stein, p. 42.
- 131. Information from Claude Duthuit.
- 132. Vollard, p. 73.
- 133. Cézanne, p. 557.
- 134. Boudot-Lamotte 2.
- 135. Courthion, p. 47.
- 136. Barr, p. 39 (the painting was *Head of a Boy*); see also chap. 5, n. 43.
- 137. Bussy later married her younger sister. His Paris landlady was Emma Guieysse, Louise Bréal's mother and Lady Strachey's friend (Brunt); see also Michael Holroyd, Lytton Strachey: The New Biography (London, 1995), p. 87.
- 138. Manguin, p. 405.

NOTES TO PAGES 189-203

- 139. 4–13 Nov. 1899, Cercle Artistique et Littéraire de Bruxelles (Evenepoel 2, p. 327); I am grateful to Danielle Derrey-Capon for a review of this show in Art Moderne, no. 46 (12 Nov. 1899).
- 140. Evenepoel 2, pp. 328-29, 332-35.
- 141. Marquet, p. 37.
- 142. Madeleine Octave Maus, Trente ans de lutte pour l'art (Brussels, 1980), p. 250.
- 143. Cézanne, p. 557.
- 144. Escholier, p. 29. (Cézanne showed at the Indépendants in November 1899, as also in the spring of 1901 and 1902, but his *The Blue Vase* belonged by 1900 to Eugène Blot [Cézanne, p. 329].)
- 145. Ambroise Vollard, En Ecoutant Cézanne, Degas, Renoir (Paris, 1995 [1938]), p. 48.

CHAPTER SEVEN

- 1. J. Puy/HM, 22 Dec. 1943, AMP.
- 2. For Camillo's, see Courthion, p. 26; Schneider, pp. 429, 456; and Bantens.
- Boudot-Lamotte recalled studying with Derain at Julian's in 1899 (Boudot-Lamotte 1, p. 85), but the date is given as 1904 in Derain 1994, p. 436.
- 4. Puy, p. 20.
- 5. Blake, p. 256.
- 6. Carrière 1970, p. 33.
- Grunfeld, pp. 333–34; Rothenstein, p. 322; Centenaire d'Eugène Carrière, ex. cat. (Toulouse: Musée des Augustins, 1949), p. 10.
- 8. Bantens, p. 44.
- Blake, p. 257 (I am grateful to Reginald Pye for drawing my attention to this passage).
- 10. Michel Puy, Jean Puy et son oeuvre (Paris, 1920),
- 11. J. Puy/HM, 20 May 1917, AMP.
- 12. J. Puy/M. Puy, 20 May 1917, in Puy 1988; and J. Puy/HM, 20 Jan. 1913, AMP.
- 13. Puy, p. 24.
- 14. Ibid., p. 17.
- 15. Boudot-Lamotte 1, p. 85; J. Puy/HM 17 June 1952, AMP.
- 16. Puy, p. 22.
- 17. "Propos rapportés par Georges Duthuit," ts., AMP (Derain was eighteen on 17 June 1898; HM was not thirty until 31 December 1899, but he described himself as a thirty-year-old throughout his thirtieth year).
- 18. Derain 1994, p. 94.
- Duthuit ts., AMP. For P. de Champaigne, see Couturier, p. 116, Fourcade, p. 91, and Flam 2, p. 106; for Christ on the Road to Calvary by Biagio d'Antonio (then attributed to Ghirlandaio),

- which Derain registered to copy January–April 1901, see Derain 1994, p. 94.
- 20. Fourcade, p. 91, and Flam 2, p. 95.
- 21. Puy, p. 27.
- 22. Ibid., p. 36, and J. Puy/HM, 1943, AMP.
- 23. Boudot-Lamotte 1, p. 86.
- 24. Ibid., p. 84.
- 25. Puy, p. 16.
- 26. J. Puy/HM, 31 Sept. 1942, AMP.
- 27. Grammont, p. 218 (HM's seascape was hung in *Paysages de France*, Galerie Charpentier, Paris, 1945).
- 28. Escholier, p. 31; Courthion, p. 28; Giraudy, p. 34.
- 29. Maupassant, p. 23.
- 30. Marquet, p. 27.
- 31. Giraudy, p. 34.
- 32. Jourdain, p. 53.
- Interview with John Rewald, ts., Barr Papers, MoMA.
- 34. Boudot-Lamotte 2.
- 35. Marquet, p. 18.
- 36. Courthion, p. 38.
- Boudot-Lamotte I, p. 87 (the stall-holder who snapped up three canvases for one hundred sous was Père Dolques).
- 38. Duthuit, p. 43; Lévy, p. 80; Fourcade, p. 86, and Flam 2, p. 81.
- 39. Boudot-Lamotte 2; Marquet, p. 27.
- Courthion, p. 34 (tourist boutiques on the rue de Rivoli bought canvases for 2.50 to 3 francs and resold them for double; see Clive Holland, In the Vortex [London, 1912], pp. 211–12).
- 41. Carco, p. 228; Courthion, pp. 31, 137.
- 42. Grunfeld, pp. 27-29.
- 43. Carco, pp. 228–29 (I am grateful to Eve Baume for establishing that the statue of Buffon by Jean Carlus, b. 1852, was eventually shown at the 1907 Salon).
- 44. Courthion, p. 27.
- 45. Besson, p. 18 (Antonio de la Gandara, 1862–1917, pupil of Gérôme, silver medallist at the 1900 Exposition Universelle, chevalier de la Légion d'Honneur, 1900).
- 46. A. Marquet/HM, n.d. [1941], AMP.
- 47. Ibid., 3 May 1945.
- 48. Marquet, p. 19; Courthion, pp. 31-33.
- 49. Courthion, p. 33; Paris Bottin, 1902.
- 50. Escholier, p. 46.
- 51. Courthion, p. 31.
- 52. Escholier, p. 38.
- Now in the Bibliothèque Municipale, St-Ouentin.
- 54. Plouchard, p. 155 et passim; Bohain's textile medals went to Létu, Saulnier et Maguin (the names of Létu and Maguin were later dropped) and H. Garnier; Bossuat & Gaudet won the Grand Prix.

- 55. Parish register, Bohain.
- 56. Information from Mme Greuze of 29 rue du Château
- 57. Information from Marie Matisse.
- 58. I am grateful to Dr. Vassaux's great-nephew, Pierre Bouvier, for much information about his uncle; details of Vassaux's collection from AMP.
- 59. Marguerite Matisse identified Vives-Eaux as the setting for Paysage avec arbres, ou Hêtres pourpres, 1901 (bought by B. Berenson, now in the Bucharest Museum), and possibly also for the 1902 painting known as Le Jardin du Luxembourg (Hermitage Museum, St. Petersburg), AMP. HM painted nothing at Bohain between 1898 and 1902, a sure sign that he spent little time there.
- 60. Puy, p. 32.
- 61. Information from Mme Clorinde Landard and Marie-Gaetana Matisse (wet-nursing and fostering were common among the women of Busigny at the turn of the century).
- Register of baptisms in Bohain, Archevêché de Cambrai.
- Le Jardin du vieux moulin, 1898, dedicated "A Mlle Mgte. Dameron homage respectueux" (AMP).
- 64. Note by Marguerite Matisse, AMP.
- 65. Duthuit, pp. 64-65.
- 66. Information from Claude Duthuit.
- 67. Courthion, p. 36.
- 68. Ibid., p. 37.
- 69. E.g., nos. 142 (dated 1890, which may be a mistake, unless Luce knew the previous occupant of HM's studio), 144 and 145 in Jean Bouin-Luce and Denise Bazetoux, Maximilien Luce: Catalogue de l'oeuvre peint, vol. 11 (Paris, 1986); HM noted Luce's address as rue Cortot, Montmartre, in his 1898 diary (AMP); and he certainly loaned his studio to Luce in 1905 (see chap. 10, n. 45).
- 70. C. Pissarro/HM, 24 Mar. 1898, AMP; see also Bailly-Herzberg, p. 466.
- 71. Tristan Klingsor, quoted in Tabarant, p. 70.
- 72. Note, AMP; for Luce's itinerant lifestyle, see Tabarant, pp. 10, 60, 73; Cazeau, p. 117; and Jourdain, p. 276.
- 73. Schneider, p. 720.
- 74. Information from Claude Duthuit.
- 75. Fourcade, p. 55.
- 76. Puy, p. 18.
- 77. Crespellé, p. 102.
- 78. Giraudy, p. 36; Crespellé, p. 100.
- 79. Escholier, p. 51 (HM dated this memory to the winter of 1899–1900 when he worked for Jambon, so either he confused the date or the family had not yet moved to rue de Châteaudun).
- 80. Fourcade, p. 317, and Flam 2, p. 189.
- 81. Fourcade, p. 294.
- 82. Ibid., p. 84, and Flam 2, p. 80.

- 83. Carco, p. 220
- 84. Bantens, p. 125, n. 162.
- 85. Boudot-Lamotte 1, p. 85, and Carco, p. 229.
- 86. Boudot-Lamotte 2.
- 87. Carco, p. 229.
- 88. Lévy, p. 75.
- 89. Courthion, p. 26.
- 90. Tristan Klingsor, La Peinture (Paris, 1921), p. 79.
- 91. Courthion, p. 26; Escholier, p. 78; Carco, p. 229.
- 92. Courthion, p. 27.
- 93. H. Manguin/Elie Faure, 14 Dec. 1904, JPM.
- 94. Flam 1, p. 37 and p. 485, n. 39.
- 95. Aragon 2, p. 96.
- 96. Detailed course notes in Duval's 1881 handbook (see note 98 below); the classes are described in Evenepoel 1, p. 257, and Maclaren, 1 and 15 Nov. 1900 and 15 June 1901.
- 97. Courthion, p. 137; Aragon 1, p. 81. Mathias Duval (b. 1844), professor of histology, Faculté de Médecine, taught anatomy at the Ecole des Beaux-Arts from 1882.
- Mathias Duval, Précis d'anatomie artistique à l'usage des artistes (Paris, 1881); for HM's first meeting with Duval, see Couturier, p. 145.
- 99. Maclaren, 15 Nov. 1900.
- 100. Grunfeld, p. 115.
- 101. Maclaren, 17 Nov. 1900.
- 102. Barr, p. 48; Flam 1, p. 85; HM told Greta Moll he paid Bevilacqua 1,800 francs in all, or more than his whole year's allowance (Moll, p. 42).
- 103. HM/J. Puy, 10-27 Aug. 1903, JPM.
- 104. Cowart, p. 22; Puy, p. 19.
- 105. Courthion, p. 65.
- 106. E. Baumann, La Vie terrible d'Henri de Groux (Paris, 1936), p. 102.
- 107. Hudson, p. 16.
- 108. Escholier, p. 162; Maclaren, 18 and 20 Jan. 1901.
- 109. Escholier, p. 162.
- 110. Puy, p. 19.
- 111. Barr, p. 52; see note 115 below.
- 112. Varenne, p. 101.
- 113. Ibid., p. 10.
- 114. Lavrillier, p. 37.
- 115. There has been much confusion about the various correction classes HM attended, especially in sculpture. He said that he first copied the Jaguar (which took him two years) in a municipal evening class in the winter of 1899–1900, continuing work on a clay model on weekends in his quai St-Michel studio before transferring to Bourdelle's class, where he met Lagare (see notes 41, 44 and 106 above). HM told Alfred Barr (Barr, p. 52) that he studied under Bourdelle at the Académie de la Grande Chaumière (founded in 1906, according to Klüver, p. 246, map 1); Rodin's academy opened in the spring of 1900

(Grunfeld, p. 405), and I am grateful to Betty Mons of the Musée Bourdelle for a contemporary flyer: "Ateliers de Sculpture RODIN DESBOIS BOURDELLE 132, Byd. Montparnasse."

116. Speech by Bourdelle at the Carrière banquet over which Rodin presided in 1904, Varenne, p. 86.

117. Rodin's speech at the tomb of Carrière in 1906 in Lévy, pp. 150–51.

118. Lavrillier, p. 37.

119. La Petite République, 1902, in Lavrillier, p. 33.

120. Daniel Marquis-Sébie, "Une Leçon d'Antoine Bourdelle à la Grande Chaumière," *Cahiers de la Quinzaine*, 19e série, no. 16 (1930): p. 34.

121. Varenne, p. 96.

122. Marquis-Sébie, "Leçon" (see note 120 above),

p. 57.

123. M. Golberg/A. Bourdelle, n.d. [1901], Musée Bourdelle; the date of Bourdelle's bust has been revised from 1898 to 1900 by Xavier Deryng in a pioneering essay exploring Golberg's importance as a modernist, especially in relation to Matisse, "Les Variations Golberg 2: La Critique d'art," in Coquio, pp. 269–85.

124. Review of Salon d'Automne, 1903, in ibid., p.

125. Ibid., p. 279.

126. See chap. 12, p. 414.

127. Salmon, p. 56.

128. Aubéry, p. 7.

129. From Golberg's *Lettre à Alexis* (1904), cited by Deryng (who argues persuasively that this anecdote was autobiographical), "Variations," in Coquio, p. 277.

130. Pierre Aubéry, "Mécislas Golberg et l'art moderne," Gazette des Beaux-Arts (Paris), Dec. 1965, p. 343.

131. Salmon, p. 101.

132. See note 126 above.

133. HM/J. Biette, 31 July 1903, AMP.

134. Varenne, p. 149; for the parable of the eagle, see Antoine Bourdelle: Ecrits sur l'art et sur la vie, ed. G. Varenne (Paris, 1977), pp. 70–73.

135. Escholier, p. 48.

136. Vollard, p. 225; Duthuit, p. 72.

137. Vlaminck, p. 31.

138. Carco, p. 20; see also Vlaminck, p. 19.

139. Information from Lydia Delectorskaya.

140. Vlaminck, pp. 11-12.

141. Jourdain, p. 215.

142. Vlaminck, p. 73; Duthuit, p. 119; J. Freeman dates this encounter as March 1901, and I agree (Fauve Landscape, pp. 66 and p. 118, nn. 32, 33).

143. Gustave Coquiot, Cubistes, futuristes, passéistes (Paris, 1914), p. 103.

144. Fourcade, p. 320 (I am grateful to Dominique Szymuziak for pointing out that in local usage, HM's parents' catchphrase—"Depêche-toi!" means "Get on with it!" or "Carry on working!" rather than "Hurry up!").

145. Courthion, p. 33.

146. Duthuit, p. 60.

147. Entry dated 30 Sept. 1944 in a notebook (now lost) cited in Schneider, pp. 134–35, n. 16.

148. Fourcade, p. 159.

149. Ibid., p. 83, and Flam 2, p. 80.

150. Letter, 1950, cited in Cowart, p. 183, n. 32.

151. Flandrin, p. 101, n. 6, and p. 193, n. 82 (Marval and Flandrin, often wrongly identified as neighbours of Matisse and Marquet, did not move to 19 quai St-Michel until after the 1914–18 war).

152. Marquet, p. 50. Jacqueline Marval (1866–1932; b. Marie-Joséphine Vallet near Grenoble) showed her first ten paintings under the invented name of Marval at the Indépendants in 1901. Her meteoric rise thereafter is amply documented in Flandrin, pp. 15–21, 69, 86–70, 162, 190, 244 et passim; and in Marval. I am grateful to Dr. Georges Flandrin for much further information about Mme Marval.

153. Flandrin, p. 47.

154. Ibid.

155. Ibid., p. 61, n. 62.

156. Mainssieux, p. 63.

157. Ibid.

158. Marcelle Marquet in Flandrin, p. 23, n. 31.

159. A. Marquet and H. Manguin/J. Marval, postcard [Aug. 1905], JPM.

160. Flandrin, p. 137.

161. Noted as a topic hotly debated by the Paris art world in the diary of Jules Flandrin's brother Joseph, 20 July 1910 (Flandrin, p. 131).

162. Schneider, p. 719, n. 21 (three of these landscapes were shown at Vollard's in 1904).

163. The place, date and sitter were identified by Auguste Matisse, AMP.

164. Information about Villars from Karl Baedeker, Switzerland, 19th ed. (Leipzig, 1901); and Henri Guignard, Paul Anex and Daniel Ruchet, Mémoires de l'aigle (Chablais Vaudois, n.d.).

165. Margarine was invented in 1869 by the French chemist Hippolyte Mège-Mouriès as part of Napoleon III's plan to improve the diet of his poorest subjects.

166. My account of this affair is based on the following documents (ADN): permit to establish a tallow foundry (fonderie de suif) issued to Gérard, 8 Oct. 1876; complaints about the foundry at 48 rue de la République forwarded to the prefect of the North, 27 Sept. 1900; report of the departmental public health inspector, 29 Oct. 1900; application filed by Gérard for an official permit to cure hides, 12 Jan. 1901; report of the commis-

sioner of police, 18 Jan. 1901; a further formal complaint laid by the mayor and population of Le Cateau, 28 Jan. 1901; report of the General Council for Health and Hygiene, Département du Nord, 20 May 1901, ratified by the prefect 10 June 1901; minute from the prefect to the sousprefect of Cambrai demanding immediate action to close the factory, institute legal proceedings against Gérard and rebuke the police commissioner, 10 June 1901. Emile Gérard died on 26 May 1903.

167. Agreement dated 5 May 1902 (succession Gérard-Denis, 27 Mar. 1906, ADN); Matisse-Thiéry marriage settlement, 8 July 1901.

168. Barr, p. 41.

169. Escholier, p. 17.

170. Ibid., p. 49.

171. Information from Lydia Delectorskaya, who had it from HM; Marguerite Matisse said that she suffered from diphtherial laryngitis ("une angine diphériqué") complicated by typhoid fever (information from Wanda de Guébriant).

172. Hôpital Bretonneau, Montmartre, admission no. 1401, 11–18 July 1901, Marguerite Matisse, age five years (she was six years nine months), of 25 rue du Châteaudun ("Observation: père"); Archives de l'Assistance Publique, Paris. In the account which she gave her son long afterwards, Marguerite Matisse remembered this crisis as taking place when she was three years old, but it seems possible that her memory telescoped two different incidents (see chap. 6, p. 186 and n. 123); photographs taken during her convalescence certainly show her with a nurse in the courtyard of the Hôpital Bretonneau.

173. AM dated this painting 1901 (AMP; Schneider, p. 311, gives 1906), a date confirmed by Jean Puy, who remembered photographing c. 1902 what was almost certainly HM's first portrait of his daughter, "petite fille de 5 ou 6 ans, habillée dans un sarreau à rayures" (J. Puy/M. Duthuit, 1 Mar. 1941, AMP).

174. Weill, p. 61; the introduction was made by Roger Marx, Barr, p. 41.

175. P. Reboux, in Weill, p. 16.

176. Weill, p. 75.

177. Ibid., p. 65.

178. Ibid., p. 57.

179. Details of sales with slightly discrepant prices in Weill, pp. 74, 77; Carco, p. 231; and AMP. See also chap. 6, n. 65.

180. Weill, p. 97.

181. Boudot-Lamotte 1, p. 85.

182. Duthuit, p. 77.

183. J. Biette/M. Duthuit, 25 Dec. 1928, AMP.

184. Courthion, pp. 132-35.

185. René Gimpel, Journal d'un Collectionneur marchand de tableaux (Paris, 1963), p. 63.

186. See note 50 above.

187. Masterminded by F. I. Mouthon in MP, 23–30 April and 1 May 1902.

188. MP, 12 May 1902.

189. DT, 11 Aug. 1902.

190. Humbert, p. 20, and MP, 20 May 1902.

191. Gilbert Guilleminault, ed., Le Romain vrai, de la 3e République 1. Prélude à la Belle Epoque (Paris, 1956), p. 318.

CHAPTER EIGHT

1. MP, 13 May 1902.

2. DT, 14 May 1902 and 21 Dec. 1902.

3. MP, 13 May 1902.

 The two Matisse premises were searched on 19 May (Humbert, p. 21; MP, 15 and 20 May 1902; and TT, 22 May 1902).

5. Humbert, p. 160.

6. Ibid., pp. 14, 18-20.

7. Indépendant de Cambrésis, 14 May 1902.

8. DT, 31 May 1902 and 8 June 1902.

9. Ibid., 5 and 7 June 1902.

10. LM, 9 May 1902. Of at least six suicides for which the Humberts were widely blamed, the most scandalous were two ruined bankers: the founder of the Girard Bank, who pulled a gun on Thérèse but missed before shooting himself in 1895, and Paul Bernard, who killed himself in October 1897 (DT, 8 May 1902 et passim).

11. The grain-merchant and distiller Paul Schotmans of Lille was murdered on a train on 16 July 1899 after refusing the Humberts a loan of 7 million francs, subsequently paid over by his brother Emile (DT, 8 May 1902, 23–24 Nov. 1902 and 12 Dec. 1902; Indépendant de Cambrésis, 14 May 1902; JR, 14 Aug. 1903); Thérèse's nephew, Paul Humbert, was also killed during a raid on his parents' home in 1898 (JR, 27 May 1902).

12. Phrase coined by Waldeck-Rousseau as the advocate representing the official receiver for the Girard Bank in court proceedings at Elbeuf in December 1898: DT, 26 May 1902 et passim; see also Martin, p. 147.

13. Pierre et Paul [pseud. A. Huc], DT, 26 Dec. 1902.

14. Martin, pp. 121-22, 133.

15. JR, 25 Dec. 1902, and Indépendant de Cambrésis, 18 May 1902; initial lists of creditors were published in the national and local press on 7–8 and 21–22 May 1902.

16. Many witnesses, especially in Toulouse, testified to the part played by Gustave Humbert, but the most damning evidence came from Léopold Sée

NOTES TO PAGES 240-250

of the Comptoir d'Alsace bank, where the former Justice Minister deposited 500,000 francs immediately after the collapse of the Union Générale bank in 1882, a catastrophe for right-wing investors which signalled the ultimate triumph of the Republican Left (TT, 24 May 1902; DT, 30 May 1902 et passim; Humbert's role is cursorily examined in Martin, pp. 108-9, 145, and in H. Dutrait-Crozon, Notes sur la justice républicaine [Paris, 1924], pp. 29-40, 174-200). A suggestive factor—carefully concealed at the time and never noticed since—is that as a young law teacher in Toulouse, Gustave Humbert married his maid, Marie-Emilie Thenière (or Thenier), whose sister was Thérèse Humbert's mother. Both were illegitimate daughters of a wealthy farmer known as Père Duluc. Thérèse's mother, Mme Daurignac, sold lingerie in the 1860s from the ground floor at 3 rue de la Pomme, Toulouse, the house in which M. and Mme Gustave Humbert rented rooms upstairs. Thérèse Daurignac was brought up there with her first cousin and future husband, Gustave Humbert's son Frédéric. All parties afterwards kept this relationship dark, presumably in order to prevent anyone from realising how closely Thérèse's fortunes depended from the start on her involvement with Gustave Humbert (DT,9 May 1902 and 23 Dec. 1902).

- 17. Martin, p. 188.
- 18. DT, 24 Dec. 1902.
- 19. Claretie, pp. 96, 100.
- 20. Ibid., pp. 95-97.
- 21. The collection is itemised in MP, 17 June 1902; TT, 20 May 1902; and in Claretie, p. 96.
- 22. Claretie, pp. 311-12.
- 23, HM/S. Bussy, 31 July 1903, in Bussy. Jean-Jacques Henner (1829–1905), grand officier de la Légion d'Honneur, painted mildly allegorical nudes which sold for 10,000 to 20,000 francs apiece; for Ferdinand Roybet, Frédéric Humbert's teacher, see chap. 7, p. 184; Juana Romani (1869–1924), also Roybet's pupil and HM's exact contemporary, already commanded prices of 3,000 francs or more per canvas; Caracollas was Carolus-Duran (1837–1917), an immensely successful fellow northerner, grand officier de la Légion d'Honneur and president of the Société des Artistes Français.
- 24. MP, 21 Dec. 1902.
- 25. Dossier Berthe Parayre, F17 24321, AN.
- 26. DT, 2 Dec. 1902, 8 June 1902 and 24 Nov. 1902.
- 27. Humbert, p. 182.
- 28. MP, 22 Dec. 1902 (he claimed to have mistaken them for potential malefactors).
- 29. HM/H. Manguin, n.d. [Sept. 1902], JPM; HM's trip to Switzerland, 18–25 Aug., from

- HM/A. Marquet, 23 Aug. 1902, Wildenstein Institute, Paris.
- 30. Trilby (London, 1894), p. 5.
- 31. Puy, p. 26.
- 32. Barr, pp. 41-42.
- 33. Note by M. Duthuit, AMP.
- 34. HM/J. Puy, 1949, in Schneider, p. 427.
- 35. Puy, p. 26, and J. Puy/HM, 23 June 1948, AMP.
- 36. Boudot-Lamotte 1, p. 87.
- 37. Puy, p. 37.
- 38. Ibid., p. 20.
- 39. J. Puy/HM, 23 June 1948, AMP.
- 40. Schneider, p. 192.
- 41. MP, 21 Dec. 1902; DT, 22 Dec. 1902.
- 42. MP, 1 Feb. 1903.
- 43. DT, 24 Dec. 1902, and MP, 23 Dec. 1902.
- 44. DT, 26 Dec. 1902.
- 45. MP, 23 Dec. 1902, and DT, 24 Dec. 1902.
- 46. MP, 24 Dec. 1902.
- 47. Ibid., 25 Dec. 1902.
- 48. DT, 26 Dec. 1902 and 3 Apr. 1903.
- 49. MP, 31 Dec. 1902.
- 50. DT, 24 Dec. 1902.
- 51. JR, 22 Jan. 1903.
- 52. MP, 23 Jan. 1903.
- 53. Ibid., 1 Feb. 1903.
- 54. HM/H. Manguin, n.d. [Feb. 1903], JPM; and H. Manguin/HM, 7 Feb. [1903], AMP.
- 55. HM/H. Manguin, n.d. [Feb. 1903], AMP.
- 56. The sum total of losses in the North was estimated at more than 25 million francs (DT, 24 Nov. 1902); lists of northern creditors—les créanciers du Nord—appeared in MP, 4 Feb. 1903, and GT, 9 Aug. 1903 (the name "Mathis" figures in the latter).
- 57. TT, 15 May 1902.
- 58. Flamant 1. These phrases and attitudes constantly recurred in my many conversations in the early 1990s with the older generation in Bohain, people who had grown up hearing stories about Matisse from their grandparents, who were his contemporaries.
- 59. Quoted in Parent interview, Nord-Matin, 8 Nov. 1952.
- 60. Flamant I. I am grateful to Monique Séverin for identifying this local artist as Paul Dantan (no relation of the better-known St-Quentinois Eugène Dantan, 1882–1960), who occasionally showed in St-Quentin.
- 61. Flamant 1.
- 62. Martel, p. 79.
- 63. J. Puy/HM, n.d. [Nov. 1909], AMP.
- 64. Quoted in John Rewald, *The Ordeal of Paul Cézanne* (London, 1950), p. 150.
- 65. Fourcade, p. 84, and Flam 2, p. 80.

66. Hudson, p. 19 (Francis Jourdain, visiting Cézanne at much the same time with Charles Camoin, got the same impression [Jourdain, p. 52]).

67. HM/S. Bussy, 15 July 1903, in Bussy; and HM/A. Marquet, 6 March 1003, Wildenstein Institute Paris

68. Information from Wanda de Guébriant.

69. Taquet interview, 1954 (newspaper clipping kindly provided by Taquet's granddaughter, Mme Jacqueline Joncourt).

70. Flamant 1.

71. HM/S. Bussy, 16 Mar. 1903, from 20 rue de l'Eglise, Boisguillaume, Rouen, in Bussy,

72. Dossier B. Paravre, F17 24321, AN.

73. HM/S. Bussy, 15 July 1903, in Bussy.

74. HM/A. Marquet, 25 Sept. 1003. Wildenstein Institute, Paris.

75. See chap. 1, n. 65. The Massés lived on the rue Peu d'Aise, opposite the side door of the Matisse

76. Archives de l'Archevêché de Cambrai; Lili Massé worked as a dévideuse like her mother and her sister. Angélique, who married in 1886 a dveworker, Charles Capella, whose son was presumably the "young Capella" painted by HM in 1903 (Bohain parish registers).

77. Flamant 1.

78. Information from Claude Duthuit.

79. Information from Jacqueline Matisse.

80. Information from Marie Matisse.

81. HM/J. Biette, 7 July 1903, AMP. I am grateful to Dr. and Mme Mercier for a tour of the premises at 24 rue Fagard, including HM's attic studio, which was known in the Matisse family as "l'atelier, rue de Cambrai" (the old Cambrai road was renamed rue Fagard after a local benefactor, Charles Fagard, d. 1886), but has previously been located by Matisse scholars above the seed store at 26 rue du Château (see chap. 1, n. 7). The property was re-let to a M. Bourbusson as soon as HM moved out in 1903, and occupied on their retirement in the 1930s by M. et Mme Auguste Matisse.

82. Barr, p. 50.

83. Schneider, p. 192.

84. Flam 1, p. 103.

85. HM/P. Matisse, 7 June 1942, PMF.

86. HM/H. Manguin and A. Marquet, n.d. [Aug. 1903], JPM.

87. HM/S. Bussy, 31 July 1903, in Bussy.

88. Ibid. 15 July 1903.

89. Information from Jacqueline Matisse.

90. Pétréaux, p. 148, and Dodeman, p. 195.

91. HM/S. Bussy, 31 July 1903, in Bussy.

92. Ibid.

93. HM/J. Biette, 7 July 1903, AMP.

94. Couturier, p. 421.

95. Buck. pp. 68-69.

96. HM/P. Matisse, 16 July 1938, PMF.

07. Flamant 1.

98. HM/I. Biette, 31 July 1903, PMF.

99. HM/S. Bussy, 31 July 1903, in Bussy.

100. Puv. p. 33.

101. Ibid., p. 36.

102. HM/S. Bussy, 15 July 1903, in Bussy. Apart from his father's cousin. Jules Saulnier (see note 114 below), the identity of HM's three backers remains uncertain: among his friends, the most likely candidates would be Auguste Bréal and Jean Puy, both of whom made a point of buying his paintings at this time (HM also outlined his scheme to Manguin, Marquet, Jean Biette and Antoine Bourdelle).

103. S. Bussy/HM, 2 Mar. 1903, AMP.

104. HM/S. Bussy, 15 July 1003, in Bussy,

105. Ibid., 31 July 1903.

106. Ibid.

107. Bussy 1996, p. 131.

108. HM/H. Manguin and A. Marquet, 7 July 1903, IPM.

109. Ibid., n.d. [Aug. 1903].

110. HM/J. Biette, 31 July 1903. AMP.

III. Ibid.

112. Level, p. 20.

113. Bourdelle outlined his scheme in a letter to Cécile de Jong, Jan. 1903, Archives, Musée Bourdelle; his reaction to HM's is described in HM/H. Manguin and A. Marquet, n.d. [Aug. 1903], IPM.

114. HM/H. Manguin and A. Marquet, n.d. [Aug.

1903], JPM, and Schneider, p. 190.

115. Information from Jules Saulnier's grandson, Serge Saulnier; and from André Alcabour, whose grandfather, Eugène Alcabour, built a modern factory for Létu, Saulnier et Maguin in Bohain in 1894. No trace remains of the château de Bohéries (which was destroyed by fire in 1907), although there is still a factory on the site, and the mediaeval stable block was restored in the 1990s.

116. HM/H. Manguin and A. Marquet, n.d. [Aug.

1903], JPM.

117. Jules Léon Ferdinand Saulnier (1850-1903) was buried on 23 Sept. 1903 in Père Lachaise Cemetery, Paris. It may or may not have been coincidence that Saulnier and Emile Gérard, both of whom signed HM's marriage certificate in the company of Frédéric Humbert—and who were both precisely the kind of businessman systematically targeted for Humbert loans-both died in their fifties in the year of the Humbert trial. Saulnier's son Raymond designed the Blériot XI, the first plane to cross the Channel from Calais

NOTES TO PAGES 261-278

to Dover in 1909 (see Gérard Maoui, Morane-Saulnier, 1911–91: 80 ans de technologie aéronautique [Paris, 1900]).

118. HM/J. Biette, 31 July 1903, AMP.

119. The picture, now in the Musée Matisse, Le Cateau, is reproduced in Schneider, p. 730; the house was destroyed in 1914–18 (along with the church, which has since been rebuilt), but the site was kindly identified for me by Georges Bourgeois and Paul Pothren. I am grateful for much information about Lesquielles at the turn of the century to M. Pothren, who interviewed in the early 1960s a Mme Lebègue whose father as a small boy had been profoundly impressed by watching HM at work on this canvas.

120. Another of the many sites identified for me by Georges Bourgeois; the various buildings in the background of this landscape (in the San Francisco Museum) still stand.

121. The current title of this painting. Le Canal de Lesquielles (Musée Matisse, Le Cateau), is a misnomer, since it shows in fact the Canal de la Sambre à l'Oise, painted at Vadencourt from a spot beside what was then a ferry and is now a bridge, looking towards lock no. 19; identified by G. Bourgeois.

122. Matisse set up his easel on the outside of the boundary wall, at the angle where it turned to run along the front of the château parallel with the stream; identified by G. Bourgeois.

123. HM/H. Manguin and A. Marquet, 27 Aug. 1903, JPM.

124. MP, 9 Aug. 1903.

125. TT, 7 Aug. 1903.

126. MP, 5 Aug. 1903.

127. JR, 10 Aug. 1903.

128. TT, 15 Aug. 1903.

129. HM/H. Manguin and A. Marquet, 27 Aug. 1903, JPM.

130. Humbert, p. 16; see also Claretie, p. 99.

131. Pierre et Paul [pseud. A. Huc], DT, 26 Dec. 1902 (Huc's father, Etienne Huc, a law professor like Gustave Humbert at Toulouse University, was called as a character witness at the trial by Mme Humbert's brother, Emile Daurignac [MP, 5 Aug. 1903]).

132. Martin, p. 143.

133. HM/S. Bussy, n.d. [autumn 1903], in Bussy.

134. J. Puy/HM, n.d. [Sept. 1903], AMP.

135. HM/S. Bussy, n.d. [autumn 1903], in Bussy.

136. Auguste Bréal (1869–1941) may well have been one of the three prospective takers for HM's subscription scheme (see note 102 above); he had married at twenty-five Louise Guieysse, niece of the Minister for the Colonies and daughter of Lady Strachey's close friend Emma Guieysse. 137. Salmon 1, p. 243.

138. Information from Hermine Bréal's daughter, Katharine Brunt.

139. H. Bréal/HM, n.d. [autumn 1903], AMP, proposing a meeting with the local councillor, M. Desplas; and HM/S. Bussy, n.d. [autumn 1903], in Bussy. The Droit des Pauvres, established in 1796 to fund the Assistance Publique, remained a sinecure administered by the Préfecture de la Seine until 1942.

140. HM/S. Bussy, n.d. [autumn 1903], in Bussy.

141. Note by AM, AMP.

142. Information from Wanda de Guébriant.

143. Manguin 1983, p. 9.

144. Dossier B. Parayre, F17 24321, AN.

145. Frantz Jourdain and Robert Rey, *Le Salon d'Automne* (Paris, 1923), p. 7; and Jourdain, p. 204.

146. Jourdain, p. 203.

147. Level, p. 17.

CHAPTER NINE

1. HM/S. Bussy, 31 July 1903.

2. H. E. Cross/C. Angrand, 7 Feb. 1904, in Compin, p. 26.

3. A. Marquet/H. Manguin, 8 Nov. 1903, JPM.

4. P. Signac/Théo van Rysselberghe, n.d. [Mar. 1904], GC.

5. Crespellé, p. 107.

6. Matisse 1993, p. 62.

7. Level, p. 17 (the contract was signed on 24 Feb. 1904 [Matisse 1993, p. 62]).

8. Courthion, p. 39.

 A. Level/HM, 18 Mar. 1904, AMP; Level, pp. 17–18.

10. Courthion, p. 39.

11. Level, p. 19.

12. Ibid., p. 16.

13. Schneider, p. 728.

14. Courthion, pp. 42, 44.

15. Rosenshine, p. 119.

16. Courthion, p. 42.

17. Billy, p. 150.

18. Weill, pp. 83, 87.

19. Ibid., p. 125; and see p. 89.

20. Vollard, p. 55.

21. Vlaminck, pp. 91-92.

22. Vollard, p. 225 (for a list of the pictures on show, see Benjamin, p. 273, n. 31).

23. Courthion, p. 43.

24. Flam 2, p. 216.

25. Courthion, p. 45.

26. Evenepoel 1, p. 83. See also the essay by René Huyghe in Hommage à Roger Marx 1859–1913: de Daumier à Rouault, ex. cat. (Musée des Beaux-Arts,

- Nancy, 1963); Cowart, pp. 30–33; and for an analysis of Marx's role in HM's career, see Benjamin, pp. 79–87.
- 27. Benjamin, p. 272, n. 22.
- 28. Carco, p. 231 (according to Carco, Vollard spent 1,000 francs on five canvases, including three Dessertes, but he seems to have confused Vollard's single 1904 purchase with the 1,000 francs Puy remembered Vollard paying HM in 1903).
- 29. Janet Flanner, "King of the Wild Beasts," Men and Monuments (New York, 1957), p. 97 (no date is specified, but it was only in the aftermath of the Vollard show that HM could have charged as much as 400 francs per painting).
- 30. Information from Claude Duthuit.
- See Roger Benjamin, "Une Copie par Matisse du Balthazar Castiglione de Raphaël," Revue du Louvre, vol. 35, no. 4 (1985): pp. 275–77.
- 32. Puy, p. 26 (Puy misremembered the date of Signac's show at Druet—it was November 1904, not 1903—but he was right about Signac's influence).
- 33. P. Signac/HM, 10 Apr. 1904 and n.d. [late May 1904], AMP; and Cachin, p. 79 (La Ramade had been let the year before to Signac's friend K. X. Roussel).
- 34. A. Marquet/HM, n.d. [summer 1904], AMP.
- 35. HM/H. Manguin, 11 July 1904, JPM.
- 36. A. Marquet/H. Manguin, 17 July 1904, and HM/H. Manguin, n.d. [Sept. 1904], JPM.
- 37. P. Signac/H. E. Cross, n.d. [1904], Archives Signac, Paris. (I am grateful to Nicholas Watkins for explaining that chambre claire was another traditional device for clarifying and ordering pictorial space.)
- 38. From Sur l'eau (1888), cited in Cachin, p. 52 (see also Françoise Cachin, St-Tropez [Paris, 1985]).
- 39. HM/H. Manguin, n.d. [Sept. 1904], JPM.
- 40. A. Marquet/H. Manguin, 20 Aug. 1904, JPM; and A. Marquet/HM, n.d. [summer 1904], AMP.
- 41. HM/H. Manguin, n.d. [Sept. 1904], and A. Marquet/H. Manguin, 8 Aug. 1904, JPM.
- 42. Carco, p. 230 (Auguste Pégurier, 1856–1936, was born in St-Tropez).
- 43. Cousturier 1, p. 12.
- 44. Signac, p. 22, and Salter, p. 71.
- 45. P. Signac/T. van Rysselberghe, 30 Sept. 1908, GC.
- 46. Signac, p. 45.
- 47. Ibid., p. 157.
- 48. Jourdain, p. 279, and P. Signac/T. van Rysselberghe, 3 Mar. 1909, GC.
- 49. Fénéon, p. 122.
- 50. Ozenfant, p. 84.
- 51. There is a graphic eyewitness account of Signac painting in Cousturier 1, p. 27.
- 52. Fourcade, p. 131, and Flam 2, p. 72.

- 53. Cousturier 1, p. 22. See also Signac 1997, p. 72.
- 54. Cousturier 1, p. 29; Cachin, p. 40.
- 55. P. Signac/H. Manguin, 1904, JPM.
- 56. Cousturier 1, p. 53.
- Both canvases were painted in St-Tropez according to a note by AM, AMP.
- 58. L'Occident, July 1904, pp. 17–30; see also Grammont, p. 15 (the points at which Cézanne's sayings parallel Divisionist theory are analysed in Bock, pp. 64–65).
- 59. Cousturier 1, p. 33.
- 60. Marguerite Duthuit, cited in Matisse 1970, p. 68; Bock (n. 9, p. 139) discounts this story but HM himself confirmed that he suffered torments of self-doubt all summer in Signac's oppressive presence (HM/A. Marquet, n.d. [summer 1904], Wildenstein Institute, Paris).
- 61. HM/H. Manguin, n.d. [Sept. 1904], JPM.
- 62. H. E. Cross/T. van Rysselberghe, 7 Sept. 1904. See also Cachin, p. 80, and Compin, p. 57.
- 63. Cousturier 2, p. 10.
- 64. H. E. Cross/HM, 21 Sept. [1906], AMP.
- Ibid., n.d. [Nov./Dec. 1905]. The close relationship between HM and Cross was first explored in Bock, p. 52; p. 131, n. 6; and p. 132, n. 10.
- 66. Henri Edmond Cross (1856–1910), son of Fanny Woollett of Southwark, London, and Alcide Delacroix, manager of a dye-works at Canteleules-Lille, anglicised his name in 1883 on the advice of his painting teacher.
- 67. In Compin, p. 32.
- 68. H. E. Cross/C. Angrand, 3 Sept. 1904, in Compin, p. 45.
- 69. This and the next quotation from I. Cross/HM, 5 June [1905], AMP.
- 70. B. Parayre/P. Matisse, 31 Jan. 1933, PMF.
- 71. HM/A. Marquet, n.d. [summer 1904], Wildenstein Institute, Paris.
- 72. H. E. Cross/HM, 21 Sept. [1906], AMP.
- See Cousturier 2, pp. 8–9 (Matisse's visit to this house is confirmed in an undated [1906] letter from Cross, AMP).
- 74. In Compin, p. 65.
- Preface to the catalogue for Cross's show at Druet's gallery, March 1905, cited in Compin, p. 71.
- 76. Signac, 13–31 Dec. 1904; Cross, 21 Mar.–8 Apr. 1905.
- 77. For the history of this painting, see Marina Ferretti-Bocquillon in Signac 1992, pp. 52–59, and Signac 1997, pp. 58–59.
- 78. In Compin, p. 51.
- 79. Signac 1992, p. 59.
- 80. The full extent of Fénéon's clandestine anarchist activity was unravelled for the first time in Halperin, pp. 242–47, 267, 271, 276.

NOTES TO PAGES 292-305

- 81. H. E. Cross/HM, n.d. [winter 1905], AMP.
- 82. Signac, p. 126.
- 83. In Compin, p. 53.
- 84. HM/H. Manguin, n.d. [Sept. 1904], JPM.
- 85. Cachin, p. 51.
- 86. Schneider, pp. 97-98.
- 87. H. E. Cross/HM, n.d. [winter 1905], AMP; Courthion, p. 126 et passim.
- 88. Signac, p. 187.
- 89. HM/A. Marquet, n.d. [summer 1904], Wildenstein Institute, Paris.
- 90. Barr, p. 54.
- 91. HM/H. Manguin, n.d. [Sept. 1904], JPM.
- 92. A. Marquet/HM, n.d. [summer 1904], AMP.
- 93. HM/R. Marx, 10 Sept. 1904, cited in Fauve Landscape, p. 64 and p. 116, n. 24.
- 94. A. Joubin cited in Matisse 1993, p. 64; and Laurence Bénézite/HM, 17 Nov. 1904, AMP.
- 95. Gil Blas, 14 Sept. 1904 (see also Bock, p. 80, and Benjamin, p. 102).
- 96. Jourdain, p. 280.
- 97. C. Guérin/HM, n.d. [Dec. 1904], AMP.
- 98. R. Piot/H. Manguin, n.d. (the meeting on 1 December was postponed to 19 December), JPM.
- 99. M. Fabre/HM, 7 Mar. 1905, AMP.
- 100. Fourcade, p. 94, and Flam 2, p. 84.
- 101. Matisse 1993, p. 64.
- 102. Puy 1989, p. 9, and J. Puy/HM, n.d. [Nov. 1909], AMP; for Marquet, see Fauve Landscape, p. 67 and p. 116, n. 34; Vollard bought 150 canvases from Manguin in March 1906 (information from Jean-Pierre Manguin).
- 103. Courthion, p. 53; see also Fauve Landscape, p. 79 and p. 117, n. 81.
- 104. Weill, p. 116.
- 105. Vlaminck, p. 74.
- 106. HM/P. Signac, 14 Sept. 1905, Archives Signac, Paris, and P. Signac/HM, n.d. [Sept. 1905], AMP; half was paid in cash, and HM chose one of Signac's paintings—*La Maison verte, Venise* (Signac 1997, p. 72)—in lieu of the rest.
- 107. Matisse 1993, p. 66.
- 108. Gil Blas, 23 Mar. 1905.
- 109. Maurice Denis, Journal (Paris, 1957), vol. 2, p. 23.
- 110. In Escholier, p. 114, and in Fauve Landscape, p. 116, n. 38.

CHAPTER TEN

- For dates of these migrations, see Judi Freeman's invaluable "Documentary Chronology, 1904–1908," in Fauve Landscape, p. 68.
- 2. Dossier Berthe Parayre, F17 24321, AN; B. Parayre/P. Matisse, 31 Jan. 1933, PMF.
- 3. See p. 326 and n. 117 below.

- 4. Combeau, p. 125.
- 5. Falguère, p. 6.
- 6. Soulier, pp. 31-32.
- 7. Ibid., p. 179.
- 8. E. Cortade, *Collioure* (Perpignan, 1988 [1952]), p. 51.
- 9. Giraudy 1, p. 13.
- 10. J. Puy/H. Manguin, n.d., JPM.
- 11. Bernardi, p. 22.
- 12. P. Signac/HM, 18 June 1905, AMP.
- Bernardi, pp. 20–22; Annuaire in Falguère, p. 184 (Matisse used the French form of her name, "Rosette," rather than the Catalan, "Rousette").
- 14. Bernardi, p. 22 et passim.
- HM/H. Manguin, n.d. [June 1906], JPM (Rousette's charges for the whole family, including Marguerite in 1906, were 185 francs a month).
- Jean Carroigt, Collioure proche et lointain: Chroniques, récits, portraits (Perpignan: Editions Massana, 1990), p. 31.
- 17. HM/H. Manguin, 15 May 1905 and 20 May 1905, JPM; B. Weill/HM, 19 May 1905, AMP.
- 18. H. Manguin/HM, 22 Aug. 1905, AMP.
- 19. Grammont, p. 19.
- 20. HM/H. Manguin, 20 May 1905, JPM.
- 21. Jules Joly and E. Frenay, Dans les Pyrénées Orientales: Notre école au bon vieux temps (Le Coteau, 1990), p. lii. For Collioure's economic plight, see also Henri Ribeill, Rétrospective sur un port de pêche (Perpignan: Editions Massana, 1989), pp. 38–66; and Ardouin 37, pp. 291–92.
- Miquel Briqueu and Ramon Gual, Cotllioure fa temps, Collioure autrefois, Revue Terra Nostra, no. 20 bis (1975).
- 23. This window over the Café Olo was identified by Bernardi (pp. 24, 46) from the various preparatory drawings made there for Le Port d'Abaill.
- 24. The spelling in this still largely oral culture varies from Port d'Avail (Soulier and Falguère) to Aval (Cortade), HM's Abaill and the modern Avall.
- Bernardi, passim, and in conversation with the author.
- 26. Duthuit, p. 225.
- 27. Cladel, p. 162.
- 28. HM/H. Manguin, n.d. [June 1906], JPM.
- 29. Ibid., and Combeau, p. 125.
- 30. La Japonaise: Woman Beside the Water, site identified in a note by AM, AMP.
- P. Signac/HM [18 June 1905] and n.d. [end of June 1905], AMP.
- 32. Identified from the canvas and its preparatory sketches by Bernardi, p. 51.
- 33. Painted in the house of the sandal-maker (note by AM, AMP), which stood on the Port d'Avall

- between the customhouse and the little chapel on the rue de la Démocratie (Bernardi, p. 25).
- 34. Bernardi, p. 10.
- 35. Ibid., p. 22.
- 36. Painted from the Square Caloni, ibid., p. 25.
- 37. Barr, p. 74.
- 38. Lydia Delectorskaya in conversation with the author.
- 30. Moll. p. 42.
- 40. HM/H. Manguin, 20 May 1905, JPM.
- 41. Cladel, p. 160.
- Terrus 1994, p. 83; information not otherwise attributed comes from Madeleine Raynal's pioneering essay in this catalogue, pp. 5–16.
- 43. Escholier, p. 70.
- 44. Terrus et Violet, ex. cat. Perpignan: Palais des Congrès, 1972, p. 5.
- 45. M. Luce/HM, postcard, n.d. [July/Aug. 1905], AMP.
- 46. Flam 2, p. 63.
- 47. Unpublished diaries of Daniel de Monfreid (see Barou, pp. 14, 16–17).
- 48. Cladel, p. 9.
- 49. Terrus 1994, p. 14.
- 50. Fourcade, p. 305.
- 51. Mirbeau, pp. 23-24.
- 52. Cladel, pp. 48-49, 102-3; Courthion, pp. 69-70.
- 53. Cladel, p. 72.
- 54. Escholier, p. 69; Bernard Lorqui, Aristide Maillol (London, 1995), pp. 41, 163–65; HM/A. Marquet, June 1905, in Fauve Landscape, p. 76 and p. 116, n. 48.
- 55. Cladel, p. 57.
- 56. Ibid., p. 56, and Slatkin, p. 69.
- 57. Hudson, p. 17.
- 58. Mirbeau, p. 25.
- 59. Escholier, p. 69; Slatkin, pp. 51-52.
- 60. Courthion, p. 70.
- 61. Escholier, p. 164.
- "Lettre de Daniel de Monfreid au peintre Louis Bausil," La Revue Provinciale (Toulouse), Dec. 1903, cited in Barou, p. 26.
- 63. Ibid., p. 18.
- 64. Information about this remarkable house party comes from Monfreid's diaries (it was Monfreid's friend Calmel who loaned Gustave Fayet his first Gauguin for an exhibition at Béziers in 1901), in ibid., pp. 18–19, 23, 26–27.
- 65. P. Gauguin/D. de Monfreid, Oct. 1900, in Barou, pp. 23–25, 116; the carvings, which reached France from Tahiti in March 1901, remained at St-Clément, except for those bought by Gustave Fayet (see note 67 below).
- 66. According to Marguerite Matisse (cited in Derain 1994, p. 116, n. 18), who said her father saw Gauguin's bois with Derain, but did not specify where.

- 67. HM said he had visited Fayet's abbaye de
 Fontfroide, just outside Narbonne (Escholier,
 p. 72), but he must have mistaken either the
 date or the place, since Fayet bought Fontfroide
 only in 1908 (he lived in 1905 in the nearby
 château de Védilhan, which also possessed an
 abbey); Fayet's diary records a visit from
 Matisse to his Paris apartment in February 1905
 (I am grateful to Fayet's granddaughter, Rosaline Bacou, for this information). For the
 Gauguin wood carvings owned by Fayet, see
 chap. 11, p. 355 and p. 60.
- 68. E. Terrus/H. Manguin, 26 Aug. 1906, JPM.
- 69. P. Signac/HM, 18 June [1905], AMP.
- 70. AM/Jeanne Manguin, postcard, 15 July 1905, JPM; HM/A. Marquet, 6 June 1905, in Fauve Landscape, p. 72; C. Camoin/HM, 28 June [1905], in Grammont, pp: 18–19.
- 71. HM/A. Derain, postcard, 25 June 1905 (this postcard was sold Hôtel Drouet, 16 Sept. 1992).
- 72. Barr, p. 54; Lévy, pp. 77-78.
- 73. Date based on AM/Jeanne Manguin, postcard, 15 July 1905, JPM ("M. Derain has been with us for 8 days").
- 74. Muxart's descriptions of Derain in Bernardi, p. 26 (the customs officer's blue cotton umbrella provided protection from rain or sun during days and nights on the lookout for smugglers in the mountains).
- 75. Derain, p. 159.
- 76. Ibid., p. 160; for Gauguin, see note 66 above (HM remembered seeing the carvings with Derain, but Monfreid's diary makes no mention of the latter [Barou, p. 44]).
- 77. I am grateful for this information to the wife of Paul Soulier's great-grandson, Mme Claudine Pascot; HM's La Poterie provențale jaune is in the Cone Collection, Baltimore Museum of Art, Derain's portrait of HM with pots in the Philadelphia Museum of Art.
- 78. Derain, pp. 167, 170; Bernardi, p. 41.
- 79. Derain, p. 167 (the character here dismissed in an editor's note as either fictional or impossible to identify—"affabulation romanesque ou allusion indéchiffrable"—was in fact Terrus).
- 80. Escholier, p. 71.
- 81. Bernardi, p. 34.
- 82. Ibid., p. 35.
- 83. Signed and dated "H. Matisse, 1950" in the Livre d'Or of René and Jo-Jo Pous.
- 84. Stein, p. 44.
- 85. Ibid., p. 48 (the notebook is in a private collection).
- 86. Information from Lydia Delectorskaya.
- 87. Bernardi, p. 28, and in conversation with the author (the move must have taken place some

- weeks after Derain's arrival, since Muxart remembered them both together at the hotel, and Signac was still writing to HM at the Hôtel de la Gare on 14 August [AMP]).
- 88. Bernardi, p. 10.
- 89. AM/Jeanne Manguin, postcard, 15 July 1905, JPM.
- 90. HM/P. Signac, 14 July 1905, Archives Signac, Paris.
- 91. Jourdain, p. 279.
- 92. Derain, p. 167.
- 93. P. Signac/HM, postcard, postmarked 14 Aug. 1905, AMP.
- 94. Au Luxembourg, Paris, 1900, signed and dedicated "A H. E. Cross témoignage de profond sympathie Henri Matisse avril 05" (now in the Rio de Janeiro museum).
- 95. A. Marquet/HM, n.d. [May 1905], AMP; I. Cross/HM, 5 June [1905], AMP (there were two versions of the *Parrot Tulips*: a Divisionist canvas praised by Louis Vauxcelles and given to the Crosses; and another, non-Divisionist painting bought by Félix Fénéon).
- 96. P. Signac/HM, 18 June [1905], AMP.
- 97. H. Manguin/HM, 22 Aug. 1905, AMP.
- 98. I. Cross/HM, 20 June [1905], AMP.
- 99. Ibid., 2 July 1905.
- 100. Schneider, p. 209 and p. 238, n. 19.
- 101. Diehl, p. 32.
- 102. H. Cross/HM, 28 Aug. 1905, AMP.
- 103. Ibid., n.d. [autumn 1905].
- 104. Ibid.
- 105. Duthuit, p. 79.
- 106. Bernardi, p. 39.
- 107. Ibid., p. 34.
- 108. Ibid., p. 38.
- 109. Ibid., p. 36 (the painting was later bought by P. Soulier, who paid for a new door for the hotel)
- 110. Derain, p. 166.
- 111. Duthuit, p. 221.
- 112. HM/P. Matisse, 12 Feb. 1945, PMF; Yama (The Pit) was published in French translation as La Fosse aux filles in 1923.
- 113. Interview with G. Apollinaire in Flam 2, p. 28, and Fourcade, p. 55; see also chap. 2, pp. 47–48 and n. 72.
- 114. Bernardi, p. 41; Derain, p. 166. Derain left by boat, docking at Marseilles on 1 Sept.; the Matisses by train via Avignon, where they hoped to meet up with Marquet on Sept. 2, HM/A. Marquet, 27 Aug. 1905, Wildenstein Institute, Paris.
- 115. Bernardi, p. 44.
- 116. Birth and death registers, Archives Municipales, Bohain.

- 117. The Archives de l'Archevêché de Cambrai, kindly examined for me by Georges Bourgeois, show that Marguerite Matisse was confirmed at Bohain on 27 May 1905 but missed making her first communion with the other sixty-four girls in her year on 25 June, making hers alone on 11 August; there are enquiries about her health in letters from the Crosses to HM, 13 Apr. [1905] and n.d. [autumn 1905], AMP; and in a letter from Dr. L. Tamboise to HM, 26 Jan. 1906, AMP.
- 118. Couturier, p. 167.
- 119. E. Terrus/HM, 2 Dec. 1905, AMP.
- 120. HM/P. Matisse, 3 Apr. 1942, PMF.
- 121. HM/P. Signac, 14 Sept. 1905, Archives Signac, Paris.
- 122. A. Marquet/H. Manguin, postcard, 8 Sept. 1905, JPM.
- 123. Cachin, p. 181.
- 124. By Halperin, p. 276 et passim; information about Fénéon not otherwise attributed comes from Halperin.
- 125. P. Signac/T. van Rysselberghe, n.d. [1905], GC. See also Halperin, pp. 351, 358–59.
- 126. F. Fénéon/HM, postcard, 27 Aug. 1905, AMP. 127. Boudot-Lamotte 2.
- 128. F. Fénéon/HM, 21 Sept. 1905, and O. Mirbeau/F. Fénéon, n.d. [Sept. 1905], AMP; Halperin, p. 359.
- 129. Derain 1994, p. 437.
- 130. A. Maillol/HM, 8 Dec. 1905, AMP; and Escholier, p. 49.
- 131. This visit is mentioned in E. Terrus/HM, 2 Dec. 1905, AMP; the Cézanne negotiations are outlined in two letters to HM from A. Maillol, n.d. [winter 1905] and 8 Dec. 1905, and one to Maillol from G. Bernheim, 24 Sept. 1905, all AMP.
- 132. Cladel, p. 78.
- 133. P. Signac/H. Manguin, n.d. [Sept. 1905], JPM; see also chap. 9, n. 106. Cross's painting, which in part inspired HM's, was Composition: Air du soir, 1893–94, see Bock, p. 69 and plate 31.
- 134. HM/S. Bussy, 19 Sept. 1905, in Bussy.
- 135. Level, pp. 19–20 (the dates, somewhat muddled in this account, can only have been autumn 1904 and spring 1906).
- 136. Information from Marie Matisse, Paris, 1996.
- 137. Couturier, p. 144.
- 138. Etienne Charles, La Liberté, 17 Sept. 1905, in Dagen, p. 44; Marcel Nicolle, JR, 20 Nov. 1905, in ibid., p. 62; and Flandrin, p. 84.
- 139. Carco, p. 221.
- 140. HM/P. Signac, 28 Sept. 1905, Archives Signac, Paris.
- 141. Level, p. 20; Jourdain, pp. 209-11.

142. H. E. Cross/HM, n.d. [autumn 1905], AMP.

143. HM/P. Signac, 28 Sept. 1905, Archives Signac, Paris.

144. Courthion, p. 52.

145. Texts in Dagen, pp. 38, 51-55.

146. Flandrin, p. 84.

147. S. Bussy/HM, 12 Sept. 1905, AMP; and HM/S. Bussy, 19 Sept. 1905, in Bussy.

148. Escholier, pp. 58-59.

149. Richardson 1, p. 411.

150. Carco, p. 231.

151. Marcel Sembat, Henri Matisse (Paris, 1920), p. 8.

152. H. E. Cross/HM, Vendredi, n.d. [end 1905], AMP.

153. Information from Claude Duthuit.

154. Stein, pp. 45–46; Gertrude Stein, whose memory was an inventive faculty, remembered the sum offered as 400 francs, but it is 300 in the carte pneumatique from the Bureau de Ventes, Salon d'Automne, 18 Nov. 1905, AMP.

155. Weill, pp. 148-49.

156. Jelenko, p. 4; Gertrude subsequently claimed credit for this transaction (Stein, p. 46), but Sarah Stein's account (in Barr, p. 58), and HM's recollections in public ("Testimony Against Gertrude Stein," *Transition*, vol. 23, no. 1 [Feb. 1935]) and private (to Pierre Matisse, 12 Feb. 1933, PMF) confirm Jelenko's version.

157. James R. Mellow, Charmed Circle (New York, 1974), p. 79 (the painting is in the Tate Gallery, London).

158. Secrétaire de la direction, Compagnie des Chemins de Fer du Midi/M. Sembat, 12 July 1905, granting HM half-price fares for himself, his wife and one child, AMP.

159. Georgette Sembat/HM, n.d. [Sept./Oct. 1905], AMP (HM had asked for help in finding work for a friend, but Mme Sembat's urgency suggests that the friend may well have been HM himself, whose situation was more desperate at this point than that of anyone else he knew).

160. M. Sembat/R. Piot, 31 Oct. 1905, and M. Sembat/HM, n.d. [31 Oct. 1905], both AMP; Henri Dujardin-Beaumetz, sous-sécrétaire de l'État pour les Beaux-arts, 1905–12, was unable to produce a state subsidy because his allocation had already been used up, but promised both immediate relief in cash and a possible state purchase.

161. M. Sembat/HM, 25 Nov. 1905, AMP.

162. Information from Claude Duthuit.

163. Richardson 1, p. 455.

164. Schneider, p. 218.

165. Janie Bussy/M. Duthuit, 24 Apr. 1957, Tate Gallery Archives, London.

166. Schneider, p. 204.

167. Information from Claude Duthuit.

168. Kean, p. 167.

169. P. Matisse/HM, 5 June 1945, PMF; the picture was La Rose.

170. Ibid., 9 Oct. 1921.

171. Ibid., 8 Feb. 1927.

172. HM/H. Manguin, 14 Dec. 1906, JPM.

173. Courthion, p. 55.

174. H. Cross/HM, Vendredi, n.d. [winter 1905], AMP.

175. Gowing, p. 57.

176. Barr, p. 82.

177. P. Signac/T. van Rysselberghe, Mercredi 18 Nov. [1908], GC.

178. Duthuit, p. 172.

179. Fourcade, p. 93.

180. Soulier, p. 179; see chap. 3, p. 79 and n. 84.

CHAPTER ELEVEN

1. Weill, p. 125.

2. Janet Flanner, "King of the Wild Beasts," Man and Monuments (London, 1957), p. 90.

Roland Dorgelès, "The Prince of the Fauves,"
 Fantasio, 1 Dec. 1910, in Flam 3, p. 88; Salmon 1, pp. 187–88; Diehl, p. 40. See also chap. 12, p. 340.

 In Gazette des Beaux-Arts, Dec. 1905, and Denis, pp. 208–9; for a summary of the relative positions of Gide and Denis, see Benjamin, pp. 86–88, 95.

5. Stein, L., p. 161.

6. Gustave Fortier/E. Druet, 17 May 1906, AMP.

 HM/H. Manguin, n.d. [May/June 1906], JPM; and Diehl, p. 40; J. Puy/H. Manguin, 1 May 1906, JPM, makes it clear that these sales took place in April.

8. HM/H. Manguin, n.d. [May/June 1906], JPM.

 8–29 Oct. 1905, Société de l'Aube, Troyes, correspondence AMP.

 See Peter Kropmanns, "Die deutsche Matisse-Première vor 90 Jahren—München 1906," Weltkunst (Munich), 1 July 1996, p. 1519.

11. Kean, p. 161; Beverly Kean in conversation with the author.

 A. Kostenevich, "Russian Collectors of French Art: The Shchukin and Morozov Families," in Collectors, p. 60.

13. Kean, p. 138.

14. G.-W. Költsch, "Shchukin, Morozov—and Germany: 1906–26," in Collectors, p. 135.

15. Flam 2, p. 203, and Fourcade, p. 118.

 Ibid.; picture identified from HM/H. Manguin, n.d. [May/June 1906], JPM, and AMP.

17. Barr, p. 82.

18. Stein, L., p. 158.

NOTES TO PAGES 343-356

- 19. Date revised from 1904 by Wineapple, pp. 451–52.
- 20. Jelenko, pp. 8–9; and see also Salmon 2, p. 56; Wineapple, p. 245; and Richardson 1, pp. 405–7.
- 21. To Sir Francis Rose (not an entirely reliable witness), in *Saying Life* (London, 1961), p. 163.
- 22. Vollard, p. 146.
- 23. Stein, L., p. 150.
- 24. Ibid., p. 195.
- 25. Salmon 2, p. 57.
- 26. Mabel Weeks, introduction to Journey into the Self: Being the Letters, Papers and Journals of Leo Stein, ed. Edmund Fuller (New York, 1950), p. xii.
- 27. Stein, L., p. 160.
- 28. HM/H. Manguin, n.d. [May/June 1906], JPM.
- 29. Ibid.
- 30. Ibid.
- Stein, pp. 41, 73 (HM told Sarah Stein that his wife wore black from head to toe when she posed for Woman in a Hat).
- 32. Note by AM, AMP.
- 33. Sarah and Michael Stein owned at one point or another well over forty works by Matisse, according to my reckoning based on records kept by AM (AMP) as well as on HM's published and unpublished correspondence; but since there is no surviving archive of their collection (which was dispersed after Michael's death in 1938), all previous accounts have tended to assign any Matisse work said to have been purchased by the Steins to Leo and Gertrude, when in fact the buyers were more often Michael and Sarah (see note 140 below). Even Margaret Potter's groundbreaking Four Americans in Paris (New York, 1970) lives up to its subtitle, The Collections of Gertrude Stein and Her Family, in doing less than justice to Gertrude's sister-in-law.
- 34. HM/P. Matisse, 12 Feb. 1933, PMF; see also HM's contribution to "Testimony Against Gertrude Stein," *Transition*, vol. 23, no. 1, supp. (Feb. 1935): pp. 2–15; Leo protested against his sister's falsifications and omissions in Stein, L., p. 152, and in *Journey into the Self* (see note 26 above), p. 150.
- 35. "Testimony Against Gertrude Stein" (see note 34 above).
- 36. Wineapple, p. 66.
- Stein, L., p. 141; there is an excellent account of San Francisco art classes in Rosenshine, pp. 37–42.
- 38. Harriet Lane Levy, 920 O'Farrell Street (New York, 1947), p. 162.
- 39. Wineapple, p. 117.
- 40. Rosenshine, p. 66.
- 41. 18 Feb. 1906, Four Americans, p. 76 and p. 86, n. 7.

- 42. The apartment is described in Jelenko, p. 7, and in Rosenshine, pp. 67–68, 71; built in 1875, next door to the modest house of the Luxembourg gardener and facing open ground to the west, 58 rue Madame still houses a Lutheran Reformed church, which has reclaimed the pillared hall on the first floor where Sarah and Michael Stein's Matisse collection once hung.
- 43. Courthion, p. 54.
- 44. Rosenshine, p. 62 (I am grateful to Wanda de Guébriant for confirming that the third painting imported by the Steins to San Francisco described here as "the last horror"—was the smaller of the Barnes Collection's two versions of the Red Madras Headdress, generally dated 1907 but painted in fact in Collioure in 1905).
- 45. Ibid.
- 46. The San Francisco Museum of Modern Art owns eight works bequeathed by Harriet Levy, together with a number of individual works acquired from Sarah Stein by other collectors.
- 47. L. Stein/H. Manguin, n.d. [end of May], 1906, JPM.
- 48. Stein, p. 54.
- 49. Stein, L., p. 170.
- 50. Olivier, p. 107.
- 51. Brassaï, Picasso & Company (New York, 1966), p. 252.
- 52. To the author, Paris, 1993.
- 53. J. Puy/H. Manguin, 1 May 1906, JPM.
- 54. L. Stein/HM, 8 May 1906, AMP.
- 55. See chap. 12, p. 420 and n. 189.
- 56. Stein, L., p. 171.
- 57. See Fauve Landscape, p. 87 and p. 118, n. 119.
- 58. Courthion, p. 100.
- 59. The two had been in contact since 1900, exchanging visits in Paris in February 1905 and in January and February 1906; imports of Algerian wine were at their height at this time, and Fayet was certainly in Algeria on business 19–22 October 1906, with a suggestive entry for those dates in his diary "Matisse, 19 Quai St Michel" (I am grateful for this information to Fayet's granddaughter, Rosaline Bacou); he was there again in December, according to a letter to HM from Maurice Fabre, 28 Dec. 1906, AMP. HM evidently had at least one introduction in Algiers (see p. 360 and note 80 below), and it is hard to think of anyone else who might have provided it.
- 60. Bacou, pp. 206–8, 217 (the works received in 1901 were La Guerre and La Paix; Fayet, who already owned Les Ondines, later acquired Oviri, L'Eau clair and Soyez mystérieux).
- 61. Information from Rosaline Bacou.
- André Suarès, Gustave Fayet et ses tapis (Paris, 1923),
 P. 8.

- 63. P. Gauguin/D. de Monfreid, 25 Aug. 1902, in Bacou, p. 208.
- 64. Rosaline Bacou kindly supplied details from Fayet's records of his purchase from HM on 25 January 1906 of four watercolours—Bord de mer, Femme dans les rochers au bord de la mer, Personnage dans une crique au bord de la mer and Femme assise vue du dos—together with a large pen-and-ink drawing (probably the Nude in a Folding Chair now in the Art Institute of Chicago); and from Druet on 30 January 1906 of Still Life with Lemon, plus another still life in April. See also note 111 below for eleven more canvases bought that autumn. Fayet bought his last three paintings by HM from Druet in March 1907 (information from R. Bacou), after which his extensive Matisse collection was sold, leaving even less trace than the Steins'.
- 65. HM/P. Matisse, 3 Apr. 1942, PMF.
- 66. Lévy, p. 81.
- 67. A. Derain/HM, 8 Mar. 1906, in Michel Kellerman, André Derain: Catalogue raisonné de l'oeuvre peint, vol. 1, 1895–1914 (Paris, 1992), pp. xlviii–xlix.
- 68. Ibid, and Vlaminck, p. 173.
- HM/H. Manguin, n.d. [end of May/early June], 1906, JPM; and HM/A. Rouveyre, 14 May 1947.
- 70. Evenepoel 2, p. 181.
- 71. Matisse 1993, p. 76.
- 72. Courthion, p. 100.
- 73. Ibid.
- 74. HM/H. Manguin, n.d. [May/June], 1006. IPM.
- 75. Philippe Zilcken, Impressions d'Algérie (Paris, 1910),
- 76. Richard Ellmann, Oscar Wilde (London, 1987), pp. 121, 129.
- 77. HM/H. Manguin, see note 74 above.
- 78. Zilcken, *Impressions* (see note 75 above), pp. 67–68, 8.
- 79. HM/H. Manguin: see note 74 above.
- 80. Le Glay/HM, Fort de la Qasba, Alger, 12 June 1906, AMP.
- 81. HM/H. Manguin: see note 74 above.
- 82. Jean and Pierre Matisse, nos. 744 and 755 in the Collioure school register for 1906, enrolled on 6 June and left on 1 August, returning the year after on 12 June.
- 83. Richardson 1, p. 417 and p. 516, n. 61; and Richardson 2, p. 30.
- 84. Information from Paul Matisse; and P. Matisse/HM, 5 June 1945, PMF.
- 85. HM/J. Biette, 7-9 Aug. 1906, AMP.
- HM/P. Matisse, 21 Nov. 1926, PMF; and information from Jacqueline Matisse Monnier.
- 87. See Soulier, pp. 180–81; Charles Naudin left Collioure in 1878 to take over the botanical garden at Antibes.

- 88. I am grateful to Ernest Py's daughter, Germaine Nadal-Py, and to his granddaughters, Mmes Figuères and Boisselot, owners of the Villa Palma, for much information, and for a tour of the house and garden in September 1993.
- 89. Information from Wanda de Guébriant; and see Pierre Schneider, "Una 'Belva' tra i Donatello," in Matisse et l'Italie, ex. cat. (Venice: Napoleonica and Museo Correr, 1987), p. 18.
- 90. Cladel. p. 154.
- 91. H. Manguin/HM, 12 May 1906, AMP.
- 92. HM/H. Manguin, n.d. [end of June], JPM.
- 93. P. Schneider cited in Matisse Sculpture, p. 257, n. 8.
- 94. HM/P. Matisse, 1 Sept. 1940, PMF.
- 95. Aragon 1, p. 89.
- 96. Marcel Sembat, Henri Matisse (Paris, 1920), p. 8.
- 97. HM/H. Manguin, n.d. [end of June], 1906, JPM (the rent was 200 francs for three months, so presumably this was Paul Soulier's house, into which the Matisses moved themselves after the Manguins' departure).
- 98. HM/H. Manguin, 14 Dec. 1906, JPM.
- 99. Manguin, p. 9.
- 100. HM/H. Manguin, 20 Sept. 1906, JPM.
- 101. HM/J. Biette, 7-9 Aug. 1906, AMP.
- 102. J. Puy/HM, 17 Aug. 1906, AMP.
- 103. A. Derain/HM, 2 Aug. 1906, André Derain: Catalogue raisonné (see note 67 above), p. L.
- 104. HM/H. Manguin, 14 Dec. 1906, JPM.
- 105. Jeanne Manguin/AM, 11 Sept. 1906, AMP.
- 106. HM/H. Manguin, 20 Sept. 1906, JPM.
- 107. E. Terrus/HM, 20 Oct. 1906, AMP.
- 108. Ibid.
- 109. E. Terrus/H. Manguin, 26 Aug. 1906, JPM. 110. A. Marquet/HM, 16 Sept. 1906, AMP; Stein,
 - L., p. 193, for Vollard.
- 111. On 4 October 1906 Fayet bought HM's Marguerite Reading, 1906, and Landscape at St-Tropez, 1904, plus nine still lifes, including Still Life with Purro, 1904, Dishes and Fruit on a Red and Black Carpet, 1906, and Still Life with Red Rug, 1906 (information kindly supplied by Rosaline Bacou). The first and last were subsequently acquired by Sembat.
- 112. HM/P. Matisse, 5 Jan. 1927, PMF.
- 113. Weill, p. 144.
- 114. Stein, L., p. 192.
- 115. Denis, p. 220.
- 116. Kean, p. 148; and see note 111 above.
- 117. Barou, p. 50.
- 118. Stein, L., p. 174.
- 119. Correspondance André Gide/Jacques-Emile Blanche, 1892–1939, ed. G.-P. Collet (Paris, 1979), pp. 154–55.
- 120. Courthion, p. 54; the date, background and implications of this episode are explored in

NOTES TO PAGES 371-385

detail in Jack D. Flam, "Matisse and the Fauves," in "Primitivism" in Twentieth Century Art: Affinity of the Tribal and the Modern, ed. William Rubin, ex. cat. (New York: MoMA, 1984), vol. 1; also in Jean-Louis Paudrat, "From Africa," in ibid.

121. R. Dorgelès, Bouquet de bohème (Paris, 1989 [1947]), p. 137; J. Warnod, Le Bateau Lavoir (Paris, 1986), p. 112.

122. Dorgelès, Bouquet (see note 121 above).

123. Stein, p. 71.

124. Barr, p. 533, n. 3.

125. Georgette Sembat/HM, n.d. [autumn 1906], AMP.

126. Information from Wanda de Guébriant. (The Matisses rented a house from Marie Astié between Soulier's house and the hotel on the avenue de la Gare.)

127. From ts. transcript of HM's notebook dated 30 Oct. 1949, PMF.

128. Rosenshine, p. 96.

129. Barr, p. 77; and Stein, L., p. 192.

130. Cladel, p. 148.

131. Courthion, pp. 67-68.

132. Ibid.; the date can be deduced from a letter from L. Stein to HM (25 Jan. 1907, AMP), commiserating on the damage to his statue.

133. Barr, p. 533; Barou's claim (p. 61) that M. Py's garden figures in the background to this canvas is weak, given that it was painted in midwinter.

134. Stein, L., p. 203.

135. HM/H. Manguin, 7 Feb. 1907, JPM.

136. Ibid., Prades, 2 Feb. 1907.

137. Ibid., Narbonne, 7 Feb. 1907, JPM (this visit had originally been planned for January, according to M. Fabre/HM, 28 Dec. 1906, AMP).

138. Postcard from HM, AM and E. Terrus to H. Manguin, 12 Feb. 1907, JPM.

139. E. Terrus/HM, 2 Dec. 1905, AMP (the box of tourons weighed four kilos, and the wine was part of Bausil's payment for a painting, E. Terrus/HM, 20 Dec. 1905, AMP).

140. S. and L. Stein/HM, 25 Jan. 1907, AMP. This acquisition of six Matisses by barter is one of several transactions previously credited to Leo and Gertrude Stein, e.g., in Fauve Landscape, p. 100; but Sarah's part of this joint letter to HM makes it clear that the bargain with Druet was in fact hers.

141. Ibid.

142. F. Fénéon/HM, 23 Feb. 1907, AMP.

143. Ibid., 11 Mar. 1907.

144. Matisse 1993, p. 79.

145. H. Purrmann cited in Barr, p. 533, n. 3 (but Flam 1, p. 491, n. 17, points out that the canvas in question—presumably Derain's Bathers 1, shown at the Indépendants in 1907—still exists. I am grateful to John Golding for explaining that Derain in fact destroyed works like *La Toilette*, painted under the influence of Picasso's *Demoiselles* rather than HM's *Blue Nude*).

146. Pach, p. 125.

CHAPTER TWELVE

1. Pach, p. 15.

 For Hans Purrmann (1880–1966), see Liesbeth Jans, "Purrmanns Studienzeit in München und Paris," in Matisse 1988, pp. 179–87; and Wolfgang Stolte, "Hans Purrmann," in ibid., pp. 195–297.

3. Matisse 1988, p. 198.

4. Flandrin, p. 236.

5. Vlaminck, p. 72.

6. Richardson 2, pp. 20, 34, and 45.

7. Flandrin, p. 236.

8. Salmon, pp. 187-88.

9. Ibid.

10. Ibid.

11. See Richardson 2, p. 31, and chap. 2, passim.

12. Vlaminck, p. 108.

13. Carco, p. 18.

14. S. Stein/HM, 7 Jan. 1936 and 19 Apr. 1946, AMP.

15. HM/S. Stein, 5 Aug. 1935, draft, AMP.

16. Levy, H., p. 6.

17. Nu étendu, Nu assis dans un paysage, Figure à la branche de lièvre; Sarah chose the fourth, Nu dans les bois, for her friend the American photographer George F. Of.

18. Levy, H., p. 32; and see chap. 11, n. 33.

19. Jelenko, p. 4; Levy, H., p. 32.

20. Note by AM, AMP.

 Jelenko, p. 5 (Therese Ehrman, b. 1885, married a first husband called Bauer, and a second called Jelenko).

22. Rosenshine, p. 97.

23. Levy, H., p. 5.

24. S. Stein/HM, 16 May 1926, AMP.

25. Four Americans, p. 162.

26. S. Stein/HM, n.d. [Oct. 1911], AMP; presumably the painting was *Intérieur aux aubergines*.

27. HM/S. Stein, 5 Aug. 1935, draft, AMP.

28. Ibid.

29. Puy, p. 27.

30. Levy, H., p. 5.

31. Stein, L., p. 192.

32. Stein, p. 13.

33. Levy, H., pp. 29-30.

34. Rosenshine, pp. 102-3.

- 35. Ibid, pp. 98, 119.
- 36. Ibid., p. 81.
- 37. Wineapple, p. 243.
- 38. Rosenshine, p. 71.
- 39. Levy, H., pp. 10, 59.
- 40. Ibid., p. 29; for the sequel, see p. 420.
- 41. H. Purrmann/K. H. Osthaus, Feb. 1907, in Collectors, pp. 130, 140, n. 7.
- 42. Ibid. (according to Purrmann, negotiations between HM and Osthaus had been in hand since the summer of 1906); for HM's ceramic triptych, see Neff, pp. 22–27 and 31–33.
- 43. Marcel Sembat, preface to L'Oeuvre du potier André Methey (1871–1920), ex. cat. (Paris: Musée Galliéra, 1921); see also Neff, pp. 28–51; and Xavier Girard, "Matisse: l'Oeuvre céramique" in La Céramique Fauve: André Metthey et les peintres, ex. cat. (Nice-Cimiez: Musée Matisse, 1996), pp. 77–88 (I have used the original spelling, "Metthey," adopted after some hesitation by the potter himself).
- 44. Sembat, preface (see note 43 above).
- 45. Neff, p. 46; see also p. 81, n. 92, and p. 231 (the tile is no. 2 in Neff's invaluable catalogue of "Matisse's Early Ceramics," pp. 219–38).
- 46. Sembat, preface (see note 43 above).
- 47. A. Marque/HM, 21. Apr. 1907, AMP.
- 48. Georgette Sembat/HM, 24 Apr. 1907, AMP.
- 49. HM/H. Manguin, 20 June 1907, JPM; information on Germaine Thieuleux (1888–1907), from Bohain and Le Cateau parish records, and Succession Gérard-Denis, 1903, ADN.
- 50. HM sent a retrospective account to H. Manguin, 20 June 1907, JPM.
- 51. Ibid.; Collioure school register records the return of Jean and Pierre Matisse on 12 June 1907.
- 52. HM/H. Manguin, 26 May 1907, from Amélie-les-Bains (this was a thermal spa in the Pyrenees where presumably his cousin died), JPM. The Wine-growers' Revolt was led by a charismatic local peasant, Marcellin Albert (1851–1921).
- 53. H. Cross/HM, n.d. [June 1907], AMP.
- 54. Barou, p. 63.
- 55. Stein, L., p. 109.
- 56. Fauve Landscape, p. 105; E. Terrus/HM, 10 Aug. 1907, AMP.
- HM/H. Manguin, 20 June 1907, JPM; and HM/F. Fénéon, 13 July 1907, in Matisse 1993, p. 79.
- 58. Derain, pp. 187, 189.
- 59. Duthuit, p. 43.
- 60. Receipt signed by HM, 12 July 1907, in Fauve Landscape, p. 104.
- For Hôtel d'Italie (address from HM's correspondence, AMP), see Karl Baedeker, Handbook for Travellers in Northern Italy (Leipzig, 1906), p. 457.
 Stein, p. 61.

- 63. Courthion, p. 108.
- 64. Rosenshine, p. 85.
- 65. Stein, L., p. 162.
- Bernard Berenson and Isabella Stewart Gardner, 1887–1924, ed. R. Van N. Hedley (Boston, 1987), P. 454.
- Mary Berenson: A Self-portrait from Her Letters and Diaries, ed. B. Strachey and J. Samuels (London, 1983), p. 140.
- 68. Fourcade, p. 57.
- 69. G. Apollinaire, "Henri Matisse" *La Phalange*, Dec. 1907, in Flam 2, p. 29, and Fourcade, p. 58.
- 70. Fourcade, p. 57, and Flam 2, p. 215.
- 71. Pach, p. 117.
- 72. Fourcade, p. 49.
- 73. Apollinaire, "Henri Matisse" (see note 69 above).
- 74. Flam 2, pp. 41–2, and Fourcade, pp. 49–50; for "Notes of a Painter" see p. 397 and note 81 below.
- 75. Pach, p. 117.
- 76. Flam makes little of this mirror-image reflection (Flam 1, p. 209, n. 17), which is implicit in everything from the rhythm and disposition of the figures to the seaside setting, the flowers, the drapery (which takes the shape of a conch-shell in Le Luxe I), even the central figure's distinctive second toe.
- 77. Bernardi, p. 25.
- 78. Barou, p. 79; the glue was casein, often used in tempera and mural painting.
- 79. Apollinaire, "Henri Matisse" (see note 69 above).
- 80. Michel Puy, "Les Fauves," reprinted in L'Effort des peintres modernes (Paris, 1933), p. 67.
- M. Golberg/HM, [July] 1907, AMP; the revival of the Cabiers was made possible by backing from a socialist commune based on the abbaye de Créteil (Coquio, pp. 50, 338–9; Salmon 1, p. 99).
- 82. Ibid, 16 Aug. 1907.
- 83. Salmon 1, p. 101.
- 84. Aubéry, pp. 55–56; for Rouveyre's subsidising Golberg, see Salmon 1, pp. 61, 102. Golberg's reputation as an aesthetician has survived, if at all, on the strength of La Morale des lignes (Paris, 1908), which was never intended to be more than a brief accompanying text to a collection of Rouveyre's far-from-radical drawings; Rouveyre himself claimed, just before he died at the age of eighty-four in 1962, that Golberg was in fact the author of "Notes of a Painter" (Aubéry, p. 104), but this was a garbled version of the chain of events first unravelled in detail in Xavier Deryng, "Les Variations Golberg 2: La Critique d'art" (Coquio, pp. 270–85), and amplified here. See also chap. 7.

NOTES TO PAGES 398-412

85. Coquio, p. 18.

86. M. Golberg/HM, 16 Aug. 1907, AMP.

87. M. Golberg/G. Apollinaire, 20 Aug. 1907, in Deryng, "Variations" (see note 84 above), in Coquio, p. 284.

88. Deryng, "Variations" (see note 84 above), in Coquio, p. 284.

 M. Golberg/G. Apollinaire, 10 Sept. 1907, in Elzbieta Grabska, "Morales et lignes," in Coquio, p. 326.

90. Ibid., 28 Sept. 1907.

91. Ibid., n.d. [Oct. 1907], in Coquio, pp. 285, 326.

92. J. Royère/HM, 26 Nov. 1907, AMP.

93. G. Apollinaire/HM, n.d. [19 Nov. 1907], AMP.

94. Aragon 1, p. 113.

95. In *Poliche*, 15 Feb. 1907, reprinted in Coquio, p. 204. 96. See HM/J. Biette, 26 Oct. 1910, in Matisse 1993,

p. 95; and Richardson 2, pp. 102, 215.

97. Puy, "Fauves" (see note 80 above), p. 68; see also Schneider, p. 728.

98. HM, "Un Jury du Salon d'Automne," Courthion Papers, GC; see also G. Apollinaire, Chroniques d'art, 1902–18, ed. L. C. Breunig (Paris: 1996 [1960]), pp. 51–52.

99. Matisse 1992, p. 137.

100. For Oskar Moll (1875–1947) and Margarete Moll, née Haeffner (1884–1987), see Dorothea and Siegfried Salzmann, "Die Bildhauerin Marg Moll" and "Der Maler Oskar Moll," in Matisse 1988, pp. 103–6, 121–29.

101. Moll, p. 41.

102. Ibid.

103. Ibid., pp. 41-42.

104. To Clara Rilke, 13 Oct. 1907, Selected Letters of Rainer Maria Rilke, 1902–26, trans. R. F. C. Hull (London, 1946), p. 151.

105. Ibid., 18 Oct. 1907, p. 156.

106. Apollinaire, Chroniques d'art (see note 98 above), p. 51.

107. Pach, p. 119.

108. Moll, p. 44.

109. Pierre Daix, Dictionnaire Picasso (Paris, 1995),

110. D. H. Kahnweiler, Mes Galeries et mes peintres (Paris, 1961), p. 27.

111. Ibid., p. 55.

112. Olivier, p. 108.

113. Flam 3, p. 120.

114. Rosenshine, p. 81; Levy, H., p. 12.

115. Levy, H., p. 5.

116. Flam 3, p. 120.

117. Françoise Gilot, Matisse and Picasso (London, 1990), pp. 157–58.

118. Couturier, p. 398.

119. Moll, p. 41. (Moll specified Thursdays, others remembered Mondays.)

120. Rosenshine, p. 101.

121. Matisse 1988, pp. 182, 198.

122. Levy, H., p. 10.

123. Gautherie-Kampka, p. 267.

124. Matisse 1988, p. 184; Courthion, pp. 55-56.

125. Moll, p. 44.

126. Weber, p. 99; Rosenshine, p. 101.

127. List of the original students based on an amalgam of Weber, p. 99 (for the "Fräulein Devard from Holland" mentioned here, see note 144 below); Rosenshine, p. 101; and H. Purrmann in Barr, p. 535, n. 5 and p. 116.

128. Weber, p. 99.

129. Rosenshine, p. 103.

130. Levy, H., p. 30.

131. Moll, p. 44.

132. Ibid., p. 41.

133. Ibid., p. 46 (there is some confusion here over the date, which must have been December 1907).

134. I am grateful to Wanda de Guébriant for confirming that the move was completed by 15 Dec. 1907.

135. Escholier, p. 80; Stein, p. 74; Courthion, p. 56.

136. Moll, p. 46.

137. Ibid., p. 44; Pach, p. 120; Matisse 1988, p. 184.

138. Matisse 1988, pp. 184 and 198.

139. Moll, p. 44.

140. Flam 2, p. 48.

141. Weber, pp. 100-101.

142. Matisse 1988, p. 200.

143. Flam 2, p. 47.

144. B. de Ward/HM, 21 Nov. 1909, AMP.

145. Weber, p. 101.

146. Ibid., p. 102.

147. Ibid.

148. Ibid., p. 103.

149. Moll, p. 45.

150. Statement by Henri Matisse on Oskar and Greta Moll, ms., AMP.

151. Moll, p. 45.

152. This and the next three quotes from HM's statement (see note 150 above).

153. Moll, p. 45.

154. H. Purrmann/K. E. Osthaus, Mar. 1908, in Collectors, pp. 130–31 and p. 140, n. 12.

155. Moll, p. 45.

156. Matisse 1993, p. 81.

157. H. Purrmann/K. E. Osthaus, May 1908, in Collectors, p. 131.

158. Ibid.; Moll (p. 45) also remembered this commission, although she vastly exaggerates the price agreed upon (Shchukin paid 1,500, not 20,000, francs).

159. For Sergei Shchukin (1854–1936), see Kean; Natalya Semyonova, "The Story of an Encounter," in Kostenevich, pp. 7–45; "Matisse's Correspondence with his Russian Collectors," ed. A. Kostenevich, in ibid., pp. 159–86; and Alexandra Demskaya and N. Semyonova, U Shchukina na Znamenke (Moscow, 1993; I am grateful to James M. Curtis for showing me his forthcoming translation, Collecting Modern Art in Moscow: A Biography of Sergei Shchukin).

160. Flam, p. 203, and Fourcade, p. 118.

161. Kean, pp. 127-28.

162. S. Shchukin/HM, 2 June 1908, in Kostenevich, p. 161.

163. Kostenevich, p. 85, and Schneider, p. 281.164. H. Purrmann/K. E. Osthaus, May 1908, in Collectors, p. 132 and p. 140, n. 17.

165. Ibid.

166. Kostenevich, pp. 161–2 (prices ranged from 900 francs for the still life to 1,500 for Game of Bowls and 4,000 for Harmony in Red).

167. Review of the annual exhibition of the International Society of Sculptors, Painters and Engravers, New Gallery, in *Burlington Magazine*, no. 59, vol. 12 (Feb. 1908), p. 272.

168. James Huneker on HM's show in July 1908 at the Photo-Secession Gallery, in Flam 3, p. 72.

169. Kostenevich, p. 16; HM took part in a mixed show put on by the Golden Fleece in Moscow in April.

170. H. Purrmann/K. E. Osthaus, May 1908, in Collectors, p. 132; and Osthaus's agent from the Folkwang Museum to HM, 5 Aug. 1911, AMP. 171. Moll, p. 45.

172. Eight postcards addressed alternately to Marquet and Manguin, written in Dieppe but posted in a single packet by HM from Munich on 15 June 1908, JPM.

173. For this trip, c. 7–14 June, see B. E. Göpel, Leben und Meinungen des Malers Hans Purrmann (Wiesbaden, 1961), p. 248.

174. HM/S. Shchukin, 6 Aug. 1908, draft, AMP. 175. H. E. Cross/HM, n.d. [summer 1908], AMP; for the dating of this change in colour, see Kostenevich, p. 92.

176. Kostenevich, p. 91.

177. Lévy, p. 75.

178. Collectors, p. 64.

179. Flam, p. 203, and Fourcade, p. 118.

180. See Semyonova, "Story" (see note 159 above), p. 10 and p. 11, n. 15; and U Shehukina na Znamenke, pp. 20–22.

181. J. Tugendhold, "The French Collection of S. I. Shchukin," Apollon (Moscow), nos. 1–2 (1914) (the essence of Tugendhold's analysis, especially his images, evidently came from conversations with Shchukin).

182. HM/S. Shchukin, 6 Aug. 1908, draft, AMP.

183. Matisse 1993, p. 86.

184. A. Marquet/H. Manguin, 23 Sept. 1908, JPM.

185. Klüver, p. 40.

186. The Bernard Berenson Treasury, ed. Hanna Kiel (London, 1964), p. 136.

187. 12 Nov. 1908, see Barr, p. 114; Berenson later bought *Copper Beeches* (colour fig. 10).

188. Olivier, p. 143. It is typical of the gratuitous animosity towards HM that even John Richardson, in his definitive life of Picasso (Richardson 2, p. 106), states as a fact on no evidence whatsoever that HM would never have made this introduction in the autumn of 1908—an assertion which flatly contradicts the evidence both of Fernande Olivier (a reliable witness who was present) and of HM's character (see note 189 below).

189. HM's generosity invariably took place behind the scenes and was recorded only in passing references in unpublished correspondence. For his support of Marquet, see pp. 81, 199; Manguin, pp. 368–9; Puy, pp. 196, 368; Derain, p. 316; Boudot-Lamotte, p. 196; Metthey, p. 388; for his persuading Vollard to buy from the first four, p. 296; for his arranging a show for Biette, see Weill, p. 126. Specific aid given to Vlaminck, Bussy and Iturrino is documented in AMP.

190. Matisse 1993, pp. 86, 87.

191. Moll, p. 46.

192. Revue Hebdomadaire, 17 Oct. 1908, in Flam 3, p. 73.

193. Vollard, pp. 262-63.

194. Flam, p. 43, and Fourcade, p. 52.
195. See G. Fiedler-Bender, "Matisse und seiner deutschen Schüler," in Matisse 1988, pp. 9–18; Courthion, p. 110; and Gautherie-Kampka, pp. 280–81.

196. See Matisse 1988, p. 202, for Purrmann's account, which is corrected and revised in Peter Kropmanns, "Die deutsche Matisse-Première vor 90 Jahren—München 1906" Wellkunst (Munich), 1 July 1996, pp. 1519—21.

197. Moll, p. 46.

198. Flam 2, p. 40, and Fourcade, p. 48.

199. Flam 2, pp. 38-39, and Fourcade, pp. 44-45.

200. Flam 2, p. 42, and Fourcade, p. 50.

Italicized page numbers indicate illustrations.

Abelard, Peter, 101 Académie Camillo, 192 Académie Colarossi, 197, 200, 402, 405 Académie de la Grande Chaumière, 217 Académie Julian, 46, 65-9, 185, 192, 447n3 African art, 354-5, 371-2, 397, 409 Agutte, Georgette; see Sembat, Georgette Aix-en-Provence, 250 Ajaccio, 158-69, 158, 162 Algeria, 355, 357-60 Algerian rugs, 359, 364-5, 397 American Art Club, 406 anarchism, 136, 291-3, 328 Matisse's experiment with, 12, 74-5, 208-9, 303 Ancelet, Emile, 34-5, 37, 38 Lycée Henri Martin engraving, 35, 35 Angrand, Charles, 288 Anthéaume, Xavier, 36, 37 Apollinaire, Guillaume, 354, 379, 395, 397, 400, 402 article on Matisse, 398-401 Aragon, Louis, 79, 364, 400 Architectural Record (journal), 403 Arezzo, 395 Armory show (1913), 386 Arpino, Rosa, 362, 362, 363 "Artistes Roussillonais," 308-9, 374, 392 artistic originality, theory of, 166-7 Audierne, 105 Austen, Jane, 328 Avenir de Seine et Marne, L' (newspaper), 150, 153, 175 Axilotte, Alexis, 371

Baignières, Paul, 109, 113 Bals des Quat'z'Arts, 64, 74–5 Banque Vassaux, 20 Banyuls, 299, 310 Barr, Alfred, 236, 254 Barye, Antoine Louis, 200 Jaguar Devouring a Hare, 200, 201, 213, 214 Bateau Lavoir, 353 Baudelaire, Charles, 84, 144, 177 Les Fleurs du Mal, 117-18, 139 "L'Idéal," 118 "L'Invitation au voyage," 293-4 Matisse's interest in, 117-19 "Moesta et errabunda," 139 "Les Phares (The Lighthouses)," 118 Baudrey, Paul, 65 Bausil, Louis, 314, 327, 375, 392 Beaux-Arts system, 50-1, 58, 62-4, 69-70, 72, 146 practical advantages of, 67, 146 Beaux-Arts theory, 69, 88, 112 expounded by Goupil, 46-7; by Degrave, 50-1, 58; by Bouguereau, 66 rebelled against by Evenepoel, 69, 108-9, 144; by Matisse, 71, 96, 103, 110-12, 123, 128-9, 142, 144; by Moreau, 72, 83, 87-8, 110-12, 144 Beauzelle, 149, 171, 172 Belle-Ile-en-Mer, 100–2, 100, 103, 117–29, 137–40, Berenson, Bernard, 386, 394, 419-20 Berenson, Mrs., 394 Berge, Joseph, 317 Berlin Secession, 378, 401, 421-2 Bernard, Emile, 284 Bernard, Paul, 450n10 Bernardi, François, 301, 306, 320 Bernhardt, Sarah, 109, 119, 131 Bernheim-Jeune gallery, 328, 329, 370, 375, 382, 393, Besson, Georges, 81 Beuzec, 104

Bevilacqua (Pignatelli), 213–15, 214, 224, 225, 242, Bréal, Louise, 267 265, 377, 382, 408 Bréal, Michel, 267, 267 Biette, Jean, 191, 225, 373, 382, 406, 420 Brébion, Paule, 197 Matisse's letters to, 255, 259-60, 261 Bretons, 100-1 Billy, André, 43, 71, 274-5 Brittany, 99-107; see also Belle-Ile-en-Mer Biskra, 358-60 Bruce, Patrick Henry, 377, 406, 408 Bitumenism, 105, 106 Buck, Pearl Bizet, Georges, 84 The Patriot, 60, 255-6 Blake, Vernon, 191, 192, 193-4 Buffon, Comte de, 200-1 Buit, Henri du, 152-3, 184, 238, 265 Blanche, Jacques-Emile, 84, 109, 371 Bulot, M., 239 Blanqui, Auguste, 329 Bloomsbury intelligentsia, 267 Burgess, Gelett, 307, 397, 403, 404 Bohain-en-Vermandois, xix-xx, 6, 7-11, 7, 11, 14, Burlington Magazine, 414 24-8, 30, 326, 43017 Bussy, Albert Simon, 88, 89, 92, 114, 117, 127, 133, 134, attitudes toward Matisse, 248-9 143, 146, 188, 258, 267, 267, 294, 332 Matisse's return in 1903, 247-9, 250-1, 253-6, 263 art of, 89-90, 259 Matisse's visits, 114-15, 204-5 background of, 89, 90 Bohéries, 261-2, 452n115 critical acclaim, 132 Bonaparte, Joseph, 163 Matisse's letters to, 241, 251, 254, 255, 256, 257, 258, Bonnard, Pierre, 395 261, 267, 268, 272, 320, 330 Bonnat, Léon, 52, 53, 72, 84, 111 Matisse's portrait of, 131, 131 Boudin, Eugène, 79, 185 Matisse's relationship with, 90-1, 132, 257-9 Boudot-Lamotte, Maurice, 74, 85, 86, 143, 179, 180, personal qualities, 90 188, 191, 192, 195, 200, 210, 211, 224, 233, 328, Self-portrait, 91 420, 4361157 Matisse's work with, 244 Cabanel, Alexandre, 308, 310 Cabanne, Pierre, 367 Self-portrait, 245 Bouguereau, William, 55, 60, 72, 87, 131 Caesar, Julius, 8 art of, 63-5 Cahey, Mme, 248 Matisse's contacts with, 63, 65-6, 67-8, 69 Cabiers de Mécislas Golberg (periodical), 221, 397-8, Self-portrait, 64 400 The Wasp's Nest (Le Guêpier), 65, 65 Caillebotte, Gustave, 134-5 Bourdelle, Antoine, 228, 259, 260, 263 Calmel (Gauguin patron), 314, 315 background and personal qualities, 216-18 Camillo, Giuseppe di, 192 Crouching Warrior with Sword, 219 Camoin, Charles, 85, 273, 295, 298, 300, 302, 316, 341, Golberg and, 220, 221 355, 362 Herakles Archer, 219 background of, 198 Maillol and, 312 Cézanne's influence on, 209-10 Matisse's work with, 216, 219, 221-2, 448n115 Self-portrait, 201 Mécislas Golberg, 220 threesome of Matisse, Camoin, and Marquet, Montauban Monument, 218-19, 312 197-200 Rodin, 219 Campbell, Thomasina, 159, 161-2 Self-portrait, 221 Canigou mountain, 309-10 Self-portrait in His Studio, 217 Capella family, 253, 452n76 studio of, 218 Carco, Francis, 331, 332, 381 Boussac, M., 183 Carmelina (model), 268 Boutiq, Jacques, 153, 154, 241, 246 Carolus-Duran, 122, 241, 451n23 Boutiq, Noélie (Nine), 153-4, 241, 266 Caron, Henri, 58 Bouvier, Léon, 45, 46 Carracci, Annibale Swiss Chalet with Pine Trees, 45, 45 The Hunt, 109, 114 Brancusi, Constantin, 215 Carrière, Eugène, 48, 50, 113, 192, 193, 277 Braque, Charles, 341 art of, 192-3 Braque, Georges, 341, 401, 403, 419 Bourdelle and, 216, 217 Bréal, Auguste, 90, 257-8, 258, 267, 4521102, 4531136 Matisse's ridicule of, 210 Bréal, Henri, 267 Matisse's work with, 193-4, 211-12 Bréal, Hermine, 267, 267 Salon d'Automne and, 260

Corsicans, 160, 161, 163 teaching career, 192, 193-4 Cour Batave, 5, 28, 429n5 turning point in his life, 197 Cousturier, Lucie, 283, 284-5 Carrington, Dorothy, 168 Couturier, Philibert Léon, 55, 60, 436n57 Casals, Pablo, 350 Rooster and Hens on the Steps, 56 Casimir-Périer, Jean, 152 Crawford, Robert Henry, 173, 237-8, 239 Cassatt, Mary, 134, 385 Croizé, Emmanuel, 52-3, 57-8, 60, 72, 97, 255 Cassirer, Paul, 378, 421 Matisse's training with, 53-4, 55-7 Catalans and Catalonia, 299, 305, 317, 354, 374 Spartan Girls Wrestling, 57 Cattui, Elie, 238 Cross, Henri Edmond, 280, 283, 286, 294, 331, 392, Cézanne, Mme, 146 Cézanne, Paul, 60, 64, 67, 73, 134, 135, 178, 180, 210, 416, 4451169 art of, 287-91, 292-3, 338 The Evening Breeze, 292 The Blue Vase, 190 The Farm, Evening, 290 colour sense, 284 The Farm, Morning, 290 death of, 371 Matisse's relationship with, 285, 286, 288-9, domination of Paris art scene, 190, 372 on line and colour, 321 321-3, 333 personal qualities, 285-6 Matisse's work, influence on, 200-10 Portrait of Mme Cross, 287, 287 Moreau, assessment of, 190 Société des Artistes Indépendants and, 272 persecution of, 250 Cross, Irma, 287, 288, 322, 392 Portrait of Ambroise Vollard, 275 Cubism, 419, 420 retrospective of 1907, 402 Cutsem, Louis van, 58, 63, 190 Three Bathers, 180-2, 181, 187-8, 190, 209, 210, 250, 329, 409 Dameron, Marguerite, 182, 206 Champaigne, Philippe de, 196 Dantan, Paul, 240 Chardin, Jean Baptiste, 71, 196 Daudet, Alphonse, 165-6 The Pipe, 85-6, 87 Daurignac, Emile, 238, 239, 264, 265 The Skate (La Raie), 86 Daurignac, Guillaume, 172 Charles V, Holy Roman Emperor, 13 Daurignac, Maria, 239 Chêne Brulé (Blasted Oak), 8-9, 253 Daurignac, Romain, 154, 238-9, 265 Cirque Medrano, 17, 197 Degas, Edgar, 64, 84, 88, 132, 183 Claretie, Jules, 240, 265 Degrave, Jules (b. Patrouillard), 50-2, 51, 57, 58, 72, Claudel, Camille, 215 Clemenceau, Georges, 150-1, 153, 176, 189, 329, 391, Delacroix, Eugène, 67, 176-7, 355 The Abduction of Rebecca, 196 Clément, Marie, 42 Delectorskaya, Lydia, 307, 353 Cocteau, Jean, 408 Denis, Maurice, 176, 297, 340, 370, 375 College of Le Cateau, 22-3, 431nn75 and 84 Dépêche, La (newspaper), 175, 176 Collioure, 298, 308, 320 Derain, André, 38, 192, 197, 207, 211, 225, 233, 278, light and colour in, 299-300 296, 328, 354, 368, 372, 376, 387, 392, 393, 403, Matisse's stay (1905), 299-326 Matisse's stays (1906-7), 360-9, 372-5, 389-92, African art, interest in, 355, 371-2 Amélie Matisse's discovery of, 294-5 art of, 195-6 The Funeral, 195 colour theory, 50, 176-8 in London, 356-7 Combes, Emile, 240 with Matisse in Collioure, 316-17, 319-21, 323-4, Concerts Harcourt, 76 325-6 Cone, Claribel, 334, 350-1 Matisse's letters to, 316, 358 Cone, Etta, 350-1 Matisse's portraits of, colour fig. 22, 317, 318, 324 Congolese Vili figure, 371, 371 Matisse's relationship with, 195-6, 316, 357, 360 Constantine, 358 Portrait of Henri Matisse, colour fig. 21, 324, 334 Coquiot, Gustave, 224 repudiation of Matisse's art, 416-17 Cormon, Fernand, 178-9 Vlaminck and, 223 Corot, Camille, 60-1, 67, 96 Derieux, Maître, 48, 54-5, 97 Corsica, 156-7, 158-69 Désossé, Valentin le, 328 light and colour in, 167-8

Desvallières, Georges, 113, 135, 331, 421 death of, 136, 189-90 de Ward, Mlle, 406, 409, 410 Man in Red, 109 Dezoteux, Maître Alfred, 40, 432137 Matisse's assessment of his work, 143-4 Diaghilev, Sergei, 296 on Matisse's Corsican paintings, 168-9 Dick, Hermann, 267 on Matisse's Dinner Table, 133 Divisionism, 46, 208, 295 Matisse's relationship with, 107-8 Cross' work in, 287-8, 289-90 La Petite Matisse, 94, 95, 117 Matisse's work in, 177-8, 283-5, 293-4, 303, 315, Self-portrait at the Easel, 108 321, 329-30 Société Nationale des Beaux-Arts, election to. political content, 292 109-11, 114 Signac's views on, 176, 281-2, 315 La Vieille Maguerelle, 108 Donato (Alfred Odonat, hypnotist), 30-2, 32 Dongen, Kees van, 228 Fabre, Maurice, 296, 315, 355, 369 Douglas, Lord Alfred, 359 fairs and festivals, 16-17 Dreyfus, Captain Alfred, 183, 239, 264 Falguère, Abbé, 299 Druet, Eugène, 227, 290, 328, 330, 356, 375, 416, 420 Faure, Elie, 38 Matisse's shows and sales with, 340-1, 369-70, 413 Faure, Félix, 152 Duccio, Agostino di, 395 Fauvism, 234, 366, 367, 387, 401, 402-3, 419, 421 Duconseil, Maître Théodore, 41, 433n46 first use of word, 332 Dufy, Raoul, 297, 370 origins of, 166 Dumas, Fernand, 314 Fayet, Gustave, 315, 327, 355-6, 356, 369, 370, 371, 374, du Maurier, George 4591159 Trilby, 102-3, 200, 242 Fénéon, Félix, 282, 291, 294, 327–8, 329, 335, 375, 393 Dumay, M., 248 Ferrier, Gabriel, 68, 69 Dumoret, M., 238 Fesch Museum, 162-3 Dumort, Maître, 242, 265 Flam, Jack D., xxi, 254 Duncan, Isadora and Raymond, 350 Flamant, Emile, 24-5, 42, 43, 249 Durand-Ruel, Paul, 131, 132, 134, 135, 215 Bohain town hall fresco, 25 Duthuit, Georges, 207, 323, 324 Flanders and the Flemish temperament, xix-xx, 13, Duval, Mathias, 212, 213 33, 69, 108-9, 144 Duveen, Joseph, 394 see also Matisse, as Flemish painter Flandrin, Jules, 89, 114, 142-3, 170, 178, 184, 185, 232, Ecole des Arts Décoratifs, 80, 89, 93, 202 Ecole des Beaux-Arts, 37, 49, 62-3, 64, 178-9 Marval and, 225-6, 227, 228 Matisse's failure of entrance examination, 69, 80 Marval Reading, 227 Matisse's work in Moreau's studio, 72, 80, 95-6, My Portrait, 226 112-13, 145-6 Flaubert, Gustave, 166, 197-8 prize for Matisse, 117 Flayelle, Paul, 34, 39, 60 see also Beaux-Arts system Fleury, Elie, 97-8, 102 Ecole Gratuite de Dessin Quentin de La Tour, Florence, 393-4 49-52, 58, 73 Fontaine, Fernand, 142, 204 Ehrman, Therese (later Jelenko), 351, 382, 461n21 Forain, Jean-Louis, 210 El Kantara, 358 Francq, Joseph, 23, 431n86 Ellissen, Maurice, 273, 274 Freemasonry, 175-6, 445n61 Eugénie, Empress, 239 Frémiet, Emmanuel, 122 Evenepoel, Edmond, 93, 110, 136 Freycinet, Charles de, 152 Evenepoel, Henri, 72-3, 87, 88, 89, 91, 93, 107, 113, Frizon, Fernand, 58 116–17, 130, 131, 132, 134, 135, 136, 139, 143, 185–6, Fry, Roger, 394 267, 277, 358 Fuzié, Guillaume, 171 art of, 108-9 background and personal qualities, 108 Gaîté de Montparnasse, 74, 192 Beaux-Arts system, revolt against, 69-70, 111-12 Gandara, Antonio de la, 201 The Cellar of the Soliel d'Or in the Latin Quarter, 111-12, Gaubert, Mme, 174, 175 112, 117, 136 Gauguin, Paul, 113, 126, 127, 188, 192, 274, 277, 342, Christ Crowned by Thorns, 109 355-6

aesthetic of, 314

conservatism, retreat to, 143-4

Guillaume, Hippolyte, 126 Matisse's attitude toward, 105-6, 314-15, 356 Guilliaume, Louis Joseph, 20, 42, 204, 229, 251 Monfreid and, 313-14 Guitry, Lucien, 243, 243 Noa-Noa, 356 popularity with younger artists, 371-2 Hadamard, David, 183 wooden sculpture, 314-15, 355 Hanotaux, Gabriel, 13, 14, 34, 35, 38, 40, 43, 44, 71 Gautier, Théophile, 63 Harcourt, Comte d', 76 Geffroy, Gustave, 138 Heem, Jan Davidsz de, 96, 118, 133 gender relations, 42-3 Dessert, 87, 132, 437n123 Genet, Jean, 94 Henner, Jean-Jacques, 241, 451n23 Gérard, Benoît Elie, 5, 6 Heymann, Emile (Père Sauvage), 371 Gérard, Emile (elder), 5, 6, 115-16, 155, 260 Hippolyte, Cousin, 39-40, 41, 79, 103, 134, 135, scandal and ruin, 230, 449n166, 452n117 Gérard. Emile (younger), 6, 12 Hoffbauer, Charles, 107 Gérard, Ernest and Lucia, 115, 439n76 Hokusai, 224 Gérard, Henri, 33, 40, 433n38 Hôtel de la Gare (Collioure), 300-1, 319 German invasion of France (1871), 9-12, 9, 22, 58 Huc, Arthur, 175, 176, 232, 239, 240, 265, 315, 392, Germany, 416, 421-2 Gérôme, Jean Léon, 50-1, 57, 72, 84, 111, 112, 131, 134 Huchet, Père, 125 Gide, André, 147, 259, 340, 359, 371 Huichlenbroich, Joseph, 136 Giotto, 393, 395 Huklenbrok, Henri, 106, 107, 108, 110, 117, 119, 133, Gloaguen, Mme, 104 135, 136, 189, 190, 438131 Golberg, Mécislas, 186, 197, 202, 209, 218, 219, 220, Humbert, Eve, 152, 239 260, 399, 408 Humbert, Frédéric, 149, 152, 154, 155, 185, 264 aesthetic of, 219-20, 221 artistic pursuits, 184-5 appearance of, 220-1 final years, 265-6 articles on Matisse, 397-9, 400 financial situation, 184 Bourdelle and, 220, 221 political career, 150, 153 death of, 221, 398, 400 threats against, 174-5 as father, 186 wedding, 173 Matisse's relationship with, 221 see also Humbert Affair modelling by, 220-1 Humbert, Frédéric, Jr., 238 La Morale des lignes, 462n84 Humbert, Gustave, 149-50, 152, 172 Golden Lion Hotel, 6, 30, 30 Humbert Affair and, 239-40, 450n16 Goncourt, Edmond de, 192 Humbert, Paul, 450n11 Goésol, 354 Humbert, Thérèse, 152, 264, 265 Goupil, Frédéric, 46 Crawford inheritance, 173, 175, 234-5, 238, 239-40 General and Complete Manual of Painting in Oils, 46-7, early years, 172-3, 445n45 48 expensive tastes, 183, 184 Gowing, Lawrence, 177 final years, 265-6 Goya, Francisco de, 70-1 financial situation, 184 Age, 71 promissory system, 183 Time (The Old Women), 71, 435139 social-political connections, 152-3 Youth, 71, 435139 threats against, 153, 174-5 Goven, Jan van, 79 wedding, 173 Grande Maison des Modes, 153-4, 182, 241, 266 see also Humbert Affair Grande Revue (journal), 421 Humbert Affair Green, Andrew, 352 financial disaster, 237-8, 242, 248 Greffuhle, Comte de, 153 Humberts' arrest, 245-6, 247 Greffuhle, Comtesse de, 131 Humberts' confrontations with Armand Parayre, Grotte de L'Apothicairerie, 124 Groux, Henri de, 107, 215, 438n32 Humberts' disappearance, 237, 239 Christ aux outrages (Christ Jeered and Spat At), 107 Humberts' trial, 264-5, 264 Zola Jeered and Spat At (Zola aux outrages), 183 long-term effect on Matisse family, 417-18 Grünewald, Isaac, 419 Matisse's involvement, 237, 246-7, 264-5 Guérin, Charles, 258, 273, 295 newspaper coverage, 237, 239, 246, 247 Guieysse, Emma, 267

Humbert Affair (continued)
opening of Humberts' safe, 234–5, 234
Parayres' involvement, 234–5, 237, 241–2, 246–7, 265
police investigation, 246–7, 252
popular interest in, 247
public officials' involvement, 239–40, 450n16
violence and mayhem, 238–9, 450nn10, 11
Humbert picture collection, sale of, 240
Huysmans, J.-K., 155–6

Iles Sanguinaires, 163, 166
Illustration, L' (magazine), 332
Impressionism, 57, 65, 87, 126, 135, 176
Institut de France, 64, 146, 201
Intransigeant, L' (newspaper), 150
Italy, 392, 393–5
Iturrino, Francisco, 420

Jacob, Max, 371, 379 Jacquin, Etienne, 155, 238, 239, 242 Jacqz family, 115 Jambon, Marcel, 202-3 James, Henry, 84 Japanese prints, 224-5 Jean, Emile, 36-7, 51, 62, 66, 72, 73, 93 Joblaud, Camille (Caroline), 78, 100, 104, 106, 116, 133-4, 142, 147, 186, 187 appearance of, 77 background of, 77-8 Belle-Ile summers, 122, 123, 137 bohemian days, 77 Matisse's portraits of, colour figs. 1 and 2, 77, 94, 95, 96-7, 113 Matisse's relationship with, 77, 92, 93, 137, 140, Marguerite Matisse's relationship with, 94, 186 pregnancy of, 93, 94 social position, 94 Joblaud, Pierre, 78 Jourdain, Félix, 378, 379 Jourdain, Francis, 223, 269, 282, 321 Jourdain, Frantz, 232, 269, 331, 332, 401 Journal de St-Quentin, 97 Julian, Rodolphe, 66 Justice, La (newspaper), 150, 153

Kahn, Gustave, 291
Kahnweiler, Daniel, 375, 379
Kandinsky, Nina, 342
Kandinsky, Wassily, 341, 386
Kelly, Gerald, 215, 250, 312
Kervilahouen, 118–19, 120–2, 126, 128, 140
Kessler, Count Harry, 313, 386
Knierim, Fräulein, 406
Kropotkin, Pyotr, 291

Krouglicoff, Mlle, 232 Kuprine, Alexander *Yama*, 325

Labori, Maître, 264 labor unrest, 24, 202, 391–2 Lagare, Marie-Vitel, 215, 216 Lancelle, Adolphe, 94, 116 Lancelle, Edouard, 6 Lange, Gabrielle, 197 Laprade, Pierre, 211, 259 Laroche, Hippolyte, 154 La Tour, Maurice Ouentin de

La Tour, Maurice Quentin de, 36, 44, 48 Self-portrait in Pastel, 48

Laurencin, Marie, 15 Laurens, Jean-Paul, 192 Lear, Edward, 167 Le Bars, Mme, 103, 104 Le Cateau-Cambrésis, 3–4, 4, 22–3, 115, 230, 260 Le Glay (art-lover), 360 Le Matelot, Stanislas, 119

Lemire, Gaston, 53–4, 58 Léona (Bussy's mistress), 92

Le Palais, 100, 118 Lépine, Louis, 152, 184, 239 Lescot, Clémence, 18

Lesquielles St-Germain, 256, 261–3 Level, André, 260, 269–70, 273–4, 330 Levy, Harriet, 349–50, 352, 381, 382, 384–5, 386, 403,

Lévy, Pierre, 166 Libre Esthéthique, 341 Linaret, Georges Flores

Linaret, Georges Florentin, 179–80, 188, 195,

446n89 Lipchitz, Jacques, 215 Loncq, Jules and Sidonie, 41 London, 356–7, 414 Matisse's visit, 155–6 Longstaff, John, 123 Lorgeoux, Georges, 77 Lorrain, Claude, 179 Loti, Pierre, 359 Loubet, Paul, 239

Louvre, 79, 85–7, 179, 195–6, 200, 279 Luce, Maximilien, 291, 295, 309, 338, 392, 4451169

art of, 208
Portrait of Henri Edmond Cross, 286
Self-portrait, 209
Lycée Henri Martin, 34–8, 35, 208

MacKnight, Dodge, 122 Maclaren, Ottilie, 213–14, 215, 217 Madagascar, 154 Mahieux, Edgard, 11, 20 Mahieux, François, 6 Mahieux, Joséphine, 30, 31–2

Maillol, Aristide, 215, 305, 308, 313, 315, 362, 373–4,	Martel, Eugène, 89–90, 89, 91, 131, 132, 146, 249, 258
386, 409	martial culture of France, 10–12, 11, 43
L'Action enchaînée, 329	Martin (banker), 183
art of, 311–12, 313	Martin, Henri, 11–12, 34, 40, 44
background and personal qualities, 310—11	Marval, Jacqueline (Marie Vallet), 170, 225–8, 227,
married life, 312–13	231, 232, 341, 449n152
La Méditerranée, 311-12, 311	Marx, Roger, 111, 114, 232, 273, 295, 331
Terrus and, 310	Matisse's relationship with, 278
Woman with a Crab, 412	personal qualities, 277–8
Maillol, Clotilde, 312–13, 313	Massé, Lili, 252, 253
Mainssieux, Lucien, 226	Massé, Mother, 18, 19, 252-3, 430n65
Mallarmé, Stéphane, 192–3	Mathieu, Pierre-Louis, 87
Manach, Père, 232	Matin, Le (newspaper), 246
Manet, Edouard, 113	Matisse, Amélie Noélie Parayre (wife), 130, 150,
A Bar at the Folies-Bergère, 103	204, 248, 250, 252, 256, 268, 279, 316, 339, 346,
Manguin, Claude, 367	353, 407, 408, 418
Manguin, Henri, 95–6, 143, 188–9, 228, 254, 272, 273,	appearance of, 148
278, 295, 296, 298, 302, 315, 316, 322, 327, 329,	birthplace of, 171
	butterfly incident, 29, 170, 181
341, 352, 354, 362, 373, 374, 375, 415, 420	in Collioure, 305, 306–7, 313, 317, 319, 320, 360, 362,
art of, 367, 368–9	363, 366, 369, 374, 390, 392
background of, 80	Collioure, discovery of, 294–5
Head of a Faun, 366–7	in Corsica, 159, 161, 165–6
with Matisse in Collioure, 366–8	education of, 150, 151
Matisse's letters to, 247, 259, 265, 271, 280, 284,	hat-pinning technique, 346–7
293, 301, 305, 337, 346, 357–8, 359, 360, 363,	hat-shop business, 153–4, 182–4, 241
368–9, 390–1, 392, 393, 416, 419	
Matisse's relationship with, 80, 82, 367, 415	Humbert Affair, 241, 246
painting technique, 81	in Italy, 393
personal qualities, 82	Marquet's portrait of, 207
Self-portrait, 367	Matisse's friends and, 205, 319–20
Standing Nude, 346, 366	Matisse's insomnia and, 233, 324–5
Steins and, 345	Matisse's portraits of, colour figs. 7, 20, and 24,
Manguin, Jeanne, 320, 362, 366, 367–8, 369	164–5, 171, 206, 242, 306–7, 306, 330–1, 335, 363
Manguin, Lucile, 268	Matisse's relationship with: companionship while
Manguin, Pierre, 366, 367	painting, 165, 233; importance of, 207, 307;
Maori carvings, 357	liberating and strengthening support of, 161,
Marie, Paul, 52-3, 58-9	181, 231, 333-4; first meeting, 147-8; honey-
Marquet, Albert, 89, 95-6, 107, 132, 133, 143, 146, 169,	moon, 155, 156; mutual attraction, 148, 155;
170, 177, 181, 188, 189, 197, 201, 224, 228, 232,	partnership aspect, 205–7, 335; wedding, 154–5;
272, 273, 279, 295, 296, 298, 315, 316, 321–2, 327,	work routine, 161
329, 341, 362, 368, 369, 407, 415, 419, 420	Marguerite Matisse's acceptance by, 186-7
background, 80–1	as mother, 206
Cézanne's influence on, 209	mother's death, 417
The Handcart, 199	pregnancies of, 170, 187
jobbing painter, work as, 202-3	rebellious instincts of, 151–2
Matisse Painting in Manguin's Studio, 297	sacrifices of, 159, 181–2, 205, 420–1
Matisse's letters to, 250, 259, 265	in St-Tropez, 284, 288
Matisse's portrait of, 368	sales of Matisse's work, 333-4
Matisse's relationship with, 80, 81-2, 415	Matisse, André (Auguste's son), 326
Matisse's work with, 224, 225	Matisse, Anna Gérard (mother), 3, 4, 10, 23, 33, 40,
painting technique, 81	45, 97, 115, 137, 204, 204, 206, 229, 229, 253, 255,
personal qualities, 81, 82	266, 326, 327, 389, 390, 391
portraits of Matisses, 207, 297	appearance of, 5
threesome of Matisse, Camoin, and Marquet,	Bohain, move to, 6, 430 <i>n</i> 7
197–200	Matisse's move to Paris (1891), 58-61
Marquet, Marcelle, 202, 227	Matisse's relationship with, 14-15

Matisse, Anna Gérard (mother) (continued) creative crisis of 1905, 316, 321-3, 324-5 Matisse's work, attitude toward, 330 division, central to his nature, 29-30, 75, 82, 222, painting by, 15 338, 381 Matisse, Auguste Emile (brother), 12, 20, 23, 39, 180, dress of, 353-4 203, 204, 206, 251 education of, 21, 22-3, 34-7, 38, 39, 431175 marriage of, 229-30, 231 "Essitam" signature, 46, 47 Matisse, Emile Auguste (brother), 12 family support system, 5, 61, 327, 336, 367 Matisse, Henri Emile Benoît, colour figs. 21 and 23, as father, 14, 43-4, 254, 256, 268, 336 23, 33, 62, 89, 99, 130, 191, 218, 236, 258, 297, 339, financial situation, 93, 116, 200, 229-31, 241, 256, 278, 302, 328–9, 334–5, 342, 354, 420–1 abandonment of painting, on the verge of, 182, first communion, 253 250, 254-5 as Flemish painter, 47, 103, 106, 108, 124-5, 128, 144 adolescent years, 34-46 on freedom, 66 aesthetic of, 27, 292, 314, 397-8, 408, 414, 422-3; in Germany, 416, 421-2 see also luxury, concept of Goya revelation, 70-1 African art, interest in, 354-5, 371-2 handwriting of, 49, 271 in Algeria, 355, 357-60 health problems, 14, 38, 39, 43, 44-5, 139-40, 242, ambition to be a clown or actor, 17, 38, 39, 40, 333, 247-8, 433n55; see also insomnia horse-riding, 17, 22 anarchism, experiment with, 12, 74-5, 209, 303 hypnotist, encounter with, 30-2 anatomical expertise, 212-13, 409 imitators, attitude toward, 402-3 appearance of, 42, 148, 179 impression made by, 191 army rejection by, 43, 433n55 insomnia, 15, 233, 324-5, 390; onset of, 139 art, fundamental shifts in, 167, 338, 378, 384, 397, in Italy, 392, 393-5 job-hunting, 178, 179, 182, 200–1, 202–3, 207, 231, artist, development as, 3, 44-6, 66, 86, 97, 278, 267-8.334 325; see also Matisse, Henri, work of: freedom; as joker and humourist, 17, 53, 74, 195, 207-8, personal style, development of; working 210-11, 415 methods as lawyer's clerk, 40-1, 48-9, 54-5, 325, 433n46 art training: Académie Julian, 65-9; with Bourin Lesquielles St-Germain, 256, 261-3 delle, 216, 219, 221-2, 448n115; Croizé's acadin London, 155-6 emy, 53-4, 55-7; early lessons in Bohain, 14; low point of 1903, 250-1 Ecole des Arts Décoratifs, 80, 93; Ecole luxury, concept of, 27, 79, 338 Gratuite de Dessin Quentin de La Tour. marriage of, see Matisse, Amélie Parayre 49-52, 58; Louvre copying, 79, 85-7; Lycée martial upbringing, 10-12, 43 Henri Martin, 35-7; with Moreau, 72, 80, mimicry, talent for, 17-18, 64-5, 223, 274 95-6, 112-13, 145-6; self-development promistress of, see Joblaud, Camille gramme, 46-8 music, love of, 20, 21-2, 53-4, 74, 76, 107, 195, 410 Belle-Ile summers, 100–2, 117–19, 121, 123–9, 137–40 naming of, 4 birth of, 3-4 nature, affinity for, 8 birthplace of, 4, 429n2 neatness and punctuality, 75, 353-4 in Bohain (1903), 247-9, 250-1, 253-6 nervous tension, 285, 324-5; see also health probin Brittany, 99–107; see also Belle-Ile summers lems, insomnia butterfly incident, 29, 170, 181, 421 North, man of the, 12, 74, 138, 190, 338; see also childhood years, xix-xx, 5, 8-32 Flanders and the Flemish temperament children's artwork, interest in, 361, 379 open house in his studio, 405 "collector syndicate" scheme, 257–8, 259–61, 263, outcast status, 58-9, 61, 81, 136-7, 143, 148, 179, 4521102 185, 204, 230, 248-9, 255, 333, 378 in Collioure (1905), 299-326 parental support, withdrawal of, 59, 70, 72, 136, in Collioure (1906-7), 360-9, 372-5, 389-92, 395-6 229-31 colour, love of, 14-15, 29, 123, 128, 144-5, 164, Paris, move to (1891), 58-61 176-8, 225, 284, 322, 338 popular songs, love of, 29, 53, 74, 143, 195 commercial success, rejection of, 146, 278-9, 286, portraiture: impulse towards, 97; theory of, xix. 394-5 xx, 48, 410-11, 422-3 in Corsica, 156-7, 158-60 professional painter, sets up as, 184

music-hall performers, drawings of, 197, 224 reputation (false) for dullness, meanness and conventionality, 17, 75, 353-4, 378-9, 381, 418, Notre-Dame series, 233 nude studies of 1900, 194, 196 464nn188 and 180 open door or window imagery, xx, 24, 49, 49, 71, Roman Catholic church, relationship with, 22, 08-9, 125, 144, 305 29, 137, 206 personal style, development of, 97, 132-3, 135-6, saint's day, 16 142-3, 144, 164, 167, 177, 179, 193-6, 210, 213, in St-Tropez, 279-81, 283-95 219, 222-4, 233-4, 284-5, 294, 321-3, 324-5, street life, fascination with, 18, 83, 197-8, 304 337-8, 396-7 student life in Paris, 72-7 Picasso's relationship with, 332, 354, 376, 379-80, studios of, 92, 95, 184, 253-4, 303, 319, 337, 406, 407, 4371145 plumb line, use of, 67-8, 195, 280, 294 in Switzerland, 228-0 postcards, 415 as teacher, 406-10 pottery, 317, 369, 387-8, 401 textiles, love for, 27, 78-9, 85, 359, 364-5, 420-1 retrospective show of 1906, 340-1 Three Bathers of Cézanne, purchase and ownership Russell's influence, 126-9, 133, 134 of, 180-2, 187-8, 190, 210, 250, 329, 409 St-Tropez paintings, 283-5, 291, 293-4 threesome of Matisse, Camoin, and Marquet, sales of, 100, 114, 115, 232, 244, 256, 261, 263-4, 267, 107-200 273-4, 278, 295, 297, 302, 329, 333-4, 341, 342, 345, in Toulouse, 170-2, 176-8 348, 356, 369-70, 375, 376, 381-2, 401, 402, 411, 413 tov theatre, 19-20, 29, 170 sculpture, 77, 95, 200-1, 212-13, 215, 216, 219, underclass, contacts with, 24, 202, 391-2 221-2, 313, 363-4, 369, 373-4 as violinist, 20, 21-2, 53, 54, 107, 195 self-portraits of 1900, 222 work ethic, 12-13, 336-7 still lifes of 1906 and after, 364 working methods, 24, 129, 294, 385 textiles in, 27, 364-6, 420-1; see also Algerian rugs younger artists, relations with, 194-5, 196, 233, and toile de Jouy cloth 378-81, 420 Toulouse paintings, 177-8 see also specific persons, organisations, and events van Gogh's influence, 138, 164, 172, 178, 179, 296 Matisse, Henri, work of Matisse, Henri, works by title academic subjects in, 96, 242-4 Albert Marquet, 368 acceptance and acclaim, 97, 112-15, 341, 401, 402, André Derain, colour fig. 22, 324 410-20 Au Luxembourg, 321, 457n94 Belle-Ile seascapes, 138-9, 141, 142, 143, 144, 196-7 Bathers with a Turtle, colour fig. 34, 411-12, 413, 414 Breton landscapes, 106, 107, 137 Belle-Ile (Le Port de Palais), (début de saison), colour ceramics, see pottery fig. 3, 128 Cézanne's influence, 209-10, 422 Belle-Ile (Le Port de Palais), (fin de saison), colour fig. Collioure paintings, 303-4, 305, 306-7, 315, 318, 320-3, 324, 325, 327, 362, 363, 365-6, 372-3, 374, Belle-Ile, Port de Palais, 128, 441n136 389-90, 395-6 Blue Nude: Memory of Biskra, colour fig. 27, 374, Corsican paintings, 164-70, 179, 276-7 375–6, 384–5, 386, 404, 421 critical response, 97-8, 135, 277, 295, 297, 331, Blue Still Life, colour fig. 28, 366 332-3, 340, 370, 396, 414 The Blue Window, 190 cut-paper decorations, 423 Le Bonbeur des peintres, 319, 319 dark period, 236-7, 242-5 Le Bonbeur de vivre (Joy of Life), colour fig. 26, 291, dining room decoration, commissions for, 116, 300, 305, 337-8, 339-40, 341, 342, 346, 348, 354, 386, 414-15, 417, 419 Divisionist works, 177-8, 283-5, 293-4, 303, 315, 362, 375, 383, 411 Bord de mer, 460n64 321, 320-30 Bouquet on a Bamboo Table, 254 as Fauve or "wild beast," 222, 332, 381 flower pieces of 1902, 244-5 Breton Serving Girl (Clotilde), 124-5, 124, 440n119 Breton Weaver, 253 Goya's influence, 70-1 Bussy Drawing in Matisse's Studio, 131, 131 landscapes of 1895, 96 The Cab, 199 Lesquielles paintings, 261-3 Camille with Lemons and Blue Jug, colour fig. 2, 96-7 Louvre copies, 79, 85-7, 109, 179, 196, 200-1, 279, Le Canal de Lesquielles, 262-3, 453n121 Marval's influence, 228 La Coiffure, 383, 389-90, 389, 401

Matisse, Henri, works by title (continued) Mme Matisse and Jean, 206 Collioure (photograph), 298 Male Model (Bevilacqua), 214 Collioure Landscape, 383 Male Singer at the Café-Concert, 198 Copper Beeches, colour fig. 10, 205, 448n59 Marguerite (painting-1901), colour fig. 13, 231 Corsican Landscape, colour fig. 8, 167, 383 Marguerite (painting-1907), 379, 380 The Courtyard of the Old Mill, 170 Marguerite (sculpture), 366 crouching figure (sketch), 310, 312 Marguerite Reading, 363, 366, 460nIII Dance, 304-5, 338, 423 Meditating Monk, 243-4, 273 death mask of Louis XV's gardener (drawing), Model in Pink Slippers, 225 Music, 389-90, 423 Derain Beneath His Beach Umbrella, 317, 318 Music (Sketch), 401 Derain Painting, 317, 318 "Notes of a Painter" (prose work), 166, 220, 221, Devideuse Picarde; see Skein-winder from Picardy 395, 397-8, 408, 414, 421, 422-3 The Dinner Table (La Desserte), colour fig. 6, 132-3, Nu assis dans un paysage, 382, 461n17 135, 136, 276, 278, 415 Nu dans les bois, 382, 461n17 Dishes and Fruit on a Red and Black Carpet, 369, Nude Before a Screen, 347, 348, 352, 383 460nIII Nude in a Folding Chair, 460n64 Dishes on a Table, 342 Nude with a White Towel, 245 Female Singer at the Café-Concert, 198 Nu étendu, 382, 461n17 Femme assise vue du dos, 460n64 Nymph and Satyr, 386-7, 414 Femme dans les rochers au bord de la mer, 460n64 The Open Door, Brittany, 125, 125 Figure à la branche de lièvre, 382, 461n17 The Open Window, Collioure, colour fig. 19, 305, 332 Game of Bowls, 413 Parrot Tulips, 322, 457105 The Gate to Signac's Studio, 284 Path Beside the Stream, 263, 263 The Green Line, colour fig. 20, 306-7, 335, 348, 352 Paysage avec arbres, ou Hêtres pourpres; see Copper Guitarist, 252, 365 Beeches The Gulf of St-Tropez, colour fig. 16, 284, 285, 293 Peach Tree in Bloom, 164 The Gypsy, 348, 383 Personnage dans une crique au bord de la mer, 460n64 half-open door of Maître Derieux's office Pierre Matisse with Bidouille, colour fig. 14, 268 (sketch), 49, 49 The Pig-Minder, 106, 113 Harmony in Red (La Desserte) (formerly Harmony in Pink Onions, colour fig. 32, 373, 378 Blue), colour fig. 35, 415, 416-17, 419, 421, 422, Pont St. Michel, Paris, 383 423, 4311100 Le Port d'Abaill, 195, 303, 303, 321, 322, 329–30 Henri Matisse Etching, 236 Portrait Medallions I and II, 77, 94, 95, 96 Interior with a Dog/The Magnolia Branch, 4311100 Portrait of Greta Moll, colour fig. 31, 410-11, 415, 422 Interior with Aubergines, 300 Profile of a Child (Marguerite), 266, 266 Interior with a Young Girl (Girl Reading), colour fig. Reclining Nude (I)/Aurora, 373-4, 373, 378, 383 La Rêverie, 4311100 The Invalid (Amélie Matisse), colour fig. 7, 165, 168-9, Rocks on Belle-Ile, 138-0 sailing boat (sketch), 304 Iris, 52 Seascape, 138, 141 Jaguar Devouring a Hare (after Antoine Louis Barye), Self-portrait (1900), 191, 222 200, 201, 212-13, 212, 219, 222, 448n15 Self-portrait (1906), colour fig. 23, 373, 378, 383 Landscape at St-Tropez, 460n111 The Serf, 213, 215, 215, 216, 219, 221-2, 383, 405-6 Large Covered Jar, 387 The Skein-winder from Picardy (La Dévideuse picarde), Little Massé, 252, 253 18, 19, 252-3, 270, 430n65 Lobster with Earthenware Jug, 124, 142 Standing Nude (drawing), 69, 70 Lucien Guitry (as Cyrano), 243, 243 Standing Nude (sculpture), 363-4, 364 Luxe, calme et volupté, colour fig. 17, 285, 293-4, 297, Standing Nude (Nu au linge), 372-3 315, 321, 323, 329, 337 Standing Nude Undressing (Rosa Arpino), 362 Le Luxe I, 306, 395-6, 401, 462n76 Statuette and Vase on an Oriental Carpet, 388 Le Luxe II, 396, 396 Still Life in Venetian Red, 421 The Luxembourg Gardens, colour fig. 11, 205, 233-4, Still Life with Asphodels, 401 448159 Still Life with Blue Tablecloth, 365 Mme Matisse, 171 Still Life with Books (My First Painting), 47, 47, Mme Matisse, Rocks, 306 4331169

Matisse, Marguerite Emilienne (Margot) (daugh-Still Life with Bottle, Jug and Fruit, 147, 443n89 ter), 100, 104, 206, 251, 267, 268, 279, 299, 326, Still Life with Chocolate Pot, 383 339, 353, 360, 362, 392, 407 Still Life with Earthenware Pot, 16, 16 baptism of, 137 Still Life with Eggs, 273 birth of, 93, 94 Still Life with Lemon, 356, 460n64 Evenepoel's portrait of, 94, 95 Still Life with Newspaper (My Second Painting), 47-8, as family lynchpin, 187, 335-6 4331169 health problems, 231, 326-7, 372, 450n172 Still Life with Purro, 284, 460n111 Still Life with Red Checked Tablecloth, 261-2, 262 Matisse's art, commitment to, 94, 268, 336 Matisse's legal acknowledgment of, 137 Still Life with Red Rug, colour fig. 29, 365-6, Matisse's portraits of, colour figs. 13 and 25, 231, 460n111 266, 266, 335, 360, 363, 363, 364, 366, 379, 380 Storm, Belle-Ile, 196-7 Matisse's relationship with, 93-4, 186, 231, 380 Studio Interior, 189 Amélie Matisse's acceptance of, 186-7 Studio Under the Eaves, colour fig. 12, 253-4 the North, attitude toward, 253 Swiss Interior (Jane Matisse), colour fig. 9, 228 personal qualities, 93, 336 La Table de marbre rose, 4311100 relationship with her mother, 94 The Terrace, St-Tropez, colour fig. 18, 284 second birthday, 123 Three Bathers, colour fig. 33, 390, 402 years alone with her mother, 186 Toulouse, Pont des Demoiselles, 177 Matisse, Pierre Louis Auguste (son), 71, 206, 266, Tulips, 252, 270 279, 299, 305-6, 320, 326, 326, 360, 367, 392, 407 Vence chapel, 24, 29 as adorable infant, 288-9 View of St-Tropez, 297 artistic pursuits, 336, 361 Woman in a Hat, colour fig. 24, 330-1, 332, 333-4, baptism of, 206 335, 343, 354, 378, 381 Woman in a Red Madras Robe, 401 birth of, 187, 203 dealer, first experience as, 336 Woman Reading, colour fig. 1, 96, 97, 113, 114, 203 health problems, 268 Young Capella, 253 Matisse's art, commitment to, 268, 336 The Young Sailor (II), colour fig. 30, 373, 378 Matisse's letters to, 254, 256, 364 Matisse, Henri Joseph (great grandfather), 4 Matisse's portrait of, colour fig. 14, 268, 360, 366 Matisse, Hippolyte Henri (father), 3, 20, 23, 39, 55, 73, 79-80, 110, 115, 203, 206, 253 naming of, 198 the North, attitude toward, 253 appearance of, 13 seafaring ambitions, 361 Bohain, move to, 6, 430n7 studio life as child, 268 education of, 21 Matisse homes in Paris, 72, 73, 75, 91, 184, 248, garment-industry career, 4-5, 28-9 407-8, 4371145, 4461114 horse-raising, 22 Matisse name, Flemish spellings of, 13, 430n39 Matisse's allowance, cut-off of, 230 Matisse store and home in Bohain, 6, 7, 183-4, 203, Matisse's legal career, 40, 41 229, 253, 43017, 4461109 Matisse's move to Paris (1891), 58-61 Maupassant, Guy de, 161, 167, 197-8, 280 Matisse's relationship with, 14, 21-2, 43-4, 70, 71, artistic originality, theory of, 166-7 93, 255-6, 327 Pierre et Jean, 166, 198 Matisse's work, attitude toward, 135-7 Une Vie, 158-9 seed-merchant business, 6 Maxence, Edgard, 88-9 work ethic, 12 Melun, 150-1, 153, 265 Matisse, Jeanne (Jane) Thiéry (Auguste's wife), Menpes, Dorothy, 104, 105 colour fig. 9, 203, 204, 228, 229 Mérimée, Prosper, 161, 167 Matisse, Jean Baptiste Henri (grandfather), 4, Metthey, André, 387, 388, 401, 462n43 Meyer, Mme, 232 Matisse, Jean Gérard (son), 181, 187, 203-4, 206, 266, Midy, Arthur, 51 279, 299, 305-6, 326, 326, 327, 330, 360, 367, 392, Millet, Jean-François, 79 Man with a Hoe, 349, 352 baptism of, 206 Mirbeau, Octave, 118-19, 132, 311, 313, 328, 329 birth of, 178 Mir Iskusstva (magazine), 296 Matisse's portraits of, 206, 360, 366 Mistinguette, 197 naming of, 198 Modern Art Circle, Le Havre, 341 the North, attitude toward, 253

Moisselin, Thérèse, 42 Ornano, Dominique Cuneo d', 165 Moll, Greta, 401-3, 406, 407, 408, 412, 420, 421, Osthaus, Karl Ernst, 386-7, 401-2, 411, 412, 413, 414 422, 4631100 Ouled-Nails desert tribe, 359 Matisse's portrait of, colour fig. 31, 410-11, 415, 422 Ozenfant, Amédée, 17, 38, 50 Moll, Oskar, 401-2, 406, 407, 463n100 Monet, Claude, 126, 133, 134, 135 Pach, Walter, 376, 378, 386, 395, 397, 402 Moreau's attitude toward, 144-5 Padua, 395 Rocks on Belle-Ile, 135, 138 painters, contempt for in France, 59, 208, 249-50 Monfreid, Daniel de, 313-14, 315, 371, 374-5, 392 Papillon, Mme, 207 Moors, 299, 359 Parayre, Alexandre, 153, 154, 241, 246 see also Algeria Parayre, Amélie Noélie; see Matisse, Amélie Noélie Moreau, Gustave, 55, 74, 87, 95, 130, 135, 156, 180, 195, Parayre, Armand, 151 banking career, 154, 237 art of, 83-4 dueling by, 151, 154 Beaux-Arts system, revolt against, 110-12 as father, 151, 175 Cézanne's assessment of, 190 final years, 266 on colour, 86 financial ruin, 237, 241 death of, 160 Humbert Affair, 234-5, 237, 241-2, 246-7, 265 Evenepoel and, 108-9 Humbert family and, 149-50, 153, 154, 174-5 Hesiod and the Muse, 83 newspaper career, 150, 153 King David, 240 personal qualities, 174 Matisse's Belle-Ile seascapes, reaction to, 142, 143, social reform efforts, 175 teaching career, 149, 154 Matisse's studio, visit to, 100-10 Parayre, Berthe, 148, 149, 150, 151, 153, 154, 162, 206, Matisse's training with, 72, 80, 95-6, 112-13, 145-6 241-2, 251-2, 266, 268-9, 288, 294, 299, 326, modern painting, rejection of, 87-8, 144-5 326, 4431105 personal disappointment, 145 Parayre, Catherine, 149, 206 Puvis and, 113-14 appearance of, 148 Self-portrait, 82 background of, 148-9 studio of, 88 death of, 266, 415, 417 teaching methods, 84-5, 145-6 financial ruin, 237, 241 Morgan, Pierpont, 394 Humbert Affair, 234-5, 237, 241-2, 246, 265 Morosov, Ivan, 412 Humbert family and, 152, 153, 172-4, 185 Moscow, 414 Matisse's relationship with, 174 Moulin de la Galette, 197 personal qualities, 174 Mounet-Sully, Jean, 32 Parayre, Paul, 170 Mouthon, F. I., 237 Patrouillard, Jules; see Degrave, Jules Munch, Edvard, 401 Peau de l'Ours art-buying syndicate, 260, 273-4 Münter, Gabriele, 386 Pechy, Père, 21 Muxart, Mathieu, 301, 306, 316, 319, 320, 323, 324, 326 Péladan, Joséphin, 421 Pelletan, Camille, 151, 239 Nambruide, Eugène, 25, 4311198 Peraldi, Jean-François, 167 Napoleon I, Emperor, 161 Périer, Frédéric, 239 Nation (magazine), 420 Petit, Georges, 131–2, 134, 233, 240, 241, 264 Naudin, Charles, 361 Petit, Jules, 58, 62, 63, 66, 73, 190 Neo-Impressionism, 290, 297, 327 Petit, Paul, 58 end of, 338 Petitjean, Hippolyte, 232 Signac's writings on, 176-7, 281-2 "Petit Quinquin" (song), 29 see also Divisionism Phalange, La (literary review), 399-400 net curtains, 51, 203 Philippe, Charles-Louis, 279 New York, 376, 386, 402, 403, 414 Picardy, 13 Nietzsche, Friedrich, 288 Picasso, Pablo, 197, 274, 300, 305, 314, 331, 332, 335, 353, 361, 399, 401 Olivier, Fernande, 403, 464n188 African art, interest in, prompted by Matisse, 371, Opéra-Comique, 76, 231 fire of 1887, 39-40 Apollinaire as an Academician, 400

Rembrandt, 48, 397 bande (gang) of acolytes, 380-1 Renaissance painting, 323, 394-5 Boy Leading a Horse, 352 Renoir, Pierre Auguste, 132, 420 children's painting, interest in, prompted by Rente Viagère savings bank, 154, 237 Matisse, 379 Republican party, 149-50, 152-3, 239-40 Cubism, 420 Revue Hebdomadaire (journal), 421 Dance with Veils (Nude with Drapery), 404, 404 Richardson, John, 464n188 Les Demoiselles d'Avignon, 379, 403, 420 Rilke, Rainer Maria, 402, 408 as foster parent, 380 Rimbaud, Arthur, 35 Leo Stein Walking, 343 Robinson, Edward G., 24 Matisse's first meeting with, 352-3 Roche, Marie-Dominique, 159-60, 161, 163 Matisse's rivalry with, 354, 403-5, 422 Rochefort, Henri, 150, 216, 250 Matisse's work, attitude toward, 354, 376 Rodin, Auguste, 101, 113, 132, 188, 250, 408 Shchukin and, 420, 464n188 Balzac, 215 Weill and, 232 Barve and, 200 Piero della Francesca, 395 Bevilacqua and, 213 Pinson, Pauline, 170-1 Bourdelle and, 216, 217, 218 Piot, René, 260, 273, 295-6, 331, 334 Carrière and, 193 Pissarro, Camille, 93, 132, 169, 190, 208, 282 Matisse's relationship with, 134-5, 178 Jean d'Acre, 213 Matisse's relationship with, 215 Self-portrait, 135 Russells and, 121, 122 Point, Maurice Quentin St. John the Baptist, 213 Portrait of Jules Degrave, 51 Walking Man, 213 Pointe du Raz, 105 younger artists, relations with, 215-16 Pont-Aven, 105-6 Romani, Juana, 241, 451n23 Pont-Croix, 103-4, 105 Rosenshine, Annette, 352, 382, 385-6, 403, 405, 406, pottery, 317, 326, 387-8 409 see also Matisse, work of: pottery Rothenstein, William, 73, 113 Pous, René and Jojo, 319 Rothko, Mark, 423 Poussin, Nicolas, 86, 144, 196, 210 Rothschild family, 240 primitivism, 371-2 Rouart, Henri, 134 see also African art Rouault, Georges, 80, 84, 88-9, 89, 110-11, 146, 228, Proust, Marcel, 84, 86 Puget, Pierre, 200 Coriolanus in the House of Tullius, 111 Purrmann, Hans, 377, 378, 386, 387, 402, 405, 407, Jesus Among the Doctors, 111 408, 411, 412, 413, 416, 421, 422 Samson at the Mill, 111 Standing Nude in the Studio, 405-6 Rouge, Frédéric, 229 Puvis de Chavannes, Pierre, 113-14, 336 Rousette, Dame, 300-1, 316, 319, 323-4, 326 Victor Hugo Offering his Lyre to the City of Paris, 113 Rouvevre, André, 398, 462n84 Puy, Jean, 170, 188, 191, 192, 196, 197, 205, 209, 216, Roux-Champion, Victor, 103, 117, 124, 128, 142 222, 225, 242, 249-50, 256, 257, 266-7, 278, Matisse's letters to, 101-2, 119, 124, 126, 127, 129 279, 295, 296, 300, 354, 368, 373, 384, 387, 420, Roybet, Ferdinand, 184, 241 4521102 Royère, Jean, 399 Bevilacqua and, 214-15 Russell, Alain, 126 on Matisse's Belle-Ile seascapes, 138-9 Russell, John Peter, 120, 178-9, 281 Matisse's influence on, 194-5 artists' colony, 120 Matisse's work with, 243-5 art of, 123, 127 Self-portrait, 244 background of, 119-20 Puy, Michel, 397, 399, 401 Matisse's art, influence on, 126-9, 133 Py, Ernest, 361 personal qualities, 120-1, 122 Red Sails, colour fig. 4, 123 Raphael The Rocks at Belle-Ile, 141 Balthazar Castiglione, 279, 295 van Gogh and, 119-20, 126, 127, 138 Raymonde (Picasso's foster child), 380 wife's importance to, 147 Rayssiguier, Frère, 140 Russell, Marianna, 120, 122-3, 140, 142, 147, Reboux, Mme, 183 440n110 Redon, Odilon, 84, 88, 356

Russell house, 119, 120 Seurat, Georges, 113, 282, 327 Rysselberghe, Théo van, 282, 285, 328, 338, 445n69 Shcherbatov, Prince Sergei, 414 Signac on His Boat, 281 Shchukin, Sergei Ivanovich, 327, 341-2, 343, 371, 422 Matisse collection, 420 Sadi-Carnot, Marie François, 152 Matisse's relationship with, 411-14, 417 Sahara Desert, 358 Picasso and, 420 Sainsère, Olivier, 278, 302 textile business, 417 St-Amand-les-Eaux, 229, 229 Siena, 395 St-Quentin, 9-10, 9, 15, 33-4, 41, 43, 46, 48, 50-1, 55, Signac, Berthe, 291, 337, 392 58, 85, 203 Signac, Paul, 208, 272, 281, 285, 287, 288, 293, 296. St-Tropez, 279-81, 283-95 297, 305, 322, 328, 419 Salmon, André, 221, 379–80, 398, 411 aesthetic of, 176-8, 281-3, 292, 315 Salon d'Automne, 211, 312, 314, 413 The Age of Harmony, 290-1, 290 1903 exhibition (first), 252, 269-70 break with Matisse, 321, 337-8 1904 exhibition, 295 in Collioure, 300 1905 exhibition, 330-3 From Eugène Delacroix to Neo-Impressionism, 176-7, 1906 exhibition, 367, 369-71 1907 exhibition, 398, 401-3 with Matisse in St-Tropez, 279-80, 281, 284, 1908 exhibition, 419 Cézanne retrospective, 402 Matisse's Luxe, calme et volupté, 329 Gauguin retrospective, 314 personal qualities, 281, 283, 284 Matisse's election to selection committee. politics of, 291-2 The Red Buoy, St-Tropez, colour fig. 15, 281 Salon de la Nationale, 211, 218, 269 Signorelli, Luca, 179 1896 exhibition, 97, 113, 114 Sisley, Alfred, 103 1897 exhibition, 135-6 Slewinski, Wladyslaw, 102 1899 exhibition, 179 Société des Artistes Français, 64 Salon des Indépendants, 196, 309 Société des Artistes Indépendants 1899 exhibition, 190 exhibition procedures, 272 1901 exhibition, 224 founding of, 272 1902 exhibition, 233 Matisse's involvement with, 295-6 1903 exhibition, 251, 252 see also Salon des Indépendants 1904 exhibition, 272-3 Société Nationale des Beaux-Arts, 100 1905 exhibition, 296-7 founding of, 113 1906 exhibition, 339-40 Matisse's election to, 109-11, 114 1907 exhibition, 375-6 see also Salon de la Nationale van Gogh retrospective, 296 Soulier, Paul, 299–300, 301, 307, 317, 338 Salon des Artistes Français, 56, 64, 87, 96 Steer, Philip Wilson, 345 San Francisco, 343, 346, 348-9, 351, 352, 375, 381, 382, Stein, Allan, 349, 351, 351, 384, 392, 402 4591146 Stein, Gertrude, 187, 334, 335, 348, 350, 351, 352, 353, Sand, George, 92 372, 373, 376, 378, 393, 409 Sanderson, Sibyl, 76 The Autobiography of Alice B. Toklas, 381 Sarraut, Albert, 392 background and personal qualities, 343-5 Saulnier, Jules, 115, 155, 203, 260-1, 439179, Matisse's relationship with, 346-7, 381, 403, 4521117 Saulnier, Marie-Louise, 133 Matisse-Picasso rivalry and, 403 Saulnier, Raymond, 115, 452n117 Stein, Leo, 348, 349, 350, 351, 352, 369, 370, 371, 378, Schneider, Pierre, 245, 254, 335 379, 383, 384, 405, 406, 409 Schotmans, Paul, 450n11 background and personal qualities, 342-5 Sée, Léopold, 450n16 Matisse collection, 334, 345, 375, 376, 403, 459*n*33, Seguret et Thabut textile house, 203 Sembat, Georgette, 334-5, 372, 388-9 Matisse-Picasso rivalry and, 354 Sembat, Marcel, 151, 175, 176, 315, 333, 334-5, 366, 370, on Matisse's Blue Nude, 374 387, 388, 392 Matisse's gratitude toward, 347

with Matisses in Italy, 392, 394, 395

Sérusier, Paul, 297

Tschudi, Hugo von, 277, 386 Matisse's relationship with, 345-6, 394 Turner, J. M. W., 155-6, 177, 357 Picasso's drawing of, 343 Stein, Michael, 334, 348, 349-52, 351, 360, 366, 381, 382, 392, 401, 406, 407, 4591133 Ugolino, Count, 213 Union Générale bank, 240 Stein, Sarah Samuels, 351, 360, 366, 377, 392, 393, 403, Universal Exhibition of 1900, 202, 203, 277-8 414, 422, 459133, 4611140 background and personal qualities, 348-50 classes with Matisse, 406, 408, 409 Valenciennes, 52 Valéry, Paul, 180 Matisse collection, 347-8, 373, 375, 378, 381-2, 383, 384, 387, 401, 414, 420, 459133, 4611140 Valloton, Félix, 15, 19 van Gogh, Théo, 46 Matisse's relationship with, 348, 350, 351-2, van Gogh, Vincent, xix, 107, 133, 147, 157, 178, 210, 381-4 281, 282, 283, 314 painting by, 405-6 Les Alyscamps, 180 promotion of Matisse's work, 334, 352, 384-5, 386, L'Arlésienne, 180 419, 420, 4591146 drawings owned by Matisse, 138, 409, 442n43 Stevenson, Robert Louis, 127 Haystacks, 139 Strachey, Dorothy, 188, 257, 267, 267 Matisse's work, influence on, 138, 164, 178, 179, 296 Strachey, Pernel, 267 The Old Peasant, Patience Escalier, 171 Strachev, Pippa, 267 The Round of Prisoners, 296 Suarès, André, 355 Russell and, 119-20, 126, 127, 138 Sur le Trimard (news sheet), 202 van Gogh exhibitions, 222-3, 296 sugar-beet industry, 7, 24 Vannier, Léon, 76, 92 Switzerland, 228-9 Vassaux, Jeanne, 20, 45 Svlva, William Vassaux, Léon, 16, 18, 20-1, 29, 38, 39, 45, 61, 73, 86, Pont-Croix mural, 105 94, 116, 137, 170, 205 Matisse's relationship with, 18-20, 76-7, 204-5 Tagore, Rabindranath, 385 medical practice, 204 Taquet, Gustave, 20, 42, 45, 204, 251 Vauxcelles, Louis, 295, 297, 332, 370, 419 Taquet, Mme, 251 Venice, 394-5 Tavernier, Israël Verhaeren, Emile, 290 Iris, 52 Verlaine, Paul, 76, 92, 138-9 Temps Nouveaux, Les (pamphlet series), 176, 445n69 Terrasse, Claude, 82 Vermandii, 8 Vermeer, Jan, 196 Terrus, Etienne, 309, 314, 315, 317, 346, 369, 374, 375, Veronese, Paolo 392, 396 La Bella Nani, 410–11 art of, 308-9 Villa de la Rocca, 158, 161, 162, 162 Collioure Bell Tower, 308 Villars-sur-Ollon, 228-9 Maillol and, 310 Violet, Gustave, 374 Matisse's relationship with, 307, 309-10, 317, 369, Vlaminck, Maurice de, 196, 225, 233, 276, 296, 316, 375, 392 317, 321, 324, 372, 379, 380-1, 387, 393 personal qualities, 307-8 art of. 223 textile industry, 7, 24-7, 25, 34, 51, 203, 417 personal qualities, 222-3 in Algeria, 359 Vollard, Ambroise, 135, 190, 211, 222, 227, 256, 275, Thénard, Père, 115, 170 314, 328-9, 341, 342, 354, 369, 378, 420, 421 Thenier, Emile, 153, 154, 450n16 background of, 276 Thiéry, Jeanne; see Matisse, Jane business tactics, 274-5 Thieuleux, Germaine, 389, 390, 390 Matisse's business advice for, 296 Third Republic, 150 Matisse's purchase of Cézanne's Three Bathers, 180, see also Republican party Thirion, Eugène, 145 187-8, 190 Matisse's relationship with, 274, 276 toile de Jouy cloth, 364-6, 365, 411, 415 Matisse's shows and sales with, 263-4, 276-8 Toklas, Alice, 346-7, 384 Gertrude Stein and, 344-5 Toulouse, 148-9, 153, 170-2, 175, 176-8, 181, 248 Toulouse-Lautrec, Henri de, 73, 107, 113, 176, 178, Vuillier, Gaston, 167 The Bay of Ajaccio, 158 328

Waldeck-Rousseau, René, 239
war memorials, 218–19
Watbot, Alphonse, 73–4
Weber, Max, 406, 409, 410
Weill, Berthe, 183, 184, 233, 257, 278, 296, 329, 334, 336, 339–40, 370, 413
art dealership, 232
business strategy, 275–6
Matisse's shows and sales with, 232, 275, 302
personal qualities, 231–2
Wéry, Emile, 92–3, 96, 100, 117, 118, 119, 121, 123, 134, 140, 269
art of, 102–3
Desperation, 102, 102

Interior of a Country Café, 103
The Last Rays, 137
photograph of Matisse, 99
Young Breton, 137
Whistler, James Abbott McNeill, 143
Wilde, Oscar, 359
Wine-growers' Revolt, 391–2
Worth, Maison, 155, 4431124

Zilcken, Philippe, 358–9 Zola, Emile, 28, 73, 250 Le Bonbeur des dames, 28 "J'accuse," 183

A NOTE ABOUT THE AUTHOR

~

Hilary Spurling was born in England and educated at Oxford University. She has been theatre critic and literary editor of The Spectator and a regular book reviewer, first for The Observer, then the Daily Telegraph. She lives in London.

A NOTE ON THE TYPE

0

The text of this book was set in Centaur, the only typeface designed by Bruce Rogers (1870–1957), the well-known American book designer. A celebrated penman, Rogers based his design on the roman face cut by Nicolas Jenson in 1470 for his Eusebius. Jenson's roman surpassed all of its forerunners and even today, in modern recuttings, remains one of the most popular and attractive of all typefaces.

The italic used to accompany Centaur is Arrighi, designed by another American, Frederic Warde, and based on the chancery face used by Lodovico degli Arrighi in 1524.

COMPOSED BY NORTH MARKET STREET GRAPHICS,
LANCASTER, PENNSYLVANIA

~

DESIGNED BY IRIS WEINSTEIN